1915, The
CULTURAL MOMENT

1915, THE CULTURAL MOMENT

The New Politics,
the New Woman,
the New Psychology,
the New Art &
the New Theatre
in America

EDITED BY

ADELE HELLER
AND
LOIS RUDNICK

RUTGERS UNIVERSITY PRESS • NEW BRUNSWICK, NEW JERSEY

Library of Congress Cataloging-in-Publication Data

1915, the cultural moment : the new politics, the new
 woman, the new psychology, the new art, and the new
 theatre in America / eds.,
 Adele Heller and Lois Rudnick.
 p. cm.
 Includes bibliographical references and index.
 ISBN 0-8135-1720-6 (cloth) ISBN 0-8135-1721-4 (pbk.)
1. United States—Civilization—1865–1918. 2. Politics and
culture—United States—History—20th century. 3. Arts,
American. 4. Arts, Modern—20th century—United
States. I. Heller, Adele.
II. Rudnick, Lois Palken, 1944–
E169.1.A1126 1991
973.9—dc20 91-6634
 CIP

Design by John Romer

Frontispiece : National Gallery of Art, Washington, D.C.,
Alfred Stieglitz Collection

Constancy, by Neith Boyce, is published by arrangement with
Beatrix Hapgood Faust. All rights, including performance,
broadcasting, and translation, are reserved. There are four
versions of *Constancy* (also called *The Faithful Lover*). TS,
Boyce Papers, Beinecke Rare Book and Manuscript Library,
Yale University.

Suppressed Desires, by George Cram Cook and Susan Glaspell,
is published by arrangement with Baker's Plays, 100 Chauncy
Street, Boston, Massachusetts 02111. Copyright © 1951 by
Walter H. Baker Company. All rights reserved. Originally
published in *The Provincetown Plays*, edited by George Cram
Cook and Frank Shay (Cincinnati : Stewart Kidd, 1921).

Change Your Style, by George Cram Cook, is published by
arrangement with Sirius Cook. All rights, including
performance, broadcasting, and translation, are reserved. TS,
Barrett-O'Neill Papers, Alderman Library, University of
Virginia.

Contemporaries, by Wilbur Daniel Steele. Copyright © 1966
by Wilbur Daniel Steele. Reprinted by permission. TS, Steele
Papers, Stanford University.

Unless lived in part on a higher level of
feeling and responsibility, I do not think
our lives make sense. Here is where art and
politics are one.

MIRIAM HAPGOOD DEWITT
NOVEMBER 29, 1906–APRIL 16, 1990

Contents

Foreword

In June 1987, several hundred people gathered in Provincetown, Massachusetts, to commemorate one of those bursts of creativeness that periodically enliven American cultural annals. The four-day conference they attended focused on the Provincetown Players, the talented group of writers and artists who in 1915 launched a theatrical revolution from their summer base at the tip of Cape Cod.

Conference sessions featured lectures on the political and intellectual context of this "cultural moment." Walking tours of literary and historical Provincetown, videotaped slide shows on the visual arts of the period, and photographic displays of the principal figures combined to re-create the atmosphere of the buoyant 1915 season. The high point, the staging of the first four plays written and acted by the Players three-quarters of a century ago, was enhanced by the presence of six descendants of the Players—Miriam Hapgood DeWitt, Beatrix Hapgood Faust, Peter Steele, Heaton Vorse, Tessim Zorach, and Joel O'Brien—who spoke of their Provincetown memories.

If they are to succeed, promoters of projects such as this conference need to be intelligent, patient, tactful—and lucky. Organizational skill is desirable, of course, but equally important are enthusiasm and resilience, the ability to choose competent coadjutors and to persuade funders that the project is worth doing. Largely owing to Adele Heller and Lois Rudnick, five years of planning, lengthy correspondence, telephone calls, trips to libraries, and laborious consultations have culminated happily in the publication of this volume.

1915, The Cultural Moment can be read as an exercise in humanist archeology, as a model of interdisciplinary collaboration, or simply as a concentrated chapter in literary and cultural history. The rebels who challenged arid artistic conventions and social injustice and channeled their protests in dramatic and visual forms were far from being feckless Bohemians. Rather they were confirming—dramatizing, really—Emerson's belief, apposite to our times as much as to theirs, that "a spirit of cowardly compromise and seeming" ends in "a frightful skepticism, a life without love, and activity without aim." For me, this book is both a celebration of a past event and a reminder that what has often been dismissed as a utopian fancy can have a significant import for later generations.

DANIEL AARON
CAMBRIDGE, MASSACHUSETTS, 1990

Acknowledgments

The idea for this book originated with the conference called "Beginnings: 1915, the Cultural Moment" that took place in Provincetown in June 1987. It was sponsored by Provincetown Playhouse on the Wharf in conjunction with the University of Massachusetts/Boston and made possible in part through grants from the National Endowment for the Humanities and the Massachusetts Foundation for Humanities & Public Policy. The preparation of this book was generously supported in part through grants from the National Endowment for the Humanities and the John Sloan Memorial Foundation, Inc.

There are so many individuals, libraries, galleries, museums, organizations, and educational institutions without whose splendid cooperation this task would have been impossible. We will never be able to thank you enough or list all your names but, nevertheless, we are deeply grateful to all who contributed to this project.

We acknowledge, first, our indebtedness to six individuals who spent time and energy on this book beyond any reasonable expectations: Robert Brown (N.E. Regional Director, Archives of American Art); Earl Davis; Erika Gottfried (Tamiment Institute Library, New York University); Nic Madormo (Archives of American Art); Richard Schmierer (USIA); and Dorothy Swerdlove (Curator, Billy Rose Collection, New York Public Library at Lincoln Center). In addition, Joshua Brown, Bill Cuffe, Yvette de Roche, Emily Farnham, Daniel Heller, Dr. Christian Geelhaar, Donato Moreno, Dale Neighbors, Jan Ramirez, Jennie Rathbun, and Pat Willis were never too busy to give time to this project.

Among the various libraries that extended every courtesy to us in our research, we wish to thank especially the Beinecke Rare Book and Manuscript Library, Yale University; Houghton Library, Harvard University; Library of Congress; New York Public Library (Berg Collection); New York Public Library at Lincoln Center (Billy Rose Theatre Collection); and the Tamiment Library, New York University.

Our thanks are due also to the American Jewish Historical Society; Amon Carter Museum; Archives of American Art, Smithsonian Institution; Art Institute of Chicago; Baltimore Museum of Art; Boston Public Library; Chicago Historical Society; City Lore; Colorado Historical Society; Columbus Museum of Art; Delaware Art Museum; Harriette and Martin Diamond; Dintenfass Gallery; Ben and Beatrice Goldstein; Guggenheim Museum; The Hague Museum; Hirshhorn Museum of Art; Kraushaar Gallery; Lower East Side Tenement Museum; Metropolitan Museum of Art; Munson-Williams-Proctor Museum of Art; Museum of the City of New York; Museum of Fine Arts/Boston; Museum of Modern Art, New York; National Gallery of Art, Washington, D.C.; National Gallery, London; New-York Historical Society; Sophia Smith Collection, Smith College; Philadelphia Museum of Art; Provincetown Art Association and Museum; Françoise and Harvey Rambach; Salander-O'Reilly Galleries; Schomburg Center for Research in Black Culture, New York Public Library; Société Anonyme; Andreas Speiser; Whitney Museum of American Art.

We are indebted to the following people for providing their photographs for the "Family Album" section: Earl Davis, Miriam Hapgood DeWitt, Yvette Eastman, Beatrix Hapgood Faust, Joel O'Brien, Louis Sheaffer, Peter Steele, Heaton Vorse, and Tessim Zorach. For permission to print the plays, we thank Walter H. Baker Company,

Boston, Sirius Cook, Miriam Hapgood DeWitt, and Peter Steele.

Finally, we thank our editor at Rutgers University Press, Kenneth Arnold, for his support and encouragement of this project from its inception to its completion, and the members of his staff, especially Christina

Blake, Marilyn Campbell, and Barbara Kopel.

ADELE HELLER
AND
LOIS RUDNICK
MARCH 1991

1915, The
CULTURAL MOMENT

Introduction

ADELE HELLER
AND
LOIS RUDNICK

In 1900, social philosophers and political scientists in Europe and the United States declared the twentieth century the dawn of a new millennium. It would be a century of peace, marking the end of the political, religious, and economic rivalries and wars that had riddled human history with death and destruction. Western civilization had, they claimed, evolved to a place on the progressive spiral of civilization that made it incapable of accepting the uncivilized barbarities of previous generations.

In the summer of 1915, a small group of men and women from New York City's Greenwich Village, dedicated to creating a millennium of social peace and justice on American shores, faced the paralyzing horror of the Great War, now entering its second of four years. World War I would take thirteen million lives and destroy a generation of young men in Western Europe. It would lay the groundwork for the future wars and revolutions of our century. It would soon absorb the lives and energies of American citizens in a swell of patriotic fervor and hysteria that all but silenced the more rebellious voices among the social, cultural, and political visionaries living in the United States in the second decade of the twentieth century.

In his memoirs, *A Victorian in the Modern World*, Hutchins Hapgood tells us that the summer of 1915 began in despair for the Greenwich Villagers who had made their annual pilgrimage to Provincetown,

Massachusetts: "All existing theories had been shown to be impotent. The sweet creative impulses of peace were no more. Individuals had stopped their spiritual existence. All were waiting. Lives were vacant." It was during this period of hopelessness that the Provincetown Players, dedicated to creating a new kind of theatre in the United States, was born. "The Provincetown movement was, in part," Hapgood tells us, "a social effort to live again—spiritually, to recover from discouragement and disappointment, to be free of the poison of self and the poison of the world."[1]

This "cultural movement" of creativity inspired the conference held in Provincetown in the summer of 1987 out of which this book of essays has grown. The conference was intended as a public celebration of the "little renaissance" in American culture that fostered the birth of the Provincetown Players. Conference participants examined the issues that informed the themes of the first four plays written and produced by the Players in July and September of 1915.

These issues, each of which has had a profound effect on the course of twentieth-century American society and culture, are the focus of our book. We examine the impact on American culture of progressive and radical politics, feminism, psychoanalysis, Postimpressionism, and the beginnings of modern theatre, employing the terms used by the generation of 1915 to define and differentiate themselves from the American past: the New Politics, the New Woman, the New Psychology, the New Art, and the New Theatre. By treating each of these movements in its own right, as well as exploring the cross-fertilization of ideas that influenced them all, we offer the reader a multifaceted lens through which to view American life at a crucial cultural watershed.

The men and women who helped to define and shape these movements were part of the first generation of Americans to respond to the human costs of our emergence as a major urban industrial power and world empire.

Their visions of a "new" America ranged from moderate to radical. But fundamental to all of them was their belief in the power of individual creative effort to reshape self and society and the power of cultural expression to humanize American life. These early twentieth-century intellectuals, writers, artists, and activists tried to address many of the questions that are still facing their descendants at the latter end of the century. How do we create a just and democratic society that allows for individual liberty while protecting the collective well-being? How do we establish a socioeconomic system that respects individual initiative but also empowers workers, women, and minorities to achieve their fair share of the national wealth that they produce? How do we create a body of art, literature, and cultural criticism that responds to personal vision but also speaks to more than an academic elite and privileged few? How do we build a vital national culture that at once provides a coherent source for our identity and incorporates the sometimes conflicting cultures of men and women and of diverse ethnic and racial groups?

In order to answer these questions, we must first look at what life was like for Americans in the first twenty years of the twentieth century. Although the gross national product and per capita income doubled between 1880 and 1920, wealth was very unevenly distributed. One-third to one-half of Americans, including a majority of people of color, lived in poverty, or so close to it that they were pushed over the line any time they suffered extended illnesses or industrial accidents—in which the United States led the world. Women and most of the nation's racial minorities were disenfranchised.[2]

The ruthless exploitation of human and natural resources created among some segments of the middle and upper classes what one historian has called "the Revolt of the American Conscience." Progressive reformers were interested in modifying a political system that they believed was essentially sound. Some were motivated by the genuine desire to make government more re-

sponsive to a broader spectrum of American society, including the fifteen million new immigrants who came to the United States between 1890 and 1915. Many were motivated by the fear that they must make the socioeconomic system minimally more equitable in order to protect their own class interests or to stave off a working-class revolution.[3]

Clean-government reformers like Lincoln Steffens worked to expose urban corruption by pointing up the collusion between American businesses and political party machines. Intellectuals like Walter Lippmann argued that social scientists should regulate the nation's industrial economy because their presumed commitment to rational and objective principles would lead them to adjust the disparity among goods, services, and human needs for the benefit of the majority. Social-justice progressives like Jane Addams worked to improve the conditions of immigrants and working-class people by promoting such causes as better housing, industrial safety, expanded educational opportunities, and greater tolerance for cultural diversity. Moderate labor leaders like Samuel Gompers fought for a "bread and butter" unionism in partnership with industry. Black nationalists like Marcus Garvey argued for a separate black economy that would serve the needs and aspirations of African American communities.

Radical leaders were more sweeping in their condemnation of the basic ill health of bourgeois America and industrial capitalism, demanding more fundamental changes in the political and economic systems of the United States: from the redistribution of the national wealth through taxation and wage regulation, to workers' wresting the national wealth and the means of production from the hands of their owners. One of the most fertile grounds for radical discourse and experimentation in politics, as well as in the arts and in social life, was New York City. By the second decade it was undoubtedly the leading center of cultural ferment in the nation, with Greenwich

Village the focal point of white radicals and Harlem in the process of becoming the race capital of black America.[4]

"Looking back on it now," Mabel Dodge Luhan—an important figure in all the new movements—wrote in her memoirs, "it seems as though everywhere in that year of 1913, barriers went down and people reached each other who had never been in touch before; there were all sorts of new ways to communicate as well as new communications." The new spirit of which she spoke found its leadership in Greenwich Village and its spiritual home at her 23 Fifth Avenue salon.[5] It permeated the theories of psychology, art, poetry, politics, and sexual relationships that made the men and women who lived in the Village imagine themselves capable of changing the mores and artistic standards, as well as the political course of the United States. Free thinkers and lovers, disparate in their creeds, goals, and degrees of radicalism, they were united by their fight against those tendencies in American life that were driving their fellow citizens in the direction of increasing standardization, mechanization, and materialism; among them, the scientific management philosophy that subordinated workers to machines in its worship of efficiency and cost-effectiveness; the increasing specialization of work that further segregated classes and divided the educated from the uneducated; the manipulations of the mass media and the burgeoning advertising industry that promoted the myth that the pursuit of happiness took place between the covers of a Sears, Roebuck catalogue.

Unlike the more orthodox Marxists of their day (and later), theirs was a revolution devoted as much to play and self-expression as it was to labor unionization and the redistribution of wealth. Daniel Aaron has noted the defining terms that connected all the new movements as they were interpreted in the Village: " 'Released personality,' 'expression of self,' 'emotion,' 'intuition,' 'liberation,' 'experiment,' 'freedom,' 'rebellion'—these phrases and words connote the prevailing tone of the 'new'

magazines, books, and plays as well as the manifestoes, art exhibitions, and political rallies between 1912 and 1917." They informed the meetings of the Liberal Club held at Polly's Restaurant on MacDougal Street, where one was equally likely to find a poetry reading, a lecture on the slaughter of coal miners in Colorado, or a discussion of working women's need for cooperative housing. And they impelled the street theatre that led a group of pagan rousters to climb the Washington Square arch and declare it an independent republic.[6]

In our examination of how this generation of artists, writers, reformers, and radicals—both within Greenwich Village and beyond—worked to create a revitalized American society and culture, we have tried to address the following questions: 1) What defined the "new" and how did it differ from the "old"? 2) How was the "new"—much of which originated in Europe—Americanized? 3) What conflicts and paradoxes were involved in creating the "new"? 4) What happened to the "new" as it became disseminated and incorporated into the larger society? 5) What has been the impact of the "new" on later social, political, and cultural movements in the twentieth-century United States?

What defined the "new" and how did it differ from the "old"? There is a set of terms that crosses the entire field of issues marking this cultural moment, at least as they were defined by the more pluralistic proponents of social, cultural, and political change. Whether we are talking about the New Woman, the New Psychology, the New Art, the New Politics, or the New Theatre, we confront language of breakdown—the breakdown of binary oppositions, of formalism, of boundaries, of hierarchies, and conventions in all spheres of American life.

In his essay "Toward a Definition of American Modernism," Daniel Joseph Singal notes the salient differences that set this generation apart from their Victorian forebears and that defined their attempt to create new cultural paradigms. Where the

Victorians made "sharp distinctions" in all realms of life—between civilized and savage, superior and inferior classes, white and colored, male and female spheres—the modernists rejected the prevailing theories that divided individuals from the social system and that placed them into separate compartments. The various "manifestations of Modernism had in common . . . a passion not only for opening the self to new levels of experience, but also for fusing together disparate elements of that experience into new and original 'wholes,' to the point where one can speak of an 'integrative mode' as the basis of the new culture."[7]

This desire for wholeness was at least partly motivated by deep-seated spiritual needs that could no longer be satisfied through conventional religious forms. One of the most important forces behind social-justice progressives was the Social Gospel movement within the Protestant ministry that called for the middle and upper classes to share the "race life" of the poor and outcasts of society. Liberal evangelical Protestantism informed the home-grown radicalism of Eugene Debs, who declared that Christianity was "socialism in action." Even advocates of free love sometimes yearned for love in a way that was religious in intensity, as though heterosexual bonds could substitute for God, while enthusiasists of Freud predicted that "psychoanalysis has in it the making of a religion." Singal notes that the arts, which had served the Victorians "as a vehicle for communicating and illustrating preordained moral truths," became for the modernists "the principal means of creating whatever provisional order human beings can obtain." In founding the Provincetown Players, George Cram (Jig) Cook looked back to the ancient Greeks, for whom theatre was an intimate part of their spiritual lives. In all these areas, then, we find faith in the ability of the new to serve some of the same needs as had older family, community, and religious traditions.[8]

The New Politics took as its broadest man-date the redefinition of the boundaries of American democracy by extending the political rights to life, liberty, and the pursuit of happiness into the economic, social, and cultural spheres of American life. During the 1912 elections, even establishment politicians were using a rhetoric that broadened the purview of the federal government. The Democratic party under Woodrow Wilson proclaimed a New Freedom, and the Progressive party under Theodore Roosevelt, a New Nationalism, both of which paid homage to the unfulfilled promise of equality of opportunity. The Socialist party, under Eugene Debs, garnered their highest percentage of votes in a national election, as well as scores of state and local offices. Certainly liberals had some justification for believing that their programs would temper, and radicals some justification for believing their programs might revolutionize, American social and political life.

Most recent historians of the period feel that there were substantial failures in both the liberal and radical agendas. However, as Nell Painter has observed, they set an important precedent for public policy in the following decades: "The federal government could . . . proclaim an intention of acting in the interests of ordinary people that a generation earlier would have been unthinkable in all but labor circles."[9] The political reforms of the Progressive Era were national in scope, including suffrage for women, the first child labor laws, and the first income, inheritance, and corporation taxes.

The New Woman was no longer bound by the separate spheres and assumed biological and intellectual limitations that kept her mother at home. She was presumably free to work, study, and determine her own life and sexual partners. During this period, middle-class women gained greater access to higher education and the professions. Working-class women, who often did not have the choice of staying at home, became actively involved in labor union organizing, while African American women took leading roles

in working for civil rights and educational reform for their people. As Lois Rudnick demonstrates, women took leadership positions in all the new movements.

Many of the issues that face contemporary women about their roles in American society were debated by women and men during this period: the roles of women in the political process; the problems involved in balancing dependence and independence, work, family, and intimate relationships; the nature versus nurture controversy over the determinants of gender. The fiction of Progressive Era women writers focused on the new possibilities for women, as well as on the constraints that racial and class barriers placed on the New Woman.

The New Psychology promised to liberate the human personality from the false dichotomies of the rational and the emotional, the spiritual and the sexual. It put artists in touch with unconscious drives that would empower their work and reformers in touch with theories that would allow them to improve society. During the 1910s, Freud's theories were first disseminated in scientific and intellectual communities. In contrast to the orthodox medical model that treated mental disorders with rest cures and drugs, Freud rooted neuroses in psychosexual development and insisted on the importance of the patient's self-insight in effecting his or her own cure.

As John C. Burnham explains, the competing belief systems of the post-Victorian world left few certainties for intellectuals, for whom the idea of a unitary self was no longer possible. Traditional models of human nature and character no longer satisfactorily explained the personal and social dysfunctions—the violence and powerful emotions—unleashed by the upheavels of life in urban, industrial society. Contemporary critics often refer to the United States as a "therapeutic" society. The roots of Americans' continual search for psychological well-being, the proliferation of therapies designed to heal psychic and spiritual disorders, and the exploration of uncon-

scious processes that has marked much of twentieth-century literature and art, had their origins in this period.

The New Art practitioners of Cubism, Expressionism, Surrealism, and of the other "isms" that defined themselves as Modernist, defied traditional ideas that art should imitate a reality serving middle- and upper-class moral and social values. Instead, they insisted on the individual artist's right to express his or her own vision of reality. As Martin Green explains, public taste had been primarily formed by the conventional and sentimental realism of art academies that stressed the importance of using classical models from the past.

The New Art defied the categories that set illusion apart from reality and subverted the hierarchy of value that privileged elite art over primitive and folk arts. In his photography, Alfred Stieglitz wanted to break down the barriers between art and technology, to have the camera, in the words of his friend the art critic Paul Rosenfeld, "serve the human spirit."[10] While many contemporary Americans are acculturated to the art of the early twentieth century, new and equally disconcerting art movements have marked our century at periodic intervals since this time. So, too, has the debate that began in this era about whose purposes and needs art should serve: to secure the world view of the dominant classes, to express personal vision, or to inspire "the masses" to fight for their own socioeconomic improvement.

The New Theatre arose against the background of a commercial theatre that was dominated by sentimental and escapist melodramas, romances, and musicals, a theatre that rarely addressed the serious political and social issues confronting American society. As Adele Heller explains, it borrowed much of its impetus from the European "little theatres" in France, Germany, England, and Russia that protested the mindless claptrap of plays produced on the traditional stage. Mary C. Henderson's photo essay illustrates that the New Theatre took root throughout the United States, in small

midwestern towns as well as in urban centers like Chicago and New York, where the stage was used as a cultural forum to address issues of importance to the ethnic, working-class, and middle-class communities in which they were located.

The small community of Greenwich Village journalists, painters, and writers who formed the Provincetown Players were in the vanguard of those in the New Theatre movement who hoped to forge a national culture that would reflect the new spirit in American social and political life. Their decision to pool their various talents to write and stage their own plays gave impetus to a little theatre in the United States that, as Robert Sarlós and Barbara Gelb point out, provided support for two of America's most important twentieth-century playwrights: Susan Glaspell and Eugene O'Neill.

How was the "new" Americanized? While Americans originated few of the theories that influenced the new thinking about human nature, society, and cultural expression, they adapted these new theories to their own needs and values, and in some cases, subordinated them to indigenous cultural and political traditions. They created their own "texts" out of the writings of Europeans such as Karl Marx, Sigmund Freud, Ellen Key, and Friedrich Nietzsche, mingling them with the ideas of American social theorists and philosophers like William James and John Dewey.

The leaders of these various movements in America have frequently been criticized by contemporary scholars for their presumed lack of intellectual seriousness and political commitment, for their eclecticism, and for their distortion of theories they borrowed from European thinkers; for example, their overly optimistic reading of Freud, which ignored his dark and deterministic views of human nature. In spite of their cogency, critiques by Frederick Hoffman, Christopher Lasch, Kenneth Lynn, and Leslie Fishbein fail in important ways to evaluate these movements fairly within the context of their time.[11]

The naive faith in the force of ideas to effect radical political and social change that many in this generation shared was not possible after World War I. Their belief in a free play of ideas and activities that would lead to the emergence of healthier individuals, and to a more equitable social and economic order, allowed them to tolerate, and sometimes to promote, a logically incompatible variety of points of view. But there is no doubt, as the essays in this book demonstrate, that most of them were serious about their political, social, and artistic ideals and commitments.

In order to comprehend what is American about Modernism, we have to acknowledge what one of the contributors to our volume, Fred Matthews, has explained about the ways in which new ideas are accepted and disseminated within any culture. He notes that "every new theory" undergoes "an inevitable process of reception through adaptation, involving creative misunderstanding, free selection, a reworking that may violate the logic or coherence of the original, and merger with pre-existing ideas that serve established centers of concern."[12]

Thus the New Politics, as practiced by the Socialist Party of America, was rooted in a populist and non-Marxist working-class tradition that identified small farmers and laborers as "citizen-producers" and borrowed the language of the American revolution to demand the promotion of the social, political, and economic well-being of all who lived in the republic. While American women borrowed ideas and practices from European philosophers and British suffragettes, some of the most important ideas about the New Woman were informed by a nineteenth-century American women's culture that had articulated values subversive of a patriarchal and capitalist ethos.[13]

Although Americans had made few innovations in the elite arts, they had a tradition of cultural nationalism that began with the nineteenth-century New England Romantic writers and that was renewed during the Progressive Era. Van Wyck Brooks's *America's Coming-of-Age* (1915) was one of the first

and most important manifestos of the era to call for American writers to forge an indigenous literature that was not dependent on European, especially British, models. Alfred Stieglitz, the foremost proponent of modern European art in the United States at this time, called for the creation of an American art that used the techniques developed by French Postimpressionists but "without that damned French flavor." Emma Goldman, influenced as much by the American poet Walt Whitman as by Russian anarchist philosophers, said she was not interested in a revolution at which she could not dance. Black socialists like Henry Harrison, seeing the inadequacy of Marxism's understanding of race in the American context, developed his own radical critique of American society.[14]

Perhaps what is most American about the avant-garde leaders of these movements are their at-once pragmatic and utopian natures. American cultural radicals seemed to have little difficulty reconciling Marx and Freud, working-class revolution with individual self-expression. In fact, the more visionary among them "wanted it all"— absolute freedom to develop the self and total commitment to a notion of community that demanded the subordination of the self to the interests and needs of others.

What conflicts and paradoxes were involved in creating the "new"? There are two central paradoxes that run through the lives and works of many of the men and women we discuss. The first, related to the above comment, is that they desired both to be individuals and, in Walt Whitman's phrase, "en masse"; the second is their drive to achieve psychological coherence while maintaining a fluid and open identity. As Singal points out, this "paradoxical quest for and avoidance of integration" is "the reason why personal identity has often become problematic and tension-ridden for those living in the twentieth century." Victorians valued sincerity and consistency in human character, based upon their belief that "character was defined largely by social role, which in

turn was normally fixed by heredity, upbringing, and vocation." Modernists believed that "one must constantly create and recreate an identity based upon one's ongoing experience in the world." They privileged "authenticity" as the most valued character trait.[15]

The first paradox was one of the most energizing, as well as one of the most problematic, aspects of the new movements we examine. It led the New Woman to expect that sexual freedom and economic independence could be reconciled with traditional obligations to family and society, as Kay Trimberger shows in her analysis of the conflicted lives of Mabel Dodge and Neith Boyce. It led the radicals of *The Masses* to believe that they could appeal to "the masses" while remaining true to liberationist values that violated the social and religious beliefs of working-class men and women. It led devotees of Freud to hours of intense self-analysis that avoided the socioeconomic sources of suffering and malaise afflicting Americans who were the least able to afford or be helped by such therapy.

This brings us to an important issue addressed in this volume: Who was left out of the "new"? a question that is closely connected with Who is doing the defining? Ernest Allen demonstrates that the New Politics, whether progressive or radical, ran up against the brick wall of racism, whose pervasive and corrosive influence on American political and economic life even the most left wing of white socialists rarely confronted. Some of the leading American suffragists and feminists used racist arguments to support the right of middle-class white women to the vote. Elizabeth Ammons argues that popular conceptions of the New Woman did not include women of color. But as both Allen and Ammons show, the fact that most whites excluded people of color did not prevent them from formulating their own concepts of the New Negro and the New Woman that sometimes paralleled and sometimes challenged those of white progressives and radicals.[16]

Just as there was a range of perspectives

on the new movements during this time, so too is there a range of perspectives among the contributors to this volume. Insofar as it is possible, we try to view the cultural moment of 1915 from the vantage points of those who were living and writing at the time, without losing the critical vision necessary to evaluate them within a larger historic context. But we too are creating our own "texts" and reading the cultural moment 1915 from our individual disciplines and training, as well as from our different political and personal temperaments. We are also influenced by the cultural moment we live in within academia that has broken down the traditional boundaries which in the past have segregated disciplines. We must now ask the questions, whose stories are we telling and whose stories have not been told? Because the readers of this volume are included in these questions, they will undoubtedly create their own texts out of our essays.

How was the "new" disseminated in the wider American culture? Our different perspectives are most evident in our evaluation of the new as it became disseminated, incorporated, and institutionalized within the larger American society. In each case, the "new" had a range of definitions that can be tracked on a vertical axis from elite to popular, as well as on a horizontal axis from moderate to radical. While the radicals of Greenwich Village sought in Freud the psychological prerequisites to social change, for example, more conservative popularizers of Freud, who wrote for a broader middle-class audience, placed him alongside other mental healers who advocated a therapeutic self-help philosophy that would "adjust" discontented individuals to society.

The contributors to this volume would agree that mainstream American culture has an almost infinite capacity to absorb—some would say co-opt—the radical edge of any new social, political, or cultural movement that comes our way. Thus, the New Woman of Greenwich Village who dreamed of a socialist-feminist revolution was a much

tamer figure when she graced the pages of middle-class women's magazines, where she was depicted as free to compete with men in sports and to fulfill her own individual needs. By the 1920s, these needs were defined by the mass media primarily in terms of her power to purchase consumer goods.

As Milton Brown notes, the New Art that so shocked and offended millions of Americans in 1913 was, by the 1920s, accorded an honorable place in some of the most prestigious museums and galleries. The prewar fluidity that marked the New Psychology—and its seemingly open-ended possibilities in contributing to societal, as well as to individual, growth and change—was rigidified in the postwar era, as psychoanalysis was increasingly institutionalized.

The contributors would also agree that the entrance of the United States into World War I was a major turning point in the fortunes of these new movements, in many cases creating such fear, suppression, and internal divisions that it was difficult for the most radical elements of the new movements to continue. In some ways, the federal government responded to the war by fulfilling long-held progressive dreams, as the first planned economy in U.S. history came into being, with the regulation of transportation, guarantees of collective bargaining for workers, and the widespread use of academic experts and social scientists as advisors and policy makers. But at the same time, immigrants, workers, and political radicals were seen as greater threats than ever to national unity and security, a view that led to massive civil rights violations by self-appointed vigilante groups and to laws that imprisoned people for criticizing the government. Although some academic experts helped in food conservation, others helped to "sell" the war to the American people in what might be called the first major national advertising campaign in the United States. Even the Provincetown Players came under the surveillance of the newly created Bureau of Investigation (later to become the FBI) for their "subversive" ideas.[17]

Although African Americans joined the

armed forces in greater numbers than their percentage in the population, urged on by leaders who believed this would prove their right to the entitlements of citizenship, blacks were segregated in the armed forces and given the most menial jobs, and they continued to be lynched—even in uniform. In 1919, one of the worst years in American history for civil violence, hundreds of blacks were injured and killed in race riots around the country, as black soldiers returned home to face continued discrimination and white soldiers demanded back the jobs that had been taken by the hundreds of thousands of blacks who had moved to the North during the war. Labor strikes in the steel, coal, and lumber industries abounded as workers lost the right to collective bargaining that was removed as soon as the war was over. The success of the Bolshevik Revolution in Russia in November 1917, and Lenin's call to carry the revolution forth internationally in 1919, led to the formation of two American Communist parties. In response to these events, and to a series of anarchist bombings, the attorney general of the United States, A. Mitchell Palmer, instigated the infamous Red Scare, during which hundreds of aliens and radicals, who he claimed were planning to overthrow the American government and the capitalist system, were imprisoned or deported.[18]

Some contributors to our volume emphasize the weaknesses and faults of the prewar movements that contributed to their dilution or destruction during the war and postwar eras, while others emphasize the politically and culturally challenging aspects of these movements, even when they did, in fact, fail to change society. In regard to the New Politics, John Buenker puts the political reforms of the Progressive Era to the litmus test of democratization and finds them particularly lacking in terms of the large number of voters who lost political ground after World War I. Eugene Leach argues that although *The Masses* may never have reached a working-class constituency, it was one of the most outstanding attempts in the history of American journalism to

merge the creative arts and radical politics.

With respect to New Art, Edward Abrahams emphasizes Alfred Stieglitz's "faith and vision" in the power of avant-garde artists to turn a materialistic society into a "cooperative commonwealth" that would benefit all men and women. His perspective is complemented by Rebecca Zurier's emphasis on the populist spirit of artists who drew realistic illustrations for *The Masses* because they believed that Modernist art could neither speak to working-class audiences nor move them to political action. In connection with the New Psychology, Sanford Gifford emphasizes the liberationist impact of Freudian psychology on creative writers and intellectuals of the era, while Fred Matthews is more compelled by its tendencies to contribute to the "culture of narcissism" that is often said to blight contemporary American society.[19]

What has been the impact of the "new" on the later political, social, and cultural movements in twentieth-century U.S. history? As Matthews's conclusion suggests, the contributors also differ over the meaning and impact of the cultural moment of 1915 on the rest of the century. For all the failures of the Progressive Era, it established a precedent for massive government intervention during the Great Depression, and for later social legislation, like that associated with Lyndon Johnson's Great Society. Starting in the 1910s, but increasingly in the 1920s, Freud's theories were used by the medical establishment and by popular psychologists to attack feminists as deviants because of their unwillingness to accept their anatomy as their destiny. But challengers of Freud have also developed social and feminist psychologies that have built on the work of some of the New Women social scientists of the Progressive Era.[20]

Americans still suffer from racism and from blindness to the strictures of social class and poverty that keep most people of color out of the voting booth and out of the economic mainstream. But the New Negro's assertion of his or her cultural pride and

political and economic rights laid important groundwork for black advancement during the Civil Rights movement of the 1950s and 1960s, and for the more pervasive acceptance of African American literature and culture within the academy and the publishing industry. Women have been sent back to the home after both World Wars and sold a bill of goods about their importance as consumers and household engineers. But they have continued to work at paid jobs outside the home and as volunteers in the myriad social-reform movements that have marked the twentieth century.[21]

Postimpressionist art today is very much a part of the establishment, having achieved the financial value and status that once belonged mainly to works of the Italian Renaissance. Although each new wave of avant-garde artists has had to fight to establish its legitimacy, there is no doubt that the battle for greater freedom of expression in the arts during the pre–World War I era paved the way for a more accepting climate for modern art in the 1920s and later.[22] Robert Sarlós notes that the Provincetown Players self-destructed when they found themselves becoming commercially successful. But they helped to lay the groundwork for a continuing tradition of experimental theatre that has had a vigorous life over the past seventy years.

The tension between the search for personal fulfillment and the desire to create a new and more inclusive human community was one that the members of the 1915 generation never resolved, perhaps because it is, ultimately, unresolvable. That some of them were able to take on such a task, and not at the same time take themselves too seriously, is one of their more delightful attributes, testified to by the extraordinary good humor and self-mockery of the first three plays written and produced by the Provincetown Players.

In keeping with the spirit of the cultural moment of 1915, Adele Heller produced the first season of their plays at the 1987 Prov-

incetown conference. We publish them here, three of them for the first time. *Constancy*, by Neith Boyce, examines the struggles of the New Woman to come to terms with the emotional costs of sexual liberation. *Suppressed Desires*, by Susan Glaspell and George Cram Cook, satirizes the uncritical reception of Freud on the part of the intellegentsia. *Change Your Style*, by Cook, pokes fun at the hot-tempered controversy over traditional versus modern art. *Contemporaries*, by Wilbur Daniel Steele, dramatizes the plight of the homeless in the pre–World War I era.

We cannot claim these plays are lost classics in the history of American drama, but they do signify a time when it was possible for writers and artists to believe in the power of cultural expression as a transformative agent in society. In explaining the first stirrings of the Provincetown Players, Hutchins Hapgood remarked that "without a truthful effort for a deeper culture, all our larger social purposes are impossible." In taking our inspiration for the format of this book from the Provincetown plays, we go back to the philosopher Saint-Simon, who first defined the avant-garde as both a political and cultural vanguard. He insisted on the centrality of artists and writers in creating "the good society" because of their power to fill "society with passion for its own well-being."[23]

No one born into the age of nuclear madness would have the boldness to predict that the next millennium will usher in a century of peace. As this book goes to press, it is difficult to know how to read the political and cultural signs in the West, in Eastern Europe, and in the Third World. Increasing political and economic instability and nationalist and ethnic hostilities co-exist with democratization and a new awarness of the world as an interdependent, global community. We can, at the least, hope that the twenty-first century opens on a world where it is not a sign of radical innocence to assume the importance of cultural politics to the health of the state.

In his speech before the U.S. Congress on

21 February 1990 regarding the changes in Eastern Europe, Czechoslovakian president Vaclav Havel called for an accompanying "global revolution in the sphere of human consciousness . . . [that] will enable us to escape from the rather antiquated straitjacket of [a] bipolar view of the world and to enter at last into an era of multipolarity." His words augur that once again the cultural winds of change blowing between Europe and the United States might renew our "vision of human freedom and responsibility," as they did during the early 1900s, and in the 1960s, the two "cultural moments" in our century when the personal and the political were joined.[24]

NOTES

1. Hutchins Hapgood, *A Victorian in the Modern World* (New York: Harcourt, Brace and World, 1939), 393.

2. See Nell I. Painter, *Standing at Armageddon: The United States, 1877–1919* (New York: W. W. Norton, 1987), chap. 1, for statistics on the emergence of the United States as an industrial society and colonial empire. In 1880, 50 percent of the American work force was engaged in agriculture; in 1920, a little over 25 percent. At the conclusion of the Spanish-American War in 1898, the United States took control of its first overseas territories, Puerto Rico and the Philippines.

3. On the "Revolt of the American Conscience," see Frederick Lewis Allen, *The Big Change: America Transforms Itself, 1900–1950* (New York: Harper & Brothers, 1952), chap. 6. Allen emphasizes the idealism of Progressive reformers. Painter (*Standing at Armageddon*) notes the "seeming unbridgeable gulf between classes" that frightened many middle- and upper-class Americans during an era of increasing labor unrest. "For many of them," she points out, "workers were a different sort of people, unpredictable and unamenable to reason, belonging to what were then called different races" (p. xxix). Most members of the middle and upper classes were Protestant, white, and native born; most working-class folk, especially in urban industrial areas, were foreign and Catholic. For other contemporary reevaluations of Progressive Era politics, see Richard Abrams, *Burdens of Progress, 1900–29* (Glenview, Ill.: Scott, Foresman and Co., 1978); Daniel T. Rogers, "In Search of Progressivism," *Reviews in American History* 10, no. 4 (December 1982): 113–132; and Richard L. McCormick, *The Party Period and Public Policy: American Politics from the Age of Jackson to the Progressive Era* (New York: Oxford University Press, 1986).

4. See Arthur Wertheim, *The New York Little Renaissance: Iconoclasm, Modernism, and Nationalism in American Culture, 1908–1917* (New York: New York University Press, 1976), xiii, where he notes the importance of New York City as the headquarters for the magazine- and book-publishing trades, as well as its unusually well-established and influential variety of ethnic cultures. He points out "the small-town atmosphere" (p. 61) of Greenwich Village (and the cheap rents), that gave it a strong neighborhood feeling and made it particularly attractive to those who moved there from small towns in the Midwest. In chap. 1 of *New York Intellect: A History of Intellectual Life in New York City* (New York: Alfred Knopf, 1987), Thomas Bender discusses the importance of the city as a port of entry for European ideas and movements, especially in the twentieth century when it has served as "a staging area . . . for cultural renovation" (p. 5). For the impact of new forms of popular entertainment, see Lewis Erenberg, *Steppin' Out: New York Nightlife and the Transformation of American Culture, 1890–1930* (Chicago: University of Chicago Press, 1981). See Gilbert Osofsky, *Harlem: The Making of a Ghetto: Negro New York, 1890–1930* (New York: Harper & Row, 1963) for a history of the complex and contradictory images and realities of Harlem as an ethnic ghetto.

5. Mabel Dodge Luhan, *Movers and Shakers* (New York: Harcourt, Brace and World, 1936), 3. See also Lois Rudnick, *Mabel Dodge Luhan: New Woman, New Worlds* (Albuquerque: University of New Mexico Press, 1984), chap. 5, which deals with Greenwich Village.

6. Daniel Aaron, *Writers on the Left: Episodes in American Literary Communism* (New York: Alfred Knopf, 1952), 7–8. For the flavor of life in the Village, see Albert Parry, *Garrets and Pretenders: A History of Bohemianism in America, 1885–1915* (1933; reprint ed., New York: Dover Press, 1960). The most recent work on the Village's literary and artistic avant-garde is Steven Watson's *Strange Bedfellows: The First American Avant-Garde* (New York: Abbeville Press, 1991).

7. Singal, "Toward A Definition of American Modernism," *American Quarterly* 39, no. 1 (Spring 1987) : 12.

8. In discussing the cultural radicalism of Greenwich Village, Henry May notes that the use of the concept of the Life Force as a substitute for the nineteenth-century's belief in natural law "often sounded like a new name for God." See *The End of American Innocence* (Chicago: Quadrangle Books, 1959), 225. For the influence of the Social Gospel on progressive reformers concerned with social justice, see Henry F. May, *Protestant Churches and Industrial America* (New York: Harper & Row, 1967). For the influences of evangelical Protestantism on native American radicalism, see Nick Salvatore, *Eugene V. Debs: Citizen and Socialist* (Chicago: University of Illinois Press, 1982). Salvatore quotes Debs on p. 165. Floyd Dell on psychoanalysis is quoted in Wertheim, *New York Little Renaissance*, p. 71. Singal, "American Modernism," p. 14. In *The Spiritual in Art: Abstract Painting, 1890–1985* (New York: Abbeville Press, 1986), Maurice Tuchman points out that one of the most important bases of abstract art in Europe and in the United States was the desire "to express spiritual, utopian, or metaphysical ideals that cannot be expressed in traditional pictorial terms" (p. 17).

9. Painter, *Standing at Armageddon*, xxxix.

10. Rosenfeld quoted in Bram Dijkstra, *The Hieroglyphics of a New Speech: Cubism, Stieglitz, and the Early Poetry of William Carlos Williams* (Princeton: Princeton University Press, 1969), 125. Stieglitz's description of how he practiced photography illuminates the influence of the New Psychology on the New Art: "When I am no longer thinking but simply *am*, then I may be said to be truly affirming life . . . the subconscious pushing through the conscious, driven by an urge coming from beyond its own; knowing its own control; trying to live in the light, like the seed pushing up through the earth—will alone have roots, can alone be fertile. . . . When I photograph I make love" (quoted in Dijkstra, pp. 102–103).

11. See Leslie Fishbein, *Rebels in Bohemia: The Radicals of THE MASSES, 1911–1917* (Chapel Hill: University of North Carolina Press, 1982), and Kenneth Lynn, "The Rebels of Greenwich Village," *Perspectives in American History*, vol. 8 (Cambridge: Harvard University Press, 1974), 335–377, for interesting discussions of the family backgrounds and relationships of the Greenwich Village rebels. Fishbein and Lynn note that the majority of them came from families whose values were not in the mainstream and who nurtured rebellion, and that a substantial number came from women-dominated homes. Fishbein says of the radicals of Greenwich Village that their rebellion was more temperamental than political and that few of them had "the intellectual maturity and sophistication necessary to comprehend the schizophrenic nature of the competing beliefs they had embraced" (*Rebels in Bohemia*, p. 4). See also Frederick J. Hoffman, *The 20s: American Writing in the Postwar Decade*, rev. ed. (New York: Free Press, 1962); and Christopher Lasch, *The New Radicalism in America (1889–1963): The Intellectual as a Social Type* (New York: Vintage Books, 1965).

12. Fred Matthews, "In Defense of Common Sense: Mental Hygiene as Ideology and Mentality in Twentieth-Century America," *Prospects IV* (New York: Columbia University Press, 1979), 460.

13. See Salvatore, *Debs*, 183, where he points out that in the 1900 presidential election, Debs ran on the platform that Socialism was "the true patriotism, more in tune with the revolutionary heritage than capitalism." On American women's alternative values, see Alice Kessler-Harris, "American Women and the American Character," in *American Character and Culture in a Changing World: Some Twentieth Century Perspectives*, ed. John Hague (Westport, Conn.: Greenwood Press, 1979), 227–242.

14. In *The End of American Innocence*, Henry May notes Brooks's sympathy with Whitman's assertion that "American regeneration was to be brought about by literature" (p. 325). See also Randolph Bourne, "Trans-national America," in *The Radical Will: Randolph Bourne, Selected Writings, 1911–1918*, ed. Olaf Hanson (New York: Urizen Books, 1977), 248–264. Bourne calls for a multicultural nationalism, based on a pluralistic appreciation for America's

ethnic diversity. On the New Negro cultural nationalists, see Nathan I. Huggins, *Voices From the Harlem Renaissance* (New York: Oxford University Press, 1976). Stieglitz quoted in Dijkstra, *Hieroglyphics,* 94. In the 1920s, Stieglitz called his gallery An American Place. For the attraction of cultural radicals to anarchist philosophy and movements, see Donald D. Egbert, "The Idea of 'Avant-Garde' in Art and Politics," *American Historical Review* 73, no. 2 (December 1967): 339–366. Wertheim quotes Emma Goldman's intention in her magazine *Mother Earth* "to voice without fear every unpopular progressive cause, and to aim for unity between revolutionary effort and artistic expression" (*New York Little Renaissance*, p. 47). There is also an anarchist tradition in American cultural history that can be traced back to the works of Thoreau.

15. Singal, "American Modernism," 14.

16. Some of the same conflicts that marked the consciousness of the New Woman also marked the consciousness of the New Negro. Women and blacks struggled with contrasting stereotypes that portrayed them as oversexed and aggressive and, at the same time, childish and passive. Both the New Woman and the New Negro experienced particularly difficult struggles over the tensions between their desire for self-realization and their commitment to community.

17. For the impact of the United States entry into World War I on the reformist and radical movements of the era, see Painter, *Standing at Armageddon*, chap. 11; David M. Kennedy, *Over Here: The First World War and American Society* (New York: Oxford University Press, 1980). On the surveillance of the Provincetown Players see Dee Garrison, *Mary Heaton Vorse: The Life of an American Insurgent* (Philadelphia: Temple University Press, 1989), 161.

18. On the postwar violence and the Red Scare, see Painter, *Standing at Armageddon*, chap. 12; also Robert Preston, Jr., *Aliens and Dissenters: Federal Suppression of Radicals, 1903–1933* (New York: Harper & Row, 1963).

19. See Christopher Lasch, *The Culture of Narcissism: American Life in an Age of Diminishing Expectations* (New York: W. W. Norton, 1979); and T. J. Jackson Lears, *No Place of Grace: AntiModernism and the Transformation of American Culture, 1880–1920* (New York: Pantheon Books, 1981). Lears blames the progressive generation's preoccupation "with authentic experience as a means of revitalizing a fragmented personal identity" for "dissolving" their dissent "into therapeutic quests for self-realization, easily accommodated to the dominant culture of our bureaucratic corporate state" (p. xix).

20. On the use of Freudian ideology to attack feminism, see Carroll Smith-Rosenberg, "The New Woman as Androgyne: Social Disorder and Gender Crisis, 1870–1936," in *Disorderly Conduct*, ed. Carroll Smith-Rosenberg (New York: Oxford University Press, 1985), 245–296. On the challenges to gender stereotyping, see Rosalind Rosenberg, *Beyond Separate Spheres: Intellectual Roots of Modern Feminism* (New Haven: Yale University Press, 1982), especially chap. 8 on Margaret Mead.

21. For an interesting analysis of the ways in which black and immigrant working-class communities resisted the mainstream mass media and consumer culture and adapted them to their own needs and desires, see Lizabeth Cohen, "Encountering Mass Culture at the Grassroots: The Experience of Chicago Workers in the 1920s," *American Quarterly* 41, no. 1 (March 1989): 6–33.

22. As Wertheim shows, the situation was in some ways better for writers and artists after the war (*New York Little Renaissance*, 245–246). Modernist literature continued to thrive, and African American literature found new audiences, as publishing companies that were interested in promoting them came into existence or expanded (e.g., Alfred Knopf, Mitchell Kennerly, and Boni & Liveright). For the influence of modern American art of the World War I era on the movement of the center of avant-garde art from Paris to New York City after 1945, see Kermit Champa, "Some Observations on American Art," in *Over Here: Modernism, The First Exile, 1914–1919* (Providence: David Winter Bell Gallery, Brown University, 1989).

23. Hapgood, *Victorian*, 393; Saint-Simon quoted in Egbert, "The Idea of 'Avant-Garde,'" 343.

24. Havel's speech to Congress is quoted in full in *Time* (5 March 1990): 14–15. For an analysis of Havel's roots in the 1960s' counterculture and its influence on what Jefferson Morley calls Havel's "radical vision of human freedom and responsibility," see "Mr. Havel Goes To Washington," *The Nation* (19 March 1990): 374–376.

P A R T O N E

The New Politics

JOHN BUENKER

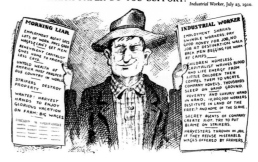
Industrial Worker, July 23, 1910.

FIGURE 1. *"Which Paper Do You Support?"* Industrial Worker, *23 July 1910. Library of Congress.*

During the two decades prior to World War I, a generation of Americans endeavored to come to terms with the implications of living in a modern, urban, industrial, multiethnic society. The efforts were so widespread and productive that contemporaries and historians alike labeled the period the Progressive Era. Even though the era's activists frequently failed to realize their objectives, they established a multitude of precedents regarding social and governmental responsibilities for the general welfare. Business regulation, workers' compensation, child-labor legislation, factory health and safety laws, aid to mothers with dependent children, the income tax, women's protective legislation, housing, and health codes, to name but the most common examples, made a permanent appearance on the American scene. Women were given the right to vote, primary elections were inaugurated, U.S. senators were subjected to direct popular election, and initiative, referendum, recall, and other devices were enacted to enhance popular control over government and politics. So sweeping were the latter reforms that the totality has frequently been dubbed the New Politics.

Although the term has been used in a perplexing number of ways, the New Politics generally involved greater popular control over the nomination, election, and legislative processes, a focus on the candidate's character and ideology instead of on ethnoreligious background or party affiliation, and numerous devices to make government as honest, efficient, economical, and nonpartisan as possible.[1]

Taken collectively, this major overhaul of the political system resulted from three closely interrelated developments: the "organizational revolution" spawned by the emergence of modern, urban, industrial society, the growing perception of serious social and economic dislocations and inequities, and the mounting frustration of large numbers of people with the seeming unresponsiveness of the old-style, ethnocultural, partisan politics. Massive, rapid industrialization and urbanization put such a premium on large-scale, consolidated activity that it increasingly became a matter of "organize or perish" for most segments of society. Farmers, workers, and professionals pursued organization as a means of protecting and advancing their respective self-interests, especially vis-à-vis big business. Ethnocultural groups formed fraternal and benevolent associations to provide economic security and preserve their cultural heritages. Civic associations, taxpayers and consumer leagues, and a plethora of organizations promoting woman suffrage, the restriction of child labor, labor and welfare legislation, Prohibition, immigration restriction, and a variety of other causes also proliferated.

Although many of these new aggregations operated primarily in the private sector, nearly all of them eventually found it necessary or desirable to engage in political activity as well. Their leaders discovered that

it was more effective, efficient, and economical to deal directly with the officeholder or government agency concerned than to work through the medium of the party apparatus. Pragmatically, they learned to "reward their friends and punish their enemies," regardless of party, and to build relationships with commissioners and civil servants because they persisted regardless of election returns. To energize the public, these new organizations relied upon open meetings, demonstrations, mass-circulation newspapers and magazines, petition drives, and direct mailing of pamphlets and brochures. At election time, they attempted to energize those voters who were sympathetic to their cause or candidates, rather than trying to "mobilize" the party faithful. Their leaders openly applied ideological and personality, rather than partisan or ethnocultural, tests to candidates and found that linking their cause to political mavericks challenging the party organization frequently enhanced their appeal. Mavericks, in turn, often discovered that political action groups could provide them with the organization, funding, and lines of communication denied them by the party hierarchy.[2]

A significant amount of this organizational activism resulted from growing perceptions of the inequities in American society and the resultant plight of various categories of disadvantaged people. By the 1890s, according to a contemporary economist, the richest one percent of American families owned 51 percent of real and personal property while the poorest 44 percent owned but 1.2 percent. The most affluent 12 percent owned 86 percent. The poorest one-half of families received only one-fifth of wages and salaries and many of their incomes fell below the poverty line, even with more than one breadwinner. Better than one-quarter of the work force faced unemployment for some period each year and frequent depressions made matters even worse. Hundreds of thousands of men constituted a "floating proletariat" who roamed in search of work; established people called

them tramps. Women made half the wages of men, blacks half of whites, and children significantly less. Industrial labor also meant long hours under dangerous and unsanitary conditions—deaths and debilitating accidents were a daily occurrence. Perhaps worst of all, there were no workers' or unemployment compensation, no old age pensions, no health and safety legislation, and no medical insurance, and labor unions were generally treated as criminal or radical conspiracies against property.

Most industrial working-class people were ethnic or racial minorities who suffered many forms of prejudice and discrimination and who lived in substandard housing. Agricultural laborers worked even longer hours for less wages, even though their workplace was somewhat less hazardous. Large numbers of Southerners, whites as well as blacks, were tenant farmers or sharecroppers who earned next to nothing. African Americans also suffered from political disfranchisement, legal segregation, and untold acts of violence. Bloody confrontations between workers and owners, between strikers and strikebreakers, between immigrants and natives, between Euro-Americans and racial minorities, occurred with alarming frequency. Increasingly, the dispossessed began

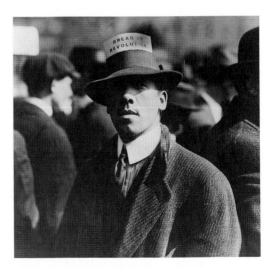

FIGURE 2. *IWW rally, New York City, 1915. Library of Congress.*

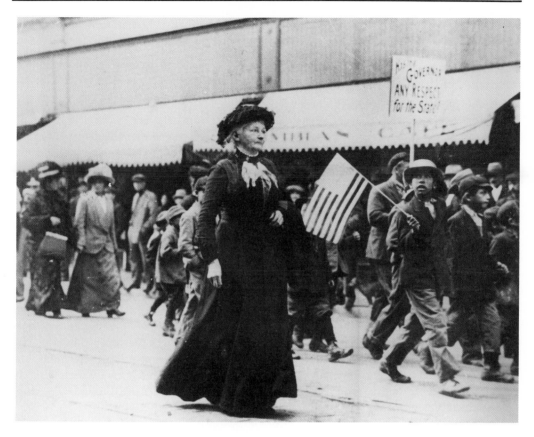

FIGURE 3. *Mother Jones at eighty-two accompanying a protest march along the main street of Trinidad, Colorado. Colorado Historical Society.*

to organize too, both politically and economically, and more comfortable Americans responded either by empathizing with them, by linking their own ambitions with lower-class aspirations, by demanding change out of fear of revolution, or by gearing up for repression. Some sought only to reform the existing socioeconomic order, others to change it through socialism or other more radical transformations. All of these, and representatives of the lower classes themselves, began to make unprecedented demands of government and of the political process.[3]

Imbued with a militant reformist spirit, organized political activists of many stripes became increasingly frustrated with the seeming unresponsiveness of old-style politics and with the apparent corrupt alliance between big business and the two major par-

ties. The old politics was partisan because nearly everyone affiliated with one of the major parties voted a straight ticket, and reared their offspring to do likewise, and because the party organization was the exclusive medium for candidate selection, voter registration and mobilization, and the printing and distribution of ballots. The old politics was ethnocultural because the chief basis for partisan affiliation was ethnic and religious and because the issues that most galvanized the electorate were those related to self and group esteem and identity and to moral outlook and values, such as Prohibition, Sunday observance, and the retention of foreign language. Elections regularly turned on which party was able to "mobilize" the greatest portion of its faithful and turnouts of 75 percent or more were

common. Indeed, both parties managed these impressive voter turnouts with such monotonous regularity that they were popularly referred to as "political machines."

By the turn of the century, however, an almost bewildering variety of people and organizations, ranging from businessmen and professionals to settlement-house workers and social scientists and from consumers and taxpayers to clergymen and moral crusaders, were interacting to produce a major overhaul of the system. All were united in the belief that the new system would give "power to the people," however they defined the latter entity.[4]

Within this apparent consensus, though, there were divisive tensions that imparted an ambiguous quality to the New Politics. Chief among these was a disagreement over whether everyone, regardless of race, gender, ethnicity, religion, or social class, was capable of functioning as a responsible voter. White Southerners were in almost universal agreement that blacks were genetically incapable of independent, responsible political behavior. The majority of white Northerners acquiesced in that belief, with only a relative handful of intellectuals, professionals, artists, and professional politicians openly dissenting. That same general division characterized attitudes toward the immigrants from southern and eastern Europe who poured into the nation's industrial cities from the 1890s on, except that the proportions were somewhat less lopsided. A sizable number of older-stock Americans retained their faith in the educative power of the nation's institutions and values, especially if these were bolstered by Americanization drives and compulsory education. They frequently found themselves in curious coalition with ward bosses and employers of unskilled labor in defense of open immigration, rapid naturalization, and voter registration.[5]

The question of women as political participants generated more variegated responses and alignments. White Southerners were re-

luctant to enfranchise women for fear that such action would reopen the issue of black participation. At best, more advanced southern progressives favored the enfranchisement of women of the "better classes" on a state-by-state basis, a position concurred in by most southern suffragists. Outside the South, support for woman suffrage was centered in the middle and upper-middle classes of both sexes, the same segments of society that most avidly advocated the New Politics in general. The greatest resistance to enfranchising women was found in the upper and lower social orders, both of which, for very different reasons, feared the consequences of augmenting the ranks of middle-class reformers. Many suffragists insisted that the better class of women were more qualified to vote and hold office than were most male immigrants and blacks.[6]

More subtle was the tension between the ideal of democracy, on the one hand, and the desire for efficiency and expertise, on the other. Woman suffrage, the direct election

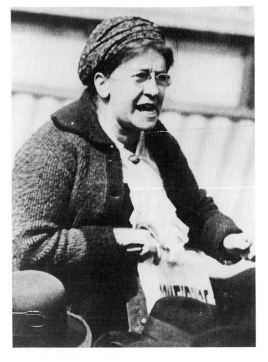

FIGURE 4. *Emma Goldman speaking at a rally in New York City, 1915. Library of Congress.*

of senators, the direct primary, initiative, referendum, and recall, and similar remedies seemed to repose great faith in the collective wisdom of the electorate. But the short ballot, civil service, and the vesting of authority in appointed officials seemed to reflect a corresponding distrust of majority rule. The latter measures were especially popular with business leaders and the "new middle class" of managers, bureaucrats, intellectuals, professionals, and technicians, but were also persuasive to anyone aware of the complexities of modern, urban, industrial life. Paradoxically, the New Politics combined a town-meeting, grass-roots conception of politics with a corporate-bureaucratic model of government. Many resolved the apparent conflict as did Charles McCarthy, Wisconsin's leading progressive theorist, by insisting that expert, apolitical administration was compatible with democracy as long as legislative and executive policymakers were subject to maximum public control. Others contended that any loss of access or influence would be offset by a modernized system of government services and by honest, efficient, and economical government.[7]

Perhaps the best way to understand the ambiguities present in the New Politics is to conceive of the concept as a continuum with an ideal "patrician" model of government and politics at one end and an ideal "popular" model at the other. The former, fostered mostly by the upper and middle classes, aimed at removing the machinery of governance as far as possible from control by the great mass of voters because patricians held them, and professional politicians, primarily responsible for the sorry state of public life. The other, favored by groups acting either from political connections to lower class people or from an intellectual commitment to democracy, believed that the answer to the problem of democracy was more "real" democracy and sought to broaden the franchise and to permit popular participation at levels of decision making where it had never been allowed before. The patrician model emphasized structure and purification of the system

through such devices as the short ballot, the secret ballot, civil service, nonpartisan, at-large elections, corrupt practices legislation, and the city manager or commission forms of municipal government. The popular model emphasized "power to the people" through such innovations as initiative, referendum, recall, primary elections, the direct election of U.S. senators, woman suffrage, and the abolition of all barriers to voting. Most would-be reformers combined elements of both models in their agendas and fluctuated between the two extremes in response to changing conditions. The situation was confused further by the fact that all disturbers of the status quo presented themselves as champions of "the people" against "the interests," even if their proposals limited political participation. Moreover, activists frequently used political innovation as a means to an end—whether that end was the enactment of social and economic legislation or the wresting of power from the political establishment. Most politicians equated reform and democracy with their own personal ambitions.[8]

Problems and tensions notwithstanding, the various advocates of the New Politics were united in the conviction that the combined effect of these myriad innovations would be to break the stranglehold on the political system so tenaciously held by corrupt professional politicians and avaricious businessmen and vice merchants. Put more positively, they would make the system much more accessible and responsive to many groups previously without significant power or leverage, such as women, African Americans, immigrants, working people, farmers, consumers, and ordinary citizens. Socialists, populists, and promoters of other radical, third-party movements were similarly optimistic that the New Politics would significantly enhance their chances of making inroads against the two dominant major parties.

The actual impact of the New Politics, however, was significantly different from its

promise. Paradoxically, the most dramatic result of the innovations supposedly designed to increase the influence of the average citizen was a precipitate decline in voter participation. Some of this drop-off resulted from the purposeful disfranchisement of southern blacks, but much of it was due to the impact of the New Politics on the electoral process. The new order eliminated many of the traditional functions and powers of the ward-based politicians who served as the vital mediators between lower-class voters and the system. It also substituted discussions of individual character and complex issues for traditional ethnocultural, partisan appeals. Candidates and interest groups increasingly bypassed the party structure and relied on personal "machines" and political action committees for organization and financing. In short, the New Politics, by design or happenstance, gradually eroded the effectiveness of political parties, which Walter Dean Burnham has called "the only devices thus far invented by the wit of western man which, with some effectiveness, can generate collective countervailing power on behalf of the many individually powerless against the relative few who are individually or organizationally powerful." Voting increasingly became a function of education and socioeconomic status; for those without such attainments, the new order seemed inaccessible, unresponsive, and incomprehensible.[9]

The impact of the New Politics on women varied significantly, mostly on the basis of socioeconomic class. Women generally played a crucial role in their own enfranchisement as well as in the enactment of other political reforms. Woman suffrage theoretically doubled the electorate but, since women initially voted in lower proportions than did men, it exacerbated the general drop in voter participation. In the long run, enfranchised women divided along much the same socioeconomic, ethnocultural, and sectional lines as did men, although they were slightly more inclined to coalesce when "women's issues" were raised. Even though the "woman's vote" hailed by activists and decried by opponents never really solidified, the fact that women generally voted like men was perhaps the ultimate justification for equal suffrage. Whatever its actual impact on the electoral balance, woman suffrage was long overdue simple justice.[10]

There can be little doubt that the effect of the New Politics on the nation's African American population ranged from devastating to indifferent. In the South, disfranchisement was the one "reform" that united the whole spectrum of otherwise disparate activists in a "white consensus." "Bigotry," Jack Temple Kirby has observed, "cut across class and reform style lines." With a few highly localized exceptions, voting by southern blacks was virtually eliminated for well over half a century. Organized efforts to disfranchise African Americans extended at least as far north as Baltimore, while advocates of literacy tests and poll taxes in other northern cities clearly included them among their primary targets. These devices were opposed most staunchly by those political machines that typically exchanged a grudging degree of patronage, recognition, and material benefits for black support. As contemporary political scientist Harold F. Gosnell remarked, "a minority group which is seeking governmental protection cannot afford to be on the losing side all the time."[11]

For the most part, blacks in northern cities sought to carve out a niche within the dominant party organization, especially if it was Republican. Moreover, reformers in Baltimore, Philadelphia, and elsewhere frequently sought to bar blacks from voting, causing W.E.B. Du Bois to insist that "the Negroes have always been suspicious that the reform movement tended not to their betterment but to their elimination from political life and consequently from the best chance of earning a living" and that the outcome of "the foolish campaign against the Negro in politics has been simply to drive out of political life the very class of Negroes needed most, and to deliver political life and activity into

the hands of the political clubs and their igno-
rant and debased followers."[12]

Du Bois himself was one of the four great
African American leaders of the early twen-
tieth century, each of whom urged a differ-
ent strategy for racial progress. Du Bois
favored educating the "talented tenth" of
the black population so that they could up-
lift their brothers and sisters by pushing
for immediate integration and civil rights
through the courts. Booker T. Washington,
representing mostly southern blacks, in-
sisted that they should postpone social
equality until they had achieved economic
security through the medium of blue-collar
employment. Marcus Garvey, a West Indian
immigrant to New York City, sought to in-
still a sense of racial solidarity and black
pride through Pan-Africanism and the var-
ious business ventures of the Universal
Negro Improvement Association. Finally,
A. Philip Randolph, an organizer in the rail-
road brotherhoods, urged blacks to form
labor organizations and build class-based
political and economic power. Among
whites, only the most cosmopolitan intellec-
tuals, artists, socialists, and settlement-
house residents openly advocated racial
equality, even in the most limited sense.
Black political power in northern cities built
slowly and its progress owed at least as much
to the self-interested collaboration of ma-
chine politicians as it did to the ideology of
independent reformers or radicals.[13]

Assessing the impact of the New Politics
on the urban industrial working class is a
complicated task. Perhaps more than did
any other segment of society, they related to
the political process through the medium
of ethnocultural, partisan politics. Only a
relatively small minority of middle-class re-
formers sought to disfranchise working-class
voters through literacy tests, poll taxes, or
residency requirements. Many sought to at-
tract working-class voters by emphasizing
socioeconomic issues and by generating in
them a broader civic consciousness as con-
sumers, taxpayers, and citizens. Labor
organizers of various persuasions and radi-

cal politicians, especially the socialists,
sought to create a class consciousness that
would transcend traditional alignments.
Samuel Gompers and the American Federa-
tion of Labor (AFL) stressed the efficacy of
rewarding labor's friends and punishing its
enemies within the existing party structure.
Socialists and other radicals urged the for-
mation of working-class third parties from
the grass roots on up. At the same time,
younger, more astute organization politi-
cians persuaded their leaders that support
of socioeconomic reforms in the interest of
the working class, supplemented by the ma-
chine's traditional appeals and services, was
the best formula for maintaining control.[14]

Not surprisingly, this clash of political
cultures produced mixed results during the
Progressive Era. Civic associations, such as
the National Municipal League and its local
affiliates, achieved their greatest successes
when they built upon the fundamentals of
machine politics, backing indigenous candi-
dates who stressed concrete economic
benefits to the community, defense of cul-
tural heritage, and recognition of ethnic
groups, along with good government.
Social-settlement workers in Chicago,
Boston, and New York experienced much
the same results. Despite its nonpartisan
strategy, the AFL found itself increasingly
acting in concert with Democrats. Working-
class parties, especially the Socialists, en-
joyed significant successes during the first
decade and a half of the new century, but
their heyday was short-lived.

Although intraparty strife over World
War I and the Red Scare of 1919 contributed
mightily to its demise, the Socialist party
was essentially a casualty of the New Poli-
tics. As socialist officeholders moderated
their programs to broaden their appeal, pro-
gressive reformers appropriated the most
popular planks of the party's platform. The
adoption of nonpartisan municipal elec-
tions allowed Democrats and Republicans to
unite behind a single anti-Socialist candi-
date while the introduction of city manager

and commission forms of government "de-politicized" urban governance. At most, the Socialists' brief success merely slowed what many scholars have identified as the most important outcome of the New Politics—the inexorable erosion of lower-class political influence.[15]

Nothing so illustrated the difficulties of the New Politics in producing real "power to the people" as did the inability of the Socialist Party of America (SPA) to sustain and build upon its initial gains vis-à-vis the two major parties and the frustration of its efforts to build effective political coalitions with women, blacks, and the immigrant, industrial working class. With a few notable exceptions, the Socialist party constituted the American Left during the first quarter of the twentieth century. There were a small number of anarchists who, by definition, refused to affiliate with any organized political movement, while the Socialist Labor party of Daniel De Leon continued to espouse orthodox Marxist doctrine, which insisted that a complete breakdown of the capitalist system followed by a violent working-class revolution would ultimately produce a classless society in which everyone would contribute according to ability and receive according to need. With the Bolshevik Revolution of 1917, the party's extreme left wing broke off to form the militant Communist Party of the United States. Beyond those groups, however, the SPA, with its commitment to gradualism, reformism, electoral politics, and parliamentary process, virtually monopolized the left end of the American political spectrum. "Prominent people in many walks of life—journalists, labor leaders, lawyers, educators, even millionaires—publicly cast their lot with the Socialist Party"; historian David A. Shannon has concluded, "it did appear that Socialism was destined to become a major force in American life." Yet it was this very success that increasingly forced the party to take on the salient characteristics of American political parties—the incorporation of frequently antagonistic factions and the propensity to construct tenuous coali-tions on issues and candidates both within and across party lines.[16]

More specifically, the Socialist party was a "coalition of regional groups that had different, even conflicting, points of view" on how to achieve the ultimate goal of the cooperative commonwealth. The right wing of the Socialist party was the Milwaukee Social Democrats who parlayed tight political organization, a mutually beneficial alliance with trade unionism, German ethnicity, and appeals for honest, efficient, economical government into a winning electoral combination. Somewhat to the left of the Milwaukeeans were the East Coast Socialists who also believed in gradualism, electoral politics, reformism, and alliance with trade unions. In the center were the Socialists of Illinois, Ohio, Michigan, and Indiana, who generally rejected alliance with the AFL and favored the creation of industrial unions that organized skilled, semiskilled, and unskilled workers together. Their leader was Eugene Debs, a railroad unionist who helped found the Industrial Workers of the World (IWW) and who was the party's perennial presidential candidate. West of the Mississippi River, and especially in Oklahoma, socialism was an emotional brand of agrarian radicalism that grew out of the old populist movement. On the extreme left were the Socialists of the Rocky Mountain and Pacific Northwest area, typified by William "Big Bill" Haywood, head of the Western Federation of Miners and the IWW. The Wobblies, as they were derisively known even to less radical socialists, believed in the formation of one big industrial union that would foment a general strike, bringing the economy to a halt and forcing the establishment of a worker-run cooperative commonwealth that would eliminate the need for government and politics. They deemed this ingenious mix of socialism and anarchism "anarchosyndicalism."[17]

Further compounding this confusing mix were the Christian Socialists, led by the over three hundred clergymen who claimed party membership and who relied upon moral sua-

sion and education, and the foreign-language federations that constituted better than one-third of the Socialist party membership by 1917. They were given special permission to conduct their meetings in the mother tongue and to emphasize their own issues and ideas. Clearly the Socialists were "strange bedfellows," and a typically American political party "in the sense that it extended from coast to coast, in almost all regions of the country, embracing a variety of social philosophies."[18]

Divided over strategy and tactics, the Socialists were in no real position to benefit from the New Politics or to make significant converts among women, blacks, or recent immigrants. Yet the SPA was the first political party to endorse "unrestricted and equal suffrage for men and women" in 1901. Socialist doctrine declared the woman question to be a vital part of the social question and regarded women as the "slaves of slaves," bound by the double chains of gender and class. The party pledged to remove all barriers that make one human being dependent upon another, which included the dependence of one sex upon the other, and formed the Women's National Committee in 1908 to "make intelligent Socialists and Suffragists of women and to secure their active membership in the Socialist Party." Pragmatically, Socialists supported woman suffrage because they believed that women were more inclined toward their party and ideology than were men. Consequently, the SPA endorsed woman suffrage in various referenda and encouraged its women members to work with suffrage organizations in campaigns. In reality, however, there were serious divisions within the SPA over whether organization and funding for suffrage activities should be separate, and over the terms of cooperation with mainstream women's organizations.[19]

If anything, socialists experienced even less success with African Americans than they did with women. Since the party was virtually nonexistent in the Old South, the failure is somewhat understandable, although Socialists can be legitimately faulted for acquiescing in the segregationist "separate but equal" preferences of their white southern members. Much less defensible was socialism's unwillingness or inability to make headway among northern urban blacks. Part of this failure can be attributed to acquiescing in the anti-black policies of the trade unions. Part of it also lay in the unwillingness of blacks to aid political radicalism. Socialists had little tangible to offer them, while the existing political and economic establishment at least offered crumbs. Socialist ideology also subordinated the race question, like the woman question, to the social question. But, at bottom, the Socialists failed because they shared the anti-black biases of white America generally, even though their animus took the form of neglect and ignorance more often than it did overt hostility. Socialist efforts to proselytize "a small but fervent number of native-born black Americans and recently arrived West Indians," in New York City, as Ernest Allen, Jr.'s essay demonstrates, ended in mutual frustration. African Americans became increasingly disillusioned with the party's insistence on the "straight socialism" of "class first" rather than "race first" and with its blatant operational racism, while Socialists bemoaned the paucity of black voters willing to desert the major parties. Black radicals eventually found more compatible comrades in the Communist party or in Garvey's Pan-African nationalism.[20]

Only in a very limited comparative sense did Socialists fare any better with southern and eastern European immigrants than they did with women or blacks. The foreign-language federations became increasingly significant over time, but they also remained fiercely independent. New York City Socialists were especially successful in enlisting Jewish and Italian garment workers, while their Milwaukee counterparts eventually made inroads into the city's Polish and eastern European population. The IWW, with its industrial unionism approach, also

enrolled a sizable proportion of southern and eastern Europeans. But the vast majority of recent immigrants and their children remained far too involved in their fraternal and benefit societies and in their churches to take Socialism seriously. The Catholic church, home to the majority of southern and eastern Europeans, was overtly hostile to socialism, while only the major party organizations could bestow sufficient material and psychic benefits. Most newcomers, like most African Americans, had little to gain and a lot to lose in adding the radical label to their already significant disabilities. Moreover, the party's intellectual and professional leadership had very little sensitivity toward the cultural values so jealously guarded by southern and eastern Europeans, and frequently treated the latter in a condescending or patronizing manner.[21]

Officially, the party stood foursquare on belief in the international solidarity of the working class and on the myth of America as asylum to the oppressed of all nations, but operationally, it cooperated with the trade unions that blamed competition from cheap immigrant labor for low wages, poor working conditions, and lack of working-class consciousness. The official position of the party was a masterpiece of double-talk, supporting legislative efforts "to prevent the immigration of strike breakers and contract laborers, and the mass importation of workers from foreign countries," while, at the same time, opposing "the exclusion of any immigrants on account of their race or nationality" and demanding that the United States "remain a free asylum for all men and women persecuted by their countries on account of their politics, religion or race."[22]

The difficulties faced by American socialists in taking advantage of the apparent opportunities provided by the New Politics, especially with regard to women, African Americans, and the immigrant working class, is explored in Eugene E. Leach's study of John Reed, Max Eastman, and the staff of *The Masses*. For nearly seven years, they labored "to remove conceptual barriers

between cultural and political rebellion as well as class barriers between intellectuals and workers." Although acknowledging that the radical magazine's editors never settled on a systematic political program, Leach demonstrates that they "subscribed to a reasonably consistent set of political ideals which they shared with other Left socialists and with the Wobblies." Chief among these was a conviction that political democracy was impossible without economic democracy. Even though some of *The Masses'* editors had little use for the SPA, all were dedicated to the socialist movement, broadly defined. Even so, their commitment to cultural radicalism, to a celebration of intellectual, artistic, and sexual freedom frequently put them at odds with many working-class radicals who were much more culturally conservative.[23]

In retrospect, the enthusiasm and optimism of the writers of *The Masses*, and their ideological allies among the Provincetown Players, may seem naive and futile. The exhilarating activism of the Progressive Era gave way to the chilling horror of the Great War and the Red Scare and the enervating stagnation of the Age of Normalcy. Although Debs received nearly a million votes for president in 1920, these were more a protest against the violation of his civil liberties as an antiwar protestor than they were an endorsement of radical politics. The Socialist party itself deteriorated so thoroughly that not even the apparent collapse of capitalism during the Great Depression was able to revive it. But the legacy of Progressive Era political activism and of social and governmental responsibility for the general welfare survived. In the 1930s, the Democratic party of Franklin Delano Roosevelt and the New Deal built a powerful political coalition of intellectuals, artists, labor unions, ethnic and racial minorities, and erstwhile progressives and radicals that, at least temporarily, reversed the trend toward political decline. Building largely upon Pro-

gressive Era precedents, the New Deal coalition produced such landmark legislation as Social Security, the National Labor Relations Act, the Fair Labor Standards Act, the Federal Deposit Insurance Corporation, and the Rural Electrification Administration. After a two-decade hiatus, a new generation of political activists translated that legacy into the civil rights, women's, peace, environmental, and youth movements of the sixties. Ever since that time, the alienation of large numbers of citizens from politics and government has clearly grown more critical, while social problems have multiplied alarmingly. If the ideological descendants of the Progressive Era activists are to have any hope of remedying that situation, they will have to begin by creating a New Politics that will truly empower all of the people.

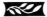

NOTES

1. See, for example, David Paul Nord, *Newspapers and New Politics: Municipal Reform, 1890–1900* (Ann Arbor, Mich.: UMI Research Press, 1981); David P. Thelen, *The New Citizenship: Origins of Progressivism in Wisconsin, 1885–1900* (Columbia: University of Missouri Press, 1972); Walter Dean Burnham, *Critical Elections and the Mainsprings of American Politics* (New York: Praeger, 1982); Richard L. McCormick, *The Party Period and Public Policy: American Politics from the Age of Jackson to the Progressive Era* (New York: Oxford University Press, 1986); Daniel T. Rodgers, "In Search of Progressivism," in *The Promise Of American History: Progress And Prospects*, ed. Stanley I. Kutler and Stanley N. Katz (Baltimore: The Johns Hopkins University Press, 1982), 113–132; and John D. Buenker, "Sovereign Individuals and Organic Networks; Political Cultures in Conflict During the Progressive Era," *American Quarterly* 40(1988): 187–204.

2. Louis Galambos, "The Emerging Organizational Synthesis in Modern American History," *Business History Review* 44(1970): 279–290; Robert H. Wiebe, *The Search for Order, 1877–1920* (New York: Hill and Wang, 1967); Samuel P. Hays, *The Response To Industrialism, 1888–1914* (Chicago: University of Chicago Press, 1957); and John Whiteclay Chambers, *The Tyranny Of Change: America in the Progressive Era, 1900–1917* (New York: St. Martin's, 1980).

3. Nell Irvin Painter, *Standing at Armageddon: The United States 1877–1919* (New York: W. W. Norton, 1987), xix–xliv; Charles B. Spahr, *An Essay on the Present Distribution of Wealth in the United States* (New York: Macmillan, 1896).

4. Richard Jensen, *Grass Roots Politics: Parties, Issues, and Voters, 1854–1983* (Westport, Conn.: Greenwood, 1983), 29–58, and Paul Kleppner, *Who Voted?: The Dynamics of Electoral Turnout, 1870–1980* (New York: Praeger, 1982), 28–54.

5. James B. Crooks, *Politics and Progress: The Rise of Urban Progressivism in Baltimore, 1895–1911*, (Baton Rouge: Louisiana State University Press, 1968); Jack Temple Kirby, *Darkness at the Dawning; Race and Reform in the Progressive South* (Philadelphia: Lippincott, 1972); and Buenker, "Sovereign Individuals and Organic Networks," 191–195.

6. Eleanor Flexner, *Century Of Struggle: The Women's Rights Movement in the United States* (New York: Atheneum, 1968), 203–261; Anne F. Scott and Andrew M. Scott, *One Half The People: The Fight for Woman Suffrage* (Philadelphia: Lippincott, 1975), 24–45.

7. Martin J. Schiesl, *The Politics of Efficiency: Municipal Administration and Reform in America, 1880–1920* (Berkeley: University of California Press, 1977), 133–198; Charles McCarthy, *The Wisconsin Idea* (New York: Macmillan, 1912), 172–187; Samuel P. Hays, "The Politics of Reform in Municipal Government in the Progressive Era," *Pacific Northwest Quarterly*, 55 (1964): 157–169.

8. Richard Hofstadter, *The Age of Reform*

(New York: Random House, 1955), 174–271; Hays, "Politics of Reform," 157–169; John D. Buenker, *Urban Liberalism and Progressive Reform* (New York: Scribner, 1973), 118–122.

9. Burnham, *Critical Elections*, 95–117; Kleppner, *Who Voted?*, 55–82. Voter turnout in presidential elections between 1900 and 1916 averaged about 12 percent less than it had in those between 1877 and 1896. In congressional elections the decline was nearly 14 percent.

10. Flexner, *Century of Struggle*, 248–293; Scott and Scott, *One Half The People*, 24–46. For a view of the woman suffrage movement that stresses its connection to social control of the lower classes, see Ross Evans Paulson, *Woman's Suffrage and Prohibition: A Comparative Study of Equality and Social Control* (Glenview, Ill.: Scott, Foresman, 1973), 85–92, 113–121, 169–89.

11. Kirby, *Darkness At the Dawning*, 7–25; Crooks, *Politics and Progress*, 54–70; Harold F. Gosnell, *Negro Politicians: The Rise of Negro Politics in Chicago* (Chicago: University of Chicago Press, 1967), 357–373.

12. W.E.B. Du Bois, "The Black Vote of Philadelphia," in *Black Politics In Philadelphia*, ed. Miriam Ershkowitz and Joseph Zikmund II (New York: Basic Books, 1973), 31–39.

13. James Stuart Olson, *The Ethnic Dimensions In American History*, vol. 2 (New York: St. Martin's, 1979), 301–312.

14. Buenker, *Urban Liberalism*, 118–162; Marc Karson, *American Labor Unions and Politics, 1900–1918* (Carbondale: Southern Illinois University Press, 1958), 29–73; Richard Oestreicher, "Urban Working Class Political Behavior and Theories of American Electoral Politics, 1870–1940," *Journal of American History* 74 (1986): 1257–1286.

15. David R. Colburn and George E. Pozzetta, "Bosses and Machines: Changing Interpretations in American History," *History Teacher* 9 (1976): 445–463; Michael McCarthy, "On Bosses, Reformers, and Urban Growth: Some Suggestions For A Political Typology of American Cities," *Journal of Urban History* 4 (1977): 29–38; James Weinstein, *The Decline of Socialism in America, 1912–1925* (New York: Monthly Review Press, 1967), 53–62, 74–84, 93–118. At its zenith the Socialist party boasted over 1200 office holders, including seventy-nine mayors in twenty-four states, and polled 6 percent of the popular vote for President. By 1920, it had been reduced to two mayors and seventeen legislators, concentrated in three states.

16. David A. Shannon, *The Socialist Party of America: A History* (Chicago: Quadrangle Books, 1955), 1–42.

17. Ibid., 43–61.

18. Ibid.

19. John D. Buenker, "The Politics of Mutual Frustration: Socialists and Suffragists in New York and Wisconsin," in *Flawed Liberation: Socialism and Feminism*, ed. Sally M. Miller (Westport, Conn.: Greenwood, 1981), 113–144.

20. Shannon, *Socialist Party*, 50–53.

21. Shelton Stromquist, "The Politics Of Class: Urban Reform and Working Class Mobilization in Cleveland and Chicago, 1890–1910," paper delivered at the Organization of American Historians Conference in Reno, Nevada, 25 March 1988; Weinstein, *Decline of American Socialism*, 63–73; Shannon, *Socialist Party*, 43–48.

22. Shannon, *Socialist Party*, 48–50; H. Wayne Morgan, *American Socialism, 1900–1960* (Englewood Cliffs, N.J.: Prentice-Hall, 1964), 71–92.

23. Shannon, *Socialist Party*, 53–61; Weinstein, *Decline of American Socialism*, 29–52, 74–92.

The Radicals of *The Masses*

EUGENE E. LEACH

Lifted on a rising tide of socialist voters and readers in 1911, a new magazine "Devoted to the Interests of the Working People" called itself *The Masses*. The idea came from Piet Vlag, a Dutch immigrant who worked as chef at the basement restaurant of the Rand School for Social Sciences in Manhattan. The bankroll came from Rufus Weeks, vice president of the New York Life Insurance Company. Vlag and Weeks launched *The Masses* chiefly to spread the gospel of worker-managed cooperatives, which they regarded as practical instruments for building socialism from the grass roots. On the side the original *Masses* published pieces on the Socialist party, labor affairs, and the suffrage movement; and it undertook a muckraking assault on the Boy Scouts of America, which the magazine denounced as a militarist plot, "an organized, craftily subsidized effort for creating the kill-lust in boys."[1]

In a sense the Boy Scouts were fitting foes for the original *Masses*, because Vlag, Weeks, and all the key editors belonged to the "yellow," antirevolutionary wing of the Socialist party. They were members of the local that was known as New York's "silk-stocking" branch, and despite their interest in educating workers they kept their distance from the grittier aspects of working-class life. The magazine's politics were clearly signalled by the position it took on the biggest internal question facing the party, what to do with the Industrial Workers of the World (IWW), the radical and rambunctious union known as the Wobblies. When the Socialist party amended its constitution to disavow sabotage and other violent methods that the Wobblies embraced (at least rhetorically), *The Masses* praised this show of respectability. "It is, and always has been, the conviction of the *Masses*," commented the editors, "that every act of violence on the part of the working class is welcomed by the capitalists as an excellent opportunity to beat us into submission." Unlike anarchism, primly observed one writer, socialism was a strictly political movement that combined protest with the promise of "healing balm."[2]

On its covers the original *Masses* usually bore portraits of statuesque proletarians, their faces shining with selfless consecration to the Cooperative Commonwealth. The magazine's relentless high-mindedness was captured in an article by George Cram (Jig) Cook three years before he invented the Provincetown Players. "In spite of its apparent concern with material well being only," wrote Cook, "the Socialist demand springs out of one of the deepest spiritual needs of man—the need to work creatively in freedom."[3]

Within two years this earnest organ of socialist uplift was transformed into one of the most "red" and reckless ventures in American publishing. Piet Vlag and Rufus Weeks discovered that they could not sell enough copies of *The Masses* to overcome its lack of advertising revenue. Consequently they decided to give up on their brainchild after putting out the August 1912 issue. A group of staff members led by cartoonist Art Young and artist John Sloan decided not just to save the magazine, but to let its hair down—to make for themselves, as Young recalled, "one magazine which we could gallop around in and be free."[4] By collectivizing the editing as well as the ownership of *The Masses*, they intended to free it of the editorial tyranny that fettered imag-

inations in other publications. The rescuers also proposed to soak up in the pages of *The Masses* some of the innovative artistic currents that were then racing through Greenwich Village.

To oversee this experiment Art Young suggested a young philosophy instructor, poet, and woman's suffrage activist named Max Eastman, who had joined the Socialist party only months before and immediately aligned himself with the Wobblies and "the whole fighting proletariat."[5] The choice of Eastman indicates that the editors desired to move the magazine far to the left of where Vlag and Weeks had positioned it.

For his part, as Eastman later recalled, prior to his election as *Masses'* editor he had been put off by "its dull make-up and very 'yellow' brand of socialism. Its brotherly evangel of humanitarianism and zeal for consumer's co-operatives I then regarded with scorn."[6] But if the magazine's cramped program left him cold, he was charmed by the spacious visions he heard in the conversation of its artists and writers: "The talk was radical; it was free-thought talk and not just socialism. There was a sense of universal revolt and regeneration, of the just-before-dawn of a new day in American art and literature and living-of-life as well as in politics."[7] Eastman agreed to try his hand at transforming the magazine, and so in December 1912, a brand-new *Masses* hit the newsstands. Artistically the experiment succeeded so well that *The Masses* became, along with the Provincetown Players, the Armory Show, and the Paterson Pageant, a leading expression and symbol of the "little renaissance" of the prewar years. Politically it succeeded well enough to earn the enmity of the establishment press and the federal government, which killed *The Masses* in 1917.

Max Eastman aspired to make *The Masses* much more than a voice for the Socialist party. Once when Socialist leader Norman Thomas complained that the magazine's sexual candor detracted from its political punch, Eastman agreed that "we would strengthen our propaganda value by toning down our expression of life. But it isn't just political propaganda, it *is* life to which the venture is primarily dedicated. I can't help it. That is deeper in me than the desire to be useful."[8] What was deeper still in Eastman and his comrades was the desire to *marry* art and politics, the interests of intellectuals and the interests of workers, in the life of the magazine. Eastman later called *The Masses* a "mixture of proletarian revolt with revolt against the genteel tradition."[9] Its editors championed a unitary vision of freedom against what they conceived as a unitary structure of oppression. Despite their insistence on the unity of art and politics, however, the expressive genius of the magazine has been justly honored while its radicalism has been ignored or dismissed.

To be sure, no candidate for office sought the endorsement of *The Masses*, nor did the magazine adopt a systematic political agenda. But by providing a forum for far-sighted social criticism, values, and goals, *The Masses* served as a creative center for the American Left. The New Politics generated not just new political structures, forms, and organizations, but also a host of fresh visions for industrial America, ranging from freewheeling fantasies like Charlotte Perkins Gilman's *Herland* (1915) and Colonel Edward House's *Philip Dru, Administrator* (1912) to works of commentary and theory like Walter Lippmann's *Drift and Mastery* (1914) and Herbert Croly's *Promise of American Life* (1909).[10] *The Masses* zestfully participated in this movement to rethink and reimagine the "promise of American life." It is for this visionary function, not for its effects on contemporary elections or platforms, that I propose we take seriously the radicalism espoused by the artists-in-politics of *The Masses*.

Some *Masses'* editors were veteran members of the Socialist party, others had no use for the party, but all were dedicated to the socialist *movement*. And for a majority the most militant and most joyful energies of the movement were embodied in the Wobblies, who became models for the "pro-

letarian revolt" *The Masses* wished to champion. It was more than coincidence that the journal was reborn when the prestige and organizing momentum of the IWW were at their peak, just months after the Wobblies had won their greatest victory in a textile workers' strike at Lawrence, Massachusetts. In effect the editors wanted to bring to journalism the qualities that the IWW applied to labor organizing—their brashness, their iconoclasm, their feeling for the most dispossessed members of American society. Dedication to socialism and admiration for the Wobblies brought together the people who put out *The Masses*, and it was for their loyalty to these dissident movements that the government eventually did the magazine in.

At first it was hard to know how seriously to take the reborn magazine. In its inaugural issue Eastman's *Masses* declared itself unequivocally "a Socialist magazine," but one that would abstain from "the fractional disputes within the Socialist Party" and appeal "to the masses, both Socialist and non-Socialist, with entertainment, education, and the livelier kinds of propaganda."[11] A statement that Eastman nailed to the masthead in early 1913 further pledged to make *The Masses*

A REVOLUTIONARY MAGAZINE AND NOT A REFORM MAGAZINE: A MAGAZINE WITH A SENSE OF HUMOR AND NO RESPECT FOR THE RESPECTABLE: FRANK, ARROGANT, IMPERTINENT, SEARCHING FOR TRUE CAUSES: A MAGAZINE DIRECTED AGAINST RIGIDITY AND DOGMA WHEREVER IT IS FOUND: PRINTING WHAT IS TOO NAKED OR TRUE FOR A MONEY-MAKING PRESS: A MAGAZINE WHOSE FINAL POLICY IS TO DO AS IT PLEASES AND CONCILIATE NOBODY, NOT EVEN ITS READERS—THERE IS A FIELD FOR THIS PUBLICATION IN AMERICA.

Sometimes the new magazine seemed more bent on comedy than on revolution. An early *Masses* ad invited the reader to put "a Little Dynamite in Your Home."[12] Another ad read:

ANARCHISTS?
O DEAR, NO!
LAW-AND-ORDER is our middle name
THE MASSES
Should be on every library table. It will entertain the babies, upset Ma, and give Pa a jolt regularly once a month.
WE GUARANTEE TO ANNOY![13]

Eastman later said of the magazine's editors, "We would give anything for a good laugh except our principles."[14]

Eastman wasted no time in getting down to principles. He immediately began painting over Piet Vlag's "yellow" ideology, shifting the magazine's emphasis from the subject of workers' cooperatives to that of class struggle. Eastman posited a "flat contradiction" between "the revolutionist" and "the reformer":

The reformer wishes to procure for the workers their share of the blessings of civilization; he believes in himself and his altruistic oratory; he tries to multiply his kind. The revolutionist wishes the workers to take the blessings of civilization; he believes in them, and their organized power; he tries to increase in them the knowledge of their situation and the spirit of class-conscious aggression. "Education and Insurrection to be adopted simultaneously!" was the battle-cry of Mazzini.[15]

There may have been a tincture of Marx in this declamation, but more revealing was Eastman's tribute to Mazzini, a romantic insurrectionist who became a saint of nineteenth-century liberalism and republicanism. Always Eastman honored "the spirit of liberty" as much as he heeded "the spirit of class-conscious aggression." In 1912–1913 his ideas owed more to the pragmatist philosopher John Dewey, his mentor at Columbia, than to any theorist of revolution. He titled his *Masses* column "Knowledge and Revolution," significantly in that order, and he defined "knowledge" as "experimental knowledge—a free investigation of the developing facts, and a continuous retesting of

the developing theories, which pertain to the end we have in view." The Deweyan pragmatist in Eastman aspired to be a scientist of socialism, purging the American Left of sloppy or unrealistic thinking.[16]

There was also a side of Eastman that admired the swashbuckling, ad hoc syndicalism of the Wobblies.[17] The Wobblies had little in the way of a formal ideology; they learned their revolutionary unionism less from Left theories than from the hard experience of miners, lumberjacks, stevedores, and migrant laborers. It was the Wobblies' faith in ordinary workers, drawn from rough-hewn knowledge of the working world, that made them so attractive to Eastman and his colleagues. Like every generation of American intellectuals since the transcendentalists, the people of *The Masses* wanted not to be cloistered and cut off from plebeian America. They felt called to translate their democratic visions into action. To Eastman the Wobblies were both intuitive pragmatists and idealists in work clothes, beckoning him by their example to take his principles out of the library and into the streets.

In his first *Masses* column Eastman proclaimed his IWW sympathies by demanding justice for jailed Wobbly heroes of the Lawrence textile strike. Fresh from their brilliant victory there, which they had achieved by unifying a diverse work force and by cultivating public support, IWW leaders were trying to soften their reputation for insurrectionary violence. Eastman followed suit. By endorsing "revolution," he carefully explained, he did not call for "a change necessarily decorated with blood and thunder." Rather what he had in mind was "a radical democratization of industry and society . . . accomplished through the conquest of power by a subjected class."[18] Exactly how the oppressed were to conquer power Eastman left unexplained, but his notion of "revolution" apparently resembled the Wobblies' dream of a general strike, a mass awakening of "the spirit of liberty and rebellion" that would one day move workers to take command of the economy for themselves.

The generic defect with "reform," in Eastman's view, was its undemocratic nature. It meant power exercised *for* workers rather than by them. In Eastman's opinion this sham was epitomized by Rooseveltian progressivism, which amounted to nothing more than "Philanthro-Efficiency"—charity designed to reconcile workers to their brutal jobs. The Progressive party appealed to plutocrats because it served business while doing nothing "to alter the inequalities in our economic life." Eastman found it amusing that labor people in Chicago called Roosevelt and Jane Addams the Gold Dust Twins, who ministered to suffering workers; but he reminded readers that reformers "will never do the work of liberating the workers of the world. That will never be done unless the workers of the world do it." Any Marxist would have endorsed this sentiment, but in the milieu of 1913 Eastman was clearly alluding to the Industrial Workers of the World.[19]

Yet the editors of *The Masses* were not disposed to reject reformers across the board. The vibrant array of reform energies known as the progressive movement was at least as plural and amorphous as the socialist movement. The Bull Moose party of Theodore Roosevelt no more perfectly embodied the whole of progressivism than the Socialist party of Debs represented all the variants of socialism. In practice Eastman and his comrades were far friendlier toward the radical Midwestern progressivism of Robert La Follette than the conservative Eastern progressivism of Roosevelt. However, the heat of their rhetoric often dissolved discriminations between the democratizing kinds of progressive reform they approved and the patronizing kinds they scorned.

Another key contributor to *The Masses*, Mary Heaton Vorse, represented a radicalism that was harder won and in many ways different from Eastman's, but she too was profoundly influenced by the Wobblies and the ideal of worker self-help. Like thousands

of contemporary women who served settlement houses and the labor movement, Vorse rebelled against a cloyingly privileged background. She was brought up in one of the wealthiest families of Amherst, Massachusetts, and educated by tutors and foreign travel. To evade the gentility prescribed for women of her class, Vorse entertained dreams of an artistic career that carried her first to Paris and then to New York, where she took classes at the Art Students' League. "I am part of the avant garde. I have overstepped the bounds!" she happily reported.[20]

Vorse soon dared to overstep other bounds. In quick succession she gave up painting, married a fledgling writer, settled in Greenwich Village, took up the writing trade herself, and achieved quick success at it. She also gained exposure to the struggles of working-class people and endured domestic strains that gave her growing empathy with oppressed women. In 1904, while living in Venice, Vorse was fascinated and touched by the solidarity of Italian workers staging a general strike. Two years later she and her family joined "A" Club, a Greenwich Village housing cooperative formed by a miscellany of intellectuals and settlement-house workers who were "all for Labor and the Arts." Meanwhile, she was contending with the bitter fruits of her rising literary success—the resentment of her husband, whose own career refused to take off, and the guilty feeling that her success had somehow caused his failure. She expressed some of this in her first book, *The Breaking in of a Yachtsman's Wife* (1908), an autobiographical novel about a bride whose skill in sailing was resented by her overbearing and insecure husband.[21]

In the years 1910–1912 a series of shocks impelled Vorse to break decisively with her origins and take up the political commitments that brought her to *The Masses*. Her husband died in 1910, leaving her the breadwinner for her young family. The following year she learned about the beleaguered lives of poor families when she joined the New York Milk Committee, a middle-class women's crusade to reduce infant mortality by distributing pasteurized milk. Although Vorse was drawn to this kind of activism, she was simultaneously being introduced to workers' movements that impressed her more. In March 1911, she witnessed the horrific Triangle Shirtwaist Company fire, in which grotesquely unsafe working conditions cost 146 young garment workers their lives. After the tragedy Vorse was moved when a young garment worker named Rose Schneiderman declared, "We have tried you good people of the public and we have found you wanting. . . . It is up to the working people to save themselves."[22]

Vorse heard the same message from the massed voices of the strikers at Lawrence, whose battles she covered for *Harper's Weekly* in early 1912. She was inspired by the strikers' courage, by Bill Haywood's serene leadership, and by the impassioned oratory of Elizabeth Gurley Flynn, which "stirred [the strikers], lifted them up in her appeal for solidarity. . . . It was as though a spurt of flame had gone through the audience. . . . Something beautiful and strong had swept through the people and welded them together, singing."[23] After Lawrence, Vorse reported years later, she and her new husband decided they

> knew . . . where we belonged—on the side of the workers and not with the comfortable people among whom we were born. . . . Some synthesis had taken place between my life and that of the workers, some peculiar change which would never again permit me to look with indifference on the fact that riches for the few were made by the misery of the many.[24]

Radicalized by what she had seen in New York and Lawrence, Vorse applied her new commitments to writing for *The Masses*. She already had a close relationship with the magazine, having become an editor and one of its cooperative owners in the winter of 1911.[25] Her first literary contribution was a

story published in May 1912 about a drunken worker who refused a patronizing offer of help from a Christian philanthropist.[26] Over the next five years Vorse would give *The Masses* several more bittersweet dialect stories about workers' lives, and she would send in firsthand acounts of major strikes from around the nation.

Vorse's courageous career reveals a face of *Masses'* radicalism that was less flamboyant and more reflective than the face shown by some of her more celebrated colleagues. She was unquestionably a person of the Left. When she traveled to an international women's peace congress in Holland, Vorse was exasperated by the political timidity shown by Jane Addams and other American delegates. Often she put herself squarely in the middle of workers' movements. In 1914, she turned her home into a headquarters for a Wobbly-instigated campaign to protest unemployment and homelessness in New York. In 1916, she went to Minnesota to write about a bitter Wobbly-led strike of iron miners, then found herself drawn into a role as "a sort of assistant to the leaders" when Elizabeth Gurley Flynn was jailed.[27]

Yet Vorse never deluded herself into thinking she could fully share the experience of workers. During her brief stint as a strike leader in Minnesota she suffered the harassment and ostracism that strikers routinely experienced. But as she later reflected, she was soon able to return to "respectability," while for the strikers the stresses of class struggle were never-ending. Instead of pretending to sever her roots in the middle class, Vorse became a self-conscious intermediary between classes, striving to persuade bourgeois folks like herself to support proletarian struggles by giving them "more knowledge of the workers' lives."[28] Her faith in the power of publicity she shared with both IWW leaders like Haywood and the muckraking progressive journalists of the day. Like other *Masses'* radicals, but with more realism and self-knowledge than most, Vorse balanced her sympathy for "revolutionists" with a supple readiness to

cooperate with reformers. Thus, she saw nothing anomalous in joining upper-class New York ladies in Carrie Chapman Catt's 1915 suffrage campaign at a time when she was devoting most of her journalistic energies to covering bitter strikes.[29]

In a sense women radicals needed to be more ideologically flexible, because they paid a higher personal price for their radicalism than their male colleagues. The sexism of those colleagues was itself a problem. During the 1914 unemployment protest campaign Vorse did domestic chores like finding beds for protestors while her husband headed the campaign's legal defense committee. And always Vorse bore the burden—and often the guilt as well—of combining her radical commitments with the demands of attending to her young family. Perhaps that is why Eastman remembered her as "abounding in energy" yet having "a permanently weary look."[30]

While many of Mary Heaton Vorse's labors for socialism, feminism, and peace took place backstage, her *Masses* comrade John (Jack) Reed always sought the limelight. If Max Eastman admired the scholarly Mazzini, Reed preferred to emulate Garibaldi. Eastman wrote exquisitely reasoned editorials, but Reed galloped from one scene of class struggle to another, always with his heart on his sleeve, writing about the oppressed and fighting alongside them.[31]

Nothing in Reed's youth had pointed him toward a life on the Left. Born into a wealthy family in Portland, Oregon, Reed had been a bored cutup in prep school and an unintellectual "activities man" at Harvard. When he graduated from college in 1910, nobody detected any particular politics in him. Reed's father, half-ruined by his own efforts to expose land frauds in Oregon, had no desire to see his son become a reformer, much less a revolutionist. When the younger Reed settled in Greenwich Village, determined to be a writer, C. J. Reed asked his friend Lincoln Steffens to take Jack under his wing and "save him for poetry. . . . Don't let him get a conviction, like me, and become serious. . . . Keep my boy laughing,

laughing and singing."[32] But Young Reed quickly acquired the defiant convictions that would inspire his early contributions to *The Masses*. Soon he was praising the poetic sensibilities of workers and proclaiming himself a Wobbly and a proponent of dynamite.[33]

In Reed's tastes for proletarian rebellion there was more than a little posturing, along with generous doses of sentimentality and mockery. He kept on "laughing and singing," only now he was doing so at the expense of his father's class. But Reed also sincerely desired an imaginative intimacy with workers and peasants which had been missing from the old *Masses* and which, given its principles, the new *Masses* needed. When Reed submitted a story about a dance-hall girl to *The Masses* soon after Eastman had taken over the magazine, Eastman printed it and asked for more.[34] Reed was soon elected to the editorial board, and his career as the knight-errant of *Masses* radicalism was underway.

Eastman recognized that Reed's passionate identification with the dispossessed complemented his own more cerebral approach to socialism. Moreover both young radicals were attracted by the Wobblies, whose penchant for "direct action"—by which they meant militant strikes and other forms of struggle against capitalism in the workplace—made the earnest politicians of the Socialist party seem a pack of Milquetoasts by comparison. When Big Bill Haywood was expelled from the party's executive committee for advocating sabotage, *The Masses* sided with him and sabotage. Plunging into the tempestuous proletarian uprisings of 1913–1914, Eastman, Reed, and their associates strived to make the magazine a true "meeting ground for revolutionary labor and the radical intelligentsia."[35]

In April 1913, Reed heard Haywood describe a Wobbly-led strike of 25,000 silk workers in Paterson, New Jersey, that was then being blacked out in the mainstream press. Resolved to throw a journalistic spotlight on Paterson, Reed rushed to the silk mills—and promptly got himself tossed into the Passaic County Jail, in the company of

Haywood and scores of strikers, after he refused to obey a policeman's order to move along. When a Wobbly lawyer bailed him out, Reed dashed back to New York to write "War in Paterson," a blazingly partisan account of the strike that appeared in the June 1913 issue of *The Masses*. Still groping to define his perspective on workers, Reed's piece was by turns mawkishly condescending and mawkishly admiring. He sketched a tableau in the jail in which the "slight and foreign-faced strikers, . . . quickened and strengthened by Bill Haywood's face and voice, looked up at him lovingly, eloquently." Yet the purpose of the article was to celebrate the heroism of ordinary people "ennobled by something greater than themselves."[36]

Adulation soon gave way to a deeper and more complex involvement with the strike. To raise money and strikers' morale, Reed volunteered to produce a dramatization of the Paterson struggle enacted by the

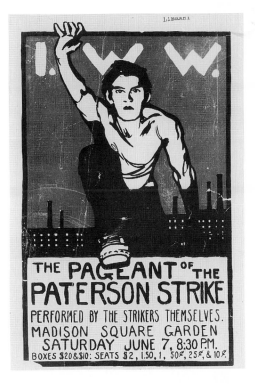

FIGURE 5. *Program cover designed by Robert Edmond Jones for the Paterson Strike Pageant, 1913. Tamiment Institute Library, New York University.*

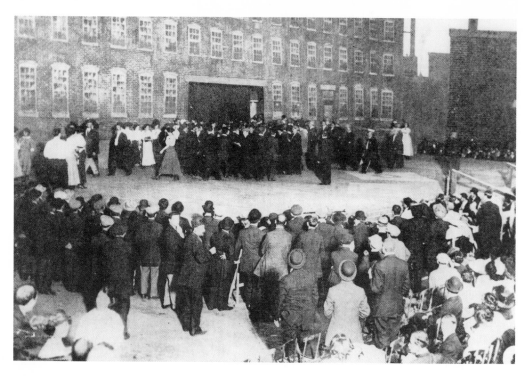

FIGURE 6. *"Picketing the Mills" scene from the Paterson Strike Pageant, 1913. Tamiment Institute Library, New York University.*

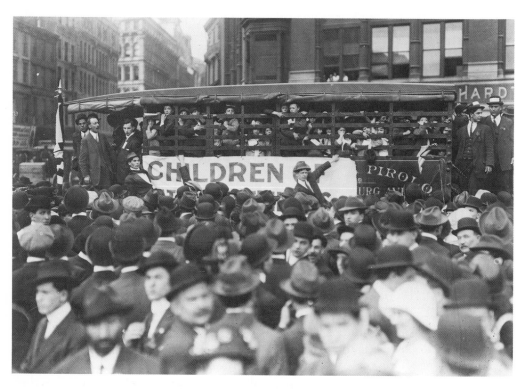

FIGURE 7. *Paterson strikers' children at May Day parade, New York City, 1913. Library of Congress.*

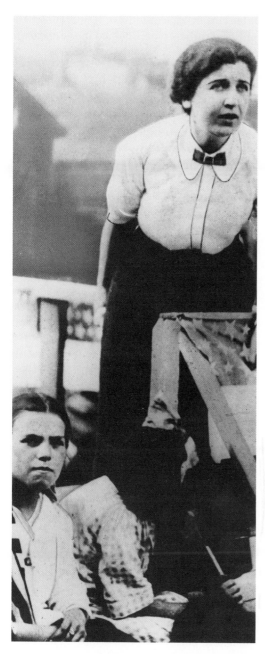

FIGURE 8. *Elizabeth Gurley Flynn at the Paterson Strike, 1913. Tamiment Institute Library, New York University.*

workers themselves. Most of the *Masses'* editors and dozens of other Villagers threw themselves into the celebrated Paterson Pageant that drew 15,000 people to Madison Square Garden, which was decorated with a mammoth "I.W.W." in red electric lights, on

7 June 1913. The staging of the pageant proved an intense and vivid school in class consciousness for both the strikers and their intellectual allies. Ignoring the "melting-pot" images of immigrant cultural gifts so much cherished by progressive reformers, the pageant "made dramatically clear that the 'new citizens' were contributing more than their dances, their songs and their folk traditions to this country : they were being forced to contribute their health, their hopes, their honor and their children."[37] As a fund-raiser the pageant was a disappointment, and eventually the strike itself was lost. But by demonstrating Village socialists' will and capacity to make common cause with workers the pageant served as a significant rite of initiation, and it accelerated the progress of *The Masses* from passive sympathy to active support of class struggles.

Soon after the Paterson strike Reed seized an opportunity to cover the Mexican Revolution. The several articles he wrote for *The Masses* combined unabashed romanticizing of Mexican earthiness with unremitting criticism of American imperialism. Then both Reed and Eastman covered the United Mine Workers strike in Colorado that had climaxed with the repulsive massacre of strikers' wives and children at Ludlow in April 1914—Reed writing for the *Metropolitan*, Eastman for *The Masses*. If originally Reed had been Eastman's star pupil in the *Masses'* school of socialism, by now the relationship was largely reversed. Much in the manner of Reed, Eastman's articles on Colorado burst with empathy for heroic strikers and seethed with sarcastic rage at the authorities. Ludlow united Eastman and Reed in the conviction that intensifying antagonism between capital and labor demanded from socialist intellectuals "the courage of action."[38]

Early in 1914, Walter Lippmann hailed John Reed's Mexican dispatches, but a few months later he had sour second thoughts about his former Harvard classmate and published them in *The New Republic*. Lippmann's "Legendary John Reed" was

really an assault on the whole political culture of the Village, which Reed had come to symbolize.[39] "Even as an undergraduate," wrote Lippmann, Reed "betrayed what many believe to be the central passion of his life, an inordinate desire to be arrested." The deeper truth, Lippmann suggested, was that Reed suffered from arrested development. Revolution and labor were for him only shining abstractions; Reed "made an effort to believe that the working class is not composed of miners, plumbers and working men generally, but is a fine, statuesque giant who stands on a high hill facing the sun." Lippmann described Reed himself as a chameleon:

He is many men at once, and those who have tried to bank on some phase of him, to regard him as a writer, a correspondent, a poet, a revolutionist, or a lover, lose him. There is no line between the play of his fancy and his responsibility to fact; he is for the time the person he imagines himself to be.

Many socialists, too, considered Reed and his magazine too lascivious, too arty, or simply too un-Party to do anything but play at revolution. The right-wing socialist writer W. J. Ghent accused *The Masses* of

mixing Socialism, Anarchism, Communism, Sinn Feinism, Cubism, Sexism, direct action and sabotage into a more or less homogeneous mess. It is peculiarly the product of the restless metropolitan coteries who devote themselves to the cult of Something Else; who are ever seeking the bubble Novelty at the door of Bedlam.[40]

Substantial matters got lost "in the welter of sex literature and illustrations that fill your columns," objected a *Masses* reader in November 1916. "As to your actual ideas, you are, I fear, merely sentimentalists in revolt. The poses that you assume may be indigenous to Greenwich Village, but they can only repel everyone who is seriously at work."[41] Had he been writing a half-century

later this critic would have found handy the phrase "radical chic," coined in the sixties to refer to merely fashionable gestures of revolt.

All disparagements of the socialism espoused by *The Masses* rested on the premise that Greenwich Villagers were Bohemians, by definition people who had withdrawn from the workaday public into private avocations. Bohemia was regarded as the last stop for artists and intellectuals after their centuries-long retreat to the margins of society. It was a zone accorded freedom of expression on condition that freedom be used only for aesthetic experiments, never for political ones. As a place of internal exile Bohemia resembled the university, with which the Village was often derisively compared. As a state of mind Bohemia was popularly associated with immaturity and the love of unreal things—of play, jokes, dreams, and make-believe—that supposedly went with youth, all of which were distinguished from engagements with the real and the possible that constituted mature political activity.

Similar attitudes have saturated scholarly commentary on *The Masses* and Village political culture ever since. The Lyrical Left that flourished in Greenwich Village has been pronounced more lyrical than Left, more therapeutic than revolutionary, more an agitated milling about than a movement. At a hostile extreme critics like Robert Humphrey have pronounced the prewar Greenwich Villagers "children of fantasy" whose puerile frolics had no purpose beyond the desire to thumb their noses at their elders. Allegedly they were gentlemen songsters off on a socialist spree, having a fling at rebellion which they knew would cost them nothing because they could always retrieve the protections and privileges they had ostentatiously flung away.[42]

Even scholars who admire the Villagers' aesthetic verve deny them consideration as serious socialists. Joseph Freeman contends that *Masses'* writers failed to overcome "the dualism between poetry and politics which

affected the pre-war radical intelligentsia."
Frederick Hoffman complains of the "in-
coherence of prewar radicalism . . . a parade
of ideas and feelings, the display of which
counted for more than clarity or precision
of expression." Calling Reed "the poet-
playboy of the Lyrical Left," historian John
Diggins dismisses as a "radiant illusion" the
"brief moment" when "cultural and social
revolution seemed to have come together"
before World War I. Leslie Fishbein con-
cludes that the radicals of *The Masses* sought
"personal salvation with more intensity
than they pursued socialist goals."[43]

Such judgments tend to measure *The
Masses* by standards the magazine rejected.
In the eyes of Socialist regulars *The Masses'*
editors may have been frivolous mavericks
who distracted attention from the hard busi-
ness of party building. But like the
Wobblies, the magazine aspired to serve not
the party but the *socialist movement.* In any

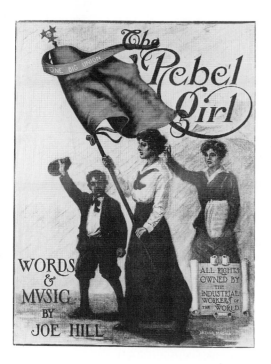

FIGURE 9. *Sheet music cover for Joe Hill's song
"The Rebel Girl," inspired by Elizabeth Gurley
Flynn. Tamiment Institute Library, New York
University.*

case Eastman, Reed, Art Young, and other
editors were surely no more self-indulgent
than other political actors of their time. To
the contrary, they were more principled
than most, and a writer like Vorse had to
make tremendous sacrifices to stick to her
principles. If the Bohemianism of *The
Masses* alienated dour comrades, it did not
dilute the sincerity of the editors' commit-
ment to socialism. Max Eastman had no
objection to Bohemianism, he told a friend
in 1916, so long as it kept "personal revolt"
subordinate to "serious social thought and
effort."[44] And notwithstanding the *Masses'*
occasional theatricality and its advocacy of
quixotic causes, the editors adopted a
coherent socialist creed which they deftly
used to interpret the events of their day.

Eastman recalled that art and propa-
ganda were the "two interests whose
satisfaction within the same covers had
made the magazine unique." But always the
claims of politics superseded those of art.
When there was a rupture between "Bohe-
mian art-rebels" and "socialists who loved
art" on the editorial board in 1916, the so-
cialists easily prevailed. Most of the brilliant
artists who worked on *The Masses* agreed
with Art Young when he said, "I believe in a
picture with a purpose. . . . Socialism al-
ways has been and I suppose always will be
the keynote of my work." And most of the
Masses' writers would have agreed with
Reed's plaintive remark, "This class
struggle plays hell with your poetry."[45]

Striving for effective socialist propa-
ganda was one thing, accomplishing it quite
another. The magazine was supposed to be
"a meeting ground for revolutionary labor
and the radical intelligentsia." As a medium
for learning about and expressing solidarity
with workers *The Masses* attracted many
Left intellectuals, but there is little evidence
that "revolutionary labor"—or working-
class readers of any political tendency—
showed up. In large part this was because
The Masses refused to trim its enthusiasms
for birth control, free love, and other prac-
tices that "would have seemed at least

inscrutable and more likely offensive to working-class readers."[46] Other socialist publications cultivated such readers more assiduously. For example, *The International Socialist Review* frequently printed essays that were as politically radical and as intellectually challenging as anything that appeared in *The Masses*, but it succeeded in building a wide proletarian readership by sticking close to the party and to working-class tastes.[47] Hence the judgment of critics that *The Masses'* commitment to proletarian causes amounted to nothing but a penchant for slumming.

Yet many *Masses'* radicals were anxiously and intelligently self-critical about their relationship with the working class. After the Lawrence strike Mary Heaton Vorse felt "some synthesis had taken place between my life and that of the workers," but she recognized that class barriers rendered the synthesis forever imperfect. Her response was to dedicate most of her writing for *The Masses*, and most of the rest of her career, to explaining workers' struggles to the comfortable people of her own class. John Reed was more prone to sentimentalize workers and to believe naively that he could feel his way into their world. But starting in Paterson he sincerely identified himself with the footsoldiers of class war around the world, and eventually his decision to sacrifice poetry to politics led him to a Bolshevik martyr's death in Moscow.[48]

Despite their reputation for Greenwich Village insularity, the radicals of *The Masses* were well adapted to the fluid and relatively tolerant milieu that prevailed throughout American politics during the years 1912–1917, before World War I and the Red Scare and corporate-controlled mass media had their lethal impacts. It was a period of transition and experimentation in all sectors of the political spectrum, including the Left; and it was a period in which tens of thousands of socialists—including Socialist party leader Eugene Debs—would have agreed with Max Eastman that "revolution" meant simply the "radical democratization of industry and society."

To most *Masses'* editors ideological consistency mattered even less than party discipline. Eastman was the magazine's theoretician, if it had one, but it was Eastman who in 1913 promised to make the *Masses* "a magazine directed against rigidity and dogma wherever it is found." As elastic as party orthodoxy tended to be, Eastman wished it still looser. When party loyalists abused him for saying kind things about Woodrow Wilson in 1916, Eastman gave them a scolding for their sectarian stiffness: "Let us try to use our brains freely, love progress more than a party, allow ourselves the natural emotions of our species, and see if we can get ready to play a human part in the actual complex flow of events."[49]

When the party started losing support in 1916–1917, Eastman blamed its leaders' tendency to put too much emphasis on Marxist theory. Eastman's own loyalty to Marxism was minimal. He paid only occasional lip service to dialectical materialism and the deterministic conception of history. He once called socialism a species of "scientific idealism"; his quarrel with Marxism was that it was neither scientific enough nor idealistic enough. Eastman advised the *Masses'* faithful to read not just Marx and Engels but Charles Beard, and often he invited Left-leaning progressives like Amos Pinchot and George Creel to contribute to the magazine.[50]

To critics such ideological eclecticism marked Eastman as a dilettante or opportunist. But if firmness of theory was the test of socialist seriousness in this period, then everybody but a few party intellectuals failed it. Nor was *The Masses* unusually pluralistic or softheaded when judged by the standards of other radical politicians. James Weinstein notes that journals like the *International Socialist Review* and *The New Review*, the latter set up in 1913 to be "the organ of the left-wing theoreticians," routinely accepted articles by socialists of every stripe

and sometimes by non-socialists, too. There was no confusion or lack of rigor in this practice; rather it reflected the heterogeneity of the movement and a faith in free inquiry. Weinstein calls the genial ecumenicism of the socialist press

> an indication of the factional fluidity which existed before 1919, and a reflection of the absence, or at least the tentative nature, of differences in principle between the several [party] groupings and tendencies. Searching and open debate was characteristic of the Socialist press in these years, not as a tactical maneuver, but because no group could assert with confidence that it had found the answers to all the problems besetting the movement.[51]

If the intellectually unfenced quality of American socialism opened spaces for maverick organs like *The Masses*, it also perpetuated a crisis of identity that wearied the faithful and put off potential recruits. Waverings and blurrings of purposes seemed to *The Masses* the principal problem besetting the movement. Thus, the magazine set for itself the task of surveying the boundaries *around* socialism, by sharpening its differences with progressives, and also *within* socialism, by campaigning against sterile sectarianism.

Apart from its antiwar crusade, no cause engaged *The Masses* more deeply than that of exposing the alleged snares and delusions of right-wing progressivism. Theodore Roosevelt, his Progressive (Bull Moose) party, and *The New Republic* (founded in 1914) made up an unholy trinity that *Masses'* editors never tired of deriding.

The passion for taking potshots at the Bull Moose undoubtedly derived from the knowledge that Socialists and Progressives were fighting for much the same constituency, the millions of voters who were fed up with the trust- and machine-ridden status quo. (*The Masses* was not alone in its competitive rancor: *The International Socialist*

Review bristled with warnings against the "nicely baited traps" set for unwary Socialists by the wily Bull Moose.[52]) John Reed's father loved TR, and it would have been easy for John to follow his example. But that was just the problem: *The Masses* pictured TR and his Progressive party as altogether too comfortable a choice, because they were minions of the old capitalist order tricked up in appealing disguise. "*The power behind the Reform Movement is the power of capital, and for that reason reforms will not injure the interests of capital,*" thundered an Eastman editorial in February 1914. Reed said that Roosevelt was at home only among "the predatory plutocrats" he pretended to scorn, while Frank Bohn called him "a political fakir of the lowest type. The place of Theodore Roosevelt in our politics parallels that of Billy Sunday in the Church." Humorist Howard Brubaker compressed *The Masses'* case against the Progressives into a collective name he proposed for the mainstream parties: the "Republigressocrats."[53]

From the perspective of *The Masses* the great need of the day was to prove that progressive reform was an imposture, that industrial capitalism could not be redeemed by middle-class do-gooders, that it had to be remade by the workers. Yet the ascendant "yellows" in the Socialist party seemed bent on collaboration, to the point that *The Masses'* cousin, *The International Socialist Review*, spoke of plots to fuse the Socialist and Progressive parties. The gradualist, starch-collared, election-focused program of Victor Berger, Morris Hillquit, and other party moderates looked more like an imitation of Republigressocrat platforms than an alternative to them. Already the Bull Moose party had moved remarkably close to the Socialist right wing; Roosevelt denounced "malefactors of great wealth" as fiercely as any Socialist, and the Progressives proposed aggressive state interventions in the economy. And already the "yellows" seemed to share the Progressives' fear of an aroused proletariat; Victor Berger seemed to regard

Haywood and the Wobblies as a greater menace than Roosevelt and the Bull Moose. It appeared possible that ultimately the Socialist party would renounce revolutionary goals altogether, adopt the optimistic revisionist Marxism of Eduard Bernstein, and content itself with striving to match the parliamentary successes of the German Social Democratic Party.[54]

Under the circumstances *The Masses* brandished phrases like "revolution" and "class struggle" not just to be provocative, but to dramatize the difference between their brand of socialism and progressive reform. And if they did not endorse violent "revolutionism," nevertheless they fully approved of workers' armed resistance to outright aggression. An event like the 1914 Ludlow, Colorado, massacre of thirteen coal miners' wives and children summoned up the editors' angry impatience with all those who advised workers to wait patiently for justice. Eastman rejoiced:

> For once in this country middle ground was abolished. Philanthropy burned up in rage. Charity could wipe up the blood. Mediation, Legislation, Social Consciousness expired like memories of a foolish age. And once again, since the days in Paris in '71, an army of the working class fought the military to a shivering standstill, and let them beg for truce. It would have been a sad world had that not happened.[55]

Such intemperate sentiments were unspeakable for *The New Republic*, the solemn oracle of Eastern progressive thought which, upon its founding in 1914, completed the triad of *The Masses'* favorite foes. Actually it was *The New Republic* that flung down the gauntlet by publishing Lippmann's acerbic "Legendary John Reed" article and by making cracks about the utopianism of *The Masses*. Eastman and his colleagues eagerly accepted the challenge.

To a degree it was the style of the new magazine that perversely fascinated *Masses'* editors. *The New Republic* was simply every-

thing that the outrageous and obstreperous *Masses* was not. In an unsigned review probably written by Floyd Dell, *The Masses* twitted its rival for its tone of majestic authority:

> One always agrees with it; and conversely, it always appears to agree with its readers. . . . It is a monument to the pleasant belief that thought is something that doesn't hurt. . . . [The *New Republic* editors] want to avoid the raw earnestness of youth, the passion of propaganda, the angry and eloquent speech of naked idealism.[56]

But the main reason for spilling vitriolic ink on *The New Republic* was the influence it seemed to exert on establishment opinion. It was almost as important as it was self-important, according to Floyd Dell, a virtual political institution "comparable in its way to the Progressive Party." Eastman suggested that the contrast between the two magazines precisely mirrored the contrast between the socialist goal of revolution and the progressive goal of reform:

> *The Masses* rests its great hope of democracy in agitation and organization of the lower classes, rather than in telling the upper classes, who do not want democracy, how they might get it, if they would only be entirely practical and consent to go very slowly step-by-step. We of *The Masses* would like to assemble the power that will do something; they of the *New Republic* are satisfied to instruct the power that won't. That is the big difference between these two groups of editors.[57]

Despite this "big difference," the radicals of *The Masses* acknowledged that on some issues *The New Republic*'s editors were potentially valuable collaborators. Understanding class dynamics and clarifying political identities mattered to *The Masses*, but electoral power mattered too, and progressive reformers attracted far more voters than the Socialist party had ever com-

manded. Thus, with a pragmatism that characterized few others on the American Left, *Masses'* editors cheerfully contemplated future alliances even with the minions of Roosevelt. Reporting on the Progressive party convention of 1916, John Reed vilified the colonel as a tool of "the munitions makers and the money trust" but voiced respect for the Bull Moose rank and file. "We, Socialists and Revolutionists, laughed and sneered at the Progressives; we ridiculed their worship of a Personality; we derided their hysterical singing of the Revival Hymn; but when I saw the Progressive Convention, I realized that among those delegates lay the hope of this country's peaceful evolution, and the material for heroes of the people."[58]

Standing with the Socialists and the Wobblies against the war, Reed, Eastman, and their comrades warmly embraced antiwar progressives like Bob La Follette. For that matter both Eastman and Frank Bohn wrote in praise of Wilson, and Reed voted for him, as long as the President posed as a peacemaker.[59] This was behavior that set the *Masses'* radicals apart from many other Left socialists, whose hostility to doctrinal enemies and the middle class had long kept them in splendid isolation.[60]

This willingness to join coalitions in pursuit of common objectives may seem to have contradicted the magazine's often-stated distrust of reformers. Yet, from the beginning *The Masses* pledged its allegiance to socialist principles rather than to the party or any of its factions. Always the *Masses'* radicals prized intellectual freedom more than ideological purity. Thus, in 1912–1913 *The Masses* spoke against sectarianism of Right and Center Socialists who expelled the Wobblies, ignored huge segments of the working class, and threatened to turn the party into a shadow of the Bull Moose. Then in 1916–1917—until the United States declared belligerency—*The Masses* resisted the Left sectarianism that might have prevented Socialists from forming alliances with fellow opponents of the war.

Other causes taken up by *The Masses* reflected a similar independence of judgment regarding the long-term interests of socialism. Though women were underrepresented on the staff, the magazine's record of support for equality for women was path breaking and persistent. Eastman, Floyd Dell, and other editors propagandized tirelessly in support of the suffrage and birth control movements. According to Mari Jo Buhle,

In its prose and visual representations the *Masses* made woman and her liberation a major subject. Never before had Socialist journalists so avidly depicted the slum woman as oppressed but nevertheless capable of a profound resistance, offered so much subjective evidence of an awakened female sensuality, and devoted itself to the fondest expectation of woman's triumph, politically, economically, and culturally. Woman's situation became for these writers and artists a way of knowing and believing, a touchstone of revolution.[61]

The Masses was ahead of its time, too, in speaking out for the homeless. During the bad winter of 1914 a twenty-one-year-old Wobbly named Frank Tannenbaum led a campaign to secure food and shelter for unemployed men in the churches of New York City. Most churches volunteered help, but at St. Alphonsus the rector called the police to drive Tannenbaum's men away. Tannenbaum landed in prison at Blackwell's Island for six months. In the April 1914 *Masses*, John Sloan pictured police shoving ragged men off church steps over the title "Calling the Christian Bluff," and for more than a year the magazine's editorial writers used the Tannenbaum case as a lens to focus attention on the indifference of established institutions to the distress of working-class people.[62]

As often happened in *Masses'* circles, what was political commentary one season became political art the next. The incident at St. Alphonsus furnished the subject of one of the

first four plays produced by the Province-town Players during their inaugural summer in 1915, a daring piece by Wilbur Daniel Steele called *Contemporaries.* The cast included Max Eastman and his wife Ida Rauh.[63]

None of this boldness or imagination, however, characterized *The Masses'* treatment of African Americans. On issues of class and gender relations the editors were courageous and farsighted, but they could seldom see past the color line. At its worst *The Masses* purveyed racist stereotypes in cartoons and poetry; at its best it sporadically protested the same stereotypes. For the most part the magazine hewed to the myopic line that racism was a by-product of capitalism, so that no special emphasis had to be given to the peculiar oppressions borne by blacks. Like the white leaders of the Socialist party, *The Masses* shrank back in fear and confusion from confronting this deepest divide in American society.[64] (As Ernest Allen, Jr., shows, despite the party's evasiveness on racial issues, black Socialists carried out vigorous organizing campaigns during this period.)

Less than two years after Max Eastman and his colleagues resurrected *The Masses* with their ebullient visions of international socialist solidarity, the outbreak of World War I jeopardized all their hopes. *The Masses* initially responded with nervous whistling in the dark. Eastman predicted that the war would so damage established institutions that the virtues of "industrial democracy" would shine forth more brightly than ever before; Art Young called on brother cartoonists not to forget the evils of capitalism in their zeal to picture the horrors of war.[65]

But by 1916, the prospect of American belligerency had become so urgent that the war sucked the magazine into its vortex. In July, *The Masses* put out a special "Preparedness Number," featuring a sarcastic and heavily documented assault on warmongering capitalists by Reed. In April 1917, the month the United States entered

the War, *The Masses* was still billing itself as "the keenest and cleverest radical magazine in the country," but by then its cleverness had long since been clouded by the grim work of resistance.[66] Most of the editors stuck with the brave dissent maintained by the Socialist party and the Wobblies. Nonetheless a minority that included Mary Heaton Vorse decided quietly to back the war effort, and ideological cracks began to appear even in the key relationship between Eastman and Reed.

Both men expressed passionate opposition to the war, and the two were tried together for violations of the Espionage Act in 1918. But Reed adopted a hard-line Marxist critique as he moved toward the infatuation with the Bolsheviks that would shortly transform him into the most vocal champion of American communism. For Reed opposition to the war and dedication to workers' revolutions were two facets of a single policy. Reaffirming the faith in ordinary people he had discovered in Paterson and Mexico, Reed argued that the American public had been cozened into supporting the "Great Illusion" of the war by "skillfully disseminated lies"; and he interpreted the Bolshevik Revolution as a triumph of the Russian masses expressing their will through Lenin and Trotsky.[67]

Though Eastman would eventually go through his own Bolshevik phase, the crisis of 1917 made him impatient with Marxist materialism, which in his view failed to explain the war. Eastman expressed a swelling distaste for the multitudes whose mob psychology he blamed for the war mania. As he moved away from Reed's mystical embrace of the common folk, in subtle ways Eastman inched toward the elitism of *The New Republic.* The ability of the Socialist party to "stand up against the patriotic stampede" was cause for rejoicing, he wrote in June 1917; but the war persuaded him, as it did Lippmann, that stampedes and other irrationalities of the herd counted for more in human affairs than his previous trust in science had allowed him to realize. Eastman

broke with the communists in the twenties, and by the thirties he was on his way toward his final rendezvous with *The National Review* and the Radical Right.[68]

Subtle differences among *Masses'* editors were irrelevant to the postal authorities who suppressed *The Masses* at the end of 1917, and to the prosecutors who almost sent Eastman, Reed, Art Young, and Floyd Dell to prison for violations of the Espionage Act in 1918. For the Post Office and the Justice Department it was sufficient to know that the principles of *The Masses* were violently at odds with the policies of the Wilson administration. The spirit that had inscribed in *The Masses* the freshest currents of American radicalism became a death warrant in

the intolerant climate of 1917. Like the Wobblies, the Socialist party, and virtually every other fountainhead of oppositional thought in America, the magazine was killed to satisfy the fanatical demand for patriotic conformity generated by the war.

The pall brought down on the American Left during the war has never been lifted. Neither the communists who survived the Red Scare of 1919–1920 nor the officials who harried them through the following decades had the slightest sympathy for the questing, experimental socialism of *The Masses*. The magazine briefly had a worthy successor in *The Liberator*, started by Eastman and Reed in February 1918, but Reed soon quit over the magazine's decision to support the war

FIGURE 10. *Defendents and supporters outside the courthouse at the time of the first* Masses *trial. Left to right: Crystal Eastman, Art Young, Max Eastman, Morris Hillquit, Merrill Rogers, Floyd Dell.* New York Call, *22 November 1917.*

FIGURE 11. *Hugo Gellert, Untitled ("Russian Peasant"), The Liberator 1 (March 1918), cover.*

effort and Eastman left a few years later. The metamorphosis of *The Liberator* into a doctrinaire Communist party organ called the *New Masses* in 1922 starkly symbolized abandonment of the impulses that had created the original *Masses* ten years earlier. "In *The Masses* and the old *Liberator*," writes Daniel Aaron, "art and politics were fused; now they were mechanically joined."[69] The difficulties of mingling, much less marrying, cultural and political activism on the Left were demonstrated by persistent hostilities between the New Left and the "counterculture," the antiwar movement and the hippie prophets of a New Age, during the sixties and early seventies. Today journals like *The Nation, Dissent*, and *In These Times* advocate a democratic socialism that continues the animating principles of *The Masses*. But the moment of freedom and fertility that beautifully melded politics with art in the pages of *The Masses* has yet to be recovered.

FIGURE 12. *"Big Bill" Haywood in Moscow at the John Reed Memorial with other Americans and Governor Kamener of Moscow (on left) and staff. Tamiment Institute Library, New York University.*

NOTES

1. George R. Kirkpatrick, "The Boy Scout Movement: To Perpetuate Docility, Stupidity and Brutality," *Masses* 1 (February 1911): 17. See also editorial and illustration in 1 (March 1911): 3–4. The Rand School was a socialist institution specializing in extension courses for adult workers. For an excellent account of the history of the magazine, see Rebecca Zurier, *Art for THE MASSES: A Radical Magazine and Its Graphics, 1911–1917* (Philadelphia: Temple University Press, 1988).

2. Charles Dobbs, "Eliminating the Anarchist," *Masses* 4 (July 1912): 5; "Berger, Legien and the Masses," *Masses* 4 (July 1912): 13.

3. George Cram Cook, "Socialism the Issue in 1912," *Masses* 4 (July 1912): 7.

4. *New York World*, 23 April 1917, quoted by Zurier, *Art for THE MASSES*, 35.

5. Max Eastman, *Enjoyment of Living* (New York: Harper & Brothers, 1948), 387–388.

6. Ibid., 394.

7. Ibid., 399.

8. Eastman to Thomas, 28 May 1917, quoted by William L. O'Neill, *The Last Romantic: A Life of Max Eastman* (New York: Oxford University Press, 1978), 42.

9. Eastman, *Enjoyment of Living*, 479, 409. Literary critic Van Wyck Brooks said of the Village before the War, "Every writer I came to know called himself a radical committed to some programme for changing and improving the world." *Days of the Phoenix: The Nineteen-Twenties I Remember* (New York: Dutton, 1957), quoted in Arthur Frank Wertheim, *The New York Little Renaissance: Iconoclasm, Modernism, and Nationalism in American Culture, 1908–1917* (New York: New York University Press, 1976), 29.

10. Gilman's story of a feminist utopia contrasted with House's tale of an America saved by a benevolent dictator, a vision of authoritarian efficiency that bore certain eerie resemblances both to Jack London's *Iron Heel* (1907) and to the *The Principles of Scientific Management* by Frederick Winslow Taylor (1911). Lippmann and Croly both spoke for the Hamiltonian strain of progressivism that produced the Progressive party in 1912.

11. "Editorial Notice," *Masses* 4 (December 1912): 3.

12. *The New Review* 1 (4 January 1913), inside back cover.

13. *The New Review* 1 (December 1913), inside back cover.

14. Eastman, *Enjoyment of Living*, 416. George Bernard Shaw called *The Masses* "equal, I should imagine, to any propagandistic comic journal in the world." Quoted by Zurier, *Art for THE MASSES*, 43.

15. Eastman, "Knowledge and Revolution," *Masses* 4 (December 1912): 5. Giuseppe Mazzini (1805–1872) was a philosopher of nationalism who devoted his life to establishing a unified and republican Italy. He founded a revolutionary society called Young Italy in 1831 and helped create a short-lived radical republic in Rome in 1849.

16. Eastman, *Enjoyment of Living*, 423–431.

17. Syndicalism was a workers' movement that first flourished in Europe in the 1880s. Though there have been many varieties of syndicalism and much debate about its essential nature, all syndicalists are revolutionary trade unionists. In 1913 the American socialist writer John Spargo provided a definition that fit the undoctrinaire form of syndicalism practiced by the Wobblies, calling it "a form of labor unionism which aims at the abolition of the capitalist system. . . . Its distinctive principle as a practical movement is that these ends are to be attained by the direct action of the unions, without parliamentary action or the intervention of the State." Quoted in Melvyn Dubofsky, *We Shall Be All: A History of the IWW* (New York: Quadrangle, 1969), 170. For a full discussion of the Wobblies' ideas, see Dubofsky, 146–170. For a brief discussion of the European origins of syndicalism, see George Lichtheim, *Marxism: An Historical and Critical Study* (New York: Praeger, 1965), 223–231.

18. Eastman, "Knowledge and Revolution," 5.

19. Eastman, "Towards Plutocracy," *Masses* 5 (October 1913): 5; "Philanthro-Efficiency," *Masses* 5 (February 1914): 5; and "Reform Strikes," *Masses* 4 (April 1913): 5.

20. Quoted by Dee Garrison, *Mary Heaton Vorse: The Life of an American Insurgent* (Philadelphia: Temple University Press, 1989), 24. Garrison is my principal source for information on Vorse's career.

21. Ibid., 25–38.

22. Ibid., 44–51.

23. Vorse, "Elizabeth Gurley Flynn," *Nation* (17 February 1926), quoted by Garrison, *Mary Heaton Vorse*, 57.

24. Vorse, *A Footnote to Folly: Reminiscences of Mary Heaton Vorse* (New York: Farrer & Rinehart, 1935), 13–14.

25. Ibid., 41.

26. Vorse, "The Day of a Man," *Masses* 2 (May 1912): 8–9, 18.

27. Garrison, *Mary Heaton Vorse*, 84–85, 89–90; Vorse, *A Footnote to Folly*, 134–149.

28. Vorse, *A Footnote to Folly*, 141.

29. Garrison, *Mary Heaton Vorse*, 89–90.

30. Ibid., 84; Eastman quoted on p. 73.

31. A revolutionary republican and crusader for Italian unification, Giuseppe Garibaldi led a small army of volunteers that overthrew the Kingdom of the Two Sicilies in 1860. Garibaldi's impetuous initiative touched off a series of events that led to the founding of the Kingdom of Italy the following year. Valuable biographies of Reed include Robert A. Rosenstone, *Romantic Revolutionary: A Biography of John Reed* (New York: Alfred Knopf, 1982); Richard O'Connor and Dale L. Walker, *The Lost Revolutionary: A Biography of John Reed* (New York: Harcourt, Brace & World, 1967); and—still the best of the lot—Granville Hicks, *John Reed: The Making of a Revolutionary* (New York: Macmillan, 1936).

32. Quoted in Robert E. Humphrey, *Children of Fantasy: The First Rebels of Greenwich Village* (New York: John Wiley & Sons, 1978), 123.

33. Reed to Robert Andrews, 17 October 1912, quoted in Rosenstone, *Romantic Revolutionary*, 98.

34. Reed, "Where the Heart Is," *Masses* 4 (January 1913); Rosenstone, *Romantic Revolutionary*, 108–109; Eastman, *Enjoyment of Living*, 406–407.

35. Eastman, *Enjoyment of Living*, 409.

36. Reed, "War in Paterson," *Masses* 4 (June 1913).

37. Linda Nochlin, "The Paterson Strike Pageant of 1913," *Art in America* 52 (May–June 1974): 67. See also Steve Golin, "The Paterson Pageant: Success or Failure?" *Socialist Review* 13 (1983): 45–77; and *The Fragile Bridge:*

Paterson Silk Strike, 1913 (Philadelphia: Temple University Press, 1988), 157–178.

38. Eastman, "Class War in Colorado," *Masses* 5 (June 1914): 5–8; Eastman, "Blasting the Uniforms," *Masses* 5 (May 1914): 5; Eastman, "The Nice People of Trinidad," *Masses* 5 (July 1914): 5–8; Eastman, "Inevitable Dynamite," "Anarchy and Rockefeller," and "In Defense of Criminals," *Masses* 5 (August 1914): 5–6.

39. Lippmann, "Legendary John Reed," *The New Republic*, 1 (26 December 1914): 15–16.

40. Quoted by Zurier, *Art for THE MASSES*, 85.

41. Paul H. Douglas, "Horrible Example," *Masses* 9 (November 1916): 22.

42. Humphrey, *Children of Fantasy*, 10–11.

43. Freeman quoted by Daniel Aaron, *Writers on the Left* (New York: Oxford University Press, 1961), 49; Hoffman quoted by Lois Palken Rudnick, *Mabel Dodge Luhan: New Woman, New Worlds* (Albuquerque: University of New Mexico Press, 1984), 76; John P. Diggins, *The American Left in the Twentieth Century* (New York: Harcourt Brace Jovanovich, 1973), 97, 33; Leslie Fishbein, "Introduction" to Zurier, *Art for THE MASSES*, 3, 7–8.

44. Eastman, *Enjoyment of Living*, 548.

45. "Impressions of Our Artists," *Masses* 1 (January 1911): 11; quoted by Aaron, *Writers on the Left*, 25.

46. Zurier, *Art for THE MASSES*, 66.

47. On *The International Socialist Review*, a well-managed magazine that combined lively labor journalism and photographs with theoretical pieces, see James Weinstein, *The Decline of Socialism in America, 1912–1925* (New York: Monthly Review Press, 1967), 75, 85, 103–105; Paul Buhle, *Marxism in the United States* (London: Verso, 1987), 92–93; and Elliott Shore, *Talkin' Socialism: J. A. Wayland and the Role of the Press in American Radicalism, 1890–1912* (N.p.: University Press of Kansas, 1988), 107, 200.

48. On Reed's meteoric and foreshortened career as a Bolshevik, see especially Aaron, *Writers on the Left*, 37–41, 65–67, and the later chapters of Hicks, *John Reed*, and Rosenstone, *Romantic Revolutionary*.

49. Eastman, "Sect or Class?," *Masses* 9 (December 1916): 16.

50. Eastman, "Socialist Doubt," *Masses* 9 (April 1917): 6–7; Eastman, "Scientific Idealism," *Masses* 4 (April 1913): 5; Eastman, "Resume," *Masses* 5 (February 1914): 5; Eastman, "Socialist Party Critics," *Masses* 9 (Feb.

1917) : 24. Eastman first discussed the harrowing possibility that "war-time psychology" and "tribal fighting loyalty" could overwhelm economic calculations and "class conscious internationalism" in an editorial titled "War Psychology and International Socialism," *Masses* 8 (August 1916) : 27–29. Beard, Pinchot, and Creel, all prominent progressives, were respectively a historian, political reformer, and journalist.

51. Weinstein, *The Decline of Socialism in America*, 86–87. Theodore Draper remarks on the receptivity of *The New Review* to ideas from all sectors of socialism, despite its affiliation with the movement's "heavier thinkers," and implies the kinship of this journal with *The Masses. The Roots of American Communism* (New York : Viking, 1957), 49. On the undoctrinaire character of the socialist movement in this period, see also Zurier, *Art for THE MASSES*, 83–86, 163.

52. Frank Bohn, "The National Progressive Party," *International Socialist Review* 13 (September 1912) : 228–232 ; Charles Edward Russell, "What Next ?," *International Socialist Review* 13 (January 1913) ; Editorial, *International Socialist Review* 13 (January 1913) : 561.

53. Eastman, "Plain Efficiency," *Masses* 5 (February 1914) : 5 ; Reed, "They Sold Them Out," *Masses* 8 (August 1916) ; Eastman, "Lost Their Promoter," *Masses* 8 (August 1916) : 10 ; Frank Bohn, "The Re-election of Wilson," *Masses* 9 (January 1917) : 15–16 ; Amos Pinchot, "The Failure of the Progressive Party," *Masses* 6 (December 1914) : 9–10 ; Howard Brubaker, "Jots and Tittles," *Masses* 6 (December 1914) : 7.

54. Editorial, *International Socialist Review* 13 (May 1913) : 829–830. On the abandonment of revolutionary aspirations by Bernstein and the German Social Democrats, see Robert Hyfler, *Prophets of the Left: American Socialist Thought in the Twentieth Century* (Westport, Conn. : Greenwood, 1984), 18–19 ; and Lichtheim, *Marxism*, 259–300.

55. Eastman, "Class War in Colorado," *Masses* 5 (June 1914) : 8. A few months later Floyd Dell reaffirmed the commitment of *The Masses* to class struggle ; "and when that struggle assumes the actual shape of war—as it did in Colorado, as it will in many places before the end is reached—we stand for war." "Socialism and the Sword," *Masses* 6 (January 1915) : 9.

56. "Sweetness and Light," Review of *The New Republic Book*, *Masses* 9 (April 1917) : 28–29.

57. Eastman, "Utopian Reality," *Masses* 9 (December 1916) : 12.

58. Reed, "Roosevelt Sold Them Out," *Masses* 8 (August 1916).

59. Reed, "A Friend at Court," *Masses* 9 (May 1917) ; Bohn, "The Reelection of Wilson," *Masses* 9 (January 1917) : 15–16 ; Eastman, "Socialist Party Critics," *Masses* 9 (February 1917) : 24.

60. Draper, *Roots of American Communism*, 30.

61. Mari Jo Buhle, *Women and American Socialism, 1870–1920* (Urbana : University of Illinois Press, 1983), 259, 262.

62. "The Church and the Unemployed," *Masses* 5 (April 1914) : 10–11 ; "Tannenbaum's Speech," *Masses* 5 (May 1914) : 3 ; Tannenbaum, "What I Saw in Prison," *Masses* 6 (May 1915) : 8–9.

63. Robert Sarlós, *Jig Cook and the Provincetown Players : Theatre in Ferment* (Amherst : University of Massachusetts Press, 1982), 19.

64. See Zurier, *Art for THE MASSES*, 15–20, 148–151. For examples of derogatory images of blacks in *Masses* artwork, see especially the drawings by Stuart Davis, 5 (November 1913) : back cover, and 5 (February 1914) ; and in *Masses*' poetry, Jane Burr, "Nigger Tilly," 8 (April 1916) : 6. Eastman rather feebly defended the magazine against charges of racism in "The Masses and the Negro," 6 (May 1915) : 6.

65. Eastman, "War for War's Sake," *Masses* 5 (September 1914) : 5–6 ; Young, "War," *Masses* 5 (September 1914) : 3.

66. *Masses* 9 (April 1917) : 2.

67. Reed, "The Great Illusion," *Masses* 9 (June 1917) : 25–26 ; Eastman, "Socialists and War," *Masses* 9 (June 1917) : 24–25. On Reed's interpretation of the Bolshevik Revolution, see Rosenstone, *Romantic Revolutionary*, 279–280 ; O'Connor and Walker, *The Lost Revolutionary*, 199–200, 208, 224–225 ; and Reed, *Ten Days That Shook the World* (New York : International Publishers, 1934).

68. "Socialists and War," *Masses* 9 (June 1917) : 24–25. Disgusted by crowd emotions that distorted public policy during and after the war years, Walter Lippmann expressed this mounting disillusionment with democracy in *Public Opinion* (New York : Macmillan, 1922) and *The Phantom Public* (New York : Harcourt, Brace, 1925).

69. Aaron, *Writers on the Left*, 95.

The New Negro

Explorations in Identity and Social Consciousness, 1910–1922

Ernest Allen, Jr.

The world of the future will look upon the world of today as an essentially new turning point in the path of human progress. All over the world the spirit of democratic striving is making itself felt. The new issues have brought forth new ideas of freedom, politics, industry and society at large. The new Negro living in this new world is just as responsive to these new impulses as other people are.

—HUBERT HENRY HARRISON, 1917

If social developments just prior to and during World War I ushered in the era of the New Politics, the New Sexuality, the New Woman, and the New American Culture, it also gave rise to the New Negro, whose relationship to these other, pioneering social trends proved to be rather problematic. The greatest parallels and intertwinings between black and white developments of the era are to be found in the New Politics where, in New York City especially, a small but fervent number of native-born black Americans and recently arrived West Indians were to cast their lot with the Socialist or Communist parties. On the other hand, within the New Culture movement, whose "participants were bound by a common commitment to demolish the genteel tradition in order to create a new American culture in its place," there were few echoes to be found among blacks.[1]

True, among New Negro radicals was to be found the general belief that art should support progressive social change. However, even black radicals tended to harbor an overwhelming desire for the projection of idealized, genteel "Negro types" in literature, and their interest in African American theatre stemmed more from the desire to steer existing productions from the realm of slapstick, vaudevillian entertainment to more serious theatrical efforts, rather than toward the kinds of radical experimentation that such drama groups as the Provincetown Players were seeking to accomplish.[2] Similarly, the subjects of Freudianism and the New Woman found few echoes within the ranks of black economic or political radicals, or the later New Negro culturalists. Moreover, except perhaps as exotic other, African Americans distinguished themselves by their relative absence from the discourse of white radicals of the period. Undeniably influenced by, but temporally lagging behind the radical political trends among whites, the New Negro movement followed its own, relatively autonomous social dynamic.

Two major questions concern us here: How did the New Negro movement—a term I employ in this essay to denote the broad array of radical political, economic, and cultural tendencies emerging from a black avant-garde located primarily in New York City— relate to its antecedents within pre–World War I African America? And what was the relation between this movement and parallel radical tendencies that emerged among white American intellectuals during roughly this same period?

In the late nineteenth century, desires for economic stability and economic democracy on the part of black tenant farmers and agrarian and industrial wage earners alike found wide, organized expression in groups such as the Colored Farmers' Alliance and the Knights of Labor. Among the masses of working-class African Americans, issues concerning oppression and the lack of formal political democracy (the right to testify in court or to vote, for example), while

certainly not ignored, tended to remain sub-
ordinate to more pressing economic and
directly allied political questions. Agrarian
protest by blacks after the 1890s would
prove sporadic. And aside from pockets of
organizing by the Industrial Workers of the
World (IWW) and federal American Feder-
ation of Labor (AFL) unions, the proletar-
ian impulse among the African American
working masses would have to wait for the
industrial unionism of the 1930s to discover
organizational bedrock.[3] Second, among the
working masses was to be found a sense of
black group identity and of a collective
black group culture existing apart from that
of the dominant American identity and
culture. While entertaining regional varia-
tions, this sense of group identity func-
tioned as a strong force in the collective
African American consciousness, man-
ifesting itself in cooperative enterprises
such as mutual-aid or insurance societies, or
other all-black institutions such as churches
and lodges.

On the other hand, within the African
American "middle class" just prior to
World War I, there existed two predominant
ideological *tendencies,* two "clusterings" of
ideological elements, if you will, both of
which ultimately drew upon opposing no-
tions of African American *social identity*
and of African American *social justice.* Dat-
ing from the early nineteenth century, the
older tendency clustered around notions of
immediate assimilation, political agitation,
and demands for full civil rights, and was so-
cially anchored in the *educated* strata of
African American professionals such as
doctors, lawyers, ministers, and teachers.
The more recent tendency revolved around
an emphasis on race pride, solidarity and
self-help, on inner-group economic and
moral improvement, and was rooted in the
growing entrepreneurial strata of the post-
Civil War era.[4] The latter, of course, was the
black worldview identified with and popu-
larized by Booker T. Washington. Consis-
tent with the class formation of the African
American business-oriented strata was the
notion that the road to black political libera-

tion could be reached through existing
portals of economic opportunity : the learn-
ing of skilled trades and the securing of
land and business ownership. Once African
Americans had made themselves indis-
pensable to the dominant economy, they
believed, there was no way that their par-
ticipation in the realm of politics could be
denied.

From the latter part of the nineteenth cen-
tury onward the struggle between these two
worldviews—the assimilationist-oriented
protest tradition and the more nationalist
and economically oriented one—represented
a struggle for ideological and political he-
gemony among the dual social fractions
comprising the black middle class. That
clash was personified in the rift between
W.E.B. Du Bois and members and followers
of the Niagara Movement on the one hand ;
supporters of Booker T. Washington and the
"Tuskegee Machine" on the other. But the
social impact of World War I, coupled with
the death of Washington in 1915, resulted
in immediate as well as long-term trans-
formations of the ideological landscape of
African America. Economically, the result-
ing South-to-North black migration of
some one-half million souls during the war
brought multitudes of blacks not only into
compact, urban communities, but also for a
great many of them, into a cash economy for
the first time. The war itself resulted in the
army service of some 380,000 black soldiers,
11 percent of whom were actually assigned
to combat units.[5] Their novel experiences—
especially of those men who saw actual
combat—instilled in them a determination
to bring back to American shores a little of
the democracy for which the United States
had supposedly fought overseas. Most im-
portantly, the spatial and political configu-
rations of northern, urban centers offered
possibilities for self-organization and physi-
cal self-defense—a potential not unnoticed
by blacks during the ensuing race riots that
rocked the North especially.

In formal political terms, black male mi-
grants of voting age were now able to

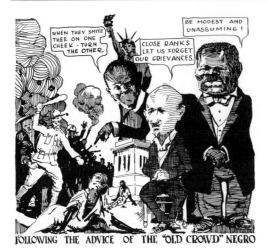

FIGURE 13. *"Following the Advice of the 'Old Crowd' Negro."* The Messenger *(September 1919), p. 17. New York Public Library, Astor, Lenox and Tilden Foundations.*

exercise the franchise; in a larger political sense, the availability of relative freedoms of expression and of association in the North allowed for participation in independent trade unions, protest groups, and the like, which (theoretically, at least) need not confine themselves to the sphere of reformism alone. And finally, the existence of relatively large and compact, black urban communities allowed for the flowering of commercially viable, black cultural expressions (from which black folk themselves did not always cull the principal economic rewards to be had). These included the production of books, magazines, and especially newspapers; a " race record " industry in the form of "separate but equal" talent recruitment, recording, and distribution of black musical forms by dominant recording companies, black theatre, with its popular but (as black "middle-class" commentators would complain) excessive emphasis upon vaudevillian forms; as well as numerous restaurants, cabarets, and notorious "buffet flats" where one might sample all possible varieties of African American life. Recently arrived southern migrants constituted a formidable political and cultural force which, in the teens and twenties, had yet to determine its

own, independent voice apart from the black petit bourgeois elements which sought to direct its formidable energies. Their sudden presence during the war transformed the face of the northern metropolis. Here was the source of the New Negro, or as A. Philip Randolph defined *him*, the "New Crowd Negro":

> As among other peoples, the New Crowd must be composed of young men who are educated, radical and fearless. Young Negro radicals must control the press, church, schools, politics and labor. The conditions for joining the New Crowd are: ability, radicalism and sincerity. The New Crowd views with much expectancy the revolutions ushering in a New World. The New Crowd is uncompromising. Its tactics are not defensive but offensive. It would not send notes after a Negro is lynched. It would not appeal to white leaders. It would appeal to the plain working people everywhere. The New Crowd sees that the war came, that the Negro fought, bled and died, and he is not yet free.
>
> The New Crowd would have no armistice with lynch-law; no truce with jim-crowism, and disfranchisement; no peace until the Negro receives his complete social, eco-

FIGURE 14. *"The 'New Crowd' Negro Making America Safe for Himself."* The Messenger *(September 1919), p. 17. New York Public Library, Astor, Lenox and Tilden Foundations.*

nomic and political justice. To this end the New Crowd would form an alliance with white radicals such as the I.W.W., the Socialists and the Non-Partisan League, to build a new society—a society of equals, without class, race, caste or religious distinctions.[6]

In a 1923 issue dedicated to the "New Negro Woman," a *Messenger* magazine editorial heralded her arrival: "In politics, business and labor, in the professions, church and education, in science, art and literature, the New Negro Woman, with her head erect and spirit undaunted, is resolutely marching forward, ever conscious of her historic and noble mission of doing her bit toward the liberation of her people in particular and the human race in general."[7] Of the seven essays written by women for this special number, six pertained to the specific roles of women; and of those six, five were addressed to the problems and possibilities of working women. Only one, which took up the question of segregation, could be said to have expressed strong feminist content.

It has been noted that "the difference between the modern woman, and the suffragist or feminist of the nineteenth century, was her insistence on the right to self-fulfillment in both public life and in relationships with men."[8] To what extent this was true for the heterosexual, middle-class African American woman of the postwar era remains to be seen. In a great many cases it was not just a question as to whether or not she desired a separate career, since the need to work outside the home was for most black women a necessity and not a luxury: "Because the Negro mother must work outside of the home to supplement the Negro father's earnings, the Negro woman teacher must must needs be mother and guide, as well as class-room instructor."[9] But most of all the New Negro Woman faced disabilities of both race and gender:

In the Negro world there is one figure the victim of a two-fold segregation and discrimination—the New Negro Woman. Woman's emancipation is strangely parallel with the Negro's struggle. Inferiority is the reason given for her oppression. She has been considered as a mere chattel, cowed and subdued, taught that she, like children, must be seen and not heard. Petted as an ornament of the home, a plaything for the male, producer of a line of warriors and race builders. Lacking all chance for development she is called inferior because because she hasn't developed. The Negro woman falls heir to all these prejudices, and to add injury to distress she is a Negro. If there is any one person against whom the doors have been closed it is the New Negro Woman. As a woman she was outside her sphere. As a Negro woman she was impossible. In industry, education and politics she is gradually coming into her own. But remember her closed doors are the thickness of two—she is first a woman, then a Negro. May the fates be kind to her![10]

While elements of the new feminism were certainly embraced by a large number of New Negro women, for them, as for New Negro men, the question of overt racism is what tended to capture their political attention.

The political and cultural impact of the newly arrived migrants to the North, the mass activity and social upheavals engendered by the war, and the occurrence of race riots in which blacks vigorously fought back, introduced a more "radical" perspective into the dualistic thought patterns of the African American petite bourgeoisie. Writing in the late 1940s, Harry Haywood spoke of the resulting emergence of a "breakaway strata" of black petit bourgeois elements during the World War I era.[11] Ideologically speaking, this heterogeneous "breakaway" was of multiple minds. For example, the protest tradition of the assimilationist-oriented, professional class fraction, held somewhat in check under Washington's influence, was accorded added momentum, with politics for some no longer merely signifying the politics of reformism.

Moreover, where the rising black entrepre-neurial strata of the late nineteenth century placed emphasis upon individual economic gain, New Negro radical intellectuals overt-ly concerned themselves with the economic plight of the masses of black folk—but with-out ceasing to support black economic entrepreneurialism. And finally, by the mid-1920s, in contrast to the traditional as-similationism of the black-educated strata, a fresh stream of African American artistic and intellectual thought emerged in the form of a reform-oriented, cultural na-tionalism. The development and refinement of literary black culture, New Negro cultur-alists believed, was the intellectual wedge par excellence which would eventually force open the door to black social equality. But the main significance of this latter trend was that the culture of the African American masses was to be taken as the base from which the new "high culture" would extend. However the presence of the awakening mass of African Americans might be interpreted by New Negro culturalists or politicos, its activities remained central to the concerns of both.

From 1900 onward, powerful ideological tendencies in the form of progressivism, so-cialism, and nationalism offered potential alternatives to Americans in general. With respect to African Americans, however, turn-of-the-century progressivism was a self-contradictory movement. On the one hand, it contributed to the spread of reform sentiments, such as that marked by the for-mation of the all-black Niagara Movement in 1905. The interracial National Asso-ciation for the Advancement of Colored People, formed in 1909, whose white founding members tilted toward either pro-gressive or socialist sentiments, was also a product of this development. On the other hand, the reform spirit of most white pro-gressives balked at any suggestion of African American civic equality. In the South, moreover, the leaders of progressive reform and of the segregationist impulse

against blacks were often identical.[12] For these latter reasons, progressivism was never truly able to gain a secure foothold among African Americans.

Yet another alternative lay in the embrace of Socialist party doctrine, which viewed the solution to the evils of modern, capitalist so-ciety in the construction of a cooperative commonwealth where the basic means of production, agrarian as well as industrial, would be in the hands of those who them-selves were the producers. Blacks such as A. Philip Randolph who embraced socialism saw in the coming of the cooperative com-monwealth the eradication of racism's raison d'être. Fundamental social conflicts within American society, they believed, were based principally upon the existence of class divisions. Racism was something that the capitalist class fostered among working-class whites in order to politically divide workers as a whole, all the better to exploit them. Consequently, the transformation of the American economic structure from one based upon capitalist exploitation to one based upon principles of socialist coopera-tion would destroy the foundation upon which racism's existence was predicated.[13] Consistently, the assertion of social identi-ties other than those of social class—for example, those of an ethnic, racial, or na-tional bent—were considered aberrations, obfuscations. The growing militancy and social questioning of at least some members of the "breakaway" entrepreneurial strata merged with socialist tendencies already grown popular in many avenues of Ameri-can society. But in appropriating these arguments as their own, Harlem radicals were led to bend and ply the strict economic determinism of the Socialist party to the complexities of black economic and political life. This they accomplished with varying degrees of success.

Political self-determination in one form or another was seen by more nationalisti-cally oriented African Americans and West Indians as a means of addressing the social ills incurred by black Americans as a whole.

As far as nationalism was concerned, there existed, to be sure, an African American tradition extending back to the free black population of the late eighteenth century. This trend to nationalism was given greater impetus during the war by demands for self-determination occurring within Europe: in the east, among Poles, Serbs, Croatians, and others; and in the west, the armed struggle for the political independence of Ireland. But African American and African Caribbean nationalists—who should really be called Pan-Nationalists since what they sought was the political liberation of both Africa and her dispersed descendants of the New World—were further divided according to visions of the social configuration of new societies they sought to bring to fruition. For example, "Left nationalists" like West Indian–born Cyril Briggs of the African Blood Brotherhood (ABB) tended to view black self-determination in socialist terms, in terms which sought to place black laborers in control of their economic destinies, thereby ensuring them political control over their own lives.[14] His own nationalism tempered more by bourgeois influences, Marcus Garvey, of the Universal Negro Improvement Association and African Communities League (UNIA and ACL), was much more traditional in economic outlook. Acknowledging the existence of social problems within capitalist society, Garvey did not view capitalism itself as the principal culprit, but instead advocated the capping of individual accumulations of wealth at one million dollars in order to keep exploitation and consequent class divisions from getting out of hand.

Hence we see that among political New Negroes of the aspiring black middle class there existed numerous competing ideologies, although they had some common bases. First, the similarities between these tendencies, and their ruptures with more conservative black petit bourgeois elements, lay in the relative social identification of their proponents with black laborers: a position which hovered somewhere between authentic "class suicide," where claims to privileged social insight based upon upper-class status would be relinquished, and a traditional penchant for radicalized, middle-class individuals to view themselves as natural leaders of the masses. Second, the differing political trends operated from the same premise: now was the moment for Africa's descendants to "have their place in the sun," to seize control over their own political destiny. If the League of Nations found self-determination for eastern European nations an appropriate course of action, then self-determination for people of African descent was equally valid. Variations upon this common theme were to be found among African American and African Caribbean nationalists, communists, and socialists.

Third, this sense of self-determination among political New Negroes found echo in the expressed need for at least some degree of independent black self-organization. This was true even for those allied with the Socialist and early Communist parties, for whom the foreign language federations of both organizations served as models of relative ethnic autonomy within larger political structures. Fourth, despite the socialist proclivities of some, the activities of all were thoroughly imbued with the entrepreneurial spirit of the era: for instance, West Indian food import projects, restaurants, steamship lines and the like, as well as magazine and newspaper publishing efforts which, in themselves, constituted petty economic strivings. Upon arriving in New York, for example, the poet and future political radical Claude McKay tried his hand as a restaurateur, and failed. More economically successful was his Jamaican compatriot and Socialist party member, Wilfred A. Domingo, who imported Caribbean food delicacies for a transplanted West Indies clientele living in New York City. The centrality of economic entrepreneuralism in Marcus Garvey's vision of a free and independent Africa goes without saying, but no less a commitment to black businesses in general could be consistently found in the pages of

Owen and Randolph's socialist-oriented *Messenger* magazine.

Finally, it is impossible not to remark upon the internationalist outlook of political New Negroes, their refusal to view the African American struggle for self-dignity and social justice in the United States in isolation from similar struggles occurring throughout the globe. It would be difficult to overestimate the impact of these anticolonial struggles, and especially the Russian revolution, on New Negro radicalization. Black Harlem radicals, for example, were quite taken with the support for colonial independence contained in the Manifesto of the Communist International issued at its first congress in March 1919: "Colonial slaves of Africa and Asia: the hour of proletarian dictatorship in Europe will sound for you as the hour of your deliverance."[15]

Aside from the five factors noted above, generally speaking, differences were profound. Torn between bourgeois nationalist and bourgeois assimilationist proclivities, the principal tension among political New Negroes lay along a nationalist/socialist divide in which questions of social identity and of envisioned social structure both played a role.

The existence of separate organizations and applied publications (*The Negro World, The Crusader, The Messenger, The Emancipator*) belies a relatively high level of cooperation between them at various points and junctures. The interaction, much of which logically revolved about the only mass-based organization among them, the UNIA, is quite revealing: Black Socialist party members A. Philip Randolph and Chandler Owen shared at least some of the goals of the early UNIA, speaking from Garvey's platform in 1918 and also, as is much better known, bitterly opposing the policies of its founder from 1922 onward. Wilfred Adolphous Domingo, also a Socialist party member and a boyhood friend of Garvey from their early Jamaica days, was the editor of Garvey's *Negro World* from its inception in 1917 to Domingo's resignation

from the paper the following year. In the wake of the decline of political radicalism in Harlem, Domingo would also become a contributor to Alain Locke's classic volume, *The New Negro*. Garvey himself attended several meetings of the short-lived League of Darker Peoples sponsored by *The Messenger* group and Madame C. J. Walker of black hairdressing fame—in part a political response to the League of Nations, which had for the most part ignored the international voices of peoples of color in its dispensing of postwar territorial claims.[16] And Cyril V. Briggs and Richard B. Moore worked together on *The Emancipator*, edited by Wilfred A. Domingo, who in turn wrote occasional articles for *The Messenger*.

Playing a singular ideological role among the developing New Negro intelligentsia from approximately 1910 to 1920, Hubert Harrison served as an early mentor for both the African American socialist and nationalist (or "Pan-Africanist") ideological camps, which would find themselves in unyielding opposition to one another by early 1920. Born in Saint Croix, Virgin Islands, in 1883, Harrison arrived in New York in 1900—over a decade prior to the migrations of most other West Indians destined to play a radical political role on American political terrain.[17] Possessing a store of knowledge many described as "encyclopedic," Harrison assumed a kind of father role with regard to his contemporaries—this despite his youth. Several years prior to the war's outbreak, he had joined the Socialist party, contributing review essays and articles to the *Call, International Socialist Review*, and *Masses* magazines, in addition to many non-Left publications. But in uptown Harlem, Harrison was perhaps best known for his street-speaking at the intersection of 135th Street and Lenox Avenue, a tradition for which he was the originator.[18] It was through such street oratory that Harrison instructed a generation of Harlemites—Randolph and Owen included—in the superiority of socialism over capitalism, helping to win a small number of converts from the black

community to the Socialist party even as he contemplated plans to leave it.

Prior to the war, Harrison once explained the genesis of American racism in the following way. During the period of slavery blacks constituted "the most thoroughly exploited of the American proletariat" and the "most thoroughly despised." The necessary contempt on the part of the ruling class toward blacks was diffused among all classes of Americans until they were supposedly saturated with it: there existed an unavoidable correlation between the dominant class and the dominant ideas of society. For Harrison, like Eugene Debs, race prejudice was a direct product of economic forces, "the fruit of economic subjection and a fixed inferior economic status." He wrote, "It is the reflex of a social caste system. That caste system in America is what we roughly refer to as the Race Problem, and it is thus seen that the Negro problem is essentially an economic problem with its roots in slavery past and present."[19] But the critical shortcoming of the Socialist party's economic determinist arguments, within which framework Harrison was attempting to argue, was that it disallowed the recognition and consequent targeting of any specific group among the proletariat for direct organizing efforts. In other words, no direct Socialist party appeal to black workers was doctrinally permissible. On the other hand, without such a special appeal, it was clear to Harrison that the attraction of African Americans to the party would be nil. Under such conditions, how would it be possible to extend the party's appeal to blacks?

In order to convince the party of its duty toward African Americans, it would be necessary to argue outside the determinist parameters of "straight socialism." First of all, argued Harrison, since the mission of the Socialist party was "to free the working class from exploitation, and since the Negro is the most ruthlessly exploited working class group in America, the duty of the party to champion his cause is as clear as day." Second, "The mass of the Negro people in America are ignorant of what socialism means. For this they are not so much to blame. Behind the veil of the color line none of the great world movements for social betterment have been able to penetrate." Clearly, special educational efforts were needed here. Third, "the Negroes of America—those of them who think—are suspicious of Socialism as of everything that comes from the white people of America. They have seen that every movement for the extension of democracy here has broken down as soon as it reached the color line." Only special efforts could overcome such a history of distrust. And fourth—doctrinal purity aside—the party had *already* "carried on special propaganda work among recently arrived immigrant Poles, Slovaks, Finns, Hungarians and Lithuanians."[20]

Harrison's four arguments added up to the need for a special Socialist party appeal to African Americans. But if the party could not be swayed on this organizing issue through positive argument, perhaps it could be convinced through an evoking of a counterrevolutionary potential on the part of blacks: "Here are ten million Americans, all proletarians, hanging on the ragged edge of the impending class conflict. Left to themselves they may become as great a menace to our advancing army as is the army of the unemployed, and for precisely the same reason: they can be used against us, as the craft unions have begun to find out."[21] Mindful to take into account the party's right wing as well as its left, Harrison also noted the support which blacks could bring to the ballot box (but also the need for the party to take a stand against their disfranchisement in the South), as well as to industrial unionism. For neither Harrison nor later black converts to socialism would it be possible adequately to address the economic and political status of African American toilers solely from within the strictures of economic-determinist dogma.

Increasingly disenchanted with the existence of racism within the Socialist party, Harrison states that 1916 was the year "that

I gave up my work as a lecturer and teacher among white people to give myself exclusively to work among my own people."[22] And it was this very same year of Harrison's break with the Socialist party that Randolph and Owen enrolled in its ranks— partly a result of Harrison's proselytizing efforts.[23]

Unsuccessful efforts had already been made by Harrison to organize black Harlemites into a Socialist party branch around 1910.[24] Provided with a formidable mass base accruing from the "great migration," that task was accorded greater feasibility under the wartime leadership of Chandler Owen and A. Philip Randolph. According to Randolph's biographer, in late summer of 1917 the Socialist party assigned the future *Messenger*'s editors the task of coordinating Morris Hillquit's mayoral campaign in Harlem: "The two editors had done this by organizing the first Socialist club in the area—the 21st A.D. Club—made up largely of their fellow radicals. This group also fanned out through the community, canvassing in Hillquit's behalf and heckling the meetings of the regular-party candidates."[25]

Early the next year, black Socialist party organizer Helen Holman was put in charge of naturalization work in the 19th and 21st Assembly Districts, wherein resided the majority of West Indian immigrants in New York City.[26] An attempt was also made to establish a branch in the "colored" section of the 19th AD, but little success appears to have come of this venture. Randolph was assigned the task of organizing the "colored section" of the 21st Congressional District, which included both the 21st and 23rd ADs.[27] The greatest flurry of activity for the year was reserved for fall, when Randolph and Owen ran for assembly seats in the 19th and 21st ADs respectively, and Rev. George Frazier Miller sought the post of U.S. representative from the 21st CD. Against the overwhelming pro-Republican sympathies of northern black voters of the era, Randolph captured a mere 7.5 percent of the vote from his district, the highest percentage showing among the three party candidates.[28]

Socialism offered a solution to the exploitation of blacks, the majority of whom were agrarian or industrial laborers. Once the social question of race was introduced, however, the rigid economic determinism of its adherents robbed the doctrine of its full, explanatory power. The hard fact was that a large segment of white American workers, both native-born and *nouveaux venus,* had succumbed to racist backwardness. This racism on the part of white laborers had its subjective as well as objective aspects, the economic essence of the latter finding itself intimately bound to the question of competition within the ranks of the working class itself. For in order to carry out effective "competition" with the capitalist class for the maintenance of wages, workers must first eliminate competition among themselves.[29] This postulate is virtually axiomatic.

The means by which such competition within labor's ranks could be eliminated, however, was quite another question: was it to be accomplished through "combinations" that included all laborers within a given branch or branches of industry, or by other means of self-regulating practices that excluded significant numbers of workers from the shops and factories? Historically, skilled workers in the United States responded to the threat of their own intergroup competition through the establishing of craft unions. This in itself was a positive historical phenomenon, one which ultimately found itself dwarfed by the negative "economist" practices of the American Federation of Labor. For through the formation of such craft institutions, in effect, "monopolies" were formed over determinate skills, the number of workers permitted into a given craft being regulated through apprenticeship programs controlled by craft union members themselves. In this way, internecine competition was met, but through a policy of institutional restriction. As is well known, this is the main process by which

black laborers have been barred from practicing skilled trades in the United States.

Possessing no such indispensable craft with which to bargain with employers, unskilled industrial workers frequently resorted to violent means for the purpose of regulating competition among themselves. Numerous "race riots," such as those which occurred during the World War I era in Chicago and East St. Louis, provide vivid examples of social phenomena in which the question of labor competition was found to be at the core.[30] So whether through organized "ritual" or constitutional provision, work stoppages, strikes, or unrestrained violence, the intended result of each of the above practices on the part of workers was the same: a curbing of job competition within their respective domains of labor.[31] These practices, then, did represent forms of class struggle, albeit not in the long-range interests of the American working class as a whole, retarding as they did any formation of mass proletarian consciousness. In the elimination of blacks and other national minorities as economic competitors, such actions on the part of white American laborers often led as much to a structural "racializing" of production relations and consequent division of the American working class along ethnic and national lines, as did direct practices on the part of industrialists themselves. (The latter benefited the most from such divisions—politically as well as economically—and encouraged fractionizing of this type up to that critical point where the eruption of interethnic hostilities among workers threatened to disrupt commodity production itself.)

It was precisely the racial segmentation described above—the specific structuring of social relations whose result was a *special oppression* of African Americans above and beyond the political oppression and economic exploitation endured by white laborers in general—that the Socialist party preferred to ignore. "We have nothing special to offer the Negro," admitted Eugene

Debs, "and we cannot make separate appeals to all the races. The Socialist Party is the party of the working class, regardless of color—the whole working class of the whole world."[32] The practical implications of such an apparently democratic and international stance (but one which masked a reality of systematic special privileges accorded a certain stratum of white labor) were that scores of black laborers thus barred from employment would be forced into strikebreaking just in order to survive. To the barriers imposed upon them under the veil of "class first," numerous black toilers responded with an equally dogmatic, but ineluctable policy of "race first," placing their interests as an oppressed nationality above all else. It is thus important to understand that this ideology of "race first," far from constituting a manifestation of petit bourgeois nationalism *alone*, possessed a decided *material* base among vast strata of black workers during the World War I and postwar periods.

The almost simultaneous departure of Hubert Harrison from and the entry of Chandler Owen and A. Philip Randolph into the Socialist party in 1916 failed to cause any immediately visible rupture between Harrison and his former "followers." For example, as late as November 1917, *The Messenger* carried Harrison's glowing review of the small book, *Terms of Peace and the Darker Races*, written by Owen and Randolph.[33] The following month, however, battle lines had been drawn: in a debate at the Palace Casino on 23 December Chandler Owen, according to Harrison's account, "fiercely maintained 'that the doctrine of race first was an indefensible doctrine'; Mr. Harrison maintaining that it was the source of salvation for the race. Both these gentlemen have run true to form ever since."[34]

His belief in socialism as fervent as ever, Harrison meanwhile was imparting to this basic conviction an increasingly nationalist interpretation. In the United States, the social effects of the war had unleashed the northward migrations of blacks and the

"red summers" which resulted; abroad, the "colored" world was partially stirred into action against the occupying colonial powers. Whereas such events demonstrated to Owen and Randolph the necessity of white, working-class allies for the black struggle, they strongly suggested to Harrison the necessity of "colored" allies on an international scale. Hence to the slogan of "class first," that rigidly determinist formula of the Socialist party to which he had formerly subscribed, Harrison posed an equally dogmatic "race first," never fully understanding the dialectic of "race" and class as they occur in the national question.[35] Whereas "class first" ignored the *special* oppression which blacks *qua* blacks suffered above and beyond that borne by white laborers, "race first" obliterated the class aspects of the African American struggle, resulting in the ideological effacement of the class character of oppression and of "movement" goals, tending to place this struggle under the tutelage of petit bourgeois political and ideological hegemony. Harrison's ideological metamorphosis culminated in a double irony, however: first, that he would be led to attack his former followers of African descent who "erringly" continued down the socialist path; second, that his immense efforts would soon be eclipsed by the success of a young man from Jamaica who had gained a start with Harrison's own organization, the Liberty League.

The Liberty League of Negro-Americans was formed by Hubert Harrison in June 1917. The organization's stated purpose was "to take steps to uproot" the two evils of lynching and disfranchisement and "to petition the government for a redress of grievances."[36] Given Harrison's commitment to socialism, one can be assured that more radical goals were involved as well. It was at the first meeting of the league that Marcus Garvey is said to have made his first positive impression upon a Harlem crowd. For all who had heard Harrison speak, the general consensus was that he was a keen and highly skilled orator.[37] Not nearly as charismatic a figure as Garvey however, Harrison's organizational abilities were also evidently somewhat less than satisfactory. As one observer of the Harlem scene remarked,

> Garvey publicly eulogized Harrison, joined the Liberty League and took a keen interest in its affairs. Harrison blundered fatally. His errors were so evident that his followers could not but observe them, so costly that interest in the Liberty League waned and Harrison's deserters soon became enthusiastic admirers of Garvey, and accordingly joined the New York branch of the Universal Negro Improvement Association and African Communities League which Garvey, in the meantime, had formed. His failure and the dissatisfaction of his followers notwithstanding, Harrison rendered memorable educational and constructive community service to the Negroes of Harlem. It may be truly said that he was the forerunner of Garvey and contributed largely to the success of the latter by preparing the minds of Negroes through his lectures, thereby moulding and developing a new temper among Negroes which undoubtedly made the task of the Jamaican much easier than it otherwise would have been. In justice to both and with equal truth, it may be declared that the success of Garvey was built on the ruins of Harrison's failure. The popularity of the former increased immeasurably . . . as he became a potent factor, his predecessor became a negligible unit.[38]

The irony of his standing in the full shadow of a Garveyism, which he himself had helped in formulating, would not escape Harrison, a fact upon which his former comrades would lightheartedly play.[39] Harrison's now open attack upon black socialists and his concomitant support for Garvey in 1919 appear to be partly motivated by an attempt to reestablish in the public domain a knowledge of the "origins" of Garvey's ideas:

One of the most taking enterprises at present is the Black Star Line, a steamship enterprise floated by Mr. Marcus Garvey of New York. Garvey's project (whatever may be its ultimate fate) has attracted tens of thousands of Negroes. Where Negro "radicals" of the type known to white radicals can scarce [sic] get a handful of people, Garvey fills the largest halls and the Negro people rain money on him. This is not to be explained by the argument of "superior brains," for this man's education and intelligence are markedly inferior to those of the brilliant "radicals" whose "internationalism" is drawn from other than radical sources. But this man holds up to the Negro masses those things which bloom in their hearts—racialism, race consciousness, racial solidarity—things taught first by The Voice and the Liberty League. That is the secret of his success, so far.[40]

In his autobiography, poet Claude McKay noted that when he began his new job as assistant editor of the left-wing *Liberator* magazine in April 1921, Hubert Harrison, "the Harlem street-corner lecturer and agitator," visited the magazine's 14th Street headquarters to tender his congratulations:

> I introduced him to Robert Minor, who was interested in the activities of the advanced Negro radicals. Harrison suggested a little meeting that would include the rest of the black Reds. It was arranged to take place at the Liberator office, and besides Harrison there were Grace Campbell, one of the pioneer Negro members of the Socialist Party; Richard Moore and W. A. Domingo, who edited the Emancipator, a radical Harlem weekly; Cyril Briggs, the founder of the African Blood Brotherhood and editor of the monthly magazine, The Crusader; Mr. Fanning, who owned the only Negro cigar store in Harlem; and one Otto Huiswoud, who hailed from Curacao, the birthplace of Daniel Deleon. Perhaps there were others whom I don't remember. The real object of the meeting, I think, was to discuss the possibility of making the Garvey Back-to-Africa Movement

(officially called the Universal Negro Improvement Association) more class-conscious.[41]

From recently published correspondence between McKay and Max Eastman we know there was at least one other such meeting in 1921 as well.[42] But far from being a mere neutral observer of these events, as his autobiography especially indicates, Claude McKay was an active leader of the African Blood Brotherhood (ABB) at the time. Moreover, the meetings held in the *Liberator* office were precursors to the entry of ABB leadership into the American Communist party.

In late May or early June, according to Bureau of Investigation reports, Rose Pastor Stokes, a key liaison between the Communist party and early black Harlem radicals, hosted a dinner party for ABB leaders Cyril V. Briggs, Wilfred A. Domingo, and Claude McKay, as well as Hubert H. Harrison and Edgar M. Grey of the Liberty League of Negro-Americans, at her Greenwich Village home.[43] There, according to Grey (who was doubling as a government informant), Mrs. Stokes offered "Russian gold" to the two organizations if they would be willing to support the Communist party's position. Harrison and Grey declined, at least partly out of commitment to Pan-nationalist ideals.[44] Brotherhood leaders, already in harmony with the Comintern's general outlook, and with a devotion to clandestine organization as zealous as that of the then existing American Communist party, readily accepted.[45] According to one account, those several meetings between black and white radicals in the *Liberator* office led to the incorporation of four key leaders of the Harlem-based African Blood Brotherhood into the American Communist party by early fall.[46] That August the ABB, with vigorous backing of the party, did attempt, albeit unsuccessfully, to influence the outcome of the second annual convention of the Universal Negro Improvement Association.[47]

But the secret organization known as the African Blood Brotherhood did not begin life as the principal recruiting arm of the Communist party among potential black constituents. Like Harrison's Liberty League of Negro-Americans and Marcus Garvey's Universal Negro Improvement Association, the African Blood Brotherhood was founded mainly in the spirit of Pan-Africanist solidarity. Ideologically closer to Harrison, however, the ABB welcomed political alliances with class-conscious white laborers. Despite the existence of contradictory dates in the historical record, it appears that the ABB was formed in the latter part of 1919.[48] Its nine-point political program, adopted in 1920, reflected the following concerns: 1) a liberated race in the United States, Africa, and elsewhere; 2) absolute race equality; 3) the fostering of racial self-respect; 4) organized and uncompromising opposition to the Ku Klux Klan; 5) a united Negro front; 6) industrial development along genuine cooperative lines; 7) higher wages, shorter hours, and better living conditions for Negro labor; 8) education; and 9) cooperation with other darker races and with class-conscious white workers.[49]

By mid-1920, the ABB boasted "over 1,000 men and women of African blood," with post commands in "various cities of the United States, in the West Indies, Central and South America and in West Africa."[50] And by the following year several of its principal leaders—notably Claude McKay and Cyril V. Briggs—joined the American Communist party.

However impressive their programs on paper or in practice, the organizational efforts of the Liberty League, the African Blood Brotherhood, black Socialists, and lesser lights would rest in the shadow of the greatest mass movement of the early twentieth century among peoples of African descent: the Universal Negro Improvement Association—or "Garvey movement" as it was popularly known. Although the UNIA did not possess the millions of members that it claimed—the best evidence comes from

Wilfred A. Domingo who estimated some 100,000 members at its height[51]—there is no question that the organization's social vision was shared by millions of adherents both within and without the United States. Among the many, complex, and often mutually contradictory ideological strands of which Garveyism was comprised, the unwavering political ideal of independent African nationhood lay at its core. Garvey's vision, moreover, was not that of a narrow nationalism, but of a Pan-nationalism: a vision which sought to politically link peoples of African descent who were part of the western diaspora with those of their continental motherland of Africa.

The initial strands of that link were to be forged in the establishment of a UNIA colony on the African continent: Liberia was the principal object of UNIA efforts in this regard, but the former German territories of Southwest Africa, the Cameroons, and Tanganyika, then under the protection of the League of Nations, were also the targets of UNIA lobbying energies. Once the colony was well established, Garvey envisioned the formation of an African empire modeled on the most powerful empire of the time—that of the British. The means by which this empire was to be established and supported, was that of mercantilism: the establishment of trade between the African continent, abundant in mineral wealth, the West Indies, rich in agrarian produce, and peoples of African descent in industrialized North America, where processing of such raw commodities would take place.[52] From a social standpoint, this global self-help enterprise would provide employment and economic security for people of African descent. And by virtue of the powerful army, navy, and air force of a politically unified Africa, it would afford them political protection as well, reaching as far as the American diaspora.[53]

Initially a Jamaican-based organization, the UNIA was established by Marcus Garvey in 1914 along the lines of Booker T. Washington's Tuskegee Institute, and was trans-

planted by Garvey to its Harlem, New York City, headquarters in 1917. Following several false starts, Garvey was able to recruit a core of adherents around which an international organization would take form. Its widely influential newspaper, *The Negro World*, was established the following year, and enjoyed an uninterrupted run until 1933, when it ceased production. One of the UNIA's most spectacular successes was demonstrated in its ability, through a separate corporate entity known as the Black Star Line, to successfully launch its own steamship enterprise in the fall of 1919. Other enterprises quickly followed in New York City: the Universal Millinery Store; the Universal Steam Laundry, and several grocery stores. Clearly seeking wider horizons was the Negro Factories Corporation, the ostensible purpose of which was to "build, own and operate factories all over these United States, the West Indies, Central and South America and Africa," but which existed mostly on paper.[54] Launched in the midst of a relatively prosperous wartime economy, the UNIA's ambitious pecuniary undertakings quickly succumbed to the postwar recession. Financial difficulties during the UNIA's first International Convention of the Negro Peoples of the World, held throughout the entire month of August 1920 in New York City, almost led to its premature cancellation.

The deterioration of the UNIA's internal economic affairs, triggered not only by unsound steamship acquisitions and abysmal management, but also by the growing inability of UNIA adherents, under depressive economic conditions, to continue making further cash contributions to, or stock purchases from the organization, was a principal factor prompting Garvey's February 1921 speaking and fund-raising tour of Panama, Costa Rica, and the West Indies. Upon completion of his successful journey, Garvey attempted to reenter the United States, only to find himself barred as an undesirable alien.

Here lies a crucial turning point in Gar-

veyism as an ideology. When finally admitted into the country at New Orleans, Garvey began a backtracking on the question of black American civil rights. Failing either to stem the zealous desire on the part of federal government agencies to prosecute him, or to secure material support for the UNIA from either liberal or conservative whites for his program, he did manage to galvanize a ferocious opposition to his plans from black middle-class elements. In early 1922, Marcus Garvey was indicted for using the mails to defraud—more specifically, for selling fraudulent Black Star Line stock through the mails. It was true that Garvey had proved himself thoroughly incapable of separating the business practices of the UNIA from its promotional activities, and had thereby left himself open to valid charges of mismanagement. But the charge of "stock fraud" seems to be little more than a manipulative effort on the part of federal prosecutors to conveniently rid themselves of a "foreign-born agitator" who, notwithstanding his recent compromises on the question of African American domestic rights, still represented a potential threat to domestic tranquility—not to mention western colonial interests in Africa and the West Indies. Lack of evidence on the prosecution's part may account for the year-long delay between Garvey's indictment (mid-May 1922) and the commencement of his court trial (mid-May 1923). In the meantime, Garvey's black political opposition outside the UNIA was goaded into action by his visit with the Imperial Giant of the Ku Klux Klan in Atlanta; the receipt of a human hand by Garvey political foe A. Philip Randolph in the mail; and, in New Orleans in early 1923, the assassination by Garveyites of a former UNIA official.[55]

To be sure, Marcus Garvey's court trial of 1923 in no way marked the end either of the indomitable leader or of his organization. For example, he managed to stun his opposition with the purchase of yet a fourth ship the following year. Yet troubling economic conditions within the United States and

growing realization that one of his most central political goals—the establishing of a beachhead on the African continent—had moved beyond his reach, seems to have propelled Garvey into an increasingly untenable ideological partnership with right-wing reactionaries.

The full story of the UNIA's decline has been told many times, and will not be repeated here.[56] Its poorly conceived and executed economic policies, made worse by cases of internal sabotage as well as by the post–World War I recession, serve mainly as negative example. The UNIA's economic nationalism, while as attractive to black entrepreneurs as that of Booker T. Washington, remained only a dream. One can only speculate what might have occurred had the UNIA established a secure foothold in Liberia or elsewhere in Africa, but the truth is that the history of modern settler colonies, however noble the initial intentions of settlers, has tended to prove disastrous to the indigenous population— Liberia offering a case in point.[57] The organization's—and Garvey's—most positive legacy lies, on the one hand, in its inspirational effect upon the post–World War II generation of African leadership, which, following the war, found itself in a position to transform the desire of African political independence into a reality. On the other hand, there is the equally unquantifiable, but nonetheless significant and lasting impression which Garveyism lent to the cultivation of positive self-image among peoples of African descent. Garvey's admonishment, "Up you mighty race, you can accomplish what you will," served as a source of inspiration not only to black folk of his own era, but to those of generations hence.[58]

Political New Negro-ism rode the crest of urban black migrations during the war as well as the attendant prosperity ushered in by the war economy. It was that relative prosperity which, for example, afforded working-class blacks the luxury of being able to pump some $600,000 into Garvey's sadly mismanaged Black Star Line over a period of four or five years. By 1922 the postwar recession had undermined the economic dreams of the UNIA and eroded the political strength of the union movement and hence the political base of the Socialist party as well—which had ignored most blacks anyway.[59] Hubert Harrison's Liberty League of Negro-Americans never really got off the ground, a victim of internal disputes which led to a fatal split in its ranks. *The Crusader*, organ of the African Blood Brotherhood, ceased publication with its January-February 1922 number.[60] By that time, too, *The Messenger* had begun to resemble more and more a black society rag, with little meaningful to say concerning political radicalism. Into this political vacuum rode the *cultural* New Negro, proclaiming a newly discovered truth that America's racial problems would be resolved though black artistic expression.

The difference between this cultural orientation to social questions and that of New Negro political radicals seeking redress within the United States was striking.[61] In their heyday, New Negro radicals had sought to modify American social relations directly and qualitatively. Their goal was a new economic and political order in the United States, which aim would be achieved through the political solidarity of the working class, black and white.[62] In contrast, cultural New Negroes such as Alain Locke and James Weldon Johnson felt that, once convinced of the artistic abilities of blacks, the political sympathies of the white middle-class could be tapped. From that wellspring would flow the support for an end to color-coordinated social inequality in America.

Radical New Negroes held that widespread notions of alleged black genetic deficiency were a *product* of a social order based on economic inequality, used by capitalists to divide, and hence to better

FIGURE 15. *Meta Warrick Fuller*, Ethiopia Awakening, *1917. Fuller's sculpture was shown at New York's Making of America Exposition. She was an important precursor as well as one of the most important artists of the Harlem Renaissance, who spent much of her artistic energy on antislavery themes during the 1910s and 1920s. Arts and Artifacts Division, Schomburg Center for Research in Black Culture, New York Public Library, Astor, Lenox and Tilden Foundations.*

rule, workers as a whole. With the overhauling of the social structure, erroneous notions of white supremacy/black inferiority would lose their fundamentally economic raison d'être and ultimately disappear on their own. Cultural New Negroes, on the other hand, effectively viewed racist notions as the *cause* of black oppression, as the principal determinant of a racially divided social structure. Shatter the claims of inferiority with indisputable evidence of black intellectual parity, and African American social equality was certain to follow.

James Weldon Johnson undoubtedly spoke for the majority of Harlem Renaissance promoters when he stated, rather idealistically, in 1921 that "the status of the Negro in the United States is more a question of national mental attitude toward the race than of actual conditions. And nothing will do more to change that mental attitude and raise his status than a demonstration of intellectual parity of the Negro through the production of literature and art."[63]

Despite general agreement, the more detailed social (and artistic) views of cultural New Negroes proved no more homogeneous than those of their more politically oriented progenitors. Paradoxically, many—like Langston Hughes, Alain Locke, J. W. Johnson, and others—would proclaim the virtues of climbing the "racial mountain," yet still be committed to the long-term assimilation of blacks into American society. Others, like staunchly assimilationist-oriented critic George Schuyler, who denied the very existence of any uniquely black artistic expression, would see no need for any intermediate stage of cultural nationalist expression. Finally, aside from the ever-present question of social identity, there was, again and always, that of social justice. One one side were partisans such as James Weldon Johnson who, along with Du Bois, saw no fundamental contradiction between propaganda and art. From this perspective protest was seen, in fact, as one of the most valuable components of black artistic expression. On the other were those such as Alain Locke and Charles S. Johnson, determined to wrest black artistic expression from the employ of propaganda—that is, to ostensibly remove artistry from the employ of politics and to concentrate more on questions of craft and form. The truth, however, was that black art was to be placed in the service of a quieter political movement that viewed long-term mediation and education as the solution to the "Negro problem." Novel though such an approach may have appeared at the time, it was in essence the

solution to the "race problem" proposed some nineteen years earlier by W.E.B. Du Bois in *The Souls of Black Folk*, whose own panacea was that of "education."[64]

Much more politically conservative in general than their first-wave counterparts, cultural New Negroes rode the hegemonic crest until the economy bottomed out in the early thirties. They would be supplanted by a movement that was as strong on social protest as had been the socialist-oriented New Negroes, but much weaker on the question of African American social identity than had been their more nationalist-oriented counterparts of the teens and early twenties.

NOTES

1. Leslie Fishbein, *Rebels in Bohemia: The Radicals of* The Masses, *1911–1917* (Chapel Hill: University of North Carolina Press, 1982), 30. See also Arthur Frank Wertheim, *The New York Little Renaissance: Iconoclasm, Modernism, and Nationalism in American Culture, 1908–1917* (New York: New York University Press, 1976).

2. On this subject see Theodore Kornweibel, Jr., *No Crystal Stair: Black Life and the* Messenger, *1917–1928* (Westport, Conn.: Greenwood, 1975), 105–131; Kornweibel, "Theophilus Lewis and the Theater of the Harlem Renaissance," in Arna Bontemps, ed., *The Harlem Renaissance Remembered: Essays With a Memoir* (New York: Dodd, Mead, 1972), 171–189.

3. Federal unions were local unions for which a charter was directly granted by the national body of the AF of L. In general this was for expediency, in instances where a group of skilled workers wanted to unionize, but where a national union for that particular craft did not exist. If and when such a national union came into being AF of L headquarters would dissolve the federal charter, and cede jurisdiction over that local to its national union. When dealing with black workers, however, the formation of federal unions became standard policy, and black workers were not usually allowed to join the national unions where their respective crafts were represented.

4. August Meier, *Negro Thought in America, 1880–1915: Racial Ideologies in the Age of Booker T. Washington* (Ann Arbor: University of Michigan Press, 1963), 165–170.

5. Bernard C. Nalty, *Strength for the Fight: A History of Black Americans in the Military* (New York: Free Press, 1986), 112.

6. A. Philip Randolph, "A New Crowd—A New Negro," *Messenger* (May-June 1919): 27.

7. *Messenger* (July 1923): 757. See also Paula Giddings, *When and Where I Enter: The Impact of Black Women on Race and Sex in America* (New York: Bantam, 1985), 193–196.

8. Elaine Showalter, ed., *These Modern Women: Autobiographical Essays from the Twenties* (New York: Feminist Press, 1989), 4.

9. Elise Johnson McDougald, "The Negro Woman Teacher and the Negro Student," *Messenger* (July 1923): 770.

10. Ruth Whitehead Whaley, "Closed Doors: A Study in Segregation," *Messenger* (July 1923): 772.

11. Harry Haywood, *Negro Liberation* (New York: International Publishers, 1948), 170.

12. August Meier, *Negro Thought in America*, 165, 184; C. Van Woodward, *The Strange Career of Jim Crow* (New York: Oxford University Press, 1974), 91–93.

13. See, for example, W. A. Domingo, "Private Property as a Pillar of Prejudice," *Messenger* (April-May 1920): 9–10; (August 1920): 69–71.

14. In the years prior to his joining the Communist party, Briggs vacillated between calls for a geographically based black self-determination both within and external to the United States, on the one hand, and a unified struggle for socialism in which blacks would play a role.

15. "Manifeste de l'Internationale Com-

muniste aux prolétaires du monde entier!," in *Manifestes, thèses et résolutions des quatres premiers congrès mondiaux de l'internationale communiste 1919–1923* (Paris: Bibliothèque Communiste, 1934), 32; facsimile edition reprinted by François Maspero (Paris: 1970). Author's interview with Richard B. Moore, 1978. Later generations of colonial peoples would contest the established order of priority between the two struggles, but that was not the question here. In contrast to the more conservative positions of the Second International, what was of note was that "colonial slaves" were considered worthy of the Comintern's political attention.

16. Activities of the League of Darker People were noted in the *New York Age* (11 January 1919); *Revolutionary Radicalism: A Report of the Joint Legislative Committee of New York Investigating Seditious Activities*, vol. 2 (Albany, N.Y.: J. B. Lyon, 1920), 1517.

17. Biographical information on Harrison is taken from J. A. Rogers, *World's Great Men of Color*, vol. 2 (1946–1947; rpt., New York: Macmillan, 1972), 611–619; and Philip Foner, *American Socialism and Black Americans* (Westport, Conn.: Greenwood, 1977), 207–218. Rogers incorrectly reports that Harrison was an editor of the *Negro World* for four years. Actually, he served there in various editorial capacities from January 1920 to March 1922. See also Jeffrey Perry, "Hubert Henry Harrison, 'The Father of Harlem Radicalism': The Early Years—1883 Through the Founding of the Liberty League and The Voice in 1917" (Ph.D. diss., Columbia University, 1986), which is the definitive source on the subject through 1917.

18. Perry, "Hubert Henry Harrison," 371–372.

19. Hubert H. Harrison, "Socialism and the Negro," in Harrison, *The Negro and the Nation* (New York: Cosmo Advocate, 1917), 21–22; original in *International Socialist Review* (July 1912). Compare with Eugene Debs, "The Negro in the Class Struggle," *International Socialist Review* (1903); reprinted in *Eugene V. Debs Speaks* (New York: Pathfinder Press, 1970), 90–95.

20. Harrison, "Socialism and the Negro," 22, 24, 22–23.

21. Ibid., 27–28.

22. Hubert Harrison, *When Africa Awakes* (New York: Porro Press, 1920), 7–8.

23. Jervis Anderson, *A. Philip Randolph:*

A Biographical Portrait (New York: Harcourt Brace Jovanovich, 1973), 76.

24. See Foner, *American Socialism and Black Americans*, 211.

25. Anderson, *A. Philip Randolph*, 94.

26. Holman's labors—essential to the success of Socialist party electoral campaigns in these districts—do not seem to have been limited to immigrants of West Indian extraction. Both Holman and Emily Jones, described as "black female socialist organizers," participated in Socialist party electoral activities in Harlem that fall. Minutes of Executive Committee of Local New York, 6 February 1918; New York *Call* (4 November 1918).

27. Randolph informed the executive committee that "a number of Negroes" there were anxious to form such a branch, to which efforts the committee decided to donate fifteen dollars monthly. But in contrast to the 21st AD, few political activities among blacks in the 19th were ever reported in the Socialist press. Minutes of Executive Committee of Local New York, 27 February 1918. Owen was drafted in late August, and thus missed the most important period of campaigning. Minutes of Executive Committee of Local New York, 4 September 1918.

28. New York *Call* (4 November 1918); Report of New York City Board of Elections, 31 December 1918.

29. Cf. Karl Marx, *The Poverty of Philosophy* (1847; rpt. Moscow: Foreign Languages Publishing House, n.d.), 165–166.

30. Cf. Elliot M. Rudwick, *Race Riot at East St. Louis, July 2, 1917* (1964; rpt. Urbana: University of Illinois Press, 1982); William Tuttle, *Race Riot: Chicago in the Red Summer of 1919* (New York: Atheneum, 1970).

31. Cf. Charles H. Wesley, *Negro Labor in the United States, 1850–1925* (New York: Vanguard Press, 1927); Sterling Spero and Abram Harris, *The Black Worker* (New York: Columbia University Press, 1932).

32. Eugene Debs, "The Negro in the Class Struggle," *International Socialist Review*, 4 (November 1903): 260; reprinted in *Eugene V. Debs Speaks*, 95.

33. *Messenger* (November 1917): 33.

34. Harrison, *When Africa Awakes*, 87. Harrison mistakenly placed the year of the debate as 1918. Jeffrey Perry, Harrison's biographer, states that Harrison's ideas on "race first" emerged during a series of outdoor and indoor

lectures given by the latter in the 1914–1916 period; Perry, "Hubert Henry Harrison," 403–404.

35. Characteristically, the biological aspects of "race" and their social aspects as manifested in the structuring of social relations were constantly confused with one another.

36. Perry, "Hubert Henry Harrison," 467.

37. For example, see the description of Harrison by Henry Miller, *The Rosy Crucifixion, Book Two: Plexus* (New York: Grove Press, 1965), 560–561; Wayne Cooper, *The Passion of Claude McKay* (New York: Schocken Books, 1973), 336–337.

38. Anselmo R. Jackson, "An Analysis of the Black Star Line," *Emancipator*, 1:3 (27 March 1920): 2. Richard B. Moore reported that dissension arising over ownership of Harrison's publication, *The Voice*, is what led to the Liberty League's demise. Cf. "The Critics and Opponents of Marcus Garvey," in John Henrik Clarke, ed., *Marcus Garvey and the Vision of Africa* (New York: Vintage, 1974), 217.

39. An article, "Discard Ambition and Ignorance," facetiously proposed Harrison's nomination for UNIA president in upcoming elections in August, 1920. Cf. *Emancipator*, 1:6 (17 April 1920): 3.

40. Hubert Harrison, "Two Negro Radicalisms," *New Negro* (October 1919), cited in *Emancipator*, 1:4 (3 April 1920): 3. The *Emancipator* reported that portions of the cited article had also been reprinted in the 27 March 1920 edition of the *Negro World*. Harrison's monthly, *The Voice*, launched simultaneously with the founding of the Liberty League in 1917, ceased publication in March 1919. In its stead appeared the ephemeral *New Negro* magazine, edited by Harrison and August Valentine Bernier (whose political identity is now obscure).

41. Claude McKay, *A Long Way from Home* (New York: L. Furman, 1937), 109. Background information on these individuals, while for the most part incomplete, can be found in Harry Haywood, *Black Bolshevik* (Chicago: Liberator Press, 1978); Foner, *American Socialism*; Theodore Draper, *American Communism and Soviet Russia* (New York: Viking, 1960). Joseph P. Fanning, a West Indian, was proprietor of Harlem's only black-owned cigar store, located on 135th Street. According to informant Edgar Grey, Fanning was an officer of the ABB; he died unexpectedly on 10 August 1921. Reports of

Agent P-138, 13 July 1921, BS 20260-2031-6; 15 August 1921, BS 198940-234; Records of the Federal Bureau of Investigation (R[ecord] G[roup] 65), National Archives, Washington, D.C. (abbreviated hereafter as DNA).

42. McKay to Eastman, 18 May 1923; in Cooper, *The Passion of Claude McKay*, 89.

43. In retrospect, an innocently worded passage in McKay's autobiography, *A Long Way From Home*, describing the personality of Rose Pastor Stokes, now assumes additional meaning. Stokes worked with a "radical Negro group," McKay recalled. "One night I was at the apartment of my friend, Grace Campbell, when Mrs. Stokes came in to attend a meeting." Originally a Socialist party member, Grace Campbell was one of those Harlem radicals whose political loyalties were eventually transferred to the CP— most likely in mid-1921. McKay's brief account indicates that his presence at Campbell's apartment, where a meeting with Stokes was about to take place, was accidental. More likely, McKay himself was there specifically to attend a meeting of that "radical Negro group" to which he also belonged. *A Long Way*, 161. Significantly, in a letter to Max Eastman in 1923 McKay notes: "My position on the Liberator I discussed seriously only with the radical Negro group in New York." McKay to Eastman, 3 April 1923, in Cooper, *The Passion of Claude McKay*. 83. Remarks by the original Russian translator of McKay's *Negroes in America* (Port Arthur, N.Y.: Kennikat Press, 1979) leave fewer doubts, but overstate the case: returning from London in 1921, McKay "applied all his efforts to creating a group of Negro revolutionaries in New York" (xviii).

44. Grey was secretary of the organization. He achieved notoriety in 1919 when, after resigning or being ousted from Marcus Garvey's UNIA, he and another former member alerted the New York district attorney to Garvey's sale of Black Star Line stock "without a license," a legal offense. He testified for the prosecution at Garvey's 1923 trial. In August 1921 Grey agreed to join the ABB for the purpose of providing a federal operative with information concerning the organization's internal affairs. Wilfred Domingo once praised Grey in the pages of the *Messenger*; had he known that in 1919 Grey sent a letter of concern regarding Domingo's radical tendencies to the U.S. State Department, he might not have been so generous. Later in the decade Edgar Grey

wrote fairly regularly for the New York *Amsterdam News*. Harrison, *When Africa Awakes*, 9–10. E. David Cronon, *Black Moses: The Story of Marcus Garvey and the Universal Negro Improvement Association* (Madison: University of Wisconsin Press, 1955), 76–77; here Grey's name is misspelled "Gray." Reports of Agent P-138, 26 August 1921, BS 202600-2031-9; 6 August 1921, BS 202600-667-76; Edgar M. Grey to United States Department of State, 8 August 1919; L. Lamar Winslow [Winston?], Department of State, to Frank Burke, Bureau of Investigation, 13 August 1919, OG 258421, DNA; *Amsterdam News* (17 November 1926); *Messenger* (March 1923): 640. Harrison, who does not seem to have been aware of the intelligence connections of his organizational secretary, had not lost his earlier pro-Left sympathies. Several weeks earlier he participated in a May Day celebration at the Peoples' Educational Forum. Radical Activities, 7 May 1921, BS 2026001628-20, DNA.

45. Report of Agent P-138, 13 July 1921, BS 202600-2031-6. Stokes was scheduled to appear at the Peoples' Educational Forum on 29 May, but did not. Report of Agent P-138, 31 May 1921, BS 198940-145, DNA.

46. From Martin Luther Campbell, Socialist party and ABB member, and owner of a tailor shop on 135th Street, an undercover agent extracted the information that by July there were two full-fledged black CP members functioning in Harlem; Campbell declined to mention them by name, but implied that one might be Richard B. Moore. (In his 1958 correspondence with Theodore Draper, Cyril Briggs mentioned Otto Huiswoud and one Hendricks [unidentified] as having already been party members when he entered the organization in 1921. Since available intelligence sources mention neither of them among those who frequented Campbell's shop, it appears safe to conclude that they were not the persons Campbell had in mind.)

47. See Theodore Vincent, *Black Power and the Garvey Movement* (Berkeley: Ramparts Press, 1971), 81–82.

48. The very first mention of the African Blood Brotherhood in the *Crusader* occurs in an advertisement appearing in the October 1919 number. For further details on the ABB, see W. Burghardt Turner and Joyce Moore Turner, eds., *Richard B. Moore, Caribbean Militant in Harlem: Collected Writings 1920–1972* (Bloomington: Indiana University Press, 1988), especially chaps. 1 and 2.

49. Arthur Preuss, A *Dictionary of Secret and Other Societies* (St. Louis, Mo.: B. Herder Book Co., 1924), 47; Reproduced in Robert A. Hill, "Introduction," *The Crusader* (New York: Garland Pub., 1987), lxvii–lxx.

50. *Crusader* (June 1920): 7.

51. Domingo cited in W.E.B. Du Bois, "Back to Africa," *Century* 105 (February 1923): 543.

52. Here I may be guilty of bringing more coherence to a UNIA economic policy that was more sloganized than carefully thought out.

53. The UNIA has often been called a "Back-to-Africa" movement, and scholars and critics even today continue to debate whether Garvey's *intent* was a wholesale "return" of Afro-Americans to the African continent or simply the transporting there of a relatively small number of blacks with skills sufficient to transform the established UNIA colony into a cornerstone for African political sovereignty. The historical record in fact supports *both* interpretations, and it may be less relevant to seek out "what Garvey really thought" on the matter of African American expatriation—a goal that becomes cloudier as each new piece of historical evidence is added—than it is to understand the political opportunism, the expedient circumstances that led Mr. Garvey to take one side, then the other.

54. *Negro World* (19 February 1921): 3.

55. Cronon, *Black Moses*, 189; 109. In an accompanying note ostensibly signed by the Ku Klux Klan, but which could have been sent just as easily by a UNIA fanatic (or, for that matter, an operative of a "dirty tricks" division of government), Randolph was warned to either join the "nigger improvement association" or risk having his own hand sent to someone else, p. 110.

56. Cronon, *Black Moses*; Vincent, *Black Power and the Garvey Movement*; Tony Martin, *Race First: The Ideological and Organizational Struggles of Marcus Garvey and the Universal Negro Improvement Association* (Westport, Conn.: Greenwood Press, 1976); Judith Stein, *The World of Marcus Garvey: Race and Class in Modern Society* (Baton Rouge: Louisiana State University Press, 1986).

57. The founding of the colony of Liberia in 1821 and its settlement by black American former

slaves the following year, resulted in the political subjugation of the indigenous population of the region and the establishing of slavery. It is somewhat startling to consider that UNIA success in Liberia would have meant the establishing of a settler colony within a settler colony.

58. This quote appeared prominently in every issue of *The Negro World.*

59. See James Weinstein, *The Decline of Socialism in America, 1912–1925* (New York: Monthly Review Press, 1967).

60. The *Liberator* also lost momentum in this period; see Daniel Aaron, *Writers on the Left: Episodes in American Literary Communism* (New York: Harcourt, Brace and World, 1961), 93.

61. Initially, and especially at their first international convention in 1920, Garveyites expressed great interest in fighting for African American rights within the U.S. But after 1921 this demand seems to have gotten lost in their efforts to secure the political and economic independence of the African continent, and as a result of his alien political status, in Marcus Garvey's apparent fear of being seen as a domestic, political threat to U.S. authorities.

62. In practical terms the more conservative elements within this political group, such as Randolph and Owen of *The Messenger,* saw the new socialist order emerging by means of the ballot, or parliamentary route. Those further to the left, Wilfred A. Domingo, for instance, tended to see this taking place through general strikes in the manner of the IWW, combined with clandestine political activity. However, this right/left polarity within the small group of socialist-oriented New Negroes—mirroring that within the Socialist party in general—was obscured by the fact that both wings embraced the IWW on account of its color-blind union activities.

63. James Weldon Johnson, ed., *The Book of American Negro Poetry* (1922; rpt. New York: Harcourt, Brace and World, 1959), 9.

64. W.E.B. Du Bois, *The Souls of Black Folk* (1903; rpt. New York: New American Library, 1969), 278.

The New Woman

Lois Rudnick

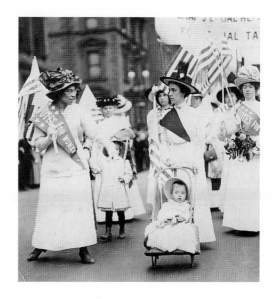

FIGURE 16. *Suffragette parade, New York City, 1915. Library of Congress.*

"When the world began to change, the restlessness of women was the main cause of the development called Greenwich Village, which existed not only in New York but all over the country."[1] Hutchins Hapgood's acknowledgment that women played a central role in changing "the world" of early twentieth-century America is only a slight exaggeration of the truth. As was true in the arts and in politics, old boundaries were stretched and hallowed conventions overturned as women asserted themselves more boldly in traditional fields and created new ones. Between 1890 and 1920 women writers and reformers made major contributions to literature and the arts, as well as to social and political reforms. In fact, American women's literary production and their impact on public policy were arguably greater during the Progressive Era than at any other time in U.S. history until recent times.

The lives and works of the new women who represent the changes to which Hapgood refers offer us a complex range of perspectives that are important to our understanding of contemporary women's issues and roles. Their concerns led them to reimagine society and the state and to raise questions feminists are still grappling with. How are women's identities created and defined? How should they be? What is woman's place in the community and in the larger society in which she lives? How should she view success? Is it pos-

sible to nurture the self, maintain a deep emotional commitment to a lover and family, and also give oneself to work and civic activity? Was the job of the New Woman to fit into existent economic and social structures or was it to redefine the very meaning of power and accomplishment?

The forebears of the New Woman worked in the women's rights and abolition movements of the nineteenth century. They paved the way for women's involvement in the world outside the home by arguing for woman's moral superiority and her "natural right" to citizenship. But nineteenth-century activists still expected women to center their lives in the home and, if they chose a public role, not to marry. Even the college-educated women of the Victorian Age were limited by the numerous constraints placed on them: the layers of clothes and tightly-laced corsets that inhibited freedom of movement and sometimes created serious health problems; the general denial of white female sexuality; the popular medical theories that asserted women's intellectual and physiological inferiority and argued that woman's anatomy—particularly her womb—was the limit of her destiny. The ideas about women's nature

perpetuated by doctors, ministers, and journalists contributed to the still-powerful prohibitions on women who spoke in public, and to the almost nonexistent professional opportunities, outside of teaching and nursing, for women.[2]

What were some the forces that helped to create the possibilities for change envisioned by the New Woman? By 1900, middle-class white women's educational, occupational, and professional opportunities had expanded dramatically in the United States. This expansion was due to a variety of factors such as the new women's colleges that opened in the post–Civil War era; the impact of mass immigration on the expansion of business and industry, which led to a substantial increase in the number of unskilled and service-sector jobs; and the growth of the public sector that was a consequence of Progressive Era reforms in municipal and state governments.

By 1900, the majority of high school graduates were women, while more women than ever before had access to higher education: "80 percent of the colleges, universities and professional schools in the nation admitted women." Lois Banner has noted one of the most important results of women's college experience: "Not only were women now able to enter such esteemed professions as law and medicine, but their new-found education also provided them with the self-confidence and critical perception that would later lead them to question their position in American society." Women academics were pioneers in the new fields of sociology and anthropology. They helped to prove, through their research, that "college women maintained levels of scholarly ability and physical health equal to those of male students." And they were among the first generation of social scientists to propose that gender was socially constructed; that is, that women were "made," not born. Novels of this era, and the autobiographies written later that reflect back upon it, explore the range of new professions opened to women, who were represented in the national census of 1910 in all but twelve professional categories. In fact, the percentages of college students, professors, and professionals who were women were greater in 1920 than in 1960.[3]

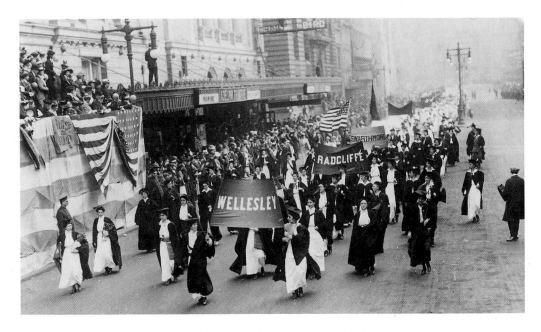

FIGURE 17. *University women march for the right to vote, Philadelphia, 1915. Culver Pictures.*

Advances in medicine—new vaccines, improved sanitation, especially in childbirth—increased the life span of women. Because of a significant drop in the birth rate (from 7 children per family in 1804 to 3.56 in 1900), more married women had increased leisure to give to volunteer organizations. For those who wanted it there was opportunity for social and political activism through a variety of forums, from women's clubs and conservation groups to suffrage and civil rights organizations.[4]

The arguments that some nineteenth-century doctors and many educated women had been making for dress reform and exercise began to take hold in the popular imagination, abetted by the new craze for bicycle riding that developed in the 1890s. The mainstream media depicted the New Woman of the 1890s as trim and physically healthy. Typically, she was dressed in a blouse and skirt and she was often shown actively engaged in sport. As Lois Banner explains in *American Beauty*: "The natural woman had come to the fore, the product of the successful campaigns of exercise advocates, the determination of college women, the popularity of young aristocrats like Ava Astor and rebellious actresses like Lillie Langtry, the power of women joining the professions and claiming the prerogatives of husbands and fathers—women who were called with suspicion 'advanced' in the 1880s and with enthusiasm 'new' in the 1890s." In the mass media, new freedoms were also related to a leisure and consumer ethic that encouraged personal indulgence rather than self-denial and self-control, while tolerating greater public and private enjoyment of sensual pleasure.[5]

Among those who were in the advance guard of defining new roles for women, it is important to distinguish two generations. The first generation was often comprised of college-educated women who came of age in the late nineteenth century. Many of these women entered professional fields that they helped to pioneer: in social work, consumer and juvenile protection, industrial health,

progressive education, and day care. Many more were involved in volunteer civic endeavors, from establishing branch libraries, to lobbying for playgrounds and public baths.

A substantial minority of these women did not marry, and a number of them lived in long-term relationships with other women in communities where women predominated. Carroll Smith-Rosenberg notes, in writing about these white, middle-class women reformers, that they developed "alternative, single-sex familial institutions which would foster women's autonomy and creative productivity. In radical new environments, on the brink of developing a host of new roles for women, the first generation of New Women wove the traditional ways of their mothers into the heart of their brave new world." Jane Addams and Charlotte Perkins Gilman are two of the most important exemplars of this generation, although Gilman was not affiliated with any particular institution.[6]

The second generation of the New Woman included many of the Greenwich Village Bohemians and radicals, among them Mabel Dodge and Neith Boyce. For them, heterosexual intimacy and sexual freedom were central to redefining a world in which both women and men could have love and meaningful work while helping to shape a more humane social and economic system. Nancy Cott defines this generation in *The Grounding of Modern Feminism*: "The women who lifted the banner of Feminism, by and large, already welcomed the idea of radical and irreverent behavior in the labor movement, art, or politics. . . . Feminism was born ideologically on the left of the political spectrum, first espoused by women . . . who, advantaged by bourgeois backgrounds, nonetheless identified more with labor than with capital and hoped for the elimination of exploitation by capital and the interventions of a democratically controlled state. . . . They embedded their critique of gender hierarchy in a critique of the social system."[7]

Although black women had more severe barriers of class and prejudice to overcome, this was also a period of remarkable social and political ferment for middle-class African American women. Thousands of women in both the North and South were involved in the national Black Women's Club movement, which was primarily devoted to the education and social welfare of African Americans. Black women also played a major role in the suffrage and civil rights movements of the era. In this period, too, working-class women established their leadership skills in unionizing unskilled workers. They were key organizers in some of the major labor strikes and acted as important catalysts in the political thinking of middle-class reformers.[8]

The woman's suffrage movement, which led to the passage in 1919 of the Nineteenth Amendment to the U.S. Constitution giving women the right to vote, became increasingly militant during the Progressive Era. Suffragists borrowed some of their new tactics from their more aggressive English colleagues and some from the working-class labor movement, as they became more adept in the use of civil disobedience, public demonstrations, and marches. This was the first time in the history of the suffrage movement that women crossed political, class, and sometimes race lines, to demand the right to vote. Part of their effectiveness was due to their strategic exploitation of the mass potential of modern media and publicity.[9]

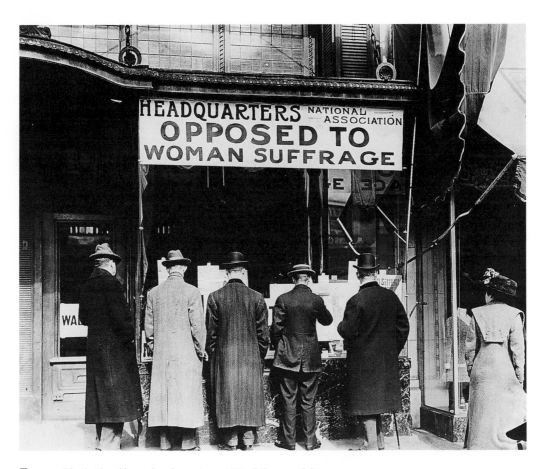

FIGURE 18. *Anti-suffrage headquarters, 1915. Library of Congress.*

The New Woman was not, however, simply the "sum" of the opportunities these victories and statistics suggest. When her image is examined closely in the writing of the era that defined her, what we discover are multiple and sometimes competing and contrasting images. The ground of her definition was continually shifting, depending on who was doing the looking. Typically, the New Woman was defined as having the attributes of independence, self-definition, physical adeptness, and mental acuity, qualities that allowed her to work, play, study, volunteer, and socialize with equal aplomb. But in reality, as both Elizabeth Ammons and Kay Trimberger point out in their essays, she was a much more conflicted figure. Sometimes the conflict between the ideal and the reality was related to Victorian conventions that were not easily let go of; sometimes it was due to the racist climate of the mainstream society that only tolerated such freedoms for white, middle-class women.

The definition of the New Woman of this era runs the political and social gamut from freedoms related to personal self-development to freedoms related to equalizing the class system. The media's favorite popularization of the New Woman was the Gibson Girl, who represented positive and healthy changes in some ways, but whose image was also limited and limiting. While she could hold her own with men in a golf match or with her quick wit, her chief purpose in life was to capture a husband. More insidiously, as Martha Banta has suggested, the Gibson Girl came into prominence during the peak time of mass immigration to the United States when many Americans were particularly anxious to define an "all-American girl" as a way of staving off the threatened mongrelization of the "pure" Anglo-Saxon race.[10]

Even among the more progressive elements of the population, the New Woman was typically conceived of as white, middle or upper-middle class. She was certainly privileged in terms of her economic security in ways that were not true for the majority of working-class women and women of color. This did not mean, however, that these women did not engage in defining their own images of the New Woman. Working-class radicals like Elizabeth Gurley Flynn, Emma Goldman, and Rose Pastor Stokes, for example, spoke and wrote publicly and forcefully of the rights of women to sexual freedom and political and economic power. In examining the lives of urban working-class women, Kathy Peiss has argued that single, working-class women were in the vanguard of the sexual revolution. They established their own variants of New Womanhood in the leisure pursuits that gave them a greater range of personal freedom than was true for most middle-class women. As Banner points out there was a working-class competitor of the Gibson Girl : "a small, flirtatious, sometimes boyish, sometimes voluptuous model of beauty," personified by the Floradora girls, the dancer Irene Castle, and the Hollywood star Clara Bow.[11]

The broad spectrum on which we can locate the new women of this era can be exemplified even within the seemingly like-minded group of women who formed the Heterodoxy Club. This was a consciousness-raising group that met for over twenty years in Greenwich Village whose political affiliations ranged from Republican to Socialist, whose sexual preferences included heterosexual monogamy, lesbianism, and free love ; and whose social perspectives embraced those of the businesswomen who wanted to make their mark in a highly competitive man's world (there was at least one stockbroker in the group) and those who wanted to transform society in accordance with a socialist-feminist agenda.[12]

Among the literary, progressive, and radical New Women of the era, we find creative writers, social theorists, and political activists whose lives and work contributed to broadening the definition of woman's nature and woman's sphere, as well as to pointing out the various forms of oppression that kept many women from achieving their full potential.

THE LITERARY NEW WOMAN

As Elizabeth Ammons has pointed out, *the great flowering of women's writing in America*, before contemporary times, was the period between 1890 and 1920. This was "a time unprecedented in American literature for the production and maintenance of women writers of outstanding talent and accomplishment." Kate Chopin, Ellen Glasgow, Edith Wharton, Frances Ellen Watkins Harper, Angelina Grimké, Susan Glaspell, Willa Cather, Charlotte Perkins Gilman, and Mary Austin, to name a few, were creating challenging works of fiction and drama about women's lives that explored social and psychological realities and possibilities in ways that had not been approached before in our literature.[13]

The women characters in the works of Chopin, Wharton, and Glasgow are the most trapped by social conventions, their lives often devastated by lack of choice. The fates of Edna Pontellier in *The Awakening* (1899), Lily Bart in *The House of Mirth* (1905), and Virginia Pendleton in *Virginia* (1913) are tragic acknowledgments of the limitations on the lives of most women in the age of the New Woman, even when they are upper class.

Harper, Grimké, and Glaspell created heroines who boldly challenged the racial and political orthodoxies of their day. A noted lecturer and civil rights advocate, Harper in 1892 published *Iola Leroy*, the first novel by an African American woman to put in the foreground a female heroine who is a political and social activist. Iola freely chooses to marry a man whom she loves and who also supports her work for the improvement of the black race. In the protest play *Rachel* (1916), Grimké's heroine refuses to marry or rear children because a racist white society allows no arena for her self-expression. Susan Glaspell's *The Inheritors* (1919) is a strikingly contemporary antiwar play, whose college-age heroine gives up her freedom to defend the civil rights of two students to speak in public during the antiradical hysteria of World War I that destroyed academic freedom on many campuses.[14]

Austin, Cather, and Gilman reimagined history and myth from women-centered perspectives. Austin's *The Land of Little Rain* (1903) contains some of the most evocative descriptions and stories in Anglo-American literature about the multicultural landscapes of the Southwest. A pioneering naturalist and champion of Native American rights, she offered an alternative vision to the myth of the West as a place of escape and personal freedom for men by "renaming the land" from a feminist perspective. Cather's *My Antonia* (1915) focuses on the lives of pioneer women who are working-class immigrants and whose strength and independence of spirit are rooted in a complex web of land and community. In 1914, Charlotte Perkins Gilman published *Herland*, the first full-length work of American feminist science fiction. It explores a utopian world of women who attempt to resocialize the three male explorers who "discover" them. The novel is marred by the implicit fascism of an imagined world in which Aryan women, living in a Latin American country, are attempting to create "the perfect race." But Gilman does provide a fascinating portrait of the social and cultural constructions of femininity that Herlanders are able to transcend by living in a world in which women define the human norm.[15]

THE PROGRESSIVE NEW WOMAN

Middle-class progressive women reformers were the heirs of a nineteenth-century belief system that claimed for women such as them the guardianship of America's morals and manners. Where their mothers and sisters did their nurturing in the home, the reformers argued that the values of community, compassion, love, and sympathy needed to be extended beyond the home. They believed that the nation needed women's "tending" if it was going to sur-

vive as a just and democratic society in the twentieth century. Many of them were inspired by the Social Gospel movement within Protestant theology that urged Christians to bring the Kingdom of God down to earth.[16]

Progressive women leaders laid the foundations for much of the important early theory and practice in the fields of sociology and social work, public policy, educational reform, conservation, and the peace movement. Many of them were among the first generation of new women who chose not to marry and who committed their lives to reforms they hoped would open the doors of American opportunity to the majority of men and women who had been excluded from the prosperity enjoyed by the middle and upper classes. At their least humane, white progressive women were patronizing and racist toward the "lower orders" they sought to "uplift" and sometimes feared; at their most humane, they shared with their black colleagues a vision of America as a multicultural democracy in which men and women of all classes and ethnic groups would work cooperatively.

In her autobiography, *Twenty Years at Hull-House* (1910), Jane Addams's perspective accommodates the multitude of national and ethnic groups that surround and participate in her Chicago settlement community. She envisions Hull-House as a model for intercultural cooperation on local, state, national, and international levels. Addams worked alongside Dr. Alice Hamilton, Frances Perkins, Florence Kelley, Grace Abbott, and other women reformers who fought for the first child labor and factory inspection laws and for the first industrial health and housing code reforms. They supported women's labor unions and were founders of the national and international women's peace movement.[17]

Addams's colleague, the black activist Ida B. Wells, organized the first antilynching movement in the United States. She earned herself a price on her head as a result of her investigations of white men's murder of black men and their rape of black women in the South. Wells was a founding mother of the first national civil rights organization, the National Association for the Advancement of Colored People (NAACP), and a major figure in the national Black Women's Club movement. Her autobiography, *Crusade for Justice* (1928), provides an eyewitness history of black politics and social reform during the Progressive Era, including her experiences with the racism of white women reformers.[18]

THE RADICAL NEW WOMAN

Radical new women were predominantly members of the second generation of feminists, who came of age in the first two decades of the twentieth century. They were inspired as much by the poetry of native-born rebels like Walt Whitman, as they were influenced by the theories of European socialists. Like their male counterparts—John Reed, Max Eastman, Bill Haywood—they were more sweeping than progressive reformers in their condemnation of the basic ill health of capitalist America as well as more demanding in their egalitarianism. Socialists like Elizabeth Gurley Flynn, the fiery working-class labor organizer of the International Workers of the World (IWW), and anarchists like Emma Goldman called for a fundamental redistribution of the wealth and social power of the nation.

The radical new women were among the first generation of American feminists to address openly issues of sexuality that progressive—as well as traditional Socialist party—women avoided. As Mari Jo Buhle describes them in *Women and American Socialism*, they "sought in sexual liberation the key to future social revolution, the destruction of 'bourgeois' values in general. They therefore linked sexual repression to the spiritual barrenness of middle-class society, its conventions and artificialities."[19]

Greenwich Village was the headquarters of radical feminism in pre–World War I America and the home base for feminist

"Your Honor: The information connected with this movement is not for personal gain or profit, but for the education of the working and professional class who harrassed by economic conditions, by the high cost of living, by the terrible congestion of our large cities, cannot decently provide for a large brood of children, as a result of which their children are born weak, are ill cared for and ill nourished."

Emma Goldman Speech in Court.

Birth Control Meeting

Friday, May 5th, 1916
8 P. M.

At CARNEGIE HALL
57th Street and 6th Avenue
TO WELCOME

EMMA GOLDMAN

FROM PRISON

And demonstrate that locking up a propagandist does not prevent the dissemination of Ideas.

We still live in a Country, where it is a crime to teach people that which no one can deny, will make the world a better place in which to live.

SPEAKERS:

ROSE PASTOR STOKES	HARRY WEINBERG
PROMINENT DOCTORS	EMMA GOLDMAN
LEONARD D. ABBOTT	And Others
MUSIC	THEODORE SCHROEDER, *Chairman*

Admission 15, 25 and 50 Cents Boxes $5.00

Tickets on sale at Mother Earth, 20 East 125th St. Tel. Harlem, 6194

If you believe that all serious minded women and men should have the right to learn about Birth Control Methods and any thing else that will better their conditions, then you can not afford to miss this meeting.

FIGURE 19. *Poster announcing a meeting on birth control. Rose Pastor Stokes Collection, Tamiment Institute Library, New York University.*

Weiser, Ida,
Dec. 4, 1916

Mrs. Rose Pastor Stokes,
88 Grove St.,
N. Y. City

Dear Mrs. Stokes:—

I have read of the wonderful work you have been doing and wonder if it would be asking too great a favor if you could help me.

I am a young mother 19 yrs old. I have been married a year and six months and have a baby 7 months old. Now Mrs. Stokes we are trying to prove up on a homestead, my husband and I and it put us back quite a bit to have the baby although we do love her and intend to have another when more able but if we could just learn a little about birth control enough to tide us over the three years we have to live up in the mountains away from a doctor and care we would be so grateful. Couldn't you send me one of the pamphlets you threw out to that crowd, or write and tell me what it contained? If not please write me why any way. Hoping to hear from you soon, I am

Yours very resp'f
Mrs. O. C. Wilson
R. F. D. #1

FIGURE 20. *Letter to Rose Pastor Stokes from a young wife desiring birth control information. Rose Pastor Stokes Collection, Tamiment Institute Library, New York University.*

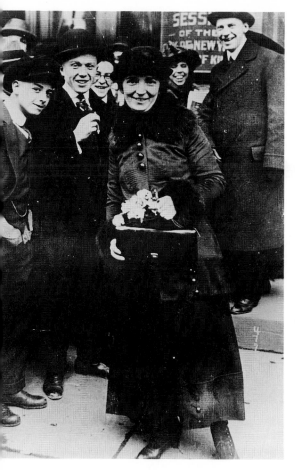

FIGURE 21. *Men jeering at Margaret Sanger as she leaves court after her arraignment, which resulted from a raid on a Brooklyn birth control clinic. She served a thirty-day sentence in the workhouse on these charges in 1916. Margaret Sanger Papers, Sophia Smith Collection, Smith College.*

control advocates crossed class lines in their hope to "create a movement that would fight for the interests of the last privileged woman." In fact, it was the most radical workers' organization of the era, the IWW, that helped to print and distribute 100,000 copies of Sanger's pamphlet, "Family Limitation," in the first months of 1915.[20]

In their book on the history of sexuality in the United States, *Intimate Matters*, Gerald D'Emilio and Estelle Freedman emphasize the revolutionary potential that birth control held out for changes in women's roles and lives: "To advocate fertility control for women through access to contraceptive devices rather than through abstinence implied an unequivocal acceptance of female sexual expression. It weakened the link between sexual activity and procreation, altered the meaning of the marriage bond, and opened the way for more extensive premarital sexual behavior among women. As birth control became more widely available and used, it also broadened the roles women might choose, as biology proved less and less to be destiny."[21]

Radical feminists believed that a fully democratic society could only be achieved if it were premised on the intellectual, political, economic, and sexual equality of men and women. Fundamental to their vision of the United States as a "cooperative commonwealth" was a government that provided communal nurseries and family planning, and a society in which wife and motherhood were choices for women, but not limiting choices. As the Feminist Alliance, a Greenwich Village women's organization, announced in its 1914 platform: "Feminism is a movement, which demands the removal of all social, political, economic, and other discriminations which are based upon sex, and the award of all rights and duties in all fields on the basis of individual capacity alone."[22]

Like contemporary women who work for these ideals, the radical feminists of 1915 felt a great deal of tension between their stated ideals about women's freedom and the pull of traditional loyalties and beliefs. They

leaders of many causes. Labor journalist and Provincetown Player Mary Heaton Vorse encapsulated the Village's feminist ethos when she wrote to a friend: "I cannot imagine anything that would affect better the moral health of any country than something which would blast the greatest number of that indecent, immoral institution—the perfect lady—out of doors and set them smashing and rioting." From here Margaret Sanger ran her birth-control campaign. As was true for the suffrage movement, birth-

experienced conflicts that are still central to many Western women's lives. They were pulled, on the one hand, by the need for personal freedom and self-development, and on the other, by the need for intimacy and community. As the focus of feminism within the second generation moved toward an increasing emphasis on the personal and the individual, many of these women lost important elements of their reformist social edge.[23] Yet, one cannot help but be moved by the struggles of women who advocated ideas that were far in advance of the general culture, as well as by the personal toll that their ideological commitments exacted on their private lives.

Male and female Village radicals worked to subvert the bourgeois morality and capitalist economics that kept women in their traditional place, and yet the new theories of female sexuality that were imported from Europe still defined women in terms of man, even while celebrating their erotic powers. In fact, one could argue that the amount of attention and energy paid to women's sexual freedom, by both men and women, ultimately worked to undermine the fight for women's economic, intellectual, and political equality, particularly when women's sexuality became *the* defining factor of her modernity in the conservative 1920s.[24]

As Neith Boyce's fiction and Mabel Dodge Luhan's memoirs demonstrate, radical new women were beset with uncertainties as they sought to redefine woman's nature and place. Their conflicts were abetted by the male feminists of Greenwich Village whose idealistic rhetoric was often undermined by what they actually wanted from the real women in their lives. Radicals like Max East-

man and John Reed supported equal job and educational opportunities for women, and they argued for "free love" as a necessary ingredient for artistic and political freedom. But what they most often sought in their own personal relationships and celebrated in their fiction and poetry were women who were joyful and exciting companions, willing to subordinate home, community, and their own desires to men's needs.[25]

Boyce's play *Constancy* demonstrates, with great wit and insight, a point that Kay Trimberger underscores: the men of Greenwich Village benefited far more than the women from the ideology of free love. Seeking a New Woman who would give them the best of all possible worlds, they wanted a lover who was always available to fulfill their sexual needs; a mother to provide them with the emotional security they lost when they abandoned their middle-class roots; and a muse to inspire them to world-transforming political and aesthetic feats.

The two essays that follow address key issues in understanding the New Woman of the Progressive Era. By focusing on the lives of two representative Village women, Neith Boyce and Mabel Dodge, Kay Trimberger shows us how the complex web of intimacy and art, the personal and the political, intertwined in the lives of this remarkable generation of women. Adapting a different focus, Elizabeth Ammons reminds us of how few women even had the choice of deciding whether or not to be "new."[26] The attention Ammons gives to fictional works by women of color, as well as by white women, adds another dimension to the New Woman, whose image—and reality—was as much affected by race and class as it was by gender.

NOTES

1. Hutchins Hapgood, *A Victorian in the Modern World* (New York: Harcourt, Brace and World, 1939), 136.

2. On Victorian ideas about woman's nature, sex roles, and sexual codes, see Carroll Smith-Rosenberg, *Disorderly Conduct: Visions of Gender in Victorian America* (New York: Oxford University Press, 1985); John D'Emilio and Estelle Freedman, *Intimate Matters: A History of Sexuality in America* (New York: Harper & Row, 1988).

3. Women's percentage in the work force increased from 15 percent in 1870 to 20 percent by 1900. For the statistics I cite in the first part of this essay, see Lois W. Banner, *Women in Modern America: A Brief History* 2d. ed. (New York: Harcourt Brace Jovanovich, 1984), chaps. 1 and 2. On the reasons for women's advances, see Nancy F. Cott, *The Grounding of Modern Feminism* (New Haven: Yale University Press, 1987), chap. 1. Rosalind Rosenberg, *Beyond Separate Spheres: Intellectual Roots of Modern Feminism* (New Haven: Yale University Press, 1982) explores the generation of women academic social scientists and their male colleagues who pioneered studies that questioned traditional gender identities and hierarchies. For statistics on the percentage decline of women college students, professors, and professionals, see William L. O'Neill, *Everyone Was Brave* (Chicago: Quadrangle Books, 1969), 304–305.

4. For women's roles in the Progressive Era conservation movement, see Carolyn Merchant, "Women of the Progressive Conservation Movement, 1900–1916," *Environmental Review* 8, no. 1 (Spring 1984): 57–85.

5. Lois W. Banner, *American Beauty* (Chicago: University of Chicago Press, 1983), 146. On the growth of the leisure ethic, see Banner, p. 175, and Linda Gordon, *Woman's Body, Woman's Right: A Social History of Birth Control in America* (New York: Viking, 1976), 180–181.

6. Carroll Smith-Rosenberg, "The New Woman as Androgyne: Social Disorder and Gender Crisis, 1870–1936," in *Disorderly Conduct*, 255. Smith-Rosenberg points out that from the 1870s to the 1920s, "between 40 to 60 percent of women college graduates did not marry" at a time when only 10 percent of American women did not (p. 253). See also Allen Davis, *Spearheads of Reform: The Social Settlements and the Progressive Movement*, 1890–1914 (New York: Oxford University Press, 1967); and Blanche Weisen Cook, "Female Support Networks and Political Activism," in *A Heritage of One's Own: Towards a New Social History of Women*, ed. Nancy Cott and Elizabeth Pleck (New York: Simon and Schuster, 1979), 412–444.

7. Cott, *Grounding of Modern Feminism*, 35. According to Cott the use of the word feminism was rare before 1910 and "frequent by 1913." It "answered a need to represent in language a series of intentions and a constituency just cohering, a new moment in the long history of struggles for women's rights and freedoms," p. 15.

8. For the accomplishments of black women activists during the Progressive Era, see Paula Giddings, *When and Where I Enter: The Impact of Black Women on Race and Sex in America* (New York: Bantam, 1984); Dorothy Sterling, *Black Foremothers: Three Lives* (Old Westbury, N.Y.: Feminist Press, 1979). For working-class women's unionizing efforts and their alliances and conflicts with middle-class women reformers see Meredith Tax, *The Rising of The Women: Feminist Solidarity and Class Conflict, 1880–1917* (New York: Monthly Review Press, 1980), and Ruth Milkman, ed., *Women, Work, and Protest: A Century of U.S. Women's Labor History* (Boston: Routledge & Kegan Paul, 1985). Cott, *Grounding*, 34, notes that "between 1905–1915 over 100,000 women struck in the needle and garment trades across the nation asking for better wages and working conditions."

9. On women's suffrage and use of publicity-generating techniques in this period, see Cott, *Grounding*, 30, and June Sochen, *The New Woman: Feminism in Greenwich Village, 1910–1920* (New York: Quandrangle Books, 1972), 141.

10. See Banner, *Women in Modern America*, 156–157; 168–169, and Martha Banta, *Imaging the American Woman: Idea and Ideals in Cultural History* (New York: Columbia University Press, 1987), 88, where she talks about how the ambiguities of the visual images of the New Woman could serve conservative as well as reformist agendas.

11. See Rosalyn F. Baxandall, *Words on Fire: The Life and Writing of Elizabeth Gurley Flynn* (New Brunswick: Rutgers University Press, 1987); Emma Goldman, *Living My Life* (New York: Dover Press, 1970), vol. 2; and Kathy Peiss, *Cheap Amusements: Working Women and Leisure in Turn-of-the-Century New York* (Philadelphia: Temple University Press, 1986), 6. Peiss reminds us that "understanding working women's culture calls for a double vision, to see that women's embrace of style, fashion, romance, and mixed-sex fun could be a source of autonomy and pleasure as well as a cause of their continuing oppression." See also Banner, *American Beauty*, 176.

12. See Judith Schwarz, *Radical Feminists of Heterodoxy: Greenwich Village, 1912–1940* (Lebanon, N.H.: New Victoria Publishers, 1982).

13. Elizabeth Ammons, "On Calling Oneself a Feminist," *Tufts Criterion* (Fall 1983): 36–38. It is important to note that most women's fiction of the period establishes heroines in fairly conventional roles. Banner notes in *American Beauty* that most Progressive Era popular fiction tended to place women's true fulfillment within the family, while Sochen argues that Boyce's and Glaspell's heroines rarely achieve the independence and creative fulfillment of their authors.

14. On Harper, see Mary Helen Washington, *Invented Lives: Narratives of Black Women, 1860–1960* (New York: Doubleday, 1987). Glaspell's *Inheritors* is reprinted in C. W. E. Bigsby, ed., *Plays by Susan Glaspell* (Cambridge: Cambridge University Press, 1987).

15. See Mary Austin, *Stories from the Country of Lost Borders*, ed. Marjorie Pryse (New Brunswick: Rutgers University Press, 1987); for Austin's and Cather's reimagining of western landscapes see Jan Monk and Vera Norwood, eds.,

The Desert Is No Lady: Southwest Landscapes in Women's Writing and Art (New Haven: Yale University Press, 1987). On Cather's use of working-class women as models of the New Woman, see Sandra M. Gilbert and Susan Gubar, *No Man's Land: The Place of the Woman Writer in the Twentieth Century*, vol. 2, *Sex Changes* (New Haven: Yale University Press, 1989), 198. On p. 184, Gilbert and Gubar point out that when Cather's young men go West in *My Antonia*, "they encounter not male freedom but female primacy." See Charlotte Perkins Gilman's *Women and Economics*, one of the earliest historical analyses of the evolution and impact of patriarchy on women's lives. (1898; rpt. New York: Harper & Row, 1966).

16. For a history of the evolution of the concept of home into the idea of the world as home in women's literature and social reform, see Dolores Hayden, *The Grand Domestic Revolution: A History of Feminist Designs for American Homes, Neighborhoods, and Cities* (Cambridge: MIT Press, 1981).

17. See Kathryn Sklar, "Hull-House in the 1890s: A Community of Women Reformers," *Signs* 10, no. 4 (Summer 1985): 658–677. Sklar argues that the success of the women leaders of Hull-House was due to their having a "strong supportive community of women" as well as to their ability to deal with male-dominated institutions of power.

18. For the racism of white women reformers, see Rosalyn Terborg-Penn, "Discrimination against Afro-American Women in the Woman's Movement, 1830–1920," in *The Afro-American Woman: Struggles and Images*, ed. Sharon Harley and Rosalyn Terborg-Penn (Port Washington, N.Y.: Kennikat Press, 1978), 17–27.

19. Mari Jo Buhle, *Women and American Socialism* (Urbana: University of Illinois Press, 1983), 260. Buhle points out that feminists issued a direct challenge to the "social purity" ideals embedded in mainstream socialism "by declaring that sex be made a major issue of revolutionary politics and women's liberation its substance" (258).

20. Vorse quoted in Cott, *Grounding*, 36; Gordon, *Woman's Body, Woman's Right*, 208.

21. D'Emilio and Freedman, *Intimate Matters*, 233.

22. Quoted in Sochen, *The New Woman*, 47.

23. See Cott, *Grounding*, 39. "By the early twentieth century it was a commonplace that the

New Woman stood for self-development as contrasted to self-sacrifice or submergence in the family." Smith-Rosenberg makes a similar point in "The New Woman as Androgyne," p. 295. On pp. 283–284, she points out that "Sexual issues had caused a serious rift within the ranks of the New Women, eroding their social cohesion and political effectiveness." Where "sexual liberation was emphatically not" a political issue for the first generation, second generation feminists "thought of sexual autonomy, not as freedom from marital oppression, but in positive terms, as the right to sexual experimentation and self-expression." An important example is the break between Jane Addams and Crystal Eastman, both of them founders of the Woman's International League for Peace and Freedom, over the issue of Eastman's "sexual flamboyance." See D'Emilio and Freedman, *Intimate Matters*, 225. Also, Gordon, *Woman's Body, Woman's Right*, notes that "Economically, socially, and politically, sexually 'free' women were as powerless as conventional women. . . . As with all women, their survival and success largely depended on pleasing men. Those in bohemian communities merely had to meet new male demands" (194–195).

24. For a more extensive critique of the ways in which corporate America in the 1920s exploited the new sexuality in order to reinscribe woman's place in the home see Stuart Ewen, *Captains of Consciousness: Advertising and the Social Roots of the Consumer Culture* (New York: McGraw-Hill, 1976), especially chap. 6, "Consumption and the Ideal of the New Woman."

25. See Sochen, *The New Woman*, 127–130; also, see Gerald L. Marriner, "A Victorian in the Modern World: The 'Liberated' Male's Adjustment to the New Woman and the New Morality," *Southern Atlantic Quarterly* 76, no. 2 (Spring 1977): 190–203.

26. See Banner, *Women in Modern America*, 8–14, for data on the still significant discrimination against women during the Progressive Era.

The New Woman as Cultural Symbol and Social Reality

Six Women Writers'
Perspectives

ELIZABETH AMMONS

"Write if you *must*, not otherwise," declared Elizabeth Stuart Phelps in *Famous Authors (Women)* in 1901. "Do not write if you can earn a fair living at teaching or dressmaking, at electricity or hod-carrying. Make shoes, weed cabbages, survey land, keep house, make ice-cream, sell cake, climb a telephone pole." Try anything, Phelps exclaimed, "before you set your heart upon it that you shall write for a living. Do anything honest, but do not write unless God call you and publishers want you and people read you and editors claim you." Even then, she warned: "Do not flirt with your pen. Emerson's phrase was, 'toiling terribly.' Nothing less will hint at the grinding drudgery of a life spent in living 'by your brains.' "[1]

The world had changed. No mid–nineteenth-century writer in the United States, even in jest, could tell her admirer to climb a telephone pole or make her living at electricity. In contrast to the nation Phelps knew as a child (she was born in 1844) early twentieth-century America offered, at least in theory, endless ways in which women could support themselves. Out of the more than five hundred occupations listed in the 1929 United States Census as reported in *Women in Gain-ful Occupations 1870 to 1920* there appear only thirty-three jobs which could not by 1910 list at least one woman employee; and all thirty-three of those—occupations such as street cleaner, aeronaut, life saver, longshoreman, railroad switchman, and butler—had to have one or more women in their ranks by 1920 to be included in the book.[2]

According to the census the spectrum of work open to women by the 1910s ran from factory hand to surgeon, farm worker to college president, and it included numerous occupations customarily reserved for men in modern Western societies: architect, carpenter, stonecutter, teamster, mail carrier, detective, banker, undertaker. Moreover, jobs unheard of a generation earlier—stenographer, typist, trained nurse, department store clerk—now presented themselves to women.

Clearly, tremendous changes in women's relationship to the world of paid work had occurred by the turn of the century. African American women, never defined by the dominant culture as too delicate or pure to work outside the home, continued to hold paid jobs, while increasing numbers of white women poured into the expanding work force. Although much of the available work did not differ fundamentally from what women throughout the nineteenth century had already been doing either for pay or not, some opportunities were new or newly available for women, or certain groups of women. During the first two decades of the twentieth century female enrollment in colleges and universities increased by 1000 percent in public institutions and 482 percent in private ones;[3] and the representation of women in the professions, defined in the census as clergy, law, architecture, medicine, photography, teaching, nursing, dentistry, and editorial and newspaper work, grew from 6.4 percent in 1870 to 10 percent in 1900 and 13.3 percent in 1920. Women employed as clerks, saleswomen, stenographers, typists, bookkeepers, cashiers, and accountants went from 0.8 percent in 1870 to 9.1 percent in 1910 to 25.6 percent in 1920.[4] So dramatic

was the influx of women, and especially middle-class white women, into the paid work force during the Progressive Era that the historian William O'Neill has called this revolution in women's participation in the labor force "the most significant event in the modern history of women."[5]

We should not, however, romanticize this change. Most women who worked for pay were limited to traditionally feminine and therefore by definition low-paying and low-status jobs. In 1910, approximately 90 percent of America's servants, laundresses, dressmakers, milliners, and boarding- and lodging-house keepers were women, and they made up only a little more than 16 percent of the remaining nonagricultural work force.[6] The great majority of women who worked held boring, badly paid jobs, and very few had significant choice about their relationship to the paid economy. Most women of color were forced to remain in the paid work force throughout their adult lives whether they wished to or not because racist economic discrimination made one-income households difficult or impossible. Conversely, most white women, whether they wished to or not, found themselves allowed to work only between their school years and marriage because they were expected, upon marrying, to return full-time to women's traditional unpaid work in the home caring for husbands, parents, children, and property. Moreover, entry into prestigious work was jealously opposed by many men. Consider, for example, the revealing drop in the number of women physicians from 9,015 in 1910 to 7,219 in 1920, a drop which coincides exactly with women's determination to invade the world of male training hospitals instead of continuing to train in separate, female-run institutions.[7]

However, if there were problems, there was also great excitement. Optimism about a new world dawning for American women ran high at the turn of the century. Elizabeth Stuart Phelps's published advice to women in 1901 to do anything but write had a practical side: Middle-class American

THE CHEAPEST
COMMODITY ON THE MARKET

Read the Progressive Woman, 50 cents Yearly, at 5445 Drexel Avenue, Chicago.

FIGURE 22. *Anton Otto Fischer, "The Cheapest Commodity on the Market,"* The Masses *1 (December 1912), p. 4. Yale Collection of American Literature, Beinecke Rare Book and Manuscript Library, Yale University.*

women by the turn of the century, theoretically at least, *could* do other things. They did not have to write.[8]

But they did write, and one of their major preoccupations as writers was precisely the world of change and, allegedly, great choice alluded to by Phelps. Indeed, such writing is one of the things that underlies the explosion in serious fiction by American women at the turn into the twentieth century—roughly, from the early 1890s to the middle of the 1920s—that literary historians are just now beginning to understand as a coherent historical development.[9] By the early 1900s—certainly by 1915—an unusually complicated network of options, conflicts, frustrations, contradictions, deceptions, and possibilities faced countless American young women. Many no longer had available the relatively settled, traditional ways of life of their mothers and their grandmothers. According to the popular, dominant-culture ideology of the New Woman, a new era of

female self-determination had arrived. This ideology asserted that, freed from prescriptions of dependence and subservience, the American woman on the threshold of the twentieth century—the New Woman—could construct her own identity: economically, socially, sexually, politically.

In any period of dramatic social change such as occurred at the turn of the century, different points of view compete and conflict. The works I will discuss give some suggestion of how widely opinion and perspective ranged on the subject of the New Woman by the 1910s. Willa Cather's novel *The Song of the Lark* (1915) and Mary Austin's *A Woman of Genius* (1912) focus on the struggle for personal, professional success of two middle-class white New Women. Jessie Fauset's 1920 novella *The Sleeper Wakes*, in contrast, traces a young black woman's arrival at an ideal of the New Woman quite different from Cather's or Austin's, an ideal grounded in communal rather than individualistic values. Angelina Grimké's play *Rachel*, written in 1916, could be said to begin with the ideal Fauset arrives at and then to use it to expose the pervasive, destructive power of white racism. Also pessimistic, Edith Wharton in her best-selling 1905 novel *The House of Mirth* and then a dozen years later in her short novel *Summer* (1917) examines the failure of the mainstream middle-class white ideal of the New Woman to reach meaningfully into the lives of white American women at either the top or the bottom of the social scale. Finally, Sui Sin Far's stories about the New Woman in her collection *Mrs. Spring Fragrance* (1912) directly challenge, in this case from a Chinese American point of view, the ethnocentricity and class bias of the mainstream white American ideal of the New Woman at the beginning of the twentieth century.[10]

Other texts could be chosen to illustrate the perspectives I have outlined, as well as perspectives quite different from the ones that concern me here. My selections are hardly exhaustive nor are my conclusions the only ones possible. My purpose in this essay is to place side by side texts by six important Progressive Era women authors whose work suggests some of the controversy that prevailed at the time. Too often, when the New Woman is described, debate about her is ignored. A sort of turn-of-the-century white dream girl is nostalgically evoked: a physically vigorous, highly educated, sexually daring, middle-class white woman whose degeneration into the flapper in the 1920s can only be explained as the cruel price tag placed on the Nineteenth Amendment by powerful white men.[11] In fact, the middle-class white ideal was liberating for many American women. At the same time, however, there were other models of the New Woman fully developed by 1915— not all of them white. Indeed, it might well be argued that the privileging of the white middle-class paradigm, then and now, has limited rather than promoted women's solidarity and freedom in the United States.

The heroine of *The Song of the Lark* offers a compelling portrait of the New Woman as popular imagery at the time most commonly pictured her. Thea Kronborg is intelligent, creative, physically robust, strong-willed, and confident. She is highly successful both at supporting herself and at fulfilling her unique talents as an individual.

Breaking from the past, Thea strikes out on her own—depends on herself. Not far into *The Song of the Lark*, a young man says to her, "There'll always be plenty of other people to take the knocks for you," to which she immediately replies with impatience, "That's nonsense, Ray. . . . Everybody's up against it for himself, succeeds or fails himself."[12] The revolution that Cather's novel records in 1915, as compared with 1815, say, is that the "everybody" who succeeds or fails for himself in this story is female. The fundamental American Dream of self-production—the ideal of the self-made man—gets played out in a woman. Thea enjoys the help and support of other people, but finally she makes her own way in life, by herself, and the success she achieves as an op-

era singer must be credited to her. Cather's talented, hard-working New Woman is allowed to venture on life as an individual, as one independent actor, and she makes of it a tremendous economic and personal success.

This victory does not come easily. Without the encouragement of her mother, a woman of keen vision and determination, and of the family friend Dr. Archie, a talented and sensitive man stranded in an inhospitable small town, Thea Kronborg, no matter how gifted, would probably never get out of Moonstone, Colorado, "a smug, self-satisfied provincial world of utter ignorance," as Cather put it in her 1932 preface to *The Song of the Lark* (vi). Thea escapes because she has ambition and others believe in her. Also, however, and this is crucial, she escapes because there is a world of possible female accomplishment and achievement open to her. There is somewhere for her to go. She can as a singer become an acclaimed, well-paid, and therefore self-sufficient, performing artist. To be sure, she must work hard and she must be able to survive great loneliness and discouragement. At points she even thinks of giving up because life as an artist is so demanding. Unlike other women, she cannot marry and have a family (the marriage she eventually makes occurs in middle age, after her childbearing years have passed) ; and most of her life is spent in railroad cars and steamships, hotel rooms and restaurants. Nevertheless, this life *is* open to her.

With application, talent, and a modicum of luck Thea Kronborg has available to her a life of independence, public accomplishment, and personal, individualistic satisfaction and self-fulfillment available to few if any respectable white women a century or even a half century earlier. At the end of the novel one of Thea's early teachers and his wife hear her sing, and the wife exclaims: "I wonder if she knows how much she owes to you." Her husband replies instantly: "She owes me nothing. . . . She paid her way" (569). In *The Song of the Lark*, Thea earns and deserves her success.

Cather's 1915 novel (and she had already told the same story two years before in her first novel about a woman, *O Pioneers!* [1913]) features as the prototypical self-made American not a man, but a New Woman.

Similarly, but more realistically, Mary Austin in *A Woman of Genius*, published three years before *The Song of a Lark*, represents in fiction the independent life of a successful, white, middle-class New Woman. Olivia Lattimore's struggle to create herself and then survive as a New Woman is more complicated than Thea Kronborg's. Austin shows Olivia, the woman of genius of her title—a woman born with the capacity to become a brilliant actress—struggling against tremendous internal as well as external obstacles. For Olivia, the desire to be new, that is, to realize her full creative potential as an individual and to follow to its conclusion her own personal ambition, exists in direct conflict with society's expectation, which she has internalized, that she will as a respectable white middle-class Protestant woman devote her life totally to supporting her husband's ambitions and emotional needs, bearing and rearing their children, and managing their house. She has no model for bringing together her desire to realize herself as an artist and her desire to have love, which means for her being part of a marriage. As she states late in the novel, "The social ideal, in which I was bred, is the villain of my plot."[13]

Consequently, although very successful as an actress, Austin's New Woman is lonely, conflicted, and often confused. Her sister finds her an inspiration. She tells Olivia that because of women like her, "Women everywhere [are] getting courage to live lives of their own. . . . The more women there are like you, the less there will be of that [oppression and abuse] for any of them. It is the conscious movement of us all toward liberty that's going round with you" (451). But Olivia shares little of her sister's enthusiasm. She does not see herself as part of a movement or community: "I'm not thinking

of the others at all. I don't even know that there are others, or at least who they are. I'm a squirrel in a cage. I go round because I must" (451).

Like Cather in *The Song of the Lark*, Austin in *A Woman of Genius* celebrates a white middle-class New Woman's strength as an individual, her potential as a creative person, her right to construct an independent life for herself, and her success as a contributor to society in the public realm. However, Austin emphasizes the pain and isolation encountered by the New Woman she imagines. *A Woman of Genius* places at the center of Olivia's story deep, unresolved conflict between heterosexual love and meaningful work. Also, it acknowledges the envy and hostility of other women toward Olivia and her consequent alienation from female community. Being new in *A Woman of Genius* is finally no less exciting than it is in *The Song of the Lark*. But it is not as easy or happy, or without its acute losses as well as gains.

Neither novel, however, is universal. Thea Kronborg and Olivia Lattimore, it is important to emphasize, do not represent "the" New Woman but two *white* New Women. In the first place, the freedom of travel which enables these heroines to go wherever they wish in the United States and to stay in whatever hotel they desire—not to mention the liberty which allows a heroine such as Thea Kronborg to journey alone to Panther Canyon in the desert of Arizona—would be extremely difficult, indeed probably impossible, for a black heroine. In the second place, the roles they win would have been closed to black performers in the United States. As the historian Paula Giddings points out, the black artist Marie Selika could sing in Europe at the turn of the century, but she could not, as Cather's New Woman can, sing major roles in major houses in America at the time. Theodore Drury states in a 1902 article in *The Colored American Magazine* that Madam Selika "compares favorably with the great singers of the world." Nevertheless: "Owing to the conditions of race questions at the present in America, Madam Selika spends most of her time abroad, where she meets with the greatest success."[14] In short, the kind of success that Cather and Austin celebrate in their novels about the New Woman did not exist for women of color.

That exclusion of women of color from mainstream American opportunities and freedoms, *plus* deficiencies within the most popularized version of the white ideal of the New Woman itself—the way, for example, in which the ideal often simply replicated privileged, self-centered, white male ideals—form a major theme in the novels of Jessie Fauset. Especially in her first novel, *There Is Confusion* (1924), which focuses on a middle-class African American woman's struggle against racism in the white-controlled world of the performing arts, she dramatizes the inaccessibility and limitations of the mainstream, white New Woman ideal. Likewise, appearing in 1920 in three installments in *The Crisis*, the official publication of the National Association for the Advancement of Colored People, Fauset's first long fiction, *The Sleeper Wakes*, is concerned with definitions of the New Woman in America. It tells the story of one young middle-class black woman's painful but successful journey away from identification with corrupt, white American values to creation of herself as a New Woman in the black community.

Amy Boldin is an orphan who grows up in a loving black household. Still, at seventeen (the same age at which Thea Kronborg leaves home for Chicago and at which Wharton's heroine in *Summer* also attempts to strike out on her own), Amy runs away. Because she is so fair that she can pass for white, she is able to take up residence in an all-white world. *The Sleeper Wakes*, as its title suggests, examines unconsciousness and consciousness. Fauset's fiction confronts us with comatose reality, Amy's nightmare sojourn in the white world, versus wide-awake and meaningful reality, her final recommitment to black America.

The moral journey through white America on which Fauset takes Amy in *The Sleeper Wakes* illustrates how not to live one's life. First Amy falls in with thirty-nine-year-old Zora Harrison, a jaded up-to-date white New Yorker adept at a very old game. Zora "had been a poor girl of good family. She had wanted to study art, she had deliberately married a rich man and as deliberately obtained in the course of four years a divorce, and she was now living in New York studying by means of her alimony and enjoying to its fullest the life she loved."[15] Free to do as she wishes, which amounts to looking good, keeping up with the latest offbeat fads, and satisfying her whims, Zora sums up her sophisticated trendy morality for Amy in a statement that echoes, with a solipsistic twist, the self-made American theme of *The Song of the Lark*: "'Everybody is looking out for himself,' she said airily." She then continues nonchalantly, "I am interested in you, for instance, not for philanthropy's sake, but because I am lonely, and you are charming and pretty and don't get tired of hearing me talk. You'd better come and live with me awhile, my dear, six months or a year. It doesn't cost any more for two than for one, and you can always leave when we get tired of each other" (Aug: 171). Self-interest and little or no sense of responsibility toward others are the rule for Zora, Fauset's flamboyant forerunner of the kind of woman F. Scott Fitzgerald would find irresistible in the 1920s; and Amy—disastrously—takes the advice of this modern white woman: "Anyway you must marry wealth,—one can always get a divorce" (Aug.: 171).

Amy's marriage does lead to divorce, although not exactly as Zora foresaw. To save a black man from lynching, Amy tells her wealthy white husband the truth, that she too is black; and he, horrified and enraged, divorces her—only to return months later to propose that they live together again, this time with her as his mistress. This ugly proposal ends in violence. The powerful white man to whom Amy was once married strikes her; and with the blow comes full and brutal comprehension for her of the interconnection between racism and white male sexual predation and exploitation.

> "Nigger," he had called her as she fell, "nigger, nigger," and again, "nigger."
> "He despised me absolutely," she said to herself wonderingly, "because I was colored. And yet he wanted me." (Oct.: 271)

No longer able to pretend that racism is not her issue—that she is somehow beyond its reaches—Amy wakes up.

The task before this new, wide-awake Amy is named but left a sketch in *The Sleeper Wakes*. She resolves not to pass—"I am colored, and hereafter I mean to live among my own people" (Oct: 272)—and she will go into business for herself so that some day she can "work and help with colored people" (Oct: 274). She does not know who her birth parents were and therefore whether she is "really" black or not, but the question itself is irrelevant. Fauset's heroine chooses to be black; she chooses to identify with an ethic, a worldview, which she perceives as African American not white; and it is within the context of that choice that she will make herself a New Woman.

> Gradually she reached a decision. There were two divisions of people in the world—on the one hand insatiable desire for power; keenness, mentality; a vast and cruel pride. On the other there was ambition, it is true, but modified, a certain humble sweetness, too much inclination to trust, an unthinking, unswerving loyalty. All the advantages in the world accrued to the first division. But without bitterness she chose the second. She wanted to be colored, she hoped she was colored. (Oct: 273)

Self-interest no longer defines Amy's outlook. Awake, she grounds her definition of adult womanhood not in self but in community.

Amy will work hard, make money (preferably off of white people [Oct.: 274]), and

develop her talents and self-reliance, all not to advance herself, or not simply to do that, but to serve and contribute to the welfare of her people. Hardly self-abnegating, Amy is exhilarated by her newfound goals. She is not giving up being a New Woman to serve others; she is redefining New Woman according to a communal, anti-individualistic ethic. "Citizen of the world, that's what I'll be," she declares (Oct: 274). In fact, this community-oriented concept of the New Woman was shared by a minority of white women at the turn of the century as well, by social activists such as Jane Addams and Emma Goldman. Within the white community, as within the black, no one definition held absolute sway. From Fauset's point of view, however, a communally focused concept was the only possible rational and moral choice for African American women, personally and socially. To be black and a New Woman, Amy comes to appreciate, is to understand that the group's and one's own welfare are interlocked.

More than a decade before Angelina Grimké wrote *Rachel*, Lester A. Walton maintained in an article in *The Colored American Magazine* that "the stage is the medium by means of which ideas—whether true or false—are disseminated; where many opinions are molded," and he went on to predict specifically: "The stage will be one of the principal factors in ultimately placing the negro before the public in his true and proper light. Instead of being ridiculed before the foot-lights as has been done for years, a sentiment will be crystalized which will be of an instructive and beneficial nature."[16] Surely, such thinking lay behind the NAACP's commissioning Angelina Grimké to write *Rachel* as part of its antilynching campaign in the 1910s.

Published the same year as *The Sleeper Wakes*, although it was written and first produced four years earlier, in 1916, Grimké's *Rachel* in many ways picks up where Fauset's story leaves off, with a confident, attractive, African American New Woman

at its center. However, the story Grimké offers does not end optimistically. *Rachel* expresses Grimké's anger and bitterness about the refusal of white America to countenance the existence of an African American New Woman.

Rachel opens with Rachel Loving the living image of a New Woman—ebullient, self-assured, well-educated, ambitious. Raised in a close-knit middle-class family, she is ready to pour her energy and education into work in the community. We first meet her standing in the door of her living room: "*In her left arm she carries four or five books strapped together; under her right, a roll of music. Her hat is twisted over her left ear and her hair is falling in tendrils about her face. She brings into the room with her the spirit of abounding life, health, joy, youth.*"[17] This young woman's immediate ambition is to teach school, an occupation for which she has trained herself by earning a degree in domestic science. Then she wishes to become a mother, the most rewarding and important work she can imagine. Racism prevents her from realizing either goal.

Rachel lives with her mother and brother, Tom, who bluntly articulates Rachel's situation as a black New Woman, saying "(*slowly; as though thinking aloud*): I hear people talk about God's justice—and I wonder. . . . Rachel is a graduate in Domestic Science; she was high in her class, most of the girls below her in rank have positions in the schools. . . . It seems our educations aren't of much use to us: we aren't allowed to make good—because our skins are dark" (41–42). Later Rachel answers a friend's question, "Rachel, do you hear anything encouraging from the schools? Any hope for you yet?"

RACHEL: No, nor ever will be. I know that now. There's no more chance for me than there is for Tom [he has trained as an electrical engineer],—or than there was for you—or for any of us with dark skins. (50)

In this play the African American New Woman's ambition is pointless and her edu-

cation useless. Prepared to be a teacher, one of the few professions open to women of color in the early twentieth century, she cannot find employment because there exist, as a result of discrimination, too many black women for too few positions.[18] In *Rachel* the Progressive Era ideal of the New Woman— the well-trained, crisply turned-out, highly competent young working woman—is a cruel joke. Rachel fits the bill, and racist America tells her to stay home and take in sewing.

Similarly assaulted is Rachel's desire to be a mother. Her expressions of ardor may strike us today as embarrassingly emotional. She closes her eyes at one point and murmurs: "I think the loveliest thing of all the lovely things in this world is just (*almost a whisper*) being a mother!" (12). Grimké's point, however, is not sentimental. In the course of the play Rachel learns that her father and stepbrother were lynched; she watches helplessly as the little neighborhood boy she loves, Jimmy Mason, gains his first lessons in racism; and she confronts, face to face, in a seven-year-old child, Ethel Lane, the crushing toll of bigotry on black children. Consequently, at the end of the play Rachel bitterly renounces her dream of motherhood; she won't marry and bring children into a world designed to torture them. Grimké's play ends tragically. Rachel will devote herself to Jimmy, her family, and the community but will never know the joy of teaching nor of marrying the man she loves and raising her own family. American racism denies Rachel Loving, a New Woman of extraordinary talent and accomplishment, the unexceptional adult life of meaningful paid work followed by marriage and motherhood—so commonplace for middle-class white women—that she wishes to create for herself.

In *Rachel* Grimké uses an image of the New Woman both to assert black pride and to name white racism for what it is, genocide. That Rachel exists testifies to the strength and determination of black America not to be crushed by racism. However, that she can neither find employment as a teacher nor

make the "normal" heterosexual adult choice of marriage and motherhood exposes the mainstream ideology of the New Woman as resolutely racist—there is no New Woman option for Rachel Loving. Indeed, the future coming into view in *Rachel* is not better but worse for all African Americans. As Ethel's mother observes grimly, and the sentiment forms a repeated refrain in the play: contrary to mainstream Progressive Era propaganda about the boundless opportunity and freedom to be had in the United States, "Every year things are getting worse" (57).

If racism closes Rachel Loving out from the kind of triumphant self-realization enjoyed by Cather's and Austin's New Women, class does much the same for the white heroines of Wharton's otherwise quite different 1905 and 1917 novels, *The House of Mirth* and *Summer*.[19]

Lily Bart in *The House of Mirth* has been so perfectly fashioned as a lady of the leisure class that, although she does not want to marry, which in her world amounts to negotiating herself on the stock exchange of marriage—bartering her freedom for economic support—she is able to support herself in no other way. "Brought up to be ornamental,"[20] she has no practical experience or useful education. When she tries to earn her living as a worker in a millinery shop, she lacks both the skills and the stamina necessary for survival and is fired. The antithesis of a New Woman, Lily Bart yearns for the freedom and self-determination of that figure and ends up dead. She embodies early in the twentieth century Edith Wharton's argument that ruling-class America is not about to allow women at the top the freedom to determine their own lives.

There are a few women in *The House of Mirth* who do seem to have some freedom: Carrie Fisher, Gerty Farish, Nettie Struther. However, these are not New Women. Carrie Fisher is a widow and completely dependent on rich people's favors and support. Gerty Farish may live independently and do useful

work in the world, but her own life is drab, dingy, and loveless. Nettie Struther, tougher and more experienced in the world than Lily, lives on the margin economically and is not single. *The House of Mirth* is about ruling-class America's refusal to permit any New Woman ideal within its ranks, or, in any truly revolutionary way, without. The perfect product of her class, which is the class that rules America in Edith Wharton's opinion, Lily realizes late in the book that she is "no more than some superfine human merchandise" (412). Despite her longings for freedom, she has been flawlessly and fatally manufactured for one purpose: to display rich people's privilege and power.[21]

Summer, focused on the other end of the social scale and written over a decade later, is no less pessimistic about the gap between the ideal and the reality of the New Woman in the United States. "How I hate everything!"[22] Charity Royall twice states at the opening of the novel, and though Wharton's rebellious seventeen-year-old longs to get

out of North Dormer, Massachusetts, the suffocating small town where she lives with her guardian, the lawyer Royall, she is doomed never to leave.

Like Rachel Loving, Charity Royall is young, healthy, and full of life. Unlike Rachel, Charity is uneducated. Originally the daughter of impoverished dejected mountain people, she may live in North Dormer as the ward of a middle-class white lawyer, but she has been no better equipped to create an independent life for herself than her demoralized mother was. Charity hates school and has no marketable skills—even if North Dormer had any jobs worth competing for. The glorious New Woman of turn-of-the-century America is as distant from backwater rural Massachusetts as the queen of England. Charity is a normal, bright, unintellectual, young, white woman living in small-town America; and according to Wharton her choices in life, despite widespread American optimism about the new world opening up for women, are no broader

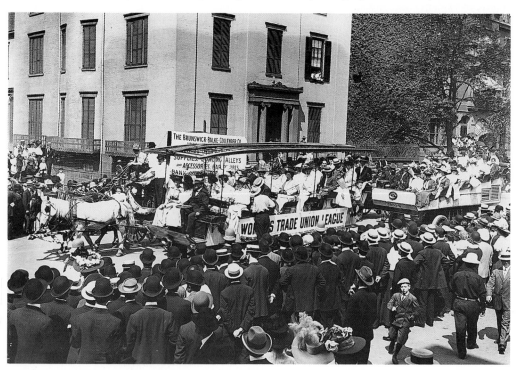

FIGURE 23. *Women's Trade Union League participating in a parade, 1915. Library of Congress.*

FIGURE 24. *Headquarters, Shirtwaist Strikers. Miss Dreier and secretary planning strike tactics. Museum of the City of New York.*

or better than they would have been two gen-erations earlier. Charity sits at the desk of the Hatchard Memorial Library, which al-most no one in town bothers to use anyway, winding some handwork around a worn copy of a nineteenth-century best-seller about female obedience to tradition, *The Lamplighter* (1854) ; and the image is tell-ing. The dusty novel might as well be new, Wharton implies, given how it, more than any recent New Woman tale, describes the options of a small-town young woman such as Charity Royall in the opening decades of the twentieth century.

Charity dreams of escape. Clearly, she would like to be new, or to have new choices. But she can conceive of neither. When she learns that she is pregnant, she can see four alternatives, all of them old : force the young man to marry her, have an abortion, move to the neighboring town and support herself and her baby by becoming a prostitute, or marry her guardian Royall, a grotesque

reenactment of traditional patriarchal mar-riage. She does the last. Royall, we are led to believe, will treat her kindly ; he too is lonely and depressed in North Dormer and he values Charity's youth and companionship. Nevertheless the marriage symbolically marks the end of Charity Royall's life. Dur-ing the wedding service, all that she can hear is the funeral of her mother the night before. "The clergyman began to read, and on her dazed mind there rose the memory of Mr. Miles, standing the night before in the deso-late house of the Mountain, and reading out of the same book words that had the same dread sound of finality " (206). At the end of *Summer*, Charity Royall, at seventeen, re-mains stuck in North Dormer, pregnant and married to the man who has literally played the role of father to her for as long as she can remember.

By the time *Summer* was published in the late 1910s, for many Americans the image of the New Woman was so familiar as to be

passé. Indeed, as early as 1896 Ellen Glasgow had had a novel rejected for publication by Macmillan and Company because "the new woman sort of thing" had "rather been done to death lately."[23] Yet for Charity Royall no such New Woman glut exists. The only New Woman she is aware of is the physician to whom she turns when she is pregnant, and that woman has virtually no comprehension of who Charity is. Dr. Merkle cavalierly advises abortion, which horrifies Charity, and then proceeds, from Charity's point of view, to rob her. For a poor, uneducated, young white woman trapped in rural poverty or small-town convention, Edith Wharton says in *Summer*, the depressing truth is that her life-choices are no newer in 1917 than they were a century earlier.

Sui Sin Far declares at the beginning of "The Chinese Woman in America" (1897): "A Chinese woman in a remote age invented the divided skirt, so it is not a 'New Woman' invention."[24] Although the statement is not dwelt on—Sui Sin Far's purpose here, clearly, is simply to provoke—her point about the ethnocentricity of white Western feminism is unmistakable. As a woman of mixed Chinese and Western parentage who chose to identify as Chinese despite virulent anti-Chinese, racist sentiment at the turn of the century, Sui Sin Far brought a highly critical eye to the claims and aims of Western feminism. In particular, as a number of stories in her 1912 collection *Mrs. Spring Fragrance* illustrate, Sui Sin Far, who was the first woman of Chinese ancestry to publish serious fiction in the United States about the Chinese American community, had strong opinions about the white American New Woman.

Those opinions were mixed. The New Woman herself, Sui Sin Far suggests in *Mrs. Spring Fragrance*, is in many ways admirable—high-spirited, well-meaning, willing to learn. However, she is also careless and full of herself and therefore often destructively ethnocentric.

A major obstacle to Chinese American female self-definition in *Mrs. Spring Fragrance* is the obtuseness of liberated white women who fail to recognize basic cultural differences between Anglo American and Chinese American gender relations. "The Wisdom of the New" and "The Americanization of Pau Tsu" show the friendship between an unmarried white New Woman and a married young Chinese man from the Chinese wife's point of view. Although such a friendship is understood as completely "innocent" by the American woman because it is not sexual, to the Chinese woman, who does not speak English, has few or no friends, and comes "from a land where friendship between a man and woman is almost unknown,"[25] the relationship can only produce enormous jealousy and feelings of public shame. That the white New Woman in each story enters and maintains her friendship with a Chinese man out of good intentions only sharpens Sui Sin Far's criticism of Anglo feminist arrogance. Who are these women to assume that their values and notions of freedom and liberation and uplift are subscribed to by all people?

The ethnocentricity of white New Women is not simply insulting; it is also deeply antifeminist—if, that is, feminism is understood to include support among women for each other. In "The Wisdom of the New," beautiful, self-assured Adah Charlton arrogantly assumes that she—worldly, educated, liberal, white—can bridge any chasm. Dripping with unconscious privilege, she visits Pau Lin, the wife of the Chinese man whom she and her aunt have befriended. "The American woman could not, of course, converse with the Chinese; but Adah placed beside her a bunch of beautiful flowers, pressed her hand, and looked down upon her with radiant eyes. Secure in the difference of race, in the love of many friends, and in the happiness of her chosen work, no suspicion whatever crossed her mind that the woman whose husband was her aunt's protégé tasted everything bitter because of her" (66).

Sui Sin Far expresses confidence in the Anglo New Woman's ability to change. Adah

Charlton and her counterpart in "The Americanizing of Pau Tsu," Adah Raymond, realize the pain they have caused the Chinese women whose husbands they have befriended, and each comes to acknowledge her own guilt and to confront her Chinese male friend with his. It is important to emphasize, however, that this self-knowledge comes too late in "The Wisdom of the New." Pau Lin has been so shaken by the behavior of her husband and Adah Charlton that she takes the life of her only child rather than see him grow up Americanized like his father.

The issue for Sui Sin Far, it seems clear to me, is choice: allowing people to be what they wish to be, or need to be, whether one wants them to be that or not. She is quite capable of admiring the Anglo New Woman. Indeed, as an unmarried, self-supporting, working woman herself, Sui Sin Far, as revealed in her autobiographical sketch in *The Independent* in 1909, "Leaves from the Mental Portfolio of an Eurasian," constructed and lived her life according to a number of modern Western feminist principles such as economic self-sufficiency, physical mobility, the pursuit of meaningful work, and the right to sexual self-definition. What she disapproved of, her fiction suggests, was infliction of those values—or *infliction* of any supposedly "superior" values—on people, and particularly women, considered benighted, backward, or otherwise inferior and in need of elevation and instruction by self-appointed, "superior" others—men or women.

This argument for tolerance in *Mrs. Spring Fragrance* appears vividly in "The Inferior Woman," in which Sui Sin Far attacks class bias and argues in favor of an inclusive rather than an exclusive construction of the ideal of the New Woman. "The Inferior Woman" contains two white New Women: upper-middle-class Ethel Evebrook, who is well educated, worldly, sophisticated, and a frequent and eloquent speaker at suffrage meetings; and Alice Winthrop, the "Inferior Woman" of the title, who is working class, self-made, and not at all politically correct in her attitudes toward men. Asked to talk at a suffrage rally about how her experience as a working woman has shown her "the suppression and oppression of women by men" (37), Alice must decline. She likes men and considers those with whom she has worked her allies and friends, not her enemies. While two older white women in the story criticize Alice for being working class and politically unsophisticated, the other New Woman, Ethel Evebrook, and the main character, Mrs. Spring Fragrance, admire her. As Mrs. Spring Fragrance, who plays the naif perfectly, says to one of the white women: "Mrs. Mary Carman . . . you are so good as to admire my husband because he is what the Americans call 'a man who has made himself.' Why then do you not admire the Inferior Woman who is a woman who has made herself?" (43).

Sui Sin Far's strongest challenge to the middle- and upper-middle-class white ideal of the New Woman, however, comes in "The Story of One White Woman Who Married a Chinese" and its sequel, "Her Chinese Husband." In the first story, the protagonist states, "I had been a working girl—a stenographer" (111) and then explains how marriage especially appealed because she was glad to leave the workplace to spend her time at home cooking, keeping house, and sewing. Her white husband, however, had more progressive notions. "He was . . . an omnivorous reader of socialistic and new-thought literature. Woman suffrage was one of his particular hobbies" (112). He develops contempt for his traditional wife, whom he considers "too frivolous." Furthermore, "he would often draw my attention to newspaper reports concerning women of marked business ability and enterprise. Once I told him that I did not admire clever business women, as I had usually found them, and so had other girls of my acquaintance, not nearly so kind-hearted, generous, and helpful as the humble drudges of the world—the ordinary working women.

His answer to this was that I was jealous and childish" (112–113).

As in "The Inferior Woman," class forms a major issue in "The Story of One White Woman Who Married a Chinese." The white woman's white husband badgers her with an ideal of New Womanhood—cold, managerial, anti-domestic—that is unappealing to her as an "ordinary working woman." For a working-class woman bound by economics to work outside the home, yet limited by education to boring jobs, staying home has a quite different look than it might to a middle- or upper-middle-class woman forced to stay home but wishing she could leave. However, the heroine's white husband, full of white liberal masculine arrogance, fails miserably to respect either the class perspective of his wife or her individual disposition. He upraids her for not wanting to work as a stenographer in a divorce court: "'Other women, as good as you, have done and are doing it,' he retorted," to which his wife replies: "Other women, perhaps better than I, have done and are doing it, . . . but all women are not alike" (118). That is the key statement for Sui Sin Far. All women are not alike. Freedom means allowing difference—cross-culturally, across classes, and individually. Telling women how they must act, think, or dream—no matter who does the telling or how well-meaning the advice—oppresses.

Contrary to popular white stereotypes of the period, which maintained that wives of Chinese men were virtual slaves, Sui Sin Far's white woman, free of her doctrinaire white husband, enjoys in her marriage to Liu Kanghi more freedom and happiness than she ever knew as Mrs. James Carson. Liu Kanghi is not perfect, the narrator of "Her Chinese Husband" is quick to acknowledge. He is hot-tempered, "imperious by nature," and gets jealous easily (138). But these are small faults compared with the verbal abuse and constant demoralization the narrator experienced with her insufferable, politically correct white husband. It is also true, however, that Sui Sin Far's anger at white male arrogance and sexual aggression often leads her to present unrealistically idealized portraits of Chinese men in *Mrs. Spring Fragrance*. Because the overwhelming majority of Chinese people allowed to live in the United States at the turn of the century were men, they became the chief target of white racist stereotypes. Clearly wishing to counter images of Chinese men as degenerate brutes, Sui Sin Far—caught in the classic contradiction between anti-racist and feminist agendas that is often set up for women of color—frequently offers incredibly idealized portraits of Chinese men.

Liu Kanghi—and here Sui Sin Far attacks white men head on—embodies a concept of manhood that embraces rather than scorns domesticity, feelings, small talk, and the nurture of small children. "To my Chinese husband," the narrator explains, "I could go with all my little troubles and perplexities; to him I could talk as women love to do at times of the past and the future, the mysteries of religion, of life and death. He was not above discussing such things with me. With him I was never strange or embarrassed" (132–133). Liu Kanghi takes seriously the everyday frustrations and stress endured by his wife: "I can see his face, looking so grave and concerned, because one day by accident I spilt some ink on a piece of embroidery I was working. If he came home in the evenings and found me tired and out of sorts, he would cook the dinner himself, and go about it in such a way that I felt that he rather enjoyed showing off his skill as a cook" (133). Not surprisingly, this man is adored by his adopted white daughter: "He took great pleasure in playing with her, curling her hair over his fingers, tying her sash, and all the simple tasks from which so many men turn aside" (136).

Perhaps most important, with her Chinese husband, in contrast to her white one, the narrator is not made to feel sexually over-

powered and inadequate. James Carson, she explains, "had constantly reproached me with being cold, unfeeling, a marble statue, and so forth" (134). We gain the strong impression that this second marriage includes sex but is not based on it; the narrator and Liu Kanghi find intimacy in many ways, but probably least importantly, sexually. Sui Sin Far's point, it is important to stress, is not reactionary. In an era before widespread contraception or reliable treatment and cure for sexually transmitted diseases, de-emphasis on sex, despite changing middle-class white ideology, could often mean more rather than less freedom for a woman.[26]

What do these six different women writers' perspectives on the New Woman as symbol and as social reality in the United States early in the twentieth century tell us—and teach us?

First, as even my tiny array of fiction reveals, there was not one New Woman at the turn of the century but a number of New Women. These models agreed on some fundamentals, such as belief in female self-determination. But they diverged greatly on other fundamentals, such as awareness of racism, class bias, oppression of women by women, the drawbacks of the sexual revolution for women, and the danger of individualism as a prime human value. Significant differences of opinion existed among women about the New Woman—who she could and could not be, what values she should embody, what issues were at stake.

Second, the fact that only one of these models, the middle-class white ideal of the New Woman—usually highly individualistic and frequently unaware of, or at least unconcerned about, racism, class discrimination, and her own exploitation and oppression of other women, especially women of color—became the most popularized version of the figure during the Progressive Era and has since been enshrined as the New Woman of the period, should give us pause. It is important that we ask how, then and now, the privileging of this particular New Woman has contributed to divisions among women that have worked against the empowerment of all women. The racism that prevents Rachel Loving from finding employment as a teacher is not simply the racism of white men, but also of white women—some of them no doubt New Women in positions of privilege and authority in the very schools that close Rachel out. The ethnocentricity that drives Pau Lin to murder her own son rather than see him grow up Americanized like his father does not come from a white man but from a white woman, a middle-class New Woman blind to her own privilege and power to oppress. The coldness and contempt that drive Charity Royall, pregnant, away from professional help come not from a male doctor but from a female one—a New Woman, assuredly, of impressive training and achievement. These challenges to popular white middle-class feminist ideology offered by women writers at the turn of the century remain vital more than half a century later.

The mainstream white ideal of the New Woman glorified in the Progressive Era remains important for what it contained—a commitment to more freedom for many women than they had ever before enjoyed.[27] By the second decade of the twentieth century many American young women had available to them a new ideal of womanhood that offered at least the possibility of significant economic, social, sexual, and political autonomy. The popular dominant-culture image of a liberated white New Woman held out the promise of real change for countless American young women in the years preceding United States entry into World War I. But that mainstream white ideal also remains important, as many women pointed out at the time, for what it lacked: understanding of the ways in which racism and class discrimination effectively intertwine with issues of gender inequality in the United States to keep true freedom for all women from occurring. The dialogue and

debate that we see when we juxtapose texts by authors such as Willa Cather, Mary Austin, Jessie Fauset, Angelina Grimké, Edith

Wharton, and Sui Sin Far suggest how complex and various women's perspectives on the New Woman were.

NOTES

1. Edward Francis Harkins, *Famous Authors (Women)* (Boston: L. C. Page & Co., 1901), 25, 26. This book was also published under the title *Little Pilgrimages Among the Women Who Have Written Famous Books*. Its companion volume *Little Pilgrimages Among the Men Who Have Written Famous Books* was published in 1902.

2. Joseph A. Hill, *Women in Gainful Occupations 1870 to 1920: A Study of the Trend of Recent Changes in the Numbers, Occupational Distribution, and Family Relationship of Women Reported in the Census as Following a Gainful Occupation*, Census Monograph 9 (Washington, D. C.: United States Printing Office, 1929), Table 115, pp. 164–165.

3. William H. Chafe, *The American Woman: Her Changing Social, Economic, and Political Role, 1920–1970* (New York: Oxford University Press, 1972), 89.

4. Hill, *Women in Gainful Occupations*, Tables 32 & 29, pp. 42, 40.

5. William L. O'Neill, *Everyone Was Brave* (Chicago: Quadrangle Books, 1969), 147.

6. Hill, *Women in Gainful Occupations*, Table 42, p. 62.

7. For the statistics, see ibid., p. 52. For analysis of this historical shift from separate to integrated medical training for women, see Virginia G. Drachman, *Hospital with a Heart: Women Doctors and the Paradox of Separatism at the New England Hospital, 1862–1969* (Ithaca: Cornell University Press, 1984).

8. For an excellent discussion of the way in which writing was the principal occupation open to respectable middle-class white women in the United States at the middle of the nineteenth century, see Nina Baym, *Woman's Fiction: A Guide to Novels By and About Women in America, 1820–1870* (Ithaca: Cornell University Press, 1978) and Mary Kelley, *Private Women, Public Stage: Literary Domesticity in Nineteenth-Century America* (New York: Oxford University Press, 1984).

9. See, e.g., my book-length discussion, *Conflicting Stories: American Women Writers at the Turn into the Twentieth Century* (New York: Oxford University Press, 1991).

10. There is excellent recent critical work on these authors. See, e.g., on Cather: Sharon O'Brien, *Willa Cather: The Emerging Voice* (New York: Oxford University Press, 1986). On Austin: Esther Lanigan Stineman, *Mary Austin: Song of a Maverick* (New Haven: Yale University Press, 1989). On Fauset: Carolyn Wedin Sylvander, *Jessie Redmon Fauset, Black American Writer* (Troy, N.Y.: Whitson, 1981), and Deborah E. McDowell, "The Neglected Dimension of Jessie Redmon Fauset," in *Conjuring: Black Women, Fiction, and Literary Tradition*, ed. Marjorie Pryse and Hortense J. Spillers (Bloomington: Indiana University Press, 1985): 86–104. On Grimké: Gloria T. Hull, *Color, Sex, and Poetry: Three Women Writers of the Harlem Renaissance* (Bloomington: Indiana University Press, 1987), chap 3. On Wharton: Elizabeth Ammons, *Edith Wharton's Argument with America* (Athens: University of Georgia Press, 1980), and Cynthia Griffin Wolff, *A Feast of Words: The Triumph of Edith Wharton* (New York: Oxford University Press, 1977). On Sui Sin Far: Amy Ling, *Between Worlds: Women Writers of Chinese Ancestry* (New York: Pergamon Press, 1990). Also, I talk in detail about five of them, Cather, Fauset, Wharton, Austin, and Sui Sin Far, in *Conflicting Stories*, mentioned above.

11. Although excellent in many ways, Carroll Smith-Rosenberg's discussion of the New Woman in *Disorderly Conduct: Visions of Gender in Victorian America* (New York: Oxford University Press, 1985) seems to me to illustrate this shortcoming.

12. Willa Cather, *The Song of the Lark* (Boston: Houghton Mifflin, 1943), 155. Subsequent references in the text are to this edition, which is available in paperback and contains the revisions Cather made in 1937.

13. Mary Austin, *A Woman of Genius* (New York: Doubleday, Page & Co., 1912), 461. References in the text are to this edition.

14. See Paula Giddings, *When and Where I Enter: The Impact of Black Women on Race and Sex in America* (New York: Bantam, 1984), 137; and Theodore Drury, "The Negro in Classical Music; or, Leading Opera, Oratorio and Concert Singers," *The Colored American Magazine* 5 (September 1902): 326. *The Colored American Magazine* and *The Crisis*, I should mention here, contain between them considerable information about black actors, theatre ventures, musical performers, and so forth in the early twentieth century (that is, from 1900 to 1920 and beyond).

15. Jessie Fauset, *The Sleeper Wakes, The Crisis*, 20 (August 1920): 171. References in the text are to this printing, which ran in *The Crisis* in August, September, and October. *The Sleeper Wakes* is also and more conveniently accessible in the Oxford University Press Schomburg Library of Nineteenth-Century Black Women Writers volume *Short Fiction by Black Women, 1900–1920*, ed. Elizabeth Ammons (New York: Oxford University Press, 1991).

16. Lester A. Walton, "The Future of the Negro on the Stage," *The Colored American Magazine* 6 (May and June 1903): 442.

17. Angelina Grimké, *Rachel, A Play in Three Acts* (1920, The Cornhill Co.; rpt. New York: Arno Press, 1969), 3. References in the text are to this edition.

18. For excellent discussion of African American women and work at the turn of the century, see Giddings, *When and Where I Enter*, and

Jacqueline Jones, *Labor of Love, Labor of Sorrow: Black Women, Work, and the Family from Slavery to the Present* (New York: Basic Books, 1985).

19. For more detailed development of the ideas about Wharton that follow, see my book-length discussion, *Edith Wharton's Argument with America*, especially chap. 2, "The New Woman," and chap. 5, "The War."

20. Edith Wharton, *The House of Mirth* (New York: Scribner, 1905), 480. References in the text are to this edition.

21. As Lily admits at the end of the novel, "I can hardly be said to have an independent existence. I was just a screw or a cog in the great machine I called life, and when I dropped out of it I found I was of no use anywhere else" (498).

22. Edith Wharton, *Summer* (New York: Scribner, 1917), 4, 7.

23. See E. Stanly Godbold, Jr., *Ellen Glasgow and the Woman Within* (Baton Rouge: Louisiana State University Press, 1972), 38.

24. Sui Seen Far (Sui Sin Far), "The Chinese Woman in America," *Out West Magazine* 6 (Jan. 1897): 59.

25. Sui Sin Far, *Mrs. Spring Fragrance* (Chicago: A. C. McClurg & Co., 1912), 56. References in the text are to this edition.

26. Excellent discussion of the relationship between birth control and changes in attitudes toward sex in the United States can be found in Linda Gordon, *Woman's Body, Woman's Right: A Social History of Birth Control in America* (New York: Grossman, 1976).

27. See, e.g., the case study of a typical white middle-class New Woman offered by Leila J. Rupp, "Feminism and the Sexual Revolution in the Early Twentieth Century: The Case of Doris Stevens," *Feminist Studies* 15 (Summer 1989): 289–309.

The New Woman and the New Sexuality

Conflict and Contradiction in the Writings and Lives of Mabel Dodge and Neith Boyce

ELLEN KAY TRIMBERGER

The New Woman in the early twentieth-century United States was a central player in a modernist movement stressing the opening of the self to levels of experience that could be fused into a new and original whole.[1] New Women would achieve self-fulfillment through a combination of meaningful work, love, and sexuality. Such personal goals were politically articulated by feminist, Freudian, socialist, and Bohemian movements centered in Greenwich Village. A more fulfilling sexual and personal life was part of their radical vision of a new society.

Examining the life and writing of two women at the vortex of Greenwich Village radicalism demonstrates, however, that combining these goals was problematic. Sexual liberation seemed especially difficult for women. The ideal of a new sexuality was often defined by men and conflicted with women's desires for intimacy and the autonomy necessary for creative work. The personal resources needed for intimacy—a deep psychological sharing with one's sexual partner—often seemed in contradiction with those necessary to achieve a strong sense of individual identity that permitted women to do their own work rather than always nurturing others. The women I will

examine did not fully overcome the contradictions they faced, but their struggles to combine sexuality, intimacy, and satisfying work gave their search a new political dimension.

The conflicts between women and men in Greenwich Village were not private or isolated. They were carried on within a community where personal life was publicly discussed. In numerous autobiographies, essays, plays, and novels, Village women and men articulated their attempts to integrate sex, intimacy, and work in equitable and satisfying marriages or personal relationships.[2] They discussed differences between women and men about monogamy; anxieties about autonomy and dependence in relationships between strong women and men; and disagreements about who was responsible for housework, child care, and nurturing if both women and men were to have satisfying work.

This public debate over struggles carried out in private life defined a new political issue. While these controversies about personal life were never articulated in a clear ideology—nor given legitimacy as political issues equal in importance to those about labor, birth control, or suffrage—they were nonetheless prefigurative of a politics of personal life that became central to New Left and feminist ideology of the 1960s.

We expect attempts to alter power imbalances in economic, political, and social stratification systems to involve strife. The struggles of Mabel Dodge and Neith Boyce exemplify the inevitability of conflict in attempts to change intimate and sexual relations—contests that may indicate personal strength within historical and cultural limitations, rather than the failure of individual relationships. By rediscovering these two lost voices of the early twentieth century and reexamining their conflicts, we may see our own struggles in more historical, and less privatized, terms.

Mabel Dodge (1879–1962) and Neith Boyce (1872–1951) were writers and

friends, two of the most prominent New Women in Greenwich Village. Mabel Dodge was "sexually emancipated, self-determining, in control of her own destiny."[3] Neith Boyce in her quiet way made as great a break with traditional femininity, as she became a prolific writer while mothering four children. Yet in their own time Mabel and Neith were best known for their "female" roles: Mabel as the rich hostess who created a famous Greenwich Village salon for radical intellectuals and activists in 1913–1914; Neith as the wife of radical journalist Hutchins Hapgood, one of the central movers in the Village. Both were also "feminine" in their appearance. Neith had red hair, green eyes, was impeccably dressed and very quiet. Mabel, while not beautiful, dressed in the latest fashion, and presented herself as a muse who would inspire male creativity.

But both women were, in other ways, quite "masculine." Neith was an extremely self-sufficient person. She was ambitious, willful, sophisticated, and sardonic. Mabel described her as courageous, and firm, with an angry determination.[4] Mabel's energy, intellect, and lust for experience were considered distinctly "unfeminine" by her community. In her autobiography, Mabel proudly reported that her third husband, the artist Maurice Sterne, told her: " ' You walk like a Prussian officer.' "[5] In addition, each woman, with different degrees of difficulty, was strongly committed to creating an autonomous identity for herself, rooted in creative work as a writer.

Neith Boyce was a novelist and playwright whose fiction portrayed the difficulties of creating new forms of intimacy between middle-class women and men. Her first novel, *The Forerunner* (1903), a fictional re-creation of her parents' marriage, demonstrated the destructive impact of capitalist entrepreneurship on personal relations. Her subsequent novels dealt with the marriages and personal relationships of her own generation. Like other feminist novelists in the early twentieth century (Edith Wharton, Kate Chopin), Boyce broke with the romantic tradition to portray personal life in a more realistic, even bleak manner. Neith's novel *The Bond* (1908), her 1915 plays, *Constancy* and *Enemies* (the latter cowritten with her husband), all portray intense struggle over the terms of heterosexual intimacy. None of the conflicts are resolved in Neith's fiction; there is never a happy or tragic ending, but only continuing struggle.[6]

The Bond was a fictionalized account of the conflicts in Neith's own marriage. The novel focused on a young married couple, Basil and Teresa, both artists, who are upper middle class. Within their marriage there is a separation that is still Victorian and quite distinct from the later twentieth-century norms for couples. Husband and wife have separate bedrooms and spheres.

What was new about Teresa's and Basil's relationship was the attempt to forge a deep psychological intimacy in their marriage. They talk constantly about their feelings, positive and negative, for each other; they talk about their attractions to others; they show each other love letters from admirers; and they admit their jealousy. Sexual passion between them is less openly discussed in the novel, but it is an indirect theme. This intensity in their relationship, even when it causes conflict, is portrayed as a positive element in their marriage. But this intensity also creates a new conflict for Teresa—an emotional dependency on Basil which begins to undermine her individual autonomy. Teresa fights her sense of powerlessness. She creates the possibility of an affair for herself, not to meet her own need for sexuality or intimacy, but to counter Basil's flirtation with another woman. Only by thus balancing the account could she sustain the sexual and psychological intensity she cherished with Basil, without losing her own identity.

Neith Boyce's exploration of such themes was ahead of her time. The short *New York Times* review said the book was about the

marriage of two young artists who "bicker, quarrel, jar and nag." An anonymous reviewer in *The Nation* asked: "Is it a sign of the feminization of our popular literature that it should give such earnest attention to the intellectual fribbles and emotional 'hoboes' who may be observed in any great city hanging picturesquely upon the skirts of Art?" The most negative and sexist review was by William Morton Payne in *The Dial*:

> We are getting a little tired of the neurotic young woman who makes unreasonable demands upon life, and is unhappy because it turns out to be less exciting than she would like to find it. A typical example of this sort of woman, who worries over her own emotions until her whole moral fiber is weakened is found in the heroine of *The Bond*. . . . We could wish that the author's delicate talent had been employed upon a worthier theme, or a theme bearing a closer relation to normal existence.[7]

None of the reviewers mention the couple's open and mutual experiments in infidelity, and their attempt to negotiate the jealousy it aroused. In 1980, it was not yet acceptable, even in intellectual and artistic circles, for a woman to imitate men by ignoring the double standard.

Boyce's *Constancy*, the first play produced by the Provincetown Players, centers on a meeting between ex-lovers, Moira and Rex, loosely based on Mabel Dodge and John (Jack) Reed. The play's focus on the issue of fidelity and infidelity was also a central conflict in Neith's marriage. Moira rejects the relationship with Rex because she lost herself in it, sacrificing all of her own interests and her friends. Such a price for a constant relationship is no longer acceptable to her. But she also rejects Rex's idea of fidelity—to love a hundred other women and at intervals to come back to her. As usual in Neith's fiction there is no resolution to the conflict. Neith has a vision of a relationship where the man would be faithful and the woman would retain a separate self and identity, but there is no sense here that she believes this is attainable.

Like *Constancy*, *Enemies* is a dialogue between a couple about differences in their conceptions of, and desires for, intimacy. She wants more autonomy; he wants her to be more interested in him. They quarrel about their jealousy over his physical and her spiritual infidelities.

Mabel Dodge was more of an activist than Neith Boyce, but her writing was also significant. Both her actions and her pen sought to liberate women and men from "the spiritual and psychological shackles of the past."[8] She was one of the fund-raisers in 1913 for the Armory Show and initiated the idea for the large workers' pageant in Madison Square Garden to support the Paterson strike by textile workers. Mabel was a supporter of the Woman's Peace Party, an early popularizer of Freudian psychology in a weekly column for the Hearst papers, and a board member and contributor to *The Masses*. In 1916 and 1917 Mabel published two short stories in *The Masses* that centered on the loss of identity for a woman who lived only through (or for) a man.[9]

In 1918, discouraged by a growing conservative political climate during World War I, and by the disintegration of the Greenwich Village circle, Mabel Dodge moved to Taos, New Mexico, where she started a campaign to preserve Native American culture and institutions, and to attract prominent modern artists and writers (including Georgia O'Keeffe and D. H. Lawrence) to the Southwest. Her four-volume autobiography, *Intimate Memories*, which she began to write in 1924 and published in the 1930s, was a critical success and is still read as one of the most important interpretations of cultural and personal changes in the early twentieth century.

On the surface the sexual and intimate experiences of Neith Boyce and Mabel Dodge represent two extreme types of a modern

heterosexual woman. Neith remained married to one man, who was probably her only sexual partner despite many flirtations and one serious "affair" where she considered leaving her husband. Mabel, on the other hand, was married four times and had many flirtatious relationships with men. As a young woman she also had a brief experience of lesbian sexuality.

Despite these different personal histories, similar conflicts and contradictions surface in their writings. They sought, but feared, sexual passion combined with deep psychological sharing partially because in intense relationships they sometimes experienced a loss of self as they fell back into the traditional role of nurturing female. Aware of this tendency, they struggled to have both an intense heterosexual relationship and satisfying work, an effort that was made more difficult because of the way intellectual men reacted to them. Attracted by their "unfeminine" strength, their sharp intellect, and their lack of sentimentality, men wanted these women to mother them. But whether the women acceded or resisted, the men felt smothered or threatened, and escaped into affairs with more traditional, usually younger, women. Sometimes the women tried to match their mates' non-monogamy, but this seemed to undermine the combination of psychological intimacy and sexuality they sought in a relationship. As either "nurturing" mother or lover/wife to a promiscuous man, Mabel and Neith found their own sexual/emotional needs unmet, their creative work thwarted, and their individual identity imperiled. A closer look at their lives will illustrate and elaborate the conflicts created by their sexual intimacy with men who were their peers, but who could not accept them as equals.

I will start with biographical sketches of Boyce's and Dodge's family background and upbringing in order to analyze both the psychological and historical/cultural resources they brought to their adult relationships.

CHILDHOOD

In autobiographies, both Neith and Mabel remembered their childhoods as lonely and lacking in parental affection. The way they coped, however, established the basis for their later strength and independence.

Neith Boyce was born in Franklin, Indiana, the second of five children. Neith attributed her unsocial and somewhat pessimistic character to the deaths of all her brothers and sisters in an influenza epidemic when she was about six, the death of another baby soon after, and her mother's subsequent emotional withdrawal. Neith was left as a solitary child in an unexpressive family in which her parents refused to talk about the deaths or to express much emotion toward her.

Neith admired her father, who was an active, extroverted Irishman, in contrast to her more rigid and New England–born mother. Yet, he was also emotionally distant. When Neith was about ten (in the early 1880s) her father, previously a book publisher in Milwaukee, bought a ranch outside Los Angeles. Here Neith lived an isolated life, where she came to love both the out-of-doors and books. Around 1885, her father cofounded the *Los Angeles Times* and they moved to the city. The success of the paper made the family temporarily rich, but Neith profoundly disliked their bourgeois family life, now enlarged by two baby girls. She retreated inward, writing teenage stories and poetry, some of which her father published in the paper. Always striving, he soon bought a rival paper, the *Los Angeles Tribune*, and became involved in real estate speculation. His real estate failures forced him to sell their house and most of their newly acquired possessions. He left his family in Los Angeles to engage in speculative mining in Colorado, but soon moved them all to Boston where he bought a partial interest in *The Boston Traveler* and a socialist magazine, *Arena*.

Mabel Ganson was born into a wealthy family in Buffalo, New York. Both

grandfathers were financiers, who achieved considerable social prominence and material wealth as members of the first generation of industrial capitalists. Mabel's father was one of sixty millionaires in Buffalo in the 1870s, but his wealth and prominence were inherited. Mabel's biographer, Lois Rudnick, provides a clear picture of how the Gansons' personal and marital unhappiness affected Mabel. Her father was trained in law, but he was an ineffectual man who never worked. The fact of Mabel's weak father and Neith's absent one was not unusual. A study of eighty-eight prominent Greenwich Villagers before World War I found that two-thirds of them were raised in households characterized by "the absence or startling weakness of the fathers."[10] Mrs. Ganson was stronger and more decisive than her husband, but also cold, unfeeling, and entirely self-centered. She had no creative outlets for her energy and talents in a life given over to visiting, hunting, and dinner parties. Mabel had no recollections "of my mother's ever giving me a kiss or a smile of spontaneous affection, or of any sign from my father except dark looks and angry sounds."[11]

Mabel, like Neith, retreated inward. She said: "As a child, I had felt no one in front of me, an unopened space with no paths in it encircled me, my parents had seemed like dim, dull figures far, far behind. I could not make them a part of my journey. I had to set off alone by myself and I was always alone."[12] While both Mabel and Neith salvaged some autonomy and personal strength from their emotionally deprived childhoods, their own ability to nurture was impaired. Perhaps because her family (especially her father) was more dysfunctional than Neith's, Mabel had less of a sense of self and was more distrustful of men.

YOUNG ADULTHOOD

As young women both Neith and Mabel were attracted to urban and unconventional intellectuals whom they met in New York City. Mabel, in addition, experienced the European intellectual world. At age eighteen they both rejected marriage and aspired to careers in journalism.

Neith did not attend college, but became friends with a group of older writers, artists, and journalists in Los Angeles with whom she spent long hours talking of books and politics. In Boston around 1890, Neith first became politicized when she met intellectuals connected with *Arena* who were socialists and feminists. When her father moved the family to New York City, Neith began to write seriously. She sold some of her stories to magazines, and became friends with other young women writers and journalists. At the age of twenty-seven, Neith got a job as the only woman reporter on *The Commercial Advertiser* and moved out of the family home into a hotel in Washington Square. Already as a teenager, Neith had decided she did not want to be married. As she wrote of herself (in the third person) in an unpublished autobiography: "Children did not appeal to her at all and neither did the troubles and difficulties she had observed in marriage. . . . It was much better to observe other people's love affairs and write about them."[13]

Perhaps because of greater pressures for conformity within the upper class, Mabel's commitment to a career was short-lived and she married at an earlier age than Neith. At her debut at age eighteen, Arthur Brisbane asked her what she wanted to do with her life. "She told the famous Hearst publisher that she did not wish to marry or to stay in Buffalo. She wanted 'to live and try to understand more and feel what life entails.' When she asked if she could go to work on his paper, 'He laughed a little I suppose, at the idea of this girl trying to leave Buffalo and all the chains holding her back, and coming, unprepared and undisciplined, to work on his paper. Women didn't do that sort of thing then.' "[14] This was the same year that Neith, seven years older, was working on a newspaper in New York City.

MARRIAGE

Despite their explicit renunciation of marriage, Neith and Mabel both married, in 1899 and 1900 respectively. Neith was twenty-seven and had established an independent identity. She was aware of some of the conflicts ahead. Mabel was twenty-one and had no faith in real alternatives for herself.

In 1898, Neith met Hutchins Hapgood, a coworker on the newspaper. Hutchins, a Harvard graduate from a Midwestern business family, became a well-known radical journalist and essayist noted for his sympathetic ethnographies of the underdog, deviant, and radical—immigrants, rebels, prostitutes, and thieves. For Hutch it was love at first sight, but not for Neith. Friends agreed that they had very different personalities and doubted a permanent relationship was possible. Hutchins, unlike Neith, was extroverted and eager for experience, with a genius for friendship. He was warm and sensuous, often childlike in his enthusiasm for life. Hutch first became friends with Mabel Dodge, and attracted intellectuals and activists from a wide range of political and social class backgrounds to help her establish her famous Fifth Avenue salon.

Hutchins, despite his ardent courtship, saw the improbability of their relationship. He wrote in a letter to his mother in 1898:

> There is a girl in N.Y. who has been much more to me than any other girl I ever knew. We are not engaged and it is practically sure that we never shall be. She is a 'new woman,' ambitious and energetic, a hard worker, more or less disliked by all my friends that know her, and she has no idea of getting married, at any rate to me.[15]

Yet it was their differences that attracted Neith, especially Hutchins's warmth and capacity for enjoyment. As she says in an unpublished autobiography: "It was the warm, life-quality in him, the capacity for enjoyment, the desire to enjoy and to have others enjoy. He loved pleasure, he was good company, he was charming. . . . He was un-reasonable, unexpected, surprising; he insisted that life should be, and was pleasant, varied, rich."[16]

Neith and Hutch were married with the explicit understanding that she would retain her name and pursue a writing career. Soon, they both left full-time newspaper work. In the next ten years she had four children and they each published four books and numerous articles and stories. A modest income from Hapgood's father made an independent life-style and some household help possible, but it was still unusual for both a husband and a wife to be equally productive. Their productivity is even more impressive when one considers the mobility of their lives. The family with small children was always moving—a six-months' trip to Europe in 1903, Chicago in 1904, back to New York in 1905, to Italy, Switzerland, and Paris between 1906 and 1909, to Indianapolis in 1909, and back to New York in 1910.

Neith was upset by her unplanned pregnancy in the second year of their marriage, because she believed that being a mother would interfere with her autonomy and her work. In the same year, 1901, Beatrice Webb, the English socialist and social researcher, recorded in her diary that she had decided not to have children because it would destroy her mind, at least for awhile.[17] Neith, however, kept writing, and she soon became very attached to her children. Especially with her first son, Neith felt an intimacy and peace that she never found with Hutchins. In her novel *The Bond*, the heroine, Teresa, says: "He [the husband] is one and I am another. . . . I am forever outside and he is a stranger to me, in spite of all. But this, this child of mine, is really mine. I shall understand it, it will comfort me, it will belong to me."[18] There is further evidence in her letters revealing that it was not her responsibilities as a mother, but as a wife, that conflicted with the autonomy Neith needed for work.

Mabel's first marriage was to an upper-class Buffalo boy whom she did not love. He

died in a hunting accident during the first year of their marriage before Mabel was twenty-two. She was left with a baby son. Unlike Neith, she loved being pregnant, but hated being a mother. She soon married a wealthy American, Edwin Dodge, whom she met in Paris. Again she did not marry for love. From 1905 to 1912, Mabel lived in Florence with Dodge and her son, decorating a beautiful villa and entertaining some of the great European and American artists, actors, writers, and musicians of her day, along with socialites and royalty. But nothing Mabel did during her years in Florence fulfilled her. Only after she had returned to the United States, separated from Dodge, and become a mover in Greenwich Village, did she meet a man whose work she admired, to whom she was sexually attracted, and who fulfilled her ideal of love. At age thirty-four she became the lover of John Reed, eight years her junior.

Like Neith and Hutchins, Mabel and Jack met as equal coworkers. They became attracted to each other through their collaboration in 1913 on the Madison Square Garden pageant to support the Paterson strike. Mabel's and Jack's relationship was very different from Hutchins's and Neith's; they lived together as lovers, but never married, and their relationship lasted only a few years. Yet the conflicts Neith and Mabel experienced in these relationships were quite similar. They discussed these issues with each other and in letters, and Neith used them for her art.

SEXUALITY AND AUTONOMY

Mabel's and Neith's struggles to find a satisfying combination of sexuality and intimacy must be seen within the context of the radical subculture of Greenwich Village. Villagers' ideas about sex and love drew on the nineteenth-century free-love tradition in the United States, the work of early twentieth-century European sexologists, and feminism.

The ideal of free love was first proposed in the United States in the 1820s by Frances Wright, a freethinker who drew on eighteenth-century libertarianism and nineteenth-century utopian socialism to oppose organized religion, slavery, and marriage. From this beginning, to its elaboration by a small radical movement in the late nineteenth century, "free love referred not to promiscuity—or sex with multiple partners—but to the belief that love, rather than marriage, should be precondition for sexual relations."[19] Free lovers attacked the sexual slavery of women in loveless marriages as "legalized prostitution," as well as the commercialized sex of actual prostitution.

But despite their opposition to marriage, many free lovers had long monogamous relationships, and others practiced what has come to be called "serial monogamy," leaving one long-term partner only because of a greater love for another. Indeed, the free love view of sexuality as a spiritual union independent of legal marriage was not so different from the romantic ideal of marriage becoming prevalent in the larger society. During courtship leading to marriage, lovers expressed or sublimated their sexual desires in the language of "blending hearts," "holy kisses," "souls that entered paradise," and "communion with the beloved."[20]

Greenwich Villagers drew much from this legacy of free love—the importance of equal sexual expression for women and men, love (not marriage, lust, or money) as the only moral criterion for a sexual relationship, and the rejection of loveless marriages. Rather than being directly influenced by earlier American thinkers, however, Villagers were exposed to free love ideas in the work of European intellectuals. Between 1905 and 1915 Villagers read the *Psychology of Sex* and *Man and Woman* by the English doctor, Havelock Ellis; *Love's Coming of Age* by his friend Edward Carpenter; and *Love and Marriage* by the Swedish feminist Ellen Key. Key, for example, advocated relationships based on "an increasingly

soulful sensuousness and an increasingly sensuous soulfulness . . . in a union in which neither the soul betrayed the senses nor the senses the soul."[21] For Key too the morality of any sexual-love relationship depended on whether it enhanced the life of the individual, not whether it led to marriage. Some Greenwich Villagers still used the spiritual language of souls meeting—Mabel and Neith's husband, Hutchins, employed these terms. But influenced by both feminism and Freudianism, many (including Mabel and Hutchins) now emphasized psychological intimacy—the ability to have open, deep, and honest communication—as the necessary concomitant for sexual love.

The nineteenth-century woman's movement had begun to demystify romantic passion. While the majority of those advocating women's rights saw only the dangers of sexuality for women, a few leaders of this movement advocated sex education, the end of sexual secrets, and relationships based not on romantic sentiment, but on understanding between equal partners. Yet pro-sex leaders also feared that sexual passion might lead women back to domesticity and thwart their efforts to attain for women a greater role in the public realm. In 1870, Elizabeth Cady Stanton warned that even egalitarian marriages could thwart individuality: "They live the lives, these married couples, generally of mutual spies and tyrants over each other, and it is the most subtle form of slavery ever instituted because it is seemingly so fair, based as it is on mutual agreement and not incompatible with the full concession of the equality of the parties to this mutual treaty of self-stultification."[22]

By 1910, feminists in Greenwich Village were less afraid of sexual passion and, at least in theory, believed that women could combine satisfying sex, psychological intimacy, and motherhood, while also doing important work and maintaining an individual identity. Historian Nancy Cott articulates the importance of sexual expression to the new feminism: A vision

"combining equality of economic choice with heterosexual intimacy was essential to Feminism in the 1910s. . . . Feminists assigned more liberatory meaning and value to passionate heterosexual attachment than did any woman's right advocates before them. Seeing sexual desire as healthy and joyful, they assumed that free women could meet men as equals on the terrain of sexual desire just as on the terrain of political representation or professional expertise."[23]

Not only women in Greenwich Village but men too postulated this ideal. Men wanted a "girl" they could both "kiss and talk to" and they wanted it to be the same "girl."[24] Such a woman could not be isolated in the domestic realm, but had to share an interest in the arts, literature, and politics. For men too the earlier vision of the fusion of two souls into a unity was replaced by an ideal of deep communication that enhanced two distinct selves.[25] Thus, a new ideal of sexualized intimacy began to replace the earlier free love norm of spiritualized sexuality.

A cultural emphasis on developing personal relationships, integrating satisfying sex and greater psychological intimacy with women who were their peers at work, appealed to men who were breaking away from the Victorian work ethic and rejecting success in established institutions. Since work was no longer so central to their self-conception, the idea that women wanted to be more engaged with work was not immediately threatening to them. But what was not considered at first by either women or men was the difficulty of achieving an equitable integration of sex, love, and work in relationships embedded in a society in which men had greater power and privilege. This gender inequality made it easy for "feminist" men to interpret the new heterosexual ideal in a self-centered way by involving women in their personal development, rather than facilitating women's new work. Could men be sexually attracted to, and love, women who talked rather than being talked to?

In 1915, for his forty-sixth birthday,

Neith wrote a poem for Hutchins about their relationship. She revealed that her initial attraction to him was based on a combination of physical appeal and the worldly interests he opened up to her:

> Your eyes were bright and ardent
> And you came into my little room like a
> whirlwind . . .
> Fain to persuade me that life was worth
> living—
> Nay more, that it was a wonderful and
> beautiful invention.
> And I denied it and said I hated life
> And told you to go away—
> But if you had gone I should have been
> much disappointed.
> For you pleased me enormously—
> I liked the shape of your hands and your
> ears
> And the thickness of your neck where it
> joins the shoulders
> (I could not love a man with big ears or
> a thin neck
> No matter how beautiful his soul)
> And your soul was beautiful too
> And I loved it.
> It was warm and sensitive
> Like your body.[26]

In this poem as in her fiction, Neith sometimes justified sexual attraction in spiritual language. But her reference to his "soul" is probably more a concession to Hutchins's Victorianism than a reflection of her own. (Hutchins called his autobiography *A Victorian in the Modern World*.) Mabel notes in her autobiography: "[Neith] didn't believe in his everlasting talk about his soul."[27] Moreover, Hutchins's "soul" in the poem is directly linked to his body, described in very direct and non-romantic language.

Mabel more than Neith still spiritualized sexuality. Abandonment to the flesh had to be justified by appeal to the sacred. "It is not enough to have the most perfect physical combination unless there is an emotional consolation at the base of it. Hearts must open and speak to each other else there is only a deepening sadness and a sense of waste with every outpouring of love." Yet Mabel wrote more directly than Neith about her sexual experiences. She said of Maurice Sterne:

> His strong, rather bland hands traveled over me, sizing up shapes, as sculptors' hands are made to do. His finger-tips were more interested in form than in sense. They were always studying. No sooner was the spasmodic embrace completed, than it was forgotten in the thoughts about Art that surged up in his mind. He began to talk about his work.[28]

Neith and Mabel at first resisted the sexual advances of men with similar worldly interests even when they were drawn to them. Neith said in the same poem:

> One night you came into my bedroom
> Where I was putting on my hat before
> the glass
> And sat down on my bed and put your
> arms about my waist
> And said in a thick voice
> "Lock the door—don't be a fool—"
> But I laughed and didn't lock the door
> And was a fool—
> Why didn't you insist?
> So we lost at least a year.

While Neith, in hindsight, had regrets about her sexual reticence, she still assumed that he should have "insisted," that the man should take the sexual initiative. Such female passivity was not just a lingering Victorian ideal, but was also advocated by the European sexologist Havelock Ellis, who believed that while women had an equal claim to a satisfying sex life, female sexuality was passive and had to be aroused by a man. He believed that a youth spontaneously became a man, but a girl must be kissed into being a woman.[29] Neith also resisted Hutchins's sexual advances out of fear for her personal and creative autonomy: "He combined the life of the mind and the life of the body. . . . But she had a feeling that it might not be

easy for her to combine them. A woman she felt might easily be swamped by the demands of physical and family life. And it was clear that H would be a demanding person, nothing half way would satisfy him. "[30]

Mabel also became apprehensive when Greenwich Village intellectuals and activists made sexual advances to her, for fear that their sexual interest in her meant they didn't take her seriously as a person. She couldn't bear to think that her situation as a single, divorced woman "was any augury of light behavior or undignified self-indulgence." Without Neith's experience as a writer before her sexual awakening, Mabel was more insecure. "Something in us wants men to be strong, mature, and superior to us so that we may admire them, thus consoled in a measure for our enslavement to them. . . . But something else in us wants them to be inferior, and less powerful than ourselves, so that obtaining the ascendancy over them we may gain possession, not only of them, but of our own souls, once more. "[31]

Mabel could gain some power over men by withholding sexual favors. With both Jack Reed and Maurice Sterne, Mabel for a long period resisted the men's demands for sexuality, in order to hold on to an intense psychological relationship with them. In addition, Mabel never sexualized most of her deep intellectual and personal relationships with creative men (Hutchins, Walter Lippmann, Carl Van Vechten, D. H. Lawrence, Andrew Dasburg, Robert Jones, and others). One of Mabel's main motivations in writing her memoirs (written when she was in her fifties) was to show the self-destructiveness of her attempts to manipulate men. She asked other women to forgive her and hoped they would learn to act differently in the future.[32] Her self-insight and self-criticism mark her distance from the nineteenth century.

Mabel's fears about her sexual involvement with creative men were not idle fancies. When she did become lovers with Jack, and later with Maurice, she lost herself in a way that Neith never did. Becoming Reed's lover meant throwing away all her own energy

and autonomy so that she couldn't bear to have him interested in anything else.

> I hated to see him interested in Things I wasn't, and didn't like to have him even look at churches and leave me out of his attention. . . . What the morning papers said was happening in Mexico, or in Russia, or at the Poles, seemed to make Reed's heart beat faster than I could, and I didn't like that. I felt doomed. . . . Each day as soon as he was gone out of the house I felt deserted and miserable and as though I had lost him forever.

Before she had sex with Maurice Sterne, Mabel took a very domineering stance toward him as she consciously sought to convert him from a painter to a sculptor. But once they were lovers, she felt power shift from her to him: "He diminished me and made me seem more of a brown wren than ever."[33] One of Mabel's *Masses* stories recognized the emptiness and destructiveness of a woman who lives only through a creative man; she comes to hate him because of the dependency and her own lack of creativity.[34]

When she lost herself to Reed and Sterne, Mabel was unable to work through her conflicts within the relationships; and although she turned to psychoanalysis for help, her solution to regain her personal integrity was to terminate the affair or to distance herself within the marriage. After breaking up with Reed, for example, Mabel was depressed, for she was "no longer borne up and supported by the male contiguity through which alone I seemed to become real to myself." But she soon regained her own power and identity. "Loosed from Reed, my powers ebbed back into my own reservoir and fed me where before they had been feeding him, and perhaps, too strong for him, had been poisoning him so he had needed to save himself from me."[35]

Mabel's solution to the loss of self she experienced in an intense sexual relationship with a man who was her peer was *not* to renounce sexuality, but to choose a different

type of man—one with whom she had no psychological or intellectual affinity. After moving to Taos, New Mexico, in 1917, she fell in love with, and married, Tony Luhan, a strong Pueblo Indian, with whom she talked little, but shared a strong spiritual bond. In this less intense relationship, Mabel retained her personal autonomy and found her voice as a writer.

STRONG WOMEN AS SURROGATE MOTHERS

Even in the radical subculture of Greenwich Village, women, including those with intellectual and artistic gifts, were still valued mainly for their maternal qualities. The European sexologists who advocated equal sexual expression for women believed that masculinity and femininity were biologically based, and that women had a special need and capacity to mother. Havelock Ellis wrote: "Woman breeds and tends; man provides; it remains so even where the spheres tend to overlap." Ellis, Carpenter, and Key all supported women's rights, but they criticized those feminists who emphasized women's need or desire to work outside the home. Carpenter stereotyped such women as without strong sexual or maternal instincts; as "mannish" in temperament and "brain-cultured." Key believed it was impossible for a woman to work outside the home and be a mother. A woman with children would need at least ten years free of any continuous outside work. Motherhood, she wrote, was a more important means of exercising creativity than writing a novel or producing a work of art. Ellis too saw women's creativity centered in their procreative abilities: "Women's brains, are in a certain sense, in their wombs," he said.[36]

In her European sojourn in the first decade of the twentieth century, Mabel assimilated Edward Carpenter's notion of the Ur-Mother, which combined Freudian ideas with ancient archetypes. Traditionally, an Ur-Mother generated babies and inspired male creativity and genius. Carpenter envisioned the New Woman as nurturing not children, but her mate. After his excursions and wanderings, a man would return to a woman "to restore his balance, to find his center of life, and to draw stores of energy and inspiration for fresh conquests of the outer world."[37]

These notions of the maternal were often seductive for women. "Mothering" not just children, but men as well, seemed a reliable source of power for a woman who felt less rewarded for her intellectual and artistic work than did the men who were her peers. But maternal caring for a man with the creative, intellectual, or political skills that the woman sought for herself could easily undermine her own sense of entitlement to, and achievement of, such capacities. Moreover, seeing herself, or being seen by her lover, as maternal interfered with the development of a sexual passion between equal partners.

Boyish Jack Reed, eight years her junior, looked to Mabel to foster his creative needs and she responded. Mabel recalled that when Reed dedicated his book *Insurgent Mexico* to his mother, she was silently angry, because she herself obscurely wanted to be his mother. When Reed returned to Mabel after breaking off his relationship to a new lover, Mabel observed: "He was like a little boy come home to his mother after an escapade, disarmingly anxious to tell her all about it. Here he was home again, the hunter home from the hills."[38] Only when Reed was sick and she nursed him, could Mabel successfully assume the mother role. A man "sick in bed reverted to an undifferentiated infantilism." But even if the men would have cooperated, Mabel recognized that being an Ur-Mother was not really what she wanted: "So I had Reed, I thought, for my own—but that was a pleasure soon over. No sooner do we get them where we think we want them, than we find we do not want them so. A man completely at a disadvantage, disempowered, and delivered up to us, we find to be no man at all. Is it possible, then, that one is more satisfied with the struggle than

with the surrender."[39] Mabel could not be sexual with a man whom she could dominate, especially when such control was at the expense of her own creativity.

Hutchins Hapgood too wanted Neith to mother him. In her letters to Hutch before they married, Neith often addressed him as "dear infant," and in several she urged him to "be a good boy" or "be a good child." Hutchins approved and encouraged this. He said in *The Story of a Lover*: "From the start, a part of her attitude was that of a mother. The very intensity of my need for her gave me at times to her the appealing charm of a child. And as her children came to her, I became more of a child to her, and, a seeming contradiction, more of a sensual need, for that element is not absent from a mother's love, and one strong feeling does not take from but adds to another."[40]

Hutchins's primary complaint about Neith was that she did not nurture him enough: "I fell in love at first sight. She did not see me— and I sometimes think she has never seen me since, although we are married, and have lived together for fifteen years. . . . Have I even been a part of her real life? Is not my recurrent feeling of almost intolerable loneliness an index, a sign of her remoteness?"[41] In his autobiographical book, *The Story of a Lover*, Hutchins describes in great detail how he continually criticized and provoked Neith to try to make her more responsive to him. In their play, *Enemies*, Neith described his efforts: "You, on account of your love for me, have tyrannized over me, bothered me, badgered me, nagged me, for fifteen years. You have interfered with me, taken my time and strength, and prevented me from accomplishing great works for the good of humanity. You have crushed my soul, which longs for serenity and peace, with your perpetual complaining."[42]

Neith's ability to write these lines of dialogue belies her claim that he had crushed her soul. At least until their forties, she resisted Hutchins's demands for more nurturing. If Neith had really given in and become the mother he craved, he probably would have run away for good, afraid of his own dependency. An ideal of intimacy so connected with the mother-child bond invokes for an adult heterosexual male early merging with the mother—a highly pleasurable, but very intimidating sensation for it threatens autonomy and boundaries of the self.[43] Hutchins recognized that his feelings of dependency on Neith led him to try to attain some autonomy through affairs. He had sexual affairs *not* with women who could dominate him like a mother, but with "cripples of broken beauty." Hutchins wanted to tell Neith—as Jack wanted to tell Mabel— about these "romantic adventures" and have the women give their blessing.[44] The modern ideology of "openness" supported their boyish need to have "mother's" approval.

Hutchins's need to see Neith—and Jack's to view Mabel—in such maternal terms, undermined the women's ability to assert their own sexual needs. This becomes especially apparent in their conflicts over promiscuity.

INFIDELITY

John Reed and Maurice Sterne were unfaithful to Mabel, as Hutchins was to Neith. All three men *habitually* flirted with and had sex with other women, behavior they had learned as young men, sanctioned by both a Victorian double standard and by a modern sex radicalism.

While the free-love tradition that shaped Greenwich Village sexual norms did not advocate promiscuity, it gave little moral or cultural support for monogamy. "Free love" provided no guidance to a couple when one party desired monogamy and the other wanted the "freedom" to love more than one person. A woman who desired monogamy could easily be called old fashioned, unsophisticated, or repressed when her husband (or male lover) offered her the freedom to experiment sexually just as he did, and claimed it would not affect their love and commitment to each other. Both

Mabel and Neith found themselves in such a situation.

Neith and Mabel had opportunities to have lovers while they were with Hutchins and Reed, and both men encouraged them to do so, but the women did not desire another lover when they were sexually and psychologically deeply involved in an intense relationship. They were deeply hurt by Hutchins's and Reed's infidelities. In a 1907 letter to Hutchins, Neith was very clear about her feelings: "I have an abiding love for you—the deepest thing in me. But in a way I hate your interest in sex, because I suffered from it. I assure you that I can never think of your physical passion for other women without pain—even though my reason doesn't find fault with you. But it's instinct—and it hurts. The whole thing is sad and terrible—yet we all joke about it every day!"[45]

Mabel too felt a contradiction between her reason and her emotion about Reed's infidelity. Despite their personality differences and their distinct marital histories, Mabel and Neith refused to be Victorian wives who suffered in silence. But as liberated New Women, how could they deprive men of their "freedom"? In a long letter she wrote to Neith in 1913, Mabel anguished about her ideological confusion:

> What is this deep down necessity in women that makes them—drives them—for their own peace to ask of men that they shall be what is called "faithful"—and which, without it, tortures love? . . . Why does it make women suffer and writhe all through? Reed and I are at separation's point because of this. . . . Before I loved him I talked logically enough about "invading other people's" personalities— about how wrong it was to want anyone to be different from what they are— . . . but now it is all different. . . . I tell him that its his "freedom" and happiness against mine because I can't be happy if I love him and he has other women and that *its not good enough*: it's not worth it. . . . Women have *always* asked men to be faithful—will men

change and become so if women *won't take less?* Or are women to get over asking it? To whom is this victory to go? *To whom is it meant to go?* . . . Why should *I accept* being unhappy when I don't *believe* in it? Yet have I the right to ask him at his age to forgo any part of experience? And what right have I to ask him to control an impulse that he doesn't believe in controlling? . . . I come back to somehow feeling I have no right to coerce—or try to coerce another person—we are both individuals—we feel differently about this—that's all. To him the sexual gesture has no importance but infringing upon his right to act freely has the first importance. Are we both right and both wrong—and how do such things end? Either way it kills love—it seems to me. This is so fundamental—is it what feminism is all about? Even now I am in the dark as to whether either one has right on his side. . . . I know all women go thru' this—but must they go on going thru' it? Are we supposed to "make" men do things? Are men to change? Is monogamy better than polygamy? Is it worse unhappiness to stay than to go? What do you think? . . . What is freedom anyway?[46]

After two years of struggle to make Reed faithful, Mabel gave up and left him. In her play *Constancy*, Neith documented Mabel's solution to Reed's infidelity. Neith obviously admired Mabel's ability to end the relationship. Moira says in the play: "I can't endure love without fidelity. It tortures me. I don't care to be the head of a harem." The character, Moira, expressed Neith's and Mabel's shared sentiments. Rex represents the opposite, male standpoint when he says: "Haven't I been essentially faithful to you. I may have fancies for other women, but haven't I come back to you?"[47] This was also Hutchins's idea of fidelity, one which he tried to impose on Neith. Neith struggled with Hutchins for at least seventeen years (1901–1918) during which time he continued to have affairs. She fought and sustained the marriage, but at a great cost to her personal autonomy and sexual needs. A

closer look at Neith's battle documents the gender inequity built into the new sexuality.

In the second year of their marriage, during Neith's first pregnancy, Hutchins began what he called "conventional affairs." Unlike his Victorian forefathers, however, he told Neith about them and urged her to experiment as well as a means to deepen their relationship. He used a novel appeal to intimacy to justify his desire for sexual exploration outside marriage. "To have her know other men intimately, was with me a genuine desire. I saw in this one of the conditions of greater social relations between her and me, of a richer material for conversation and for a common life together."[48]

Neith tried to adapt to Hutchins's view of sexuality. In 1904 or 1905 she began flirtations with other men—flirtations that she revealed to her husband. Hutchins became very jealous, even violent. Both Neith in *The Bond* and Hutchins in *The Story of a Lover* emphasize his violent reaction of jealousy. In provoking jealousy, Neith, like her heroine, Teresa, balanced some score. She rekindled his sexual attraction and enabled herself to forgive his affairs.

Several years later (1908–1909), in response to Hutchins's continuing affairs, Neith had a serious relationship (although probably not a physical affair) with an old college friend of Hutchins. In a 1909 letter to a friend, Hutchins complained that Neith had a romantic feeling that she would like a double life with two men, and possibly two families.[49] The same letter goes on to document how Hutchins's jealousy turned him into a conventional, egotistical, and possessive husband, who wanted to enforce Neith's duties as a wife and mother.

The Story of a Lover details how Neith could not leave Hutchins. At his insistence she ended the other relationship, but then she had a nervous breakdown—during which Hutchins both cared for the children and helped nurse her back to health.

All of this conflict in their marriage happened *before* the Hapgoods joined the Greenwich Village circle about 1910. Although Mabel Dodge and others mention men in the Village who were attracted to Neith, there is no evidence that she continued her spiritual infidelities or was motivated to experiment with physical affairs. Hutchins, however, had at least two affairs in the Village that were more prolonged than those he described earlier. Neith was hurt again, but influenced now by the Village's ideal of liberated sex, she tried to accept his idea that love for her was not threatened by physical infidelities. She tried to minimize the importance of his affairs, and take a cool and aloof attitude. She wrote to Mabel:

> As to your famous question "Why do we want men to be monogamous?" I should respond: Do we? So long as they won't be, why should we want them to be? Why want anybody to be what they are not? Perhaps we like the excitement of catching them in flagrante delicti—and their excuses are so amusing! An absolutely faithful man, but what's the use of discussing him—he's a mythical creature.[50]

In practice Neith could not sustain this attitude. Sometime in November or December 1915 Hutchins wrote to Neith that he had fallen in love. Neith replied: "So you confess to being 'in love' with Lucy! Suppose I told you I was 'in love'—oh, what thunder, sighs, sobs and curses you would emit!"[51] Neith tried to accept the affair, but to set limits when and where Hutchins could see Lucy. Since Lucy Collier and her husband were friends too of Mabel's, Neith wrote to her about it, trying to take a light tone.

But other letters reveal that Neith's real feelings were more negative. Many years later after rereading her letters about this affair, Neith wrote again to Mabel Dodge Luhan: "How noble I was. How patronizing. And of course all the time I was nothing of the sort."[52] In fact, his sexual promiscuity undermined her own sexuality. Neith admitted this in a 1916 letter to Hutchins:

> I know that your physical infidelities (beginning very early) hurt that instinctive

feeling for you in me—that I wished to be reasonable about it—that I therefore tended to be more aloof in my feeling about you—because otherwise it would have hurt more. . . . It will help us to feel we've both been wrong—for we have—we have both been ignorant and careless and reckless about our relationship.[53]

Up until this time conflicts about sexuality and intimacy fueled both Neith's and Hutchins's creativity; it was the subject of most of her, and some of his, writing. But the continuing turmoil seemed to sap Neith's energy. She published very little after this, while Hutchins went on to publish two major autobiographies.

Nor did Hutchins change. In 1917–1918 he had an affair with a young married actress in the Village. In his autobiography written in the 1930s, Hutchins discussed the affair, saying that the woman's husband threatened to beat him up. In contrast, Hutchins claimed, "the deep and beautiful Neith understood it perfectly, and never had a word of objection."[54] The few letters that remain from this period indicate that, on the contrary, Neith did get angry. At the same time, however, she partly blamed herself for his affairs. She said in a 1918 letter to Hutchins: "I remember long ago my Danish friend, Laura, said to me 'You will be a good mother, but a bad sweetheart,' and I guess she was right. I have not the amorous imagination as you have—so I couldn't be what you wanted."[55] Hutchins, to his credit, later recognized how he had undermined Neith:

Her deepest passion was to construct; she needed to build, to feel that of her own will she was bringing to the relation. Her personal work, her writing, had been the way in which she felt she was herself. There it was all her own doing; if she could have felt that our relation was her construction, not mine, she would have loved me more. . . . She did not so much want to be wooed as to woo![56]

In a society where men had more power than women, male inconstancy increased the power imbalance between women and men. Neith's attempt to participate in an open marriage failed to right that inequity, for she was adapting herself to a man's sexuality, rather than asserting her own sexual needs. Mabel too tried to hold on to Sterne, not by accepting his flirtations, but by removing other women from the scene. When Maurice started flirting with Neith during a summer in Provincetown in 1915 (or 1916), Mabel made up some grievance with the Hapgoods and stopped seeing them for six months. Mabel soon realized that Maurice would not change.

Mabel never lost herself the way Neith did in trying to adapt to a male-defined sexual liberation. However, Mabel ended up in a marriage to the Native American Tony Luhan, which was perhaps not so different from the union of separate spheres characteristic of the mid-nineteenth-century American bourgeoisie. Mabel retained her autonomy and developed a stronger sense of herself, but she may have also lost her sexual drive. One clue is seen in the extremely hostile (unpublished) review she wrote in 1925 of an exhibit of Georgia O'Keeffe's paintings. O'Keeffe had explicitly asked Mabel to write the review, because she believed Mabel "could write something about me that the men can't. . . . There is something unexplored about women that only a woman can explain." It was the openness of O'Keeffe's sensuality that offended Mabel. As Mabel's biographer, Lois Rudnick, analyzes Mabel's review: "At a time in her life when she was working to evolve beyond her primary sexual instincts, she found O'Keeffe's seemingly exaggerated adoration of genitalia disgusting."[57]

Although for a few years, Mabel was content to escape the conflicts and turmoil of modern relationships, she soon became bored by Tony's long silences and lack of intellectual interests. After 1922, Mabel spent part of every year in cosmopolitan centers and used her money, hospitality, charm, and intellect to entice a great number of leading writers, artists, and intellectuals to Taos for short or long visits. Tony and Mabel stayed

together despite his sexual infidelity and her occasional flirtations, probably for some combination of a positive personal bond, and her feeling for Pueblo culture and how it healed and restored the alienation bred by Anglo society. Their marriage, however, was not based on the modern ideal of an intense and equal psychological and sexual sharing.

CONCLUSION

Several prominent cultural historians, especially Christopher Lasch and T. Jackson Lears, have characterized the lives and writing of the pre–World War I Greenwich Village circle, including Mabel and Neith, as focused on a desperate preoccupation with the self, arising from a breakdown in community relations and male authority, and resulting in a devaluation of political action.[58]

In contrast, I see the time Neith and Mabel spent struggling with men—and talking about their sexual conflicts—as the beginning of a new sexual politics. The feminism of the early twentieth century envisioned a New Woman who could be satisfied both sexually and in her work, but it had not yet found a way to address the pain that women like Mabel and Neith experienced in their personal relationships and use it to fuel a public movement. It was *not* that their personal preoccupations made Mabel and Neith devalue politics, but rather that political movements (even a feminism focused on suffrage, labor struggles, birth control, or professional advancement for women) didn't speak to the problems that they experienced in their relationships and community.

The quest of Neith and Mabel, and of many other women of their generation, for personal realization prefigured a politics of personal life that developed later in the century. Theirs was not an isolated, individual struggle, but one carried on within a relatively cohesive community. Their cultural moment in 1915 was that of an innovative *community* promoting *individual* expression and growth. However, the culture of this community, especially its sexual culture, was still defined by the hegemony of male experience and not yet subject to a feminist critique.

Our culture is now more feminist, but our communities are weaker, and our personal struggles often as difficult. Contemporary feminism gives women support to leave individual men, and supports some women to become lesbians, but we await the development of a feminist politics of heterosexuality that will make any woman's struggle with her man less that of an isolated individual. In the meantime, we can gain personal sustenance from the example of Mabel Dodge Luhan and Neith Boyce: they managed their disappointments and compromises in a way that dignified their struggle without a nostalgic return to conventional subordination. Their example indicates that our search for meaningful work and love in egalitarian relationships is not apolitical, ephemeral, or self-centered. Like them, we are still intimate warriors in a pivotal cultural conflict of the twentieth century.

NOTES

1. Daniel Joseph Singal, "Towards a Definition of American Modernism," *American Quarterly* 39, no. 1 (Spring 1987).

2. For examples see: Ellen Kay Trimberger, "Feminism, Men and Modern Love," in *Powers of Desire: The Politics of Sexuality*, ed. Ann Snitow, Christine Stansell, and Sharon Thompson (New York: Monthly Review Press, 1983), 131–152; Mabel Dodge Luhan, *Movers and Shakers* (1936; rpt. Albuquerque: University of New Mexico

Press, 1987) ; Mary Austin, *No. 26 Jayne Street* (Boston : Houghton Mifflin, 1920).

3. Lois Rudnick, *Mabel Dodge Luhan: New Woman, New Worlds* (Albuquerque : University of New Mexico Press, 1984), ix.

4. Luhan, *Movers and Shakers*, 133.

5. Ibid., 373.

6. *Enemies* and a condensed edition of *The Bond* are reprinted in my edited volume, *Intimate Warriors: Portraits of a Modern Marriage 1899–1940* (New York : Feminist Press, 1991). Other novels by Neith Boyce are *The Folly of Others* (1904), *The Eternal Spring* (1906), and *Proud Lady* (1923). She also published an autobiographical account of her relationship to her son Boyce and his early death at age eighteen, *Harry* (1923). She pursued these same themes in numerous magazine stories, many of which are collected in the Hapgood Collection of the Beinecke Rare Book and Manuscript Library, Yale University.

7. *New York Times*, 13 June 1908, 335 ; *The Nation*, 7 May 1908, 427 ; *The Dial*, 16 Aug. 1908, 91.

8. Luhan, *Movers and Shakers*, x.

9. "A Quarrel" is in the September 1916 issue of *The Masses* ; "The Parting," October 1916 ; and "The Eye of the Beholder," October 1917.

10. Kenneth Lynn, "The Rebels of Greenwich Village," *Perspectives in American History*, 3 (1974) : 366.

11. Mabel Dodge Luhan, *Background* (New York : Harcourt, Brace & Co., 1936), 23.

12. Ibid., 265.

13. Neith Boyce, "Autobiography," p. 75 in the Hapgood Collection, Beinecke Rare Book and Manuscript Library, Yale University.

14. Quoted in Rudnick, *Mabel Dodge Luhan*, 22.

15. 15 May 1898 letter from Hutchins Hapgood to his mother in the Hapgood Collection, Beinecke Rare Book and Manuscript Library, Yale University.

16. Boyce, "Autobiography," 75.

17. Webb is quoted in Ruth Brandon, *The New Women and the Old Men: Sex and the Woman Question* (New York : W. W. Norton, 1990), 109.

18. Neith Boyce, *The Bond* (New York : Duffield & Co., 1908), 145.

19. John D'Emilio and Estelle Freedman, *Intimate Matters: A History of Sexuality in America* (New York : Harper & Row, 1988), 84.

See also Hal D. Sears, *The Sex Radicals: Free Love in High Victorian America* (Lawrence, Kans. : Regents Press, 1977).

20. D'Emilio & Freeman, *Intimate Matters*, 161, 84.

21. Ellen Key, *Love and Marriage* (New York : G. P. Putnam's Sons, 1911), 20, 23.

22. "On Labor and Free Love: Two Unpublished Speeches of Elizabeth Cady Stanton," edited and annotated by Ellen DuBois. *Signs* 1, no. 1 (Autumn 1975) : 266. See also William Leach, *True Love and Perfect Union: Feminist Reform of Sex and Society* (New York : Basic Books, 1981) ; and Ellen DuBois and Linda Gordon, "Seeking Ecstasy on the Battlefield: Danger and Pleasure in Nineteenth Century Feminist Sexual Thought," *Feminist Studies* 9, no. 1 (Spring 1983) : 7–25.

23. Nancy Cott, *The Grounding of Modern Feminism* (New Haven : Yale University Press, 1987), 45.

24. Floyd Dell, a journalist for the radical paper *The Masses*, and in the same Greenwich Village circle as Neith and Mabel, made this comment in his autobiographical novel, *Mooncalf*. See my article, "Feminism, Men and Modern Love."

25. See Niklas Luhmann, *Love as Passion: The Codification of Intimacy* (Cambridge, England : Polity Press, 1986).

26. "To H. H. at 46," unpublished poem in the Hapgood Collection, Beinecke Rare Book and Manuscript Library, Yale University.

27. Luhan, *Movers and Shakers*, 46.

28. Ibid., 428, 377.

29. Quoted in Sheila Rowbotham and Jeffrey Weeks, *Socialism and the New Life: The Personal and Sexual Politics of Edward Carpenter and Havelock Ellis* (London : Pluto Press, 1977), 169.

30. Boyce, "Autobiography," 159.

31. Luhan, *Movers and Shakers*, 58, 228.

32. Ibid., 375.

33. Ibid., 217, 424.

34. Luhan, "A Quarrel."

35. Luhan, *Movers and Shakers*, 286, 319.

36. Rowbotham & Weeks, *Socialism and the New Life*, 112, 170, 171 ; Key, *Love and Marriage*, 217, 228.

37. Edward Carpenter, *Love's Coming of Age* (New York : Mitchell Kennerley, 1911), 40–41.

38. Luhan, *Movers and Shakers*, 257, 354.

39. Ibid., 229.

40. Hutchins Hapgood, *The Story of a Lover* (New York: Boni & Liveright, 1919), 89.

41. Ibid., 7, 63.

42. Neith Boyce and Hutchins Hapgood, *Enemies, The Provincetown Plays: Second Series* (New York: Frank Shay, 1916), 105.

43. For a theoretical discussion of the relationship between female mothering and the construction of male and female sexuality, see Nancy Chodorow, *The Reproduction of Mothering* (Berkeley: University of California Press, 1978), part 3; and Dorothy Dinnerstein, *The Mermaid and the Minotaur: Sexual Arrangements and Human Malaise* (New York: Harper & Row, 1976), chap. 4.

44. Hapgood, *Story of a Lover*, 173.

45. Letters between Neith and Hutchins are in the Hapgood Collection in the Beinecke Rare Book and Manuscript Library, Yale University.

46. Letters between Mabel and Neith are in the Luhan or in the Hapgood Collections, Beinecke Rare Book and Manuscript Library, Yale University.

47. The manuscript for Boyce's play *Constancy* is in the Hapgood Collection, Beinecke Rare Book and Manuscript Library, Yale University.

48. Hapgood, *Story of a Lover*, 158–159.

49. Letter to Mary Berenson. In the Berenson Collection, Beinecke Rare Book and Manuscript Library, Yale University.

50. December 1915 letter in the Luhan Collection, Beinecke Rare Book and Manuscript Library, Yale University.

51. Lucy Collier was a Smith College graduate who did some journalism, but she is best known as the wife of John Collier, a social worker. He founded The People's Institute in New York City in the early years of the century to help immigrants preserve their native cultures. Collier became the Commissioner of Indian Affairs in the Roosevelt Administration after Mabel got him interested in the plight of Native Americans.

52. 1941 letter from Neith to Mabel in the Luhan Collection, Beinecke Rare Book and Manuscript Library, Yale University.

53. Letter in Hapgood Collection, Beinecke Rare Book and Manuscript Library, Yale University.

54. Hutchins Hapgood, *Victorian in the Modern World* (Seattle: The University of Washington Press, 1972), 430.

55. Letter in Hapgood Collection, Beinecke Rare Book and Manuscript Library, Yale University.

56. Hapgood, *Story of a Lover*, 175.

57. Rudnick, *Mabel Dodge Luhan*, 234–235.

58. Christopher Lasch, *The New Radicalism in America: 1889–1963* (New York: Vintage Books, 1965); T. Jackson Lears, *No Place of Grace: Anti-Modernism and the Transformation of American Culture, 1880–1926* (New York: Pantheon Books, 1981).

PART THREE

The New Psychology

JOHN C. BURNHAM

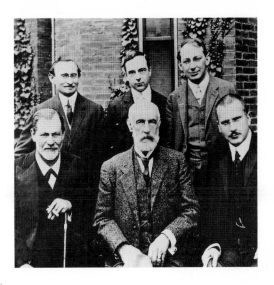

FIGURE 25. *Sigmund Freud and his colleagues at the famed Clark University conference which marked the beginning of the American psychoanalytic movement. Top, left to right: A. A. Brill, Ernest Jones, Sandor Ferenczi. Bottom, left to right: Sigmund Freud, G. Stanley Hall (president, Clark University), Carl C. Jung. Culver Pictures.*

In 1915, a New Psychology meant mostly the teachings of Sigmund Freud and what he called psychoanalysis. Freud had shown how it was possible to interpret human thought and behavior not only in terms of the traditional conscious mind but also in terms of the primitive and regressive mental tendencies that entered awareness only indirectly. Later, after 1920, additional versions of unwitting and spontaneous physiological functions—such as conditioned reflexes—came to be included under the heading of a New Psychology. But in 1915, what people understood as Freud's ideas constituted the New Psychology.[1]

The New Psychology attracted intellectuals who were dissatisfied with old formulations and who were fascinated with the relationship of their internal perceptions and feelings with the social and natural worlds in which they lived. Among thinkers in the United States, it was part of the general intellectual movement that appeared as the revolt against formalism—the breaking down of old lines of conceptualization and inquiry and the dissolution of boundaries between intellectual categories, disciplines, and social groups, a revolt that was in the interest of finding new ways of looking at the universe and especially of looking at human beings and institutions.[2] As will be explained throughout this section, Freud broke down traditional ideas of reason, of intention, and of will; his thought therefore became a major force in undermining formalism.

From one point of view, Freud's work was the culmination of major trends of the nineteenth century. American intellectuals enthusiastically embraced the idea that it might be possible to control the world through a science that increasingly demonstrated that nature was no longer mysterious. Lightning was electricity. Disease was the product of germs. By 1900, knowledge and technology had indeed provided human beings with astonishing abilities to restrain and manipulate—or at least understand—nature.

In the wake of Darwin's suggestion that humans were beasts, partisans of traditional rationality were further confronted with the fact that human beings were the source of not only reason but anomalous and uncontrollable behavior. Worse, people could detect in themselves feelings that were often at odds with their rational selves. Must we, asked philosopher-psychologist William

James in 1909, "believe human experience to be fundamentally irrational?"[3] In the increasingly secular world of the late nineteenth century, theological explanations such as original sin no longer sufficed to explain irrationality in either oneself or in other supposedly rational human beings. It was in this setting that many Americans found in Freud's ideas a means of demystifying, decoding, and it was hoped, controlling irrational thought and behavior.

SPLITTING AND REDUCING THE SOUL

There were other intellectual changes besides the post-Darwinian notion that human beings were only somewhat evolved animals. Probably the most important nineteenth-century change concerned ideas about a person's soul, which included his or her very being as well as mental operations. For a long time, physiologists, physicians, and some psychologists under the influence of science had tended toward formal psychophysical reductionism; that is, the attempt to explain human thinking and behavior in terms of presumably simpler physical processes: at first the nervous system and reflexes and then, ultimately, all events in the human body interpreted as simply physics and chemistry. American intellectuals often had a vision of a reality in which the soul "really" consisted of physiological and/or chemical events, operating in physical terms exactly comparable to the mechanical association psychology to which most intellectuals subscribed at that time. (Such thinkers visualized thinking processes as the aggregation of myriad series of ideas that automatically called each other into consciousness, as "table" will make most people, by association, think "chair.")

But such a mechanical, telephone-exchange model of thinking on either the psychological or the physiological level still did not easily, or for long, explain emotional life. More importantly, it could not explain many abnormal phenomena such as hypnosis, multiple personality, faith cures, and madness. Nor did the traditional academic psychology of sensations, feelings, and will successfully account for evidence of human irrationality.[4]

A quite different belief from reductionism, but one equally potent, a belief in romantic individualism, also affected large numbers of American thinkers deeply. For the romantic individualists of the progressive years at the opening of the twentieth century, subjective feelings were especially important. One significant symptom of this trend, besides a flourishing Christian Science movement, was the spontaneous, nonsectarian New Thought movement. New Thought was basically an attempt to unite the individual soul with the soul of God by emphasizing subjective experience. New Thought and kindred romantic individualisms sought, as one partisan put it, to "more adequately interpret the facts of experience and at the same time satisfy the deep yearning of the human spirit." Such thinkers enunciated and extended a common belief that each individual had capacities that were untapped, potential that was unrealized— and that thinking the right thoughts would lead to personal fulfillment. One could think oneself to optimum functioning in life by the "practical use of the occult powers of the soul," as New Thought exponent John B. Anderson put it in 1911.[5]

New Thought advocates were more successful in selling the idea of the power of thought and the potential of a real and better self than they were in preserving the idea of a unitary soul. Literary historians have long since pointed out that Victorian intellectuals found themselves having to make choices that were not keenly felt in earlier generations. Is there a God? Which form of government is correct? What is the true esthetic principle? With so many options for individual choices in life opening up, Victorians detected inner conflicts of unprecedented intensity, and the idea of a unitary soul—or person—was no longer

easily tenable.[6] Such was the atmosphere in which the generation of 1915 grew up—the soul had many conflicting choices and many scientific and perhaps spiritual constituents, even, paradoxically, multiple personalities within one person.

Once the self was understood as fragmented, the question of what was the real self opened up with a vengeance, for to most American thinkers, it was no longer obvious. Just at this point, Sigmund Freud began to publish his findings on human psychology, in which he talked of instinctual drives and mechanisms and unconscious processes. It was therefore inevitable that thinkers who were concerned about the real self, not to mention other realisms and issues such as free will, would look at psychoanalytic ideas. "Those who have followed the Freudian literature," noted a reviewer in the *American Journal of Psychology* shortly after Freud's only American visit, in 1909, "know with what infinite patience and detail the clinical cases are followed up as the investigator penetrates to layer below layer of the patient's soul."[7]

VIEWING FREUD IN TERMS OF THE FAMILIAR

As Americans heard about Freud, they used familiar terms to conceptualize what he was saying. They often misunderstood and distorted his ideas, and they diluted them with somewhat similar contemporary notions, particularly ideas about subconscious mental events that were connected with hypnotism. Freud himself used traditional ideas in his formulations. In particular, he believed that thought processes proceeded by means of the association of ideas. And he, like others, had learned from Charles Darwin that humans were animals. Freud's contribution therefore was to show how it was possible to make bestial instincts and irrational emotions fit into a mechanistic association psychology. Because he provided practical means for understanding

how instinctual drives distorted conscious thinking and rational behavior, his ideas had unusual success before World War I and for decades after. Pre–World War I Americans learned about Freud against a background of environmentalism and science that emphasized the hope of controlling nature as well as the anomalous and troubling evidence of irrationality in human feelings and behavior.

As a means of psychotherapy, psychoanalysis enabled one person—the therapist—to influence another—the patient—in profound ways. Reformers—including many intellectuals—who believed that by changing the environment, they could improve the world, were inspired by the power of the new therapy in two different ways. Clearly pessimistic hereditarian beliefs in mental pathology were disproven by the success of therapy. And if individuals could be cured by educating people with Freudian insights, the world in general would be made a better place with similar kinds of education. Psychoanalysis, noted one prewar observer, mobilized energy "exquisitely fitted for increasing man's control over his environment."[8]

Freud's ideas came in at many levels of American intellectual life. To provide more specific background for the two essays that follow, I shall describe briefly how Americans learned about Freud, for psychoanalysis was a theory and method within the field of medicine that was picked up by avant-garde intellectuals only in the late teens. I shall give special attention to what was happening in 1915, for it was just about that time that the status of psychoanalysis changed so that it became personally important for intellectuals. Then I shall describe the form most thinkers encountered first: the idea of hidden motives—particularly sexual motives—in human behavior. Hidden motives were part of the intellectuals' search (as in literary realism and naturalism) for a workable reality, indeed, for the real self. To this search, psychoanalysis contributed both understanding—how do we know which of

our feelings and perceptions are valid?—
and objectivity. Finally, it is necessary to
take account of Americans' unrelenting quest
for the latest, the newest, the most modern.

LEARNING ABOUT
PSYCHOANALYSIS

Intellectuals in general were always aware of
the very latest developments in the technical
field of medical psychology. In 1915, for
example, Pearce Bailey, the preeminent neu-
rologist, reviewed psychoanalyst Otto
Rank's book *The Myth of the Birth of the
Hero*, not in a medical journal, but in the
New Republic, the chief political-literary
organ of advanced intellectuals. As Sanford
Gifford notes in his essay, specific intercon-
nections between physicians and literary
people were of great importance in this
period. But even earlier there was a tradi-
tion of literary and general intellectual
interest in abnormal psychology. Hypno-
tism, faith cures, and other phenomena were
familiar to thinkers of the late nineteenth
century, including readers of a variety of
types of literature, and even physiologically
oriented academic psychologists found that
student and public demand forced them to
go beyond their narrow experiments on the
senses and thinking and to deal with baffling
phenomena such as dreams, pathological
forgetting, involuntary writing, and
posthypnotic suggestion.[9]

Beginning especially around 1908, a few
Americans began to publish accounts,
mostly technical accounts, of the ideas that
Freud was still developing. They often com-
mented that he had devised a psychological
schema that explained the baffling phenom-
ena far better than did traditional psycholo-
gies. But for some time, these observations
about Freud's work were peripheral to al-
most all American intellectuals. Then
during the year 1915, the place of psycho-
analysis in the perceptions of well-read
Americans changed.

What was different about 1915? Some his-
torians have pointed to the popularizations
that Max Eastman published in *Everybody's*
magazine that year ("Exploring the Soul
and Healing the Body" and "Mr. Er-er-er—
Oh! What's His Name?") as landmarks. An-
other major popularization appeared in a
general magazine, *Good Housekeeping*.
Other historians have taken a wider sample
of periodical coverage and noticed that the
number of articles on Freud and psycho-
analysis indexed in the *Reader's Guide*
increased dramatically in 1915. From 1910
to 1915, between one and five articles ap-
peared each year. In 1915, the number
jumped to ten. Moreover, two important
books appeared that were suitable for the
general reader: James Jackson Putnam's
Human Motives and Edwin B. Holt's *The
Freudian Wish*.[10]

Clearly something was happening in 1915.
In the thinking of a critical number of
Americans, psychoanalysis had reached such
importance that they actively published on
the subject and found receptive editors and
readers, whether lauding psychoanalysis or
attacking it. Learning about psychoanalytic
ideas became an urgent matter among lead-
ing thinkers. Much evidence confirms Floyd
Dell's recollection: "Everyone at that time
who knew about psychoanalysis was a sort of
missionary on the subject, and nobody could
be around Greenwich Village without learn-
ing a lot about it."[11]

Not only did the quantity of presentations
of which intellectuals would have been
aware change, but so did the quality. In pre-
ceding years, members of the educated
public had read about the innovations that
physicians had introduced in the treatment
of nervous diseases. Many of the publica-
tions were reports by clinicians themselves
on a new type of achievement in medicine
and the development of a technical proce-
dure, psychotherapy, which often included
psychoanalysis. Only here and there did a
writer suggest that one approach or another
of Freud's might be applicable to everyone,
as did Edwin M. Weyer in the *Forum* in 1911

when he invited readers to look into their own dream lives.[12]

What began happening in 1915 was that a significant number of American thinkers started to make psychoanalysis and psychoanalytic ideas part of their own worlds, so that psychoanalysis became more than just a new tool in the hands of expert professionals who could apply it to a passive clientele. As the detailed content of Freud's ideas became increasingly important and personally relevant to American intellectuals, their writings constituted the real transition. Walter Lippmann, the still young radical, observed in 1915 that the lay person could no longer remain neutral in the doctors' debate over Freud; the consequences of the outcome were too great and went beyond the medical realm.[13]

Later, in the 1930s and after, psychoanalysis reverted once again very largely to being a medical specialty, with the familiar symbol of treatment on the couch, by a trained expert. But in the 1915 period, psychoanalysis became a general intellectual phenomenon. Freud's work was therefore an exciting aspect of the time when there was an avant-garde blazing a trail for the rest of high culture. One distressed critic of 1914, who opposed all "advanced" thinking, made explicit what everyone knew when he listed psychoanalysis along with other innovations of the time that he considered undesirable such as "occultism, symbolism, cubism, futurism, modernism . . . [and] the problem play."[14]

HIDDEN MOTIVES

The most conspicuous aspect of the New Psychology to show up in the work of American avant-garde writers was the idea of hidden motives, as exemplified in the Provincetown play *Suppressed Desires*. People at the time identified hidden motives as a part of psychoanalysis, but the idea clearly was not new.[15] Why, then, the sense that Freud had provided fresh insight?

Members of the avant-garde had, for the most part, grown up when socialism was a major aspect of the thinking of large parts of the American intelligentsia.[16] Many of the self-conscious rebels of the pre–World War I era had learned something of Marx, and it was therefore a commonplace of stimulating conversation among advanced thinkers to seek the hidden motives of specific people, typically how a person's actions reflected his or her economic interests. This was a crude and direct kind of reductionism, namely, to deny surface motives and rationality in a given case and instead ascribe actions to attempts of that person to exploit others under the capitalist system. The Rockefeller charities of that period, for example, were frequently characterized in such terms.

Many of these analyses of economic motives, as Waldo Frank pointed out to me once, involved motives of which the person was unaware—truly hidden motives. So one advanced thinker would accuse another of inadvertently acting in the interest of his or her own pecuniary gain. This type of thinking then set the stage for these same thinkers to take up the Freudian variety of hidden motives. As Florence Kiper Frank noted in 1916—anticipating the popularization of psychoanalysis through the drama—it was quite possible for psychosexual determinism to replace economic determinism in interpreting the affairs of human beings.[17]

Freud added two elements to the concept of hidden motives First, he showed that hidden motives were selfish in many ways other than economic, including wishes that one was omnipotent and that one had every instinct gratified; indeed, people at the time tended to think that psychoanalysis meant a reductionism in which all human motives became sexual in one way or another. As early as 1914, the editors of *Current Opinion* ran an article entitled "How Psycho-Analysis Has Obsessed the World with Sex." The sexual content and symbolism of sexuality distracted both advocates and critics of psychoanalytic thinking. Warner Fite, writing

in the *Nation*, for example, called a book of Jung's "five hundred-odd pages of incoherence and obscenity." Psychoanalytic writers, Fite continued, made every statement not "of the order of 'the day is warm' or 'this is a chair' . . . the expression of a motive not merely sexual, but incestuous."[18] Advanced thinkers such as those at Provincetown were repelled as well as fascinated and distracted by sexual content, as Fred Matthews points out. They explored the implications of this material: What if Freud was basically correct in his emphases?

But Freud's most unique contribution was to provide the psychological mechanisms by means of which hidden motives influenced a person's thoughts and actions—and by means of which another person could analyze those thoughts and actions and reduce them so as to discover primitive and infantile motives. The mechanisms at that time included such things as condensation (in which more than one idea and motive were collapsed into a single expression; for example, a child's calling a teacher "Mom") and symbolization (in which, for instance, snakes and steeples in dreams surreptitiously represented a phallus in the dreamer's mind, or an empty chair meant someone had died). It was finding these unobvious keys to behavior and thought that so appealed to the avant-gardists who took up psychoanalysis. Intellectuals of that day accepted the possibility that Freud had devised a practical way to discover the elusive reality that they—like scientists—were seeking. Waldo Frank at one point asserted that the success of the revivalist Billy Sunday was due to his unwitting use of "the conversion-mechanism:—the channeling of an instinctive desire away from an expression that is forbidden to one that is disguised and not forbidden. It is unsafe to give open leash to sexuality, so turn the passion into fear of Hell and glut your worry by 'hitting the trail' [evangelizing]. It is uneconomic to get drunk on alcohol, so wave a flag and get drunk on God."[19]

The new insights into what made people do

what they did had a substantial impact on the American intelligentsia. Sherwood Anderson remembered what it was like a couple of years before the founding of the Provincetown Players when he was a still undiscovered young writer in the Chicago renaissance group:

> We . . . were wallowing in boldness. Freud had been discovered at the time and all the young intellectuals were busy analyzing each other and everyone they met. Floyd Dell was hot at it. We had gathered in the evening in somebody's rooms. Well, I hadn't read Freud . . . and was rather ashamed of my ignorance. Floyd walked up and down before us. . . . I had never before heard such talk. How it flowed from him. . . . And now he had begun psyching us. Not Floyd alone but others in the group did it. They psyched me. They psyched men passing in the street.[20]

INSTINCT AND SEXUALITY

Freud's ideas worked into still other, related, intellectual trends. American thinkers of the early twentieth century tended to explain behavior in terms of instinct and will. Will was familiar and traditional, and it fitted into the individualism of the time and the credo of self-improvement and self-development that was part of the American drive for both individual and community success in that period. Will was central to the conscientiousness of progressive reform as well as the mysticism of New Thought.[21] Hidden motives constituted just another form—an unconscious or subconscious form—of will. And one could use conscious will power against pernicious motives—once they were discovered. Instinct, by contrast, was not traditional.

Instinct was originally an animal, not a human, attribute. By the turn of the century, however, important figures such as the American psychologist William James were talking about *human* instincts. The old

psychological category of the feelings was giving way to the independent emotions, which thinkers such as the influential British writer William McDougall identified as the psychological aspect of instinctual activity. By 1915, one of the most important and successful theories of the instincts was that of Sigmund Freud, who argued that instinctual drives—many of them sexual—constituted a major aspect of the hidden self.[22]

As Freud's ideas became more widely disseminated, the relationship of romantic love to the new views of sexuality generated increasingly more thought and concern. Love, as it developed in Victorian society, was believed to provide the glue that held marriage together and that guaranteed the promise that monogamy would be personally fulfilling for both partners. More open attitudes toward sexuality were growing because reformers wanted to make marriage more gratifying so as to cut down on the spread of venereal disease as well as to strengthen the family. Some radicals believed that increased sexual openness and gratification assisted in more authentic self-expression. Other thinkers believed that Freud tended to reduce rational motives to often basely emotional drives. Regardless of viewpoint, informed intellectuals like Susan Glaspell and George Cram Cook saw that any behavior at all, however respectable, could be attributed to sexual motives. "The differential essence of religion," wrote Theodore Schroeder in 1914, "is always reducible to a sex ecstasy."[23]

THE SEARCH FOR A NEW REALITY

Thinking in terms of hidden motives, and even of instinct and sexuality, was not, however, the whole of the intellectuals' reception of Freud's work. Psychoanalytic ideas appealed to American thinkers in Greenwich Village and elsewhere for other reasons, also, particularly as part of the quest for a more accurate and satisfying reality. With the acceptance of Freud's ideas, psychology came to play a substantial role in the work of artists and writers who found that their own ideas of nature, particularly human nature, were changing. Experimenters in art and literature were seeking ways to move beyond surface appearances and discover underlying elements in the same way that social scientists explored a scientific approach to the human mind and character.[24]

There were two basic approaches to using psychoanalysis to search for a more authentic reality. One was following the hidden motives to uncover the "real self," which was presumably not obvious. The other was trying to free oneself from impediments to seeing the truth clearly—what came to be called gaining objectivity—since if one uncovered hidden motives, one could presumably compensate for their influence or even overcome them.

Freud showed how untoward elements in the real, hidden self had to be justified to one's conscious self. Many thinkers, especially in the late nineteenth century, had suggested that human beings were not honest with themselves. Such "rationalizing" self-justification (to use a psychoanalytic term) was a device particularly familiar to the Provincetown generation. They had learned it from the Victorians, for whom one of the cardinal preoccupations had been hypocrisy—selfish and unadmirable behavior covered over by self-justification. Using the New Psychology to identify ever more shocking kinds of hypocrisy was therefore a natural activity for the sons and daughters of middle-class Victorians. What were identified before World War I as "shocking" psychoanalytic interpretations were almost invariably attempts to unmask hypocrisy in the most moralistic way, to condemn someone, for example, for behavior that grew, unconsciously, out of primitive jealousy or frustration.[25] The motive to unmask hypocrisy is prominent in *Suppressed Desires*.

Closely allied to this motive was the attempt

of thinkers to attain a clearer grasp of psychological and social reality by taking a more scientific—and presumably more objective—point of view. "We draw the hidden into the light of consciousness," wrote Walter Lippmann, "record it, compare phases of it, note its history, experiment, reflect on error, and we find that our conscious life is no longer a trivial iridescence, but a progressively powerful way of domesticating the brute." Psychoanalysis could and did embody the power of science to solve problems by helping people face unpleasant facts. Yet the blind faith its theories inspired was tellingly satirized by Glaspell and Cook.[26]

PSYCHOANALYSIS AS THE "NEW"

The fact that Glaspell and Cook could already be critical of the New Psychology fad in 1915 suggests that that psychology was well on its way to making an impact in terms of an important set of ideas about the human condition. These new ideas were an integral part of the exciting changes taking place in American culture. At a time when critics attacked the contemporary stage for not meeting the important ideas and issues of the time, the movers and stirrers of the Progressive Era hoped that psychoanalysis would lead creative thinkers to world-shaking innovation. Indeed, psychoanalysis set a standard, as one commentator in the self-consciously revolutionary journal *The Masses* noted in the spring of 1915: Gordon Craig's book on the theatre, he said, was "in its field as revolutionary as the theories of Freud."[27] Reformers were using the idea of revolt not just to get rid of old forms and traditions, but to introduce new ones.

It was against this background of a variety of forces that the Provincetown Players and other intellectuals took an interest in Freud's work and in the rest of the New Psychology that became associated with it.[28]

Unlike other currents, as in art, for example, the enthusiasm for psychoanalysis that American thinkers manifested was not imported from either the Continent or from the traditional intellectual leadership that had come from England. Rather, Americans showed a peculiar affinity for Freud. They used psychoanalysis, for example, to explain the neurotic invalidism that so many Americans around the turn of the century blamed on modern civilization. Whatever the particular reasons, many people at that time noticed this national interest in Freud's new insights. In 1917, Leo Stein, who knew intellectuals of both the old and new worlds, commented about psychoanalysis: "One of the reasons why it is being accepted so much more easily here than in the center of a wiser and more reflective civilization, is that, on the whole, we feel rather less attainted by it. We feel it as discoveries in a new and interesting field rather than as something that tears deeply at our vitals."[29]

The Provincetown group saw clearly that psychoanalysis had great potential for modern thinking.[30] As Gifford and Matthews show in their essays, Freud was leading the Provincetowners and other avant-garde intellectuals to profoundly new ways of viewing human conduct. They tested Freudian ideas skeptically, but they also took them seriously and gained considerable mastery of the principles—the "discoveries in a new and interesting field," just as Stein observed. As Provincetowners discovered and reacted to Freud, they not only led but represented the larger American intelligentsia.

After World War I, the enthusiasm of the avant-garde to learn about Freud's teachings continued, and popularization of the kind pioneered in 1915 spread to other literate segments of the population. At first the expanded popular interest helped intensify many thinking Americans' narcissistic preoccupation with their selves. By the end of the 1920s, some cultural leaders were already beginning to explore the possibilities of using psychoanalytic insight to help

manipulate individuals in an increasingly organized and coordinated urban society.[31] In the mid–twentieth century, a new avant-garde generation began to explore the contradictions of a therapy that could relieve disabilities but at the same time change people to fit the system rather than transform the social structure.

NOTES

1. The term New Psychology is actually anachronistic for the year 1915. The book that named and defined it was A. G. Tansley, *The New Psychology and Its Relation to Life* (London: G. Allen and Unwin, 1920). See John C. Burnham, *Paths into American Culture; Psychology, Medicine, and Morals* (Philadelphia: Temple University Press, 1988), chap. 5.

2. H. Stuart Hughes, *Consciousness and Society; The Reorientation of European Social Thought, 1890–1930* (New York: Alfred Knopf, 1958). One recent version of the traditional account of the revolt against formalism is Daniel Joseph Singal, "Modernist Culture in America: Introduction," *American Quarterly* 39 (1987): 5–26.

3. William James, *A Pluralistic Universe: Hibbert Lectures at Manchester College on the Present Situation in Philosophy* (London: Longmans, Green, 1909), 211.

4. As early as the 1890s Americans recognized that the time was ripe for a "new" psychology; but the restricted psychology of the conscious turned out to be only a stopgap for the well informed. When a significant number of them learned about Freud's work, they believed that a truly new psychology had arrived. John C. Burnham, *How Superstition Won and Science Lost: Popularizing Science and Health in the United States* (New Brunswick: Rutgers University Press, 1987), especially pp. 85–95.

5. John Herman Randall and John B. Anderson, quoted in Richard Weiss, *The American Myth of Success: From Horatio Alger to Norman Vincent Peale* (New York: Basic Books, 1969), 130, 133; also see in general.

6. Burnham, *Paths into American Culture*, especially chap. 1.

7. Merle Curti, *Human Nature in American Thought; A History* (Madison: University of Wisconsin Press, 1980), which also summarizes much of the literature. Francis Jones, in *American Journal of Psychology* 21 (1910): 169.

8. Carl Rahn, review of White, *Mechanisms of Character Formation*, in *Psychological Bulletin* 14 (1917): 327.

9. See, for example, Curti, *Human Nature in American Thought*, especially chap. 10. Pearce Bailey, review of Rank, *The Myth of the Birth of the Hero*, in *New Republic* 2 (1915): 160–161. Another writer in that journal that year, for instance, Philip Littell, "Books and Things," *New Republic* 2 (1915): 186, referred to unconscious desires in a casual way as if everyone would understand the context of the allusion. See, for example, Leonard T. Troland, "The Freudian Psychology and Psychical Research," *Journal of Abnormal Psychology* 8 (1914): 405–428.

10. Max Eastman, "Exploring the Soul and Healing the Body," *Everybody's Magazine* 32 (1915): 741–750, and "Mr. Er-er-er—Oh! What's His Name?" *Everybody's Magazine* 33 (1915): 95–103. Max Eastman, *Heroes I Have Known, Twelve Who Have Lived Great Lives* (New York: Simon and Schuster, 1942), 263, believed that his articles constituted "the first popular American exposition of [Freud's] theories and methods of healing." Peter Clark Macfarlane, "Diagnosis by Dreams," *Good Housekeeping Magazine* 60 (1915): 125–133, 278–286. Gisela J. Hinkle, "The Role of Freudianism in American Sociology" (doctoral diss. University of Wisconsin, 1951), 10; cf. *Recent Social Trends in the United States; Report of the President's Research Committee on Social Trends* (New York: McGraw-Hill, 1933), 397. James Jackson Putnam, *Human Motives* (Boston: Little, Brown, 1915); Edwin B. Holt, *The Freudian Wish and Its Place in Ethics* (New York: B. W. Huebsch, 1915). One could add

to the list Isador H. Coriat, *The Meaning of Dreams* (Boston: Little, Brown, 1915). Nathan G. Hale, Jr., *Freud and the Americans; The Beginnings of Psychoanalysis in the United States, 1876–1917* (New York: Oxford University Press, 1971), 397, 417. A year-by-year description of popularization appears in John C. Burnham, "Psychoanalysis in American Civilization Before 1918" (doctoral diss. Stanford University, 1958), chap. X.

11. Floyd Dell, quoted in Frederick J. Hoffman, *Freudianism and the Literary Mind* 2d ed. (New York: Grove Press, 1957), 58.

12. See, for example, [G. Stanley Hall], "Twentieth Anniversary of Clark University," *Nation* 89 (1909) : 284–285; "Psychoanalysis, Getting at the Facts of Mental Life," *Scientific American Supplement* 71 (1911) : 256; Edward M. Weyer, "The New Art of Interpreting Dreams," *Forum* 45 (1911) : 589–600. Burnham, "Psychoanalysis and American Civilization," chap. X; Hale, *Freud and the Americans*, chap. XV. At that time, for example, the intelligent public learned about what astronomers could see through a giant new telescope. Reporting on the specialized and inaccessible work of experts and researchers was therefore the model for the initial popularizing of psychoanalysis. Indeed, an article devoted to psychoanalysis that was published in *Current Literature* 50 (1911): 167–169, was called "A Medical Report from a New Psychological World."

13. Walter Lippman, "Freud and the Layman," *New Republic* 2 (1915) : sup. 9–10. In the type of popularizing I am discussing, there was little sensationalism, and it was written primarily by intellectuals for well-read people if not also intellectuals. Only in the 1920s did vulgarization for the wider public become important.

14. John C. Burnham, "From Avant-Garde to Specialism: Psychoanalysis in America," *Journal of the History of the Behavioral Sciences* 15 (1979) : 128–134. F. X. Dercum, "An Evaluation of the Psychogenic Factors in the Etiology of Mental Disease," *Journal of the American Medical Association* 62 (1914) : 756.

15. Burnham, *Paths into American Culture*, chap. 5.

16. Dorothy Ross, "Socialism and American Liberalism: Academic Social Thought in the 1880's," *Perspectives in American History* 11 (1977–1978) : 7–79.

17. Florence Kiper Frank, "Psycho-

Analysis: Some Random Thoughts Thereon," *The Little Review* 3 (1916) : 15, 17. James Oppenheim, *War and Laughter* (New York: Century Co., 1916), 60, provides a particularly cogent example.

18. "How Psycho-Analysis Has Obsessed the World with Sex," *Current Opinion* 46 (1914) : 441–442. Warner Fite, review of Carl G. Jung, *Psychology of the Unconscious*, in *Nation* 103 (1916) : 127. Hale, *Freud and the Americans*, has especially stressed sexual content as a dynamic in the spread of psychoanalysis.

19. Waldo Frank, "Valedictory to a Theatrical Season," *Seven Arts* 2 (1917) : 365. The mechanisms are central, for example, in the popular exposition, William A. White, *Mechanisms of Character Formation: An Introduction to Psychoanalysis* (New York: Macmillan, 1916).

20. Sherwood Anderson, *Sherwood Anderson's Memoirs* (New York: Harcourt, Brace, 1942), 243–245.

21. Weiss, *The American Myth of Success*. Burnham, *Paths into American Culture*, especially chap. 14.

22. See especially Hamilton Cravens, *The Triumph of Evolution; American Scientists and the Heredity-Environment Controversy 1900–1941* (Philadelphia: University of Pennsylvania Press, 1978); Burnham, *Paths into American Culture*, chap. 4.

23. Theodore Schroeder, "The Erotogenic Interpretation of Religion: Its Opponents Reviewed," *Journal of Religious Psychology* 7 (1914) : 23; obvious error corrected.

24. For example, 1915 was the year that Nancy E. Sankey-Jones *(Theodore Schroeder's Use of the Psychologic Approach to Problems of Religion, Law, Criminology, Sociology and Philosophy, A Bibliography* 2d ed., [Cos Cob, Conn.: n.p., 1922], 2) points out Schroeder's work "distinctly shifted to that of the Freudian" viewpoint. The general quest for reality in the early twentieth century is put into one important context in Richard Wightman Fox and T. J. Jackson Lears, "Introduction," in Richard Wightman Fox and T. J. Jackson Lears, eds., *The Culture of Consumption: Critical Essays in American History, 1880–1980* (New York: Pantheon Books, 1983), xiii-xv. The entire context appears in Curti, *Human Nature in American Thought*.

25. The classic exposition is Walter E. Houghton, *The Victorian Frame of Mind, 1830–1870* (New Haven: Yale University Press, 1957), chap.

14. See in general Burnham, "Psychoanalysis in American Civilization," 336–338, 376–380, and Hale, *Freud and the Americans*, 421–433. Cf. Richard C. Cabot, "Veracity and Psychotherapy," *Psychotherapy* 1 (1909) : 32–33.

26. Peter Novick, *That Noble Dream: The "Objectivity" Question and the American Historical Profession* (Cambridge : Cambridge University Press, 1988), contains a current intellectual history of the problem. Walter Lippman's *Drift and Mastery: An Attempt to Diagnose the Current Unrest* (New York : Mitchell Kennerley, 1914) was a typical contemporary document; the quote is from p. 269.

27. See, for example, Waldo Frank, "Valedictory to a Theatrical Season," *The Seven Arts* 2 (1917) : 366–367. "R. J." [probably Robert Jones], in *The Masses* 10 (May 1915) : 16.

28. W. David Sievers, *Freud on Broadway: A History of Psychoanalysis and the American Drama* (New York : Hermitage House, 1955), 55–56, claims that psychoanalysis actually appeared on the American stage a month before *Suppressed Desires*, in the form of an association test in a comedy by Clare Kummer called *Good Gracious, Annabelle.*

29. See the comparative essays in *Comparative Studies in Society and History* 24 (1982) : 531–610. Leo Stein, "American Optimism," *Seven Arts* 2 (1917) : 90. Stein of course was by that time already in Provincetown itself; Mabel Dodge Luhan, *Movers and Shakers* (New York : Harcourt, Brace, 1936), 406.

30. Some suggestion of the wider context is in Arnold Goldman, "The Culture of the Provincetown Players," *Journal of American Studies* 12 (1978) : 291–310.

31. See especially Catherine Covert, "Freud on the Front Page: Transmission of Freudian Ideas in the American Newspaper of the 1920's" (doctoral diss. Syracuse University, 1975), and Burnham, *Paths into American Culture*, chap. 5.

The American Reception of Psychoanalysis, 1908–1922

SANFORD GIFFORD

When E. E. Cummings wrote about the "Young Woman of cambridge, mass. / to whom nobody seems to have mentioned ye old Freudian wish,"[1] he was referring to one of the well-known popularizations of psychoanalysis, E. B. Holt's *The Freudian Wish and Its Place in Ethics*, published in 1915. But contrary to Cummings's stereotype, of "a certain Young Woman unacquainted with the libido / and pursuing a course of study at Radcliffe college," the young lady's mother had probably learned quite a bit about the libido from Professor Holt. He might well have been her mother's psychology instructor, as the author of a popular lab manual in 1903. Holt was also an academic colleague of Cummings's father, who was both a Unitarian minister and a popular professor of sociology at Harvard. Far from being the Freudian apostle of sex that Cummings implied, Professor Holt was a moralist as well as a popularizer of psychoanalysis. A student of William James, Holt had attended Freud's lectures at Clark University in 1909 and hailed Freud for giving us "the first key which psychology has ever had which fitted."[2]

Psychoanalysis has become a subject for historical study only within the past twenty years. Until Burnham's 1967 monograph, there was only Ernest Jones's biography of Freud in 1959, and Oberndorf's 1953 history of American analysis.[3] Both Jones and Oberndorf were analysts, with the advantages and drawbacks of having participated in the events they described. Hence we owe to Burnham, Nathan Hale, and other subsequent professional historians[4] our familiarity with the date 7 September 1909, when Freud lectured at the twentieth anniversary of the founding of Clark University at Worcester, Massachusetts.

For psychoanalysis, Freud's Clark lectures were the equivalent of the 1913 Armory Show for the history of modern painting in the United States. The occasion came close to the often-quoted turning-point that Virginia Woolf proposed for a change in modern sensibility: "On or about December 1910, human nature changed." In the history of psychoanalysis in the United States, however, there is a cluster of significant dates that precede the Clark Vicennial in 1909.

The initially warm reception of Freud's ideas was based on the false assumption that analysis was merely one of many popular psychotherapies of suggestion. The psychotherapy movement had evolved, like psychoanalysis itself, from the work of Charcot and other French neurologists, who treated hysteria by means of hypnosis. The movement reached its maximum popularity at the turn of the century and flourished with special intensity in New England, among the medical elite like J. J. Putnam and Morton Prince and among philosophers and psychologists like Josiah Royce and William James. The psychotherapy of suggestion formed an avant-garde of its own, until it was superseded by psychoanalysis.

There is an irony in Freud's warm reception in the United States, a country which he had never loved and, in fact, held strong preexisting prejudices against. Some of these prejudices were irrational, as in blaming his indigestion on American cooking, and

others reflected conventional nineteenth-century European attitudes toward Americans as sexually inhibited and totally preoccupied with money and profit.[5] But Freud's apprehensions about the American weakness for popularization and indiscriminate eclecticism proved to be well founded, amplified by the techniques of the "new journalism" of the popular press. In that "Age of Reform," an increasingly well-educated public sought remedies in psychoanalysis for many emotional needs: for the "cure" of neurotic illness (as the psychotherapies of suggestion already had), for sexual liberation, and for a more nearly perfect political system. Freud, as we shall see, had explicitly exempted analysis from ethical judgments and from utopian aspirations toward a better society. But in our efforts to recreate Freud in our own image, as Burnham notes, "Freud became the agent not so much of psychoanalysis as of other ideas current at the time . . . as environmentalism, as sexology, as a theory of the psychogenic etiology of the neuroses. . . . His followers often believed not so much in *his* work as in evolution, in psychotherapy, and in the modern world."[6]

PRECURSORS OF FREUD'S LECTURES AT CLARK, 1909

American recognition of Freud goes back to William James's favorable review of Breuer and Freud's *Studies on Hysteria* and to praise of his theories in Robert Edes's Shattuck lecture, *The New England Invalid*. Havelock Ellis had paid his respects to Freud in 1899, incorporating generous quotations in his *Studies in the Psychology of Sex*, along with references to Gertrude Stein's researches on automatic writing.[7] James himself had accepted all forms of mental healing and suggestion, from Breuer and Freud's "cathartic method" to faith healing and Christian Science, as equally valid manifestations of what he called "the mind-cure movement." With his own characteristic optimism, James attributed the popularity of these movements to their "practical fruits," and wrote that "the extremely practical turn of character of the American people has never been better shown than by the fact that this, their only decidedly original contribution to the systematic philosophy of life, should be so intimately knit up with concrete therapeutics."[8]

James's former student, G. Stanley Hall, was a leader in the new field of experimental psychology that James had created, as well as president of Clark University. Hall's monumental book on adolescence[9] had mentioned Freud favorably, and he invited Freud to lecture at Clark's twentieth anniversary celebration to advance the cause of psychotherapy. In his letter to Freud, Hall mentioned Pierre Janet's American visit in 1907, and how his lectures on the psychology of suggestion had influenced "our younger students of abnormal psychology from the exclusively somatic and neurological to a more psychological basis. We believe that a concise statement of your own results and point of view would be exceedingly opportune, and perhaps in some sense mark an epoch in the history of these studies in this country."[10] Besides Hall's interest in encouraging psychotherapy and the scientific study of sexuality, he probably hoped that Freud's ideas could lead to social and political reforms.

William James attended the Clark lectures, along with another former student of his, James Jackson Putnam. As a leader of the psychotherapy movement in Boston, Putnam had already published his observations on the treatment of hysteria at the Massachusetts General Hospital, "With Remarks on Freud's Method of Treatment by Psycho-Analysis."[11] Putnam's paper, despite its echoes of Freud's "cathartic method," deserves to be called the first analytic paper in English. Freud himself called Putnam "the first American to interest himself in psychoanalysis."[12] Putnam's conversion from skeptical sympathizer to a believer in the "cause" of analysis took place sometime

after his meeting with Ernest Jones at Morton Prince's house in 1908. Putnam invited Freud and Jung to his Adirondack camp after the Clark lectures, and his correspondence with Freud continued until Putnam's death in 1918.[13]

An important meeting in the early summer of 1909, attended by both Putnam and Jones, preceded the Clark lectures in September. This first meeting of the American Therapeutic Society was organized by Frederick Gerrish, Morton Prince, and other leaders of the psychotherapy movement. Prince gave an ebullient opening address on the psychotherapies of suggestion, and Putnam spoke enthusiastically about Freud's new contributions to treatment. Jones gave a more detailed account of Freud's current theories, firmly differentiating "psychoanalysis" from all other psychotherapies of suggestion. In contrasting the passive analyst, who invites his patient's active participation, with the authoritarian hypnotist and his passive "subject," Jones demonstrated how free association was "in almost every respect the reverse of treatment by suggestion."[14]

THE BEGINNINGS OF PSYCHOANALYTIC INSTITUTES

After Freud's lectures at Clark, the first institutions of a fledgling psychoanalytic movement were established, only a few years after the first European analytic societies in Vienna, Zurich, and Berlin. Jones persuaded Putnam to be the president of the American Psychoanalytic Association in 1911. A. A. Brill had established the New York Psychoanalytic Society a few months before this, to preserve a separate identity within the International Psychoanalytic Association.

In New York, analytic interest had emerged from a group of young psychiatrists at Manhattan State Hospital on Ward's Island, encouraged by Adolf Meyer, who was chief from 1902 to 1909. The young analysts were led by Brill, who had studied with Carl Jung in Zurich in 1908 and had visited Freud with Ernest Jones that summer.

In Baltimore the new Phipps Clinic at Johns Hopkins Medical School opened in 1910 with Adolf Meyer as chief. In Washington, D.C., William A. White led an eager group of young analysts at St. Elizabeth's Hospital. Putnam founded the first Boston Psychoanalytic Society in 1914. American analytic societies differed from each other, shaped by local conditions and the personality of their leaders. Putnam and Brill were very different in age and background, but they shared an unshakable optimism and boundless energy for promoting "the cause" of psychoanalysis. Putnam came from a distinguished, eccentric Yankee family. He was extremely reserved and modest, but highly respected for his scientific achievements. Though he was already sixty-two when he met Jones in 1908, he published over twenty psychoanalytic papers before his death in 1918 and lectured indefatigably at medical meetings.

In contrast, Brill was thirty-four when he visited Jung at the Burghölzli in 1908, a Jewish immigrant from Central Europe. Brill had arrived penniless and alone on the Lower East Side of New York, supported himself by giving chess and mandolin lessons, and worked his way through medical school. He had rejected Jewish religious traditions and found a fatherly mentor in Frederick Peterson, a leading neurologist who advised him to study with Jung in Zurich. Brill was above all an open, affable, highly gregarious man, unpretentiously retaining the accent and appearance of an East Side immigrant. With his love of jokes and his great generosity, he was a natural leader of the analytic movement and widely admired among nonanalysts.

Both Putnam and Brill were dedicated Freudians, but each had his typical differences with their founding father. Like Oberndorf and other New York analysts, Brill shared the American antipathy to lay analysis and sought to make analysis part of psychiatry and general medicine. Putnam

had no prejudices against nonmedical analysts and appointed a clinical psychologist to the staff of Massachusetts General Hospital, L. E. Emerson. Putnam's differences with Freud were philosophical, as in his unsuccessful attempts to introduce ethical considerations and his own neo-Hegelian idealism into psychoanalytic theory.[15] Neither Freud nor Ernest Jones were convinced.

In his correspondence with Freud, Putnam pursued his ethical ideals undaunted, and Freud teased him gently, in a characteristic encounter between American innocence and European experience. When Putnam asked why psychoanalysts who had been analyzed remained "far from being perfect persons," Freud replied that he himself was

> far more primitive, more modest and more unsublimated than my dear friend in Boston. . . . The unworthiness of human beings, including the analysts, always has impressed me deeply, but why should analyzed men and women in fact be better? Analysis makes for integration but does not of itself make for goodness. I do not believe, as do Socrates and Putnam, that all vices originate in a sort of obscurity and ignorance. I feel that one puts too great a burden on analysis when one asks that it realize each of one's dearest ideals.[16]

In another letter to Putnam, Freud admitted that he considered himself "a very moral human being," in the sense of striving not to hurt others, "even when one is harmed by such behavior." But he disavowed any pride in this and said he had no explanation for this kind of "social morality." As for sexual morality, he wrote, "as society—and at its most extreme, American society—defines it, [it] seems very despicable to me. I stand for a much freer sexual life. However, I have made little use of such freedom." In reply, Putnam tried to convince Freud "that you believe in free will and in religion as much as I do," and that "*a complete analysis would leave one, theoretically, a perfect person*" [italics added].[17]

THE AMERICANIZATION OF FREUD

Thus Putnam insisted, in his nineteenth-century idealism and quasi-religiosity, that Freud was actually an optimist, even a believer in the perfectibility of man, despite Freud's explicit disavowals of all utopian aims. And if Putnam, one of Freud's best-read followers, could make such interpretations, other Americans were even more likely to find in Freud's work what they wanted to believe. As we have learned from Burnham, Hale, and others, Americans saw Freud as 1) an environmentalist, 2) a therapeutic optimist about the treatability of all mental illness, and 3) an advocate of sexual and political reform. There was some truth in each of these wishful assumptions, but much less than Freud's American followers wished to believe.

1) *Environmentalism.* Psychoanalysis emphasized the influence of life events on individual development, in the traumatic theory of neurosis during childhood, and in the "accidental factors" that precipitate mental illness in later life. By stressing trauma and life experience as well as genetic predispositions, Freud was deliberately opposing the nineteenth-century European organicists and advocates of "hereditary degeneration." But he also maintained an emphasis on both the innate and the experiential and proposed a perpetual interaction between them.

2) *Therapeutic Optimism.* Freud's theories were based on the assumption that the *neuroses* could be treated, even "cured," as the psychotherapies of suggestion had already demonstrated. But Freud always adhered to his original view that the *psychoses* were unanalyzable, because the delusional distortions of the psychotic transference could not be changed. Some Swiss analysts, including Jung, and many of Freud's American followers, refused to accept this restriction. William A. White, at St. Elizabeth's in Washington, D.C., applied psychoanalysis enthusiastically to every

kind of mental illness, including chronic schizophrenia.

3) *Sexual and Political Reform*. Freud believed that the restrictions of "civilized" sexual morality increased the incidence of neurosis. But he was far from an active advocate of sexual reform, because he also considered neurosis an inevitable result of civilization and the source of our highest cultural achievements. Yet another element in the American attraction to psychoanalysis was the hope of curing social and political ills. This aim, which was rarely stated, can often be inferred from the accounts of analysands who were later disillusioned by analysis. Freud himself never applied his theories to political issues until his later cultural essays of the 1920s. He was consistent in his low opinion of human nature, his pessimism, and his belief in the non-perfectibility of human beings.

Though Freud lacked the temperament of the sexual reformer, he was inevitably hailed as one because of the central importance of sexual repression in the formation of neurotic symptoms. In Breuer and Freud's pre-analytic *Studies on Hysteria*, repressed sexual impulses were "converted" into physical symptoms.[18] These dramatic paralyses could be relieved by uncovering repressed wishes and forgotten traumatic events. Freud's *The Interpretation of Dreams* extended the theory from symptom formation to the normal psychology of dreams, jokes, and slips of the tongue, which could be analyzed to reveal the underlying unconscious impulses. Freud's *Three Essays in the Psychology of Sex* presented the concept of infantile sexuality as a universal, as well as normal, series of stages in human development. Havelock Ellis's *Studies in the Psychology of Sex* for a time was more widely known than Freud's own writings, and Ellis quoted Freud extensively. Thus in the popular American mind, Freud was enlisted as an ally and supporter of Ellis in the cause of sexual reform and the benefits of sex education.[19]

Freud himself wrote only one polemical paper during this period that seemed to advocate changes in social attitudes toward sex, "'Civilized' Sexual Morality and Modern Nervousness". The essay begins as a commentary in support of a book, Von Ehrenfels's *Sexual Ethics*, which attacked nineteenth-century hypocrisy about monogamy and the double standard. Like other medical moralists of the period, Freud believed that "'civilized' morality" depleted sexual vitality and reduced our capacity for survival in the evolutionary process. He assumed that the fathers of urban neurotics had come to the city from "rough but vigorous families, living in simple, healthy, country conditions," and that they had raised their offspring to higher cultural levels through their self-made exertions. Freud supported this cliché of city versus countryside by referring to Binswanger and Krafft-Ebing, conventional psychiatrists of his time. He quoted an American, George Beard, as being the first to recognize the effects of urban life in causing "modern nervousness." Perhaps America carried these urban conditions to an extreme, Freud suggested, "with its unbridled pursuit of money and possessions" and its advanced technology, especially the telephone and telegraph. "The injurious influence of civilization," Freud continued, "reduces itself in the main to the harmful suppression of the sexual life of civilized peoples (or classes) through the 'civilized' sexual morality prevalent in them ... [although] generally speaking, our civilization is built upon the suppression of instincts," both aggressive and sexual.[20]

Freud's moralizing against "'civilized' morality" was irresistible to Havelock Ellis and other popularizers of sexual reform. Freud's essay was translated and reprinted in the *American Journal of Urology* in 1915, and again in 1931 as a pamphlet by Eugenics Publications. Emma Goldman, who had attended Freud's lectures at Clark, carried away the optimistic message that the lifting of sexual repression would eventually undo the supposed intellectual inferiority of

women. As she later wrote in 1931, "The arbitrary and pernicious dictum of total continence probably also explains the mental inequality of the sexes. Thus Freud believes that the intellectual inferiority of so many women is due to the inhibition of thought imposed upon them for the purpose of sexual repression."[21]

This passage in Goldman can be found almost verbatim in Freud's 1908 essay, where he disputed Moebius's concept of "women's 'physiological feeblemindedness.'" Freud wrote: "I think that the undoubted intellectual inferiority of many women can rather be traced back to the inhibition of thought necessitated by sexual suppression." By this he meant educational attitudes which forbade girls and young women from "concerning themselves with sexual problems though they nevertheless feel extremely curious about them." Such an education "frightens them by condemning such curiosity as unwomanly and a sign of a sinful disposition. In this way they are scared away from *any* form of thinking, and knowledge loses its value for them. The prohibition of thought extends beyond the sexual field."[22]

Emma Goldman, who read widely in German and English, traveled back to Europe on speaking tours, as well as study trips in search of what was new in radical thought. In 1907–1908 she may have read Freud's essay in a German journal, *Sexual Probleme*, which continued an earlier periodical called *Mutterschutz*, literally "Mother-Protection" or "The Protection of Motherhood." There is an echo of this title in her own publication, *Mother Earth*, which she had founded in 1906, although she explained its title by some poetic associations to spring.

Even before this, in 1896, Goldman had been impressed by Freud when she heard him lecture to medical students in Vienna, where she was studying midwifery under the pseudonym of Mrs. E. G. Brady. When she heard him again at the Clark lectures in Worcester, she herself was lecturing on anarchism from the hospitable lawn of the

Rev. Eliot White. With the advantage of understanding Freud's German, she admired him for "the lucidity of his mind and the simplicity of his delivery." Among the pompous professors, "stiff and important in their university caps and gowns," she saw him "in ordinary attire, unassuming, almost shrinking . . . like a giant among pygmies."[23] Thus she succeeded in seeing him almost as a proletarian, as Putnam had seem him as a true believer. Elsewhere in her memoirs, Goldman indicated that she had found what she needed among Freud's theories: how to eliminate female intellectual inferiority by lifting sexual inhibitions.

THREE EARLY EXPERIENCES WITH PSYCHOANALYSIS

As a self-educated European radical, Emma Goldman had no difficulties with Freud's theories of femininity, probably because he saw women's intellectual and emotional handicaps as imposed by society and hence susceptible to change, a view that contradicted the biological theories of innate inferiority advocated by Moebius and other German neurologists. As far as we know, Goldman felt no need to undertake personal psychoanalysis. From other members of the Greenwich Village intelligentsia, among whom Goldman was a familiar figure,[24] we have three self-observed reports of their own analyses: Mabel Dodge Luhan, Floyd Dell, and Max Eastman. All three were seeking help with personal conflicts, and all three were engaged in radical political activity, but only Eastman acknowledged his hope of political enlightenment through analysis, and his later disillusionment.

The most prominent of these analysands was Mabel Dodge Luhan, whose famous salon at 23 Fifth Avenue was so influential in publicizing psychoanalysis, modern art, the IWW, and other radical causes. In a classic description, Lincoln Steffens wrote

about her Wednesday evenings in 1915–1916:

> It was there and thus that some of us first heard of psychoanalysis and the new psychology of Freud and Jung, which in several discussions, one led by Walter Lippmann, introduced us to the idea that the minds of men were distorted by unconscious suppressions. . . . There were no warmer, quieter, more intensely thoughtful conversations at Mabel Dodge's than those on Freud and his implications.[25]

Mabel Dodge's account of her two analyses can be found in the third volume of her memoirs, *Movers and Shakers*.[26] She learned about Freud during the heyday of her New York salon, 1913–1915, when Brill talked at her Wednesday "Evenings," and she consulted Smith Ely Jelliffe briefly about a frightening experience with peyote. But when she sought psychoanalytic treatment for herself, she had given up her Fifth Avenue apartment and moved to a farm at Croton-on-Hudson. She chose Jelliffe to discuss a long-standing conflict: her inability to resolve a tormenting relationship with the painter Maurice Sterne. She was immediately fascinated by Jelliffe's imagination and by his voluble discourse on symbols, myths, and their bodily representations.

> I enjoyed my visits three times a week to Jelliffe's office. He had a speculative mind with an amusing intuition. As he turned my attention more and more upon the inner workings of my own nature, curious spiritual events began to occur. . . . I was able to tell, not only everything about myself, but all about Maurice. I grew calm and self-sufficient, and felt superior to him in the evening when, returning from New York, I found him still in the grip of his nervous fears and worries.[27]

The modern reader may be surprised by Jelliffe's prodigious flow of intellectualizing comment, even allowing for his patient's predilection for this approach. "It was in-teresting to watch my soul provide exciting subjects to discuss with Jelliffe. Something would turn up from down below to keep the ball rolling—and he and I chased it about. We talked for hours."[28] Even more surprising was Jelliffe's involvement in a kind of family therapy, attending her parties on the farm, interviewing her closest friends, and actively trying to interest them in being analyzed themselves.

Despite Dodge's rapid relief from depression and anxiety, and her joyful claim that Sterne "found me changed because I was free of him," her treatment still centered around their relationship. She believed that Jelliffe was "trying to pry us apart," while Jelliffe protested that he only wanted to make her independent and able to make her own decision, uninfluenced by him. Dodge herself acknowledged that she "could not face losing my torturer!" and that she had "never admitted to [Jelliffe] that Maurice *was* detrimental to me." Finally, after about a year, "when the amusing speculations ceased to amuse . . . the old fatigue and depression came back."[29] In the spring of 1916 Mabel Dodge discontinued her analysis, and turned to Emma Curtis Hopkins, a former disciple of Mary Baker Eddy. Mrs. Hopkins had left Christian Science for a more mystical form of faith healing, which she practiced at the Iroquois Hotel on West 44th Street, in a darkened room filled with fresh flowers. Even during her analysis with Jelliffe, Dodge was also having occasional sessions with Nina Bull, a pupil of Mrs. Hopkins.

After a summer in Provincetown, Dodge sought further analysis with Brill, then the best-known analyst in the United States. In Brill she found a very different approach, a practical, common-sense program for regulating her everyday life and choosing a suitable career. Brill brushed aside her wish to talk about her "very bad Oedipus complex." "'Never mind about that,' said Brill, seated across from her at a mahogany desk, 'I want your dreams. I want you to organize your life so that you have plenty of

occupation and I want you to bring in at least one dream every time you come.'" By "organize" he meant "'Make a program and stick to it. . . . Do you like to paint or write? My impression is you are out of place in the country. I think you should be working with a number of people. I may be wrong but I believe *people* constitute your best medium.'"[30]

Despite their endless arguments about where she should live and what she should do with her life, Dodge liked Brill at once and had confidence in his integrity. As much as she regretted giving up the "interesting speculations" that she had enjoyed with Jelliffe, she accepted Brill's emphasis on adaptation to the world as it was. "Brill was all for action, whereas Jelliffe was speculative and considered the play of the psyche and the mind a good outlet in itself. Apparently nothing counted unless it was painted, written down or formulated into some life-pattern composed of persons and their movements." She got the impression that "my previous existence at 23 Fifth Avenue, with its Movements, Leagues, Unions, its Evenings and all . . . constituted the perfect adjustment for me."[31]

She concluded that Brill believed "repressions were involuntary and that only sublimations could be treated," and that "neurotics were the only people who accomplished anything in the world." She attempted to discuss these issues, asking whether sublimations were "byproducts and their chief function [was] not to create beauty and a more abundant life but to keep people out of insane-asylums." Brill told her to stop "trying to be clever and tell him a dream." When she asked if a manic-depressive could "cure herself," implying that this was Jelliffe's diagnosis, Brill interrupted: "'That's enough. You are not here for conversation.'"[32]

Unhampered by "analytic neutrality," Brill's active technique quickly led Dodge into the public role of a newspaper columnist, through her friendship with Arthur Brisbane of the *New York Journal*. Brisbane asked for "two or three little *feuilletons* a week, upon any subject I cared to write about, and paid me $30 apiece for them!"[33] Brisbane was even more directive as an editor than Brill had been as an analyst, and Mabel Dodge soon acquired wide popularity. Her opinions about mother love, the role of working women, and other issues of the day were syndicated throughout the country in the Hearst papers. She was able to work as a journalist without leaving her farm, in spite of Brill's conviction that she belonged in the city, and Brill seemed unconcerned about her relationship with Maurice Sterne. After a time, however, she began to wonder "exactly what I was working *for*, since my depression had ceased and I was enjoying perfect health." Dodge concluded that she was writing her column in order to "pacify" Brill, and that in coming under his influence she had lost some of her convictions and "a good deal of color out of my life *along with the surplus of tension*" (italics added).[34] In other words she was more comfortable but less imaginative. She found herself concealing from Brill all her religious and mystical beliefs, which he had scorned, as well as the resumption of her "treatment" with Mrs. Hopkins.

Dodge married Maurice Sterne in August 1917, and after another confrontation about his infidelity, she sent him to explore the Southwest. At that moment she fell ill, with "a mysterious aching and swelling in the left side of my throat, in the thyroid gland." She ceased to have dreams, and Brill suggested an interruption in the analysis. This presumably psychosomatic symptom vanished very quickly under the physical ministrations of a masseuse sent by Mrs. Hopkins, whose touch "sang the pain to sleep." Dodge next consulted a medium in Brooklyn, whom she had heard about at Adele Lewisohn's (some members of the Lewisohn family were patients of Brill). The medium was an apathetic young woman who went into a trance and had visions of Dodge surrounded by Indians and guided by an older man.[35]

Dodge soon had her own dream, in which

Sterne's face, "with its handsome features and its alien Oriental expression," was replaced by another face, "with green leaves twinkling and glistening all around it—a dark face with wide-apart eyes, . . . an Indian face [that] affected me like a medicine. . . . I sighed and let it take me and cleanse me." Shortly afterward, on 30 November 1917, she received an enthusiastic letter from Sterne that began : " Do you want an object in life ? "[36] Then he extolled the beauties of New Mexico and her possible role in saving the Indians and their culture, threatened by the insensitivity of the U.S. Indian Bureau. Mabel Dodge soon joined him, to spend the rest of her life in Taos, pursuing the rescue of Indian culture and a great many other literary and cultural projects.

How much use Mabel Dodge made of her two analyses is very difficult to judge from her published self-observations. She seemed highly responsive to any form of treatment for the relief of acute symptoms of depression and inertia, and she made a brief though successful career as a newspaper columnist under Brill's tutelage. But asking herself "whom she was doing this for" harks back to her childhood difficulties in being a "self-starter" and waiting for "the boys to take the initiative and suggest things."[37] Although this seems an exaggerated form of the "expected" passivity imposed on upper-class girls by nineteenth-century society, Dodge's lifelong problem with satisfying relationships and lasting professional roles was more complex. She recognized its relation to her exceptionally chilly, emotionally isolated upbringing, with parents who had no affection for each other or for her. She was not a dilettante, and her dedication to successive causes was sincere and effective, but she needed to recreate a new identity many times over in the course of her life. These very qualities make her a touchstone for the cultural changes of her time, but not a fair test case for the efficacy of early psychoanalysis. No present-day ana-

lyst would expect significant results from such short periods of analysis.

Until the 1930s, however, brief analyses were quite common, and the styles of both Jelliffe and Brill illustrate other differences from accepted analytic practice, even a decade or two later.

The next two examples of analysands who published their experiences, Floyd Dell and Max Eastman,[38] were also prominent figures in the "little renaissance" of Greenwich Village and Provincetown who knew Mabel Dodge very well. As Dell wrote in 1915, when he was editor of *The Masses* :

Psychoanalysis is the greatest discovery made by intellectual conversationalists since Bergson and the IWW. Nothing quite so provocative of argument has happened since Nietzsche. As a science it has been going on quietly this score of years or more. But as a topic of polite conversation, it first saw the light of day a short while ago in the throbbing studios of Washington Square, where it immediately [sup]planted Cubism, Imagism, and Havelock Ellis.[39]

Dell was a Middle Westerner from Davenport, Iowa. He came to Greenwich Village in 1913 from Chicago, which was undergoing its own "little renaissance" with Harriet Monroe's magazine *Poetry*, the writings of Carl Sandburg, Theodore Dreiser, and Sherwood Anderson, and the new architecture of Louis Sullivan and Frank Lloyd Wright. In Chicago, Dell had already heard of psychoanalysis, and he had tried to interest Anderson in Freud's theories. In New York he was active on the prewar *Masses* and in the Provincetown Players.

Dell began his analysis in 1917 with Dr. Samuel A. Tannenbaum, who was popular among Village radicals. Known for his views about the ill effects of " 'civilized' sexual morality," he suggested the possible therapeutic value of sex with prostitutes. This shocked many physicians, including analysts like Brill, who reemphasized Freud's

belief that analysis should be conducted in a state of sexual abstinence. Dell wrote that Tannenbaum "later repudiated the whole Freudian theory, but at that time he was orthodox."[40]

Dell wrote very little about why he undertook psychoanalysis, but he believed he had been prepared for analysis by working on his novel, which resurrected many childhood memories, and by his "familiarity with the technique of 'associating' to words." Dell claimed "there was no time lost in resistance. . . . Memories, dreams and associations poured out of my mind in a never ending torrent."[41] His analyst gave no interpretations and let him interpret his dreams for himself.

> Nor did he tell me I had a terrific mother-complex, and was narcissistic, had a great deal of unconscious homosexuality, and a variety of other frightful-sounding traits; I found all that out myself and told him. He offered me no advice upon my private life; it was my own idea that I should not have any love affairs while I was being analyzed.[42]

Dell wrote enthusiastically about the results of his analysis, how he gained greater confidence in his writing and was enabled to accept the responsibilities of marriage. Although the analysis was "much interrupted and never completed," he believed it gave him nothing less than "a new view of the whole world. These psychoanalytic ideas affected literature, criticism, education, love, family life, child-rearing," and provided the basis for a new understanding of history, "not supplanting the Marxian one but supplementing it. Here was an idea of the same importance as the Copernican idea, the Darwinian idea, the Marxian idea." Along with this change in outlook, Dell noticed that he wrote better than he ever had, and discovered in himself a new happiness and self-confidence. "My character was not made over . . . but I could see it in its habitual op-

eration. . . . I was not the blind victim of unsuspected motives; I was happier and freer even in my follies, of which I was to perform a plenty."[43]

Few patients have written such eloquent testimonials to the therapeutic benefits of analysis, especially about the access of new psychic energy that emerges when repressions are lifted. Dell's comments suggest an intelligent reading of analytic literature, and his strong emphasis on the recollection of childhood memories through free association may reflect his own interests as much as his analyst's technique. Nevertheless Tannenbaum, the most radical of the early analysts and eventually a defector, conducted a most orthodox analysis by present-day standards, to judge from Dell's emphasis on his analyst's neutrality, his attentive, silent listening, and his non-interpretive style.

Our third example, Max Eastman, was chief editor of *The Masses*. Initially the strongest advocate of analysis, in his memoirs he gives an interesting glimpse of pre-analytic psychotherapy as well. Eastman wrote that Freud had been his teacher and, "by proxy at least, my Father Confessor."[44] Eastman's parents were both Protestant ministers, and his mother had already had consultations with Brill long before Eastman began his analysis with Jelliffe in 1914.

Eastman had had two previous treatment experiences, the first in the residential treatment of a neurotic back pain that had disabled him for a year and a half after he graduated from college. This took place in 1906 at Dr. Sahler's New Thought Sanitarium at Kingston-on-the-Hudson, where Eastman aptly described the regime as "a practical-minded first cousin to Christian Science, a mixture of suggestive therapeutics, psychic phenomena, non-church religion, and a business of conquering the world through sheer sentiments of optimism."[45] Besides moral uplift Eastman

encountered both hypnosis and spiritualism, as well as a beautiful attendant named Rosanna. He fell in love with her, conducted her into hypnotic trances in which she had two personalities, but he became frightened when she fell in love with him.

His second sanitarium experience, for the same back symptoms, was at Bethel, Maine, under the care of the celebrated Dr. George Gehring, a follower of Dr. Frederick Gerrish, of Portland, Maine, whose dramatic cures by hypnosis exemplified the preanalytic psychotherapies of suggestion. Gerrish was president of the American Therapeutic Society in 1909, when Jones and Putnam had talked of Freud's theories. Gerrish and Gehring, and later Austen Riggs, helped create a New England tradition, the "medical psychotherapy" of Robert Edes, Richard Cabot, Joseph Pratt, and other physicians and surgeons who treated neuroses by hypnosis, group therapy, and "moral re-education."[46] Grateful patients with complex and disabling neurotic symptoms talked and wrote about this inspirational atmosphere, as in Robert Herrick's novel, *The Master of the Inn* (1915), which was based on his experience at Bethel with Gehring.

For Eastman, the treatment at Bethel began with a detailed autobiography, which he was asked to write and discuss at great length. Then Gehring made a diagnosis of "imperfect nerve tissue . . . which all the Brahmins have," and gave the prognosis that Eastman might never get well but could learn to live a useful life. This was followed by sedative doses of strontium bromide and bedside visits from Gehring whose "gruff, gentle voice" would "'suggest' tranquility and fortitude rather than health." Then, after a long, tightly scheduled regimen of enforced activity and repose, Eastman became convinced that his pain was "an idea stuck in the subliminal, an obsession, and nothing else."[47] Eastman noted the simplemindedness of the technique, which recalled his mother's moral injunctions to deal with conflict by trying to "think it out and

dare it to hurt." Nevertheless, after three "amazingly happy months," his symptom was cured, except for a lingering need for ritualized naps.[48] He left to begin his life's work in New York, on New Year's Day, 1907.

Eastman called Gehring "the man who saved me from a life of invalidism,"[49] but he expressed no such praise for his later analyst, Smith Ely Jelliffe. Eastman consulted Jelliffe in New York City during the winter of 1913–1914, at the suggestion of Dr. Beatrice Hinkle, whom he had met during a brief return visit to Dr. Sahler's sanitarium at Kingston. After several blissfully happy years of marriage with his first wife, Ida Rauh, and the birth of their daughter, Eastman had fallen into a protracted agony of guilt, depression, and fear of enslavement that was destroying their relationship. He attributed this suffering to a minor infidelity which he had confessed to his wife, but he was unable to talk either to her or to his sister, Crystal, with whom he had a close relationship. To Dr. Hinkle, however, he "poured out . . . the tangled mass of thoughts and feelings," describing her as "an enthusiastic psychoanalyst" who had been a student of Carl Jung in Zurich.[50] Eastman hoped she would analyze him, but she recommended a male analyst and referred him to Jelliffe, perhaps the best-known in New York after Brill.

Eastman was accepted for analysis "for a fee that would be a song today," for four sessions a week. He continued for several months in the winter and spring of 1914, but gave up his analysis in "the fateful summer . . . [when] Ida and I joined the trek of New York's intelligentsia to Provincetown." He described Jelliffe as "a round-bodied, hearty, friendly, energetic doctor, prodigious in memory, bursting at the seams with knowledge, credulous of unverified ideas (as Freudians must be). . . . He was a Niagara talker, and as I am a Lake Ontario listener, our sessions were more like a lecture course than a clinic. I read Freud and every book on Freud then available in English, rehearsing the doctrine point by

point with its agile-minded apostle, and becoming once more a kind of amateur specialist in mental healing."[51]

Although Eastman liked Jelliffe and claimed he felt "the peculiar affection . . . Freud calls 'transference,' " his analysis seemed to remain on a didactic, intellectualized level. "My problems, needless to say, were not solved by this feat of learning." No new memories of childhood were uncovered, and the unconscious contents that emerged from his dreams all seemed equally plausible : "Homosexuality, mother fixation, Oedipus, Electra and inferiority complexes, narcissism, exhibitionism, autoeroticism, the 'masculine protest,' I never heard of an infantile fixation of which I could not find traces in my make-up." Because of this ready acceptance, Eastman claimed that he had "no strenuous 're-sistance' " to analysis, but he complained that he had never experienced "the healing pain at confronting my true nature that those liberated by psychoanalysis like to boast about."[52]

Eastman wondered whether a more skeptical analyst might have helped him understand more about himself than Jelliffe, from whom he had merely "learned about Freud's psychology." Jelliffe was "too glib with ideas," and his interpretation of Eastman's radicalism as an Oedipal reaction against his father, seemed too simplistic. After a later consultation with Brill, who pointed out his strong "mother fixation" and attachment to his sister, Eastman found "Brill . . . no more convincing to me theoretically than Jelliffe was, but he has an intuitive sensitivity toward people that makes him a master in the clinic. They both had, I must add, a breadth and sweetness of character that did much to launch Freud's doctrines on a high plane in America."[53]

In these three accounts of Dodge, Dell, and Eastman, there is a certain consistency in their portrayals of Brill and Jelliffe, especially of the latter as a verbose intellectualizer. Eastman even consulted Brill as a potential second analyst, like Mabel Dodge,

and gives a sympathetic picture of him in his autobiography. But Eastman gradually turned away from analysis, perhaps because Freud failed to supply the understanding of social conflicts that he was seeking. Walter Lippmann, who had been the earliest New York intellectual to interest himself in analysis, explicitly sought to apply Freud's theories of sublimation to social and political conflicts : "Instead of tabooing our impulses we must redirect them. . . . The assumption is that every lust is capable of some civilized expression." Lippmann became interested in psychoanalysis during the summer of 1912, when he was sharing a cottage with Alfred Kuttner, who was then translating *The Interpretation of Dreams* into English.[54]

Other members of the same radical circles were more influenced by Jung, who had given a series of lectures at Fordham University in 1912. The American public, including many early analysts, tended to ignore the differences between Freud and Jung, even after Jung had renounced the libido theory and made his final break with the international psychoanalytic movement in 1914. Jelliffe remained sympathetic to Jung until the mid-1920s, and several of his lay assistants were analyzed by Jung. Beatrice Hinkle, a prominent Jungian, analyzed James Oppenheim, editor of *The Seven Arts*, an important cultural magazine of the period. Oppenheim eventually became a Jungian therapist himself. In 1919, according to the minutes of the New York Psychoanalytic Society, Oppenheim was censured by the society as one of the "quacks" who were accused of "practicing medicine without a license," in other words practicing as lay therapists.[55]

This is not the place to discuss the fierce controversies over lay analysis that dominated the 1920s and continue up to the present. But our "medical fixation," as Freud called our insistence that only physicians were suitable for psychoanalytic training, was the chief characteristic that set American psychoanalysis apart from the European analytic movement. The censure of

Oppenheim in 1919 was the harbinger of a new, more conservative era in analytic training. When native American analysts reestablished contact with Europe, they found a new psychoanalytic training institute in Berlin. This marked a change in the organization of analysis, with an increasing emphasis on regulations and more elaborate training standards. The process was inevitable, and important for the future quality of analysis, but the immediate effect was to dampen the lively interplay among early psychoanalysts, radical political figures, and the writers and painters of the Modernist movement.

In the 1920s, there was also a general tendency for the Village intellectuals to become more conservative, like Dell, or to turn away from analysis altogether, like Lippmann and Max Eastman. The young radicals' initial optimism, and their earnest hopes of finding in psychoanalysis solutions to intractable social problems, may seem naive in retrospect. But their zeal and enthusiasm were sincere, not merely a fashionable vogue, and their healthy desire to shock bourgeois conservatives was shared by the early analysts. Established analysts like Brill and Jelliffe, who continued as leaders of the next analytic generation, were rarely accused of exploiting the sexual elements in Freud's theories for the sake of sensationalism and publicity. On the contrary, American analysts were accused of deemphasizing the sexual etiology of neurosis and overemphasizing "sublimation" in the arts and sciences as a safe and eminently "practical" application.

TWO AMERICAN POPULARIZERS: ANDRÉ TRIDON AND THEODORE SCHROEDER

Besides the serious early analysts and their radical followers, there were also opportunists who did exploit Freudian sexual theories for their shock value and for their own self-advertisement. Some of these sensational popularizers also set themselves up as therapists, gave public lectures, and called themselves analysts. Some wrote best-sellers on psychoanalysis, just as American members of the psychotherapy movement and the early American analysts had done, in contrast to the European practice of publishing analytic articles in learned journals. This type of popularization confirmed Freud's worst apprehensions about Americans' capacity for eclecticism, vulgarization, and the dilution and distortion of his theories. Hale, among other historians, has suggested that these "wild" analysts played a part in exaggerating the American antipathy to lay analysis.[56] Two brief examples, Theodore Schroeder and André Tridon, will suffice to illustrate varieties of the phenomenon, the first an eccentric who bordered on respectability, the second an unabashed publicity seeker.

Schroeder was a lawyer, active in the Free Speech League, which was founded by Lincoln Steffens in 1911 to protect the rights of radicals like Emma Goldman to give public lectures. As a self-proclaimed foe of religious hypocrisy, Schroeder used analysis to discredit religion with as much shock value as possible. He wrote articles like "The Erotogenesis of Religion" and "Revivals, Sex and the Holy Ghost," one of which was published in the first issue of the *Psychoanalytic Review* (1913–1914).[57] His relentless need to talk about "the obscenity of religion" led Steffens to confess: "I believe in Free Speech for everyone but Schroeder."[58]

André Tridon was a French émigré who came to New York in 1903 at the age of twenty-five. According to Hale, he "wore a lustrous black beard, dressed impeccably and would gild his toenails for costume parties," which Dell had organized at the *Masses* as Pagan Routs. Tridon was said to have worked with Emma Goldman at the anarchist Ferrer School, but there is no reference to Tridon in her memoirs, nor in Drinnon's

biography of Goldman, and Tridon neither quotes nor refers to Goldman in his chapter on free love.[59] Hale suggests that Tridon may have translated Freud's 1908 essay on "'Civilized' Sexual Morality and Modern Nervousness" for Dr. William J. Robinson, the medical reformer and advocate of sex education who first published it in English.

Schroeder was a compulsive talker, and Tridon was an amazingly glib and facile writer who published six books on psychoanalysis between 1919 and his early death in 1922. He listed himself as a member of the Medico-Legal Society of New York and the Adlerian psychoanalytic society in Vienna. He repudiated romantic love, Bergson's élan vital, religion, and conventional morality. He embraced all analytic theories indiscriminately, as well as some behaviorism and questionable endocrinology. He portrayed analytic treatment as effortless, and his books were so popular, according to Bernard de Voto, that he made "every sofa a consulting-room." As Hale succinctly concludes, Tridon "successfully identified psychoanalysis with Greenwich Village, free love, birth control, debunking and socialism. It is no wonder that the appalled Freudian physicians soon took steps to see that no layman could become a psychoanalyst."[60]

Distaste for sensationalism was not a sufficient argument against lay analysis, because charlatans like Tridon were easy to identify and rarely sought admission to the analytic establishment. Ironically, those who were rejected for membership by the New York Psychoanalytic Society included some reputable lay therapists like the Jungian James Oppenheim, and Louise Brink, who had been analyzed and trained by Jelliffe.

CONCLUSIONS

The early New York analysts and the Greenwich Village intellectuals drifted apart during the 1920s, as the postwar years ushered in a more conservative era. The analytic movement, as a minority group within medicine and psychiatry, still retained some revolutionary aura and continued to attract unorthodox followers. But the eccentric individuality of the pioneer analysts, with their exuberance and their naiveté, succumbed to the need for organization. Under new rules and regulations, Brill was leading the New York Psychoanalytic Society on what he believed was the path to scientific respectability. This meant the acceptance of psychoanalysis by the medical establishment. Brill's renewed attacks on lay analysis and lay therapists reinforced native American prejudices and widened the gap between American and European analysis.

As for the Village intelligentsia, although it continued to include political radicals and avant-garde painters, John Reed was dead, Emma Goldman lost her battle against deportation, and others suffered from the quasi-McCarthyite postwar atmosphere of political repression. Among the three analysands whose self-descriptions we have examined, Eastman and Dell became more conservative, and Mabel Dodge withdrew to "the edge of Taos Desert." Each one had reported some beneficial results of treatment, Dell perhaps the most enthusiastic and articulate, but all three turned away from psychoanalysis to other interests. One radical editor of the period, James Oppenheim, became a full-time Jungian psychotherapist.

With so few clinical examples, generalities about early American psychoanalysis must be limited. But there were marked individual differences in style among the three analysts, and striking differences from present-day psychoanalytic practice. Of the three, Tannenbaum was the most politically radical and yet came closest to the conventional style of later years: the relatively silent analyst, encouraging free associations and sparing of his own interpretations. Jelliffe's overwhelming verbosity, along

with a great deal of intellectualizing and free-wheeling theoretical speculation, sounds far from present-day practice and idiosyncratic even for that early period. The consistency between Dodge's and Eastman's accounts of Jelliffe's personal style suggests that it was not evoked by his analysands' individual personalities.

A surprising difference from current analytic practice was the "active technique" of Brill, then America's foremost analyst, with his direct intervention in his analysands' life decisions, and, in Dodge's case, even in the details of daily life. This disregard of traditional "analytic neutrality" was apparently justified by Brill, on theoretical grounds, as a means of "manipulating his patient's sublimations," according to Dodge's account. Such an approach may have contributed to Brill's effectiveness as a therapist, which many colleagues have commented on, but the method belongs to psychotherapy, not analysis. That this was Brill's predilection, and not merely Dodge's need for a dominating mentor, is confirmed by members of the Lewisohn family, who recall how Brill played the part of a ubiquitous family adviser for many decades. He analyzed or treated several family members and actively entered into decisions about schools, careers, and even vacation plans.[61]

With so much unexamined intervention by the analyst, the present-day analyst would not be surprised that little attention was paid to transference analysis. This was then and now the accepted cornerstone of the psychoanalytic process: to understand how the patient's early attachments to parents are reenacted in his or her relationship with the analyst. In fairness to Brill, however, Dodge's later unpublished (1937–1948) account of Brill describes his technique quite differently. She begins with the "wide mahogany table between us . . . a rampart, making everything very impersonal." She recalls again his insistence on dream interpretation, but she emphasizes his "clear, cold technique" and his infinite patience in waiting for his analysand's own

"discovery that all the answers are within himself."[62] In short, she portrays him twenty years later, after her return to New York in 1937, as a more conventional analyst, more silent and uncritical, less active and intrusive in his therapeutic interventions. We cannot be sure whether Brill had changed, or Dodge was perceiving him differently.

To sum up the initial reception of psychoanalysis in the United States, we have seen how American enthusiasm was based partly on real collective needs and partly on certain wishful misunderstandings. The real needs were for a practical treatment of neuroses and a theory of unconscious motivation, both of which had been partially met by the psychotherapies of suggestion. The wishful elements included the need to see Freud as a more active social reformer than he actually was, both in overthrowing sexual taboos and in creating the possibility for a better political system. There was some promise of both in psychoanalytic theory, but Freud was neither an activist in the sexual revolution nor a utopian believer in human perfectability, as some followers wished him to be.

Was the tendency to embrace Freudian ideas, along with Marxian socialism, women's suffrage, and avant-garde painting, all as forms of Modernism, more pronounced in this country than in Europe? Perhaps the same kinds of Americans had always been drawn to the same variety of radical causes, as Quakers and Swedenborgians were also abolitionists, some Marxists were vegetarians and teetotalers, and "advanced" artists and writers tended toward "progressive" politics. In other words, early American Modernists saw no contradiction between turning inward toward self-understanding and outward toward political action to change society.

This may have been less true of the first analytic generation in Europe, where Freud himself saw changing the world and exploring the mind as almost opposite endeavors. As a schoolboy Freud was first drawn toward political action; he envied his class-

mate Heinrich Braun, the "Young Lion" who became a leading Social Democrat in Germany. Freud's decision to study medicine seemed a turn down another path that led through philosophy, Darwinian evolution, neuroanatomy, and hypnosis to the discovery of the unconscious. This was a different direction from his schoolmates Victor Adler, the socialist leader, and Theodore Herzl, the father of Zionism.

The first analytic generation in the United States, from 1908 to the early 1920s, attracted Modernists and political radicals, as we have seen, while the American analysts of the twenties became more conservative. An opposite pattern seemed to prevail in Vienna, where the early analysts, including Freud, remained politically slightly to the right of center. Then in the twenties, a few Viennese "political analysts," like Otto Fenichel and Siegfried Bernfeld, moved to Berlin, attracted by the new training institute and the more radical political and cultural atmosphere.[63] These radical trends in psychoanalysis were obliterated in continental Europe by Nazism, while the British literary radicals in the 1930s continued to search for a synthesis between Marxian and Freudian theory.[64] The effort failed, under the rise of Stalinism and the Second World War, but the goal remains, despite Freud's anti-utopianism, as a theoretical ideal that is periodically revived, as during the 1960s. The ultimate wish-fulfillment, for "a more perfect human being" within a more equitable society, is a yearning for synthesis that may always recur in one or another place or time, just as it inspired the Modernist artists and writers of Greenwich Village in 1915.

NOTES

1. E. E. Cummings, *Collected Poems* (1923; New York: Harcourt Brace, 1938), 201.

2. E. B. Holt, *The Freudian Wish and Its Place in Ethics* (New York: Henry Holt, 1915), vii.

3. John C. Burnham, *Psychoanalysis and American Medicine: 1894–1918*, Psychological Issues Monograph (New York: International Universities Press, 1967); Ernest Jones, *The Life and Work of Sigmund Freud*, 3 vols. (New York: Basic Books, 1953, 1955, 1957); C. P. Oberndorf, *A History of Psychoanalysis in America* (New York: Harper & Row, 1953).

4. Nathan G. Hale, Jr., *Freud and the Americans: The Beginnings of Psychoanalysis in the United States, 1876–1917* (New York: Oxford University Press, 1971); *James Jackson Putnam and Psychoanalysis* (Cambridge, Mass.: Harvard University Press, 1971); and Peter Gay, *Freud: A Life for Our Time* (New York: W. W. Norton, 1988).

5. Gay, *Freud*.

6. Burnham, *Psychoanalysis and American Medicine*, 214.

7. Josef Breuer and Sigmund Freud, *Studies on Hysteria*, Standard Edition 2 (1893–1895); Robert T. Edes, "The New England Invalid," *Boston Medical and Surgical Journal* 133 (1895): 53–57, 77–81, 101–107; Havelock Ellis, *Studies in the Psychology of Sex*, vol. I (1897–1910; rpt. New York: Random House, 1936).

8. William James, *The Varieties of Religious Experience* (1902; New York: Random House [Modern Library], 1929), 94.

9. G. Stanley Hall, *Adolescence* (New York: D. Appleton, 1904).

10. Quoted in Hale, *Freud and the Americans*, 208.

11. James J. Putnam, "Recent Experience in the Study and Treatment of Hysteria at the Massachusetts General Hospital: With Remarks

on Freud's Method of Treatment by 'Psycho-analysis,'" *The Journal of Abnormal Psychology* 1 (1906) : 26–41.

12. Freud, Preface to J. J. Putnam, *Addresses in Psycho-Analysis* (London: Hogarth Press, 1921), iii.

13. Nathan G. Hale, Jr., *James Jackson Putnam*.

14. Frederick H. Gerrish, ed., *Psychotherapeutics* (Boston: Badger, 1909), 101.

15. Putnam, "Recent Experience."

16. Quoted in Hale, *James Jackson Putnam*, 187–188.

17. Ibid., 189, 195.

18. Breuer and Freud, *Studies on Hysteria*.

19. Freud, *The Interpretation of Dreams*, *Standard Edition* (1900), 4 :1–338; 5 :339–625 (London: Hogarth Press, 1953) ; *Three Essays on the Theory of Sexuality*, *Standard Edition* (1905), 7 :135–243; and Ellis, *Studies in the Psychology of Sex*.

20. Freud, " 'Civilized' Sexual Morality and Modern Nervousness," (1908), *Standard Edition* 9 :182, 185.

21. Quoted in Hale, *Freud and the Americans*, 270.

22. Freud, " 'Civilized' Sexual Morality," 199.

23. Emma Goldman, *Living My Life*, 2 vols. (New York: Alfred Knopf, Dover Edition, 1970), 455.

24. See Arthur F. Wertheim, *The New York Little Renaissance. Iconoclasm, Modernism and Nationalism in American Culture, 1908–1917* (New York: New York University Press, 1976).

25. Lincoln Steffens, *The Autobiography of Lincoln Steffens* (New York: Harcourt, Brace, 1931), 655–656.

26. Mabel Dodge Luhan, *Movers and Shakers* (Albuquerque: University of New Mexico Press, 1985; originally volume three of *Intimate Memories*). Hereafter cited as *MS*.

27. *MS*, p. 439.

28. *MS*, p. 445.

29. *MS*, p. 467.

30. *MS*, p. 505.

31. *MS*, p. 505.

32. *MS*, p. 506.

33. *MS*, p. 507.

34. *MS*, pp. 511–512.

35. *MS*, pp. 532–533.

36. *MS*, p. 534.

37. Quoted in Lois Rudnick, *Mabel Dodge Luhan: New Woman, New Worlds* (Albuquerque: University of New Mexico Press, 1987), 16.

38. Floyd Dell, *Homecoming, An Autobiography* (New York: Farrar and Rinehart, 1933), 293–295. Hereafter cited as *H*. Max Eastman, *Enjoyment of Living* (New York: Harper and Brothers, 1948). Hereafter cited as *EL*.

39. Quoted in Wertheim, *The New York Little Renaissance*, 71.

40. *H*, p. 293.

41. *H*, p. 294.

42. *H*, p. 295.

43. *H*, p. 294.

44. Cited in Wertheim, *The New York Little Renaissance*, 70.

45. Quoted in Hale, *Freud and the Americans*, 246.

46. Lawrence S. Kubie, *The Riggs Story: The Development of the Austen Riggs Center for the Study and Treatment of the Neuroses* (New York: Paul B. Hoeber, 1960) ; Edes, "The New England Invalid"; Sanford Gifford, "Medical Psychotherapy and the Emmanuel Movement in Boston, 1904–1912," in *Psychoanalysis, Psychotherapy and the New England Medical Scene, 1884–1944*, ed. G. E. Gifford, Jr. (New York: Science History Publications, 1978).

47. *EL*, p. 259.

48. *EL*, p. 260.

49. *EL*, p. 261.

50. *EL*, p. 490.

51. *EL*, p. 491.

52. *EL*, p. 491.

53. *EL*, pp. 492–493.

54. Cited in Wertheim, *The New York Little Renaissance*, p. 72.

55. Minutes of the New York Psychoanalytic Society, 1911–1933, p. 27.

56. Hale, *Freud and the Americans*. Hale's unpublished chapter of 1987 has added some new and interesting details; personal communication, 1987.

57. Theodore Schroeder, "The Wildisbuch Crucified Christ. A Study in the Erotogenesis of Religion," *Psychoanalytic Review* 1 (1913–14) : 129–148

58. Quoted in Hale, *Freud and the Americans*, 271.

59. Goldman, *Living My Life*; Richard Drinnon, *Rebel in Paradise: A Biography of Emma Goldman* (Chicago: University of

Chicago Press, 1961) ; Tridon, *Psychoanalysis and Love*. (New York : Brentano's, 1922).

60. De Voto quoted in Nathan Hale, unpublished chapter and personal communication, 1987.

61. Virginia L. Kahn and Joan Simon, personal communications, 1989.

62. Luhan, "Psycho-Analysis with Dr. Brill," typescript, 10 pp., Mabel Dodge Luhan Papers, 1937–1948, Beinecke Rare Book and Manuscript Library, Yale University, pp. 1–5.

63. See Russell Jacoby, *The Repression of Psychoanalysis: Otto Fenichel and the Political Freudians* (New York : Basic Books, 1983).

64. See R. Osborn, *Freud and Marx, A Dialectical Study* (London : Victor Gollancz Ltd., Left Book Club Edition, 1937).

The New Psychology and American Drama

FRED MATTHEWS

The first decades of the twentieth century witnessed a major reappraisal of beliefs about the nature and responsibilities of men and women, their relation to others and to that generalized other called society. One of the focal points of this reappraisal was the crystallization of a new dramatic style, a new sensibility, and a new moral code in the early work of the Provincetown Players. The Provincetown Moment was a point of crisis and change in the thinking (and feeling) of the small but influential cadre of Americans who thought of themselves as "intellectuals," as reasoning men and women who had a duty to subject customary beliefs and practices to critical scrutiny. We can illuminate what was new in the Provincetown Moment by comparing the attitudes toward psychology and ethics in the new drama with those of popular plays in the preceding decade. To understand the new view of human nature, we must first feel the inner power of the older psychology.[1]

Victorian and Edwardian drama employed a set of psychological assumptions drawn from eighteenth-century neoclassicism, and ultimately from Aristotle. In this worldview, social conventions were an essential foundation of personality. Properly internalized through the exertion of will in pursuit of duty and hardened into habit, they would become foundations of the "character" each person constructs. Person-

ality was a structure built up by the channeling of presocial impulses into patterns sanctioned by society. There was no single fixed system of psychology in the nineteenth century, but a general orientation and vocabulary of familiar (if imprecise) terms did exist, drawn from a mix of Christian theology with moral philosophy. The soul or self was composed of a threefold set of faculties, or powers, habitual modes of interpreting and responding to experience. The basic faculties were reason, the power of perceiving experience accurately and forming reliable judgments on it; sentiment, heart or affection; and will, the power to act. These terms faded as psychology became an academic discipline at the end of the nineteenth century, but the vision of the self as something constructed by proper stimuli and conscious effort—this remained powerful in popular thought and in the psychology taught in schools.[2]

An influential early twentieth-century expression of this psychology was the theory of the looking-glass self offered by the Michigan sociologist Charles Horton Cooley. For Cooley, "the kind of self-feeling one has" is molded by the "imagination of how one's self" appears to significant others:

> The character and weight of that other, in whose mind we see ourselves, makes all the difference. . . . We are ashamed to seem evasive in the presence of a straightforward man, cowardly in the presence of a brave one, gross in the eyes of a refined one, and so on. We always imagine, and in imagining share, the judgments of the other mind.

A growing self became mature by building a comprehensive personal ideal out of the reflective judgments of significant others. Continued sensitivity to others was crucial; the "ingrowing sort of mind," indifferent to others' reactions, displayed "gross and persistent egotism," which would be expressed through "sensuality, avarice, narrow and ruthless ambition, fanaticism" and some-

times even crime. This was a strikingly *social* psychology, since the primary humanizing force was the internalizing of other people's expectations to form stable and responsive patterns of behavior.[3]

This psychological theory explains why Victorian plays (like Hollywood movies in the era of censorship) had to have characters who were unambiguously good or bad. Theatre was more than entertainment; it was a means of socializing and maintaining proper socialization, and a potent one just because it entailed intense emotional expression and confrontation. A reviewer of Langdon Mitchell's sophisticated success of 1906 warned against the growing cleverness of social comedy, which was beginning to mock at necessary verities: "*The New York Idea* is very up to date. . . . Gentlemen like Mr. Mitchell do not appreciate, perhaps, the power of the medium at their command, and, therefore, do not stop to think that they should be . . . very careful, how they use it, lest they should sow evil in minds not able to understand the good they intend."

As *Life*'s critic shows, observers were worrying over the stability of the moral code before Provincetown, though challenges mainly came from European critics like Ibsen rather than from native writers. Homegrown dramatists usually adopted an ambiguous stance, urging that moral conventions be enforced with sympathy and kindness. This theme of understanding was central to Clyde Fitch's hit of 1907, *The Truth*, which carefully affirmed the moral absolutes while extending empathy to a woman who pushes against their boundaries.[4]

Fitch's popular hit is the first of three plays whose juxtaposition reveals the evolution of attitudes toward personal morality in what was to traditionalists its ultimate sense, that is, the acceptance of marital fidelity as permanent and necessary. In Fitch's play it is inconceivable that Becky, his heroine, could have been anything but an innocent flirt; indeed, her realization that her husband could think otherwise helps her to grow morally, to become responsibly ma-

ture. Augustus Thomas's *As a Man Thinks* of 1911 is a reply to Ibsenite demands for a woman's right to self-expression. Here adultery is a clear possibility. But its justification is presented vividly, only to be crushed under the weight of a sociological argument for the necessity of marital fidelity and the triviality of individual happiness. One of the founders of the Provincetown Players, Susan Glaspell, brought this new sensibility to full fruition in her 1930 play, *Alison's House*, in which no fewer than four different family members embody the costs and benefits of different paths out of the dilemma of passion against loyalty, paths ranging from stoic fidelity to open desertion. All three plays, along with others of the era, suggest how emblematic the issue of divorce became in the first third of the twentieth century, as the ultimate expression of concern for permanence and stability in a chaotic urban world.[5]

The fact that Augustus Thomas should write a play on this theme shows how important the issue of fidelity had already become for educated playgoers by 1911. Aged fifty-four and one of the most successful of theatrical craftsmen, Thomas had a generation of shrewdly calculated melodramas and local-color plays behind him. After an unsuccessful effort to "sell" radical prolabor plays in the 1890s, he had perfected the craft of giving the audience just what it wanted, with parts invented to fit the talents of particular actors—a common practice on the celebrity-oriented Broadway stage. *As a Man Thinks* remains a fascinating document on several levels, not least in the use of a secularized but morally traditionalist Jewish physician, Dr. Seelig, as its spokesperson and hero. Kindly and understanding, but also unrelenting on axioms, Dr. Seelig offers a defense of the double standard in terms of its function in preserving the trust needed for social stability.

SEELIG: Elinor. (*pause*) Do you hear that rattle of the railroad?
ELINOR: Yes.

SEELIG: All over this great land thousands of trains run every day starting and arriving in punctual agreement because this is *a woman's world*. The great steamships, dependable almost as the sun . . . all move by the mainspring of man's faith in woman—man's *faith*. . . . This old world hangs together by love . . .

MRS. SEELIG: Not man's love for woman.

SEELIG: No—nor woman's love for man, but by the love of both—for the children. Men work for the children because they believe the children are—their own. . . . There is a double standard of morality because upon the golden basis of woman's virtue rests the welfare of the world.[6]

Seelig's defense of the double standard is based on the practical wisdom embodied in moral conventions—an argument made by eighteenth-century conservative philosophers like Edmund Burke and David Hume, which would have a new flowering in the functional sociology of the mid–twentieth century. It is revealing that the audience-sensitive Thomas used such a conservative argument for moral absolutes. He left implicit the connective logic, that civilization depends on private property, the inheritance of which depends on faith in legitimacy. This insistence that everything would collapse if the integrity of the most intimate human relation was clouded may now seem distant. Still, we might recall that conservatives today would claim that the instability and violence of the intervening century have been due partly to the growing insecurity of human relations fostered by the disintegration of the family.

Augustus Thomas's attack on the consequences of "liberation," the subject of divorce and its alleged consequences, suggests that the new code of liberated morality, which would dominate the Provincetown plays, was already appearing on Broadway. This code has been called "narcissistic" by John Burnham and "liberationist" by me. Although the labels imply different judgments, we seem to be naming aspects of the same elephant: a demand for romantic self-fulfillment, for the acting out of impulses, rather than for prudent self-control to protect others from hurt. The word "romantic" may cause confusion, since the apostles of liberation often condemned the Victorians for their romanticism—by which was meant romantic *idealism*, the belief in sublimation of "lower" to "higher," more "civilized" goals, in the necessity and nobility of self-sacrifice. For apostles of romantic liberation, on the other hand, truth lies in emotions that can be suppressed only at enormous cost, leading to dullness if not despair. One's "real self" lies not in carefully lacquered layers of internalized convention but in ineradicable individual needs for love and creativity.

In the second decade of the twentieth century, there appeared on Broadway a concern for subjective experience—for dreams, memory, and forgetting, the suppression of painful ideas, popularized through Sigmund Freud's lectures at Clark University in 1909. David Belasco's *Return of Peter Grimm* turned on the effort to recover suppressed childhood memories. Percy MacKaye's *The Scarecrow* offered a tragic contrast between a character's ego-ideal and the self presented to the world. Arthur Hopkins's *The Fatted Calf* of 1912 dealt directly with psychotherapy of a Freudian variety. Rachel Crothers wrote several "discussion plays" about the question of sexual morality and economic independence for women.[7]

The early Provincetown plays reveal how pervasive the "liberationist" worldview had become in the avant-garde theatre, where it was intensified by the intellectuals' own sense of alienation from a humdrum, conformist society. The self-consciously young intellectuals of Chicago, Greenwich Village, and Provincetown insisted on the truth and reality of immediate human feelings against the crushing demand that they be subordinated to such abstract ideals as social stability. As the 1960s remind us, this rebellion against convention is a continuous strain in American culture, first articu-

lated by the nineteenth-century romantic movement.

The exemplar of romantic liberation for many young intellectuals, including the Provincetown Players' George Cram (Jig) Cook, was Friedrich Nietzsche, whose works were appearing in English translation and evoking commentaries by H. L. Mencken and others in the years surrounding 1910. Susan Glaspell recorded Nietzsche's impact on Cook in the years just before they founded the Players. Nietzsche, said Cook, "saved my soul from Tolstoi, Jesus and Mr. and Mrs. Browning"—that is, from an ethic of service, sentimentality, and self-submergence. *Ecce Homo* was especially dear to Cook; its strident aphorisms champion triumphant, guilt-free selfhood against the suppression, conformism, and resulting intolerance of the Christian middle classes. Nietzsche's ideal of the liberated personality testing the limits of possibility anticipated Cook's love for classical Greece. For both men, the aristocracy of Homeric times was a model of masterful, "truth-telling" transcendence, which Christianity had subordinated to a slave morality of caution, subservience, and hypocrisy. Indeed, when we apply the phrase New Psychology to Cook, it refers to Nietzsche rather than to Freud, Jung, the behaviorists, or the later Americanized psychoanalysis which stressed adjustment to an environment taken as given. There were important continuities between Nietzsche and Freud; the latter acknowledged the philosopher as his great anticipator. But Cook's and Glaspell's mocking attitude toward popular psychoanalysis reflects the difference between Nietzschean transcendence and the more analytic and therapeutic stance of the Freudians.[8]

The salience of Nietzsche for the intellectuals of the 1910s suggests their "modernity," and the relation of "modern" moral and social beliefs to the more familiar notion of Modernism in the arts, which they also championed. Alternative geometries, the watershed in physics symbolized by Einstein, philosophers like Bergson,

William James, and Whitehead, all aided the breakup of the consensus that "things are as they seem" which had in America remained dominant throughout the nineteenth century, stabilized by the Scottish commonsense philosophy taught in the colleges. At the same time, as Daniel Boorstin has pointed out, the modern city forced the educated to replace the traditional notion of universal human nature with the romantic concept of a plurality of cultures; similarly, it prepared people to accept the abandonment of classical formalism in the arts as in science. The sensuous experience of modern urban life helped both to inspire and to popularize Modernism—Manhattan testified to William James's ontology of radical empiricism, a flux of stimuli which forced the observer to become aware that he or she was imposing order, not discovering it. Katherine Kuh argues that the essence of artistic Modernism is "Break-up"—the smashing of traditional aesthetic axioms, like tonality in music and classical perspective in painting, to be replaced by a variety of self-consciously invented and individual standards. In terms of form, the "imitation" of external reality was replaced by original juxtapositions of the basic materials that had made up the "finished" work of art demanded by Victorian—and classical—taste. Decomposition and recomposition—from Schoenberg's twelve-tone system, to Kandinsky's creative juxtapositions of geometric forms (the ultimate elements of reality), to John Marin's kaleidoscopic collages of the experienced elements of New York City—became the essential method of the self-consciously modern.[9]

In ethics as in art, modernity meant the breakup of the cake of customary appearances, to be replaced by an unstable process of interwoven individual elements. As belief in eternal moral truths, whose incorporation was necessary for a mature personality, declined, the sentient individual came to seem an end-in-itself rather than a temporary link in a permanent network of family and community. Yet often the passionate urge to

"decompose" the solidified weight of established society was accompanied by an equally passionate desire to recompose a purer and more authentic community. Jig Cook, for example, saw the Provincetown Players as a special life-giving community separated out from the bourgeois mass.[10]

The Modernist sensibility entailed a radical transvaluation of the traditional psychology. The fully realized personality would now be one able to express its inner core of emotion and talent, since to suppress that core would be to murder the soul and become an echo of the environment. From this perspective, Cooley's looking-glass self was a terrifying denial of potential, an endless interior hall of mirrors that could create only anxious imitation. Here we can discern the link between the Modernist morality and the various movements summed up in the phrase New Psychology. The two elements of the New Psychology most popular among intellectuals—Freud, and theories explaining personality in terms of glands—repudiated the nineteenth-century mainstream in their stress on a human core that was either presocial or hardened in very early life. Popular exponents of the New Psychology tended to stress that major human drives were hidden, were "deep" in the self, rather than visible on the surface—an assumption that echoed a familiar romantic polarity. Psychoanalysis, of course, offered a mechanism, that of unseen "complexes" or charges of diverted emotion, which explained both the cause and the cost of culturally sanctioned suppression.[11]

The early Provincetown plays expressed, and often parodied, the New Psychology and new morality. In Edna Millay's *Aria da Capo*, the wittiest of the lot, Pierrot "unmasks" the emotional complexes within socialists and humanitarians, two of the roles, or sublimative identities, cherished by the older generation of progressives who faithfully devoured the *New Republic*.

PIERROT: Don't stand so near me! I am become a socialist. I love humanity, but I hate

people. Columbine, put on your mittens, child; your hands are cold.
COLUMBINE: My hands are *not* cold.
PIERROT: Oh, I am sure they are. And you must have a shawl to wrap around you, and sit by the fire.
COLUMBINE: Why, I'll do no such thing! I'm hot as a spoon in a tea-cup!
PIERROT: Columbine, I'm a philanthropist. I know I am, because I feel so restless. Do not scream, or it will be the worse for you![12]

The most vivid, but also the most ambivalent, use of the New Psychology in the Provincetown plays was made by the theatre's founding couple, Jig Cook and Susan Glaspell. Their writings are of special historical value because of an unusually direct therapeutic element, a double reaction to their own experience. Having escaped painfully from the rigid constraints of Davenport, Iowa—where Cook's first wife cited his failure to shave daily as evidence of mental cruelty—they soon saw the "talkiness," the verbal convolutions in which Greenwich Village indulged, to be a new set of constraints rather than a true liberation. The result was *Suppressed Desires*. While it is difficult to disagree with a recent description of this play as "an inconsequential comic satire," the aesthetic judgment should not obscure its historic importance. Through its use of popularized Freudian mechanisms, and its pungent satire on their effortlessness and futility, the play offers evidence for the power of the psychoanalytic cult among intellectuals; its continuing popularity among little-theatre groups suggests the spread of Freudian "psyching" out to ever-broader segments of the middle class. The play begins with a blunt example of the way psychoanalytic ideas could become vehicles of guilt rather than liberation. Henrietta, the liberated Freudian wife, tells her distempered husband: "It isn't the coffee, Steve dear. There's nothing the matter with the coffee. There's something the matter with *you*." Steve grudgingly admits that "there may be something the matter with

my stomach." Henrietta replies scornfully: "Your stomach! The trouble is not with your stomach but with your sub-conscious mind." In good Freudian fashion, resistance to insight is interpreted as evidence for its accuracy: Steve's rejection of his illness shows how deep it is.[13]

The plot of *Suppressed Desires* centers on Henrietta's naive sister from Chicago, who is "subconsciously" in love with her brother-in-law Stephen. In attempting to "psych out" what she perceives as Mabel's malaise, Henrietta at first encourages her to boldness. To avoid madness, Henrietta insists, suppressed desires must be acted out. The conflation of two distinct Freudian concepts, conscious suppression and unconscious repression, probably stems from the older psychology of conscious will: If something is "there," in the self, then reason and will could uncover it. She gives her sister the example of another woman driven almost to insanity by similar repression of subconscious sexual impulses.

> HENRIETTA: It happens, Mabel, that this suppressed desire was on the point of landing Mary Snow in the insane asylum. Are you so tightminded that you'd rather have her in the insane asylum than break the conventions?
> MABEL: But—have people always had these awful suppressed desires?
> HENRIETTA: Always.
> STEVE: But they've just been discovered.
> HENRIETTA: The harm they do has just been discovered. And free, sane people must face the fact that they have to be dealt with.
> MABEL (*stoutly*): I don't believe they have them in Chicago.
> HENRIETTA (*business of giving Mabel up*): People "have them" wherever the living Libido—the center of the soul's energy— is in conflict with petrified moral codes. That means everywhere in civilization.

Henrietta goes on to explain that Steve's dreams of melting walls indicate a "loss of grip" in his profession as architect. Steve and Mabel, however, consult a professional analyst, Dr. Russell, who allegedly offers a different interpretation. Stephen's suppressed desire is to escape from Henrietta's "hen-pecking" into the wilderness, while Mabel's dream of being told to "Step, hen!" is a semantic play on the name of Stephen, whose last name is Brewster and whom she wishes to "be rooster" to her. The play ends with a skeptical appraisal of the search for hidden motives; it is helpful to know what has been suppressed, but sometimes wishes should remain unfulfilled. Acting out may be too costly, if it disrupts the lives of others; to insist on wish fulfillment is to regress into childhood narcissism.[14]

Suppressed Desires illustrates the tendency of the New Psychology to be reinterpreted by those who experienced its effects. The reinterpretation usually modified or superseded the narcissistic or liberationist reading (acting out is essential for health) with a different interpretation of its practical import, what John Burnham calls the "social control" and I've dubbed the "therapeutic" reading of these ideas. In this new reading, the primary fact is the existence and otherness of other people, who must matter to us; so self-expression must remain aware of the needs of others. This reinterpretation occurred at various stages in the maturing process of many intellectuals. *Suppressed Desires* is one of the first evidences that the process had begun. Cook and Glaspell were not ridiculing the New Psychology as such, but rather the pseudo-liberation of talk therapy and the dangers of liberation carried into narcissism. Indeed, its real originality may lie in its presentation of the easy use of pop Freud as a new kind of self-imprisonment, a voluntary entrapment of intellectuals in conceptual cages of their own construction, which could be as confining as the Victorian conventions.

A striking example of liberation turned narcissism comes in another early Provincetown one-acter, Pendleton King's *Cocaine*, where the addict Nora urges Joe, her lover-hustler, to join her in suicide: "Joe, we've had such a wonderful time. We've known everything

there is to know in the world worth knowing. Don't let's go down hill. We've reached the top. Let's let this be the end." The weak-willed but more detached Joe resists; he is not so sure there may not be new pleasures ahead. But his resistance does not stem from a Victorian belief in the duty to struggle on against all odds. From the standpoint of the older psychology and ethics, Nora's pro-posal of a death pact is immoral even beyond marital infidelity. King was probably mock-ing both Nora's romanticism and Joe's male confidence that another streetcar always ar-rives, though the mockery is less overt than that in *Suppressed Desires*. It may be sig-nificant that Glaspell and Cook were not so young by 1915—Cook was forty-two, Glaspell either thirty-three or thirty-nine. They had had time to reflect on the tendency of every benefit to have its cost.[15]

The skepticism of Glaspell and (argu-ably) Cook toward romantic acting out casts light on the movement from a liberationist to a therapeutic interpretation of the New Psychology, that is, to one concerned with "adjusting" troubled individuals to the ex-isting social order. Different explanations are plausible; probably all of them played a part. On the sociological plane, artists and intellectuals, the antennae of the race, tend to react most swiftly to new ideas, while professionals, like psychiatrists and social workers, have institutional inertia to over-come and therefore incorporate new ideas more slowly but with more permanence. Age cohorts will have somewhat divergent interpretations of a new idea, with the youngest usually the most intense and un-ambiguous. Glaspell and Cook illustrate the greater irony with which more experienced people will treat the latest illumination. They have had the chance to work through new ideas and their effects on emotional satisfaction, and so try to arrive at an inner synthesis incorporating the realization that other people remain other, that uninhibited acting out leads not to nirvana but to isolation.[16]

Indeed, some of the young intellectuals ended by returning to a neo-Victorian or-thodoxy not so unlike that of Augustus Thomas. Floyd Dell, the talented younger friend of Cook from Davenport, spoke harshly in his memoirs (published in 1933, when he was forty-five) of Cook's rationaliz-ing his own "failure" into a cult of failure as the true success in a soulless society. Glaspell, who had a prolific career after Cook's legendary death in the heroic Greece he had longed for, tried in her plays and novels to strike a balance between the two poles, liberation and conformity, a balance that expressed the central dilemma of her generation's existence. Her later plays dis-play another central concern, closely related to liberation/conformity.

Most of the early Provincetown plays were quite traditional in dealing with gender roles and the allegedly natural dif-ferences between the sexes. Liberation, in any drastic sense, was for men only; women, while justifiably frustrated by the restric-tion to the domestic sphere, were assumed to be naturally different, though superior in crucial traits. Glaspell was impatient with the traditional definitions, but she was also never quite sure that they were wholly false; and her ambivalence energizes her plays. The earliest and most famous, *Trifles*, accepts the traditional dichotomy between the "rational" and public male world and the sensitive, homey, "trifling" world of feminine detail. But it turns the tables by showing that only empathy with trifles could solve a crime, that masculine impatience and insensitivity to nuance and relation de-feated the men's own intentions. If a message must be derived, it would seem to be that the different mental orientations exist—whether due to nature or nurture is not explored—but that the empathy and ho-lism of the feminine style are essential supplements to the reductive, splitting-apart style of masculine logic.

In her most radically Modernist play, *The Verge*, staged just after World War I in a

moment of excited experiment, Glaspell gave full range to her ambivalence by creating a brilliant woman scientist who tries to push back the barriers to understanding and expression, but ends by moving past the ability to communicate with others into madness and violence. Claire hopes to create new forms of plant life that will destroy the boundaries of natural species, just as she hopes to find true expression by breaking down the rules of grammar. *The Verge* belongs to a genre which harks back to Mary Shelley's *Frankenstein*, and had an immediate parallel in the expressionist film *The Cabinet of Doctor Caligari*; but its focus on a female Prometheus, and its central theme of the cost of destroying given categories, suggest a reaffirmation of rules and limits as barriers against madness.[17]

Glaspell's calmest expression of the conflict between transcendence and sacrifice was the play that briefly brought her national attention by winning the Pulitzer Prize in 1930. *Alison's House* was based on the life and afterlife of Emily Dickinson, especially the long effort of the Dickinson clan and executors to control Emily's reputation. Apparently due to objections by the literary heirs, Glaspell relocated "Alison" to her own youthful turf, the Mississippi shores of Iowa. It's a touching work, which plays off against each other the traditional code of loyalty to family and the Modernist demand for self-fulfillment. While Modernism gets the best lines, and the enormous cost of respectability is brought home vividly, Glaspell also makes clear the high cost of self-expression in guilt, loneliness, loved ones wounded or cast out. Responsibility to the self could not be harmonized costlessly with responsibility to the loving, watchful, and censorious community that had nurtured the self. Still, as Glaspell implied in a clever bit of dialogue, the rule of history was change, and moral codes, like clothes, would come to seem obsolete. The implicit message seems to be that in the modern urban world a greater tolerance would reduce the anguish

that nonconformity entailed in a world of tight traditional communities.[18]

This conclusion, however commonplace with theorists of modernization, may have been hasty and optimistic. The issues are far from dead; indeed, the latter half of the twentieth century seems to have been a rerun of intellectual conflicts that became visible at the end of the nineteenth century. The Beats foreshadowed a burst of romantic liberationism during the 1960s, a coming-out of conventional roles that mixed, often uneasily, with the political activism of the same years. The cult of the liberated, expressive self has left strong residues among educated Americans, but it has also stimulated intense reactions among those who have seen it as a threat to the sublimations on which social stability depends. Quentin Anderson wrote a powerful Freudian critique of the immaturity of the "imperial self" which he found in quintessentially American writers like Emerson, Whitman, and Henry James. Brilliant Marxists like Christopher Lasch condemn the "culture of narcissism" for producing weak, scattered personalities incapable of the focused action needed to change a society of self-indulgent consumers (he might have cited Millay's Pierrot). On the popular level is what pollsters have dubbed neo-traditionalism, the revulsion, in the name of "family values," against personal liberation and the consequent creation of alternative life-styles. This resurgent cultural conservatism harks back to the ethics and psychology repudiated by Modernism: schools should teach a single moral code dogmatically, since mainstream values are "given" in the structure of human nature. Pluralistic teaching of values is a threat to proper character formation, since malleable youth may pick up harmful signals from what they read.[19]

An interesting question arises from the strength of this neo-traditionalism. Despite the obvious impact of the Provincetowners' cult of romantic liberation, what kinds of

judgment about them will dominate by the time of their centenary in 2015? As Susan Glaspell knew well by 1930, "Everyperson her own historian" continues to reinterpret the significant past through filters colored by the anxieties of the present. Given the trends apparently gathering strength as our fin-de-siècle commences, the philosophical framework of the twenty-first century may be set not by Cook's Nietzsche but by Aris-

totle or Aquinas; and the Provincetown moment may appear not as a flashpoint of creative liberation but as a regressive rebellion against universal values that helped to intensify the anguish of the twentieth century. Whether the wheel of ethical fashion will turn again, in the continuing alternation between control and liberation, classicism and romanticism, remains to be seen.[20]

NOTES

1. For the general cultural context of the Provincetown Moment, see Henry F. May, *The End of American Innocence: The First Years of Our Own Time, 1912–1917* (New York: Alfred Knopf, 1959).

2. On the two major organizing principles of secular psychology in the nineteenth century, associationism and faculty theory, see Gardner Murphy and Joseph K. Kovach, *Historical Introduction to Modern Psychology* (New York: Harcourt Brace Jovanovich, 1972), 28–37, 58–59, 164–172. An outstanding biography using this theory of personality formation, which stresses the influence of literature on an isolated self, is Robert Davidoff, *The Education of John Randolph* (New York: W. W. Norton, 1979). On the persistence of this theory into the mental hygiene movement of the early twentieth century, see Fred Matthews, "In Defense of Common Sense: Mental Hygiene as Ideology and Mentality in 20th Century America," *Prospects IV* (1979): 459–516, esp. 475–479.

3. Charles H. Cooley, *Human Nature and the Social Order*, rev. ed. (1902; New York: Scribner, 1922), esp. 182–185, 392–395, 412. The extent to which Cooley's theory codified nineteenth-century opinion can be seen in a comment Frederick Douglass made in 1865: "Men are so constituted that they derive their conviction of their own possibilities largely from the estimate formed of them by others." Quoted in Jean Matthews, "Race, Sex, and the Dimensions of Liberty

in Antebellum America," *Journal of the Early Republic* 6 (Fall 1986): 289.

4. The review of Mitchell's play is in *Life*, 29 November 1906, quoted in John Gassner, ed., *Best Plays of the Early American Theatre: from the Beginnings to 1916* (New York: Crown Publishers, 1967), x1. Fitch's *The Truth* is reprinted in Gassner, *Best Plays*, 485–510. On Fitch's career, and his last play, *The City*, which embodied serious criticism of business ethics, see Arthur Hobson Quinn, *A History of the American Drama: From the Civil War to the Present Day.* vol. 2: *From Augustin Daly to the Death of Clyde Fitch* (New York: Harper, 1927), esp. 289–293.

5. William O'Neill, *Divorce in the Progressive Era* (New Haven: Yale University Press, 1967); Susan Glaspell, *Alison's House* (New York: S. French, 1930); Augustus Thomas, *As a Man Thinks* (New York: Duffield & Co., 1911); Donald N. Koster, *The Theme of Divorce in American Drama, 1871–1939* (Philadelphia: University of Pennsylvania Press, 1942).

6. Thomas, *As a Man Thinks*, 147. Thomas is probably the most forgotten of once-famous American playwrights, likely due to his audience-pleasing strategy and his lack of verbal magic. But some of his plays have broader scope and greater emotional power than those of Fitch and Mitchell. See Quinn, *History*, and Thomas's memoirs, *Print of My Remembrance* (New York: Scribner, 1922).

7. See John C. Burnham, "The New Psychology: From Narcissism to Social Control," in *Change and Continuity in 20th Century America: The 1920s*, ed. John Braeman et al. (Columbus: Ohio State University Press, 1968), 351–398. The parallel contrast between liberationist and therapeutic readings: Matthews, "In Defense of Common Sense," 461–462. On Rachel Crothers, see Brenda Murphy, "The American Discussion Play: The New Woman Meets the Popular Audience," paper, American Studies Association, San Diego, 1985. For Belasco, MacKaye, and Hopkins, see W. David Siever, *Freud on Broadway: A History of Psychoanalysis and the American Drama* (New York: Hermitage House, 1955), 41–48. Siever notes that Hopkins's *The Fatted Calf* has not survived; his analysis is based on the play's reviews.

8. For the self-image of young intellectuals as realists unmasking the romantic idealism of Victorian sublimation, see Sophus Keith Winther, *Eugene O'Neill: A Critical Study* (New York: Random House, 1934), 3–12. O'Neill restored a Darwinian sense of human animality against "the romantic ideal with its exaggerated hopes and its false values." The key text of Nietzsche for Cook was *Ecce Homo*; see *Basic Writings of Nietzsche*, ed. Walter Kauffman (New York: Modern Library, 1968), 673–793, esp. 674, 709–712, 728, 747, 784, 790–791. For Cook's passionate response to Nietzsche, see Susan Glaspell, *The Road to the Temple* (New York: F. A. Stokes, 1927), 134–148. The connection between psychological and philosophical levels is made by Roger Scruton, who notes that Nietzsche "reacted against the Hegelian thesis that the individual achieves freedom and self-realization only in the institutional forms which complete and constrain him." From *Descartes to Wittgenstein: A Short History of Modern Philosophy* (London: Routledge & Kegan Paul, 1981), 191.

9. Katherine Kuh, *Break-Up: The Core of Modern Art* (Greenwich, Conn.: New York Graphic Society, 1965), esp. 11–15. A parallel, though more socially grounded vision of Modernism emerges from Marshall Berman's vivid *All That Is Solid Melts into Air* (New York: Simon and Schuster, 1982). Daniel Boorstin, *Lost World of Thomas Jefferson* (Chicago: University of Chicago Press, 1948), 246–248.

10. On the "modern" consciousness, see Walter Kaufmann, *Hegel* (Garden City: Double-day, 1965), 154–157. On the romantic polarity of social types that spread from Paris, see Cesar Grana, *Bohemian versus Bourgeois: French Society and the French Man of Letters in the 19th Century* (New York: Basic Books, 1964), and Richard C. Miller, *Bohemia: The Protoculture Then and Now* (Chicago: Nelson Hall, 1977). On the self-conscious "intellectual" as rebel from and critic of "mainstream" values, a valuable account in broader context is Lewis Coser, *Men of Ideas: A Sociologist's View* (New York: Free Press, 1970). This sense of "intellectual" as overlapping "Bohemian" is probably the commonest in modern usage, but Edward Shils develops the ideal-typical "intellectual" as more like a systematic philosopher than a Greenwich Village explainer: see Shils, *The Intellectuals and the Powers, and Other Essays* (Chicago: University of Chicago Press, 1977), esp. 3–23.

11. Burnham, "New Psychology"; F. H. Matthews, "The Americanization of Sigmund Freud: Adaptations of Psychoanalysis before 1917," *Journal of American Studies* 1, no. 1 (Fall 1967): 39–62.

12. George Cram Cook and Frank Shay, eds., *The Provincetown Plays* (Cincinnati: Stewart & Kidd, 1921), 49.

13. For failure to shave as mental cruelty because it violated community standards, see Floyd Dell, *Homecoming: An Autobiography* (New York: Farrar & Rinehart, 1933), 161. Glaspell's vivid memoir, *The Road to the Temple*, conveys Cook's charisma as well as his enthusiastic vagueness. Robert Sarlós's *Jig Cook and the Provincetown Players* is authoritative; but Helen Deutsch and Stella Hanau, *The Provincetown: A Story of the Theatre* (New York: Farrar and Rinehart, 1931), retains value as the story seen by contemporaries. On Cook, see esp. ix–xi, 3–47, 53–55. Quotations from *Suppressed Desires*: Cook and Shay, eds., *Provincetown Plays*, 11–13. The judgment about the play's aesthetic quality, along with a valuable discussion of Glaspell's work, is in C.W.E. Bigsby, *A Critical Introduction to 20th Century American Drama*, vol. 2: 1900–1940 (Cambridge, England: Cambridge University Press, 1982), 20–35.

14. Cook and Shay, eds., *Provincetown Plays*, 21.

15. Ibid., 88–89.

16. Burnham, "New Psychology." This in-

terpretation is based on Glaspell's *Road to the Temple* and the attitudes displayed in the *Provincetown Plays*.

17. Glaspell's ambivalence about a separate female "nature," or cultural style or orientation, has echoed down to the present, and will likely continue to generate controversy and research. See the symposium on the work of Carol Gilligan: Linda K. Kerber et al, "On *In a Different Voice*: An Interdisciplinary Forum, "*Signs: Journal of Women in Culture and Society* 11 (Winter 1986), 304–333. The relative conventionality of gender-role expectations in the early Provincetown plays can be seen especially in Louise Bryant's *The Game*, where The Girl is to be The Youth's liberated companion and support, but not an independent artist or individual; and in Neith Boyce's *The Two Sons*, where a mother finds her stereotypically "masculine" son more reassuring than her "sensitive" and "artistic" son. See *Provincetown Plays, Series One* (New York: Frank Shay, 1916), 28–45; *Provincetown Plays, Series III* (New York: Frank Shay, 1916), 145–169. On Glaspell's life and writings, it is instructive to compare Arthur E. Waterman, *Susan Glaspell* (New York: Twayne, 1966)—a useful work despite a strong tendency to condescend to Glaspell while coming to life when Cook appears—with recent reappraisals influenced by the feminist movement. The central work here is C.W.E. Bigsby, *Plays by Susan Glaspell* (Cambridge, England: Cambridge University Press, 1987), with a thoughtful introduction. Bigsby's comments on *The Verge* (19–23) are most perceptive; he notes that Cook held a traditional view of reason as male and unselfish emotion as female, which Glaspell doubted but never repudiated. Floyd

Dell's sneer at Cook, which reveals the intolerance built into the norm of "maturity," is in *Homecoming*, 263–264.

18. Susan Glaspell, *Alison's House*. The belittling of this play can be sampled in the most recent discussion of her work, Michael Goldman, "The Dangerous Edge of Things," *Times Literary Supplement* (5–11 February 1988), 139.

19. Quentin Anderson, *The Imperial Self: An Essay in American Literary and Cultural History* (New York: Alfred Knopf, 1971). Christopher Lasch, *The Culture of Narcissism* (New York: W. W. Norton, 1979). On specifically religious neo-traditionalism, see Robert Wuthnow, *The Restructuring of American Religion: Society and Faith since World War II* (Princeton: Princeton University Press, 1988), esp. 173–215. Wuthnow's data suggest strongly that the primary motives underlying the fundamentalist revival are moral and even political: the belief in a "given" worldview, shared by all, was challenged by the romantic pluralism of "the 1960's."

20. The massive sales and generally friendly reviews (outside liberal-intellectual strongholds) given to Allan Bloom, *The Closing of the American Mind* (New York: Simon and Schuster, 1987), suggest the breadth of the reaction against the kind of liberationist Modernism championed by the Provincetown writers and intellectuals. A more reasoned attack on Modernism is found in the work of the English neo-Aristotelian philosopher Roger Scruton, who argues for the necessity of tradition, convention, and even prejudice as supports for personal development. Roger Scruton, *The Meaning of Conservatism* (Totowa, N.J.: Barnes & Noble, 1980), esp. 135–139.

The New Art

MARTIN GREEN

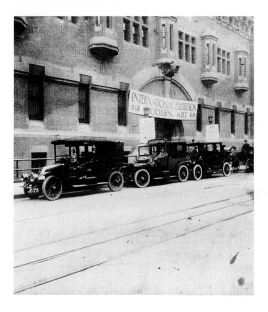

FIGURE 26. *The International Exhibition of Modern Art (The Armory Show), 69th Infantry Regiment Armory, Lexington Avenue and 25th Street, New York, February 17–March 15, 1913. Walt Kuhn Papers, Archives of American Art, Smithsonian Institution.*

If we compare the New Art with this book's other topics, we shall be struck by certain differences. Perhaps these derive first from a precedent set by another place and time— from the powerful historical presence of the 1913 Armory Show of Modern Art. Provincetown in 1915 must be overshadowed by New York in 1913 as a place where the New Art was presented. Second, the new artists had an unusually vulnerable and obvious enemy to defy, a literal academy (the National Academy of Design). In some other areas, like that of the New Woman, the sense of change was more diffuse, the enemy to defy more protean; in others, like the New Theatre, Provincetown in 1915 had as good a claim as any other place and time to be the historical crux.

The academy was the American equivalent of the Salon in Paris, an elite and conservative institution, against which all new painters had to rebel. There had been a New York Academy of Design since 1825. Some of its members split off in 1877, and called themselves the Society of American Artists, holding an exhibition of their own in 1878. But the power of the old institution had proven too great. The rebels found the path of defiance nonviable, and in 1906 they reemerged with the parent institution, to become the National Academy of Design.

The title of associate of that academy carried prestige, and membership was self-perpetuating. In the annual exhibition the jury that decided which works should be hung carried white cards that exempted their own works from judgment. Their aesthetic creed can be summed up as a belief in composition, the study of the human figure, the primacy of drawing over color, and the use of models from the past. If we interpret these precepts by reference to the paintings of the great Renaissance tradition, we shall see well enough how far these painters were from creating "modern art."

Let us try to define that concept from a cultural-history point of view.[1] Beginning in France, and in the middle of the nineteenth century, artists felt the need to free their art from complicity with bourgeois taste and from that taste's origins in the bourgeois state. Responding to the same historical facts as socialist revolutionaries, and in some ways in step with them, the painters rebelled against their society.

The fine arts have traditionally been used to beautify, dignify, and enhance the ceremonial life of institutions: there are poets laureate, official painters, composers of coronation music, and so on. These arts are housed in museums, concert halls, and theatres, which have special boxes for presidents, mayors, and official guests, just as

there are parades and concerts for generals and bishops. And the visual artists, who deal with patrons and palaces, presidents and millionaires, more than do, say, writers, have a specially close relationship with power. They have to deal with all that follows from possession, with theft, fraud, authentication, collecting, and security. Their art is property, often civic or national property. How then to escape serving one's political masters? How to serve one's own gods, and not theirs?

The artists of Modernism broke free by an insurrection within the realm of art, a coup d'état which made an enemy enclave within high culture. Picasso and Matisse painted pictures incomprehensible, and insulting, to the bourgeois even as connoisseur. One might almost say they confiscated his sense of sight; at least they poisoned the reassuring pleasures of visual aesthetics for him—those of landscape and sexual loveliness, as well as those of pictures. This was a guerilla war waged against the bourgeois class and its domination, its representatives in the ateliers, its Renaissance traditions, and its Greek and Roman heritage. The great talents in a sense refused to be adults and citizens; they allied themselves to children, to primitives, to madmen, and against the dominant gender, race, and class. They denied reality via their denial of realism. This was the art which reached the United States in the Armory Show of 1913.[2]

In this section Milton Brown gives us a detailed account of the Armory Show and its effects on American collections and art galleries, on critics and practicing artists—on American taste as a whole. He reminds us of its character as a scholarly exposition of the roots and branches of modern art (its heritage from the past and its divergent theories) and points to the quite surprising differences between American and French taste, at least as expressed in the prices paid for the works on exhibit.

The phrase the New Art was of course an aggressive slogan, signaling a welcome to any kind of break with tradition. If we think of the variety of artists, from Odilon Redon to Braque, and the variety of schools, from Cubism to Expressionism, and the variety of periods in the work of a single painter like Picasso, we shall despair of defining the New Art in any way but negatively. It was *not* (or said it was not) a continuation of the great Renaissance-based traditions of portraiture, landscape, altarpieces, and mythological scenes.

It is useful to define a few of the terms that come up in discussing modern art. There are of course many, competing, definitions: these are adapted from Peter and Linda Murray's *Dictionary of Art and Artists*.[3] Cubism, the father of all abstract art, derived from the efforts of Braque and Picasso to replace the purely visual effects of Impressionism with a more intellectual conception of form and color. These two artists followed Cézanne, but developed further the idea of the unity of the two-dimensional pictorial surface and the analysis of forms and their interrelations. Thus, in practice, they superimposed several views of the object, one upon another.

Symbolism was a literary idea to begin with, but Gauguin and his friends began to paint forms that were both decorative and abstractions of ideas, using bright colors and separating them by black lines. Redon developed the personal and fantastic side of this. Fauvism is a term applied to the work of Matisse, Derain, Vlaminck, Rouault, and a few others, for a few years after 1899, work which featured violent colors and distorted forms assembled in flat patterns. Orphism was defined by Apollinaire in 1913 as art that is endowed with reality solely by the artist. In the work of Delaunay, the best known Orphist, this meant that color was dominant over form. Expressionism, which derived from the work of Van Gogh and Munch, was strongest in Germany and Scandinavia; two Expressionist groups were *Der Blaue Reiter* and *Die Bruecke*. Their work employed distortions of line and color to create an emphatic and "expressive" style which communicated strong emotion.

Two more of these terms are usefully defined by Nic Madormo of the Archives of American art. Synchromism was a doctrine favoring completely abstract or semiabstract color designs; influenced by such diverse sources as Cézanne and Michelangelo, it was formulated in Paris in 1913 by the Americans Stanton Mac-Donald Wright and Morgan Russell. Dada was an international movement in the arts, established in Zurich in 1916 and characterized by complete nihilism, disillusionment, and disgust with civilization. A product of World War I, Dada glorified the antirational, the anti-aesthetic, and the amoral. Cynical and rebellious, the Dadaist poets and artists included Tristan Tzara, Louis Aragon, Hans Arp, Man Ray, Max Ernst, and Marcel Duchamp.

Such was the New Art. We should perhaps remind ourselves of the kinds of paintings this most completely displaced: the old art, which aged by decades in a few days in 1913. Two kinds seem to me especially interesting to the cultural historian: mural painting, as done by Kenyon Cox (a keen critic of the Armory Show moderns) and by John White Alexander (president of the National Academy); and the realistic city paintings of John Sloan and his associates. The second group included Robert Henri, Albert Glackens, George Luks, and Everett Shin, all men who wanted to rebel against both the dead hand of tradition and the foreign hand of Paris Modernism. They were called the New York, or Ashcan, realists. (Ashcan was a label applied to them some years later.)

Like the painters of contemporary Paris, the Ashcan realists wanted to break the grip of bourgeois taste on the ideas of beauty and art. But they did so primarily by asserting a new vulgarity of topic and vigor of manner—by introducing new subject matter which offended against propriety. Because they continued to aim at visual realism, unlike the Modernists of Paris, they failed to profit by the excitement of the latter's project of changing the very idea of art and dominating the public's sense of sight.

Robert Henri had returned from a trip to Europe in 1891, and gathered round him a group of young men interested in art—those named above. They all drew for newspapers and magazines, and so learned how to depict events in ways that satisfied "the average man." They had studied the Punch artists Keene and Leach. Then Henri introduced them to more ambitious French and Spanish artists—Goya and Daumier, Guys and Gavarni. The Ashcan realists nearly all moved to New York City around 1895, where they began to take their art more seriously. They wanted to paint the people of the city, many of them immigrants, in their unheroic actuality. One of Sloan's pictures is of an old woman finding a pair of corsets in an ashcan. But they also took part in the founding of the American Association of Painters and Sculptors, which organized the Armory International Exhibition of Modern Art. They were then the avant-garde of American art and expected such a show to promote their cause. In fact, it relegated them to history, because the European painters so far outshone them.

The mural painters (and their allies, like the sculptors of patriotic statues) were not so categorically avant-garde as the realists. But it is still interesting to ask why they came to seem so irredeemably old-fashioned in 1915. The answer seems to have something to do with theirs being a public art: public in its themes and its locations—its dependence on large institutions, civic or industrial. It was not necessarily conservative or elitist in a political sense, well suited as it was to celebrate heroic figures of labor or revolution, but it was official. As such, it was a cousin to the masque and pageant movement that tried to reconcile the traditions of art with the rituals of American democracy. Percy MacKaye, the theorist of pageant theatre, was in fact a friend and admirer of John White Alexander. (MacKaye's 1912 book *The Civic Theatre* is dedicated to Alexander, whom it salutes as "Artist Citizen.")[4] Pageants, like murals, had liberal or even radical possibilities, as John Reed's Paterson Strike

Pageant showed. But one of the strongest drives in the New Art, of all kinds, was an aversion from the public and official.

One of the reasons the New Art attracted so much attention around 1915 was that aesthetic radicalism then seemed allied to political radicalism, one way or another. But that alliance was uncertain. There were at least three issues of debate: political radicals often thought art should serve the masses; artists often thought art should have its own revolution, in aesthetic matters; and there were those, represented by Stieglitz, who believed that a new language of art would itself bring about a social revolution.

To the second two groups, the language of politics often seemed too philistine (ignorant of art), too official (as in election rhetoric), to be aesthetically radical. This was one of the problems that plagued the alliance between political and aesthetic radicalism. In verse, for instance, many of John Reed's poems of adventure read disconcer-

tingly like Rudyard Kipling's. An anonymous poem in the songbook of the Industrial Workers of the World (IWW) was not implausibly attributed to Kipling, the great public artist of his day in language, who had made adventure the myth of imperialism. One of the strains in the New Art that became powerful was very hostile to any such rhetoric. Twenty years later, of course, the Spanish Civil War aroused enough left-wing solidarity on a political issue to call forth public art of a Modernist kind. But in 1915, the Cubists, and others, were turning away from political themes and styles, as also from nature and the human form, at least as traditionally treated. That is why so many of the public felt betrayed and insulted when they saw the new paintings at the Armory Show. (In Provincetown there were few Postimpressionists until later: the New Art was slow to arrive there.)

On the other hand, some close allies of the New Art were still inspired by the piety of public service. Katherine Dreier, friend and

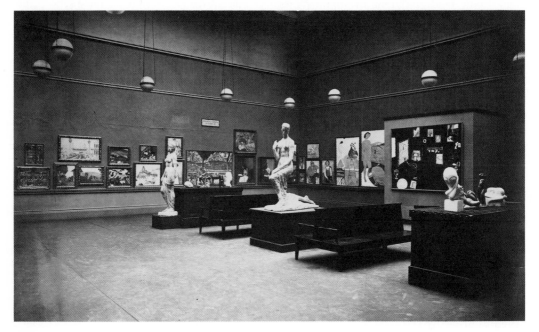

FIGURE 27. *The International Exhibition of Modern Art (interior view). Photograph copyright © 1990, The Art Institute of Chicago, all rights reserved.*

patron to Marcel Duchamp, is a key example, discussed in my book *New York 1913*. Rebecca Zurier points to the attempts made by *The Masses'* artists, especially at first, to diffuse the appreciation of great art, as a cultural value, among the working class; and to the debt of its artists to the Englishmen William Morris and Walter Crane, who have something in common with the mural painters. This left-wingers' kind of social piety survived to trouble Modernism, after the philanthropists' kind had faded.

However, it was Cubism, and to a lesser extent other forms of Modernism, which was to triumph, in the immediate future. This is not a fact to take for granted; other kinds of Modernism, displaying more emotion and more energy, might have seemed likely to win the American preference. But, as Milton Brown points out, Cubism "seemed to have created a totally new world, which was not without visual analogies to contemporary industrial life. . . . [Its] obvious intellectual control and technical precision" won it a fairly quick acceptance. It was, in fact, associated with "the classical" significantly often, and so had a kind of conservative character.

Edward Abrahams reminds us in his essay of the profound connections between Modernism in art and revolution in cultural and even political terms. Alfred Stieglitz said, "I have always been a revolutionist," and according to Abrahams claimed to be "much more *active* in a revolutionary sense than most of the so-called Communists." Political leaders like Big Bill Haywood thought this nonsense, but Stieglitz even claimed one of their key words, saying that he strove for "justice in the fullest sense of the word," as well as for "freedom of experience." Stieglitz's philosophy was summed up in three principles. Two of them are familiar enough in aesthetic discourse: the artist's need fully to express himself or herself; and pluralism, the desirability of having a number of options open to both painters and lovers of painting. Stieglitz's third principle, however, is political: "a movement that would change the world." Abrahams's judgment is that this promise was unfounded, but also that it was sincere and infectious, and one of the constituting principles of the New Art.

When a new art constitutes itself, it also constitutes an old one—that which is being left behind—and the painters of sordid or ordinary street scenes, who clustered around Robert Henri and John Sloan, found themselves supplanted in the avant-garde position they had built up. However, while protesting the new ideas and the new reputations, these painters began to experiment in the same directions themselves. Most striking, perhaps, was the case of Stuart Davis, a *Masses* artist and a social realist, who, Milton Brown notes, was turned completely around by the Armory show. He was the one of all his friends who was most able to profit by the challenges of Modernism.

On the whole, as Rebecca Zurier says, the graphic look of *The Masses* always "had sources other than contemporary Modernist art," and it remained hostile to most of the artistic change taking place around it. One explanation is that Cubism had a severe and testing highbrow aspect, whereas the journal's editorials proclaimed "enjoy the revolution," and recommended a mocking satirical freedom to both its contributors and its readers. Satire reconciled the often conflicting aims of artistic freedom and "speaking to the masses." This linked their venture to the satiric songs, cartoons, and slogans of the IWW, and to a broad range of traditional American humor. These artists learned from Sloan the importance of warm feeling, and from Henri the technique of the quick autographic sketch and the "honest line." But the New Art was interested in other values.

If one looks at the New Art of 1915 in the context of the New Psychology, the New Woman, the New Politics, and the New Theatre, one sees a confluence. From all corners of the intellectual map people were coming together to demand changes, some in politics, some in art, which had, or seemed to

have, a good deal in common. But then, just a few years later, one sees a dispersal beginning, as political and aesthetic radicalism began to run along diverging tracks. For instance, Marcel Duchamp, who was one of the most influential artists of the period after 1915, was also one of the least politically minded. And his influence was felt by a number of movements, variously called Futurism, Mechanism, Precisionism, as well as the Dada and Surrealism more identified with him. He and his friends may be said to have made an ironic cult of speed and force, associated with the city, with engineering, and with mechanical forms. In this, and in his paradoxical attacks on the concept of art itself, he separated himself from many groups within the New Art, as well as from the attempt to ally art and politics.

Duchamp aside, Stieglitz probably did more than anyone else to promote the naturalization of modern art in America. It was painters who had been at one time or another his protégés, like Marsden Hartley, Max Weber, John Marin, Arthur Dove, Charles Demuth, and Georgia O'Keeffe, who went on to develop Modernist styles of their own, which accommodated American subject matter in a new way. Stieglitz was a formalist, believing in a direct equivalence between certain shapes and certain emotions. In this way his ideas were not unlike those of the Bloomsbury group in London. Clive Bell's idea of significant form was very like Stieglitz's. He joined to this, as did Bloomsbury, a somewhat Platonic idealism. To him, art was creativity; it was an end in itself, and an all-justifying end. And he, much more than Bloomsbury, translated this creed into a practical program for the encouragement of talented and experimental visual artists. One of the most remarkable of these was Georgia O'Keeffe, who became Stieglitz's wife. However, O'Keeffe's case shows us, as did Duchamp's, that there were centrifugal forces of dispersal at work in the art world, as well as the divergence between art and politics already noted.

One such force was represented by Mabel Dodge's departure from New York in 1917, followed as it was by that of several avant-garde artists, who settled around her in Taos. They found in the New Mexican landscape and Pueblo culture a renewal of a communal faith that had seemed to starve in the city. A sense of the sacred was one of the things Stieglitz had looked to Modernism to create; and Georgia O'Keeffe was one of those artists who made their homes in New Mexico. Stieglitz himself, however, stayed in New York. His gallery, 291, exhibited Marcel Duchamp's scandalous ready-made urinal, "transformed into art" by the simple legend "Fountain," a very different direction for Modernism.

These divergences and dispersals broke up the coming together of the radicals we describe, and so spoiled the partly political empowerment it brought to its participants. This had not been just a matter of using the word "new," or even the concept. There had been a general sense that a lot of old lies had been exposed, a lot of chains had been broken, a lot of blindness and weakness had been overcome. There was a sense of power which made them feel that even brute facts like death and disease, armies and explosives, prisons and factories, might be weakened from within, by a withdrawal of general assent—that they might tumble down, if simply denied or defied by some brave spirit.

Stieglitz was one spokesman for that sense of empowerment in America. Mabel Dodge was another, and Gertrude Stein, in her way, was a third. But this was not just an American phenomenon, although it lasted longer here, where the gap between 1913 and 1915 was just a matter of two years. In England, as a result of the outbreak of World War I, that gap became an abyss, and by 1915 D. H. Lawrence and E. M. Forster had lost the sense of power and promise they had had before.

However, if one looks back just a little, to Forster's novel *Howard's End* (1910), one can find the sense of London as artistic subject formulated in just the way the

New York artists felt their city. It would be hard to find in any other novel a better preliminary and equivalent to Joseph Stella's paintings of the Brooklyn Bridge, and to what Rebecca Zurier calls the Stieglitz group's "ecstatic paeans to skyscrapers and the excitement of Coney Island at night." Duchamp, Francis Picabia, Albert Gleizes, and Jean Crotti, not American themselves, were leaders in generating this paradoxical enthusiasm for New York as the city of the future, and for machinery as conquering life. Yet, Forster himself could not write about London in the way he prescribed in his novel. He found *his* source of power in the countryside, in nature; as did the artists of

Taos, and as did his greater contemporary, D. H. Lawrence, whom Mabel Dodge summoned to Taos to help her spread her romantic gospel. Thus, the split or dispersal that occurred in American painting after 1915 occurred in English writing also.

The issues are with us still: nationalism versus internationalism; political radicalism versus the aesthetic kind; the need for a pure art versus the need for a wide audience; the claims of the big city as subject versus those of regional landscapes and cultures. All this surely makes more plausible the claim that the same large forces were at work internationally that came to the surface in Provincetown in 1915.

NOTES

1. See Martin Green, *New York: 1913* (New York: Basic Books, 1988).

2. A good discussion of these issues can be found in Daniel Singal's "Towards a Definition of American Modernism," *American Quarterly* 39, no. 1 (Spring 1987): 7–26.

3. Peter and Linda Murray, *A Dictionary of Art and Artists* (New York: Praeger, 1966).

4. Percy MacKaye, *The Civic Theatre* (New York: Mitchell Kennerly, 1912).

The Armory Show and Its Aftermath

MILTON W. BROWN

The generation of American artists who brought back to the United States from Paris tidings of a new art in the early years of this century laid the groundwork for the later emergence of American art into maturity and independence. In those years American art was becalmed in a sea of self-satisfaction, convinced of its growing eminence, expounding its virtues, blind to the fact that it had already become irrelevant. Unaware of the new winds in the offing, academic artists went about the routine rituals of salons, prizes, elections, sales, and commissions, comparing themselves to their peers abroad, who were equally myopically concerned with the same rituals, and finding themselves worthy. But there were artists, after the turn of the century, who felt an unease, who were uncomfortable with the formulas of art or for success, and who were seeking new ways of defining themselves and their times. A new spirit was in the air, relating to the new century, to new science and technology, and to new ideas in sociology, psychology, education, and sex.

In the field of art, however, many of the radical, even revolutionary changes that had occurred in Europe in the last years of the nineteenth century were scarcely known in the United States. In the first decade of this century American artists in Paris were beginning to discover Postimpressionism, Fauvism, and then Cubism. They were no longer satisfied with academic instruction and with exhibiting at the Salon. In 1905, the apartment of Leo and Gertrude Stein at 27 Rue de Fleurus became a salon for American artists, and in New York Alfred Stieglitz opened the Little Galleries of the Photo Secession. In 1908, "The Eight" showed for the first and only time as a group at the Macbeth Gallery; Stieglitz exhibited drawings by Rodin and then Matisse; and Max Weber was the first of the avant-garde artists to return with the new gospel. An Independent Artists exhibition was held in 1910, and the famous Armory Show in 1913. Maurice Prendergast, who had discovered Cézanne in 1907, was already painting like a Fauve by the time of the Armory Show (color plate 1). These were all steps in the gradual but revolutionary transformation of American art.

There has been an increasing tendency in recent years to push back the date of American involvement in the avant-garde artistic movements of the twentieth century, even attempts to establish that involvement as innovative. However, although the American variations on European themes have their own fascination, one can hardly claim a major role for them in the international development of Modernism before the Armory Show. Alfred H. Maurer, who went to Paris before the turn of the century, was followed by a whole generation of younger artists. Some of them, who were more or less permanent residents, and others through them, got to meet leading Modernists working in Paris, and were obviously influenced by what they saw and heard. Still, there was little any of them had done before the Armory Show that could be considered avant-garde by Parisian standards.

Most of American involvement in Modernism dates from the Armory Show, which has by now achieved the status of a myth, and like all legends, even young ones, the facts of its occurrence seem lost in a distant past. Yet, like all myths, it impinges so immediately on our consciousness, remains so vivid in its imagery and so heroic in scale,

that it is difficult to identify the legend with the actual event.

Walt Kuhn, who played so large a role in the Armory Show, was the "bard" who, twenty-five years after it happened, set down the heroic outlines of the epic story for all time. Although other writers have presented the story with their own literary embellishments and personal interpretations, none has ever been able to add much to the fundamental pattern of the myth that he outlined in a small pamphlet, *The Story of the Armory Show*, published in 1938. The future surely will remember the Armory Show in its mythic guise, no matter what we do to recreate it art historically.

Late in November 1911, the painters Jerome Myers, Elmer MacRae, and Walt Kuhn, exhibiting in the Madison Gallery, and Henry Fitch Taylor, director of the gallery and a painter himself, discussed the plight of the American artist and the problems of exhibiting. After holding several meetings, they invited a group of sympathetic artists to join them in founding a new society later to be known as the Association of American Painters and Sculptors (AAPS). On 2 January 1912 they elected a slate of officers: J. Alden Weir, president; Gutzon Borglum, vice president; Elmer MacRae, treasurer; and Walt Kuhn, secretary. The very next day, when the newspapers carried the story of the formation of the new association, together with an attack on the National Academy of Design, Weir, who had been elected in absentia, resigned. This was an unexpected and serious blow, but within a week Arthur B. Davies, one of the older members of the new association, was induced to take his place.

The election of Davies not only made the Armory Show possible but eventually determined its character. Davies had unquestioned status as one of America's leading painters, useful connections with a group of wealthy women patrons, the necessary knowledge of art, a refined taste, and, in spite of his retiring nature, an unsuspected grasp of organizational procedure. It was he who gave the exhibition its final artistic character and physical form.

Davies was subsequently attacked for transforming the Armory Show from the original plan of an exhibition of progressive American art to a field day for European radicalism. But the intention of the association from its inception was to exhibit living art whatever its national origins. Despite the lip service paid to this ideal, many of the members had in mind an exhibition along the lines of "The Eight" Show or the 1910 "Independents," but on a much larger scale. They rented the 69th Regiment Armory on Lexington Avenue at 25th Street in New York City, to house what they hoped would be a spectacular show of contemporary art. The next crucial step was taken only in the late summer when Davies saw a catalogue of the *Sonderbund* Show, an exhibition of modern art then current in Cologne. He sent it on to Kuhn, on a painting trip in Nova Scotia, with the note, "I wish we could have a show like this."[1] Kuhn wired him to secure steamer reservations; there was just time to catch a boat that would get him to Cologne before the close of the show.

Arriving in Cologne on the day the show closed, Kuhn managed to see it while it was being dismantled, and, fired by what he saw, he set out to assemble a similar collection for New York, visiting The Hague, Munich, and Berlin, contacting dealers, and arranging for loans. Finally in Paris he found Alfred Maurer, Jo Davidson, and Walter Pach, all of whom lent a hand, but especially Pach, who introduced Kuhn to the latest art and the most advanced artists as well as to dealers and collectors. Together they worked at rounding up the most daring examples of French art. Late in October, Kuhn found the affair coming to a head and becoming too large to handle alone. He cabled Davies for help and the latter came immediately, arriving in Paris in early November. The two men spent the next ten days in

frantic activity, and after tying up all the loose ends, they left Pach in charge as European representative of the association and went to London to see the "Second Post-Impressionist Exhibition" at the Grafton Gallery, an exhibition of modern art organized by the prominent art critic Roger Fry. They were somewhat disappointed by the display; but they found things they wanted, especially the Matisses, featured in the show, and made arrangements to include them. On 21 November they sailed jubilantly for home.

Shortly after their arrival in the States, they announced to the press that the core of their February exhibition would be a great collection of the most radical art of Europe, about which the American public had as yet heard only vaguely. Then followed the almost superhuman job of handling over five hundred foreign works and collecting almost twice that many American examples, converting the armory into a set of galleries, hanging the exhibition, getting up a catalogue, having it printed, and completing the endless smaller tasks necessary to mount such an exhibition. All of it was done, voluntarily, and with great dedication, by this small group of twenty-five artists, the total membership of the association. Some of them were not exactly happy at the turn of events, but there was very little they could do about it.

When the exhibition opened on the evening of 17 February 1913, the thousands of invited guests who jammed the armory (fig. 26) to capacity were treated to a dazzling display. The great empty space of the armory had been converted into a maze of rooms, the partitions covered with burlap and decorated with greenery, all of it brilliantly lit and capped by a dome of cloth streamers. The regimental band blared its repertory of tunes, the elegantly dressed crowd buzzed with excitement, John Quinn[2] made a short speech, and the International Exhibition of Modern Art was officially opened.

As an event, the exhibition was a sensa-tion. Press coverage was extensive and highly laudatory of the AAPS and the job it had done. The show was hailed as a "miracle," a "bomb shell," and "an event not on any account to be missed."[3] It was not until the critics took over from the reporters that the bricks began to fly. They spewed venom on Matisse and ridicule on the Cubists. The "crazy" art of the Armory Show became the talk of the town and, as publicity increased, attendance skyrocketed. New York had an artistic circus and no one wanted to miss it.

It is difficult to say exactly how many people saw the show in New York. Although there has been a tendency to increase the figure with the passage of time, somewhere around seventy-five thousand would be a fair guess. The attendance during the first two weeks was not overwhelming, but consistent publicity helped. The numbers kept mounting to a climactic last week, and one newspaper reported twelve thousand visitors on the last day. On Saturday evening, 15 March, to the accompaniment of a band, a jubilant and spontaneous snake dance closed a momentous event in American art. A champagne supper for member artists and critics was a victory celebration.

The collection then went on to Chicago where it was shown at the Art Institute from 24 March to 16 April (fig. 27). It consisted of most of the foreign section plus a selected representation of American works, totalling about five hundred objects. Chicago was titillated by the advance publicity but, being also provincially defensive, it assumed a hostile "show me" attitude. The general excitement was abetted by a concerted effort on the part of the faculty of the Chicago Art Institute's art school to ridicule the show in the galleries and to inflame the student body to burn Matisse and Brancusi in effigy, as well as Walter Pach, who was in Chicago trying to explain modern art. The purported discovery of six toes on a Matisse nude was enough to relegate the new art to derision, but nearly two hundred thousand people came to see the exhibition.

Reduced to about two hundred fifty exam-

ples from the foreign section, the collection then moved on to Boston, where it was shown at Copley Hall from 28 April to 19 May. Kuhn thought that as an exhibition this was the best of the three. But Boston was never really aroused. The show was neither a financial nor a publicity success. Other cities clamored for it in whole or in part, but the instigators felt by then that the job had been done and they decided, in the words of Walt Kuhn, to "chop it off in Boston."

The Association of American Painters and Sculptors did not survive the brilliant success of the Armory Show. It never put on another exhibition, was riven by dissension, which culminated the following year in the resignation of eight of its members, and only settled its last accounts in 1916. But even from a purely physical viewpoint, the organization of the Armory Show and its display in three cities to some three hundred thousand viewers was a momentous achievement, sometimes overlooked in our emphasis upon its artistic consequences.

The Armory Show may not have been the largest exhibition of art ever held in this country, but it was beyond question the most important. Of course, it is difficult to assess precisely the effect of such an event upon a culture. However, in this case the dramatic presentation of the New Art had so obvious an impact upon both public and art world that its importance cannot be overestimated. The fact that it still remains in our memory is proof enough of its impact. Rumors of strange and revolutionary developments in European art had found their way to these shores somewhat earlier. Alfred Stieglitz had been doing his part at the Photo-Secession Gallery, 291 Fifth Avenue, since 1908, and for the next five years 291, as the gallery was called, offered America, or at least New York, the work of the avant-garde, both foreign and native. Although some American artists had discovered the new movements for themselves while studying abroad and had brought back the word, this awareness of stirrings, of new directions, was limited to a fairly small group

in the art world of New York. The importance of the Armory Show lay in the fact that it collected all these strands, arranged them into a grand design, and challenged the public to look.

The show itself was, first of all, staggering in size, filling the Armory with about thirteen hundred works of art, including large scale sculpture. Also, it was a daring display of a new and revolutionary art which had never before been seen here on such a scale. It was, perhaps, the first, great media event in art. But beyond that—a fact which is rarely remembered—it was a coherent and fairly comprehensive, even "scholarly" presentation of the development of "modern art." The exhibition was really two in one, with the radical foreign works imbedded in a great, somewhat anomalous mass of American art. The intention had been to show the most advanced work in this country as well as abroad, but what was considered progressive here had little relation to the revolutionary art of Europe. As a result, although our critics "thanked the Lord" for "American sanity" and "honest craftsmanship," the Europeans stole the show.[4] One critic at least was led to comment that after the exhibition was digested we might become "less stolidly complacent over the achievements of our painters."

Considering the fact that the men who selected the European works were neophytes on the outside looking in, the results were remarkable. Endowed with hindsight, we can discern obvious gaps, but in the context of that time, the selection was excellent. If one considers the built-in lag of American culture, the Armory Show was an astonishing feat. The only weaknesses in the show were due not so much to unfamiliarity with the whole range of European artistic experiment, as to faults in judgment or exigencies of circumstances. The organizers knew at least something of German Expressionism, and even included Wassily Kandinsky (fig. 28) and Ernst Kirchner, but they considered the movement derivative and unimportant. On the other hand, they

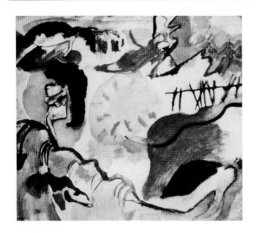

FIGURE 28. *Wassily Kandinsky,* Improvisation
*#27 (1912). Oil on canvas, 47¹/₈ × 55¹/₄". The
Metropolitan Museum of Art, New York, The Al-
fred Stieglitz Collection, 1949 (49.70.1).*

expected to include the Futurists and
announced their participation to the press,
but the Futurists were finally excluded, pos-
sibly because they insisted on exhibiting as a
group. There is no question that the French
school was judged to be central, an opinion
with which there can be little argument, and
in this area there were no serious oversights.
The Fauve representation included Matisse,
Albert Marquet, Georges Rouault, André
Derain, Maurice de Vlaminck, and Raoul
Dufy. Among the Cubists were Pablo Pi-
casso, Georges Braque, Albert Gleizes, and
Fernand Léger. They showed Robert De-
launay, the Orphist, as well as a large range
of lesser, and less radical, artists, like André
de Segonzac, Othon Friesz, Roger de la
Fresnaye, and Marie Laurencin. The French
section was comprehensive and more ad-
vanced than at either the Sonderbund or
Grafton shows and included the latest
works, not only of some of the established
radical artists, but also of those who had
scarcely been heard of previously, like Fran-
cis Picabia, the Duchamp-Villon brothers,
and Constantin Brancusi.

The arrangement of the European section
was the conception of Arthur B. Davies. The
historical segment was planned partly to es-
tablish the legitimacy of modern art, but

mostly to explain its development. Although
he did not always have adequate examples, it
was his intention to trace the evolution of
French painting from Ingres through
Delacroix, Corot, Daumier, Courbet, the Im-
pressionists and Postimpressionists, to the
art of the twentieth century. We may argue
with some of his classification and formula-
tions, but basically his presentation tallies
with the story of modern art as we accept it
today.

The "old masters" of modern art, Cézanne,
Van Gogh, Gauguin, and Seurat, on the whole
were treated seriously, if not sympathet-
ically, and some critics even complained that
they were not well enough represented.
Cézanne's *Old Woman with Rosary* (ca.
1896) (fig. 29), now in London's National
Gallery, at $48,000 was the highest priced
modern work in the exhibition. Pach almost
persuaded the millionaire industrialist
Henry C. Frick to buy it, but the art dealer
Joseph Duveen, who was selling the tycoon
"old masters," seems to have talked him out

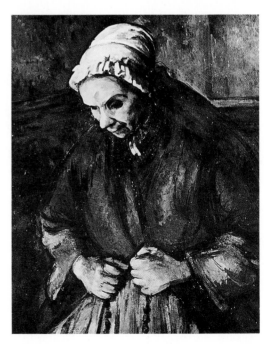

FIGURE 29. *Paul Cézanne,* Old Woman with
Rosary *(ca. 1896). Oil on canvas, 31³/₄ × 25³/₄".
National Gallery, London.*

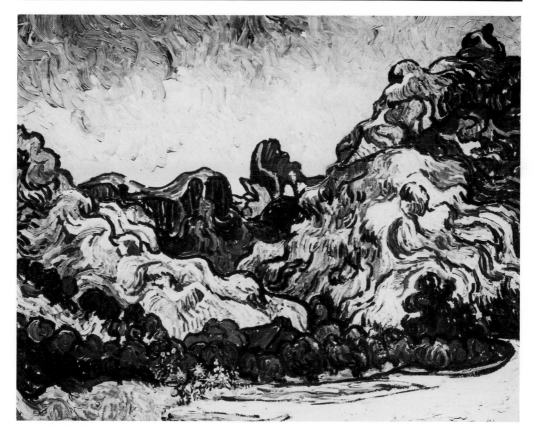

FIGURE 30. *Vincent Van Gogh,* Mountains at Saint-Rémy *(1889). Oil on canvas, 28¹/₄ × 35³/₄". The Justin K. Thannhauser Collection, Solomon R. Guggenheim Museum, New York.*

of it. (It did not sell.) Cézanne was generally described by critics as a sort of bumbling, fanatical recluse, without much talent; still, even his detractors begrudgingly admitted a certain native power in his art. Van Gogh (fig. 30), probably because of the many lurid stories of his life, including all the details of cutting off his ear, was characterized as a madman, at best a passionate amateur. Yet it was difficult to deny the emotional intensity of his expression. Gauguin (fig. 31) attracted most of the critical flak, perhaps because of the mixture of nudity and exoticism in his painting, along with the reported stories of his desertion of wife and family and his immoral activities among the natives of the South Sea Islands. He was violently attacked as a depraved charlatan—Cézanne and Van Gogh were apparently perceived as too naive

to be dishonest; they were simply incompetent. On the other hand, one could hardly deny the sumptuous beauty of Gauguin's design and color. In comparison, Seurat escaped relatively unscathed (he was represented by only two small paintings) perhaps because his work was so close to Impressionism that a fanaticism for small dots rather than bold dashes was not so upsetting. All of them, but especially Cézanne, achieved a new if grudging recognition as important artists.

However, the great and unexpected "discovery" of the Armory Show was Odilon Redon (fig. 32), whose enigmatic fantasies were well received, thus vindicating the judgment of Davies and Kuhn who had gambled on playing him up "big." Of all the avant-garde artists, he was accorded the most favorable press reception. His esoteric

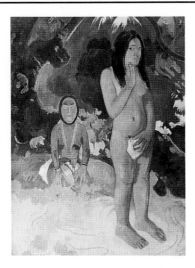

FIGURE 31. *Paul Gauguin*, Parau na te Varua ino (Words of the Devil) *(1892). Oil on canvas, 36¹/₈ × 27". National Gallery of Art, Washington, D.C., Gift of Averell Harriman Foundation in memory of Marie N. Harriman.*

FIGURE 32. *Odilon Redon*, Roger and Angelica *(ca. 1910). Pastel, 36¹/₂ × 28³/₄". The Museum of Modern Art, New York, Lillie P. Bliss Collection.*

symbolism and exotic forms did not seem to disturb the critics and he was hailed as a great master, perhaps because the ravishing quality of his color and the poetic and mystical content of his art appealed to a taste conditioned by the poetic tonalism of James A. M. Whistler and Arthur B. Davies. Redon was by far the most successful of the exhibitors and the phenomenal acceptance of his work occurred here before it did in France and while he was still alive. Thirteen of his paintings and twenty prints were sold from the Armory Show. The Duchamp-Villon brothers proved the most successful in sales after Redon, even though their critical reception was not favorable. Raymond Duchamp-Villon sold three of his four sculptures in the exhibition. Marcel Duchamp sold all four of his paintings and Jacques Villon all nine of his.

We have become accustomed to the art that once shocked America. Many of the show's scapegoats have emerged as blue-chip masters, as the public had been warned they might. The scandal of the show was the Duchamp *Nude Descending a Staircase* (fig. 33), which served as the favorite butt of

the joke-makers. It was described as an "explosion in a shingle factory," or as "Rude Descending a Staircase" (fig. 34); a prize was offered to anyone finding the nude, jingles were written, cartoons were drawn, people came to stare and giggle, and someone decided that the nude was not female but male.[5] Brancusi's *Mlle. Pogany* (1912) (fig. 35) was also susceptible to ridicule, and someone else poured out his mock passion in a poem entitled "Lines to a Lady Egg." But unquestionably the leading target of the American critics was Henri Matisse. No one suffered the lacerating critical assault that he did; it was angry, vicious, and almost psychotic in its ferocity. Perhaps because Matisse was the most completely represented of all the contemporary artists (the selections shown included some of his greatest works), the impact of his art was especially strong. His style exhibited a distortion of form and an erratic use of color which was incomprehensible. Fauvism in its emotional violence was foreign to

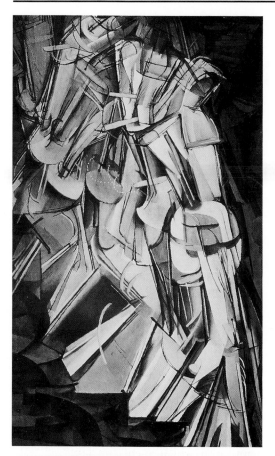

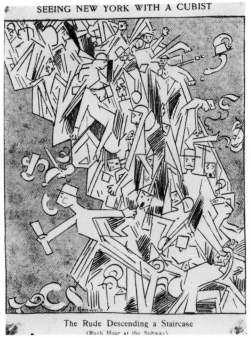

SEEING NEW YORK WITH A CUBIST

The Rude Descending a Staircase
(Rush Hour at the Subway)

FIGURE 34. The Rude Descending a Staircase (Rush Hour at the Subway). *Walt Kuhn Papers, Archives of American Art, Smithsonian Institution.*

FIGURE 33. *Marcel Duchamp,* Nude Descending a Staircase, No. 2 *(1912). Oil on canvas, 58 × 35". Philadelphia Museum of Art, Louise and Walter Arensberg Collection.*

American taste. Matisse was blatantly undermining all the accepted and recognizable forms of art, the nude, the still life, the portrait, genre or symbolic themes. His art appeared to American eyes as willful impertinence, a denial of all aesthetic standards. What the public saw was, of course, not the ravishing sensuousness of Matisse's later years which has become so popular but the harshly iconoclastic works of his more revolutionary youth (fig. 36).

Unlike Matisse, that so-called "genius of disorder and destruction" who was assailing the fortress of tradition, the Cubists seemed to have created a totally new world and one which was not without visual analogies to contemporary industrial life.[6] As a result Cubism received, if not acceptance, at least more tolerant treatment. The obvious intellectual control and technical precision of Cubism prevented the indictment of incompetence usually directed against the Postimpressionists and Fauves. It even led in some cases to the criticism of Cubism for overintellectuality and mechanical rendering. Among the Cubists, Picasso was represented by such dated examples of Fragmented Cubism as *Woman with Mustard Pot* (1910) (fig. 37), whereas by 1913 Picasso and Braque were already beyond Analytical Cubism and into Collage and the beginnings of Synthetic Cubism. Braque, at least in *Poster for Kubelik* (1912) (fig. 38), was more up to date. The Cubist contingent also included Gleizes, represented by his noted *Man on the Balcony* (1912) (fig. 39), and Léger. Alexander Archipenko had four large sculptures, including *Family Life* (1912)

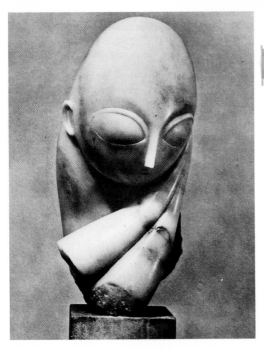

FIGURE 35. *Constantin Brancusi*, Mlle. Pogany *(1912). Plaster. Philadelphia Museum of Art, Louise and Walter Arensberg Collection.*

(fig. 40), destroyed during World War I. One of the major surprises of the Armory Show was the attention paid to Picabia (fig. 41). He did not have the international reputation of Picasso or Braque, but his paintings at the exhibition were more striking in both size and color, so that to an American audience with no experience in Cubism, he could appear as the major figure of the movement, and he was often treated in critical reviews as the leading representative of the style.

The impact of the Armory Show shattered the even complacency of American art. What the public saw was a New Art that was shocking rather than reassuring and the "fakers," the "madmen," the "degenerates" were abused, reviled, and jeered. The press and public laughed, the critics, with their standards crumbling around their ears, fulminated, but it was all to no avail. The Armory Show had done its job. One critic from the *New York Globe* guessed that

"American art will never be the same again," and it wasn't.[7]

In the first place, the death warrant of the National Academy of Design had been signed; it was never taken seriously again. The younger artists, certainly, were no longer interested in showing at the academy or being elected to membership. It had been revealed as ingrown and unenterprising, and its image as a national institution was destroyed. The press was delighted with the show because it supplied such lively copy, and the public was entranced by the carnival atmosphere. But most of all the Armory Show affected the artists of America. Those who had already become involved with the new tendencies were strengthened by confirmation that they were part of the wave of the future. The younger men and women who saw the future for the first time were inspired to change directions.

By sales standards the Armory Show was an unqualified success. Something in the neighborhood of $45,000 (long before present-day inflated prices) was realized from the sale of approximately two hundred fifty works (including about one hundred prints), of which about two hundred were foreign and about fifty American. Curiously, the prices for American works were much higher than those for European. Especially surprising was the fact that almost all the most advanced works, including those of the Cubists, were sold out.

Overnight the United States became a market for modern art. John Quinn, convinced by Kuhn, took his first plunge into contemporary art and the Chicago lawyer Arthur Jerome Eddy ran him a close, adventurous second. Among other now well-known collectors who bought from the Show were Lillie P. Bliss, Walter Arensberg, Albert C. Barnes, and Stephen C. Clark. The Metropolitan Museum of Art paid the highest price for a single work, $6,700, for the *Colline des Pauvres*, the first purchase of a Cézanne by an American museum. Alfred Stieglitz bought the Kandinsky *Improvisation* and a San Francisco dealer, Frederic

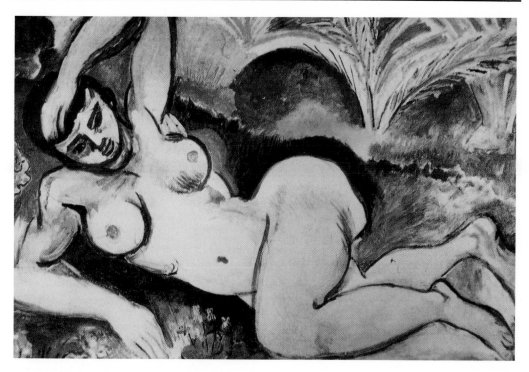

FIGURE 36. *Henri Matisse*, Blue Nude (Souvenir de Biskra) *(1907). Oil on canvas, 36¹/₄ × 55¹/₄". The Baltimore Museum of Art, The Cone Collection, formed by Dr. Claribel Cone and Miss Etta Cone of Baltimore (BMA 1950.228).*

FIGURE 37. *Pablo Picasso*, Woman with Mustard Pot *(1910). Oil on canvas, 28³/₄ × 23⁵/₈". Collection Haags Gemeentemuseum, The Hague.*

FIGURE 38. *Georges Braque*, Le Violon *(L'Affiche de Kubelik)* (Poster for Kubelik) *(1912). Private collection, Switzerland.*

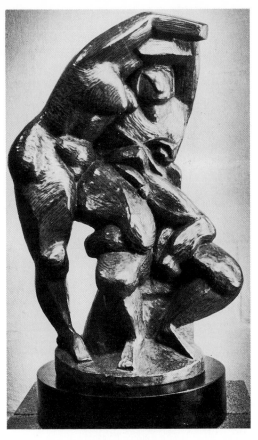

FIGURE 40. *Alexander Archipenko,* Family Life *(1912). Sculpture was destroyed.*

FIGURE 39. *Albert Gleizes,* Man on Balcony (Portrait of Dr. Morinand) *(1912). Philadelphia Museum of Art, Louise and Walter Arensberg Collection.*

C. Torrey, bought Duchamp's *Nude*, sight unseen.

The logjam was broken. If people were buying, someone had to sell, and new galleries specializing in modern art began to spring up. In December 1913, Charles Daniel, former bartender and artists' friend, opened a gallery dedicated to American contemporary art. In the early part of the next year, Stephen Bourgeois, who had lent to the show, opened a gallery to handle "old and modern masters." These and some of the older establishments, like 291, the Folsom, which had shown some of the moderns, and Macbeth, which represented "The Eight," had new

competitors. Montross began to exhibit more advanced art; the Carroll Gallery, with John Quinn as angel, got into the act; and so did the Modern Gallery, which was backed by Walter Arensberg and directed by Marius de Zayas. Postimpressionism found its way into museums and galleries in other cities. The Carnegie Institute in Pittsburgh had a small exhibition of what it claimed to be American Postimpressionists and the Taylor Galleries in Cleveland advertised a show of "Postimpressionism." In New York itself, American moderns were shown at the National Arts Club and in smaller and more intimate galleries as the Gamut Club, the Liberal Club, the Thumb Box Gallery, and the Cosmopolitan Club. This new atmosphere, and these new opportunities for artists, were all direct responses to the Armory Show.

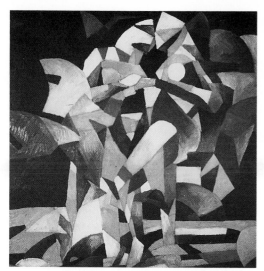

FIGURE 41. *Francis Picabia,* Dances at the Spring *(1912). Oil on canvas, 47¹/₂ × 47¹/₂". Philadelphia Museum of Art, Louise and Walter Arensberg Collection.*

In an effort to publicize American Modernism, Stieglitz, Willard Huntingon Wright, writer and art critic of the *Forum* magazine and brother of Stanton MacDonald Wright, the Synchromist painter, along with several others organized the Forum Exhibition, held at the Anderson Galleries, 13 to 25 March 1916. The exhibition was announced as a "critical selection" of "good examples," cutting the wheat from the chaff of American Modernism and presenting it in a more intimate and manageable format than at the Armory Show. The exhibitors were selected largely from the Stieglitz group and the Daniel Gallery. The emphasis was definitely on abstraction or "pure" art and a rejection of subject matter and "realism." Perhaps because of Wright's involvement the impact of Synchromism was strongly represented. The exhibition was important as an indication of what American painters had been doing since the Armory Show.

The radicalization of American art culminated in the Independents' Exhibition in 1917. Patterned on the French *Salon des Indépendants*, and intended to set progressive art on a stable footing and to rival the suc-

cess of the Armory Show, the twenty-five hundred works by thirteen hundred artists from thirty-eight states turned out to be a bedlam of styles in varying degrees of competence. Even the scandal attending Marcel Duchamp's urinal, submitted under the title of *Fontaine* and signed R. Mutt, did little to disguise the unwieldiness and mediocrity of the exhibition, which got lost in the excitement of the country's entry into World War I. In any case, by this time in the United States and Europe, the national, academy, official, or independent exhibitions were all passé; museums and commercial galleries became the new venue of contemporary art.

The first wave of Modernism swept over American art in the decade following the Armory Show, and there was no ignoring its force and ubiquity. The Armory Show had had as its slogan "The New Spirit"; the new spirit had become the modern spirit. Although the avant-garde artists in New York clustered around two artistic poles—Alfred Stieglitz's 291 gallery and the Arensberg salon—these were neither mutually exclusive nor repellent and even shared personnel and relationships.[8] The influence of these circles on those who belonged was in many cases crucial, but the development of Modernism in post–Armory Show years was more general and cut across such boundaries. Neither 291 nor the Arensberg circle were esthetically unifying agencies nor were their participants stylistically homogeneous. The evolution of Modernism in the United States does not follow rigidly definable patterns, perhaps in part because the history of European Modernism came here telescoped and filtered. Most American artists had not taken part in the more recent developments, except in a peripheral sense. Having participated in a Matisse class is not to have been a Fauve, to have seen a Picasso is not the same thing as having been a Cubist. Thus, the Americans were essentially derivative and eclectic, though they developed rather original variations and personal styles. It is impossible and really not valid to characterize individual American artists as

either Fauves, Cubists, or Futurists, but it is possible to trace the influence of various European tendencies on American artists.

At this point the American avant-garde artists' knowledge of European Modernism was largely limited to what they had seen abroad before the war, at the Armory Show, or at 291 (they did not visit Europe again until after the war). They were aware of Fauvism, Cubism (mostly Analytical), but knew very little of German Expressionism until the 1920s. The Fauvist influence in America was limited, perhaps, because it presupposed a certain esthetic sophistication to accept its irrationality, "wildness," and simplification. Maurer and Weber were the most obviously derivative from Fauvism, especially from Matisse. Except for his essays in Cubism in the last years of his life, Maurer comes closest to the Fauve sensibility. Weber had studied with Matisse for a short time, and his early work, before he returned to the United States, was heavily indebted to the French master, but this phase was superseded by an involvement with Cubism and it was not until the 1930s that he reverted to a kind of Fauve calligraphy. Marin showed strong affinities with Fauvism in the tensions of his compositions and, especially, in the closeness between feeling and facture, but he was essentially a lyrical artist, and always susceptible to Cubist intrusions (color plate 2).

Only Konrad Cramer and Marsden Hartley had any connection with German Expressionism. Hartley had gone to Germany in 1913, exhibited with *Der Blaue Reiter* group in Munich[9] and at *Der Sturm* Gallery in Berlin. He was intimate with *Der Blaue Reiter* circle and obviously influenced by them and especially Kandinsky. The military paintings he did then were derivative, but at the same time original and very personal variations on German Expressionism (color plate 3).

Of all the Modernist styles, Cubism was the most influential, the one movement that was truly widespread. It may have appealed to Americans because of its apparent rationalism, in contrast to the emotional and intuitional aspects of Fauvism. At the same time, an ingrained cultural optimism may explain the failure of American artists to respond to the nihilism of Dada or the social violence of Futurism. Cubism seemed to be a search for fundamentals, for the essential truths of the material and contemporary world, placing artists somehow on a footing comparable to scientists. The period of greatest Cubist influence was from the Armory Show through World War I. During the 1920s Cubism was domesticated in the form of Precisionism or simply disappeared. The growth of abstract art in the 1930s arose out of new conditions, under different influences, and affected a new group of artists.

In this earlier period when many were experimenting with Cubism (it is almost impossible to name an artist who was not), the general pattern was toward a progressive assimilation or eventual rejection of Cubist elements rather than a logical investigation of further possibilities. Both Duchamp and Picabia had come out of Cubism and their presence in New York had a particular impact on artists in the Arensberg circle, but they transmitted mechanism and Dada rather than orthodox Cubism.

John Marin was most intuitively related to Fauvism, as has already been pointed out, but his involvement with Cubism was deep and, if not continuous, at least continual. It is to be seen in the calligraphic embroidery of his earlier work and the planimetric structure of his later, and throughout in the oscillating spatial relations in reference to the picture surface. On the other hand, though Max Weber's commitment to Cubism was quite short (1913–1919), it was complete, and remarkably knowledgeable (color plate 4). Weber, in his earliest work on his return to the United States, was clearly under the influence of Matisse, and was then inspired by the primitivism of his friend Henri Rousseau. But after the Armory Show, he became an instant Cubist, first in the Analytical phase, and by 1915 already

Synthetic—all of this without having been abroad since 1908. His Cubist works of this period are quite unique in internal consistency, sense of style, and personal vocabulary. The introduction of Futurist elements occurred very early and gives his Cubist period paintings an uncanonical look.

Marsden Hartley's Cubist affinity was apparent even in his German paintings, but after his return to the United States in 1915 he had a short but very interesting Cubist phase in Provincetown, and some aspects remained with him throughout his career. But he was fundamentally an Expressionist, an emotional and poetic painter who shifted in response to compulsions that are sometimes apparent and central and at others mysteriously peripheral. Then there were many artists who had only a passing encounter with Cubism, such as Walt Kuhn, Morris Kantor, Andrew Dasburg, Henry Lee McFee, or William Zorach.

Arthur G. Dove has a special place in this period of American history. He is the earliest to have moved decisively in the direction of abstraction. The series of six small paintings called *Abstractions* (1911) (fig. 42) were perhaps as advanced along that road as Kandinsky, with whose work Dove's early efforts have affinities. Dove had been in Paris and must have known the work of the Fauves and Cubists there and from exhibitions at 291, but the nature of that influence or the specific steps in Dove's development toward abstraction are not clear. His involvement with abstraction always remained very personal, based on nature, poetic and evocative in color and form, avoiding total nonobjectivity, and really outside the boundaries of Cubist hegemony or its evolution in Europe. Even in his later collage experiments, derivative from Cubism, he transformed esthetic manipulation into a symbolic statement or a Dada visual pun. Dove maintained his personal vision, hardly touched by changing styles or fashions, becoming richer and more powerful in color and more abstract in form

in his latter years. His art remained always outside the mainstream of international abstraction and has therefore often been perceived as particularly American.

Georgia O'Keeffe was the last and the youngest of the artists to join the Stieglitz entourage. From the Midwest, she had a varied and struggling career as a student, artist, and teacher. Her major influence seems to have come from Arthur Wesley Dow, the very influential esthetician and teacher at Columbia University Teachers' College. In 1915, dissatisfied with what she had done to that point, she began afresh with a series of daring, visionary abstract charcoal drawings which she sent to a friend who showed them to Stieglitz. Thus began the lifelong connection of the two. He hung the drawings in a group exhibition and then gave her her first one-woman exhibition in 1917, the last to be held at 291. O'Keeffe's early works were remarkably original and personal, and on the whole the most consistently abstract; yet, they seem not to have any discernible relationship to the European avant-garde that had influenced so many other American artists. Like Dove, with whom she shared a long and mutual admiration, her style remained very individual and recognizably American. However, her color range is not earthy, like Dove's, but prismatic, suggesting some connection with Synchromism. The earliest watercolors of 1916 are strikingly simple and abstract, but those of the next year reveal clear references to the landscape of the Southwest. The most impressive work of this early period are the brilliantly colored abstractions of 1918–1919, as, for instance, *Orange and Red Streak* and *Blue and Green Music* (color plate 5). They have often been described as musical, and the titles would suggest such an interpretation. Their rhythmic impact is obvious; they also project a strong three-dimensional movement in space, which may again imply some relation to Synchromism.

Stuart Davis was probably the most original and inventive of the Americans working in the Cubist idiom, finally achieving an

FIGURE 42. *Arthur G. Dove*, Abstractions Nos. 1–6 *(1911?). Terry Dintenfass, Inc., New York.*

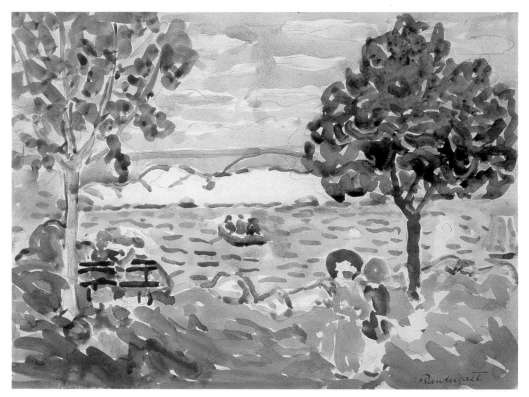

PLATE 1. *Maurice Prendergast,* Cape Ann *(1912–1914), watercolor, $9^1/_2''$ × 13''. Charles Henry Hayden Fund, Museum of Fine Arts, Boston.*

PLATE 2. *John Marin*, A Study of the Sea *(1917), watercolor and charcoal on paper, 14″ × 16³/₄″.*
Columbus Museum of Art, Ohio, Gift of Ferdinand Howald.

PLATE 3. *Marsden Hartley*, Portrait of a German Officer *(1914–1915), oil on canvas, 68¹/₄″ × 41³/₈″. The Metropolitan Museum of Art, New York, The Alfred Stieglitz Collection, 1949 (49.70/42). Photo © 1986 by the Metropolitan Museum of Art.*

PLATE 4. *Max Weber*, Chinese Restaurant *(1915), oil on canvas, 40″ × 48″. Whitney Museum of American Art, New York, Gift of Gertrude Vanderbilt Whitney (31.382).*

PLATE 5. *Georgia O'Keeffe,* Blue and Green Music *(1919), oil on canvas, 58.4 cm. × 48.3 cm. The Art Institute of Chicago, Gift of Georgia O'Keeffe to the Alfred Stieglitz Collection (1969.835). Photo © 1990 by The Art Institute of Chicago, all rights reserved.*

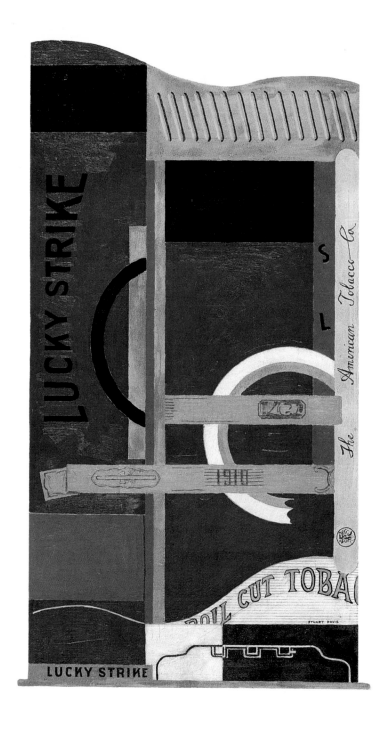

PLATE 6. *Stuart Davis,* Lucky Strike *(1921), oil on canvas, 33¼″ × 18″. The Museum of Modern Art, New York, Gift of the American Tobacco Company, Inc.*

PLATE 7. *Morgan Russell*, Cosmic Synchromy *(1913–1914), oil on canvas, 16¹/₄″ × 13¹/₈″. Munson-Williams-Proctor Institute Museum of Art, Utica, N.Y.*

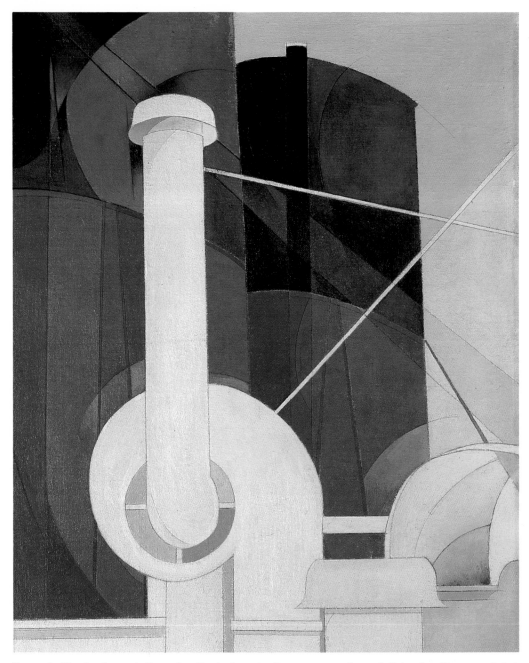

PLATE 8. *Charles Demuth,* Paquebot, Paris *(1921), oil on canvas, 25″ × 20″. Columbus Museum of Art, Ohio, Gift of Ferdinand Howald.*

authentic variation on its basic formulas. Davis had been a disciple of the Ashcan school and a contributor to the radical magazine *Masses*, but the Armory Show, at which he had shown four watercolors, turned him completely around. He entered a period of experimentation, which led in a somewhat erratic sequence through Analytical Cubism, Fauvism, a pseudo-collage phase which evolved into a kind of proto–Pop Art (color plate 6), a brilliant sequence of machine abstractions, and a detour into Precisionism, before he arrived at the first phase of his mature style in the late 1920s and early 1930s, but most of this happened after World War I.

Synchromism was a short-lived movement initiated in 1913 by two young American painters in Paris, Morgan Russell and Stanton MacDonald Wright. Among other American painters working in a similar abstraction idiom in the period immediately prior to, during, and after World War I, were Patrick Henry Bruce, Arthur Burdett Frost, Jr., James Daugherty, Andrew Dasburg, Morton Schamberg, Joseph Stella, and Thomas Hart Benton. Synchromism has been described as an offshoot of Orphism or at least related to it. Although Russell and Wright knew Robert Delaunay and his work, there is evidence that the Synchromists could have developed independently of Orphism, along parallel lines of thought and from a study of similar sources, such as Neoimpressionist color theory and the late watercolors at Cézanne.

Although some Synchromist compositions are less abstract than is commonly supposed, being originally rooted in representational imagery, the degree of abstraction which was sometimes attained accounts for their continuing significance as precursors of more recent abstract painting. Obviously aware of Synchromism's resemblance to Orphism, Russell and Wright argued that Orphist color was merely decorative, and did not express volume. However, critics of the time failed to see much difference (color plate 7 and fig. 43).

FIGURE 43. *Stanton MacDonald Wright*, Conception Synchromy *(1915). Hirshhorn Museum and Sculpture Garden, Smithsonian Institution, Washington, D.C., Gift of Joseph H. Hirshhorn, 1966.*

The Synchromist exhibition at the Carroll Gallery in New York in 1914 did have some influence on other American painters, particularly James Daugherty, Andrew Dasburg, and Thomas Benton. Morton Schamberg's abstractions appear to have evolved independently. Joseph Stella also shows strong affinities with the color abstraction of the Synchromists. Arthur B. Davies had a transitory involvement with the style, especially in the mural *The Dance* (1915).

A. B. Frost and Patrick Henry Bruce, like Russell, were originally introduced to the Parisian Modernist milieu through Gertrude and Leo Stein in the period 1907–1911. However, while Russell and Wright pursued independent study of color theory with a Canadian painter, Ernest Tudor-Hart, Frost and Bruce became intimates of the Delaunay atelier. Bruce, in particular, was accepted by the French and

FIGURE 44. *Patrick Henry Bruce*, Composition III *(1916). Société Anonyme, Yale University.*

The most radical manifestations of Modernism in America were the product of temporarily expatriated French artists working in New York. Duchamp and Picabia, joined by Gleizes and Jean Crotti for a time, generated an enthusiasm for the United States as the country of the future. New York's urban landscape and American advanced technology were hailed as manifestations of modernity. At the time of Duchamp's arrival in the United States he had already passed through phases of Fauvism, Cubism, and Futurism, and was exploring the intricacies of what would later be called Dada. His interest in certain inherently mechanistic, constructivist, and precisionist features of Analytical Cubism led him from the mechanistic illusionism of the *Nude Descending a Staircase* (1912) to the mechanistic constructionism of the *Large Glass* (1915–1923) (fig. 45). In his

FIGURE 45. *Marcel Duchamp*, The Large Glass (La mariée mis à nu par ses célibataires, même) *(1915–1923). Philadelphia Museum of Art, Bequest of Katherine S. Dreier.*

praised by critics for his entries in the salons. In 1913, Apollinaire wrote of the *Salon d'Automne* that a painting by Picabia and Bruce's *Composition* were the two "best." Frost returned to America in 1914 and proselytized among painters on behalf of chromatic abstraction. Bruce remained in Paris, but moved out of Delaunay's orbit with the execution of six large *Compositions* (fig. 44), five of which were bought by Katherine Dreier for the Société Anonyme[10] and are now at the Yale University Art Gallery. These large canvases are extraordinary for their brilliant tonalities and cascading, dynamic stripes and half circles, somewhat in the manner of earlier Picabia abstractions.

FIGURE 46. *Man Ray*, The Rope Dancer Accompanies Herself with Her Shadows *(1916). Oil on canvas, 52″ × 73³/₈″. Museum of Modern Art, New York, Gift of G. David Thompson.*

own development, Duchamp followed the "manipulation" of Cubism to the manipulation of ideas and to Dada, but it is perhaps due to him more than anyone else that mechanism took root in America.

One would expect mechanical forms in painting to appear at this time in the United States. The Futurists had been the first to use such forms with a consciousness of their implications, followed later by the English Vorticists, the Russian Constructivists, the French Purists and Fernand Léger. Duchamp and Picabia were among the earliest to experiment with mechanical forms and their activities took place in New York; but their Dada attitudes, involving complex philosophical, psychological, and sexual connotations, in mechanomorphic relationships, couched in symbolist imagery, were largely lost on American artists, who like most Americans, accepted the machine as a positive force.

The major exceptions were Man Ray and John Covert, though the latter did not abandon his academic style until after 1918. Greatly influenced by Duchamp, Man Ray began experimenting with mechanical forms as well as techniques, such as the airbrush. His *Rope Dancer Accompanies Herself with Her Shadows* (1916) (fig. 46) is obviously related to Duchamp's *Large Glass* begun in 1915. Morton L. Schamberg, on the other hand, seems to have adopted the machine as subject shortly before his death, and almost as early as Picabia, but with an entirely different ideological stance. He avoided the complex aesthetic and psychological attitudes of his European contemporaries, though *God* (ca. 1918), composed of a mitre box and plumbing trap, is a rather obvious response to Duchamp's *Fontaine* (1917), which created such a scandal at the first Independents Exhibition that year. Schamberg accepted the machine world for what it

FIGURE 47. *Charles Sheeler,* Abstraction : Tree Form *(1914). Collection of Françoise and Harvey Rambach.*

was and found it a rich new source, not of theoretical disquisition, but of artistic inspiration. His were the first classic icons of modern technology embodying a machine aesthetic and representing mechanical forms with an idealized purity, without the romantic pessimism and intellectual involutions of the Dadaists. However, the fact that we do not understand the function or process of the machine may be a residue of Dadaism.

How much influence Schamberg had on his close friend Charles Sheeler is difficult to assess, but the latter, whose name has become almost synonymous with Precisionism, was then primarily still experimenting with Synchromism and Cubism (fig. 47). Meanwhile, Charles Demuth was going through a Cézanne/Cubist phase. He had also acquired a taste for mechanical forms and Dada titles from Duchamp. His early proto-Precisionist watercolors of about 1917 show a simplification of form and a strong sense of pattern

without much distortion. Already visible is Demuth's aesthetic dandyism which later led him to strip the industrial scene of its crudeness and discover a delicacy in the neat juxtaposition of architectural surfaces (color plate 8). Almost overlooked in this emergence of the machine image in American art was Oscar Bluemner from Germany, who very early and independently developed a personal variation of the industrial landscape, high-keyed in color and dramatic in form. Joseph Stella also stands somewhat apart in the handling of industrial themes, perhaps because he originally derives from Futurism and was more imaginatively involved with creating an emotional equivalent rather than a representation of the industrial landscape and the machine. After the Armory Show, Stella's first work, *Battle of Lights, Coney Island* (1913) (fig. 48), was clearly Futurist, but he later turned from the motor aspects of Futurism to a less mobile, though essentially dynamic, representation of mechanism as in *The Bridge* (1918).

Precisionism, the one recognizable, stylistically coherent, and original American style to emerge in the post–Armory Show period, was the result of the coalescence of mechanism and the domestication of Cubism. The origins of the style may be traced back to the formal research of Cézanne and certainly Cubism, but it becomes inextricably involved with concepts of industrial and mechanical functionalism. The Precisionist simplification and rationalization of forms in space down to fundamentals is the aesthetic equivalent of machine production and mechanical precision. Most artists who evolved into Precisionists came through a Cubist phase; none lingered long over abstraction. But Precisionism, as a movement, really belongs to the 1920s.

With the end of the war, the United States entered a period of economic expansion and world power. The 1920s witnessed a new surge of cultural nationalism and a return to "normalcy," which had its equivalence in

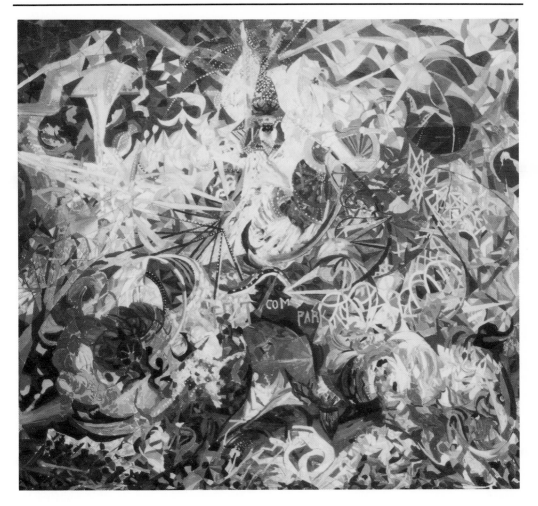

FIGURE 48. *Joseph Stella,* Battle of Lights, Coney Island *(1913). Société Anonyme, Yale University.*

European art as well. It was expressed here in a search for American ethos and subject, and a revival of realism. The period of extreme experimentation with new art forms was gone and American art entered an era of consolidation, digestion, or domestication to last until the economic, social, and political crises of the 1930s, when a whole new galaxy of imperatives changed the course and forms of art.

NOTES

1. See Milton W. Brown, *The Story of the Armory Show*, rev. ed. (New York: Abbeville Press, 1988), 65. The Walter Kuhn and the Walter Pach Papers, Archives of American Art and the Elmer MacRae Papers, Hirshhorn Museum and Sculpture Garden, Smithsonian Institution, remain the richest source of original documents pertaining to the Armory Show.

2. John Quinn was a noted collector of modern art.

3. See Brown, *Armory Show*, 108–109. As secretary of the Association of American Painters and Sculptors, which organized the Armory Show, Walt Kuhn was sent reviews of the show from a newspaper clipping service. These notices, excerpts of which are quoted throughout this essay, can be found in the scrapbooks of the Walter Kuhn Papers.

4. Ibid., 10.

5. Ibid., 136–137.

6. Ibid., 172.

7. Ibid., 109.

8. Walter C. Arensberg was a prominent collector of modern art, whose circle consisted mostly of Dada artists and a younger group who went on to become Precisionists. His studio on West 57th Street served as a salon for leading literary and artistic radicals. He wrote free verse and gave financial aid to such artistic experiments as the Modern Gallery, run by De Zayas. Prominent in the Stieglitz circle were the Postimpressionist painters Marsden Hartley, John Marin, Arthur Dove, and Georgia O'Keeffe.

9. *Der Blaue Reiter* was an association of Expressionist artists founded by Wassily Kandinsky and Franz Marc in Germany. It held its first exhibition in Munich from December 1911 to January 1912.

10. The Société Anonyme was an international society founded by Katherine Dreier in 1920, with the assistance of Marcel Duchamp. Dreier was an important promoter of avant-garde art who founded the society to promote the understanding of modern art in America.

Alfred Stieglitz's Faith and Vision

EDWARD ABRAHAMS

"I hope somebody does get down the real history of all that's happening at 291," Edward Steichen wrote Alfred Stieglitz in November 1913. "I really think you are shaping one of the most vital things in the evolution of America."[1] While hard to comprehend today, in 1913 Steichen, Stieglitz, and numerous fellow artists and critics believed that 291, a small, fourth-floor art gallery on Fifth Avenue, a few blocks north of Greenwich Village in New York City, could change the country's destiny. After America entered World War I in April 1917, however, both men concurred that 291 never possessed the power to redefine American life they thought it had only four short years before. Though their faith in their vision of art inspiring the nation's life may no longer be accessible—and may indeed seem excessively naive—it was nonetheless very real, if for a brief and profoundly creative moment.

While Steichen ridiculed the fantasy of his earlier years after 1917 and went on to earn a small fortune and make his reputation in commercial photography, Stieglitz looked back on his activities at 291 nostalgically in the knowledge that their creativity would never be repeated in his lifetime. Even two decades later, during the Great Depression, when many writers redefined radicalism, linking its cultural expression to a dispassionate representation of the American scene, as in the paintings of Ben Shahn or the photography of Walker Evans, Stieglitz held his ground. In 1935, when Waldo Frank, chairman of the League of American Writers, a left-wing organization that wanted to infuse a sense of class consciousness into American culture, expressed his disappointment after Stieglitz refused to join the cause, Stieglitz exclaimed, "I have always been a *revolutionist.*"[2]

Unlike most intellectuals in the thirties who were reexamining the links between art and social change, Stieglitz refused to reconsider his point of view. He thought that art alone had the power to liberate society. The springs that fed his Modernist vision, tapped at the beginning of the century, had not run dry. In 1935, he still believed, as he had thirty years previously, that creative men and women, by force of their cultural contributions, could establish a new world not only for themselves but for everyone. Stieglitz justified calling himself a "revolutionist" because he assumed that these individuals, if not stifled by traditional society and conventional expression, could inaugurate a real revolution based on personal freedom and social change, his main goal and chief object of all his work. Thus, he considered himself "much more *active* in a revolutionary sense than most of the so-called Communists," who in his eyes were like engineers whose new designs called for the same tired materials.[3] If the Left's new vanguard maintained that the road to a revolutionary culture lay in altering the material conditions of life, Stieglitz argued, as he had for years, that only competing art forms, diverse means of expression, alternative life-styles, a reintroduction of the sacred into modern life, and new relationships between men and women could lead to meaningful change.

Alfred Stieglitz, the key figure in introducing modern art to the American public before the Armory Show, could claim legitimately that he was a "revolutionist" because he was in fact a Modernist. He believed that self-expression, a commitment

to cultural pluralism, and the development of new communities which, in their fullest form, would launch a new nationalism based on art—not for art's sake, but as he often put it, *for life's sake*—could turn the consolidating and, he thought, dehumanizing institutional developments of the twentieth century in new directions. Like other "cultural Modernists," as Randolph Bourne dubbed them in 1918, Stieglitz unfortunately had no clearly conceived plan that might have permitted him to bring about social regeneration through cultural renewal and reconcile the inherent conflict between collective liberation and personal expression. Rather, he relied solely upon his "faith and vision" to change the world. And, while "faith and vision" did create a revolution in American art, they could not by themselves establish the cultural revolution Stieglitz and his friends described. Like John Reed, Max Eastman, Randolph Bourne, and scores of other people with whom Stieglitz joined to make up the "Lyrical Left"—that loose coalition of cultural radicals who dreamed of changing the world with pens, paintbrushes, and new publications during the Progressive Era—Stieglitz failed to realize his dream.

Stieglitz's claim to being a "revolutionist" rests mainly on his activities at 291 from 1907 to 1917 (fig. 49). With the help of the photographer and painter Edward Steichen, Stieglitz founded the Little Galleries of the Photo-Secession, later called 291, in 1905 in order to show photography as art. A pioneer in the development of photography as a legitimate art form, Stieglitz first envisaged his gallery and a new journal, which he founded at the same time, *Camera Work*, as showcases for his contention that photography could provide an avenue to original self-expression, just as painting and sculpture had.

While his success or failure in that venture is still debated by photography's admirers and critics, Stieglitz believed he won his "fight for photography" very quickly. He did so by taking some of the most dramatic

FIGURE 49. *Alfred Stieglitz*, Self-Portrait *(1907), evokes the forty-three-year-old photographer's sense of himself as a serious, somewhat detached, and contemplative artist. National Gallery of Art, Washington, D.C., Alfred Stieglitz Collection.*

and personally expressive pictures in the history of the genre—photographs that have shaped our view of modern American life in the first decade of the century as well as reflected the personal vision of their creator. A wistful photograph like *Spring Showers* (1901) (fig. 50), for example, captures the photographer's melancholy sense of himself as well as showing unsentimentally the cool sweetness of spring in New York City. Similarly, *The Hand of Man* (1902) (fig. 51), a shot of an oncoming locomotive emitting heavy black smoke into the gray clouds above, illustrates the burgeoning mood of a new, aggressive urban civilization while also conveying the artist's sense of his own sexuality.

But Stieglitz soon recognized that he would not be able to achieve his larger goal of revitalizing American culture by showing only photographs, and he therefore turned

FIGURE 51. *Alfred Stieglitz*, The Hand of Man *(1902) illustrates the burgeoning mood of the new urban and industrial landscape. National Gallery of Art, Washington, D.C., Alfred Stieglitz Collection.*

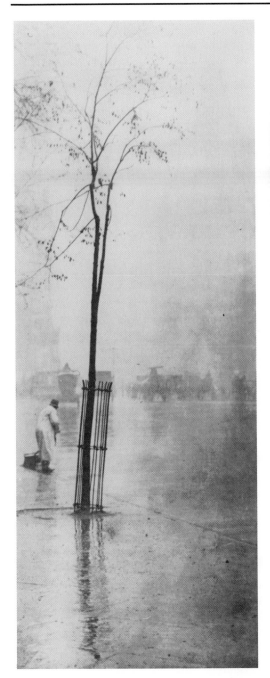

FIGURE 50. *Alfred Stieglitz*, Spring Showers *(1901) captures Stieglitz's melancholy sense of himself at a time when he felt his life lacked direction and purpose. National Gallery of Art, Washington, D.C., Alfred Stieglitz Collection.*

his attention to other art forms. When the watercolorist Pamela Colman Smith asked him in 1907 to show her primitive, Symbolist drawings, he readily agreed, noting that the change in medium meant no change in message. For Stieglitz, they represented "honesty of aim, honesty of self-expression, [and] honesty of revolt against the autocracy of convention."[4] Smith herself conceived of her work as a criticism of American culture. "It seems to me," she wrote in her exhibit's catalogue, "that fear has got hold of this land. Each one has a great fear of himself, a fear to believe, to think, to do, to be, to act."[5] But Smith's watercolors, rooted as they were in nineteenth-century Symbolist painting, did not shock or even disturb the large bourgeois audiences which came to see—and to buy—them at 291 (fig. 52).

Actually, the Smith exhibition was a rather inauspicious beginning for the series of outstanding and provocative shows of avant-garde painting and sculpture that followed. Between 1908 and 1913, the year of the Armory Show, Stieglitz introduced Rodin, Matisse, Toulouse-Lautrec, Cézanne, Rousseau, and Picasso to American audiences, which were completely unprepared

FIGURE 52. *Pamela Colman Smith,* The Blue Cat *(1907), a symbolist watercolor that aimed to unlock the secrets of the subjective world, appealed to Stieglitz, who shared the artist's goal. Yale Collection of American Literature, Beinecke Rare Book and Manuscript Library, Yale University.*

for the visual revolution these painters inaugurated (figs. 53 & 54). The critics were outraged, and the institutional art world abhorred the challenge Stieglitz's downtown gallery presented to the public. Even someone as perceptive as Georgia O'Keeffe, Stieglitz's future wife, thought that Rodin's drawings on display at 291 in 1908 were "just a lot of scribbles."[6] Critics like James Huneker, J. E. Chamberlain, and Kenyon Cox called the European Postimpressionists "madmen," "lunatics," and "impostors." According to the conservative Royal Cortissoz, the modern painters sought "to turn the world upside down" by violating the laws of order of art and society.[7] On this, at least, Stieglitz agreed.

Stieglitz's background helped prepare him to appreciate the New Art. He grew up in a comfortable East Side New York City home in which art and culture were an integral part of the family's life. Stieglitz's father, a businessman and a Sunday painter, in fact, set an example for his son by offering financial assistance to favorite artists, Fedor Encke, the German genre painter, being the most well-known. Where the elder Stieglitz combined business and culture successfully, his son attempted to pit one against the other, in part to outdo his father as the better patron of the arts. Stieglitz too was the kind of person who never accepted normal social standards. As a young boy, for instance, he said his favorite color was black, and, as a grown man, he claimed he always felt "uprooted," never part of any group.[8] Repelled by genteel

FIGURE 53. *August Rodin,* Kneeling Girl— Drawing No. 6 *(n.d.), shocked its audience with both its style and content when Stieglitz introduced it in Rodin's first exhibition in the United States in 1908. The Art Institute of Chicago, Alfred Stieglitz Collection (1949.895). Photograph copyright © 1990 The Art Institute of Chicago, all rights reserved.*

FIGURE 54. *Pablo Picasso,* Nude *(1910). Stieglitz purchased this drawing as one of the eighty-three watercolors and drawings he mounted for Picasso's first show in the United States in 1911. Stieglitz recommended that the Metropolitan Museum of Art buy all eighty-three pictures for two thousand dollars to preserve the collection, but the museum's curator of painting "saw nothing in Picasso," and said his "mad pictures would never mean anything in America." Metropolitan Museum of Art, New York, The Alfred Stieglitz Collection (1949) (49.70.34).*

society, he had no commitment to its aesthetic standards, particularly the notion that art should either decorate or uplift but certainly never challenge cultural sensibilities. His ability to appreciate and support a revolution in art was also aided by his European education. Stieglitz spent nine years in Germany between 1881 and 1890, where, as a student and a young photographer, he immersed himself in late nineteenth-century neo-romantic German culture. The Germanic concern for linking the individual to the supernatural world and emancipating the spirit, or the *Geist*, as the Germans called it, provided an intellectual foundation for Stieglitz's future forays into abstract art and cultural criticism.

Equally important, by 1910, Stieglitz had developed three interrelated principles which enabled him to become a spokesman for the avant-garde. First, he emphasized repeatedly the necessity and legitimacy of self-expression which, as modernization proceeded at an accelerating pace in the social and economic spheres, became in response more and more personal, idiosyncratic, and subjective. Second, he refused to endorse any single school of thought or mode of expression, preferring to attack the traditional academic conception of art and society by eschewing its cardinal tenet, namely rigid adherence to clearly defined cultural standards. That notion led him to adopt a radically new pluralist frame of reference which, in turn, welcomed new forms of art in all fields. And finally, most importantly, he believed he was contributing to a movement that was indeed going to change the world.

Stieglitz's own search for an authentic, self-defined style as a photographer persuaded him to support other artists' quests for liberation from the confines of tradition. It was natural therefore that he welcomed the new Postimpressionists' experiments with line, color, and space. His basic belief that the artist's cultural imperative was to express himself led Stieglitz to endorse the Modernist revolution in the arts.

"Why should you presume to tell an artist what he should do?" he asked rhetorically in 1913. "When he is working, he is not thinking of you or me, or anybody else; he is only satisfying a need of expressing something which is within him."[9] In short, Stieglitz's appreciation of individual differences conditioned him to understand that the new modern artists, by looking inward and expressing what they felt, conveyed more powerfully and more accurately the nature of the post-Freudian world than those who simply painted realistically what they saw.

Stieglitz realized with the avant-garde in Paris, and soon in New York as well, that realistic representation had reached a dead end in its ability to express the artist's newly discovered inner life, and so he designed 291 as, in his words, "a splendid laboratory to study psychology."[10] In an age of science that emphasized the primacy of facts at the expense of spirit, advanced artists had to find some way of staying ahead of what society considered beautiful in order to challenge the civilization from which they felt alienated. Modernists could do so, Stieglitz contended, by proclaiming the power of autonomous forms to convey sensation without imitating nature and without resorting to what 291's critic Marius de Zayas called "fanciful symbolism," referring to the late nineteenth-century efforts in European art and poetry to penetrate the mysteries of the universe—in particular love and death—through the use of defined, and frequently trite, symbols.[11]

Even if Stieglitz had not been predisposed towards a Modernist conception of art, his pluralist posture would have led him to at least seriously consider it. He had been experimenting with the tenets of cultural pluralism since 1902 when he arranged the first Photo-Secession exhibit in which he consciously embraced all methods of photographic printing and development. He insisted then, as he did later, on giving all forms of expression a chance to be seen. In *Camera Work*, which under his editorial direction became the major modern art

journal of the day, he so often published dissenting opinions that he felt compelled to point out that the journal's "policy . . . consists in printing any point of view or any idea, whether we approve of it or not."[12] In 1915, when modern art seemed to have triumphed in New York's main galleries, Stieglitz noted in jest, "If worst comes to worst and the members of the National Academy of Design can find no other place to exhibit their pictures, I will cheerfully give them the use of No. 291."[13]

Stieglitz, nevertheless, did not consider self-expression an end in itself. Nor did his commitment to pluralism make him a Modernist. Only the third component—his basic conviction that his efforts in the field of art had revolutionary repercussions in the world at large—provided the linchpin which held his worldview in place. "Our strength has been," Stieglitz often said, "that we have had faith in our work and that we have had a definite goal."[14] When asked to define it, he responded most frequently by exclaiming, "We are striving for freedom of experience and justice in the fullest sense of the word."[15] In Stieglitz's mind, the link between freedom and justice lay in his firm belief, as he often put it, that "art and life are synonymous."[16] And, if they were indeed the same, then it followed that concentrating one's mind on self-expression was not an indulgent exercise in art for the sake of art but a noble effort that could make a real difference in human affairs.

If art could revitalize society, though, it also meant that American artists could not imitate European styles and expect their work to express and, in turn, shape life in the United States. Like the critic Randolph Bourne, who in 1914 suggested that Americans reject their "cultural humility" and devise in its place "a new American nationalism," and like the editors of *The Seven Arts*, James Oppenheim, Waldo Frank, and Van Wyck Brooks, who in 1916 dedicated their monthly to expressing that new national culture, Stieglitz decided that he could further his goals more effectively by

FIGURE 55. *Alfred Stieglitz*, Arthur Dove *(1914 or 1916). Dove was one of a group of modern American painters that included John Marin, Marsden Hartley, and Georgia O'Keeffe, whose art Stieglitz supported and promoted. National Gallery of Art, Washington, D.C., Alfred Stieglitz Collection.*

promoting American artists. [17] After introducing the most advanced European art, following the Armory Show he decided paradoxically to sponsor American artists almost exclusively, becoming patron and mentor to America's first modern painters: John Marin, Arthur Dove (figs. 55 & 56), Marsden Hartley, and his future wife, Georgia O'Keeffe. Stieglitz assumed with Walt Whitman that an artist's work should be rooted in the place he or she lived, and contended with his contemporaries that new forms of expression could indeed radicalize American life. As he wrote in 1914, "My whole life in this country has really been devoted to fighting the terrible poison which has been undermining the American nation. As an American, I resented the hypocrisy, the short sightedness, the lack of construction, the actual stupidity in control everywhere."[18]

FIGURE 56. *Arthur Dove,* Nature Symbolized No. 2 *(1911). Dove is considered the first American painter to explore the principles of abstraction to convey his appreciation of the American landscape. The Art Institute of Chicago, Alfred Stieglitz Collection (1949.533). Photograph copyright © 1990 The Art Institute of Chicago, all rights reserved.*

Stieglitz thought he was launching a revolution when he introduced modern art in the United States. Living in an increasingly secular era, he invested in the act of artistic creation the power and purpose former generations had reserved for religion. He often noted that he felt out of place, in the new age of science and technology, even though paradoxically his camera was a product of the new machine age. This is why, in addition to showing modern art for the first time in the United States, Stieglitz also introduced children's art and African sculpture to American audiences at 291 between 1912 and 1916. He believed with other romantics that neither children's nor "primitive" peoples' creativity had been stifled by the rational society he felt compelled to oppose. In the final analysis, though, to break through the awesome perceptual barriers of realistic representation required a faith similar to that which Stieglitz placed in his ideas on behalf of the artist and modern art. "It is seven years now," he wrote in 1912, "that I have been running the little place at '291' and I have not missed but two days during the whole time. During this period about 160,000 people have come up and they have been shown something which is unique in America or in Europe. Many of them are be-

ginning to see that back of the so-called Exhibitions there is something bigger than just what is hung on the walls; there is an idea, a spirit. But few seem to grasp its meaning, a hand full possibly do."[19]

On that somewhat somber note, Stieglitz pointed to the ultimate failure of his proposed revolution. If he was a prophet, as he liked to believe, leading the way to a new radical culture, he did so in a language not many people could comprehend. And, if they could understand it, they discovered in Stieglitz's passionate rhetoric no clearly conceived way of translating 291's idealistic principles into a program of action that might have resulted in the social change the Modernists so desired. Sadly, when the right of artistic self-expression would be fully accepted by society, when the tenets of cultural pluralism would become a bulwark of a conservative consensus, and when the paintings of Postimpressionist "wild men" would be worth more than the museums that housed them, few would recall the revolutionary promise Stieglitz and other cultural radicals had once seen in modern art.

Among the last works of art exhibited at 291 was Marcel Duchamp's urinal, a "Ready-made," as he called it, which Duchamp submitted to the Society of Independent Artists' exhibition in 1917 under the pseudonym R. Mutt (fig. 57). Although it had promised to show any work presented, the society's selection committee rejected Duchamp's "Fountain" as inappropriate, if not scandalous. "The Richard Mutt Case" soon became the *cause célèbre* of American art. Duchamp challenged that because "Mutt" had "created a new thought for that object," he had contributed a work of value.[20] In submitting his "Fountain," Duchamp, who later claimed that "the concept of the Ready-made" may have been "the most important single idea to come out of (his) work," pressed pluralism to its furthest limits.[21] With a single imaginative act, he abolished any distinction between art and life, rejected completely criticism's legitimacy, and called attention to his own

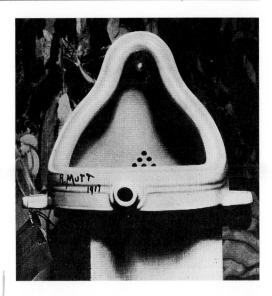

FIGURE 57. *Alfred Stieglitz, Marcel Duchamp's* Fountain *from the* Blind Man *(1917), shown by Stieglitz at 291 after the Society of Independent Artists rejected it. Stieglitz understood that Duchamp sought to abolish any distinction between art and life through his imaginative act of showing a commonplace object as art. Philadelphia Museum of Art, Louise and Walter Arensberg Collection.*

self-proclaimed right of determination. Duchamp was in effect saying that there were no artistic standards, values, or customs outside of his own choosing to which he would adhere.

Stieglitz was one of the few people at the time who understood Duchamp. Seeing the connection of Duchamp's statement to 291's aims, he had the "Fountain" moved to the gallery, where in April 1917, he exhibited the "Ready-made" and photographed it for posterity. Within a month of the urinal's appropriate, if unheralded exhibition, 291 closed its doors and *Camera Work* ceased publication for good, ending a chapter in the history of American art.

The immediate cause for 291 and *Camera Work*'s demise was the beginning of Prohibition in August 1917. Financial support for Stieglitz's gallery and publications had depended in large part on his wife's steady income from her family's brewery in

Brooklyn. When, following United States entry into World War I, the government forbade the use of valuable foodstuffs to manufacture alcoholic beverages, Stieglitz was forced to terminate his experiments. "My family and I," he wrote the publisher Mitchell Kennerley in May, "have been badly hit. So badly, that I am compelled to give up 291 and *Camera Work*."[22]

The letter was one of the few times Stieglitz acknowledged the importance of money in running 291 and in putting out his publications. It would be inaccurate, however, to suggest that Prohibition alone dried up the support for America's avant-garde. Had Stieglitz's financial position not deteriorated, it would have been inconceivable for him to have continued as he had before April 1917 after America joined the war. The faith, or now more clearly the fiction, on which 291 and *Camera Work* were based— that art by itself might change society— could no longer be sustained once the aims of war defined the nation's social purpose. In the face of a universal conflagration, Modernism, which had been predicated upon both social confidence and the most extreme definitions of freedom, seemed like a spent force. Even Stieglitz himself, though he had great difficulty comprehending what the war was really about, recognized that 1917 marked the end of his dream. Only months after Wilson's declaration of war, he lamented, "Of course the War as a background emphasizes all the weaknesses which I tried to overcome all these years—in which I failed."[23]

Earlier, Marius de Zayas, who happened to be in Paris in September 1914, recognized what the war would do to the world the avant-garde lived for. "I left France and especially Paris in a very bad condition," he wrote Stieglitz. "Since the war *started* it seemed that all intellectuality had been wiped out. I believe that this war will kill many modern artists and unquestionably modern art. It was time, otherwise modern art would have *killed* humanity."[24] De Zayas's final note still reflected the formi-

dable potency to reorder the world he and Stieglitz assumed Modernism possessed.

The idea that art could kill (even metaphorically) was becoming increasingly more difficult to believe in, as the war demonstrated conclusively how little power artists actually had. Recognizing that the song of his "faith and vision" had been drowned out by the drums of martial music, Stieglitz felt that he needed to proffer some sign of a symbolic suicide in April 1917 to indicate the end of the life he had led since 1905. He threatened to destroy the numerous editions of *Camera Work* he still owned unless someone would buy them at reduced rates. Succeeding in selling *Camera Work*, he chose instead *291*, an experimental magazine that came out in twelve issues in 1915 and 1916, as the object for his wrath and despair. An innocuous letter in the Alfred Stieglitz Archive at Yale bears silent witness to *291*'s demise.

> 291 Fifth Ave., New York
> April 12, 1917

> American Waste Paper Co.
> 70 Green St., New York

> Gentlemen:

> Under separate cover we are sending you a copy of a paper called '291'. We have several hundred pounds of this paper which we wish to dispose of. What could you give us per pound for this paper?

> Awaiting your reply, very truly yours,
> Alfred Stieglitz

He received $5.80 for his sacrifice; some eight thousand copies of the magazine were turned into pulp.[25]

In keeping with primitive ritual, Stieglitz undoubtedly hoped that his destruction of *291* would lead to a rebirth of his vision, which had so dramatically and unalterably transformed American culture. Following the war, he opened other galleries, though in comparison to 291, they were on the periph-

ery of the art world and introduced no new artists. To be sure, he also did some of his most outstanding photography after 1917, including his revolutionary, abstract equiv-

alents series. Still, no magical rite, however bold, could restore the unfulfilled—and unfounded—promise of modern art by it-self creating a new society.

NOTES

The Alfred Stieglitz Archive is in the Beinecke Rare Book and Manuscript Library, Yale University, New Haven, Connecticut.

1. Edward Steichen to Alfred Stieglitz, November 1913, Alfred Stieglitz Archive.

2. Alfred Stieglitz to Waldo Frank, 6 July 1935, Alfred Stieglitz Archive.

3. Ibid.

4. "The Editor's Page," *Camera Work* 18 (April 1907) : 37.

5. Pamela Colman Smith catalogue, *Alfred Stieglitz Scrapbook*, no. 4. 64, Alfred Stieglitz Archive.

6. *Georgia O'Keeffe: A Portrait by Alfred Stieglitz*, intro., Georgia O'Keeffe (New York: Metropolitan Museum of Art, 1978), n.p.

7. Royal Cortissoz, "The Post-Impressionist Illusion," *Century Magazine* 85 (April 1913) : 813.

8. Alfred Stieglitz, *Mental Photographs: An Album for Confessions of Tastes, Habits, and Convictions* in the possession of Frank Proser of Lake George, N.Y.; Alfred Stieglitz, "Thoroughly Unprepared," *Twice-A-Year*, 10–11 (Fall-Winter 1943) : 249.

9. Quoted in Marius de Zayas and Paul B. Haviland, "A Study of the Modern Evolution of Plastic Expressionism, 291" (1913) : 17.

10. Alfred Stieglitz to Heinrich Kuhn, 14 January 1912, Alfred Stieglitz Archive.

11. Marius de Zayas, "Modern Art in Connection with Negro Art," *Camera Work* 48 (October 1916) : 7.

12. "Editorial," *Camera Work* 14 (April 1906) : 17.

13. Quoted in Marius de Zayas, "How,

When, and Why Modern Art Came to New York," *Arts Magazine* 54 (April 1980) : 112.

14. Alfred Stieglitz to George Davidson, 10 April 1909, Alfred Stieglitz Archive.

15. Agnes Ernst, "New School of the Camera," *New York Sun*, 26 April 1908.

16. Alfred Stieglitz to Spencer Kellogg, 17 December 1913, Alfred Stieglitz Archive.

17. Randolph Bourne, "Our Cultural Humility," *Atlantic Monthly* 114 (October 1914) : 506. *The Seven Arts* appeared twelve times in 1916 and 1917 until World War I led to a loss of funds for the antiwar journal. Dedicated to expressing a new American culture, the magazine published Sherwood Anderson, Randolph Bourne, John Dos Passos, Kahlil Gibran, and Paul Strand among others.

18. Alfred Stieglitz to Fritz Goetz, 23 December 1914, Alfred Stieglitz Archive.

19. Alfred Stieglitz to R. Child Bayley, 29 April 1912, Alfred Stieglitz Archive.

20. *Blind Man*, 2 (May 1917) : 5.

21. Quoted in Arturo Schwarz, *The Complete Works of Marcel Duchamp* (London: Thames and Hudson, 1969), 39.

22. Alfred Stieglitz to Mitchell Kennerley, 17 May 1917, Alfred Stieglitz Archive.

23. Alfred Stieglitz to Paul Strand, 18 August 1917, Alfred Stieglitz Archive.

24. Marius de Zayas to Alfred Stieglitz, n.d., Alfred Stieglitz Archive.

25. See Alfred Stieglitz, "The Magazine *291* and the Steerage," *Twice-A-Year*, 8–9 (Spring-Summer 1942, Fall-Winter 1942), 135. A rare complete edition of *291* is now worth tens of thousands of dollars.

The Masses and Modernism

REBECCA ZURIER

"Frank; Arrogant; Impertinent: searching for the True Causes, A Magazine Directed Against Rigidity and Dogma wherever it is found," *The Masses* embodied the spirit of experiment and rebellion that characterized its extraordinary era.[1] Staffed by many artists and writers allied also with the Provincetown Players, *The Masses* blended culture and politics, poetry, economic theory, drawings, and labor news side by side in the oversized format of a well-produced art magazine. In cartoons and writing, its editors explored subjects such as the New Woman, the New Politics, the New Psychology, and the New Literature with wit and aplomb.

But where, in all of this radical amalgamation, was the New Art? Although *The Masses* was founded by artists who described their venture as "a revolutionary and not a reform magazine," the "revolutionary" New Art seen at 291 and the Armory Show (and parodied in George Cram [Jig] Cook's play *Change Your Style*) found little quarter in its pages. The distinctive graphic look of the magazine had sources other than contemporary Modernist art. Throughout its life the journal remained hostile to most of the artistic change taking place around it. This seeming anomaly is significant because it shows that the cultural ferment alive in 1915 did not manifest itself identically in all fields. There were divisions and inconsistencies among the different trends and groups

involved. The story of art in *The Masses* suggests some of the contradictions inherent in its cultural moment.

Founded in 1911, in its first incarnation *The Masses* revealed artistic and intellectual roots in nineteenth-century Christian socialism. Its editors enlisted the support of a group of successful commercial writers, illustrators, and cartoonists who supported the socialist cause to publicize the activities of European workers' cooperatives to American audiences while appealing to "the masses" with fiction, poetry, and art. In keeping with the nineteenth-century vision of peaceful, evolutionary progress toward an ideal cooperative commonwealth, the magazine published didactic articles and easily legible drawings designed to inspire visions of a better future. Charles Winter's figure of *Enlightenment* (fig. 58) shows this approach.

Such high-minded images, printed alongside translations from stories by Tolstoy and Zola, reveal an ideal of art as morally uplifting. *The Masses'* early editors assumed that if the proletariat could be taught to appreciate great works of art, these works would eventually exert an improving influence. Their attitude found parallels in efforts by contemporary reformers to establish workers' choral societies, to arrange museum loan exhibitions in working-class neighborhoods, and to distribute reproductions of old-master paintings through settlement houses.[2] With their purpose of exposing "the masses" to great cultural traditions—and their implied condemnation of the popular commercial culture of Coney Island and Tin Pan Alley—such activities gave little support to the experiments and innovations that would characterize the New Art.

Despite its noble intentions, the original version of *The Masses* received scant popular support and went out of business after fourteen months of publication. When the magazine was restructured at the end of 1912 its layout changed along with its editorial policy. The motivating force behind the re-

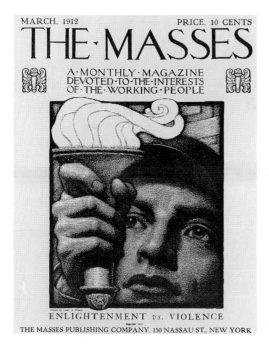

MARCH, 1912 PRICE, 10 CENTS

THE·MASSES

A·MONTHLY·MAGAZINE
DEVOTED·TO·THE·INTERESTS
OF·THE·WORKING·PEOPLE

ENLIGHTENMENT *vs.* VIOLENCE

THE MASSES PUBLISHING COMPANY, 150 NASSAU ST., NEW YORK

Figure 58. *Charles Allen Winter, "Enlightenment vs. Violence." The Masses 3 (March 1912), cover. Tamiment Institute Library, New York University.*

vived journal was a group of artists seeking a magazine modeled after left-wing European satiric magazines that printed bold cartoons and political commentary in an oversized format. Some of these artists had been affiliated with *The Masses* from its inception; others joined for the chance to create and control their own journal with high-quality reproductions and no distracting advertisements. Most of the artists and writers who contributed to the revived *Masses* made their livings working for popular magazines and were disgusted with the demands of commercial journalism. As Susan Glaspell said of contemporary plays, commercial magazine articles were "patterned" according to formulas established by the marketplace.[3] For some of the artists a resentment of commercialism—as much as an awareness of social injustice—led them to question capitalism and turn to socialism. Art Young expressed this critique in a cartoon showing the capitalist press as a

bordello where Madame Editor and various writers wait on their client, Big Advertising (fig. 59).

In an effort to break traditional hierarchies, the staff of *The Masses* proposed restructuring the magazine as a worker-owned cooperative with all stock held by the artists and writers, thereby identifying artist with worker and worker with owner. They instituted collective editorship, carried out by group vote at monthly meetings. This process offered contributors what no other journal provided: complete artistic control over editorial decisions, and the freedom to answer to no one but themselves. The arrangement proved especially attractive to artists resentful of the traditional use of art—by magazines on both the Left and the Right—as illustration subordinate to preselected texts. Art in *The Masses* played a role separate but equal to that of writing, and received comparable space. Writers, too, responded to the opportunity to publish unconventional, idiosyncratic, commercially unviable or politically "incorrect" material. John Reed described *The Masses'* open policy in a provocative manifesto: "We refuse to commit ourselves to any course of action except this: *to do with the Masses exactly as we please.* . . .We have perfect faith that there exists in America a wide public, alert, alive, bored with the smug procession of magazine platitudes, to whom What We Please will be as a fresh wind."[4]

By promising "to do What We Please and Conciliate Nobody," *The Masses* challenged not only the commercial press but also the publications of the American Socialist Party. The publishing establishment responded with libel suits, while critics on the Left charged *The Masses* with frivolity, eclecticism, Bohemianism—how could a journal that condemned the church and advocated free love claim to represent working-class Americans? Although never able to resolve the conflict of purpose, the editors clung to their ideas of "A Free Magazine" as a matter of principle. Their wide-ranging taste, and distrust of "dogma wherever it is found,"

THE FREEDOM OF THE PRESS

FIGURE 59. *Art Young, "The Freedom of the Press."* The Masses 4 *(December 1912), pp. 10–11. Courtesy Earl Davis.*

set *The Masses* apart from the more single-minded publications of other American leftists and eventually contributed to the magazine's lasting vitality. Today the socialist journal *The Appeal to Reason*, which achieved a vastly greater circulation than *The Masses* in the 1910s, holds little but historical interest while cartoons in *The Masses* continue to hit their marks and much of the prose can be read with pleasure.

As important as *The Masses'* commitment to social change, collective decision making, and artistic freedom was the staff's commitment to not taking itself too seriously. In contrast to the pious, humorless tone of most Socialist party publications, editorials in *The Masses* proclaimed "enjoy the revolution"; its members sought to outrage rather than inspire their readers. *The Masses'* humor testified to the editors' idea that any revolution should accommodate wit, pleasure, and creative expression; however,

humor could serve as a powerful political tool when used to attack injustice and provoke controversy. Many of the celebrated lawsuits brought against *The Masses* originated in attempts to censor its cartoons. Satire offered one way to reconcile *The Masses'* often conflicting goals of "appealing to the masses" while offering its artists freedom to do "what we please": it encouraged its readers to question authority. The editors noted that the combination of humor and political commentary was part of a long American tradition and linked their venture to the satiric songs, cartoons, and slogans employed by the IWW.[5]

In keeping with the journal's confrontational tone, the art that appeared in the revamped *Masses* departed from the allegorical images of mighty workers favored by its earlier editors and those of other conservative socialist publications (fig. 79). Its cartoons expressed a much wider range of

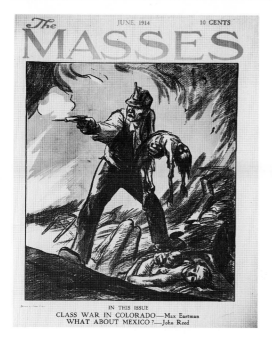

IN THIS ISSUE
CLASS WAR IN COLORADO—Max Eastman
WHAT ABOUT MEXICO?—John Reed

FIGURE 60. *John Sloan, "Ludlow, Colorado."* The *Masses* 5 *(June 1914), cover. Tamiment Institute Library, New York University.*

social concerns. Advocating the direct-action tactics of the IWW, *The Masses* devoted some of its strongest cartoons to the labor movement, including stirring coverage of the massacre of striking miners in Ludlow, Colorado (fig. 60). John Sloan's 1913 cartoon "Calling the Christian Bluff" (fig. 61) commemorated efforts by the anarchist leader Frank Tannenbaum to organize unemployed men in New York—later the inspiration for the play *Contemporaries*. In a departure from the Socialist party's more conservative position, *The Masses* took a strong stand against racism, symbolized in Robert Minor's cover drawing of a lynching "In Georgia" (fig. 62). The New Woman appeared in drawings that protested women's wages and supported the suffrage movement (fig. 63). *The Masses* combined its support of economic equality with a consideration—sometimes idealized—of woman's inner nature, as seen in John Sloan's series of cartoons depicting "Adam and Eve, the True Story" (fig. 64). Although many of the

drawings and articles about women were contributed by men, there were a few women feminists on the staff, among them the journalist Inez Haynes Gillmore, Provincetown denizen Mary Heaton Vorse, and the now forgotten cartoonist Cornelia Barns. Barns's wry view of modern women can be seen in her drawing of two would-be feminists titled "My Dear, I'll be economically independent if I have to borrow every cent!" (fig. 65). *The Masses* continued to challenge Socialist party orthodoxy in its early and unwavering opposition to World War I. Artists whose work was rejected by mainstream newspaper editors contributed powerful antiwar cartoons (fig. 66). At the same time, *The Masses* printed social satire along with parodies of Greenwich Village mores and a whimsical affront to the sacred cow, "Old Mother Tradition" (figs. 67, 68).

The journal's promise of artistic freedom also attracted contributions of pictures with no overtly topical message from "fine" artists who were sympathetic to the journal's political aims and appreciated the opportunity to see their work reproduced in an attractive format. The occasional gift of figure studies from Jo Davidson, Arthur B. Davies, Abraham Walkowitz, and Pablo Picasso—all participants in the 1913 Armory Show—formed an ironically dainty and romantic counterpart to the strong images of women in Robert Minor's cartoons against censorship (figs. 69, 70). Such juxtapositions, which eventually occasioned the well-known quip about "pictures of nudes in *The Masses*. . . . How does that help the working classes?" are quite understandable in light of the journal's support of artistic self-expression and a lingering hope that the enjoyment of art might not be limited to the leisure class. After all, it was an IWW songwriter who had issued the call for "bread and roses."[6]

Despite its eclectic contents, *The Masses* achieved a consistent visual impact through the efforts of the artists and cartoonists who belonged to the full-time editorial board. Most of these men and women had studied

Calling the Christian Bluff

FIGURE 61. *John Sloan, "Calling the Christian Bluff." The Masses 5 (April 1914), pp. 12–13. Tamiment Institute Library, New York University.*

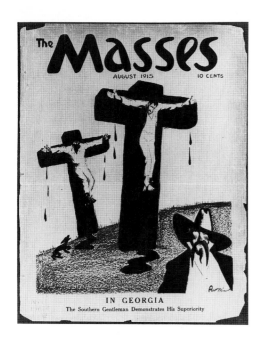

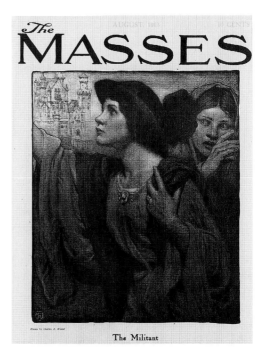

The Militant

FIGURE 62. *Robert Minor, "In Georgia: The Southern Gentleman Demonstrates His Superiority." The Masses 6 (August 1915), cover. Tamiment Institute Library, New York University.*

FIGURE 63. *Charles Allen Winter, "The Militant." The Masses 4 (August 1913), cover. Courtesy Earl Davis.*

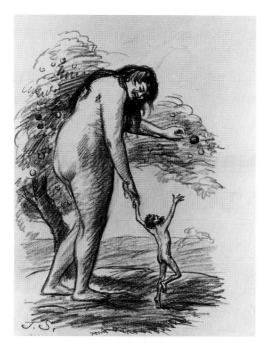

FIGURE 65. *Cornelia Barns, "My Dear, I'll be economically independent if I have to borrow every cent!" The Masses 6 (March 1915), p. 7. Courtesy Earl Davis.*

FIGURE 64. *John Sloan, "Adam and Eve, The True Story—He Won't Be Happy 'Til He Gets It!" The Masses 4 (March 1913), p. 9. Delaware Art Museum, Wilmington, Gift of Helen Farr Sloan, 1986.*

with the influential teacher and painter Robert Henri, and shared his enthusiasm for the quick, autographic sketch, the "honest" line, and a form of artistic realism that could be used to celebrate the lives of humble people—a subject they sought out in the working-class neighborhoods of lower Manhattan. Their interests allied them with the group of artists known as the Ashcan school, all of whom trained on newspapers (in the days when papers printed artists' sketches instead of photographs), worked with Henri, and created an art based on the life of New York's streets. John Sloan, a leading artist of the Ashcan school and *The Masses'* equivalent of an art editor, set the tone for much of the art in the journal; his cover drawing "The Return from Toil" (fig. 71) is close to his paintings and prints of the period. Also on the staff were George Bellows, Stuart Davis, Henry Glintenkamp, and Glenn Coleman—all developing reputations as

FIGURE 66. *Robert Minor, "Army Medical Examiner: 'At last a perfect soldier!'" The Masses 8 (July 1916), back cover. Tamiment Institute Library, New York University.*

FIGURE 67. *Henry Glintenkamp, "He: 'Did you know that I am an Anarchist and a Free-lover?' She: 'Oh, Indeed!—I thought you were a Boy Scout.'" The Masses 8 (December 1915), p. 12. Tamiment Institute Library, New York University.*

Ashcan school artists in these years—and several cartoonists who worked in a similar mode. Their unpretentious, sympathetic drawings of everyday people fit in well with the magazine's political slant without moralizing or talking down to their intended audience. The drawings' links with journalism gave them a popular source that the editors probably thought would appeal to "the masses," while breaking with traditions of magazine illustration.

From Henri, too, came *The Masses'* admiration for the great nineteenth-century French cartoonist Honoré Daumier, whom turn-of-the-century followers revered for his ability to combine human compassion and moral outrage. Left-wing cartoonists and traditional art critics united in the belief that Daumier had transformed the cartoon with the seriousness of high art. The example of an artist who achieved greatness "with his lithographic pencil and the cheap paper of a periodical" suggested a way to

take art off the gallery walls and bring it to the people.[7] In an effort to capture the effect of Daumier's crayon technique with up-to-date reproductive methods, Sloan worked with printers and photoengravers to reproduce drawings that captured the crispness and tonal nuance of lithographs.

The influence of Daumier, and Sloan's technical innovations, encouraged artists of *The Masses* to produce images of disturbing strength, from the forceful cartoons of Robert Minor—"big, black brutal things," in the words of his colleague Kenneth Chamberlain—to Stuart Davis's expressionistic drawings of black life in New Jersey (fig. 72).[8] The crayon style united the diverse interests of the artists on *The Masses'* staff and encouraged them to cross the boundaries that usually separated "high" art from social satire or political protest. The Ashcan school artist George Bellows drew characteristic images of boys playing on an East Side dock, but also pro-

FIGURE 68. *Frank Walts, "Old Mother Tradition." The Masses 6 (June 1915), cover. Courtesy Earl Davis.*

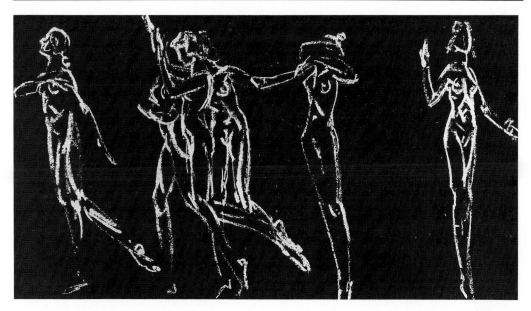

FIGURE 69. *Arthur B. Davies, "Melodies."* The Masses *8 (August 1916), p. 8. Courtesy Earl Davis.*

duced Daumier-like drawings that skewered bourgeois foibles, then went on to deploy the lithographic crayon's shadow and expressive line in a moving indictment of Southern racism, "Benediction in Georgia" (figs. 73,

FIGURE 70. *Robert Minor, "O Wicked Flesh!"* The Masses *8 (October-November 1915), p. 20. Tamiment Institute Library, New York University.*

74). At the same time, the professional cartoonist Maurice Becker (who recalled becoming "an addict of Daumier" in Henri's classes) could turn from using the crayon technique for violent antiwar messages to the gentle irony of a drawing of a street peddler titled "Harbinger of Spring" (fig. 77).[9] Daumier's example provided inspiration for each of these types of imagery.

Further uniting the artists of *The Masses* was a shared hatred of capitalist magazine art, typified by the commercial cover girl (fig. 75). A bathing beauty drawn by the popular illustrator James Montgomery Flagg reveals the tactics Flagg used during World War I in his famous "I Want You" poster: both images grab the viewer's attention. To artists of *The Masses*, the cover girl represented the forces of capitalism because it used art—and by implication sex—to sell a magazine filled with illustrated advertisements designed to sell goods. Stuart Davis responded with a parody, based on a drawing of two women he observed in Hoboken, titled "Gee, Mag, Think of Us Bein' on a Magazine Cover!" (fig. 76). Executed in a deliberately unglamorous crayon technique,

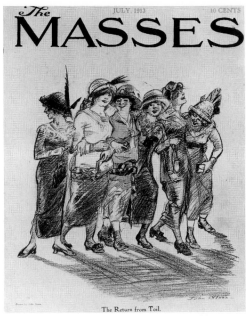

FIGURE 71. *John Sloan, "The Return from Toil."* The Masses 4 *(July 1913), cover. Tamiment Institute Library, New York University.*

FIGURE 72. *Stuart Davis, "Jersey City Portrait."* The Masses 6 *(July 1915), p. 10. Tamiment Institute Library, New York University.*

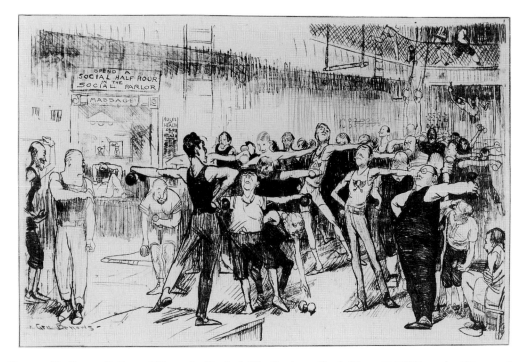

FIGURE 73. *George Bellows, "'Superior Brains': The Business Men's Class, 1913." Transfer lithograph.* The Masses 4 *(April 1913), pp. 10–11. Boston Public Library, Print Department, Gift of Arthur H. Wiggin.*

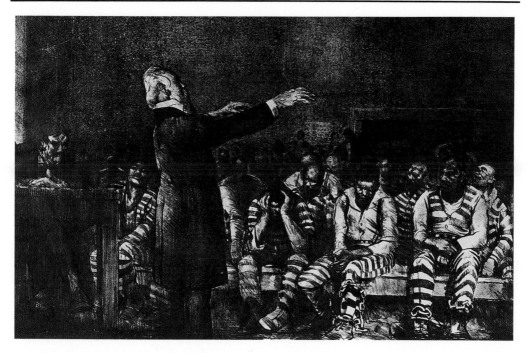

FIGURE 74. *George Bellows, "Benediction in Georgia" (1916). Lithograph.* The Masses *9 (May 1917), pp. 22–23. Boston Public Library, Print Department, Gift of Arthur H. Wiggin.*

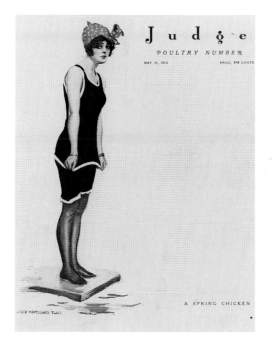

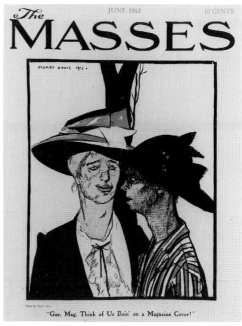

FIGURE 75. *James Montgomery Flagg, "A Spring Chicken."* Judge *64 (31 May 1913), cover.*

FIGURE 76. *Stuart Davis, "Gee, Mag, Think of Us Bein' on a Magazine Cover!"* The Masses *4 (June 1913), cover. Courtesy Earl Davis.*

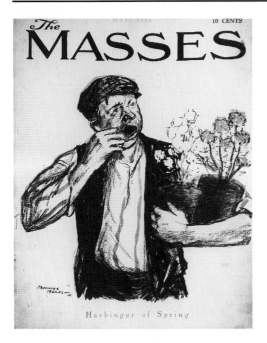

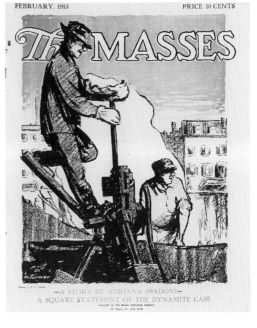

FIGURE 77. *Maurice Becker, "Harbinger of Spring." The Masses 8 (May 1916), cover. Courtesy Earl Davis.*

FIGURE 78. *H. J. Turner, Untitled ("Men at Work"). The Masses 4 (February 1913), cover. Courtesy Earl Davis.*

Davis's drawing mocked the slick presentation of commercial art.

Outraged readers dubbed such drawings "foul" or "crude" and wondered at the journal's "insistent harping on the shadows of life." One queried, "Isn't anything all right?" Eastman countered that *The Masses* offered an alternative to the images of "slippery girls in tights and tinted cupids" that dominated conventional magazines.[10] Although debates later raged over the political effectiveness of "pictures of ash cans and girls hitching up their skirts in Horatio Street," these drawings constituted a significant challenge to the traditional portrayal of workers in both the capitalist and socialist press.[11] With its specific detail and seemingly casual presentation, Henry Turner's drawing of a construction worker is a far cry from the idealized figures favored in socialist propaganda and comes closer instead to the savvy workingmen presented in IWW cartoons (cf. figs. 78, 79, 1). Although Sloan denied any specific polit-

ical message in his images of "life as I see it," *The Masses'* pictures of New York's poor at work and play provided a new labor iconography. It suggested another way of fulfilling the journal's promise to "appeal to the masses" without talking down to them, "with entertainment, education, and the livelier kinds of propaganda."[12]

Although *The Masses* challenged many artistic traditions, it consistently shied away from publishing Modernist or nonobjective art and literature. In 1915, *Poetry* magazine published T. S. Eliot's "Love Song of J. Alfred Prufrock," while *The Masses'* poetry page was titled "Orchids and Hollyhocks." The journal's sole response to the Armory Show was John Sloan's satire of Cubism entitled "A Slight Attack of Third Dimentia" (fig. 80). Artists affiliated with the Stieglitz group did not join the *Masses* staff, and those Modernists who did donate occasional drawings tended to offer conventional figurative works.[13]

The reasons for this division may have to

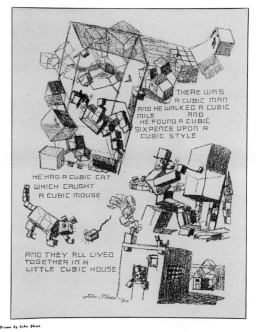

FIGURE 79. *Walter Crane, "The Triumph of Socialism."* Comrade 2 *(February 1903), cover.*

FIGURE 80. *John Sloan, "A Slight Attack of Third Dimentia Brought on by Excessive Study of the Much-Talked-of Cubist Pictures in the International Exhibition at New York."* The Masses *4 (April 1913), p. 12. Tamiment Institute Library, New York University.*

do with the editors' taste—Eastman and the literary editor Floyd Dell never did learn to appreciate unstructured verse—and may in part have pertained to conflicts among the social groups that characterized the political, intellectual, and art worlds of New York in 1915.[14] For example, Stieglitz and Henri seem to have considered each other rivals and may have discouraged their followers from participating in each other's projects. Few artists published in both *Camera Work* and *The Masses.* Yet members of both groups did interact in other situations—at the anarchist Ferrer Center, at Mabel Dodge's salon, at political fund-raising events, and, of course, at Provincetown.[15] A photograph showing John Reed at work in his study with a copy of William Zorach's geometric poster for the Provincetown Players in the background (fig. 128) suggests that at least some of *The Masses'* stalwarts enjoyed the New Art. Moreover, the *Masses'* artists themselves were not uniformly unsympathetic to modern trends. By 1915, Sloan, Bellows, and

Davis were experimenting with nonobjective color, irregular space, and other Expressionist trends in their paintings but continued to publish only realist drawings in *The Masses.*[16] Rather than being hostile to, or unaware of Modernism, editors of *The Masses* seem to have shared an unstated understanding that modern art and writing did not belong in the pages of their magazine.

The main reason why *The Masses* rejected Modernism was that it seemed incompatible with the goals of participating in current political struggles and using down-to-earth humor to appeal to the working class. The New Art's defenders described the movement as esoteric and idiosyncratic, as "the painting of *emotions*—the painting of pure line and color compositions for the sake of the pleasure such harmonies afford—the *expression of one's inner self.*"[17]

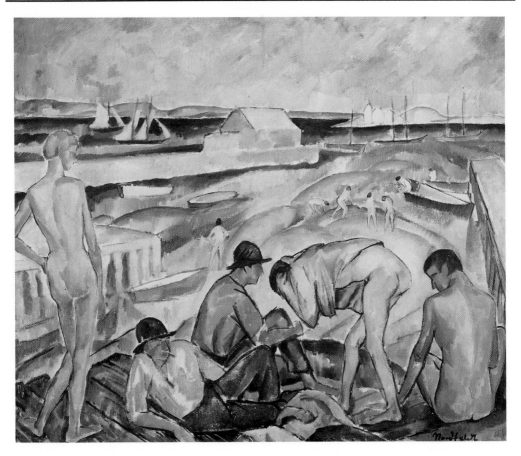

FIGURE 81. *B.J.O. Nordfeldt*, Figures on the Beach *(1916). Oil on canvas, 29″ × 36″. Private collection, Atlanta, Georgia. Photo courtesy of Richard York Gallery, New York.*

Unlike the Ashcan school artists who based their work on a realist rendition of contemporary urban life, American Postimpressionists returned to the traditional subjects of still life, figure studies, portrait, and landscape, then altered color, form, and brushwork to express their own perceptions or emotions. The Provincetown artist B.J.O. Nordfeldt (renamed Bordfelt in *Change Your Style*) employed a high-keyed palette and Cézanne-like modeling in depictions of New England bathers (fig. 81). Charles Demuth (who played the young Postimpressionist Marmaduke Marvin in Jig Cook's play) used expressive distortion of form in the watercolors he made in Provincetown around 1915. Marguerite Thompson Zorach, active in the Provincetown Players after 1916, moved from Fauve-

inspired color to decorative patterning in her landscape views, while her husband, William Zorach, followed Gauguin's example and investigated folk or "primitive" art in search of purer means of expression. (Similar ideas inspired Marmaduke's admiration for a painting "done in the real spirit of primitive sculpture. Faultlessly naive.")[18]

Stieglitz encouraged his protégés to explore new possibilities of emotion and imagination in their art. Of the painters who exhibited at 291, John Marin, Charles Sheeler, and Alfred Maurer used Fauvist color and brushwork in their paintings, while Georgia O'Keeffe and Arthur Dove went beyond Postimpressionism to explore intuitive forms of pure abstraction. Perhaps Jig Cook was thinking of their work when

Marmaduke explains, "It doesn't represent anything. It's just itself. It's pure creation."

Such uncompromising subjectivity complemented the period's concerns with psychology, individual liberation, and anarchism, but flew in the face of *The Masses'* attempts to communicate with a general audience. The utter incompatibility of the two views of art is evident in the words of Roger Fry, a critic whose writings shaped American perceptions of Modernism for most of the twentieth century : "Art is an expression and a stimulus of the imaginative life, which is separated from actual life. . . . In art we have no moral responsibility—it presents a life freed from the binding necessities of actual existence."[19] This exclusive philosophy of art for art's sake would seem to block the possibility for constructive interaction between art and politics.

Other currents in American Modernism around 1915 departed even further from the view of art and life expressed in *The Masses.* Cubism—what Marmaduke called "my Paris stuff "—inspired a number of American followers ; Marsden Hartley's *Provincetown Abstraction* (fig. 82) shows one attempt to interpret the forms of sailboats according to geometric principles. Contemporary critics complained that Cubism "appears to be a too purely personal equation to be intelligible to others than the artist himself . . . for art that communicates nothing expresses nothing." This view contrasts with John Sloan's description of the role of graphic art : "Drawing is a human language, a way of communication between human beings . . . realities seen with the heart and mind. The graphic artist makes a human document." The perceived opposition between "personal" and communicative art may explain Sloan's initial lack of enthusiasm for the Cubist work he saw at the Armory Show.[20]

Futurism received more enthusiastic coverage in the American press during the years *The Masses* published. Even before Italian Futurist works were exhibited in this country, American audiences saw reproductions of pictures that claimed to fuse space with

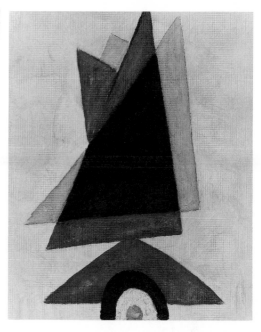

FIGURE 82. *Marsden Hartley*, Provincetown Abstraction *(1916). Oil on paperboard, 19⅞ × 15⅞".* *Amon Carter Museum, Fort Worth, Texas.*

speed, read interviews and manifestoes advocating the destruction of the past, and heard reasoned explanations of the concepts of simultaneity and dynamism.[21] Artists of the Stieglitz group responded with ecstatic paeans to skyscrapers and the excitement of Coney Island at night. But *The Masses* avoided such images of modern technology, concentrating instead on intimate views of bathers talking at the Coney Island pier, or the narrow streets and neighborhoods of New York's oldest quarters. Technology appeared only as an intrusion or a threat : Art Young's cartoons equated skyscrapers with "commercial greed," *Efficiency* with a sinister engine, and portrayed World War I as the ultimate product of the capitalist machine (fig. 83). Unlike Futurist polemicists who condemned history as *passéiste, Masses* writers, even in their most visionary calls for remaking society, took pains to connect themselves with radical traditions by evoking the names of Thomas Paine, Patrick

EFFICIENCY

FIGURE 83. *Arthur Young, "Efficiency."* The *Masses* 6 *(July 1915), p. 9. Tamiment Institute Library, New York University.*

Henry, and the original rebel, "Comrade Jesus."[22]

Conflicting views of people, machines, and history also separated *The Masses* from the lively circle of New York Dadaists.[23] Members of the two groups associated in other contexts—the Modernist poet William Carlos Williams selected one of Stuart Davis's Gloucester drawings, quite similar to those published in *The Masses*, for the frontispiece to his book of poems *Kora in Hell*.[24] But their approaches could not have coincided in the pages of *The Masses*. Although the irreverent wit of the Dadaist magazine *291* sometimes paralleled *The Masses'* attacks on traditional pieties, the socialist journal could not share Dada's detachment, its violence or, perhaps, its freedom. Given their partiality toward the female figure, *The Masses'* editors would never have published a mechanical drawing of a spark plug with the label "Portrait of a Young American Girl in the State of Nudity," and despite their professed agnosticism, they preferred the image of Christ the agitator to that of Morton Schamberg's assemblage of plumbing equipment titled "God."[25] Once again faith in the value of action joined with the artists' emphasis on everyday people to reject an art that displaced the human body

In light of the changes taking place at the time, *The Masses'* consistent espousal of a realist art rooted in the particulars of the observable world, and corresponding lack of sympathy for formalist abstraction, seems almost reactionary. The magazine appears positively earthbound when compared with the art and writings of contemporary European utopian movements that explored new visual language as part of an attempt to envision a new world (fig. 84). Abstract artists at work in Holland, France, England, Germany, and Russia before the 1917 revolution, considered themselves an international avant-garde in the military sense : a corps of "shock troops" leading society into the future.[26] As Edward Abrahams has shown, Stieglitz may have had a similar idea of the artist's role in social progress. Yet in some ways the art in *The Masses* came closer than any American Modernism to another one of the central tenets of the European avant-garde : the idea of breaking down the barriers between art and life.

Recent discussions of the avant-garde have begun to question the assumed relationship between formal innovation and radical social change. Although Mabel Dodge and Hutchins Hapgood viewed the artistic impact of the Armory Show as part of a general spirit of "revolt," subsequent writers have noted that certain aspects of artistic Modernism had conservative social implications.[27] The idea of art as a separate realm, defended eloquently by Roger Fry and embraced by many American artists, perpetuates traditionally elitist ideas of artistic autonomy or "apartness" that by implication mandate the "social inconsequentiality" of any aesthetic activity. While these Modernists challenged previous *styles*, the current argument goes, the truly avant-garde movements posed a more threatening challenge to the existing social order by "attacking the institution of art" itself.[28]

When Picasso glued newspaper clippings onto a painted canvas, or de Stijl artists turned from easel painting to creating prototype environments, they acted on the radical goal of "integrating art into the praxis of life" : bringing art down to earth, transforming the everyday with artistic

Figure 84. *Kasimir Malevich,* Suprematist Composition: Red Square and Black Square *(1915). Oil on canvas, 28 × 17¹/₂". Museum of Modern Art, New York.*

avant-garde movements relied heavily on the graphic arts, whether in the form of "little magazines" or mass-distributed posters, and made lasting contributions to the development of modern typography and graphic design.[30] Like the editors of *The Masses* who cited Daumier's example, avant-garde artists realized that mechanically reproduced and mass-distributed images need not be seen as inferior imitations of "original" art but could be marshaled to make new forms of art available in new ways, to new audiences, while dismantling the mystique that surrounded the traditional idea of "art for art's sake." This idea presented a marked contrast to the practice of conventional art magazines, including Stieglitz's *Camera Work*, which printed photographic reproductions of art made to be shown in galleries. Like Soviet posters and Dada photomontages, drawings in *The Masses* were intended for publication, the "originals" often altered or lost in the course of production. The true "originals" were the printed pages themselves.

Yet despite similarities in technique, tactics, and social outlook, *The Masses* continued to print figurative art while contemporary European avant-garde movements embraced nonrepresentational forms. Many European artists shared the Dutch painter Mondrian's faith that a style reduced to universal absolutes—up and down, pure colors, and laws of geometry—could unite mankind by transcending local differences and point the way to a better world. These ideas were put into practice after the Bolshevik Revolution, when state-sponsored artists designed abstract posters in the hope of communicating to illiterate viewers and inspiring a diverse people with a sense of national purpose. But while European artists believed that a new society demands a new consciousness and a new visual language, *The Masses* sought to connect its art with the existing physical world. Its artists could not share the dream of an art based on pure geometric forms: just as the revamped *Masses* had rejected traditional formulas for depicting

means. German Dada demonstrations that burlesqued political figures and ended in street riots fulfilled a related mission of involving the viewer as an active participant rather than a passive observer—not unlike the way *The Masses* used satire to engage readers in active criticism (by laughing at a cartoon, the reader commented on a social problem). The aims of these avant-garde movements were realized most fully in postrevolutionary Russia, where trains covered with abstract paintings carried messages into the hinterlands, huge crowds participated in public pageants, sculpture was paraded through the streets of Moscow, and artists enlisted in the construction of a new society.[29]

Significantly, most of the European

FIGURE 85. *Maurice Sterne, Untitled ("Female Figures")*. The Masses *9 (April 1917), p. 25. Collection of Harriette and Martin Diamond.*

the ideal worker, it resisted the universal abstraction of utopian Modernism.

Emulating their hero Walt Whitman, artists of *The Masses* delighted in observable particulars. They saw their subjects in terms of small details, everyday incidents, The People as an infinity of individuals. Nor could they have embraced the idea, espoused by Russian Constructivists in the 1920s, of using abstract art to disorient viewers and thereby shock them into imagining an alternative system.[31] Instead they preferred Sloan's belief in drawing as "a means of communicating . . . realities seen with the heart and mind." This approach is linked with the multifaceted background of the American Left and with *The Masses'* cultural moment. Straddling the nineteenth and twentieth centuries, *The Masses* looked to Marxian theory and pragmatist philoso-

phy as well as to the day-to-day actions of the American labor movement; to Daumier and to modern New York; to psychological exploration and to casual humor.

The balance between art and politics, theory and practice, individual expression and collective purpose that supported the art in *The Masses* was short-lived.[32] By 1916, debates arose over the value of printing art with no specific propagandistic "message," and most of the realist artists quit the staff. They were replaced with professional political cartoonists who devoted their efforts to protesting American involvement with the escalating war in Europe. Nonpolitical images printed after that time by and large abandoned the streets of New York to retreat into visions of laughing women and idyllic landscape. A painting of nudes contributed by Mabel

Dodge's lover, Maurice Sterne, could even be termed Postimpressionist (fig. 85). John Reed's rueful remark that "this class struggle sure plays hell with your poetry"[33] suggests that art and politics remained separate categories in many people's minds, and that the realists' efforts to fuse art and life no longer seemed plausible.

The artistic possibilities and conflicts that *The Masses* exemplified have characterized American debate over the nature of political art ever since. For a brief period in the 1920s a successor journal, the *New Masses*, described itself as "a magazine of American experiment" and adapted techniques from Russian avant-garde graphics, only to return to figurative art under a policy of socialist realism in the 1930s. Ten years later the artists and writers of *Partisan Review* argued that only an advanced, abstract, and disengaged art could embody the "freedom" that any political movement must strive to defend—this view has since been used to deny the aesthetic value of any art with overtly political content.[34] Today, artists and historians continue to discuss the meaning of abstraction and figuration, propaganda and "pure" art, and the avant-garde itself. In light of these subsequent debates, the synthesis that *The Masses* achieved in 1915—when John Sloan read labor statistics and the Wobblies' leader Big Bill Haywood discussed the nature of modern art—seems even more remarkable.

NOTES

1. Quotation is from the editorial statement printed (with occasional variations in wording) inside the front cover of every issue of *The Masses*, beginning in March 1913.

2. On philanthropic art patronage in the late nineteenth century see Russell Lynes, *The Tastemakers: The Shaping of American Popular Taste* (New York: Harper, 1955), 157–161, and Thomas Bender, *New York Intellect: A History of Intellectual Life in New York City, from 1750 to the Beginnings of Our Own Time* (New York: Alfred Knopf, 1987), 217–219.

3. Susan Glaspell, *The Road to the Temple* (New York: Frederick A. Stokes, 1927), 248.

4. Statement by Reed from unpublished manuscript ca. 1913, Reed Papers, Houghton Library, Harvard University. This statement, revised by Eastman, formed the basis of the editorial statement cited in note 1. See Rebecca Zurier, *Art for The Masses: A Radical Magazine and Its Graphics, 1911–1917* (Philadelphia: Temple University Press, 1988), 37–38.

5. See Max Eastman's discussion of humor in *The Masses* in his autobiography, *Enjoyment of Living* (New York: Harper, 1948), 416. For a selection of IWW material see Joyce Kornbluh,

ed., *Rebel Voices: An I.W.W. Anthology* (Ann Arbor: University of Michigan Press, 1964).

6. Lyric from a song written during the 1912 strike in Lawrence, Mass. See Kornbluh, *Rebel Voices*.

7. Review of a Daumier exhibition, *New York Times*, 9 February 1913.

8. Quotation from interview with Kenneth Chamberlain by Richard Fitzgerald, 10 August 1966, typescript in the Library of the University of California, Riverside.

9. Becker quoted in Richard Fitzgerald, *Art and Politics: Cartoonists of the Masses and Liberator* (Westport, Conn.: Greenwood, 1973), 104. Chamberlain, Davis, and Becker summered in Provincetown.

10. Quotations from letters to the editor, and replies, *The Masses* 7 (December 1915): 20 and 8 (April 1916): 25; see also Eastman's article, "What is the Matter with Magazine Art?" published in *The Masses* 6 (January 1915): 12 and later issued as a book, *Journalism vs. Art* (New York: Alfred Knopf, 1916).

11. Quotations from an interview with Art Young cited in "Clash of Classes Stirs 'The Masses'," *New York Sun*, 8 April 1916, an article

published during the time of *The Masses'* artists' strike. For the complete story of the strike see Zurier, *Art for The Masses*, 52–57. On the origins of the term "Ashcan school" see Zurier, "Picturing the City: New York in the Press and the Art of the Ashcan School, 1890–1917" (Ph.D. diss., Yale University, 1988), pp. 1–3.

12. On traditional labor imagery see Patricia Hills et al., *The Working American* (ex. cat., District 1199, National Union of Hospital and Health Care Employees, 1975) and Harry R. Rubenstein, "Symbols and Images of American Labor": (1) "Badges of Price" and (2) "Dinner Pails and Hard Hats," *Labor's Heritage* 1 (April and July 1989): 36–51, 34–49. The relationship between Sloan's paintings and his work for *The Masses* is discussed in Patricia Hills, "John Sloan's Images of Working-Class Women: A Case Study of the Roles and Interrelationships of Politics, Personality, and Patrons in the Development of Sloan's Art, 1905–16," *Prospects* 5 (1980): 157–196. Quotation is from "Editorial Notice," *The Masses* 4 (December 1912): 2.

13. See for example the drawings by Walkowitz, Davidson, Davies, Storrs, and Picasso cited above.

14. For Eastman's taste in poetry see his article "Lazy Verse," *New Republic* 8 (9 September 1916): 138–140 and the anthology *Enjoyment of Poetry* (New York: Scribner, 1913); on Dell see Arthur Frank Wertheim, *The New York Little Renaissance: Iconoclasm, Modernism, and Nationalism in American Culture, 1908–1917* (New York: New York University Press, 1976), 36–37.

15. The Ferrer Center is described in Paul Avrich, *The Modern School Movement* (Princeton: Princeton University Press, 1980) and Francis Naumann, "Man Ray and the Ferrer Center: Art and Anarchy in the Pre-Dada Period," *Dada/Surrealism* 14 (1985): 10–30; Henri and Bellows taught, Stieglitz lectured, the *Masses'* artists Chamberlain, Minor, and Becker, and the Modernists Ben Benn, George F. Of, and Man Ray studied there. Ashcan school artists and members of the Stieglitz group worked together in organizing the Armory Show and the Forum (1916) and Independents (1917) exhibitions, and participated in activities of the People's Art Guild, discussed in Zurier, *Art for The Masses*, 106–107. The members of the *Masses* group most involved with the Provincetown Players were writers rather than artists (Sloan and Davis pre-

ferred Gloucester for vacations); few of the artists active in Provincetown ever published in *The Masses.*

16. See Davis's paintings reproduced in Peter Morrin et al., *The Advent of Modernism: Post-Impressionism and North American Art, 1900–1918*, ex. cat. (Atlanta: High Museum of Art, 1986), 80–81 and the multiple-viewpoint drawing discussed in Bram Dijkstra, *Cubism, Stieglitz, and the Early Poetry of William Carlos Williams* (Princeton: Princeton University Press, 1969), 74–76; also Sloan's paintings executed in Gloucester in the summer of 1915 (e.g., *Fassett's Cove*, Kraushaar Galleries), and Bellows's painting *Matinicus Harbor, Late Afternoon* reproduced in Mahonri Sharp Young, *The Paintings of George Bellows* (New York: Watson-Guptill, 1973), 99.

17. See Morrin, *Advent of Modernism*, and the influential writings on modern art by the British critic Roger Fry, Gertrude Stein's brother Leo Stein, and the American collector and critic Arthur Jerome Eddy. Quotation is from Eddy, *Cubists and Post-Impressionism* (Chicago: McClurg, 1914), 11. *The Masses'* literary editor Floyd Dell expressed a similar view in his editorial, "What Does It Mean?" *The Masses* 8 (April 1916).

18. Nordfeldt is discussed in Judith Zilczer's essay, "The Dissemination of Post-Impressionism in North America: 1905–1918" in *Advent of Modernism*, 27; his work is illustrated pp. 138–41. For examples of work by Demuth, the Zorachs, and Benn see *Advent*, pp. 82–83, 180–183, 60–61; Barbara Haskell, *Charles Demuth*, ex. cat. (New York: Whitney Museum of American Art, 1988) and Marilyn Friedman Hoffman, *Marguerite and William Zorach, the Cubist Years: 1915–18*, ex. cat. (Manchester, N. H.: Currier Gallery of Art, 1987)—I am grateful to Tessim Zorach for bringing this publication to my attention.

19. Fry, "An Essay in Aesthetics" (1909), reprinted in *Vision and Design* rev. ed. (1920; London: Oxford University Press, 1981), 15.

20. Quotation is from J. N. Laurvik, *Is it Art?* (New York: International Press, 1913), 13. See also Henry R. Poore, *The New Tendency in Art: Post Impressionism, Cubism, Futurism* (Garden City: Doubleday, 1913). Sloan's remarks are from verbatim statements transcribed by Helen Farr Sloan on deposit in the Helen Farr

Sloan Library, Delaware Art Museum, Wilmington, Delaware. In later years Sloan came to acknowledge Cubism as "a return to . . . the grammar and composition of art": see Sloan, *Gist of Art: Principles and Practise Expounded in the Classroom and Studio*, comp. Helen Farr Sloan, (1939; rev. ed., New York: Dover, 1977), 44.

21. See John Oliver Hand, "Futurism in America: 1909–14," *Art Journal* 41 (Winter 1981) : 337–342. André Tridon, author of some of the first articles explaining Futurism to American audiences, was a stockholder of the original *Masses* in 1911 and 1912. See also Louis C. Fraina's article "The Social Significance of Futurism," published in the socialist journal *New Review* 1 (December 1913) : 964–970.

22. Leslie Fishbein discusses the role of religion in *The Masses* in her Introduction to Zurier, *Art for The Masses*, 20–25.

23. On New York Dada, see William Agee, "New York Dada, 1910–30," *Art News Annual* 34 (1968) : 104–112; the special issue of *Dada/Surrealism* 14 (1985); Dickran Trashjian, *Skyscraper Primitives: Dada and the American Avant-Garde, 1910–1925* (Middletown, Conn.: Wesleyan University Press, 1975).

24. On Davis and Williams, see Dijkstra, *Cubism, Stieglitz*, 74–76 (Davis published two related drawings that use more conventional perspective in *The Masses* 7 [December 1915 and January 1916]). John Sloan commemorated an uproarious evening spent with Marcel Duchamp atop the arch at Washington Square in the etching *Arch Conspirators*, discussed in Peter Morse, *John Sloan's Prints: A Catalogue Raisonné of the Etchings, Lithographs, and Posters* (New Haven: Yale University Press, 1969), 209. Meetings of the Society of Independent Artists, and soirees sponsored by Mabel Dodge and the collector Walter Conrad Arensberg, provided other points of contact for the two groups. Sloan, Bellows, and Eastman attended evenings at Arensberg's apartment: see Rudolf E. Kuenzli, "Introduction," *Dada/Surrealism* 14 (1985) : 1.

25. See the drawing by Francis Picabia published in the journal *291* 5–6 (July–August 1915) and Schamberg's sculpture (ca. 1916) now in the collection of the Philadelphia Museum of Art.

26. Daniel Robbins, "From Symbolism to Cubism: The Abbaye of Creteil," *Art Journal* 23

(Winter 1963–1964) : 111–216; Hans L. C. Jaffé et al., *De Stijl: 1917–1931, Visions of Utopia*, ex. cat. (Minneapolis: Walker Art Center, 1982); Valerie Fletcher, *Dreams and Nightmares: Utopian Visions in Modern Art*, ex. cat. (Washington: Hirshhorn Museum and Sculpture Garden, 1983). See also the publication of the British Vorticist movement, *Blast* (1914–15) and essays by Wassily Kandinsky in the German *Blaue Reiter Almanach* (1912). Linda Nochlin traces the origins of the term in her article "The Invention of the Avant-Garde: France, 1830–80." *Art News Annual* 34 (1968) : 10–19.

27. Mabel Dodge, "Speculations," *Camera Work* (June 1913) : 6; Hapgood, "Art and Unrest," *New York Globe*, 27 January 1913. The following discussion is indebted to Peter Bürger, *Theory of the Avant-Garde* (1974; Minneapolis: University of Minnesota Press, 1984). Renato Poggioli, *The Theory of the Avant-Garde* (1962; Cambridge: Harvard University Press, 1968), offers an earlier interpretation. For a historical perspective, see Donald Drew Egbert, "The Idea of 'Avant-garde' in Art and Politics" *American Historical Review* 73 (December 1967) : 339–366.

28. Bürger, *Theory of Avant-Garde*, 35, xxxvi, 22.

29. Quotation is from Bürger, *Theory of Avant-Garde*, 49. For examples of avant-garde attempts to transform life through art, see Anatole Kopp, *Town and Revolution: Soviet Architecture and City Planning, 1917–1935* (1967; rev. ed. New York: Braziller, 1970), Nancy Troy, *The De Stijl Environment* (Cambridge: M. I. T. Press, 1983), and *Art Into Life: Russian Constructivism, 1914–1932*, ex. cat. (Seattle: Henry Art Gallery and Rizzoli International, 1990).

30. Ida Katherine Rigby, *An Alle Künstler! War—Revolution—Weimar*, ex. cat. (San Diego: San Diego State University, 1983); Szymon Bojko, "Agit-Prop Art: The Streets Were Their Theater," in Stephanie Barron, ed., *The Avant-Garde in Russia, 1910–1930: New Perspectives*, ex. cat. (Los Angeles: County Museum of Art, 1980), 74–76; *Art for the Masses: Russian Revolutionary Art from the Merrill C. Berman Collection*, ex. cat. (Williamstown: Williams College Museum of Art, 1985).

31. Yves-Alain Bois, "El Lissitzky: Radical Reversibility," *Art in America* 76 (April 1988) : 161–181.

32. Debates on these issues and their

implications are discussed further in Zurier, *Art for The Masses.*

33. Dodge spent the summer of 1915 with Sterne in Provincetown; they were married in August 1917, a few months after Sterne's drawing appeared in *The Masses.* Reed quoted in Eastman, *Love and Revolution: My Journey Through an Epoch* (New York: Random House, 1964), 107.

34. On the 1930s and 1940s see James Gilbert, *Writers and Partisans: A History of Literary Radicalism in America* (New York: Wiley, 1968); Serge Guilbault, *How New York Stole the Idea of Modern Art: Abstract Expressionism, Freedom, and the Cold War* (Chicago: University of Chicago Press, 1983); and articles collected in Francis Frascina, ed., *Pollock and After: The Critical Debate* (New York: Harper & Row, 1985).

The New Theatre

ADELE HELLER

Whether in literature, plastic art, the labor movement . . . we find an instinct to loosen up the old forms and traditions, to dynamite the baked and hardened earth so that fresh flowers can grow.

—HUTCHINS HAPGOOD, *NEW YORK GLOBE*,
27 JANUARY 1913

FIGURE 86. *Wharf Theatre, Provincetown Playhouse. Courtesy Adele Heller.*

In 1915, everything was "new." There was the New Poetry, the New Art, the New Education, the New Woman, the New Politics, the New Psychology, and the new little magazines like *The Masses* and *The Seven Arts*. Isadora Duncan danced the new dance that broke with classical balletic forms. Frank Lloyd Wright designed a new architecture that derived its styles from the American landscape. The slogan of the 1913 Armory Show was "The New Spirit." Where, among these new movements, was the American theatre?

In 1912, when the "little renaissance" first came to life in Chicago with an explosion of poetry led by writers Vachel Lindsay and Sherwood Anderson, Broadway producer David Belasco staged a fully equipped, ready-to-operate Childs Restaurant for the final act of the romantic comedy *The Governor's Lady*. James O'Neill, the father of Eugene O'Neill, was playing his twenty-fifth consecutive year in the role of the swashbuckling Edmond Dantès, in a touring version of the romantic melodrama *Count of Monte Cristo*. In 1913, when the Armory Show was causing riots in the streets of New York, *Peg O' My Heart* was a smash hit of Broadway and on its way to a record-breaking 603 performances.

By the second decade of the century, it was clear that theatre was "needing the breath of life."[1] It was equally clear that the creative impulse in modern drama was not going to be advanced by Broadway, the symbol of a traditional and commercial theatre that dominated the country at the time. In her memoirs, Susan Glaspell succinctly and tellingly summed up the impact of the commercial theatre of their day on the young intellectuals of Greenwich Village:

We went to the theatre and for the most part came away wishing we had gone somewhere else. Those were the days when Broadway flourished almost unchallenged. Plays, like magazine articles, were patterned . . . seldom did they open out to . . . where it surprised or thrilled your spirit to follow. They didn't ask much of you, those plays. Having paid for your seat, the thing was all done for you, and your mind came out where it went in, only tireder. An audience, Jig said, had an imagination.[2]

THEATRE AND DRAMA IN PRE–TWENTIETH-CENTURY AMERICA

When Susan Glaspell, George Cram (Jig) Cook, and other founders of the Provincetown Players spoke out against the lack of imagination, intellectual nourishment, challenge, and excitement in the mainstream theatre of their day, they were rebelling against a 200-year-old American theatrical tradition that had rarely ventured beyond the safe and mundane. It was a tradition that was mostly imitative of European themes and forms, one that catered to popular taste and presented no view of social problems or the human condition beyond that which could be cleared up in time for the final curtain.

In the eighteenth century, American theatre was still very much British and remained so long after the states won their independence. Lewis Hallam managed the first well-organized acting company sent to America from London (1752) ; it performed its repertory of twenty-four plays in Williamsburg, New York, Philadelphia, Charleston, and Jamaica. Not long after, there were a few clues that something "American" was about to happen. When colonists started to mobilize troops for the approaching revolution, Hallam's successor, David Douglass, promptly changed the name of his troupe from the Company of London Comedians to the American Company of Comedians even though they were as English as the repertory they performed.[3]

Although the nation was still too young and vast to have universally recognizable American themes, there were some easily identifiable character types introduced to American audiences with great success: the Yankee, the Indian, the immigrant, the cowboy, and the riverboatman among them. *The Contrast* (1787), by Royall Tyler, was the first professionally produced American comedy. It was written by an American, used American characters who had an American point of view, and was performed by American actors. In it, good-natured, rural types with homey virtues are pitted against fashionable city-slickers with European polish. Tyler is credited with introducing the stage Yankee and other characters with adjectival names that denote their worth: Colonel Manly teaches us what good citizens need to learn while Billy Dimple represents surface, urban chic.[4] Comedy best captured the American spirit of the time. It was still too early for serious drama to make any inroads as an expression of contemporary America.

In the nineteenth century, American theatre followed the growth and development of a nation in search of its own identity. Where frontiers opened in the West, so went the American stage. Actors set up in barns, social halls, breweries, courthouses, tepees, basements, hotel dining rooms, and mills. Showboats with built-in stages plied the Mississippi for more than one hundred years, offering a variety of plays from *Hamlet* to *Ten Nights in a Barroom*, along with sketches, circus acts, monologues, museums, improvisations, and vaudeville. Beginning in 1843, white comedians, their hands and faces blackened with burnt cork, entertained with "colored" minstrel shows that exploited stereotypes of African American slaves.[5]

The number of theatres along the Atlantic seaboard also increased. At first, England supplied the actors for all the new theatres, but gradually, American stock companies were created. Several distinguished—and some lesser known—actors and stage managers decided to make the United States their permanent home. Laura Keene, Mrs. Louisa Drew, and the Booth, Jefferson, and Wallack families were among those who became part of the marrow of American theatre.[6]

Along with increased industrial development in the mid-nineteenth century, there was a fast-growing middle-class population that was largely uneducated, had money to spend, and looked to theatre as a source of entertainment. Here they found villains to

hiss and heroes to cheer, comedians to laugh at, and romances that tugged at their heart-strings. Early in the nineteenth century the subject matter of drama dealt mostly with Indians, the American Revolution, and costumed romances. Rural situational comedies and urban satire, usually in the style of ballad opera, were popular then. By mid-century, farce and melodramas in the form of mysteries, historical romances, and domestic comedies became audience favorites.[7]

As the network of railroads expanded, European stars and native players who outgrew local acting companies would travel to make short but more frequent appearances with other stock companies. With stars on the program, business increased. Soon, the stars brought along several supporting players to perform with them. It didn't take long before whole troupes of actors headed by stars replaced stock-company performances. The stars became very powerful: They demanded higher wages, decided what plays would be performed, and established touring circuits of river and railroad cities.[8] In New York, theatre management discovered that more money could be made from the long run of a single, popular play than from a repertory of plays performed by one company. Furthermore, after an initial long run on Broadway, a hit show could be sent intact to play theatres in major cities or, while the show was still attracting sizable audiences on Broadway, hastily put-together-and-rehearsed "duplicate companies" could be sent to the provinces where performances were billed "Direct from New York." Broadway became the showcase for hits and stars. *The Count of Monte Cristo* played for fifty years with one star. *Uncle Tom's Cabin* held the record for a Broadway hit and a profitable tour that lasted for more than eighty years. Different versions of these "Tom shows," as they were called, sometimes played in the same city and competed with each other.[9]

By 1880, there were approximately five thousand theatres in three thousand five hundred cities in America.[10] With more than one hundred thousand miles of railroads webbing the country, hits and stars could play hundreds of theatres. With the successful touring system of the road and long runs on Broadway as the established economic forms of theatre in America, it didn't take long for an enterprising theatre syndicate to gain control of a string of theatres, dictating which companies would play where with what vehicles and under what terms. As Walter Eaton noted, "The ambitious actor or producer who might wish to experiment or to do some fine thing limited in its appeal, either had to do it as best he could, at his own risk, and often in a poor theatre, or give it up."[11] By 1896, almost every theatre in the United States was controlled by the syndicate. Theatre business was big business, and big hits the prime objective.

It wasn't until the twentieth century that American drama seriously began to test the thematic and characterological possibilities of the stage. In this evolutionary process, two earlier plays should be noted: Dion Boucicault's *Octoroon, or Life in Louisiana* (1859) bears mention because it touched on the hitherto unexplored social issue of miscegenation, albeit ever so lightly. James A. Herne's *Margaret Fleming* (1891) advanced thematic content and characterization in a way that was daring in its realistic portrayal of an Ibsenesque heroine and her philandering husband. Shocked by the discovery of her husband's affair and his illegitimate child, Margaret, who suffers from glaucoma, becomes blind. In the final scene of the play, she agrees to take Philip back, but not into her boudoir. She confronts him over the double standard of behavior for wife and husband at a time when it was not fashionable to discuss this issue in public. Margaret asks him: "Suppose—I—had been unfaithful to you?"[12]

Although the play dealt with controversial material, the subject was handled within the bounds of conventional, bourgeois standards of marriage and family. William Dean Howells and Hamlin Garland, who championed the production of *Margaret*

Fleming, believed that theatre needed to be more than simply entertainment; that it could function as a major force for promoting social reforms and raising the consciousness of Americans about values in society. In 1891, Howells and Garland were ahead of their time. It took a new generation of playwrights to confront these issues more openly, and write with compassion about relationships between the sexes.[13]

ROOTS OF THE NEW THEATRE

It was "an organic thing like a plant growing" is the way Mary Heaton Vorse described the first stirrings of the Provincetown Players.[14] From letters and memoirs of nostalgic participants we read accounts of the Players' emergence that contain few facts, often contradictory. What seems to have been a spontaneous decision by the group to put on plays has somehow taken on the proportions of a grand myth. But the choice of theatre as a communal activity was not mysterious at all. It was, rather, well timed, suited to the talents of the group, and logical under the circumstances.

An even more powerful myth claims modern American drama began with Eugene O'Neill. Reinforced by many scholars and theatre historians who have neglected to give the Provincetown Players their due—before and after they discovered Eugene O'Neill in 1916—it has deprived O'Neill of his rightful antecedents.[15] It has also led to the neglect of the complex forces in American culture and abroad that helped to shape both the Players and O'Neill. By placing the Players in the context of their times, by noting some of their influences and theatrical accomplishments, we can begin to gain clearer insights into the processes that helped change the course of modern American drama.

What were some of the most important conditions that allowed a "new" theatre to develop at the turn of the twentieth century and that laid the groundwork for the birth of the Provincetown Players? We have seen that they did not have what Van Wyck Brooks termed a "usable past" in American dramatic or theatrical history; yet they played a major role in creating a dramatic tradition—one that nurtured talent, was communicated to artistic peers and to the public, and then was passed on as a legacy to future generations. According to Henry May, you need to have a tradition to defy a tradition. What tradition did they use?[16]

In the late 1880s, August Strindberg sounded a clarion call for theatrical freedom based on a new realism and the unity of the play, production, and stagecraft:

> Let us have a free theatre where there is room for everything but incompetence, hypocrisy, and stupidity!... where we can be shocked at what is horrible, where we can laugh at what is grotesque, where we can see life without shrinking back in terror if what has hitherto lain veiled behind theological or aesthetic conceptions is revealed to us.[17]

In late nineteenth-century Europe, there were some playwrights who were writing realistic plays even before there were theatres to stage them, actors to make them come alive, directors to unify the productions, or audiences to respond to them. Then in 1889 in Paris, André Antoine opened the Théâtre Libre as a showcase for plays that could not be produced elsewhere. Antoine rehearsed the company as an ensemble, explored naturalistic acting styles, and used directing techniques to enhance realistic plays. He launched the Théâtre Libre as a private playhouse on a subscription basis to generate funds needed for productions and to help develop audiences for the new realistic drama through the insured patronage of a subscriber audience who then shared in testing new methods and materials. Antoine's theatre provided a stage for Tolstoy's *The Power of Darkness*, and Hauptmann's *The Weavers*, Ibsen's *Ghosts* and *The Wild Duck*,

and Strindberg's *Miss Julie*. The theatre served as a model for Otto Braum's *Freie Bühne* in Berlin, J. T. Grein's Independent Theatre in London, Stanislavsky's Moscow Art Theatre, and for the little theatre movement in America.[18]

The "new" stagecraft introduced at that time in Europe by theorist Adolphe Appia and designers Gordon Craig and Max Reinhardt forever altered the production methods of theatre and enabled playwrights to develop new techniques in writing. Lights and settings were used far more expressively than they had ever been before. Their stage-craft involved a fusion of all elements of design and action specific to each play. Previously, an actress might bring along a trunkful of costumes to wear that were flattering to her but had no reference to the lights, sets, or costumes of the other actors—or to authenticity. Interiors lacked historical accuracy. A tree used in a set was usually one that happened to be in stock. But with the "new" stagecraft, settings were "not a picture but an image," not a background but an environment. Whether a setting was suggestive, symbolic, or abstract, it was inspired by the playwright, brought to life by the actors and focused on the play.[19]

With Robert Edmond Jones, set designer for the Provincetown Players from their beginnings, the art of American stage design came into its own. Jones had studied with Max Reinhardt in Berlin and was committed to his concept of "total theatre." When he returned to this country in 1914, Jones was commissioned to design Anatole France's one-act play *The Man Who Married a Dumb Wife* (1915) directed by Harley Granville-Barker for the New York Stage Society. Jones's success catapulted him into the front ranks of American stage design and inspired other designers to shake themselves loose from the outworn concepts of the past.[20]

When awareness of the European theatrical experiments reached American shores, it seized the imagination of young rebels who were dissatisfied with Broadway, anxious to experiment with their own new

forms, and eager to present on their native stages plays that dealt realistically with social problems, the arts, politics, and sexual mores. Although there had been several scattered Broadway productions of plays by Ibsen, Strindberg, Hauptmann, and other realist playwrights before 1915, they were short-lived in the profit-oriented theatres and were said to have been produced only to placate stars such as Minnie Maddern Fiske and Alla Nazimova.

The Abbey Players provided the necessary spark, touring in America in 1911–1912 with plays by Yeats, Synge, Lady Gregory, and Lennox Robinson. Synge's *The Playboy of the Western World* caused riots when it opened in New York City. Eugene O'Neill, who saw the entire repertory, said in an interview: "It was seeing the Irish Players that gave me a glimpse of my opportunity."[21] A year later when the Abbey Players performed in Chicago, Jig Cook and Floyd Dell were in the audience. They were much impressed by the ensemble work and acting style of the group whose plays were deeply rooted in the realism of Irish life. The Abbey's efforts to create a national theatre that had both artistic and social aims would be paralleled by the aims of the Provincetown group. "Quite possibly there would have been no Provincetown Players," wrote Susan Glaspell, "had there not been the Irish Players. What he [Cook] saw done for Irish life, he wanted for American life—no stage conventions in the way of projecting with the humility of true feeling."[22]

Ethnic theatres flourished on the Lower East Side of New York during the opening decades of the century when immigration was at its peak. The vitality of the dramatic productions and the important role these theatres played in the social and community life of their audiences also had a profound impact on the men and women who became the Provincetown Players.

Ethnic theatre played several roles: providing audiences with inexpensive entertainment; introducing the classics and

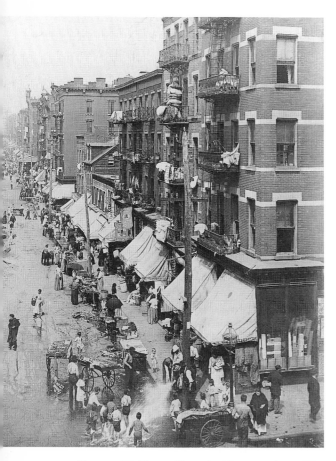

FIGURE 87. *Hester Street looking west from Clinton Street, showing Lower East Side tenements where Eastern European Jewish immigrants settled at the turn of the century. The New-York Historical Society, New York City.*

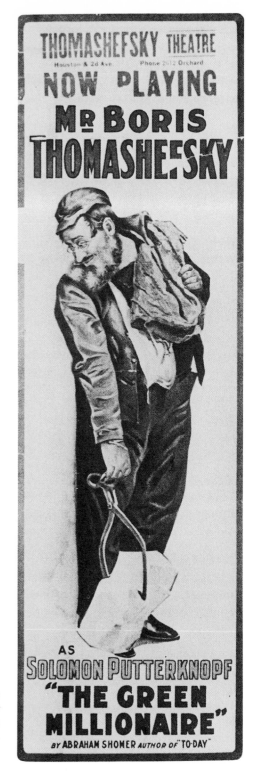

FIGURE 88. *Poster for Boris Tomashevsky in* The Green Millionaire, *ca. 1910. The new arrival, or "greenhorn," was a popular subject for comedy on the immigrant stages. American Jewish Historical Society, Waltham, Mass.*

FIGURE 89. *A cartoonist's impression of the behavior of the same audience attending an "American" performance at an uptown theatre (top) and at a downtown Yiddish theatre (bottom). From* The Big Stick, *a humorous Yiddish newspaper, 1909.*

contemporary drama by way of adaptations and translations; serving as an agent of Americanization; exposing audiences to social problems such as temperance, birth control, pacificism, and the status of women. Ethnic theatre also functioned as a focus for social life, providing a place where individuals and families could come together to talk, eat, find old friends, and meet new ones.[23] Already an established center of culture and the main port of entry for European ideas, New York was constantly being enriched by the confluence of avant-garde writers, painters, reformers, and immigrants—especially East European Jews—who had settled on the Lower East Side. The Villagers were attracted to them

both because of their difference and because their "values were familiar ones, intensified and clothed in new, exciting symbols."[24]

What was familiar was their desire for progress, their moral idealism, their dream of a better life and a willingness to fight for it, and their hunger to learn. What was different was the cast of characters: it included intrepid anarchists, union organizers, Talmudic scholars, flamboyant actors, pious women with shawls covering their heads, fervent socialists, the overworked shopkeeper and young, idealistic garment workers.[25] To the Village rebels, the Lower East Side had a drama and color all its own: streets throbbed with people and the sounds of pushcart vendors hawking their wares. There were cafés where people of all political persuasions gathered for serious discussions or heated arguments over a tall glass of tea. And there was vital theatre.

Hutchins Hapgood, one of the chief chroniclers of the time, wrote extensively about Yiddish theatre in his book *Spirit of the Ghetto* (1902). He also reviewed Yiddish plays for the newspaper *The Commercial Advertiser*. Neith Boyce captured the essence of what ethnic theatre meant to the Villagers in her autobiography:

> They were fascinating. . . .Even when I did not understand the language, I could follow the drift of the play. . . .The audiences were live and responded to one another. I thought that with far less resources than Broadway theatre, the foreign stage made for better productions. There were German plays of Hauptmann and Sudermann; the Italian version of Shakespeare and exciting puppet plays and endless Chinese plays that carried on from one night to another; and the turbulent Yiddish melodramas, with the audience shouting. There was a stream of life, rich, full, picturesque.[26]

Although the Provincetown Players were nonprofessionals in theatre, they had earned recognition as writers, journalists, and painters, which served them well in the new

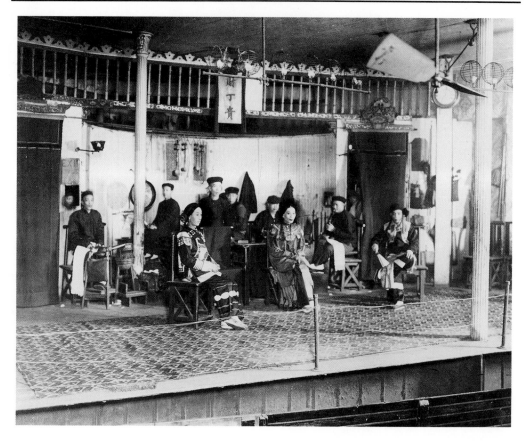

FIGURE 90. *A Chinese play performed in Chinatown, New York City, 1907. Byron Collection, Museum of the City of New York.*

theatre venture. In addition, several already had written plays, or been involved in theatre in the Village.

In 1913, Henrietta Rodman opened the reorganized Liberal Club, "A Meeting Place for Those Interested in New Ideas" in a brownstone at 137 MacDougal Street. It became the center of Village life for discussion, "close dancing," fundraisers called "pagan routs," poetry readings, arguments and lectures—from birth control to the single tax to the "new" stagecraft. Polly Holliday and Hippolyte Havel, who ran the restaurant below, provided good food at cheap prices. A few of the members formed their own little drama group to present original skits. Floyd Dell, who would be a founding member of the Provincetown Players, wrote and staged *What Eight Mil-*

lion Women Want, The Idealist, and *The Perfect Husband.* Among the Liberal Club membership were many who later became active in the Washington Square Players and the Provincetown Players: Jig Cook, Susan Glaspell, Max Eastman, Ida Rauh, Hutchins Hapgood, Neith Boyce, Mary Heaton Vorse, John Reed, Alfred Kreymbourg, Charles Demuth, Harry Kemp, Floyd Dell, Edna St. Vincent Millay, publisher Frank Shay, Teddy and Stella Ballantine, Lucy Huffaker, and Upton Sinclair.

The two climactic events of prewar cultural radicalism—the Armory Show and the Paterson Strike Pageant—signified a break with the past and "a climate of strong hopes for a change for the better in all things." The Paterson Strike Pageant recognizably belonged to the realm of theatre. The monthly

FIGURE 91. *Papa Manteo's life-sized marionettes, 109 Mulberry Street, New York City. The Manteo family performed the chivalric episodes of* Orlando Furioso, *derived from the French* Song of Roland. *Photo courtesy of Martha Cooper/City Lore.*

magazine *The Independent* called it a pageant of the present and "a new thing in our drama," that at the same time returned to the origins of drama.[27] There were six episodes in the presentation. They had been suggested to John Reed by the strikers themselves. Fifteen hundred strikers became actors in the event. They carried banners and sang and marched up Fifth Avenue to Madison Square Garden where an audience of 15,000 cheered them on. According to Mabel Dodge, "Bobby" Jones insisted upon making it into a "Gordon Craig affair," which meant that a roadway was cleared through the seating from the stage out through the entrance to the Garden to encourage audience participation.[28] At one point during the reenactment of the slain striker's funeral along the roadway, members of the audience left their seats to join in the procession behind the actor-striker-mourners.

Several future Provincetown Players and close friends of the group participated in the pageant: John Reed directed the event; Robert Edmond Jones, who staged it, also designed the program cover. John Sloan was in charge of scenery. Mabel Dodge helped with the financing. Hutchins Hapgood headed a group of ninety Villagers who served as an advisory committee. Jig Cook and Susan Glaspell were in the audience.

Response to the artistry of the event was universally favorable. "Life passes over insensibly into a certain, simple form of art," wrote Hutchins Hapgood in his account for the *New York Globe*. He perceived of the transformation as something "great" and "almost unprecedented." Other newspapers called the pageant "a new art form" and "spectacular." Certainly it was theatre in response to social issues. Susan Glaspell called it "the first labor play." Randolph Bourne challenged anyone who had seen the pageant to ever forget that evening when "an entire labor community dramatized its wrongs in one supreme outburst of group emotion." He added that "it stamped into one's mind the idea that a new social art was in the

American world, something genuinely and excitingly new."[29] The Paterson Strike Pageant was close to George Cram Cook's dream of theatre emanating from a group working together to express a common ideal.

THE RISE OF THE NEW THEATRE

The little theatre movement that emerged at the turn of the century played an important role in the cultural renaissance that swept across the land in the second decade of the twentieth century. In the following essay, Mary C. Henderson chronicles a period of American theatrical and social history that is all but forgotten today. The most important art theatres, personalities, and productions are highlighted through illustration and text, enabling the reader to see the images and understand their link to the cultural life of that moment.

Two art theatres that preceded the Provincetown Players deserve special consideration in our discussion, not only for their innovative productions and the fact that they were risk takers in presenting avant-garde plays, but also because they helped create audiences for realistic plays in this country. In 1912, Maurice Browne opened the Little Theatre of Chicago on a bare stage in "an empty room hitherto used for storage."[30] Here he introduced American audiences to Euripides as well as to the searing and satiric plays of contemporary European playwrights—William Butler Yeats, August Strindberg, and Bernard Shaw. Inspired by the work of the independent theatres in Europe, fueled by the recent performances of the Abbey Players in this country, and energized by a concomitant explosion in the arts that was occurring in Chicago at the time, Browne and his wife, actress Nellie Van Volkenburg, were "both afire" to stage plays that the commercial theatre did not offer. They also wanted to apply their own innovative ideas and techniques to realistic plays

and to modern reinterpretations of ancient Greek drama.

Their production of Euripides' *The Trojan Women* (1912), directed by Browne with settings by B.J.O. Nordfeldt, a future Provincetown Player, was a Gilbert Murray verse translation that attracted widespread attention. Jig Cook, who was tremendously impressed by the Browne production, was responsible for making the connection between the Provincetown Players and ancient Greek theatre, thus providing the Players with a "usable past" to serve as the basis for creating a tradition. "If there is nothing to take the place of the common religious purpose and passion of the primitive group, out of which the Dionysian dance was born, no new vital drama can arise in any people."[31]

The Little Theatre of Chicago had loyal followers whose influence was far-reaching: Eugene V. Debs, Lincoln Steffens, Clarence Darrow, Emma Goldman, Mrs. Havelock Ellis, Theodore Dreiser, and Harley Granville-Barker were among those who attended regularly. In addition to Jig Cook, Floyd Dell also attended as did Lawrence Langner, Edward Goodman, and Philip Moeller, the founders of the Washington Square Players. During its five years of existence, the Little Theatre of Chicago presented 130 plays, of which 55 had not been performed previously.[32] Browne's theatre served as a catalyst for both the Washington Square Players and the Provincetown Players.

The Washington Square Players first came to life, as legend has it, with an impromptu performance of Lord Dunsany's *The Glittering Gate* (1914) at the Liberal Club. Copies of the play happened to be on the bookshelves, Robert Edmond Jones happened to be there to stage it, and Edward Goodman, Helen Westley, Philip Moeller, and others happened to want to perform it.[33] Whether or not the story is true is unimportant, since we know that the Washington Square Players was founded by members of the Liberal Club. Lawrence Langner wanted to form a new theatre group and convinced two of his friends, Philip Moeller and Edward Goodman, to join him in the venture. Some of the other founding members would be prominent figures in the Provincetown Players, notably George Cram Cook, Susan Glaspell, Floyd Dell, Max Eastman, Ida Rauh, Teddy Ballantine, Lucy Huffaker, and John Reed.

The stated artistic policy of the Washington Square Players was to produce plays of "artistic merit," with preference given to American plays, but also to produce works of European authors which had been ignored by commercial managers. The group opened at the Bandbox Theatre, uptown at 57th Street, on 19 February 1915, with three one-acters by Lawrence Langner, Edward Goodman, and Maurice Maeterlinck. Four more bills were performed that season. The next season they added to the number of weekly performances and increased the ticket price from fifty cents to one dollar to help pay salaries of actors and house staff, and the theatre rental. The third season they rented larger quarters, the Comedy Theatre on Broadway. At the end of the third season they had produced a total of sixty-two plays, with almost half written by European playwrights.

Among the Villagers at the time there was a growing interest in forging a new American cultural identity. It would be modeled on the art and literature of Europe, but independent of it. *The Seven Arts* magazine was one of the foremost advocates of cultural nationalism. In his concern for the number of European playwrights being produced by the Washington Square Players, Waldo Frank added his voice of protest in an article written for the magazine:

These spirits of revolt—Andreyev, Wedekind, Maeterlinck, Romains—are not true for us. They have not reached up through labored fields that are our own. Absorption in them is a natural growth for their countrymen; for the American it is a dangerous trick.

We have our own fields to plow; our own

reality to explore and flush with vision. Let us do this first; humbly and doggedly as lowly toilers must.

The Washington Square Players dissolved in 1918 because of the high costs involved in maintaining their professional standards of production and because of the war. Soon after, the founders of the group headed by Lawrence Langner started the Theatre Guild, which he described as the "little theatre grown up."[34]

Although the Washington Square Players did not discover any major playwrights, the group contributed much to the rise of the new theatre. Among the actors it nurtured were: Roland Young, Katharine Cornell, Rollo Peters, Margaret Mower, Marjorie Vonnegut, Frank Conroy, and Helen Westley. It gave encouragement to designers Robert Edmond Jones, Lee Simonson, and Rollo Peters and performed works by playwrights Zoë Akins, Eugene O'Neill, Susan Glaspell, and Ben Hecht.

As little theatre groups, both the Washington Square Players and the Provincetown Players had much in common, but there were also important differences between the two in practice and philosophy. When Jig Cook resigned from the Washington Square Players, he let it be known that they were not sufficiently experimental for him nor were they interested enough in nurturing American playwrights. Some of his dissatisfaction may also have been personal. Glaspell and Cook's play *Suppressed Desires* had been turned down for production by their committee of readers as being "too special."

The Provincetowners created a laboratory theatre for new American plays without regard to their commercial value. Completed productions were considered neither "successes" nor "failures," but referred to simply as "results" of an experiment. Settings were minimal and expenses were kept low. Lawrence Langner pointed to some other differences between the two theatres:

The Provincetown . . . was always a more personal expression of the authors behind it than was our group, with the result that it tended to develop its authors rather than its audience. . . . It was frankly experimental as to plays while the Washington Square Players were attempting to present productions which would be in healthy competition with plays of Broadway. The Washington Square group fought the issue of the art theatre *versus* the commercial theatre; it sought to produce its plays at the Comedy Theatre [on Broadway] in competition with commercial attractions.[35]

THE PROVINCETOWN

George Cram Cook was a visionary, a "chief inciter to the first experiments," a founder, and the spiritual leader of the Provincetown Players. In his essay for this volume Robert Sarlós characterizes Cook as a "rule-breaker and rule-maker." Cook dreamed of a theatre generated by a community of artists and writers whose convictions about the power of art to transform life were synchronous with his own. The model and inspirational force for theatre was always Greek, which led to a focus on the interrelationship of the arts. "The arts fertilize each other," said Cook. "The dancer creates in space attitudes of sculpture and in time makes them flow rhythmically into each other like the successive notes of melody. Our minds are now full of the madness of painting that wants to be like music."[36] In his essay, Robert Sarlós points out how this concept was translated by Jig Cook into everyday theatre practice.

Jig has been both praised and criticized for his leadership, personality, and contributions to theatre. Edna Kenton called him "the single spirit dedicated wholly to the experiment." Eugene O'Neill said that Jig "represented the spirit of revolt against the old, worn-out tradition, the commercial theatre, the tawdry artificialities of the stage." Floyd Dell, on the other hand, was openly critical of Jig's ways and wrote de-

risively in his memoirs of Jig's sense of personal failure.[37] Jig's talents as a catalyst, visionary, and source of inspiration do not lend themselves easily to objective measurement. There are those who thought of Cook as impractical and disorganized; however, he did successfully hold together a creative and heterogeneous group that wrote plays in, through, and for the organization he led.

The Provincetown Players created one of the most valuable of the early experimental theatres that helped to establish American drama as a serious art form. The plays its members wrote reflected the ferment of the times and gave rise to a theatre with a distinctly American voice. When Jig Cook urged the creation of a "native stage for native plays," he was very much in step with the other cultural rebels of his generation who sought to replace the outworn ideas and modes of a genteel tradition with a new American art and literature that could revitalize American life. Jig wrote of himself and his peers: "It is for us to prove that the finest culture is a possibility of democracy."[38]

The first inkling of their collective effort can be found in a letter from Hutchins Hapgood addressed to his father, written 7 July 1915, in which he mentions the reading of Neith Boyce's *Constancy* the previous evening in Provincetown: "Last night we read a clever one-act play to several people here, and we all liked it. We are going to act in it. Or, rather, as there are only two characters in it, Neith and Joe O'Brien will be the actors and the rest of us spectators."[39] Nine days later, the play was paired with Glaspell and Cook's *Suppressed Desires* and performed for a group of friends in the living room of the Hapgood's East End beach cottage. Robert Edmond Jones staged both plays. For *Constancy*, it consisted of a couch with colorful cushions and two lamps on either side of a double door that opened onto a verandah. In the background was the bay and the lighthouse at Long Point. After *Constancy*, the audience turned their chairs around to watch *Suppressed Desires* for

which Jones rearranged the setting to be an apartment in Greenwich Village.

Two days after the performance, Neith Boyce wrote a letter to her father-in-law describing the first production of the plays:

I can hardly believe that a month has passed since we came down. Time flies here . . . and I judge each day as it goes. I do love being here. Nothing happens. One day is like another. . . . We . . . have a pleasant group of people about us . . . Bayard Boyeson, Mabel Dodge, "Bobby" Jones, etc. . . . and then our friends who are always here [Mary Heaton Vorse, Joe O'Brien, Margaret and Wilbur Daniel Steele]. You will be amused to hear that I made my first appearance on the stage Thursday night!! I have been stirring up the people here to write and act plays. We began the season with one of mine. Bobby J. staged it on our verandah.

The colors were orange and yellow against the sea. We gave it at 10 o'clock at night, and really it was lovely—the scene—I mean. I have been highly complimented on my acting. . . . I wish I had more interesting things to tell you—but as I said, nothing happens here.[40]

The next morning, Mary Heaton Vorse turned over a pier that she owned, with a two-story fish shed and two smaller buildings on it, to the excited playgivers who converted it into a theatre. Two bills, each with two one-act plays, were presented during the remainder of the summer: the first bill was a repeat of the plays performed at the Hapgood beach cottage. The second bill consisted of George Cram Cook's *Change Your Style* and Wilbur Daniel Steele's play *Contemporaries*.

The interval of two decades or so between the flowering of avant-garde theatre in Europe and the emergence of the Provincetown group in 1915 provided important preparation time for American drama to develop into a literary art form. First, there needed to be time for the "new drama" of Europe to make its way to the United States

and to find an audience through subscription-based little theatres. Only after Americans had absorbed and created an audience for European avant-garde plays were they ready for O'Neill's experiments.

In the summer of 1916, when Eugene O'Neill first came to Provincetown, it was fortuitous timing: He had written sixteen plays but never had any produced; the Provincetowners in turn were anxious to find new plays for production. What O'Neill needed was a laboratory to continue his work, a place where he could fail, an atmosphere of stimulation and encouragement. He had submitted plays to Broadway and to the Washington Square Players, all of whom had rejected them.[41] So, for O'Neill, after "experiencing life" for five years, taking formal training in play writing, and then writing plays, production was the next logical step. In the essay that concludes this book, Barbara Gelb discusses the importance of the Provincetown Players to Eugene O'Neill's growth and development as one of America's foremost dramatists.

Inspired by their discovery of a major playwright in O'Neill, buoyed by the success of their second summer of theatre in Provincetown, and confident that they could continue their experiments for a wider audience, the Provincetown Players decided to continue their operation in New York. Although no one of the group really wanted a constitution and bylaws, a majority realized that with the move and the new expanded venture, it would be best to have them. At a meeting held in the wharf theatre, 4 September 1916, twenty-nine people signed on as active members of the newly named Provincetown Players. An active member was a person who would "write, act, produce or donate labor" to the productions. It was resolved that the "club" would have two officers, a president and a secretary-treasurer. Minutes of the meeting were signed by Louise Bryant. A constitution was commissioned.

The following evening, the group met again, and the constitution was ratified. In addition to active members, there would be associate members, who would pay in advance for a season of production, and club members, who simply would be entitled to buy tickets for single performances. Resolutions—in lieu of bylaws—related to the philosophy and modus operandi of the group. It was resolved that: (1) "The primary object of the Provincetown Players is to encourage the writing of American plays of real artistic, literary and dramatic—as opposed to Broadway—merit"; and (2) "That such plays be considered without reference to their commercial value, since this theatre is not to be run for pecuniary profit."[42]

THE LEGACY

Even without Eugene O'Neill's towering achievements, the accomplishments of the Provincetown Players were considerable. For two summers in Provincetown and six seasons in Greenwich Village, they presented audiences with ninety-seven original plays written by forty-seven American playwrights. The Players' use of ensemble acting, their focus on the creative function of a group working together and integrating all elements of performance, as well as their commitment to the connections among social and cultural concerns and personal values, established a precedent for companies such as the Workers' Drama League, the New Playwrights' Theatre, the Group Theatre, the Federal Theatre Project, and later groups such as the Living Theatre, the San Francisco Mime Troupe, and the off-Broadway and regional theatres of today. Playwrights such as Clifford Odets, Edward Albee, Lillian Hellman, Tennessee Williams, and Arthur Miller—to name a few—continued to write in the dramatic tradition the group established.

The Provincetown Players contributed in other ways to the legacy of American theatre by giving prominence to the writer and director—rather than the actor—as the

most important shapers of meaning, and by providing playwrights with an atmosphere of freedom from all but artistic considerations. European "little theatres" with subscription audiences nurtured playwrights of world stature—the Théâtre Libre, Ibsen and Strindberg; the *Freie Bühne*, Sudermann and Hauptmann; the Moscow Art Theatre, Chekhov, Tolstoy, and Gorky; the Independent Stage Society, Bernard Shaw. So, too, did the Provincetown Players in providing a forum for the works of Eugene O'Neill and Susan Glaspell. In more recent times, theatre groups following in their tradition have continued to support fine playwrights: The Circle Repertory Company is associated with the work of Lanford Wilson; the Goodman Theatre, David Mamet; Playwrights Horizons encourages the works of Wendy Wasserstein and Christopher Durang; the Yale Repertory Theatre has showcased August Wilson.

In locating and creating a "usable past," the Provincetown Players set the stage for a continuing tradition of innovative theatre practices and experiment in modern American drama.

NOTES

1. Hutchins Hapgood, *A Victorian in the Modern World* (New York: Harcourt, Brace, 1939), 394.

2. Susan Glaspell, *The Road to the Temple* (New York: Frederick A. Stokes, 1941), 248.

3. See Ethan Mordden, *The American Theatre* (New York: Oxford University Press, 1981), 5.

4. See Mary C. Henderson, *Theatre in America* (New York: Harry N. Abrams, 1986), 45.

5. See Kenneth MacGowan and William Melnitz, *The Living Stage* (Englewood Cliffs, N.J.: Prentice-Hall, 1955), 388.

6. Ibid., 375.

7. Mordden, *American Theatre*, 7, 8.

8. MacGowan, *Living Stage*, 371, 381.

9. Ibid., 387; Henderson, *Theatre in America*, 24.

10. MacGowan, *Living Stage*, 371, 383.

11. Walter Prichard Eaton, *The Theatre Guild: The First Ten Years* (New York: Brentano's, 1929), 18.

12. Arthur Hobson Quinn, *A History of the American Drama* (New York: Appleton-Century-Crofts, 1936), 140. Excerpt from drama review that appeared in *The New York Times* is quoted in C.W.E. Bigsby, *A Critical Introduction to Twentieth Century Drama* (Cambridge: Cambridge University Press, 1982), 2.

13. See Henderson, *Theatre in America*, 60.

14. Mary Heaton Vorse, *A Footnote to Folly* (New York: Farrar and Rinehart, 1935), 129.

15. See Charles Lock, "Maurice Browne and the Chicago Little Theatre," *Modern Drama*, 31 (March 1988): 106.

16. Van Wyck Brooks, "On Creating a Usable Past," *Dial* 64 (April 1918): 337–341; Henry F. May, *The End of American Innocence* (New York: Alfred Knopf, 1959), 250.

17. Quoted in Kenneth MacGowan, *Footlights Across America* (New York: Harcourt, Brace, 1929), 26.

18. See J. L. Styan, *Modern Drama in Theory and Practice* (Cambridge: Cambridge University Press, 1981), 31–32.

19. Robert Edmond Jones, *Dramatic Imagination: Reflections and Speculations on the Art of the Theatre* (New York: Duell, Sloan and Pearce, 1941), 24–25, 27.

20. See Henderson, *Theatre in America*, 204.

21. Quoted in Arthur Gelb and Barbara Gelb, *O'Neill* (New York: Harper & Row, 1960), 150.

22. Glaspell, *Road to the Temple*, 218.

23. See Maxine Seller, *Ethnic Theatre in the United States* (Westport, Conn.: Greenwood, 1983), 6–9. For background information on Yiddish theatre of the Lower East Side during

the four decades of the great migration from East Europe, see Irving Howe, *World of Our Fathers* (New York: Harcourt Brace Jovanovich, 1976), 460–496; and for a more extensive history of Yiddish theatre, see Nahma Sandrow, *Vagabond Stars: A World History of Yiddish Theatre* (New York: Harper & Row, 1977).

24. May, *End of American Innocence*, 283.

25. Ibid., 283.

26. Neith Boyce, "Unfinished Autobiography," TS, p. 4, Boyce Papers, Beinecke Rare Book and Manuscript Library, Yale University.

27. Martin Green, *New York, 1913: The Armory Show and the Paterson Strike Pageant* (New York: Scribner, 1988), 11, 204. For valuable background information on the Paterson strike, see John Reed, "War in Paterson," *The Masses* 5 (June 1913); for information on how the idea of the pageant originated, see Robert A. Rosenstone, *Romantic Revolutionary: A Biography of John Reed* (New York: Random House, 1975), 126–130; also, see Mabel Dodge Luhan's scrapbook entitled "Paterson Strike" in the Mabel Dodge Luhan Collection, Beinecke Rare Book and Manuscript Library, Yale University. And for excerpts from his article on the pageant that appeared in the *New York Globe*, see Hapgood, *A Victorian in the Modern World*, 351–352.

28. See Mabel Dodge Luhan, *Movers and Shakers* (New York: Harcourt, Brace, 1936), 204.

29. Hapgood, *A Victorian in the Modern World*, 351–352; Glaspell, *Road to the Temple*, 250; Randolph Bourne, "Pageantry and Social Art," MS, p. 6, Bourne Collection, Columbia University, New York, N.Y.

30. Maurice Browne, *Too Late to Lament; An Autobiography* (Bloomington: University of Indiana Press, 1956), 120.

31. Quoted in Edna Kenton, "The Provincetown Players and the Playwrights' Theatre, 1915–1922," MS, p. 3, Elmer Holmes Bopst Library, New York University. According to Kenton, Jig Cook and Neith Boyce jointly formulated this statement. See also, Arnold Goldman, "The Culture of the Provincetown

Players," *Journal of American Studies* 12 (December 1978): 297.

32. Browne, *Too Late to Lament*, 377.

33. See Oliver M. Sayler, *Our American Theatre* (New York: Brentano's, 1923), 77.

34. Waldo Frank, "Concerning a Little Theatre," *The Seven Arts* 1 (December 1916): 164; Lawrence Langner, *The Magic Curtain* (New York: Dutton, 1951), 75.

35. Langner, *Magic Curtain*, 102.

36. Quoted in Glaspell, *Road to the Temple*, 245.

37. Edna Kenton, "Provincetown and MacDougal Street," in *Greek Coins, Poems by George Cram Cook* (New York: George H. Doran, 1925), 21–22; told by O'Neill to his biographer, Barrett Clark, in 1924. Barrett Clark, *Eugene O'Neill, the Man and His Plays* (New York: Robert M. McBride, 1929), 43; Floyd Dell, *Homecoming* (New York: Farrar and Rinehart, 1933), 254–255, 262–267. In a review of *Homecoming*, written for the *New York Globe* and excerpted in his autobiography, Hapgood refers to Dell's portrait of Cook as "totally inadequate." Hapgood, *A Victorian in the Modern World*, 315–316.

38. Quoted in Glaspell, *Road to the Temple*, 225.

39. Letter from Hutchins Hapgood to his father, Charles Hapgood, dated 7 July 1915. Hapgood Papers, Beinecke Rare Book and Manuscript Library, Yale University.

40. Letter from Neith Boyce to her father-in-law Charles Hapgood, dated 17 July 1915. Boyce Papers, Beinecke Rare Book and Manuscript Library, Yale University.

41. See Louis Sheaffer, *O'Neill, Son and Playwright* (Boston: Little, Brown, 1968), 323.

42. Information concerning the organization of the Provincetown Players comes from "Minute Book of the Provincetown Players, Inc. From September 4, 1916 to November 8, 1923"; Theatre Collection of the New York Public Library at Lincoln Center. See also Helen Deutsch and Stella Hanau, *The Provincetown: A Story of the Theatre* (New York: Russell and Russell, 1959), 16–17, 33–39.

Against Broadway

The Rise of the Art Theatre in America (1900–1920) A Photographic Essay

MARY C. HENDERSON

The theatre is a crucible of civilization. It is a place of human communion. It is in the theatre that the public soul is formed.

—VICTOR HUGO

In the fall of 1887, a young clerk from the Paris Gas Company opened the doors of a little theatre at 37 Elysée des Beaux Arts to present a short, starkly realistic play based on a story by Émile Zola, a work that had been refused presentation by the amateur group to which he belonged. The young man was André Antoine, the play was *Jacques Damour*, and the little theatre was named the Théâtre Libre by its enthusiastic founder. Years after this momentous event, a French critic was to reminisce: "We had the air of good Magi in mackintoshes seeking out some lowly and glorious manger. Can it be that in this manger the decrepit and doting drama is destined to be born again!"

Antoine's little venture was to prove successful beyond his dreams. It sparked the creation of similar experimental art theatres throughout Europe, and these in turn launched the era of modern theatre and drama in the Western world. From the Moscow Art Theatre in Russia to the Abbey Theatre in Ireland, from Ibsen in the north to Pirandello in the south, conventional theatre in Europe was shaken at its roots. New theories evolved about every aspect of

FIGURE 92. *Unidentified production, Hull-House Theatre, ca. 1900. Chicago Historical Society.*

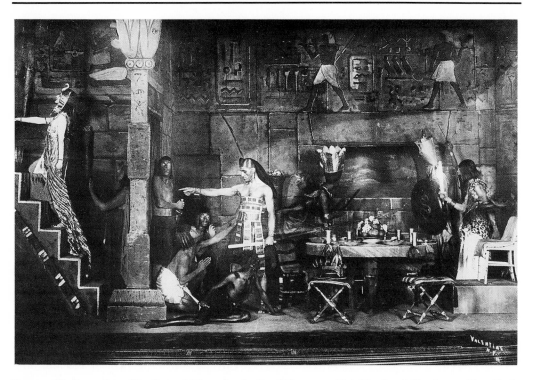

FIGURE 93. *Scene from* The Queen's Enemies, *by Lord Dunsany, Neighborhood Playhouse, New York, 1916–1917. Billy Rose Theatre Collection, The New York Public Library at Lincoln Center, Astor, Lenox and Tilden Foundations. During its existence, the Neighborhood Playhouse presented many "firsts" on the American stage, among them* The Queen's Enemies *by Lord Dunsany. Directed by Alice Lewisohn and Agnes Morgan, it had costumes designed by Aline Bernstein and scenery by Howard Kretz-Coluzzi and Warren Dahler. Kneeling in center stage is Nubian slave George Abbott, who worked for the Neighborhood Playhouse for $30 per week, at the beginning of his career in New York.*

the theatre and spread like wildfire, gradually migrating into the mainstream theatre of its time.

In America, the progress of Antoine and his imitators was followed avidly by American intellectuals. In Boston, William Dean Howells and Hamlin Garland found a play, a playwright, and a theatre and for a few days in 1891, they created their own "théâtre libre" at Chickering Hall with a short-lived production of James A. Herne's *Margaret Fleming*, a play that dealt uncompromisingly with the results of middle-class marital infidelity. But the time was not ripe for the emergence of a genuine art theatre movement in America nor was the basis for it clearly visible at this time in the history of American theatre. Broadway and the rialtos

of the major cities were being inundated with flimsy star vehicles and the rest of the country was suffering through shoddy road shows advertised as "Direct from Broadway" or makeshift productions of hoary melodramas patched together for the provinces.

The first tentative steps toward an alternate theatre came with the dawning of the new century and from an unexpected place. Jane Addams and Ellen Gates Starr, the founders of Hull-House, a settlement house located in the slums of Chicago, decided that the best way to lure the uneducated poor from the trashy melodramas of the low-class theatres and the tawdry atmosphere of the variety halls was to involve them in dramatic activities at Hull-House. In 1893, the Dra-

matic Section presented its first full-scale production; in 1899, it had its own theatre; and in 1900, its first professional director, Laura Dainty Pelham. Mrs. Pelham gradually fashioned her charges into a well-organized troupe, who could play Shaw, Pinero, and Ibsen along with Shakespeare (fig. 92). But the aims of the Hull-House Players remained sociological, not artistic, and never progressed past the amateur stage.

The success of the Hull-House experiment was emulated again and again. In New York, the Henry Street Settlement, through the largesse of Alice and Irene Lewisohn, took the amateur activities from the settlement house and moved them in 1915 into an elegant little theatre, the Neighborhood Playhouse, and mingled professional with amateur to create interesting and experimental theatre (fig. 93). In the same year, Stuart Walker used the Christadora Settlement House in Manhattan's Lower East Side to launch his experiment with a tiny portable theatre that could be packed into ten large cartons with its own lighting system, cyclorama, and scenery, and could be set up indoors or out in a few hours' time. Walker's theatre justified its existence on one snowy Christmas night in 1916, when he set up his Portmanteau Theatre and gave a performance for the homeless and destitute sitting on park benches in Madison Square (fig. 94).

Rural America was not without its incursions into theatre as a social and cultural force. When Alfred G. Arvold joined the faculty at the North Dakota Agricultural College in Fargo, he discovered that most of his students and their families had never seen a play. In 1914, he took over an unused room in the administration building and founded the Little Country Theatre with his stated aim to put "culture into agriculture." Not only did he produce and direct plays, he established a network of theatrical activities for the entire state, offering himself and the resources of the college to farmers and rural folk for presenting plays, pageants, and festivals (fig. 95). His colleague Frederick Koch did the same for North Carolina,

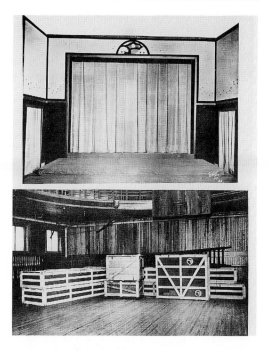

FIGURE 94. *Portmanteau Theatre, New York, 1915. Billy Rose Theatre Collection. The New York Public Library at Lincoln Center, Astor, Lenox and Tilden Foundations.*

founding the Carolina Playmakers in 1918, with its home at the University of Carolina at Chapel Hill. It has since become something of a national institution (fig. 96).

As admirable as they were, these little theatres used drama as an instrument for educational, cultural, or social benefit rather than for introducing revolutionary concepts in the form and practice of the theatre. It remained for small bands of intellectuals throughout the country to make their rebellion against Broadway more eloquent and more lasting. The art theatres that evolved in the early years of the century had much in common. All of them were founded by someone with a zeal that amounted to an obsession to create a new form of theatre. All of them began modestly and most existed under strained financial circumstances, relying on subscriptions and in some cases, passing the hat. All began with a rousing

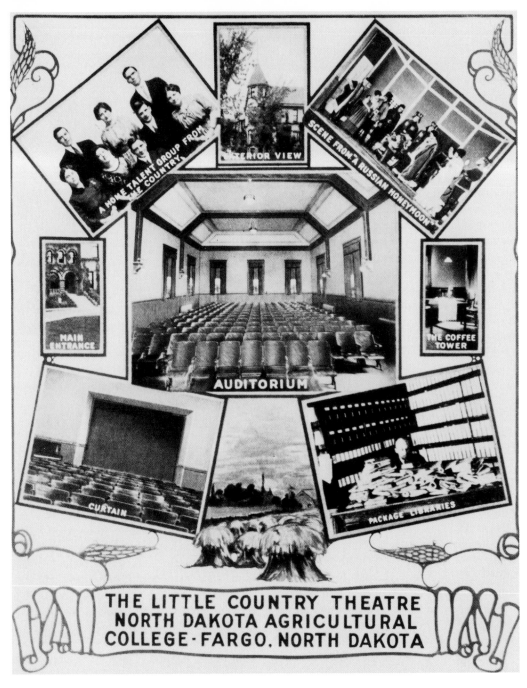

FIGURE 95. *Poster for the Little Country Theatre, Fargo, North Dakota. Billy Rose Theatre Collection, The New York Public Library at Lincoln Center, Astor, Lenox and Tilden Foundations.*

FIGURE 96. *Scene from* Peggy, *by Harold William-son, Carolina Playmakers, 1919. Billy Rose Theatre Collection, The New York Public Library at Lincoln Center, Astor, Lenox and Tilden Foundations. Using the campus of the University of North Carolina as his base, Frederick H. Koch founded the Carolina Playmakers as a folk theatre. He stimulated students in his playwriting classes to write out of the Carolina experience to create a literature for the area. Peggy was a tragedy about tenant farmers. Koch's lasting achievement was the discovery of the playwright Paul Green, whose plays eventually reached Broadway.*

through devoted philanthropists. The groups were characterized by youth and earnestness and attracted audiences almost in equal measure from the regular theatre-going public and from members of their own generation who shared their aspirations and interests. When the mission of the little theatres of this era was accomplished, most quietly disbanded. Their success was their own undoing.

The group considered today to be the seminal theatre organization of the era was the Chicago Little Theatre founded by the English actor Maurice Browne and his American wife, Ellen Van Volkenburg, in 1912. On the thinnest of purses, they leased a back room on the fourth floor of the Fine Arts Building on Michigan Avenue and shaped it into a tiny theatre seating ninety-one people with a stage the size of the proverbial postage stamp. Their designer, C. Raymond Johnson, performed small miracles of stagecraft with his impressionistic scenery washed in color and light, to enhance the poetry of their dramatic presentations (fig. 97). Their theatre was to prove an inspiration for others in Chicago and throughout the country (fig. 98).

manifesto to change the theatre and to experiment with the form, content, and presentation of dramas. Many wanted to stimulate a truly American theatre through supporting playwrights who would write plays about American society and character, damning or praising, as long as they were truthful depictions. Most were inspired by the currents of thought and ideas drifting from Europe: Freud, communism, abstract art, feminism, unionism, free verse, free love, and the new literature.

All of them began presenting their plays in makeshift spaces, which became a supreme test of their ingenuity and imagination. The lucky few graduated into elegant little theatres designed and constructed for them through the loyalty of their constituents or

FIGURE 97. *C. Raymond Johnson's design for* The King of the Jews, *by Maurice Browne, Chicago Little Theatre, 1917. Billy Rose Theatre Collection, The New York Public Library at Lincoln Center, Astor, Lenox and Tilden Foundations.*

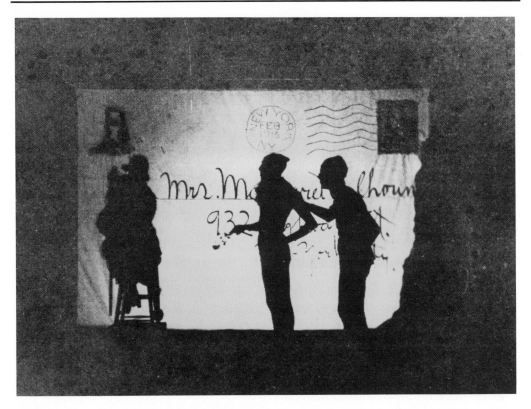

FIGURE 98. *Scene from* Mrs. Margaret Calhoun, *by Ben Hecht and Maxwell Bodenheim, Chicago Workshop Theatre, 1917. Billy Rose Theatre Collection, The New York Public Library at Lincoln Center, Astor, Lenox and Tilden Foundations. Founded in 1916, the Chicago Workshop Theatre was intended to be just that: a workshop where Chicago writers and artists could give vent to their ideas. Mrs. Margaret Calhoun was designed somewhat expressionistically by J. Blanding Sloan. In the play, the playwrights "gave human form to the phrases of a love-letter and these pale greenish silhouettes were caused to appear behind a translucent drop, painted to represent a huge envelope" with a torn end.*

In the 1910s, New York's Greenwich Village became the mecca for young intellectuals and artists and the area teemed with all sorts of experimentation for its own sake. In the back room of a bookstore, in the winter of 1914–1915, a group who christened themselves the Washington Square Players began to present original one-act plays and to put into practice the continental stagecraft enunciated by Adolphe Appia and Gordon Craig (fig. 100). They eventually moved out of the back room into the Bandbox Theatre and later the Comedy Theatre in the theatre district. In 1915, a few of the members were thrown together in Provincetown, where they decided to continue their experiments.

They found four one-act plays by members worthy to produce, presented them modestly, then agreed to meet the following summer to repeat the experience (figs. 102–103).

In the summer of 1916, they chanced upon the plays of Eugene O'Neill, and under the guidance of the charismatic George Cram (Jig) Cook, the newly formed Provincetown Players transferred activities to Greenwich Village. They found a home on MacDougal Street and there they enjoyed (in two locations) a half-dozen years of extraordinary achievement before the inevitable waning of enthusiasm, disaffection of key members, and drying up of talent set in. Most of the groups were to journey through

FIGURE 99. *Butler Davenport outside his theatre in New York City. Billy Rose Theatre Collection, The New York Public Library at Lincoln Center, Astor, Lenox and Tilden Foundations. In 1915, actor Butler Davenport took over the tiny Bramhall Theatre on East 27th Street and began producing and starring in his own plays. His highly self-indulgent little theatre managed to hang on until 1923, when he decided to make it a free theatre with a policy of producing classical and untried plays with all-amateur casts. During the 1930s, Mayor Fiorello La Guardia strolled into the theatre out of curiosity and was impressed enough by its mission to exempt the theatre from all taxes.*

the similar rites of passage (figs. 101, 104–109).

Understandably, New York City was in the forefront of much of the new revolutionary ferment. It had the first black art theatre, the Negro Players, under the sponsorship of Mrs. Emilie Hapgood and Robert

Edmond Jones. It had the first free-admittance theatre when Butler Davenport decided to make his eight-year-old venture a service to the public (fig. 99). It had the first gentrified art theatre when Winthrop Ames built a small gem-like playhouse in the middle of the new burgeoning theatre district on West 44th Street to present full-length plays that would have never found a hearing on the commercial stage (fig. 110). The cosmopolitanism of America's first city made it easy for experimental groups to form and fulfill their dreams, and to disappear when they satisfied their purpose or ran out of inspiration.

If Chicago was the birthplace of the little theatre movement and New York the home of its greatest achievements, the rest of the country tried not to be outdone by America's first and second cities during this period. In Detroit, the Society of Arts and Crafts sponsored theatrical activities under the leadership of Sam Hume in 1916. The Vagabond Players of Baltimore presented a play by the young H. L. Mencken, one of its members (fig. 111). There were notable little theatres in Boston, Philadelphia, Cleveland, Madison, Pasadena, Los Angeles, and Galesburg, Illinois (figs. 112–114). During the eventful decades from 1900 to 1920, almost every state in the union had at least one dedicated band of amateurs. At the end of the period, there were more than a thousand little theatres throughout the land.

The little theatres changed the course of American theatre. If they can be credited only with uncovering the talents of Eugene O'Neill, Paul Green, Elmer Rice, Robert Sherwood, and Susan Glaspell, they can be said to have fulfilled their mission. But they also gave opportunities to a generation of talented designers who placed America in the forefront of stagecraft in the world in the ensuing decades. Robert Edmond Jones, Cleon Throckmorton, Lee Simonson, Norman Bel Geddes, Aline Bernstein, Sam Hume, Livingston Platt, and C. Raymond Johnson came out of the art theatre movement and demonstrated what could be done

FIGURE 100. *Scene from* Another Way Out, *by Lawrence Langner, Washington Square Theatre, 1916–1917. Billy Rose Theatre Collection, The New York Public Library at Lincoln Center, Astor, Lenox and Tilden Foundations. The setting for* Another Way Out *was designed by Joseph Platt and reflects the effects of European Modernist painting on the theatrical avant-gardists in New York. Although the Washington Square Players were strapped for money, as were most of the similar groups, their daring and imagination could produce some startlingly original concepts in scene and costume design on small budgets.*

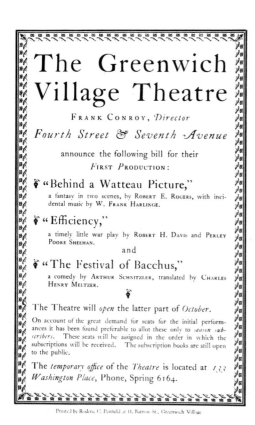

The Greenwich Village Theatre

FRANK CONROY, *Director*

Fourth Street & Seventh Avenue

announce the following bill for their
FIRST PRODUCTION:

❦ "Behind a Watteau Picture,"
a fantasy in two scenes, by ROBERT E. ROGERS, with incidental music by W. FRANK HARLINGE.

❦ "Efficiency,"
a timely little war play by ROBERT H. DAVIS and PERLEY POORE SHEEHAN.
and

❦ "The Festival of Bacchus,"
a comedy by ARTHUR SCHNITZLER, translated by CHARLES HENRY MELTZER.

The Theatre will *open* the latter part of *October.*

On account of the great demand for seats for the initial performances it has been found preferable to allot these only to *season subscribers.* These seats will be assigned in the order in which the subscriptions will be received. The subscription books are still open to the public.

The *temporary office* of the *Theatre* is located at *133 Washington Place*, Phone, Spring 6164.

Printed by Roderic C. Penfield at 11, Barrow St., Greenwich Village

The Greenwich Village Theatre

FOURTH STREET AND SEVENTH AVENUE
NEW YORK
FRANK CONROY, DIRECTOR

FIGURE 102. *Blanche Stillson's woodblock print of the Wharf Theatre, Provincetown. Courtesy of the Malicoat-Dunigan family.*

FIGURE 103. *The first subscription list, Provincetown Playhouse, 1915. Billy Rose Theatre Collection, The New York Public Library at Lincoln Center, Astor, Lenox and Tilden Foundations. The early Provincetown Players reacted to their experience in various ways. Some thought it mere recreation; others felt that they were all bonded within an historical moment. But all contributed more than their time, talents, and energy. The cash account for the first season lists both members and subscribers and the amounts of money they donated. Like all other art theatres of the period, the Provincetown experiment depended on the largesse of its members as well as the audience.*

FIGURE 101. *Greenwich Village Theatre program, 1917. Billy Rose Theatre Collection, The New York Public Library at Lincoln Center, Astor, Lenox and Tilden Foundations. Frank Conroy, one of the many "graduates" of the Washington Square Players, became the director of the Greenwich Village Theatre on Sheridan Square, a small but elegantly appointed playhouse. The early programs featured a drawing of the theatre by Hugh Ferriss, and the cast of the first bill of one-act plays included Fania Marinoff, who temporarily left her promising movie career to be associated with the experimental group.*

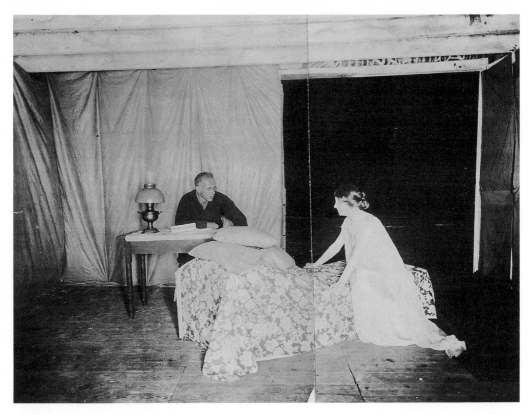

FIGURE 104. *Scene from* Enemies, *by Neith Boyce and Hutchins Hapgood, Provincetown Playhouse, 1916. Courtesy of Miriam Hapgood DeWitt. Written by Neith Boyce and Hutchins Hapgood and played by them sometime during the summer of 1916,* Enemies *was repeated in New York in the fall of the same year with settings by Robert Edmond Jones. Hapgood later recalled in his autobiography that although he wrote his own part, he had difficulty recalling lines and had had to appear on stage book in hand. The play is a study of the trials of a marriage.*

with scenery and lighting on small stages with limited funds but unlimited genius. Finally, the little playhouses created an audience for their experiments, an audience that would endure discomfort in extremis as it sat on hard benches, in all kinds of makeshift spaces (old stables, lofts, basements, saloons, office buildings, private homes—and at least one abandoned fish house), and in all kinds of weather for the chance to be present at one shining moment in the theatre.

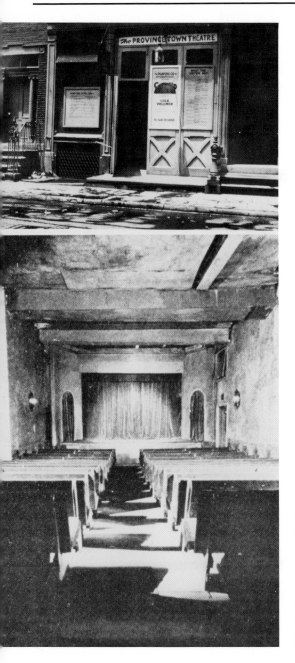

FIGURE 105. *Provincetown Playhouse, New York City, 1918. Billy Rose Theatre Collection, The New York Public Library at Lincoln Center, Astor, Lenox and Tilden Foundations. The first quarters of the Provincetown Players, newly transplanted from Massachusetts in the fall of 1916, was the parlor floor of a brownstone at 139 MacDougal Street in Greenwich Village. In 1918, the group moved into a larger space at 133 MacDougal that had been in its time a storehouse and a stable. This provided a larger stage and an auditorium that could accommodate nearly two hundred patrons in relative comfort with wooden benches with backs and cushions.*

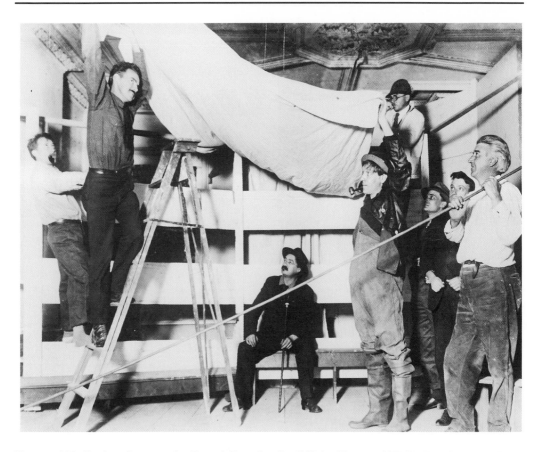

FIGURE 106. *Setting the scene for* Bound East for Cardiff, *by Eugene O'Neill, Provincetown Play-house, New York, 1916. Left to right: Francis Burrell, O'Neill, Hippolyte Havel, William Stuart, B.J.O. Nordfeldt, Frank Jones, Henry M. Hull, George Cram Cook. Museum of the City of New York.*

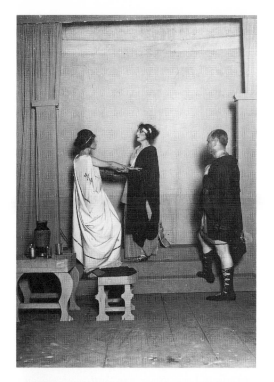

FIGURE 107. *Scene from* The Athenian Women, *by George Cram Cook, Provincetown Playhouse, 1918. Billy Rose Theatre Collection, The New York Public Library at Lincoln Center, Astor, Lenox and Tilden Foundations. The most ambitious undertaking of the Provincetowners to date was the full-length play* The Athenian Women *by George Cram Cook, a serious reworking of the theme of* Lysistrata. *It had a cast of thirty, three acts, and six scenes, all of which strained the limited resources of the group. In the scene shown are Ida Rauh, Sidney K. Powell, and an unidentified player. Ida Rauh was often called the "Duse of MacDougal Street."*

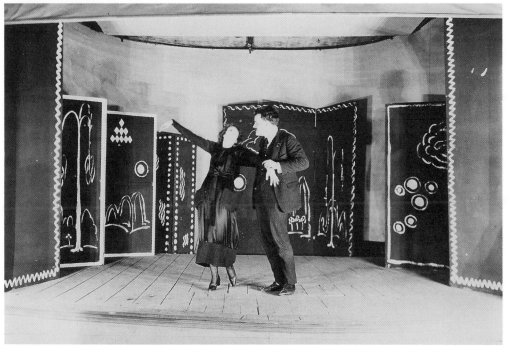

FIGURE 108. *Scene from* Aria da Capo, *by Edna St. Vincent Millay, Provincetown Playhouse, 1919. Billy Rose Theatre Collection, The New York Public Library at Lincoln Center, Astor, Lenox and Tilden Foundations. Caught in rehearsal without proper costumes or set are Norma Millay (Columbine) and Harrison Dowd (Pierrot). (The architect Hugh Ferriss, not shown, played the part of Cothurnus.) Edna St. Vincent Millay directed the production, which was considered the best of the season. The play became a favorite of other art theatres and continued to be performed frequently in the ensuing years.*

FIGURE 109. *William Zorach, charcoal drawing of Eugene O'Neill, 1921. Museum of the City of New York. Original members of the Provincetown Players, William and Marguerite Zorach contributed their talents both as actors and artists to the theatrical experiment. William Zorach, who turned to sculpting later in his career, set down this impression of Eugene O'Neill.*

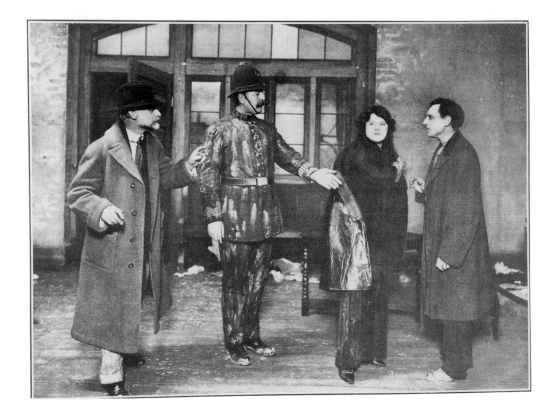

FIGURE 111. *Program of the Vagabond Players, Baltimore, 1916–1917. Billy Rose Theatre Collection, The New York Public Library at Lincoln Center, Astor, Lenox and Tilden Foundations. The stated purpose of the Vagabond Players "to produce new works by American authors and important plays of foreign writers that would otherwise not be produced" reflected the general aims of most art-theatre groups in America during the early decades of the twentieth century. The Players' theatre held sixty seats, which were sold by subscription. On the opening bill of the 1916–1917 season was* The Artist *by the young Baltimoran H. L. Mencken, who was also a member of the play-reading committee.*

FIGURE 110. *Scene from* The Pigeon, *by John Galsworthy, Little Theatre, New York, 1912. Billy Rose Theatre Collection, The New York Public Library at Lincoln Center, Astor, Lenox and Tilden Foundations. Winthrop Ames opened the Little Theatre with a play by John Galsworthy that had never been presented in America. Like all of Galsworthy's plays, it was steeped in social message. The Pigeon concerns an impractical and idealistic artist who shares his small bounty with anyone who asks for it and is eventually duped by rascals. The message of the play is that there will always be those who will be irreclaimable.*

FIGURE 112. *Hedgerow Theatre, Moylan-Rose Valley, Pa., ca. 1923. Billy Rose Theatre Collection, The New York Public Library at Lincoln Center, Astor, Lenox and Tilden Foundations.*

FIGURE 113. *Prairie Playhouse, Galesburg, Ill., 1915. Billy Rose Theatre Collection, The New York Public Library at Lincoln Center, Astor, Lenox and Tilden Foundations. Through hard work and determination and a little more than a thousand dollars, three young people, J. A. Crafton, Abby Merchant, and Mark Reed, transformed the White House Saloon (pictured at top) into the 120-seat Prairie Playhouse (bottom) in Galesburg, Illinois, a town with a population of 25,000. After the first season, they sold the theatre to the local Drama League, which turned it into a civic enterprise to stimulate local playwriting and to perform the best modern American and European plays.*

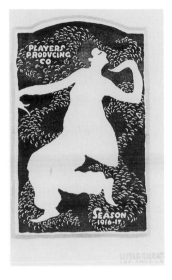

FIGURE 114. *Program for the Little Theatre of Los Angeles, 1916. Billy Rose Theatre Collection, The New York Public Library at Lincoln Center, Astor, Lenox and Tilden Foundations. Aline Barnsdall founded the Players Producing Company with a mingled professional and amateur company and opened with a tragedy,* Nju, *by the Russian Ossip Dymow. Mrs. Barnsdall commissioned Frank Lloyd Wright to design a theatre for the following season, but it was never built.*

BIBLIOGRAPHY

Arvold, Alfred G. *The Little Country Theatre.* New York: Macmillan, 1923.

Browne, Maurice. *Too Late to Lament.* London: Victor Gallancz Ltd., 1955.

Cheney, Sheldon. *The Art Theatre.* New York: Alfred A. Knopf, 1925.

Coad, Oral Sumner, and Edwin Mims, Jr. *The American Stage.* Vol. 14, *The Pageant of America.* New Haven: Yale University Press, 1929.

Deutsch, Helen, and Stella Hanau. *The Provincetown: A Story of the Theatre.* Reprint of 1931 edition. New York: Russell & Russell, 1972.

Dickinson, Thomas H. *The Insurgent Theatre.* New York: B. W. Huebsch, 1917.

Green, Harriet L. *Gilmor Brown: Portrait of a Man and an Idea.* Pasadena, Calif.: Burns Printing Co., nd.

Hewitt, Barnard. *Theatre U.S.A.* New York: McGraw-Hill, 1959.

Hughes, Glenn. *A History of the American Theatre.* New York: Samuel French, 1951.

Langner, Lawrence. *The Magic Curtain.* New York: E. P. Dutton, 1951.

"The Little Country Theatre," *Century Magazine*, July 1915.

Macgowan, Kenneth. *Footlights Across America.* New York: Harcourt, Brace, 1923.

MacKaye, Constance D. *The Little Theatre in the United States.* New York: Henry Holt, 1917.

McCleery, Albert, and Carl Glick. *Curtains Going Up.* New York: Pitman, 1939.

Perry, Clarence A. *The Work of the Little Theatres.* New York: Russell Sage Foundation, 1933.

Pollock, Channing. "Great Oaks from Little Theatres," *Green Book Magazine*, February 1917.

Shalett, Sidney M. "B. Davenport Et Cie," *New York Times*, 31 March 1940.

Sherwin, Louis. "Have You a Little Theatre in Your Town?," *Metropolitan Magazine*, March 1917.

"The Theatre That Comes to You," *The Theatre*, July 1916.

Jig Cook and Susan Glaspell

Rule Makers and Rule Breakers

ROBERT K. SARLÓS

Among characteristics considered typical of creative people—artists, scientists, thinkers —is the tendency to flout accepted standards of civilized behavior, the ambition "to go beyond established limits," the urge to rebel against and break rules.[1] The familiar conception of the avant-garde conforms to this proposition: Even without clear relevance to controversial issues, artistic experiments are usually seen as deliberate attempts to shock the public.

Margaret Anderson, fearless editor of the *Little Review*, most aptly expressed this idea for the turbulent period around World War I in America when she wrote, "Anarchism and art are in the world for exactly the same kind of reason."[2] No wonder, then, that individuals and groups of the avant-garde are often regarded with suspicion, and alternately labeled "Bohemians" (once a synonym for gypsies), or "reds" (a synonym for revolutionaries), regardless whether they are, or regard themselves as such. Frequently ignored by advocates of the art "establishment" as well as by the innovators is the fact that defenders and attackers of current artistic conventions mutually depend on interaction.

The Provincetown Players as a whole certainly fit such apellations. In its chaotic existence from inchoate beginnings during the summer of 1915 in Provincetown through convulsive cessation of public activity in MacDougal Street—adjacent to Greenwich Village's focus, Washington Square—in the spring of 1922, this avowedly amateur Little Theater flew in the face of the American theatre's commercial traditions and, in some respects, of basic creative modes Western theatre has known for over two thousand years.[3]

Why would a theatre group, the bulk of whose work was created in Manhattan, insist on calling itself Provincetown Players? The answer lies in what the painter, Marsden Hartley, called "that remarkable and never repeated summer at Provincetown," one he believed "was really huge in import, and huge in various satisfaction."[4] In that inspired, ecstatic summer of 1915 a nameless and amorphous creative collective came into being, which—reconvening after a winter's pause—by the end of the summer of 1916 became the Provincetown Players, "an organic thing like a plant growing."[5]

Legend has it that Provincetown, a sleepy fishing village with a sizable Portuguese colony on the tip of Cape Cod, was discovered and claimed on behalf of Greenwich Village's Bohemian population by the writer Mary Heaton Vorse in 1907. Gradually it became a summer resort for artists and writers outside the mainstream. That summer of 1915, so gratefully recalled by Hartley twenty years later, a group of artistic and social anarchs sought escape and healing from pervasive disillusionment with World War I on the dunes and in the gardens of Provincetown through communal drinking and talking. The loose circle that had formed around Mabel Dodge included Hutchins Hapgood, Dodge's confidant; Ida Rauh, a renegade from the Washington Square Players, with her as yet unacknowledged husband, Max Eastman, who edited the irreverent revolutionary *The Masses*; and John Reed, the poet-playboy destined for Soviet sainthood, who had been Mabel's lover but was now escorting Louise Bryant, his future wife. Reed played host to the painters

Hartley and Demuth, and to his roommate of Harvard days, the scene designer Robert Edmond Jones. There were also the Schoonmakers, primarily interested in politics, the short-story writer Wilbur Daniel Steele, the Zorachs (he a painter, she a tapestry maker), and other seers and thinkers.

Whether talk turned to the war, love and marriage, or psychology, suspicion and bitterness were the divisive common denominators. But the deeper into despair they drank and debated themselves, the more clearly an antidote to the world's poison seemed within their reach: they had to create together and for each other. Coalescing around the Commercial Street home of the short-story writer Susan Glaspell and her husband George Cram Cook, a novelist and former professor of Greek, this group of rebels channelled a multitude of personal and social frustrations into group expression through near-spontaneous theatrical performance. Cook, whom everybody called by his boyhood nickname, Jig, and who had more unfulfilled dreams than the rest, played the crucial role of catalyst. He, more than anyone else, held the group together from the beginning. His belief in Dionysian spontaneous group creativity and his flair for inspiring others' artistic creativity seem to have been the essential factors. United by their disenchantment, and nourished by such diverse sources as Plato's *Republic* and Thoreau's "Civil Disobedience," the ideas of Marx and Veblen, Freud and Nietzsche, Maria Montessori and the communitarian movement—this intensely creative group moved toward a communal writing and staging of plays. By September 1916, the collective moved to New York and established itself as the Provincetown Players (also known as The Playwrights' Theatre).

Most significant movements in theatre history are attempts at rebellion, reform, or innovation, and most individuals who initiate such attempts to do so on grounds of their expertise in the field. The Provincetown Players, however, based their own rebellious efforts on a proud confession of ignorance and consequent defiance of theatrical tradition. A most unusual organization, it stood for theatre as collective creativity in which the person temporarily functioning as playwright served as a first among equals. This group of dedicated amateurs expected and required its active members to be by turn playwrights, actors, designers, stagehands, playreaders, and business managers; and proposed to have the member whose script was about to be staged in charge of production. Most plays were one-acts, three or four of which were customarily organized into "bills," thus the rotation of functions in this cooperative process was, in theory, constant. Most of these plays would never have reached the stage had not artistic considerations rather than commercial ones been paramount.

In effect, the Players combined their search for a distinctly American theatrical expression by means of artistic innovation with a thoroughly irreverent anarchist operation. Yet, not all members of the group were either conscious political leftists or dedicated artistic and social iconoclasts. Rather, they were united mainly by a desire to pursue in freedom their individual artistic expression—in front of a supportive public and yet, regardless of fiscal considerations—whether in or out of step with prevailing standards. Thus, alongside those who embodied rebellion in all aspects of creative and private life were others who worked, lived, and raised their children in harmony with values of Main Street America. Even the rebels chose different paths: some strove to offend sensibilities at every turn; others followed the pattern of still waters that run deep.

This paradox within the Provincetown Players of simultaneous straining against and complying with conformity is perhaps best exemplified by the artist couple who served as the group's ideologues and founders: Jig Cook and Susan Glaspell. Whereas Cook frequently and fervently attacked conventional thinking and working, Glaspell undermined

accepted norms subtly, often with the conse-
quence of not being recognized until much
later. In their own creative spheres, each has
been acknowledged to have made a unique
contribution: Susan is always accounted the
most significant playwright next to Eugene
O'Neill to have emerged from the Players; Jig
is recognized as undisputed prime mover of
this little theatre, embodiment and sustainer of
its spirit, as well as mainspring of its demise:
progenitor, avatar, and angel of death in one.

Glaspell's function as a solid rock in the
midst of Cook's roaring torrent has not been
sufficiently credited either in the institu-
tional history of the Provincetown Players
or in the couple's artistic collaboration (de-
spite tangible evidence of her larger and
much superior output). If Susan's share in
the group's collective creation is less well
told—because less understood—than Jig's,
that is in part due to their respective person-
alities, which largely determined their
nominal roles and manner of functioning
within the group as well as their disparate
artistic achievements.

Because of his role in its birth, and his con-
tinued behavior as general factotum, Cook
was elected president of the Players' organi-
zation when it was formalized in September
1916, in the wake of the discovery of Eugene
O'Neill and in preparation for the conse-
quent move to New York. Glaspell, on the
other hand, held no office with the group un-
til added to the executive committee four
years later. This was in part because unlike
Jig, who placed the stimulation of others'
creativity ahead of his own writing ("too
generous for his own good as artist"[6]),
Susan zealously guarded the time needed for
hers—she had been earning a living that way
for years. But she, too, loved the type of so-
cial life that was an organic part of the
Provincetown Players, whether on the Cape
or in the Village. Her creative work, too,
was stimulated by the boozy camaraderie
and, perhaps as a result of keeping Jig com-
pany, in her later years she developed both a
drinking problem and a sympathy for oth-
ers' alcohol or nicotine addiction.[7]

Glaspell did help in the management of
the theatre, especially after the move to 139
MacDougal in Greenwich Village and the in-
stallation of M. Eleanor Fitzgerald as
secretary (in effect, business manager) in
the fall of 1918.[8] With her regular and reli-
able presence on Provincetown "bills" (as
programs usually consisting of three one-act
plays, and running two long weekends, were
called) either as author or as actress,
Glaspell was to remain a mainstay of the
group. O'Neill was the only playwright who
had more scripts performed by the Prov-
incetown Players, and he took no part in
running the organization after playing an
active role in its formation, although he
spent time at the "club-rooms" (also known
as "Christine's"), above the theatre.

Susan's support—both overt and tacit—
was indispensable for Jig's chief function as
leader and perhaps his most potent artistic
"product" as well: his continuous and leg-
endary outpouring of inspirational power.
This force seems to have found three noisy
and explosive paths: tireless, gregarious, un-
inhibited and unfettered talking, drinking,
and love-making. Cook pursued these as
manifestations of the triple province of
Dionysos—intoxication, sexual rites, and
theatre: different forms of release from
routine and mortality—which he saw not as
a social safety valve, but rather as the basic
building material of a creative community.
Of talking and drinking Glaspell attempted
to make virtues; his philandering she at least
seems to have accepted.[9] Cook was also much
given to feverish and strenuous physical ac-
tivity[10] leading (perhaps like drinking and
sex) to contemplation and writing (though
infrequently to polished completion),
whereas Glaspell's finely honed writing
seems to have blossomed from an intense in-
trospection. Jig, devotee of Dionysos, was
more than matched by Susan, priestess of
Apollo.

Although most of Jig's leadership ac-
tivities resist attempts at systematic
documentation, sufficient testimony bears
out the fact as well as the effect of each

method of inspiration.[11] First, according to heard or read reminiscences, Cook was forever talking, holding forth, persuading, arguing—while twisting his gray forelock—for binding a loose gathering of creative individuals into a group that would create collectively. ("One man cannot produce drama. True drama is born only of one feeling animating all the members of a clan—a spirit shared by all and expressed by the few for the all."[12]). Second, drinking for him was the next—in practice almost inseparable—step in this spiritual activity of building a Dionysian community. As Hutchins Hapgood observed,

> it was perhaps in conversation that the creative quality of Jig's imagination was most entrancingly manifested. When [some] of us . . . were sitting with our flagon of red wine, or slowly sipped whisky, and the gentle excitement was suffused through Jig's being, then picturable ideas flowed like rippling streams from his laughing mouth. His eyes danced with the joy of ideas becoming poetic realities.[13]

Cook was contemptuous of those who "drank only with their bellies. [For] true drinking is an affair of the head and heart." And, when communal drinking—which Jig insisted was part of the group's creative function—got heavy at the MacDougal Street theatre, more than once he bid the assembled members to stop and leave the remainder of the fabled Fish House Punch to him, proclaiming, "I guarantee to intoxicate all the rest of you."[14]

Third, as a young man, Cook saw the sex act partly in spiritual terms: "What makes the slipping squeeze and clasp of luscious flesh an affair of the spirit is that one's whole being is in it. The energy we call spiritual—it is all fused and glowing there. Soul touches soul in that fierce joy—that torture of delight."[15] This early amorous sentiment had clearly grown, perhaps sublimated, into the religious urge expressed in his play *The Spring* (1921), in which the

music of water was supposed to "make it easier to reach that deep level where I am you and you are me!" and where a young professor, drinking from the spring of the Sauk Chief, Black Hawk, asks, "Does each soul connect with every other? Am I in some way one with every man?"[16]

By contrast, Susan was as private a person as Jig was public: "Her genius [was] for entering the solitudes of others while yet devoutly preserving her own."[17] Consequently, Glaspell's provision of solid support for many members of the Players (including her husband), as well as for the group as a whole, has resulted in few explicit statements. She has been described as a "mediator between the idealist and the rest of humanity"[18]—but she was an idealist herself, and more a peacemaker than a "mediator." Observers generally praise her infinite patience and kindness pouring oil over troubled waters. While Cook's personality can best be evaluated from abundant factual and anecdotal accounts, Glaspell's spirit and activity are best judged on the basis of her writing: her plays, her biography of Jig, and her letters regarding the Experimental Theatre, Inc.,[19] the Players' successor that operated on the group's former premises.

Despite their common Midwestern roots, and although both were consistent breakers of rules, the contrast between the personalities and activities of Jig and Susan could not have been more palpable. It began by their growing up with very different family backgrounds in Davenport, Iowa, "a town that had a Cook Memorial Library, the Cook Home, and a Cook Memorial Church . . . there having been no Glaspell Home for the Friendless." But if his family was part of the conformist establishment, Jig's education and career did not follow smooth or predictable paths. Having entered at fifteen what was then the State University at Iowa City and gone to Harvard as a senior, he studied in Heidelberg and Geneva. Upon returning from Europe, Cook taught at Iowa

and Stanford, during which time he got married; he also wrote and published his first novel, *Roderick Talliafero*, in 1902. Again, he chose an unconventional path. He decided to leave the university in order to "escape from over-intellectuality." He set out to combine a writing career with truck farming in Iowa—not a money-making venture, but probably a conscious attempt to emulate Thoreau. For the next several years most of his writing was done in a Farm Journal not for publication. During this time also, Jig's compulsive, energetic, and infectious public philosophizing began. In the service of a growing belief in "the oneness of all men's minds in the human mind"[20] he founded, with Floyd Dell, the Monist Society, essentially a club for nonconformists and free thinkers. There, in 1907, he met Susan. Before embarking on his second marriage, he developed an intense friendship with her that soon turned to love, and eventually into a third and final marriage in 1913. By that time he had published his second, and last, novel, *The Chasm* (1911).

Meanwhile Glaspell had graduated from high school and contributed columns to society magazines while working as a legislative reporter for the hometown paper. Then, in the 1890s, this "adventurous Davenport maiden had the *temerity* to go to college"— at Drake University in Des Moines.[21] After earning a baccalaureate, Susan returned to Davenport determined to earn her living as a full-time writer. A first novel, *The Glory of the Conquered*, was published in 1909 while she was in Europe, in order to make it easier for her "to resist all . . . temptations . . . a bright attractive girl like you [is] exposed to."[22] Before the birth of the Provincetown Players Glaspell produced two more novels, *The Visioning* (1911) and *Fidelity* (1915). She then turned her attention to the drama, but also continued to publish short stories at the rate of two to three a year until 1922.[23] After Cook's death she wrote his luminous biography, *The Road to the Temple*. Between 1928 and her death in 1948, she won the Pulitzer Prize with one play, collaborated on another

with her second husband, and saw six more novels and a children's book into print.

From his adolescence, Jig was preoccupied with the passage of time, with signs of that passage, and with the past; even the future he saw as a reclaiming of the past. That in part explains his projected Dream Cities—attempts to create a new Athens in America—and his yearning from an early age to visit Greece: "Why not be a Greek Thoreau, living with Homer and the mountains, the olives, the grapes, the fish, the shepherds, the sailors, and the sea? . . . I'll do it as soon as I can."[24] He attempted to dramatize seriously the story of Aristophanes' *Lysistrata*, which ridicules women's power and a marital sex strike as methods for ending war, in his *Athenian Women* (1918); he returned to the Sauk Indians' visions by means of automatic writing and other forms of ESP in *The Spring*. Finally, with his failed attempt to turn the Provincetown Players into a "Beloved Community of Life Givers," he made the long sought pilgrimage to Greece in 1922, where he died two years later.

Unlike Jig, Susan always looked for seeds of the future. Her pioneers in *Inheritors* (1921) demonstrate pacifism and anti-colonialism; all her dramatic protagonists (and a large majority in her fiction) are women, who often "make it" in a man's world. Even from the grave they affect survivors as in *Trifles* (1916), *Bernice* (1919), and *Alison's House* (1930). At their best or worst, which are at times inseparable, these women partake of "the battle between a life instinct and a death instinct"[25] and are intent on creating something unprecedented, as in *The Verge* (1921) and in *Alison's House*.

Turbulence and incompleteness on the one hand, finely polished, calm surface over a turbulent depth on the other, are the chief distinguishing marks of the creativity of Jig and Susan, respectively. The deceptive conclusion easily drawn is that Cook was a rebel while Glaspell stood for status quo, but nothing could be farther from the truth.

While Jig gregariously, explosively, and aggressively harangued friends and strangers about the need for returning to Plato's "Beloved Community of Life Givers" by means of collective creation, Susan came forth from periods of withdrawal with finely wrought yet profoundly disturbing works. Her short stories, though mostly of the conventional "local color" variety, are notable for "careful details and skillful characterization";[26] and her regional novels follow with great sensitivity the fates of Midwestern characters revolting against a fixed conservative order during the disintegration of the American Dream. Finally, Glaspell's striking plays—her highest achievement—satirical or serious, explore foibles and dark corners of both the social establishment and its nonconformist fringes. They are always experimental, either in theme, plot and character construction, or style and language usage, whether in the realistic or expressionistic mode. As Ludwig Lewisohn wrote in reviewing her *Plays* (1920), they invariably reflect the tension between wanting to conserve and to uproot the social order: "Behind Miss Glaspell's hardihood of thought hover the fear and self torment of the Puritan. She is a modern radical and a New England schoolteacher; she is a woman of intrepid thought and also the cramped and aproned wife on some Iowa farm. She is a composite, and that composite is intensely American."[27]

The first dramatic venture for both Cook and Glaspell was their collaboration in 1915 on a short comedy that the Washington Square Players deemed "too special," *Suppressed Desires*. Along with cleverly spoofing the burgeoning practice of home-bred psychoanalysis, they lovingly satirized the foibles of the intellectual, Bohemian milieu they were living in. A series of self-parodying scripts by various founding members followed the example. Among them, Cook's clever, yet awkwardly written *Change Your Style* suggests that although Jig was willing to laugh at pseudo-

intellectual attitudes (in this case, toward modern art), the polished dialogue was most likely Susan's contribution. This assumption is supported by her first solo one-act, *Trifles*, which was written on Jig's expressed command for the coalescing Provincetown Players. It is still considered a masterpiece by critics, and it is still popular. In it, Glaspell's precise attention to mood, milieu, plot, and character appropriate for a murder mystery is exceeded only by shrewd and subtle feminist satire. Neighbors of the housewife alleged to have killed her husband find (and ultimately conceal) the motive by sifting a series of "trifles" (culminating in a bird whose neck was broken) that escape official investigators who ridicule the ladies' concerns. But Glaspell also makes clear "that the women, too, have failed one another."[28]

Her next script, performed after the Players' move from Provincetown and during The Playwrights' Theatre's first New York season in March 1917, was *The People*, a transparent satire of the personnel and modus operandi of the radical little magazine *The Masses*. Even though the characters—as one would expect in a caricature—are none too subtle, they are still flesh and blood humans. It was in fact in this play, that Jacques Copeau was "touched to the depth of his soul" by the "simplicity of her presence" in the author's performance as the Woman from Idaho.[29] The comedy deals with the magazine in crisis: it is nearly defunct. Each editor knows the reason: there is too much of the others and not enough of him in the pages. The poet demands more poetry, the artist more pictures; Light Touch wants more frivolity, Earnest Approach thinks there is too much already. A Boy from Georgia, a Man from the Cape, and a Woman from Idaho arrive: they *are* the people, and they renew the editors' inspiration.

Close the Book, a witty social satire, was on the opening bill of the players' second New York season in November 1917. Susan based the plot on Jig's own struggles against

Midwestern conformity's bastions as represented by family and university. When Peyton Root's determination to marry a gypsy girl does not sufficiently shock his family, the two of them proceed to find derogatory "fine print" about his ancestors. The skillful dialogue renders the rebels as comical as those they rebel against.

The Outside, Glaspell's most unconventional one-act, followed on the third bill, in late December. Two hurt women, rich and eccentric Mrs. Patrick, who cannot bear signs of life, and her local servant, simple, perennially silent Allie Mayo, inhabit an abandoned lifeguard station on the Provincetown dunes (it was in reality furnished by Mabel Dodge and later occupied by O'Neill). Self-exiled from society, the initially unfriendly women are forced into contact with life when a group of men bring a victim of drowning to be rescued. Glaspell hands the life force in the person of the servant a victory over the death wish of her mistress. It is a compellingly constructed script that uses the setting as well as the actors in symbolic ways. On account of its nonlinear plot, archetypal characters, and spare dialogue, it has been called a forerunner of Camus's and Beckett's absurdist plays.[30]

In *Woman's Honor*, on the seventh and last bill of the season, Susan returned to satirizing both conventional morality and the nonconformist poseur. In order not to compromise the honor of the woman with whom he spent the night in question, a young man accused of murder is unwilling to use the tryst as alibi. After numerous women come forward to volunteer that very exculpation, the Prisoner pleads guilty in disgust.

The following season (1918–1919) saw Glaspell's second, and last, cowritten one-act comedy with Cook. *Tickless Time* treats Jig's obsession with the passage of time. Thinly disguised as Ian Joyce, he wants to banish, and therefore buries, all artificial time keepers in favor of true time, as indicated by the sun. But discovery that the sundial does not account for all of the sun's

variations reveals perfection in keeping true time, and thus in the pursuit of all absolute truth, as illusory.

Bernice, Susan's first long play followed in March 1919.[31] With a skillful Ibsenesque structure that has been deservedly praised, it accomplished a coup de théâtre she had employed on a smaller scale in *Trifles*. The action revolves around, and all characters are revealed through their relationship to, a heroine dead before the action commences. As in *The Outside*, Glaspell again affirms the redemptive value of the life force, but here it is the structure imposed by the departed woman on her own death that provides the surviving, and formerly unworthy, husband with a new lease on life.

Glaspell's next full-length play, *Inheritors*, came near the end of the fourth (1919–1920) season, that catapulted the Provincetown Players to fame with O'Neill's *The Emperor Jones*. Seen especially in that context, *Inheritors* is clearly not a dramatically innovative play. Its daring resides rather in a provocative confrontation of old and new values that results in the destruction of the American Dream. Through a plotline that spans three Midwestern generations, the script traces the process in which "the pursuit of wealth has replaced the pursuit of ideals."[32] This involves such diverse issues as the pioneers' treatment of Indian tribes, the political inheritence of Hungarian refugees from the 1848 War of Independence, racism and free speech in regard to Hindu students championing an independent India, and conscientious objectors protesting World War I. The play avoids the awkward use of "complex symbolism of the kind that had made Cook's *The Spring*, which treated the same theme [earlier in the same season], confused and turgid." Despite its conventional structure, in a good performance *Inheritors* can and did lead to "a compelling, disturbing dramatic experience."[33]

No play of Susan Glaspell's justified better Isaac Goldberg's early recognition that she "leans toward the rebellious woman"

and is "largely the playwright of woman's selfhood"[34] than *The Verge*, performed as the first bill of the Provincetown Players' final, 1921–1922, season. It is her strongest rule breaking, and her most overt treatment of the feminist theme. She not only extracts women's liberation from encrusted social shackles, but she also explores the dangers in making that position (and by implication, any radicalism) absolute. It is also Glaspell's most innovative script, with its jarring use of language that often seems to belong to the human potential movement of the 1960s, and by its extreme demands on the scene designer and on the leading actress.

Claire, the heroine, wants to break with patterned existence and achieve "integrity in otherness" both in her experimental greenhouse—the set was used here as a striking visual symbol—that is dedicated to producing plants that are not better or prettier, but radically different from previous ones, and in her personal life. Surrounded by men named Tom (lover), Dick (friend), and Harry (husband), she finds little support for, and less understanding of, her endeavor. She retreats alternately to the greenhouse and to a twisted tower, "like some masonry that hasn't been." When the laboriously bred "Edge Vine," although it seems to "go outside what it was," fails to reproduce, Claire brutally uproots it. She is equally ruthless with her disowned daughter, Elisabeth, whom she sees as an automaton of social conformity. Another experimental plant, "Breath of Life," shows itself capable of reproduction, and Tom Edgeworthy (yes, the symbolic names *are* too much) of spiritual companionship. He finally understands that Claire's experiments are seeking "a door on the far side of destruction." But even the possibility of Tom's support threatens to suffocate Claire. Afraid she will stop creating new life by enjoying what she has, in a final embrace she strangles her lover, then almost madly whispers, "Nearer, Nearer—my *God*. To Thee, Nearer—to Thee," as the curtain falls.

Contemporaries as well as recent critics have showed both bewilderment toward and appreciation of the play, seeing it as an imperfect but remarkable work of art.[35] Even though Glaspell had not ended her playwriting with *The Verge*, she never surpassed its achievement. Her next effort, *Chains of Dew*, a full-length comedy, remains deservedly unpublished. The action revolves around a Midwestern couple, Seymour and Diantha (Dotty) Standish. A bank director and a vestryman, he eases the burden of respectability by leading a secret life as a romantic poet. On regular excursions to New York, Seymour hobnobs with radical literati, who decide to liberate him from Midwestern bondage. But when Dotty shows herself capable of intelligent life, and wishes to bring her husband's hidden aspirations into the open, Seymour is unable to cope. He needs to have two worlds apart, so he can always yearn for the distant one. Although the theme of Susan's last Provincetown play is worthy, the craftsmanship is creaky and her usual polished wit conspicuously absent.

After Jig Cook's Delphi funeral, culminating in the removal of a stone from Apollo's temple to mark his grave, Glaspell returned from her two-year sojourn in Greece and wrote her husband's poetic biography, *The Road to the Temple*, basing it in large part on his Farm Journal, other unpublished manuscripts, notes, and letters sent and unsent. She remarried, wrote *The Comic Artist* (1928) with Norman Matson, her second husband; and *Alison's House* (1930), the Pulitzer Prize–winning play about Emily Dickinson's legacy of private embarrassment and public treasure. Although its theme continues Susan's steadfast concern with uncompromising truthfulness to one's personal integrity, it is not as successful in structure or in dialogue as some of her earlier work, nor is it as experimental. More than *Alison's House*, her 1921 script, *The Verge*, deserved the prize.

In the prime of her theatrical creativity

(1917–1921), Susan Glaspell was often regarded by critics as O'Neill's equal. But after O'Neill's conquest of Broadway both her reputation and Jig's languished for decades. It is time they both received recognition as potent but different forces in the reshaping of American theatre. The women's movement has helped rediscover the lasting values of Glaspell's dramatic writing—proof perhaps that the milder and steadier sort of rule breaking is in the long run more effective. Jig's inspiring craziness is increasingly acknowledged in the process of reappraising Susan. Yet, to judge by its performance history, *The Verge* is still ahead—of *our* time, too.

NOTES

1. Anne C. Roark paraphrases an unnamed researcher, in "The Secrets of Creativity," *San Francisco Chronicle Examiner, This World* (12 November 1989) :12 (earlier published in the *Los Angeles Times*). In her general, and popular, survey of current theories of creativity, she summarizes and cites artists and such scholars as Frank Barron, Mihály Csíkszentmihályi, Nancy C. Andreasen, and Kay Redfield Jameson. For his part, Frank Barron, *Creativity and Personal Freedom* (Princeton, Van Nostrand, 1968), considers it a "mark of greater [mental] health to be unruly" (4), and expands the claim to the point that "rebellion . . . is very often the mark of a healthy character" (144).

2. "Art and Anarchism," *Little Review* (March 1916) :3.

3. See my *Jig Cook and the Provincetown Players: Theatre in Ferment* (Amherst : University of Massachusetts Press, 1982).

4. Marsden Hartley, "Farewell, Charles," in Alfred Kreymborg et al., eds., *The New Caravan* (New York : Macaulay, 1936), 556–557.

5. Mary Heaton Vorse, *Footnote to Folly* (New York, Farrar and Reinhart, 1935), 129.

6. Susan Glaspell, *The Road to the Temple* (London : Ernest Benn, 1926), vi.

7. Marcia Noe, *Susan Glaspell; Voice from the Heartland* (Macomb, Ill. : Western Illinois University, 1983), 70–74.

8. A characteristically paradoxical move for the Provincetown Players. On the one hand, the change of headquarters was financed by the philanthropist banker Otto Kahn, and on the other, "Fitzi," as she was called, had been a close associate of the anarchist leaders Emma Goldman and Alexander Berkman.

9. All erstwhile Provincetown Players I interviewed or corresponded with, except Ida Rauh, mentioned or hinted at a strongly suspected affair between Cook and Rauh, who was also Glaspell's rival for the distinction of the group's best actress. It has been suggested that the "sabbatical" the Cooks took from the theatre during the 1919–1920 season was caused as much by Susan's jealousy as the need for both of them to get some writing done. Others mentioned as Jig's sometime lovers were Louise Bryant, Edna St. Vincent Millay, and Eunice Tietjens.

10. The best-known public manifestation of this was surely his building of a plaster cyclorama (the famous "Dome") for *The Emperor Jones*; and of private ones, his construction of an elevator for Susan, when she developed heart trouble, in their Provincetown home. For the former, see Sarlós, *Jig Cook*, 124–128, and 204–206; for the latter, Glaspell, *Road*, 177–178.

11. For a detailed discussion of Cook's inspirational leadership, based on published and unpublished accounts, both laudatory and pejorative, see Sarlós, *Jig Cook*, 50–54.

12. Quoted in Glaspell, *Road*, 194.

13. Hutchins Hapgood, *A Victorian in the Modern World* (New York : Harcourt, Brace, 1939), 374–375.

14. Quoted in Glaspell, *Road*, 92 and 204. For the origin and recipe of Fish House (or Provincetown) Punch, see Sarlós, *Jig Cook*, 79–80.

15. Cook's letter to Mollie Price, 23 August 1906, cited in Robert E. Humphrey, *Children of Fantasy: The First Rebels of Greenwich Village* (New York: Wiley, 1978), 98.

16. Quoted in Glaspell, *Road*, 228.

17. Letter from Nilla Cram Cook, 10 February 1976, cited in Noe, *Susan Glaspell*, 10.

18. John Chamberlain, "A Tragic-Comedy of Idealism," *New York Times* (12 April 1931) : 4, cited in Arthur E. Waterman, *Susan Glaspell* (New York: Twayne, 1966), 103.

19. Headed by O'Neill, Robert Edmond Jones, and Kenneth Macgowan, the group was informally known as the Triumvirate. It became increasingly clear that in arguing for a more businesslike operation as well as for more professional artistic direction, O'Neill and his various associates, chief among whom was Macgowan, were in fact trying to distance themselves both from Jig Cook's person and his style of running The Playwrights' Theatre. (Edna Kenton's voluminous reports to Greece regarding dissolution of the Players and formation of the Triumvirate are uniquely informative about the roles played by Susan and Jig as well as other active participants.)

20. Glaspell, *Road*, 10, 92, 227.

21. Elizabeth McCullough Bray, "Panorama of Cultural Development Here in Last Half a Century," *Davenport Democrat* (31 March 1929) : 4, cited in Noe, *Susan Glaspell*, 15. My emphasis.

22. Letter from her mother to Susan, cited in Noe, *Susan Glaspell*, 25.

23. Waterman, *Susan Glaspell*, 21–22.

24. Glaspell, *Road*, Cook cited in Humphrey, *Children*, 87.

25. C.W.E. Bigsby, ed., *Plays by Susan Glaspell* (Cambridge: Cambridge University Press, 1987), "Introduction," 11.

26. Waterman, *Susan Glaspell*, 22.

27. Ludwig Lewisohn, *Nation* (3 November 1920) : 509–510.

28. Bigsby, *Plays*, 11.

29. Jacques Copeau, *Registres, I: Appels*, ed. Marie-Hélène Dasté and Suzanne Maistre Saint-Denis (Paris: Gallimard, 1972), 146, cited in Sarlós, *Jig Cook*, 73.

30. Bigsby, *Plays*, 14.

31. It was not the first long play done by the Players, having been preceded by Cook's *The Athenian Women* a year earlier. The evening was "filled" by the use of John Reed's agitprop fantasy about the Versailles Peace Treaty as a curtain raiser.

32. Bigsby, *Plays*, 18.

33. Waterman, *Susan Glaspell*, 78.

34. Isaac Goldberg, *The Drama of Transition* (Cincinnati: Stuart Kidd, 1922), 474.

35. Alexander Woollcott, *New York Times* (15 November 1921) :23; Percy Hammond, *New York Tribune* (15 November 1921) :8; Ludwig Lewisohn, *Nation* 14 (December 1921) :708–709; Bigsby, *Plays*, 25.

Family
Album

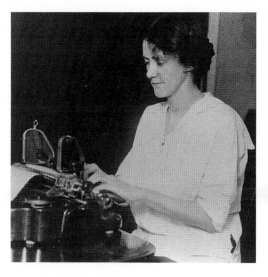

FIGURE 115. *Susan Glaspell. Henry Ward and Albert A. Berg Collection, The New York Public Library, Astor, Lenox and Tilden Foundations.*

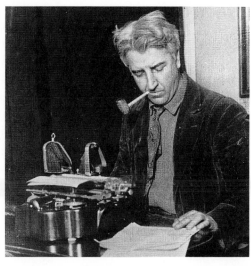

FIGURE 116. *George Cram (Jig) Cook. Henry Ward and Albert A. Berg Collection, The New York Public Library, Astor, Lenox and Tilden Foundations.*

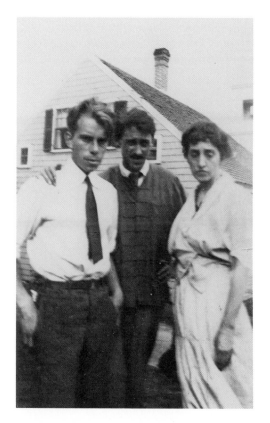

FIGURE 117. *Stuart Davis, Charles Demuth, and Susan Glaspell in the yard of the Cook-Glaspell house, Provincetown, 1915. Courtesy Earl Davis.*

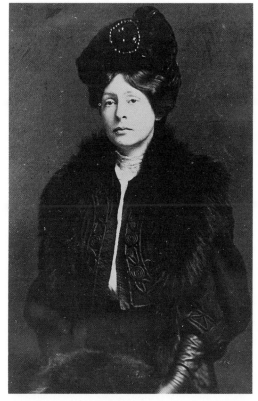

FIGURE 118. *Neith Boyce as a working journalist for the newspaper* The Commercial Advertiser. *Courtesy Miriam Hapgod DeWitt.*

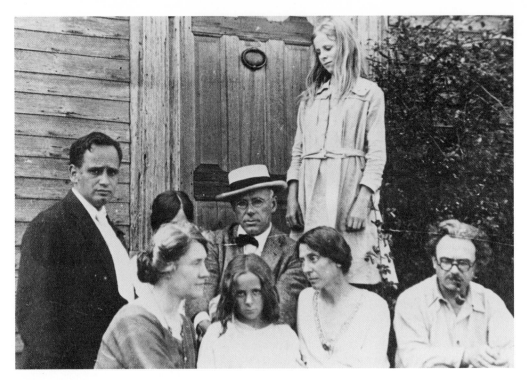

FIGURE 119. *Front row, left to right: Susan Glaspell, Beatrix (Trixie) Hapgood, Mary Heaton Vorse, Hippolyte Havel. Back row, left to right: Harry Weinberger, Neith Boyce (face hidden), Hutchins Hapgood, Miriam Hapgood (standing). Courtesy Miriam Hapgood DeWitt.*

FIGURE 120. *Joe O'Brien, a labor journalist married to Mary Heaton Vorse. Courtesy Joel O'Brien.*

FIGURE 121. *Mary Heaton Vorse. Courtesy Joel O'Brien.*

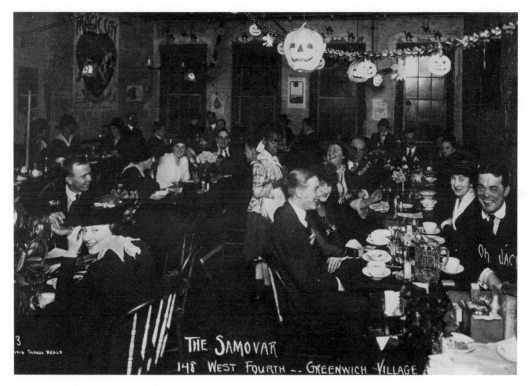

FIGURE 122. *John Reed (right foreground) at the Samovar, an eatery in Greenwich Village. Photo by Jessie Tarbox Beals, Museum of the City of New York.*

FIGURE 123. *John Reed visiting Mabel Dodge in Provincetown. The man at left is believed to be Robert E. Rogers, a Harvard classmate of Reed's. John Reed Collection, Houghton Library, Harvard University.*

FIGURE 124. *Max Eastman. From the archives of Mrs. Max Eastman, courtesy of Yvette Eastman.*

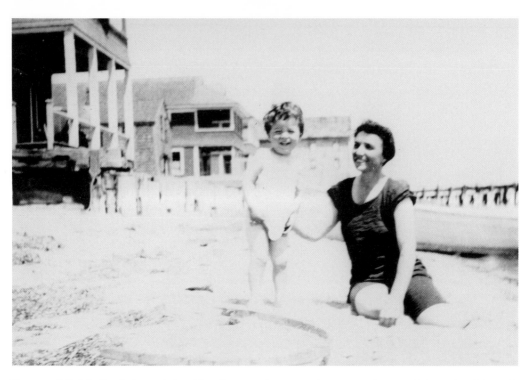

FIGURE 125. *Ida Rauh (married to Max Eastman), actress, lawyer, sculptor, with son Daniel on the beach at Provincetown. From the archives of Mrs. Max Eastman, courtesy of Yvette Eastman.*

FIGURE 126. *Wilbur Daniel Steele, author of* Contemporaries, *on the dunes in Provincetown. Courtesy Peter Steele.*

FIGURE 127. *Andrew Dasburg visiting Mabel Dodge and John Reed in Provincetown. Andrew Dasburg Papers, Archives of American Art, Smithsonian Institution.*

FIGURE 128. *John Reed. Culver Pictures.*

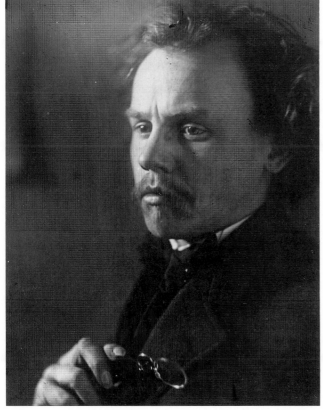

FIGURE 129. *B.J.O. Nordfeldt. Nordfeldt Papers, Archives of American Art, Smithsonian Institution.*

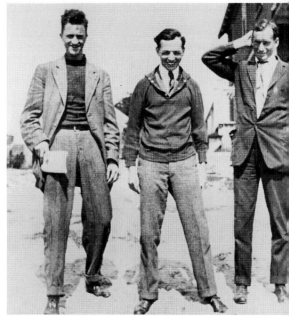

FIGURE 131. *Left to right: Kenneth Russell Chamberlain, Maurice Becker, and poet Harry Kemp, Provincetown, ca. 1916. From the archives of Mrs. Max Eastman, courtesy of Yvette Eastman.*

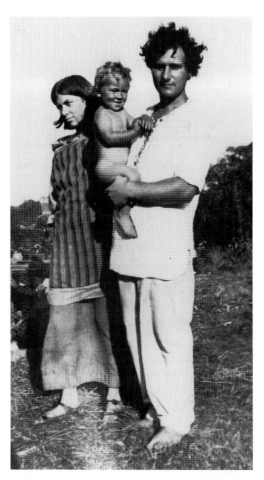

FIGURE 130. *Marguerite Zorach and William Zorach holding their son, Tessim, Provincetown, 1916. Courtesy Tessim Zorach.*

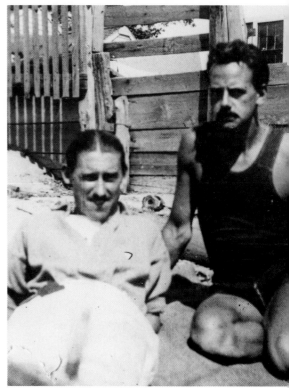

FIGURE 132. *Charles Demuth and Eugene O'Neill in Provincetown, 1916. The Whitney Museum of American Art Archives, courtesy of Mr. Louis Sheaffer.*

The First Provincetown Plays

From the program notes for "Beginnings," produced by the Provincetown Playhouse and performed at the Provincetown Art Association, September 1983

MIRIAM HAPGOOD DEWITT

Great change has overtaken this country and this town since the plays you are to see tonight were first produced. Sixty-eight years ago, Provincetown was a quiet fishing village. The few summer people were mostly artists and writers who chose this as a beautiful and inexpensive place to carry on their work. It was comparatively isolated then— the journey from New York by boat and train took nearly twenty-four hours—yet the winds of change were shaping the future here as elsewhere, as the far-reaching revolutions of the twentieth century swept the country. Among them were the modern movement in painting, realism in theater, the feminist movement, and the scientific probing of the human psyche.

The Provincetown Players are justly famous because they created the sympathetic atmosphere that gave O'Neill his start in 1916. But not only were the lesser plays of 1915 a setting of the stage for the great dramatist; in themselves they carried the seeds of the future. They were beginnings in many senses of the word and for that reason they are relevant today. The title "Beginnings" for this production refers not only to the past, but, I hope, to the future and to the building of a new theatre here where a new era began.

LOIS RUDNICK AND ADELE HELLER

Constancy was based partly on Neith Boyce's struggles to come to terms with the issue of free love within her own marriage and partly on the love affair that her friend Mabel Dodge was having with John Reed. Dodge and Reed became lovers in 1913, shortly after they worked together on the Paterson Strike Pageant. Before becoming lovers, they worked together as equal partners. Once they became lovers, Mabel succumbed to the age-old dependency of women whose worlds revolve around their men's. Because of Mabel's incessant demands for constancy, and his refusal to meet them, she and John separated frequently. The first time that he left her, she took an overdose of veronal, an incident referred to obliquely in Boyce's play. Other aspects of their affair are treated more openly in the play.

When World War I broke out, Reed was in Paris, where he fell in love with a mutual friend of his and Mabel's. Reed convinced her to leave her husband in order to marry him. Two months later, Reed fell out of love with her. In January 1915, he returned to the United States, with two gold wedding rings in his pocket and the expectation that Mabel Dodge would be waiting faithfully for him in the wings. Dodge rejected his proposal, changed her mind, but then, in July 1915, she asked Hutchins Hapgood to return Reed's ring and write him that she would not marry him. In the same month, Neith's play was produced, a fascinating example of how the web of life and art, the personal and the political, intertwined in the lives of this remarkable generation.

The "Weiniger" whom Rex (Reed) quotes during the play is Otto Weininger, a German

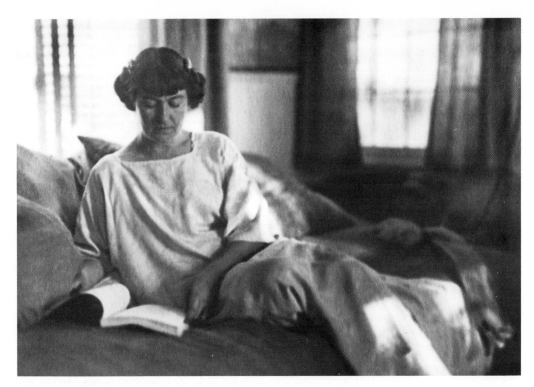

FIGURE 133. *Mabel Dodge at Finney Farm, Croton-on-Hudson, c. 1915. Yale Collection of American Letters, Beinecke Rare Book and Manuscript Library, Yale University.* (Constancy)

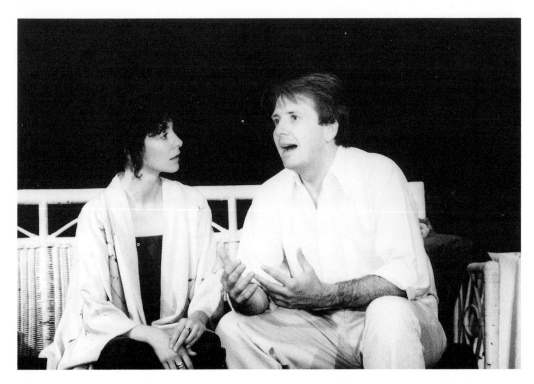

FIGURE 134. *Mary Woods in the role of Moira and Michael Rothaar in the role of Rex in* Constancy, *produced by Provincetown Playhouse at the Wharf during the conference "Beginnings: The Cultural Moment, 1915," Provincetown, 1987. Photo by Daniel Heller.*

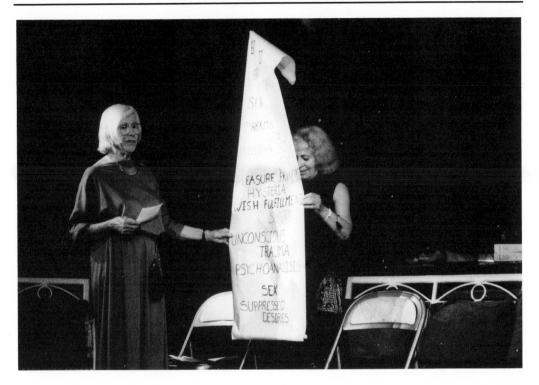

FIGURE 135. *Miriam Hapgood DeWitt (left) with a replica of the scroll she made at age eleven, which she asked people to read and sign if they believed in psychoanalysis. Beatrix Hapgood Faust on the right. At the conference "Beginnings," Provincetown, 1987. Photo by Daniel Heller.* (Suppressed Desires)

FIGURE 136. *Cornelia Barns, "Psycho-analysts,"* The Masses *9 (October 1917). Tamiment Institute Library, New York University.* (Suppressed Desires)

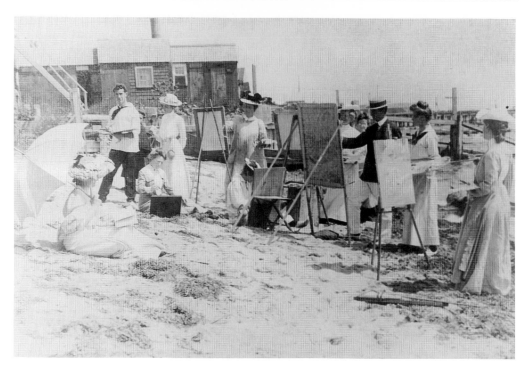

FIGURE 137. *Charles Hawthorne's art class on the beach. Provincetown, 1915. Provincetown Art Association and Museum.* (Change Your Style)

FIGURE 138. *Mabel Dodge, date unknown. Dodge's attire here is very similar to Myrtle Dart's in* Change Your Style. *Yale Collection of American Letters, Beinecke Rare Book and Manuscript Library, Yale University.*

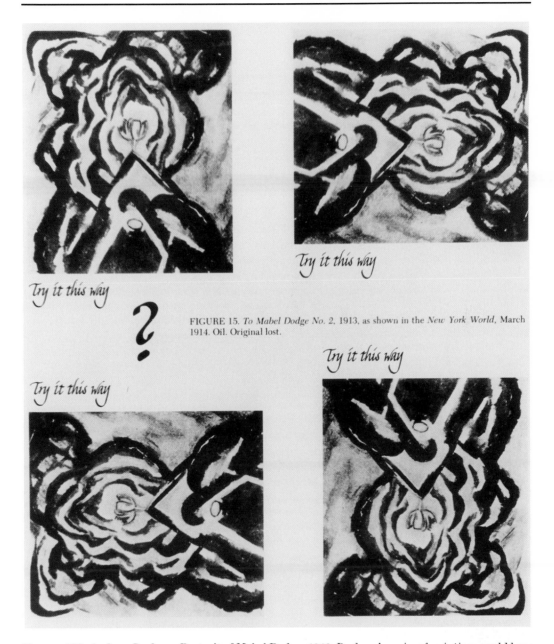

Try it this way

Try it this way

?

FIGURE 15. *To Mabel Dodge No. 2*, 1913, as shown in the *New York World*, March 1914. Oil. Original lost.

Try it this way

Try it this way

FIGURE 139. *Andrew Dasburg*, Portrait of Mabel Dodge, *1913*. *Dasburg's series of paintings could have been a model for the abstract work purchased by Myrtle Dart. Mabel Dodge Luhan Collection, Beinecke Rare Book and Manuscript Collection, Yale University.* (Change Your Style)

psychologist who wrote a profoundly misogynistic book called *Sex and Character* (1908).

Suppressed Desires is a satire on the intelligentsia's obsession with psychoanalysis. The character of Henrietta, the arch-Freudian, is not based on a particular Greenwich Village person; she is rather an exaggerated type of the Village intellectual who yearns to "psych" anyone and everyone in sight. Henrietta takes to a literal—and hilarious—

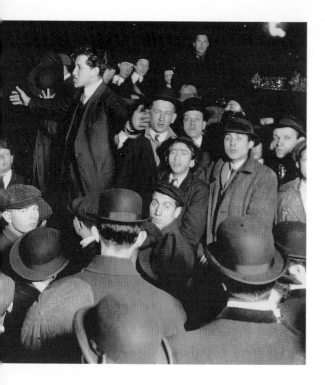

FIGURE 140. *Frank Tannenbaum addresses a crowd of unemployed strikers in Union Square, New York City, 1913. UPI Newsphotos/Bettman Archives.* (Contemporaries)

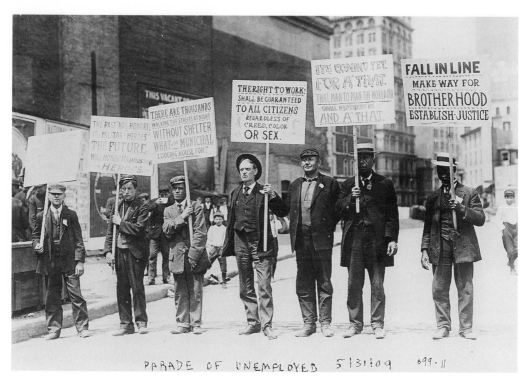

FIGURE 141. *Parade of the unemployed, 31 May 1909. Library of Congress.* (Contemporaries)

extreme the triumvirate of Freudian ideas that were of greatest interest in the Village: the interpretation of dreams, hidden motives, and unconscious desires. In her "Reminiscences" during the Provincetown conference, Miriam DeWitt recalled that Freudianism had even penetrated the consciousness of the children of the Villagers. To the audience's delight, she unrolled a long scroll of paper on stage that was filled with "psych" lingo (see fig. 135) and then described how at about age eleven, she and Nilla Cook, the daughter of Jig, would walk up and down Main Street in Provincetown reading off the "forbidden" words for anyone who was willing to listen.

Change Your Style is a comic study of the battle between traditional and modern art. Kenyon Crabtree, the traditional artist with whom the young hero of the play is supposed to be studying art, is based on two figures of the time. One, Kenyon Cox, was a strident critic of Postimpressionist art; the other, Charles Hawthorne, was the head of a well-established academic art school in Provincetown who trained students in traditional landscape painting. Bordfeldt, the rebel artist with whom our hero is studying on the sly, is a thinly veiled disguise for Bror Nordfeldt, a leading American Postimpressionist painter who, in fact, played Bordfeldt in the first production of the play. Myrtle Dart's character is probably based on Mabel Dodge, a patron of modern art who was involved in the Armory Show. The abstract painting that Myrtle purchases in the play could very well be based on one of a series of portraits that Andrew Dasburg had done of Mabel Dodge that were exhibited in 1914. The paintings were printed in the *New York World*, 8 February 1914 (see fig. 139) with the accompanying commentary: "In her presence [Dasburg] seems to feel like a torso stripped of skin and palpitating in roast beef flavors of deep red and shining white; away from her his thrill collapses and the torso is jammed, twisted and flattened as if a motor car had run over it. . . . In one of the sequences, witness the unfolding of the torso and the exposure of the artist's heart in blossom as a tulip, with an amethyst shining in place of the navel."

With the encouragement of Mabel Dodge, Alfred Stieglitz planned to devote an issue of his magazine *Camera Work* to a comparison of the art of the insane with the art of the Modernists. When Dodge asked for entree into Bellevue Hospital, the head psychiatrist told her that he thought the "artists themselves" should "apply for admission to the psychopathic ward: that the exhibition at the Armory was the best evidence of mental derangement flaunted in public he had ever seen" (Luhan, *Movers and Shakers.* p. 73).

Contemporaries is the most serious and the most daring, both politically and theatrically, of the first series of plays. It is also, sadly, the most relevant to our times. Inspired by the plight of men who were homeless and out of work in New York City during the winter of 1914, it is set in biblical times, in order to reinforce the parallel between Jesus as a rebel leader, who spoke out against the Pharisees of the church in his day, and Frank Tannenbaum, a young IWW organizer, who led a group of homeless men into the shelter of a church. The priest called the police, who threw them out and arrested Tannenbaum, whose trial became a cause célèbre. He was convicted of disturbing the peace and sentenced to a year in prison. As Wilbur Daniel Steele's son Peter explained in notes he wrote for the Provincetown production, "The play is an allegory. It is not evident at the beginning where the action takes place nor the time." It was originally produced in very dim light, so that the setting in Jerusalem is not clear until the coming of sunrise at the play's end. Up until then, the impression that is given from the dialogue is that the play is set in an urban ghetto. (For more information on Tannenbaum's action and the subsequent trial and publicity, see Luhan, *Movers and Shakers,* pp. 96–116.)

CONSTANCY

A DIALOGUE

by Neith Boyce

CHARACTERS

MOIRA

REX

A room, luxurious and gay, in delicate, bright colors. Long arched windows at the back open on a balcony flooded with moonlight, overlooking the sea. In the center of the room a long sofa piled with bright cushions.

Moira, sitting at a desk under a shaded lamp, writing busily. She is dressed in a robe of brocade with straight lines, brilliant in color.

A whistle sounds under the balcony. She looks up, glances at a tiny clock on the desk, which delicately chimes twelve, smiles and finishes her phrase. A second whistle, prolonged. She rises and goes out on the balcony, leans over the rail.

REX (*Off*): Moira.

MOIRA: Rex. There you are. Come 'round, the door is open.

REX: The door. The door. Oh, very well . . .

(Moira comes back into room, laughing softly. She glances into mirror, touching the circlet around her temples, takes cigarette, lights it, stands leaning against end of couch, looking R.

Enter Rex in cape and soft hat which he drops on floor as Moira lazily takes two steps to meet him, with both hands held out.)

MOIRA: Well. Well. Here you are.

REX (*Quickly*): Yes. I've come back.

MOIRA (*Lazily*): You have come back. How well you're looking.

REX: I'm not well. I'm confoundedly ill. I'm a wreck.

MOIRA: Oh, no. Come here, let me look at you. (*Draws him nearer lamp*) Well, you're a little thinner, but it's becoming. And you do look tired. But then you've had a long journey. Come, sit down and make yourself comfortable.

(She drops onto couch and draws him down.)

REX: Comfortable.

MOIRA: Yes; why not? (*Tosses cushion behind his head.*) There. Will you have something to eat? A drink?

REX (*Darkly*): No, Moira.

MOIRA: Have a cigarette. I think I've some of your kind left. Look over there.

REX: Oh, never mind. (*He is gazing intently at her; mutters*) I don't care what kind.

MOIRA: You don't care. And I've kept them all this time. Well then, have one of mine.

(She leans to take one from desk, offers it to him; he lights it absently, looking at her steadily as though perplexed.)

REX: Thanks. Moira, I must say you look well.

MOIRA: Yes, I am—very well.

REX: And—happy?

MOIRA: Oh, very busy, and—yes, pretty happy, I should say.

REX (*Gloomily*): I'm very glad.

(She smokes luxuriously, looking at him. He smokes nervously, looking at her.)

MOIRA: And now tell me all about yourself, my dear. It seems ages since you went away and yet it's only four months . . . but such a lot of things have happened.

REX: Yes. A lot indeed. (*Abruptly*) I wrote you.

MOIRA: Oh yes, but letters . . . There's a lot one doesn't say in letters.

REX: Yes, there is. (*Gets up, strides to railing, hurls cigarette out, comes back and stands back of couch.*) Moira, the last thing on earth I expected was that you should receive me like this.

MOIRA: But why, Rex. How did you expect me to receive you? With a dagger in one hand and a bottle of poison in the other?

REX: Well, I don't know. But (*bitterly*) I didn't expect this.

MOIRA: But what is this?

REX: You know well enough. You treat me as though I were an ordinary acquaintance, just dropped in for a chat.

MOIRA: Oh, no, no. A dear friend, Rex . . . Always dear to me.

(*She leans over languidly, drops cigarette in tray, takes gray knitting from desk and knits.*)

REX: Friend. (*Walks away to window*) When we parted four months ago we weren't friends. We were lovers.

MOIRA: (*Sweetly*): Yes, but you know a lot of things have happened since then.

(*She knits with attention.*)

REX: Well . . . (*Stops for a moment then turns toward her with indignation*) Well, even if things have happened. I don't see how you can have changed so completely.

MOIRA (*Counting stitches*): One, two, three . . . Well, my dear Rex, you've change a good deal yourself.

REX (*Vehemently coming back.*): I have not changed.

MOIRA (*Dropping her knitting and looking around at him.*): Well . . . Really . . .

REX (*Hotly*): Of course I know what you mean. Perhaps its natural enough for you to think so.—

MOIRA (*Coolly*): Yes, I should think it was.

REX: And yet I did think you were intelligent enough to understand. But even if I had changed as completely as you thought, I still don't understand why—why you are like this.

MOIRA: This again. (*Puts up hand to him*) My dear Rex, I'm awfully glad to see you again. Do come, sit down and let us talk about everything.

REX (*Dolefully*): Glad to see me. (*He sits at end of sofa*) I didn't think you'd let me in the door.

MOIRA: You didn't? (*Springs up suddenly, drops knitting.*) Rex, you didn't expect to come by the ladder, did you?

REX: Well, no—

MOIRA: I believe you did. This romantic hour, your boat, your whistle—just the same—I know you looked for the ladder.

REX: No, no, I didn't. I tell you I didn't think you'd see me at all. But what have you done with it, Moira?

MOIRA: The ladder? (*Walks across to table, opens drawer, drags out rope ladder, comes back to couch.*) Here it is.

REX: So—you've kept it.

MOIRA: Yes—as a remembrance.

REX: Only that?

MOIRA: Absolutely. If you like I'll give it to you now.

REX: To me.

MOIRA: Yes. You might find use for it some time.

REX: Moira.

MOIRA (*Laughing*): Well, you know, my dear Rex, you are incurably romantic—and then, you're still young. As for me, my days of romance are over.

REX (*Leaning towards her, violently*): I don't believe it. I believe you love some one else. I've

believed it ever since your telegram to me. Otherwise you couldn't have behaved so—so—

MOIRA: So well?

REX: If you call it that.

MOIRA: I do, of course. I think I behaved admirably. But you're wrong about the reason. I don't love anyone else and I don't intend to. I've done with all that.

REX (*Softened, taking her hand.*): No, Moira.

MOIRA: Yes, indeed. (*Sits up, drawing her hand away, more coolly.*) As to my telegram, what else could I do? You had fallen in love with Ellen. You telegraphed me, "Let us part friends"—

REX: But, Moira—

MOIRA (*Quickly*): Then came your letter telling me that you and Ellen loved one another; that this was the real love at last; that you felt you never had loved me—

REX: Yes, but Moira—

MOIRA: You reminded me how unhappy you and I had been together—how we had quarrelled—how we had hurt one another—

REX: Yes, yes, I know, but listen—

MOIRA: And then you begged me to forgive you for leaving me—so—I did forgive you. What else could I do? I couldn't hold on to you when you loved and wanted to marry another woman.

REX: Moira, if you won't listen to a word from me, how can I explain to you?

MOIRA: Why, Rex, I'll listen to you all night if you like . . . but I don't see that you have anything to explain.

REX: Well, I have, though. You've got an entirely wrong idea of this business . . .

MOIRA: I don't see that. Your letters were quite explicit. You were tired of me—

REX: I was not.

MOIRA: You fell in love with another woman, younger, more beautiful—

REX: Moira—

MOIRA: That's all natural enough. I know what men are. They're restless, changeable. You wanted to marry this one—just as—

REX: I didn't want to marry her.

MOIRA: You didn't? You wrote me—

REX: Well, perhaps I did, or thought I did, just then . . . But really it was she that wanted to marry me.

MOIRA: Oh, Rex, you wrote me—

REX: Oh, I admit I was in love with her. Yes, I was, for a while and I was willing to do anything she wanted, then.

MOIRA: Well, then.

REX: But, Moira, what I can't understand is your giving me up like that—like a shot, without a struggle.

MOIRA: But, my dear Rex, what else—

REX: When I think what you were last year. What scenes you made if I even looked at another woman. How you threatened to kill yourself when I had just a casual adventure.

MOIRA: Yes—that's true—I did.

REX: Well, what can I think now except that you have absolutely ceased to love me.

MOIRA: But, my dear Rex, did you want me to go on loving you when you had left me for another woman?

REX: I never left you.

MOIRA: Oh.

REX (*Hastily*): But, anyhow, it isn't a question of what I wanted. It's a question of fact. You stopped loving me. The real truth is you never never loved me.

MOIRA : Oh, yes, I did, Rex.

REX : No, else you couldn't have stopped. It's true; it's true. "Love is not love that alters when it alteration finds or bends with the remover to remove."

MOIRA : Oh, my dear Rex, you are really wonderful. How about you? You stopped loving me.

REX : I never stopped loving you.

MOIRA : Oh, heavens. You wrote me that you never had loved me.

REX : Never mind what I wrote. I was in a very excited frame of mind—and wrote a lot of things I didn't mean. And you must remember Ellen was there at my elbow, and of course her point of view influenced me a lot.

MOIRA (*Coldly*) : Naturally. And what was her point of view?

REX : Why that we were fatally in love; had fallen in love at first sight and that we were to marry and settle down together.

MOIRA : Well, that certainly seemed to be your point of view.

REX : I tell you, Ellen was right there, influencing me . . . And there's no doubt I was in love with her at the time. She's lovely, you know. I was mad about her.

MOIRA : Why do you say was—was—was? You're still in love with her, aren't you?

REX : No, Moira, I don't believe I am. Of course I have a feeling about her—she is beautiful—But even if I were in love with her, Moira, this about marrying—

MOIRA : Well, what about it?

REX (*Springing up and pacing the floor.*) : Moira, I don't want to marry. As to settling down, I simply can't.

MOIRA : But you promised her, didn't you?

REX : I did. And of course if she insists, I suppose I'll have to keep my promise. That is, I'll marry her, but I won't settle down. That I cannot do. Why, Moira, listen—(*Throws himself in corner of couch, leans forward.*) What do you think she expects? She expects me to live with her in a little suburban house, and come back every night to dinner, and have a yard with vegetables, and a sleeping porch facing the east. Oh, Moira. (*Buries his face in his hands.*)

MOIRA : Well, my dear Rex, if you love her—

REX (*Savagely*) : I couldn't love anyone like that.

MOIRA : Well, how do you love her, then?

REX (*Moodily*) : Why—I loved her as a beautiful, poetical creature, a bit of plastic loveliness—Moira, you ought to see her; she is lovely—er—she was unhappy, too. She needed to be made love to. I made love to her; I loved her in a way, but, Oh, Moira, not as I loved you.

MOIRA : What? My dear boy . . .

REX (*Surprised*) : Surely you know Moira that I have loved you ever since we met; that I never ceased loving you; that I could never love anyone else as I love you.

MOIRA : But, my dear Rex, you wrote me.

REX : Oh, I wrote you, I wrote you . . . I've already explained to you that I wasn't in a state of mind to know what I meant then. You remember, too, that you and I parted with a quarrel.

MOIRA : What of it? You wrote me right after that quarrel that you adored me more than ever . . .

REX : Well, so I did . . . But don't you see, the fact that we had quarrelled so terribly, just at parting—well, it made me feel desperate. And so—

MOIRA (*Ironically*) : And so—you fell in love with Ellen.

REX : Well, yes, that's only natural, just at first. But now, you see, I've had time to think it over and I know—why what did you think I meant when I wrote you that I was coming back?

MOIRA: Meant? Meant? Why I supposed you meant you were coming to pay me a friendly visit and make sure of my forgiveness.

REX: Forgiveness, yes, but real forgiveness, Moira.

MOIRA: Yes, yes, I do really forgive you. I don't bear you any malice at all.

REX: Then you do really love me, Moira, after all.

MOIRA: I'm very fond of you, my dear, and always shall be.

REX: No, no, that isn't what I mean and you know it. I love you just as I always did, only more, I think. I've come back to you, Moira.

MOIRA: But—my dear Rex—Ellen.

REX: I've written Ellen that I can't honestly promise to do what she wants . . . I've told her that I will marry her if she still wants me to, but that I can't settle down . . . That I must have my freedom—and that probably she wouldn't be happy with me. I have been as honest with her as I could be—Just as I was always honest with you.

MOIRA (*Smiling pensively*): Yes, you always told me that, too.

REX: You see, I haven't deceived either of you. I may have deceived myself at times—when I thought I didn't love you, for instance. But I know now that I do and always shall. And so, Moira, do you forgive me?

MOIRA: I've told you so.

REX: And love me?

MOIRA: In a way, yes—I always shall.

REX: No, not in a way. As you did before, Moira. Surely you haven't altogether stopped loving me.

MOIRA: No, not as I did before. That was a disease, a madness. I was mad with jealousy of you . . . I was miserable. I tried to keep you faithful to me—and I couldn't. I don't want to go back to that.

REX: You don't want to go back?

MOIRA: No. To have you leave me again in a few months—or weeks—for another woman? No.

REX: Moira, I was always faithful to you, really. I always shall be. I should always come back.

MOIRA: That is your idea of fidelity. You would always come back.

REX: Yes, always. I couldn't help myself. I couldn't stay away for long. I couldn't forget you.

MOIRA: You forgot me easily.

REX: I never forgot you. Didn't I write you nearly every day? You were always on my mind. I saw you suffering, wounded, desperate, perhaps even doing what you threatened once—you know—

MOIRA: Kill myself?

REX: I thought everything. I was in despair about you. Even your letters, so calm and generous, didn't reassure me. I knew your pride.

MOIRA: So you thought I was wearing a mask of cheerfulness and resignation.

REX: Yes, and I thought it noble of you.

MOIRA: And at the same time you thought I must be in love with some one else. You said so.

REX: Well, I didn't know what to think. That's the truth.

MOIRA: The one thing you couldn't believe was that I had ceased to feel about you as a lover.

REX: Yes, that was it; I admit it.

MOIRA: And yet you'll admit, too, that it was the right and reasonable thing to do.

REX: Oh, right and reasonable.

MOIRA: If I had behaved like a jealous fury, showered reproaches on you, threatened you, pursued

you, tried to get you away from Ellen, that from your point of view would have been the natural thing for me to do.

REX: Yes, if you loved me.

MOIRA: Well, Rex, I don't think so. I knew that you would leave me some day. You're young, and as you say yourself, you must have your freedom. So when it came I took the blow, for it was a blow. I adjusted myself to the change.

REX: Very easily.

MOIRA: Well, it is done, now.

REX: And you don't want to undo it? You don't want me back?

MOIRA: As a friend, yes; always. Love passes. Friendship endures.

REX: Love never ends—real love. But you know nothing about it. You never loved me.

MOIRA: I did, Rex. I lived only for you for a year and I wasn't happy. Don't you remember how I absorbed myself in you, gave up all my other interests, gave up my friends, could see nothing and nobody but you; was careless and indifferent to everyone but you? And I wasn't happy.

REX: That is exactly it. Did I want you to give up your interests and your friends? Did I want you to see nothing and nobody but me? Didn't I want you to be free of me and let me be free of you—sometimes.

MOIRA: In love one cannot be free. I was constant to you every moment, while I loved you.

REX: While you loved me. That's not my idea of constancy.

MOIRA: No, your idea of constancy is to love a hundred other women and at intervals to come back—to me.

REX: Moira, you drove it too hard. You tied yourself and me down hand and foot. And now you say it is ended for you. Now because I've been what you call unfaithful you throw me off. And that is your idea of constancy.

MOIRA: I can't endure love without fidelity. It tortures me. I don't want to be the head of a harem. Yes, it is ended.

REX (*Goes to balcony, stands looking out.*): Look. How many times have I come to you; come up over this balcony? And you were happy then. You didn't want to push me away then.

MOIRA: It was a fever. What is real is what I feel for you now; a warm affection, a—

REX: I don't want that. I want you back as you were before.

MOIRA: You want to make me miserable again. No, Rex.

REX: (*Kneels on couch, leans toward her and takes her in his arms. She does not resist.*): I can't believe you mean it. Kiss me. (*She kisses him. He draws back suddenly and lets her go.*) You do mean it. You don't care any more. (*He drops down on couch. She leans over and caresses his hair.*)

MOIRA: Now, Rex, you are just a boy, crying for the moon. As long as you haven't got it you are dying for it. When you get it you go on to something else. I understand you very well and I think you are the most charming and amusing person I know, and I shall always be really fonder of you than of anyone else.

REX: (*Jumping to his feet.*) The moon. You are the moon, I suppose, and you are certainly as inconstant. How can you change like this? I come back to you loving you as I always did, the same as ever, and I find you completely changed; your love for me gone as thought it had never been. And you tell me it is no new love that has driven it out. I could understand that, but this . . . It is true, as Weininger said, women have no soul, no memory. They are incapable of fidelity.

MOIRA: Fidelity.

REX: Yes, fidelity. Haven't I been essentially faithful to you. I may have fancies for other women but haven't I come back to you?

MOIRA (*Looking at him with admiration*): Oh, Rex, you are perfect; you are a perfect man.

REX: Well, I can say with sincerity that you are a complete woman.

MOIRA: After that I suppose there is no more to say. We have annihilated one another.

REX (*Furiously snatching up cloak and hat*): I shall leave you.

MOIRA: But you will come back.

REX: Come back. (*He turns to her*) You know I shall. I can't help it. And we shall see.

MOIRA: Yes, shan't we. Oh, by the way, I promised you this. (*Holds up the ladder*)

REX: You'd better keep it.

MOIRA: No, Rex. (*Drops the ladder at his feet.*)

REX: I am going. You never loved me.

MOIRA: Oh, yes I did, Rex. Have you forgotten?

REX: I have forgotten nothing. It is you who have forgotten. It is you who have been unfaithful. I come back to you and you treat me like a stranger. You turn me out. You say you no longer love me.

(*Regarding her with passionate reproach.*) And you told me you had forgiven me.

MOIRA: So I have.

REX: You mean—by ceasing to love me. Do you think anyone wants that sort of forgiveness?

MOIRA: That's the only sort anyone ever gets.

REX: No. (*with emotion*) Forgiving means forgetting.

MOIRA (*With a wide gesture*): Well, I have forgotten—everything.

REX (*With a violent movement toward her*): You—(*Stops and they stand looking at one another*) And you have called me inconstant. (*He backs toward the door with a savage laugh*) Constancy!

(*Moira stands looking at him, motionless.*)

CURTAIN.

This copy reprinted with permission of Miriam Hapgood DeWitt for production purposes.

SUPPRESSED DESIRES

by George Cram Cook and Susan Glaspell

CHARACTERS

HENRIETTA BREWSTER

STEPHEN BREWSTER

MABEL

SCENE I: *A studio apartment in an upper story, Washington Square South. Through an immense north window in the back wall appear tree tops and the upper part of the Washington Arch. Beyond it you look up Fifth Avenue. Near the window is a big table, loaded at one end with serious-looking books and austere scientific periodicals. At the other end are architect's drawings, blue prints, dividing compasses, square, ruler, etc. At the left is a door leading to the rest of the apartment; at the right the outer door. A breakfast table is set for three, but only two are seated at it—HENRIETTA and STEPHEN BREWSTER. As the curtains withdraw STEVE pushes back his coffee cup and sits dejected.*

HENRIETTA: It isn't the coffee, Steve dear. There's nothing the matter with the coffee. There's something the matter with you.

STEVE (*Doggedly.*): There may be something the matter with my stomach.

HENRIETTA (*Scornfully.*): Your stomach! The trouble is not with your stomach but in your subconscious mind.

STEVE: Subconscious piffle! (*Takes morning paper and tries to read.*)

HENRIETTA: Steve, you never used to be so disagreeable. You certainly have got some sort of a complex. You're all inhibited. You're no longer open to new ideas. You won't listen to a word about psychoanalysis.

STEVE: A word! I've listened to volumes!

HENRIETTA: You've ceased to be creative in architecture—your work isn't going well. You're not sleeping well—

STEVE: How can I sleep, Henrietta, when you're always waking me up to find out what I'm dreaming?

HENRIETTA: But dreams are so important, Steve. If you'd tell yours to Dr. Russell he'd find out exactly what's wrong with you.

STEVE: There's nothing wrong with me.

HENRIETTA: You don't even talk as well as you used to.

STEVE: Talk? I can't say a thing without you looking at me in that dark fashion you have when you're on the trail of a complex.

HENRIETTA: This very irritability indicates that you're suffering from some suppressed desire.

STEVE: I'm suffering from a suppressed desire for a little peace.

HENRIETTA: Dr. Russell is doing simply wonderful things with nervous cases. Won't you go to him, Steve?

STEVE (*Slamming down his newspaper*): No, Henrietta, I won't!

HENRIETTA: But, Stephen—!

STEVE: Tst! I hear Mabel coming. Let's not be at each other's throats the first day of her visit. (*He takes out cigarettes. MABEL comes in from door left, the side opposite STEVE, so that he is facing her. She is wearing a rather fussy negligee in contrast to HENRIETTA, who wears "radical" clothes. MABEL is what is called plump.*)

MABEL: Good morning.

HENRIETTA: Oh, here you are, little sister.

STEVE: Good morning, Mabel.

(*MABEL nods to him and turns, her face lighting up, to HENRIETTA.*)

HENRIETTA (*Giving* MABEL *a hug as she leans against her.*) : It's so good to have you here. I was going to let you sleep, thinking you'd be tired after the long trip. Sit down. There'll be fresh toast in a minute and (*Rising*) will you have—

MABEL : Oh, I ought to have told you, Henrietta. Don't get anything for me. I'm not eating breakfast.

HENRIETTA (*At first in mere surprise*) : Not eating breakfast ? (*She sits down, then leans toward* MABEL *who is seated now, and scrutinizes her.*)

STEVE (*Half to himself.*) : The psychoanalytical look !

HENRIETTA : Mabel, why are you not eating breakfast ?

MABEL (*A little startled.*) : Why, no particular reason. I just don't care much for breakfast, and they say it keeps down—(*A hand on her hip—the gesture of one who is "reducing"*) that is, it's a good thing to go without it.

HENRIETTA : Don't you sleep well ? Did you sleep well last night ?

MABEL : Oh, yes, I slept all right. Yes, I slept fine last night, only (*Laughing*) I did have the funniest dream !

STEVE : S-h ! S-t !

HENRIETTA (*Moving closer.*) : And what did you dream, Mabel ?

STEVE : Look-a-here, Mabel, I feel it's my duty to put you on. Don't tell Henrietta your dreams. If you do she'll find out that you have an underground desire to kill your father and marry your mother—

HENRIETTA : Don't be absurd, Stephen Brewster. (*Sweetly to* MABEL.) What was your dream, dear ?

MABEL (*Laughing*) : Well, I dreamed I was a hen.

HENRIETTA : A hen ?

MABEL : Yes ; and I was pushing along through a crowd as fast as I could, but being a hen I couldn't

walk very fast—it was like having a tight skirt, you know ; and there was some sort of creature in a blue cap—you know how mixed up dreams are—and it kept shouting after me, "Step, Hen ! Step, Hen !" until I got all excited and just couldn't move at all.

HENRIETTA (*Resting chin in palm and peering*) : You say you became much excited ?

MABEL (*Laughing*) : Oh, yes ; I was in a terrible state.

HENRIETTA (*Leaning back, murmurs.*) : This is significant.

STEVE : She dreams she's a hen. She is told to step lively. She becomes violently agitated. What can it mean ?

HENRIETTA (*Turning impatiently from him.*) : Mabel, do you know anything about psychoanalysis ?

MABEL (*Feebly.*) Oh—not much. No—I— (*Brightening*) It's something about the war, isn't it ?

STEVE : Not that kind of war.

MABEL (*Abashed*) : I thought it might be the name of a new explosive.

STEVE : It *is.*

MABEL (*Apologetically to* HENRIETTA, *who is frowning*) : You see, Henrietta, I—we do not live in touch with intellectual things, as you do. Bob being a dentist—somehow our friends—

STEVE (*Softly.*) : Oh, to be a dentist ! (*Goes to window and stands looking out.*)

HENRIETTA : Don't you see anything more of that editorial writer—what was his name ?

MABEL : Lyman Eggleston ?

HENRIETTA : Yes, Eggleston. He was in touch with things. Don't you see him ?

MABEL : Yes, I see him once in a while. Bob doesn't like him very well.

HENRIETTA: Your husband does not like Lyman Eggleston? (*Mysteriously.*) Mabel, are you perfectly happy with your husband?

STEVE (*Sharply.*): Oh, come now, Henrietta—that's going a little strong!

HENRIETTA: Are you perfectly happy with him, Mabel?

(*STEVE goes to work-table.*)

MABEL: Why—yes—I guess so. Why—of course I am!

HENRIETTA: Are you happy? Or do you only think you are? Or do you only think you *ought* to be?

MABEL: Why, Henrietta, I don't know what you mean!

STEVE (*Seizes stack of books and magazines and dumps them on the breakfast table.*): This is what she means, Mabel. Psychoanalysis. My work-table groans with it. Books by Freud, the new Messiah; books by Jung, the new St. Paul; the Psychoanalytical Review—back numbers two-fifty per.

MABEL: But what's it all about?

STEVE: All about your sub-un-non-conscious mind and desires you know not of. They may be doing you a great deal of harm. You may go crazy with them. Oh, yes! People are doing it right and left. Your dreaming you're a hen—(*Shakes his head darkly.*)

HENRIETTA: Any fool can ridicule anything.

MABEL (*Hastily, to avert a quarrel.*): But what do you say it is, Henrietta?

STEVE (*Looking at his watch.*): Oh, if Henrietta's going to start that!

(*During HENRIETTA's next speech settles himself at work-table and sharpens a lead pencil.*)

HENRIETTA: It's like this, Mabel. You want something. You think you think you can't have it. You think it's wrong. So you try to think you don't want it. Your mind protects you—avoids pain—

by refusing to think the forbidden thing. But it's there just the same. It stays there shut up in your unconscious mind, and it festers.

STEVE: Sort of an ingrowing mental toenail.

HENRIETTA: Precisely. The forbidden impulse is there full of energy which has simply got to do something. It breaks into your consciousness in disguise, masks itself in dreams, makes all sorts of trouble. In extreme cases it drives you insane.

MABEL (*With a gesture of horror.*): Oh!

HENRIETTA (*Reassuring.*): But psychoanalysis has found out how to save us from that. It brings into consciousness the suppressed desire that was making all the trouble. Psychoanalysis is simply the latest scientific method of preventing and curing insanity.

STEVE (*From his table.*): It is also the latest scientific method of separating families.

HENRIETTA (*Mildly.*): Families that ought to be separated.

STEVE: The Dwights, for instance. You must have met them, Mabel, when you were here before. Helen was living, apparently, in peace and happiness with good old Joe. Well—she went to this psychoanalyzer—she was "psyched," and biff! —bang!—home she comes with an unsuppressed desire to leave her husband.

(*He starts work, drawing lines on a drawing board with a T-square.*)

MABEL: How terrible! Yes, I remember Helen Dwight. But—but did she have such a desire?

STEVE: First she'd known of it.

MABEL: And she *left* him?

HENRIETTA (*Coolly.*): Yes, she did.

MABEL: Wasn't he [good] to her?

HENRIETTA: Why yes, good enough.

MABEL: Wasn't he kind to her?

HENRIETTA: Oh, yes—kind to her.

MABEL: And she left her good kind husband— !

HENRIETTA: Oh, Mabel! "Left her good, kind husband!" How naïve—forgive me, dear, but how bourgeoise you are! She came to know herself. And she had the courage!

MABEL: I may be very naïve and—bourgeoise—but I don't see the good of a new science that breaks up homes.

(*STEVE applauds.*)

STEVE: In enlightening Mabel, we mustn't neglect to mention the case of Art Holden's private secretary, Mary Snow, who has just been informed of her suppressed desire for her employer.

MABEL: Why, I think it is terrible, Henrietta! It would be better if we didn't know such things about ourselves.

HENRIETTA: No, Mabel, that is the old way.

MABEL: But—but her employer? Is he married?

STEVE (*Grunts.*): Wife and four children.

MABEL: Well, then, what good does it do the girl to be told she has a desire for him? There's nothing can be done about it.

HENRIETTA: Old institutions will have to be reshaped so that something can be done in such cases. It happens, Mabel, that this suppressed desire was on the point of landing Mary Snow in the insane asylum. Are you so tight-minded that you'd rather have her in the insane asylum than break the conventions?

MABEL: But—but have people always had these awful suppressed desires?

HENRIETTA: Always.

STEVE: But they've just been discovered.

HENRIETTA: The harm they do has just been discovered. And free, sane people must face the fact that they have to be dealt with.

MABEL (*Stoutly.*): I don't believe they have them in Chicago.

HENRIETTA (*Business of giving MABEL up.*): People "have them" wherever the living Libido—the center of the soul's energy—is in conflict with petrified moral codes. That means everywhere in civilization. Psychoanalysis—

STEVE: Good God! I've got the roof in the cellar!

HENRIETTA: The roof in the cellar!

STEVE (*Holding plan at arm's length.*): That's what psychoanalysis does!

HENRIETTA: That's what psychoanalysis could *un*-do. Is it any wonder I'm concerned about Steve? He dreamed the other night that the walls of his room melted away and he found himself alone in a forest. Don't you see how significant it is for an architect to have *walls* slip away from him? It symbolizes his loss of grip in his work. There's some suppressed desire—

STEVE (*Hurling his ruined plan viciously to the floor.*): Suppressed hell!

HENRIETTA: You speak more truly than you know. It is through suppressions that hells are formed in us.

MABEL (*Looking at STEVE, who is tearing his hair.*): Don't you think it would be a good thing, Henrietta, if we went somewhere else? (*They rise and begin to pick up the dishes. MABEL drops a plate which breaks. HENRIETTA draws up short and looks at her—the psychoanalytic look.*) I'm sorry, Henrietta. One of the Spode plates, too. (*Surprised and resentful as HENRIETTA continues to peer at her.*) Don't take it so to heart, Henrietta.

HENRIETTA: I can't help taking it to heart.

MABEL: I'll get you another. (*Pause. More sharply as HENRIETTA does not answer.*) I said I'll get you another plate, Henrietta.

HENRIETTA: It's not the plate.

MABEL: For heaven's sake, what is it then?

HENRIETTA: It's the significant little false movement that made you drop it.

MABEL: Well, I suppose everyone makes a false movement once in a while.

HENRIETTA: Yes, Mabel, but these false movements all mean something.

MABEL (*About to cry.*): I don't think that's very nice! It was just because I happened to think of that Mabel Snow you were talking about—

HENRIETTA: *Mabel* Snow!

MABEL: Snow—Snow—well, what was her name, then?

HENRIETTA: Her name is Mary. You substituted *your own* name for hers.

MABEL: Well, *Mary* Snow, then; *Mary* Snow. I never heard her name but once. I don't see anything to make such a fuss about.

HENRIETTA (*Gently.*): Mabel dear—mistakes like that in names—

MABEL (*Desperately.*): They don't mean something, too, do they?

HENRIETTA (*Gently.*): I am sorry, dear, but they do.

MABEL: But I'm always doing that!

HENRIETTA (*After a start of horror.*): My poor little sister, tell me about it.

MABEL: About what?

HENRIETTA: About your not being happy. About your longing for another sort of life.

MABEL: But I *don't*.

HENRIETTA: Ah, I understand these things, dear. You feel Bob is limiting you to a life in which you do not feel free—

MABEL: Henrietta! When did I ever say such a thing?

HENRIETTA: You said you are not in touch with things intellectual. You showed your feeling that it is Bob's profession—that has engendered a resentment which has colored your whole life with him.

MABEL: Why—Henrietta!

HENRIETTA: Don't be afraid of me, little sister. There's nothing can shock me or turn me from you. I am not like that. I wanted you to come for this visit because I had a feeling that you needed more from life than you were getting. No one of these things I have seen would excite my suspicion. It's the combination. You don't eat breakfast (*Enumerating on her fingers*); you make false moves; you substitute your own name for the name of another *whose love is misdirected*. You're nervous; you *look* queer; in your eyes there's a frightened look that is most unlike you. And this dream. A *hen*. Come with me this afternoon to Dr. Russell! Your whole life may be at stake, Mabel.

MABEL (*Gasping.*): Henrietta, I—you—you always were the smartest in the family, and all that, but—this is terrible! I don't think we *ought* to think such things. (*Brightening.*) Why, I'll tell you why I dreamed I was a hen. It was because last night, telling about that time in Chicago, you said I was as mad as a wet hen.

HENRIETTA (*Superior.*): Did you dream you were a *wet* hen?

MABEL (*Forced to admit it.*): No.

HENRIETTA: No. You dreamed you were a *dry* hen. And why, being a hen, were you urged to step?

MABEL: Maybe it's because when I am getting on a street car it always irritates me to have them call "Step lively."

HENRIETTA: No, Mabel, that is only a child's view of it—if you will forgive me. You see merely the elements used in the dream. You do not see into the dream; you do not see its meaning. This dream of the hen—

STEVE: Hen—hen—wet hen—dry hen—mad hen! (*Jumps up in a rage.*) Let me out of this!

HENRIETTA (*Hastily picking up dishes, speaks soothingly.*) : Just a minute, dear, and we'll have things so you can work in quiet. Mabel and I are going to sit in my room. (*She goes out left, carrying dishes.*)

STEVE (*Seizing hat and coat from an alcove near the outside door*) : I'm going to be psychoanalyzed. I'm going now! I'm going straight to that infallible doctor of hers—that priest of this new religion. If he's got honesty enough to tell Henrietta there's nothing the matter with my unconscious mind, perhaps I can be let alone about it, and then I *will* be all right. (*From the door in a low voice.*) Don't tell Henrietta I'm going. It might take weeks, and I couldn't stand all the talk.

(*He hurries out.*)

HENRIETTA (*Returning.*) : Where's Steve? Gone? (*With a hopeless gesture.*) You see how impatient he is—how unlike himself! I tell you, Mabel, I'm nearly distracted about Steve.

MABEL : I think he's a little distracted too.

HENRIETTA : Well, if he's gone—you might as well stay here. I have a committee meeting at the book-shop, and will have to leave you to yourself for an hour or two. (*As she puts her hat on, taking it from the alcove where STEVE found his, her eye, lighting up almost carnivorously, falls on an enormous volume on the floor beside the work table. The book has been half hidden by the wastebasket. She picks it up and carries it around the table toward MABEL.*) Here, dear, is one of the simplest statements of psychoanalysis. You just read this and then we can talk more intelligently. (*MABEL takes volume and staggers back under its weight to chair rear center, HENRIETTA goes to outer door, stops and asks abruptly.*) How old is Lyman Eggleston?

MABEL (*Promptly.*) : He isn't forty yet. Why, what made you ask that, Henrietta?

(*As she turns her head to look at HENRIETTA her hands move toward the upper corners of the book balanced on her knees.*)

HENRIETTA : Oh, nothing, Au revoir.

(*She goes out. MABEL stares at the ceiling. The book slides to the floor. She starts; looks at the book, then at the broken plate on the table.*) The plate! The book! (*She lifts her eyes, leans forward elbow on knee, chin on knuckles and plaintively queries*) Am I unhappy?

(CURTAIN)

SCENE II : *Two weeks later. The stage is as in Scene I, except that the breakfast table has been removed. During the first few minutes the dusk of a winter afternoon deepens. Out of the darkness spring rows of double street-lights almost meeting in the distance. HENRIETTA is at the psychoanalytical end of STEVE's work-table, surrounded by open books and periodicals, writing. STEVE enters briskly.*

STEVE : What are you doing, my dear?

HENRIETTA : My paper for the Liberal Club.

STEVE : Your paper on— ?

HENRIETTA : On a subject which does not have your sympathy.

STEVE : Oh, I'm not sure I'm wholly out of sympathy with psychoanalysis, Henrietta. You worked it so hard. I couldn't even take a bath without its meaning something.

HENRIETTA (*Loftily.*) : I talked it because I knew you needed it.

STEVE : You haven't said much about it these last two weeks. Uh—your faith in it hasn't weakened any?

HENRIETTA : Weakened? It's grown stronger with each new thing I've come to know. And Mabel. She is with Dr. Russell now. Dr. Russell is wonderful! From what Mabel tells me I believe his analysis is going to prove that I was right. Today I discovered a remarkable confirmation of my theory in the hen-dream.

STEVE : What is your theory?

HENRIETTA : Well, you know about Lyman Eggleston. I've wondered about him. I've never seen him, but I know he's less bourgeois than

Mabel's other friends—more intellectual—and (*Significantly*) she doesn't see much of him because Bob doesn't like him.

STEVE : But what's the confirmation ?

HENRIETTA : Today I noticed the first syllable of his name.

STEVE : Ly ?

HENRIETTA : No—egg.

STEVE : Egg ?

HENRIETTA (*Patiently.*) : Mabel dreamed she was a *hen.* (*STEVE laughs.*) You wouldn't laugh it you knew how important names are in interpreting dreams. Freud is full of just such cases in which a whole hidden complex is revealed by a single significant syllable—like this egg.

STEVE : Doesn't the traditional relation of hen and egg suggest rather a maternal feeling ?

HENRIETTA : There is something maternal in Mabel's love, of course, but that's only one element.

STEVE : Well, suppose Mabel hasn't a suppressed desire to be this gentleman's mother, but his beloved. What's to be done about it ? What about Bob ? Don't you think it's going to be a little rough on him ?

HENRIETTA : That can't be helped. Bob, like everyone else, must face the facts of life. If Dr. Russell should arrive independently at this same interpretation I shall not hesitate to advise Mabel to leave her present husband.

STEVE : Um—hum ! (*The lights go up on Fifth Avenue. STEVE goes to the window and looks out.*) How long is it we've lived here, Henrietta ?

HENRIETTA : Why, this is the third year, Steve.

STEVE : I—we—one would miss this view if one went away, wouldn't one ?

HENRIETTA : How strangely you speak ! Oh, Stephen, I *wish* you'd go to Dr. Russell. Don't think my fears have abated because I've been able to restrain myself. I had to on account of Mabel. But now, dear—won't you go. ?

STEVE : I—(*He breaks off, turns on the light, then comes and sits beside HENRIETTA.*) How long have we been married, Henrietta ?

HENRIETTA : Stephen, I don't understand you ! You *must* go to Dr. Russell.

STEVE : I have gone.

HENRIETTA : You—what ?

STEVE (*Jauntily.*) : Yes, Henrietta, I've been psyched.

HENRIETTA : You went to Dr. Russell ?

STEVE : The same.

HENRIETTA : And what did he say ?

STEVE : He said—I—I was a little surprised by what he said, Henrietta.

HENRIETTA : (*Breathlessly.*) : Of course—one can so seldom anticipate. But tell me—your dream, Stephen ? It means— ?

STEVE : It means—I was considerably surprised by what it means.

HENRIETTA : *Don't* be so exasperating !

STEVE : It means—you really want to know, Henrietta ?

HENRIETTA : Stephen, you'll drive me mad !

STEVE : He said—of course he may be wrong in what he said.

HENRIETTA : He *isn't* wrong. *Tell* me !

STEVE : He said my dream of the walls receding and leaving me alone in a forest indicates a suppressed desire—

HENRIETTA : Yes—yes !

STEVE : To be freed from—

HENRIETTA: Yes—freed from— ?

STEVE: Marriage.

HENRIETTA: (*Crumples. Stares.*) : Marriage!

STEVE: He—he may be mistaken, you know.

HENRIETTA: *May* be mistaken?

STEVE: I—well, of course, I hadn't taken any stock in it myself. It was only your great confidence—

HENRIETTA: Stephen, are you telling me that Dr. Russell—Dr. A. E. Russell—told you this? (*STEVE nods.*) Told you you have a suppressed desire to separate from *me?*

STEVE: That's what he said.

HENRIETTA: Did he know who you were?

STEVE: Yes.

HENRIETTA: That you were married to me?

STEVE: Yes, he knew that.

HENRIETTA: And he told you to leave me?

STEVE: It seems he must be wrong, Henrietta.

HENRIETTA (*Rising.*) : And I've sent him more patients— ! (*Catches herself and resumes coldly.*) What reason did he give for this analysis?

STEVE: He says the confining walls are a symbol of my feeling about marriage and that their fading away is a wish-fulfillment.

HENRIETTA (*Gulping.*) : Well, is it? Do you want our marriage to end?

STEVE: It was a great surprise to me that I did. You see I hadn't known what was in my unconscious mind.

HENRIETTA (*Flaming.*) : What did you tell Dr. Russell about me to make him think you weren't happy?

STEVE: I never told him a thing, Henrietta. He got it all from his confounded clever inferences. I—I tried to refute them, but he said that was only part of my self-protective lying.

HENRIETTA: And that's why you were so—happy—when you came in just now!

STEVE: Why, Henrietta, how can you say such a thing? I was *sad.* Didn't I speak sadly of—of the view? Didn't I ask how long we had been married?

HENRIETTA (*Rising.*) : Stephen Brewster, have you no sense of the seriousness of this? Dr. Russell doesn't know what our marriage has been. You do. You should have laughed him down! Confined—in life with me? Did you tell him that I *believe* in freedom?

STEVE: I very emphatically told him that his results were a great surprise to me.

HENRIETTA: But you accepted them.

STEVE: Oh, not at all. I merely couldn't refute his arguments. I'm not a psychologist. I came home to talk it over with you. You being a disciple of psychoanalysis—

HENRIETTA: If you are going, I wish you would go tonight!

STEVE: Oh, my dear! I—surely I couldn't do that! Think of my feelings. And my laundry hasn't come home.

HENRIETTA: I ask you to go tonight. Some women would falter at this, Steve, but I am not such a woman. I leave you free. I do not repudiate psychoanalysis; I say again that it has done great things. It has also made mistakes, of course. But since you accept this analysis—(*She sits down and pretends to begin work.*) I have to finish this paper. I wish you would leave me.

STEVE (*Scratches his head, goes to the inner door.*) : I'm sorry, Henrietta, about my unconscious mind.

(*Alone,* HENRIETTA'S *face betrays her outraged state of mind—disconcerted, resentful, trying to*

pull herself together. She attains an air of bravely bearing an outrageous thing.—The outer door opens and MABEL *enters in great excitement.*)

MABEL (*Breathless.*): Henrietta, I'm so glad you're here. And alone? (*Looks toward the inner door.*) Are you alone, Henrietta?

HENRIETTA (*With reproving dignity.*): Very much so.

MABEL (*Rushing to her.*): Henrietta, he's found it!

HENRIETTA (*Aloof.*): Who has found what?

MABEL: Who has found what? Dr. Russell has found my suppressed desire!

HENRIETTA: That is interesting.

MABEL: He finished with me today—he got hold of my complex—in the most amazing way! But, oh, Henrietta—it is so terrible!

HENRIETTA: Do calm yourself, Mabel. Surely there's no occasion for all this agitation.

MABEL: But there is! And when you think of the lives that are affected—the readjustments that must be made in order to bring the suppressed hell out of me and save me from the insane asylum—!

HENRIETTA: The insane asylum!

MABEL: You said that's where these complexes brought people!

HENRIETTA: What did the doctor tell you, Mabel?

MABEL: Oh, I don't know how I can tell you—it is so awful—so unbelievable.

HENRIETTA: I rather have my hand in at hearing the unbelievable.

MABEL: Henrietta, who would ever have thought it? How can it be true? But the doctor is perfectly certain that I have a suppressed desire for—

(*Looks at* HENRIETTA, *is unable to continue.*)

HENRIETTA: Oh, go on, Mabel. I'm not unprepared for what you have to say.

MABEL: Not unprepared? You mean you have suspected it?

HENRIETTA: From the first. It's been my theory all along.

MABEL: But, Henrietta, I didn't know myself that I had this secret desire for Stephen.

HENRIETTA (*Jumps up.*): Stephen!

MABEL: My brother-in-law! My own sister's husband!

HENRIETTA: *You* have a suppressed desire for *Stephen!*

MABEL: Oh, Henrietta, aren't these unconscious selves terrible? They seem so unlike *us!*

HENRIETTA: What insane thing are you driving at?

MABEL (*Blubbering.*): Henrietta, don't you use that word to me. I don't *want* to go to the insane asylum.

HENRIETTA: What did Dr. Russell say?

MABEL: Well, you see—oh, it's the strangest thing! But you know the voice in my dream that called "Step, Hen!" Dr. Russell found out today that when I was a little girl I had a story-book in words of one syllable and I read the name Stephen wrong. I used to read it S-t-e-p, step, h-e-n, hen. (*Dramatically.*) Step Hen is Stephen. (*Enter* STEPHEN, *his head bent over a time-table.*) Stephen is Step Hen!

STEVE: I? Step Hen?

MABEL (*Triumphantly.*): S-t-e-p, step, H-e-n, Hen, Stephen!

HENRIETTA (*Exploding.*): Well, what if Stephen is Step Hen? (*Scornfully.*) Step Hen! Step Hen! For that ridiculous coincidence—

MABEL: Coincidence! But it's childish to look at the mere elements of a dream. You have to look *into* it—you have to see what it *means!*

HENRIETTA: On account of that trivial, meaningless play on syllables—on that flimsy basis—you are ready—(*Wails.*) O-h!

STEVE: What on earth's the matter? What has happened? Suppose I *am* Step Hen? What about it? What does it mean?

MABEL (*Crying.*): It means—that I—have a suppressed desire for *you!*

STEVE: For me! The deuce you have! (*Feebly.*) What—er—makes you think so?

MABEL: Dr. Russell has worked it out scientifically.

HENRIETTA: Yes. Through the amazing discovery that Step Hen equals Stephen!

MABEL (*Tearfully.*): Oh, that isn't all—that isn't near all. Henrietta won't give me a chance to tell it. She'd rather I'd go to the insane asylum than be unconventional.

HENRIETTA: We'll all go there if you can't control yourself. We are still waiting for some rational report.

MABEL (*Drying her eyes.*): Oh, there's such a lot about names. (*With some pride.*) I don't see how I ever did it. It all works in together. I dreamed I was a hen because that's the first syllable of *Hen*-rietta's name, and when I dreamed I was a hen, I was putting myself in Henrietta's place.

HENRIETTA: With Stephen?

MABEL: With Stephen.

HENRIETTA (*Outraged.*): Oh! (*Turns in rage upon* STEPHEN, *who is fanning himself with the time-table.*) What are you doing with that time-table?

STEVE: Why—I thought—you were so keen to have me go tonight—I thought I'd just take a run up to Canada, and join Billy—a little shooting—but—

MABEL: But there's more about the names.

HENRIETTA: Mabel, have you thought of Bob—dear old Bob—your good, kind husband?

MABEL: Oh, Henrietta, "my good, kind husband!"

HENRIETTA: Think of him, Mabel, out there alone in Chicago, working his head off, fixing people's *teeth*—for you!

MABEL: Yes, but think of the living Libido—in conflict with petrified moral codes! And think of the perfectly wonderful way the names all prove it. Dr. Russell said he's never seen anything more convincing. Just look at Stephen's last name—Brewster. I dream I'm a hen, and the name Brewster—you have to say its first letter by itself—and then the hen, that's me, she says to him: "Stephen, Be Rooster!"

(*HENRIETTA and* STEPHEN *collapse into the nearest chairs.*)

MABEL: I think it's perfectly wonderful! Why, if it wasn't for psychoanalysis you'd never find out how wonderful your own mind is!

STEVE (*Begins to chuckle.*) Be Rooster! Stephen, Be Rooster!

HENRIETTA: You think it's funny, do you?

STEVE: Well, what's to be done about it? Does Mabel have to go away with me?

HENRIETTA: Do you want Mabel to go away with you?

STEVE: Well, but Mabel herself—her complex—her suppressed desire—!

HENRIETTA (*Going to her.*): Mabel, are you going to insist on going away with Stephen?

MABEL: I'd rather go with Stephen than go to the insane asylum!

HENRIETTA: For heaven's sake, Mabel, drop that insane asylum! If you *did* have a suppressed desire for Stephen hidden away in you—God knows it isn't hidden now. Dr. Russell has brought it

into your consciousness—with a vengeance. That's all that's necessary to break up a complex. Psychoanalysis doesn't say you have to *gratify* every suppressed desire.

STEVE (*Softly.*) : Unless it's for Lyman Eggleston.

HENRIETTA (*Turning on him.*) : Well, if it comes to that, Stephen Brewster, I'd like to know why that interpretation of mine isn't as good as this one ? Step, Hen !

STEVE : But Be Rooster ! (*He pauses, chuckling to himself.*) Step-Hen B-rooster. And *H*enrietta. Pshaw, my dear, Doc Russell's got you beat a mile ! (*He turns away and chuckles.*) Be rooster !

MABEL : What has Lyman Eggleston got to do with it ?

STEVE : According to Henrietta, you, the hen, have a suppressed desire for *Egg*leston, the egg.

MABEL : Henrietta, I think that's indecent of you ! He is bald as an egg and little and fat—the idea of you thinking such a thing of me !

HENRIETTA : Well, Bob isn't little and bald and fat ? Why don't you stick to your own husband ? (*To STEPHEN.*) What if Dr. Russell's interpretation has got mine "beat a mile" ? (*Resentful look at him.*) I would only mean that Mabel doesn't want Eggleston and does want you. Does that mean she has to have you ?

MABEL : But you said Mabel Snow—

HENRIETTA : *Mary* Snow ! You're not as much like her as you think—substituting your name for hers ! The cases are entirely different. Oh, I wouldn't have *believed* this of you, Mabel. (*Beginning to cry.*) I brought you here for a pleasant visit—thought you needed brightening *up*—wanted to be *nice* to you—and now you—my husband—you insist—

(*In fumbling her way to her chair she brushes to the floor some sheets from the psychoanalytical table.*)

STEVE (*With solicitude.*) : Careful, dear. Your paper on psychoanalysis ! (*Gathers up sheets and offers them to her.*)

HENRIETTA : I don't want my paper on psychoanalysis ! I'm sick of psychoanalysis.

STEVE (*Eagerly.*) : Do you mean that, Henrietta ?

HENRIETTA : Why shouldn't I mean it ? Look at all I've done for psychoanalysis—and— (*Raising a tear-stained face*) what has psychoanalysis done for me ?

STEVE : Do you mean, Henrietta, that you're going to stop *talking* psychoanalysis ?

HENRIETTA : Why shouldn't I stop talking it ? Haven't I seen what it does to people ? Mabel has gone crazy about psychoanalysis !

(*At the word " crazy " with a moan MABEL sinks to chair and buries her face in her hands.*)

STEVE (*Solemnly.*) : Do you swear never to wake me up in the night to find out what I'm dreaming ?

HENRIETTA : Dream what you please—I don't care what you're dreaming.

STEVE : Will you clear off my work-table so the Journal of Morbid Psychology doesn't stare me in the face when I'm trying to plan a house ?

HENRIETTA (*Pushing a stack of periodicals off the table.*) : I'll *burn* the Journal of Morbid Psychology !

STEVE : My dear Henrietta, if you're going to separate from psychoanalysis, there's no reason why I should separate from *you*.

(*They embrace ardently. MABEL lifts her head and looks at them woefully.*)

MABEL (*Jumping up and going toward them.*) : But what about me ? What am I to do with my suppressed desire ?

STEVE (*With one arm still around HENRIETTA, gives MABEL a brotherly hug.*) : Mabel, you just keep right on suppressing it !

(CURTAIN)

CHANGE YOUR STYLE

by George Cram Cook

CHARACTERS

MARMADUKE MARVIN, JR. *A Post-Impressionist.*

MARMADUKE MARVIN, SR. *His Father.*

KENYON CRABTREE. *Head of an Academic Art-School.*

BORDFELT. *Head of a Post-Impressionist Art-School.*

MYRTLE DART. *Lover of the Buddhistic.*

MR. JOSEPHS. *Landlord and Grocer.*

TIME

9 A.M. SEPTEMBER.

PLACE

PROVINCETOWN.

SCENE

A wharf studio interior with white wooden walls. In the back wall is an outer door and a studio window, in the left side wall a curtained bedroom door. In the left rear corner is a couch with yellow cover, orange cushions, and some bright-colored odds and ends. A clump of sunflowers fills the corner half way to the ceiling. Near the left front corner stand two white chairs by a table which is strewn with books, pipes, cigarettes, matches, flowers, an unlighted candle in its stick, a telegram. On the walls are a few post-impressionist unframed canvases and some hastily executed, grotesque drawings with heavy lines—charcoal, colored chalk—figures and faces. Near the right rear corner is an easel; behind this somewhat to its left is a stack of canvases leaning against the back wall. Tacked on the back door is a grotesque drawing, and one on cardboard stands on the floor so that it is nearly concealed when the open door is swung back against the wall.

(No one on stage at curtain. Snores from bedroom, a knock at the outer door. No response from bedroom.)

BORDFELT (*Outside*): Hey there! Marmaduke! (*Door opens. Enter Bordfelt carrying folded easel, blank canvas on stretcher, and sketching kit.*) Snoring! (*He sets down things, goes to bedroom door, pulls aside curtain and shouts*) Marmaduke! Hey, Marmaduke!

MARMADUKE JR.: (*From bedroom*) Eh?

BORDFELT: You goin' to work with me today? It's nine o'clock? What's the matter with you?

MARMADUKE JR.: What's the use o' working?

BORDFELT: Were you on a bat again? Were you soused last night?

MARMADUKE JR.: Yes—my last dollar. Never expect to see another.

BORDFELT: What's the matter with your father? Doesn't the old boy stake you?

(Wrapped in a big orange felt blanket, bare legs showing, Marmaduke Jr. staggers into the room. His hair is wild, his eyes are wild. He clutches a telegram on the table and hands it to Bordfelt)

MARMADUKE JR.: That's from my father.

BORDFELT (*Reads*): "Arrive in car tomorrow morning. Marmaduke Marvin."

MARMADUKE JR.: That came last night.

BORDFELT: Well, he's about due. You'd better pull yourself together and get dressed. What's the matter? What is there so bad about his coming?

MARMADUKE JR.: He's been giving me fifty a month, but last May he saw some of my Paris stuff

and had a fit. Said it was cubic insanity. Called it six-year-old dabbing. Said no more of his money for that. He gave he three months to change my style. He sent me here to study with Kenyon Crabtree.

BORDFELT: That Presbyterian art-school!

MARMADUKE JR.: Crabtree did our family portraits twenty years ago—deadest salon stuff—and my dad still thinks he's the last word.

BORDFELT: Does he want you to paint like that old mummy!

MARMADUKE JR.: I'd rather starve! That's about what I'll do, though. Dad had reconciled himself to the high-brow idea of having one painter in a banker's family—but a good, respectable, high-priced painter—like Crabtree. Not a painter like you, Bordfelt.

BORDFELT: You! Do you think you're a painter like me?

MARMADUKE JR.: No. I'm a free spirit, and you—you're an academician turned inside out. I think about as much of that new art-school you make a living out of as you do. I have managed to learn a bit working around with you.

BORDFELT (*Picks up book on table and reads*): "Yogi Philosophy," Are you interested in Yogi Philosophy?

MARMADUKE JR. (*Absently*): Oh, enough to borrow a book about it.

BORDFELT (*Picks up easel, etc.*): Well, I'm for work. Could I help any by talking to your father?

MARMADUKE JR.: He wouldn't think any more of your stuff than he does of mine.

BORDFELT (*At door*): I'm sorry you have to lose that fifty a month. You might learn to paint some day.

MARMADUKE JR.: Thanks.

(*A knock at outer door*)

BORDFELT: Your father! Well, I'm off. Let me know if I can do anything. (*He opens the door, revealing Mr. Josephs*)

JOSEPHS (*With gentle deference*): Excuse me, but could I see Mr. Marmaduke?

BORDFELT: He's hardly—up. (*Half closes door, speaks low to Marmaduke Jr.*) It's your landlord!

MARMADUKE JR.: Oh, let him in. Might as well face it now. Come in, Mr. Josephs. (*Exit BORDFELT. Enter JOSEPHS.*)

JOSEPHS: Good morning. Sorry to trouble you, Mr. Marmaduke, but there's a lady wants a place to meditate in. Sounds funny, doesn't it, but she has money. It's Mrs. Dart. She likes the sound of the waves under this pier. Rich people can get what they like. She's a nice woman. Talks just like anybody—has no pomp and pride. She'll pay the rent in advance, and you're three months behind—but if you think maybe you could pay something sometime before next winter—

MARMADUKE JR.: I can't pay anybody anything anytime.

JOSEPHS: If only my store customers were paying any cash this summer—

MARMADUKE JR. (*With inspiration*): Would you take a canvas for the rent?

JOSEPHS (*Looking around the floor*): Canvas? What canvas?

MARMADUKE JR. (*Going to stack of canvases*): All these pictures may be immensely valuable some day. Take these nude bathers—(*He sets on the easel an oil painting with cubistic-looking nudes*)

MR. JOSEPHS: Are those people?

MARMADUKE JR. (*Complacently*): Done in the real spirit of primitive sculpture. Faultlessly naive.

JOSEPHS: Eh?

MARMADUKE JR.: Faultlessly naive.

JOSEPHS : Is that my beach they're on ? Why, it's against the law for those people to go on that beach without bathing suits ! What if the selectmen should see this ? What's to keep them from holding me responsible ?

MARMADUKE JR. : But if you didn't know they were people, how should the selectmen ? I won't tell them. (*Sets another picture on easel, standing the first one against its foot.*) Perhaps you'd rather have this one.

JOSEPHS : Is that a porch in that lower corner with people looking at the harbor ?

MARMADUKE JR. : No, that's an acute angle with a splash of purple. (*Observes that it's upside down. Turns it*) It doesn't represent anything. It's just itself. It doesn't imitate anything. It's pure creation.

JOSEPHS : Eh ?

MARMADUKE JR. : It's pure creation.

JOSEPHS : But how long do you think it will take these pictures to get valuable, Mr. Marmaduke ? I've got to make a payment on my store building in December, and my creditor—maybe he'd rather have the money.

MARMADUKE JR. (*Setting another picture on easel*) : Here—how do you like this one ?

JOSEPHS : Is that—is that an eye ?

MARMADUKE JR. : An eye ? Yes, call it an eye. Yes, exactly—the eye of God ! Now you take that and hang it in your store. With the eye of their Maker on them people will soon pay up enough to make up my rent.

JOSEPHS : Oh Mr. Marmaduke, so many of those people aint got no religion ! I wish I could accomodate you, but my circumstances—I'll have to take the cash in advance from Mrs. Dart.

(*Knock at door*)

MARMADUKE JR. : My father ? (*Braces*) Well. (*Calls*) Come in. (*Opens door*)

(*Enter Mrs. Myrtle Dart in East Indian robe and turban. Sees Marmaduke, and halts surprised*)

MYRTLE DART : Oh ! I was looking for Mr. Josephs. Is someone already renting this studio, Mr. Josephs ?

JOSEPHS : Mr. Marmaduke Marvin has been, Mrs. Dart, but he's leaving.

MYRTLE DART : I was going to send my things here this afternoon, but—

JOSEPHS : That'll be all right, Mrs. Dart. Mr. Marmaduke is leaving this morning.

MYRTLE DART : (*Looks intently at Marmaduke, then at his room. Catches sight of the Yogi Philosophy book on the table. Moves to it swiftly, picks it up.*) : Are you reading this ?

MARMADUKE, JR. : Why, yes.

MYRTLE DART (*Significantly*) : So am I. I love it. (*Looks at pictures.*) And you are a painter. (*Taps volume*) Do you paint—this ?

MARMADUKE JR. : Paint Nirvana ?

MYRTLE DART : But the feeling created by the knowledge of Nirvana ! Oh for an art that could but hint at that ! (*Looks at picture on easel*) Wait ! Let me look. Do not explain. Mysterious ! Why does it impell me to pronounce the holy syllable OM ? It gives me vision of that infinity the Yogi sees within himself. Is it the spiritual form of the navel ? The plexus of the sun, the symbol of cosmic introspection ! Did you *know* you were painting that ?

MARMADUKE JR. : The navel ? Well, I—of course, something unknown to me within me may have known.

MYRTLE DART : I want it. I must have it. It isn't sold, is it ?

MARMADUKE JR. : No. No, it isn't sold.

MYRTLE DART : I'll take it. What is its price ?

MARMADUKE JR.: (*Low to Josephs*) How much do I owe you?

JOSEPHS: Seventy-five dollars.

MARMADUKE JR.: I don't see how I can let that go, Mrs. Dart, for less than seventy-five dollars.

MYRTLE DART (*Opens bag, takes out bills*): Here is a hundred. May I take it now?

MARMADUKE JR.: The picture? Don't you want me to frame it for you?

MYRTLE DART: I must have it now. I must carry it myself—with my own hands. (*She takes picture from easel, glides to the door, and goes out without closing it*)

MARMADUKE JR. (*Stares at money*): Well, I'll be—

MR. JOSEPHS: Rich people get what they like. A minute ago I could have had that for nothing. They've begun already.

MARMADUKE JR.: What have?

MR. JOSEPHS: The pictures. They've begun to get valuable already.

MARMADUKE JR.: This feels too much like a dream. That Mahatma woman couldn't possibly exist except in a dream—or a hangover. (*Puts hand to forehead.*) You look substantial enough, Mr. Josephs. Nothing dream-like about you. Well, one can't pay real rent with dream-money. Is that seventy-five dollars?

JOSEPHS (*Taking money*): But then she don't get the studio after all. I'll have to tell her right away. Excuse me. (*Exit hastily after Mrs. Dart, not closing door*)

(*Marmaduke Jr. turns toward bedroom, sees Yogi book on table, skims a sentence, smiles, kisses the book, goes into bedroom. After a moment MAR-MADUKE SR. in cap and linen duster, with motoring goggles pushed up on his forehead and a cane, appears in doorway. Looks in, sees no one, enters.*)

MARMADUKE SR. (*Looking at picture of nude bathers.*): Good God! (*Looks at pattern picture*) Merciful heavens! (*Looks at picture on back wall*) Fifty dollars a month for this!

MARMADUKE JR. (*Sticking head out of bedroom*): Oh, hello, Dad. You here?

MARMADUKE SR.: Did Kenyon Crabtree teach you to do *this?*

MARMADUKE JR. (*Disappearing*): I'll be dressed in a few minutes.

MARMADUKE SR. (*Looking at watch*): Quarter of ten and not up yet!

MARMADUKE JR. (*Off*): I've been delayed this morning. People here on business.

MARMADUKE SR. (*Grunts*): Business! What business do you do?

MARMADUKE JR.: Have you had breakfast?

MARMADUKE SR. (*Severely*): Two hours ago. (*He catches sight of fierce chalk drawing of man's head on floor behind door*) Holy God! (*Swings door aside, picks up drawing. Gives a start, seeing another drawing on door*) What a nightmare! (*Still looking at door he sets back the drawing in his hand, reversing it. He does not see the Matisse-like head and breasts of the fat woman on the back of the cardboard, but turns toward bedroom storming*) Have you got any real pictures to show, or are they all like these?

MARMADUKE JR. (*Strides from bedroom strug-gling into shirt, shakes hands in passing*): Dad, I've simply got to have some coffee first. (*Backs to outer door*) I'll be back in ten minutes. (*Runs into Kenyon Crabtree in doorway. He is dressed in immaculate white flannels, wears a little imperial, no moustache, carries folding, horn-rimmed glasses on cord.*) Excuse me, sir! Whom did you wish to see?

CRABTREE: I was looking for Mr. Marmaduke Marvin—Mr. Marmaduke Marvin.

MARMADUKE JR.: I am Marmaduke Marvin Junior.

MARMADUKE SR. (*Who has been scowling at a drawing beside the bedroom door*) : Why, it's Crabtree! Glad to see you, Kenyon. (*Advances and shakes hands.*)

CRABTREE : I am happy to see you.

MARMADUKE SR. : Do you mean to say you don't even *know* Mr. Crabtree? Here studying art with him and never laid eyes on him. Never saw him till this minute! Of all the deceitful, dishonorable— !

MARMADUKE JR. (*With dignity*) : I'll discuss the whole matter with you—*after* breakfast. (*Exit Marmaduke Jr.*)

MARMADUKE SR. : Well, of all the impudent, high-handed— ! (*Words fail him*)

CRABTREE : I gather that the young man's conduct has not pleased you.

MARMADUKE SR. : Pleased me! I sent him here to study with you. Have you ever laid eyes on him?

CRABTREE : No.

MARMADUKE SR. : And look at the stuff he paints! Look at it! (*Crabtree crosses front to look*) It's a disgrace to the family! (*Marmaduke Sr. looks closer at picture at foot of easel*) And look at that! (*Jabs at right lower corner of canvas with stick*) Just look at that! He has the effrontery to put his name—my name—on that atrocity! (*Turns away overcome, and crosses toward table, his voice suddenly weepsy*) What do you suppose possesses him to paint like that? Why does he *want* to paint like that!

CRABTREE (*Regards pictures mournfully and sighs*) : God knows!

MARMADUKE SR. : (*Still lachrimose*) I ask you candidly, Kenyon—could they possibly be worse?

CRABTREE : They could not. They deliberately violate every canon of sane art—apparently for the mere perverse pleasure of violation.

MARMADUKE SR. (*Dropping into chair at right of table*) : He's hopeless! I gave him three months to reform, the three months is up, and—oh! (*Ges-*

ture of despair toward pictures) I told him he'd get no more money out of me unless he changed his style. Let him starve awhile and maybe he'll be a bit more tractable.

CRABTREE : That seems a desperate remedy, and yet—it is a desperate case. He's been running around with a Mr. Bordfelt, the head of a *post*-impressionist art-school that actually *teaches* this sort of thing. They've even misled some of my pupils.

MARMADUKE SR. : If I gave him another chance he'd do just the same thing over again. I have to put the screws on him.

CRABTREE : Oh, if all parents would only adopt such serious measures, it would soon put a stop to this false affectation. (*Sitting down*) Well, you'll have luncheon with me, will you not?

MARMADUKE SR. : Thanks. Well, I'm so upset by this disappointment—How are you Kenyon? How have you been?

CRABTREE : Oh, my health's good enough, but it's been a miserable year for pictures. (*Pause*) I haven't sold one—and only one gold medal.

MARMADUKE SR. : You haven't sold a picture? Why, I thought your income came to thousands every year.

CRABTREE : I've had to cut down my scale of living. I've been able to put up only fifteen rods of new white lattice fence this year. This hectic stuff is all that gets talked about.

MARMADUKE SR. (*Arrested by novel idea*) : Why, is that so?

CRABTREE : Work in good taste no longer commands any publicity. One might as well play a flute in a brass band. (*Marmaduke Jr. and Bordfelt appear in doorway*) Not that people *like* this crazy stuff—it shocks them. But unfortunately—after the shock—they seem to lose all interest in sane art. The furor kicked up by these so-called *post*-impressionists—

MARMADUKE SR. : You don't mean to say people *buy* this sort of thing?

CRABTREE : No, they are ruining us without in the least benefiting themselves. Nobody *buys* their stuff.

MARMADUKE JR. (*Stepping into room, chortles*) : Is that so? (*Marmaduke Sr. and Crabtree turn sharply in their chairs.*)

MARMADUKE SR. (*To Marmaduke Jr.*) : What do you mean by that?

(*Bordfelt crowds past Marmaduke Jr. and marches up to Crabtree*)

BORDFELT : I'm sorry, Mr. Crabtree, that we artists are hurting the picture business.

CRABTREE : Failure to sell your pictures, Mr. Bordfelt, is not infallible proof that you are a true artist.

MARMADUKE JR. (*Closing door*) : That's true. People do sometimes buy your stuff.

MARMADUKE SR. : What gave you that gleam of intelligence?

BORDFELT : To be more interested in selling one's pictures than in painting them is infallible proof that one is no artist at all.

MARMADUKE JR. (*Suddenly gloomy*) : Are you referring to me? (*Leans back dejected against the door.*)

MARMADUKE SR. : I haven't met this gentleman.

CRABTREE (*As he and Marmaduke Sr. rise*) : Mr. Bordfelt, Mr. Marvin. (*They do not shake hands*)

MARMADUKE SR. : I want to say to Mr. Bordfelt that there's something wrong in the head of anyone whose income depends on the sale of pictures and is not interested in their sale. That's been the case with my son now for two or three years, and I'm not thanking you, sir, for encouraging him in his folly. I sent him here to straighten out, and it looks as though he might have done it if it hadn't been for you.

BORDFELT (*Angrily*) : I refuse to be the goat because your son does not choose to paint in the style of 1890! It's your own fault, sir. You should have begotten him twenty-five years sooner!

MARMADUKE SR. (*Roars*) : You shouldn't have been begotten at all! (*He strides over to Marmaduke Jr.*) Are you going to stand there and allow your friends to be impudent to your father?

MARMADUKE JR. : I have faith in my father's ability to be more impudent than they are.

MARMADUKE SR. : Impudent—I? I—impudent! (*He storms left front*) Young man, what you're going to get from me now is a first class chance to show how much ability you have to make your own living.

BORDFELT (*In chair near front, back to audience*) : Well, he sold a painting this morning.

MARMADUKE SR. (*Dumbfounded*) : Sold a painting! *He?*

CRABTREE (*Excited*) : Sold a painting!

MARMADUKE SR. : Sold one of these things?

CRABTREE : Who bought it?

MARMADUKE SR. : Who was fool enough to buy it?

BORDFELT (*To Marmaduke Jr.*) What was her name, Marmaduke?

MARMADUKE JR. : A Mrs. Dart.

CRABTREE : Myrtle Dart?

MARMADUKE JR. : I believe that was her name.

CRABTREE : Not *the* Myrtle Dart?

MARMADUKE JR. : Talked like a female Mahatma. Wore an East Indian robe and turban. Placid person being intense and stealthy.

CRABTREE : It's she. Queer but influential. At least certain wealthy circles will talk about a picture bought by Mrs. Myrtle Dart. Mr. Marmaduke I congratulate you. Your star is ascending.

MARMADUKE SR. (*Genially*) : Well, well! And Crabtree hasn't sold a picture for a year. How much did you get for it, Marmaduke?

MARMADUKE JR. : Only a hundred.

MARMADUKE SR. : A hundred. Well, that's a beginning, that's a beginning. Can't expect five thousand for the first one, hey Crabtree?

CRABTREE : Certainly not. And sometimes not for the last one.

MARMADUKE JR. (*He hurls to the floor a flower he has been holding*) : It's disgusting!

MARMADUKE SR. : Disgusting? It's fine? What is there disgusting about it? It's the best thing I've heard for a month.

MARMADUKE JR. (*Goes front center, sits, back to audience, in chair vacated by Bordfelt, leaning over its back.*) I've had nothing but mercenary emotions since I sold that picture. It's transforming. It's like a cat's first taste of blood. I have a carnivorous desire to sell. I don't want to be carnivorous. I don't want to be caught by the horrible American moneylust. I don't feel like an artist any more. I'm commercialized. I might as well paint like Crabtree! (*Drops head on arms.*)

CRABTREE : What!

MARMADUKE JR. (*Springing up*) : Yes, sir, I *will* paint like Crabtree. I'll join his class tomorrow!

MARMADUKE SR. : Hold on there! Crabtree hasn't sold a picture for a year! His pupils are going over to Bordfelt. The tide is turning. You mustn't change your style now, my boy, after you've begun to catch on. (*Pats Marmaduke's shoulder*) Put it through now on this line. I'll see you over the rough spots.

CRABTREE : We must adapt ourselves to a changing world. You, Marmaduke, sound a warning that I for one, am not too stiff-necked to heed. Could I arrange with Mr. Bordfelt for a few— discreetly private—lessons in post-im*pres*sionism.

BORDFELT : The new movement in art does not desire converts who joint it for mercenary motives.

(*Knock at door. Marmaduke Jr. opens it revealing Myrtle Dart, behind her Mr. Josephs with the picture she bought.*)

MYRTLE DART : (*Strides front center and turns pointing*) Please bring that thing in, Mr. Josephs. (*He enters*) Just set it there where it came from. (*He sets picture on easel.*) (*To Marmaduke Jr.*) You sold me that picture as a follower of Yogi. You said something within you knew you were shaping the sacred umbilicus—the symbol of that self-contemplation which reveals Nirvana! And five minutes before, *what* had you told *him?*

MARMADUKE JR. : Why—I—I don't—What did I tell you?

JOSEPHS : I'd rather not say anything to make trouble for anybody.

MYRTLE DART (*Sternly*) : Mr. Josephs, what did this man tell you that thing was?

JOSEPHS : He said—he said—I understood you to say it was the eye of God! (*Marmaduke Jr. claps hand to forehead.*) I understood you wanted me to hang it in my store to make my customers pay up.

MYRTLE DART : A thing to collect grocer's bills!

JOSEPHS : When you and Mrs. Dart agreed what it was, it did seem queer to me that the same picture could be a heathen belly button and the Christian eye of God.

MYRTLE DART : I won't have anything to do with your banal eye of God!

MARMADUKE JR. : Well, if you insist on looking at a work of art from the point of view of vulgar realism!

MYRTLE DART : There's your work of art. Please give me my money!

MARMADUKE JR. : I've spent seventy-five of it. Here's what's left. (*Offers her twenty-five. Marmaduke Sr. standing left front gives an inarticulate growl.*)

MYRTLE DART : How perfectly outrageous! Do you expect me to give you seventy-five dollars for nothing?

MARMADUKE JR.: I'm offering you every cent I have. I don't see what more I can do.

MYRTLE DART: You owe me one hundred dollars. (*She leaves majestically*)

CRABTREE: Well, I declare!

BORDFELT: Hump!

MARMADUKE JR. (*Looks after her impotently. Turns to picture and brightens*): It isn't sold! It isn't sold at all! I'm uncommercialized! I don't have to paint like Crabtree. I won't paint like Crabtree.

CRABTREE: I believe I'll reconsider too, Mr. Bordfelt. The results of *post*-impressionism seem a little too precarious. With my expenses—it's imperative that a picture should stay sold.

MARMADUKE SR. (*Exploding*): If you had the spunk of a rabbit *that* picture would have stayed sold. Why didn't you tell her a sale's a sale? You! It wouldn't do you any good to change your style. You couldn't take care of yourself anyhow!

MARMADUKE JR.: But if she didn't want the picture— ?

MARMADUKE SR.: You thought you'd just let it go and get the seventy-five out of me. Well, you'll not get it!

JOSEPHS (*Anxiously*): But where will he get it? I never ought to have spoke to Mrs. Dart about the eye of God! Oh dear! I never thought she'd get so mad. Wouldn't you thought she'd like the eye of God better than—Oh dear! It's me that spoiled your sale!

MARMADUKE JR. (*Nobly*): It's all right, Mr. Josephs. You didn't mean to get me into trouble.

JOSEPHS: But I did. Seems to me I ought to get you out. Don't you think that picture'll be a good deal talked about—bein' sold as a heathen billy-goat and sent back as the eye of God? Lots o' people be wantin' to see it. Don't you think if I hang it in my store it might be good for trade? I'll take it. There's the seventy-five. (*Takes picture*) This pays the rent for next month. (*Goes to door*) I'll take down the sign "Think!" in my store and put this in its place. (*Exit*)

MARMADUKE SR.: There's certainly something that looks out for children and fools!

MARMADUKE JR.: My art appeals to the plain people anyway.

CRABTREE (*Moving to the door*) Well, his rent is paid for a month, but if the hundred dollars goes to Mrs. Dart, how is he going to eat?

MARMADUKE SR. (*Stamping past Marmaduke Jr.*): The revelation he has made of his business capacity forces me to the conclusion that I owe it to society to support him—as a defective! (*Exeunt Marmaduke Sr. and Crabtree*)

BORDFELT (*Laughing*): A defective!

MARMADUKE JR. (*Resentful*): A defective!

BORDFELT: But supported, Marmaduke! Supported! Oh to be a defective!

MARMADUKE JR. (*Disconsolately pouring himself a drink.*): *Defective!*

BORDFELT: All artists ought to be supported as defectives. Then we'd be free to do real stuff.

MARMADUKE JR: (*Mutters*) Defective!

BORDFELT (*Going to door*): No more paternal art criticism!

MARMADUKE JR. (*Brightening*): That's *so!*

BORDFELT: No more fatherly interest in your style!

MARMADUKE JR. (*Jumps up smiling*) Yes,—and no more boomerang sales. (*He smiles*) Well here's to defective artists. (*He drinks to the audience*)

CURTAIN

CONTEMPORARIES

AN EPISODE OF THE CHURCH RAIDS

by Wilbur Daniel Steele

CHARACTERS

SAM, *a youth.*

HIS FATHER.

HIS MOTHER.

A LODGER.

OLD JOHN, *another lodger, half-wit.*

A PRIEST.

AN OFFICER.

Time : Later in the night following the first church raid.

Place : In a congested quarter of the city ; a single small room on the ground floor.

The curtain discovers the stage dark, save for a feeble jet of flame high on the back wall, right. A piece of board propped in front of this screens it from the eyes of the sleepers and further reduces its influence upon the gloom. Through the one small window, at the height of a man's head in the left third of the back wall, wheels an occasional pencil of brilliance as a light passes in the street. On the right wall is the door. Three couches, or pallets, may be seen, low to the floor; one in the left rear corner, beneath the window, two further along in the middle of the back wall. On one of the latter, as the curtain rises, may be seen the dim figure of a man, propped up on an elbow, scratching himself vigorously, slapping the coverlet, whining and grumbling.

LODGER : Damn the vermin ! If I hadn't paid for a week I'd go sleep in the gutter and be comfortable (*Yawns*) I wish I could sleep.

(*Falling back, he thrashes about for a moment, and then grows quieter. A man's snoring is audible from the couch in the corner. While the snoring continues, a figure is seen to arise furtively, climb on the foot of the couch and crane out of the window. A light, passing in the street, shows for an instant the face of a woman of perhaps fifty, lined and tired, the mouth sagging at the corners, the hair wild from tossing. On the pallet she steps down and steals across the floor, barefooted, to judge by the softness of her tread. After listening for a moment, crouched down beside the door, she starts back across the room, moaning a little and rubbing her hands together. The snoring in the corner culminates in a choking gasp and the snorer sits up abruptly.*)

THE FATHER : Huh—wh-who is—Oh, is that you ?

THE MOTHER : Yes, it's me.

FATHER : What's a matter ?

MOTHER (*hesitantly*) : No-nothing.

FATHER (*with a querilous impatience*) : Well, come on back to bed then. You woke me up. (*Lies back grumbling*) . . . worked 's hard 's I do . . . wanta sleep . . . night. (*Sits up again with a suspicious jerk*) Look here, has Sam come in yet ? Say ! Why don't you answer ? Has that boy come in yet ? (*After a brief pause, grimly*) So *that's* it, is it. All right, we'll tend to *that*. Just wait. Wait !

(*He lies back with his arms folded. The woman, after a moment of vacillation, takes one step toward the couch.*)

MOTHER : What you going to—to do to him ? It don't seem to do—much good—to—to beat him.

FATHER (*grimly*) : Wait ! That's all. Just wait—and see. (*Lifts himself on an arm and gestures across the room.*) Old John asleep on the floor there, all right ?

MOTHER : No. He aint come in either.

FATHER (*raising his voice to a reckless pitch in anger*) : They aint out *together*, don't tell me. Sam's never gone out with that crazy old fool.

LODGER (*sitting up suddenly*) : Say, look here, you two. What kind of a place is this, anyway ? I thought I was paying my good money for a place to sleep.

FATHER (*belligerently*) : You did, did you.

MOTHER (*running toward him with hands up in desperate expostulation*): Shhh! Hush. Now, now! (*Turning toward the lodger, almost fawning*) That's all right. Don't mind him, he's all nervous. Yes, yes, we'll be quiet. Sure, we'll be quiet. (*Sitting down on the edge of the couch and whispering fiercely to her husband, who seems still upon the point of breaking out*) Shhh—keep quiet, will you. You'll make him mad and he'll go—and times as hard as they is. Now, now—hush up.

(*At a sound of feet running somewhere outside she gets up and stands beside the couch, staring toward the door, her hands clenched against her bosom. The door swings open slowly; a figure slips in with the utmost caution, pausing midway to bend and take off his footgear; one of them, escaping his hand, falls to the floor.*)

FATHER (*startled*): What's that? Say! That you, Sam?

(*The figure remains silent, crouching back against the wall and striving to control his breathing which comes in the hard sobs of a runner.*)

FATHER: *Sam!*

SAM (*in a voice scarcely audible*): Yeh.

FATHER: So! Where you been.

SAM: Nowheres.

MOTHER (*nervously*): Go on, get in bed, Sammie. (*To her husband, appealingly, with a motion toward the lodger.*) In the morning, Matt—not now. Le's be quiet now. He'll be mad if he wakes up again.

LODGER (*with a weary sarcasm*): *Again?* Joke!

MOTHER: See?

FATHER (*ignoring the others; to the youth.*): Been nowheres, eh? Been a-bed in the house all evening, eh? What you puffing so for? Been running? Somebody after you?

(*During this speech there has been a growing number of feet running, now the pursuit passes beneath the window, making a tumult. The youth*

sneaks hastily across to the unoccupied couch, gets down and pulls a blanket over him. While he is doing this, the door opens once more, furtively, and a figure, crawling in unobserved by the other occupants of the room, wriggles into the dark corner, left, rear, and remains there, huddled up, heaving slightly. The runners pause for an instant outside and the voices are heard; muffled.*)

PRIEST: In here! I saw him turn in here!

OFFICER: Naw, naw, down there further.

(*The pursuit passes on. The lodger, who has been sitting up, listening, turns to look down at the couch beside him with growing interest.*)

LODGER: A-hah! So-*hoh!*

FATHER: *Sam!*

SAM (*his voice muffled by the bedclothing*): I aint done a thing. Honest—I—I aint d-d-done a thing. Just go round and holler a little with the crowd. I wanted to come—come home—right after we left the church, but they—

MOTHER (*astonished*): Church? Church, you say? What was doing at the church?

FATHER: I aint heard of nothing and I got a job there—I ought to.

SAM: Aw, just raisin' the devil with the folks there, and the priests.

MOTHER: *What?*

FATHER (*for the moment quite helpless; in a falsetto voice*): Wha'—wha'—what's the boy talking about?

SAM (*uncovering his face, not unpleased by the impression he has made*): Sure. It's that new gang that claims ever'thing's wrong. You know—you heard about 'em. The crowd that's holdin' meetin's of the workin' people—trying' to start somethin'—you know. They got a speaker there that—well, I aint ever heard a fellow talk like that one does. Comes right straight out about the churches and the priests and all, and they's scared to touch him on account of the mob, and the mob's with 'im.

FATHER (*wildly; appealing to everybody*): What's the boy talking about? Why's he lying this way?

MOTHER (*standing with her hands pressed desperately against her cheeks*): Sam—shhh. Don't talk no more tonight. Le's all be quiet and go to sleep. There Matt! (*Leans down and tugs with a gentle insistence at her husband*) Lay down Matt and be quiet. He don't mean nothing. (*Lies down*)

SAM (*smartly*): I don't, eh!

LODGER (*musing*): So they've got around to the churches at last, have they. Hmmm! Well—I thought they would, before they got through. I've heard that fellow talk. Lot of good they'll get out of it. . . . (*Looking at the youth, ironically*) So you're a regular anarchist, Sammie. And who led *you* into the fold?

SAM: Huh?

LODGER: I mean, how did you come to get mixed up with this?

SAM: Oh! Well they fed the gang the other day. Some of the boys was up, and they was talkin' about it. But there wasn't no feed this time.

LODGER: Ha-ha-ha. We've got a wild one here. He went for the feed. He's going to undermine society and do away with the home. The feed—that's what gets 'em.

SAM (*a little piqued*): But there was sport, anyhow. You ought to have heard the folks in the church squeal when that organizer says the place ought to be tore down, for all the good it done people, and he'd tear it down himself if he felt like it. And the priests hollerin' that there's the holy bread there, and him comin' right back at 'em, sayin' it was holy just 's long 's there wasn't any men hungry. Wow—you should a seen 'em. Big, fat slobs, he calls 'em, livin' off the poor widows 'n'orphans. And I thought sure they was goin' to pinch him—only he got away. Oh, say—I come near forgettin'—you know Old John! Well, Old John was right up in the bald-headed row, hollerin' halleuja with the best of 'em.

LODGER: The babes and the simpletons—burning with a holy fire.

(*During the course of the lad's speech, the father has gotten up from the couch, moving very slowly and as though with difficulty. He advances, stiff-legged, and stands at the foot of the lad's couch. At the end of the lodger's speech he raises his arms over his head, shaking in a paroxysm of rage. The mother, sinking down beside her couch, watches him in a horrified silence.*)

FATHER (*stammering wildly*): Ugh—ugh— (*His arms fall down suddenly limp; his chin sinks in his neck; he walks back to the couch unsteadily, sits down and buries his face in his palms. His naked shins loom faintly in the dark.*) God help me. If I touched him now I'd kill him. I can't understand. I can't understand. Fourteen long years I've worn my knuckles bare to give him a coat to his back and food to put in his belly—and now—and *now! Now! This* is my pay. (*Pauses for a moment, rocking his head and groaning*) When I was a boy my father put the fear of God in my heart; he showed me how to be a law-abiding man—how to fill the place God had given me to fill, make an honest living, leave an honest name behind me. And God knows I've tried to pass it on to *him*—over there. And now—and *now! Now!* (*Jerks up his head and goes on rapidly in a tone of apprehension*) What if somebody seen him in that crowd of jailbirds? Somebody that knows him. And me with a church job. (*Outraged*) And he'd do *that* to us. Turn his father and mother out in the street—when they're old. The worm! The mean little worm! (*Still more loudly, letting himself go in an abandonment of fury*) I wish he was dead before he come to this day. I wish—I wish to God—

MOTHER (*horrified, rising and clutching at him*): Oh, don't. Hush, Matt. Don't say things like that—even—even in m-m-make-b'lieve. Somebody might hear you. Don't.

FATHER (*drunk with his own words*): I do! I do! I wish he'd never been born. I wish to God—

(*A sudden loud knocking on the door makes them all turn. They remain in attitudes of dismay, rigid and silent. The knocking is resumed, more violently. A voice is heard outside.*)

OFFICER: Open up there. All dead inside there? Open the door. Open up!

MOTHER (*wringing her hands*): Oh dear! Oh dear! Oh dear!

(As the summons continues, she starts across the room, pressing her two hands against her cheeks and moaning. When she has come almost to the door, it is thrust open a crack, discovering a pale, uncertain light without, and the shadow of a head in a helmet cast across the further jamb.)

OFFICER: What d'you say in there? Here, turn out, somebody—and get a move on.

MOTHER *(craning her head around the edge of the door, bewildered)*: Yes, yessir! What's a matter—what you want, sirs? We're *honest* folks here.

OFFICER: Yes, I guesso. Honest like a grave robber. Where's the crook?

MOTHER *(in shrill distraction)*: I—I don't know what you mean. We're honest, respectable, workin' people here. Oh dear—dear—

OFFICER: That's all right, but I want my man. That's all.

MOTHER: But—but I *tell* you—

PRIEST *(outside)*: Just a moment, my man. If you'll let me talk with her. *(To the mother)* My good woman . . . Hello! What's this? Don't I know you? Wait a minute. Hmmm. You have a husband.

MOTHER: Ye-yessir.

PRIEST: Hmmmm. I think I know him, don't I?

MOTHER: No—n-n-nosir—I don't b'lieve so, sir. No sir. No sir.

PRIEST: Hmmm. Well, I'll talk with him, if I may.

MOTHER *(in profound agitation)*: Well—he's—ugh—he's away, sir. You can't talk with him because, you see—he's away, you see.

PRIEST: Hmmm. I see. *(To his companions)* Now, now, just a minute. *(To the woman.)* Hmmm. Well. The point is, a fellow ran in here a few minutes back—*not* with your permission, I may hope. No, no, don't lie, please. We saw him; so you may as well tell the truth.

MOTHER *(snivelling)*: We're all honest folks here.

PRIEST *(without)*: Come, come! Don't keep saying that. Is the fellow here or isn't he? We'll get no sleep tonight.

MOTHER: Oh, dear. Oh, dear.

PRIEST *(angrily)*: Is he? Say!

MOTHER: He didn't do nothin' wrong. Honest he didn't do nothin'—

PRIEST *(triumphantly)*: Aha! Now we're coming to it,

MOTHER: But I tell you he aint done nothing bad, sirs. He wouldn't—he aint that kind, Sam aint. A little micheevious mebby—like any other boy. You was boys once, sirs. You wouldn't hold *that* up agin him—

PRIEST: Humph! Nothing wrong! I like that! It's nothing wrong then to cheer on the desecration of a church of God; nothing wrong, then, to hold up a servant of God in the open street, insult him with the vilest language, tear off his coat and run away with it howling blasphemies. Nothing wrong! Humph! But here, here. We can't stand here all night, bickering with an old woman. . . .

OFFICER: Well, well! Step back and let me in.

PRIEST: Just a moment. Let me! *(to the woman)* Now will you be reasonable. You know, as well as we do, that a thing like this can't be passed over. We've got to have him out one way or the other. Now will he come out peacibly, without rousing the neighbors, or—

MOTHER *(hastily)*: Yessir—yessir. Don't come in. I'll bring him out, sir.

(She turns and staggers toward the lad's couch. Her husband comes from the other corner, hesitating, making wild, tragical, impotent gestures.)

MOTHER *(sobbing and choking)*: My boy! My boy! What have you done, Sam. Oh, Sam, my boy. Sam! *(Turning to the man, in an imperious whisper)* Get back, Matt. *Don't* let 'em see you, Matt. *Don't* let 'em see you, for God's sake. *(Matt sneaks back to bed, the mother sinks down at the foot of the lad's couch, sobbing through her fingers)* What have you done? What have you done? Oh, my boy, my boy, my boy.

OFFICER (*shaking the door*): Get a move on in there—or I'll have to help you.

MOTHER (*springing up and tugging at the lad's arm.*): Come—come—you got to go out. They won't hurt you, Sam. Just go out a minute, Sam. Come qu-qu-quick, Sam.

SAM (*blubbering in terror*): I aint done nothin'. Le'me go. I aint done nothin', I tell you.

OFFICER (*Impatiently.*): Well, what d'you say in there?

MOTHER: My boy—Sam—you *must* come. (*Half drags him from the couch and urges him across the floor*) They won't hurt you, Sam. They wouldn't hurt you—they're good men. Oh, my boy—my little boy. Come—you gotta come—

SAM (*struggling and screaming*): No—n-n-no—le'me go back to bed. Please, mother—*mother*—I aint done nothin'. Oh, please—I'll be good—

MOTHER (*pushing him into the bright aperture*): Th-th-there sirs. (*panting terribly*) There s-s-sirs. There's my boy.

(*There is a moment of confrontation, tense and breathless.*)

PRIEST: Why—why—there's been some mistake. This boy—why, this isn't the fellow.

(*As the mother sinks down by the door, with a revulsion of weakness, the lad, released, rushes back and tumbles on the couch, dragging the clothing over him.*)

MOTHER: Oh, thank God—thank God!

OFFICER: But where's the man then?

PRIEST: Yes. See here, where's the man that came in here?

MOTHER (*springing up with renewed energy*): Why—why—there *aint* been anybody *else*, sirs. Sam's the only one's come in here. Honest, sirs. I'm tellin' the truth, sirs. Why—why—*can't you see I'm tellin' the truth?*

PRIEST: Yes, she's telling the truth. We've been on the wrong track. I suppose we might as well go on home.

OFFICER: Not so fast! What I want to know is, where's the boy been this time of night. (*To the woman*) He's been running around with that gang o' church robbers. Don't try to deny it.

MOTHER (*growing fearful again*): He's only mischeevious, sirs. He don't mean nothin', sirs.

OFFICER: Well, we'll have him out anyway!

PRIEST: Oh come now; what good will it do to shut the lad up. A good beating, now—that's better. A good sound thrashing.

OFFICER: That's the idea, now. I'll tend to that—thorough. I know how. I got 'em of my own.

MOTHER (*appealing*): Oh now, sirs—please sirs. My man will beat him—er—when he comes home. Oh, he'll beat him, sirs, and never fear. He—he'll beat him harder'n *you* would—a pile harder, sirs. He'll almost *kill* him, my man will, when he hears.

OFFICER: Well, well; have your own way about it. Only send him up to me tomorrow with blue welts on him. I want to see for myself. (*To the other*) Come along, we may as well go and get a little sleep.

(*The door slams shut and footsteps are heard retreating outside. The mother, after listening a moment; drags to the boy's couch, where she kneels, buries her head in her arms, and sobs, almost inaudibly. The father, rolls from side to side, groaning.*)

FATHER: The shame of it! The shame of it! And if they ever find out!

(*After a moment there comes a low rapping on the door; it opens, dark now, and the figure of the Priest enters cautiously.*)

PRIEST (*uncertainly*): I—I say there—where's the lad?

MOTHER (*jumping up hastily*): Here. Right here, sir. *This* way, sir. Wh'-what you want, sir?

PRIEST: Just a word with him.

(*He advances, groping, stumbling once with a sharp exclamation, and stands over the couch. The mother has retreated toward her side of the room and stands as if to screen her husband from discovery. The priest speaks in a deep, round voice, not altogether from a certain professional quality. His finger-tips rest together in front of his stomach.*)

PRIEST: My son, my son! I had to come back. I could not go away without saying a word to you. I want to help you, because you are in need of help. You have committed a grievous sin; a sin against your Heavenly Father; a sin against the laws of the state. Yet, somehow, I cannot bring myself to believe that you knew clearly what you were doing. There is good in you, my son—perhaps—great good. It is my business to help you bring that good to the surface; to give you wise counsel; to guide your young feet clear of the pitfalls that lie in the path of the unwary. Ah! Now there is a most grievous spirit of unrest abroad among the people today—the devil stirs in his hell and rocks the world. An evil thing! But it seems good to the young: it is something new, and to a certain type of mind, especially the mind of the young, the new thing has ever the appearance of the good thing. 'We will throw off all restraint: our conscience shall be our law,' they cry—forgetting that the conscience, untutored in righteousness, is like the desire of a little babe who cries for the lamp which would sear his tender skin—forgetting, too, that these laws which he would cast off in favor of his conscience are, in themselves, the crystalized conscience of all the generations of men gone before, directly inspired by the great Author of Conscience, God. Now, my son, think hard for a moment. Do you really believe that you know what is best for you—better than your father and mother, and their fathers and mothers, back through the long procession of the years?

SAM: Ugh-ugh. Nosir, nosir.

PRIEST: There, there! Ah, if people would but stop to think—honestly *think*—for a moment.

SAM: Yessir, yessir.

PRIEST: You are not *bad*, my son.

SAM: Nosir, nosir.

PRIEST: I feel sure you have a desire to do the right things, to grow up in the fear of God Almighty, to be a decent, sober member of society, able to look your neighbor in the face.

SAM: Yessir, yessir.

PRIEST: Ah, that is good. And I want to help you, my son. You will want to see me a little while each day now. From time to time, perhaps, you can bring some of the other lads with you. We want them all to be good, don't we, you and I?

SAM: Yessir, yessir.

PRIEST: And—ah—when you are going soberly about in the streets, if you should chance to hear any wild, violent or sacrilegious talk, you—ah—you will bring me word of it as quickly as possible, will you not? We're fighting this together, you and I.

SAM: Yessir, yessir.

PRIEST: Ah, that's good, that's good. We'll pull out of this, my son. Well—I think that is all. Don't worry, my lad. Go to sleep. I will take care of you. The church of God is a shield and a buckler (*Moves to the door, opens it, and pauses*) I bid you all good-night. Ah—my good woman—you may tell your husband not to beat the lad *too* hard, won't you. Ah—good night. And the Blessings of God. (*Goes out, closing the door*)

MOTHER: Ah, he's a good man—a good man.

LODGER: He's a wonder—a marvel. One of the best I ever saw, and I've seen some handy ones.

MOTHER: Yes, and so kind to us poor people. Sam, aint you ashamed now?

LODGER (*speculatively*): Hmmm! What would you call it? Not blackmail, of course—not among that class of people. Hmmm! I give it up. . . . Oh, Sammy my son; now you won't forget to run right straight off and tell the good priest if you hear any rough-looking character hollering: "Hey, everybody: come on let's go tear down a church and strangle a couple of babies!" Will you?

SAM : Nosir, nosir.

LODGER : Like a machine (*Sitting up and nursing his knees in his arms, musing reminiscently*) I may be down and out now, but I've seen a bit of life, here and there. I've been through it all, both sides. I followed the priests, till I learned half my lesson : I followed the new prophets, one after another, till I learned the other half. It's hard on the system, but now, at least, my eyes are clear. I can see the whole show at once, and be amused. It's not amusing when one sees only one side of it : it's serious, soul-searing business then, isn't it, Sam ?

SAM : Yessir.

MOTHER (*in a whisper to her husband*) : What's he talking about ?

FATHER : I dunno.

LODGER : Ten years ago—five years ago—I suppose I'd have been up there at the church with the mob, waving my arms and bellowing for the world to turn over. I'd swallow the whole program, bolt it down—and rub my belly for more. It always tastes good to the hungry man. Because, you see, it's never entirely wrong. There's always a coating of essential truth. Oh, they think they've got it, you know, these chaps. . . . Yes, I'd be up there and swallow the hook, and then, when this one passed on—got his head broken, or, if he's wiser, got his little bit from the Big Fellows and vanished out of sight— why, I'd be there with my mouth hanging open for the next one, along with the rest of the sheep . . . But now—no more. I'm through. I don't know what gospel this particular prophet is preaching—

MOTHER (*in an agitated whisper to her husband*) : What's he saying, Matt ?

FATHER (*uneasily*) : Look here, sir, I—I won't have no blasphemies talked in my house—not after what's happened tonight. Y' hear ?

LODGER : Ha-ha. Hold on there ! Easy ! I'm talking on your side, brother.

FATHER (*sullenly*) : Well, I dunno. I aint got much schooling, but I'm a decent, sober, hard-workin' man, and I don't want no trouble.

LODGER : That's right. That's perfectly safe. Now what I was saying—I don't know what his particular medicine is—I'm not interested. What I want to know is, how does it work on the man himself ? What's his game ? What's behind him ? Now somebody tells me he was run out of his own town by the good citizens. Once, that would have been enough for me—a guarantee of his good character. Now, I want to know more about it. There are several things a man may be run out of town for, some of them rather nasty. Then there are some women in his crowd. I used to know one of them myself, and in those days she belonged to anybody—anybody with the price, that is. "Well," they say, "*But*—but now she's in the great fight—can't a woman turn over a new leaf "—and so forth and so on. Sure ! Only, *I want to know!* Perhaps it's all right for this fellow to get himself taken up by some of our very best people—feted and feasted (after working-hours) by some of the rottenest-richest men in this town. Maybe. I don't know. Perhaps it's all right for him to have a meet-up in his place, late one night when nobody's looking, with a certain party—a party very close to the place where church money comes in. Perhaps it's all—

(*He breaks off sharply, and all start up and stare at the left-rear corner, from whence there arises now a high, quavering voice.*)

OLD JOHN : It's lies—all lies—lies, lies, lies, lies. He's a better man 'n you are, 'n' a thousand like you—'n' a million like you. *What* y' talk like that fer ?

MOTHER : Wh-why, it's Old John. Wh'—why—

FATHER (*outraged, in a voice of thunder*) : When did you sneak in here. Tell me quick, 'r I'll—

OLD JOHN (*in a terrified falsetto*) : Right after Sammy. Nob-b-body seen me—honest.

MOTHER : Why, he's been here all along. (*Wailing*) I lied. I lied to the good priest. Matt, Matt—he's made a liar out o' me—Oh, *what* 'd happen— *what* 'd happen if they was to find him here now ? After me sayin'—

FATHER (*getting up and starting forward a step, pointing an angry finger*) : Get out o' this house. *Now!* D'you hear me, old man. Get out before I

wring your skinny old neck. And don't you never show your face round here—never again. Hear? Get! *Get!*

OLD JOHN: A-a-all right, I'm gittin'. Can't y' see I'm gittin'? (*He edges along the wall toward the door, one arm crooked defensively over his head, but when the father settles back a step with his hands on his hips, the old man stops and begins to protest once more with his frail, high passion.*) But–but that man ought'n' to say them things about *him*. Oh, if he on'y *knowed* the man. If he'd on'y *talked* with 'im. The' aint a shadder in his soul. He's poor an' weak, but that don't make no matter—he's here to stan' up fer the poor an' the weak. He knows they're fixin' to git 'im: he's knows they're *goin'* to git him before they git through. He knows he aint done nothin' wrong, an' yit he aint got the show of a murd'rer, the way justice is now. But all that don' make no matter. He jes' goes on an' on. An' his work's goin' on after he's gone. . . . Yes, yes, I'm gittin'. Can't y' see I'm gittin' fast's I can. (*Crawls another yard or so and bursts out afresh, even louder now, with the abandon of an infatuated zealot*) He's goin' to make the world over, he is. I'm as good 's the richest man in this city. It's comin' our turn now. The earth belongs to us: we been last a long time, an' now we're goin' to be first. It's a new world comin'—a—a beautiful, *glorious* world. No more every feller tryin' to git the best of the next feller. No, no. All brothers—one big fam'ly o' brothers—help instead o' hender—love instead o' hate. (*As the father starts forward with his fists high over his head*) Yes, I tell y' I'm gittin' out. (*Gains the door, pulls it open and crouches, half in, half out. In a culminating scream*) He's the savior of the world! He's the savior of—

(*The father, rushing him, lunges out fiercely with his foot, then slams the door and stands with his back against it, breathing heavily.*)

OLD JOHN: (*without, in diminuendo*): Ow— ow—ow—ow—

LODGER: There you are. There's a specimen. What you going to do with it?

FATHER (*Vindictively*): We're goin' to shut it up, that's what we're goin' to do with it. We're goin' to clean out this town, and give decent men a chance to breathe. (*He starts back slowly toward his couch, but halts in the middle of the floor with his eyes fixed on the window. For some time past it has been brightening by imperceptible degrees: now it shows a rectangle of dull red.*) Look! It's gettin' light already. Another day! Another day to work in. (*Stretches his arms out and yawns, ending with a groan*) Work, work—from before sunrise till after sundown. It aint too much fun. I'd like to lay abed 's well 's the next man: eat fine food; wear soft clothes. But God didn't put me in that place, an' God knows better'n I do. Listen! (*Moves nearer the window*) I hear the camels gruntin' up out of the Vale of Kedron, an' the watchman cryin' already from the wall beyond Damascus Gate. I got to hurry. A skin of wine— the pick o' the best. It's for the High Priest to-day. . . . Wife!

MOTHER: Yes, yes—I'm getting up.

(*Throwing a dark garment over her shoulders, she goes to take down from the wall the small lamp, fashioned of baked earth, with a wick floating in olive oil. This she sets on the floor near a large block of stone, hollowed in the center. Squatting before it and pouring a handful of grain into the hollow, she begins to beat it with a pestle, crooning a monotonous measure. Meanwhile the father gropes about near the couch.*)

FATHER (*complainingly*): Where's my coat gone to? Oh, I got it here. And now where's the wine-skin? Who's taken my wine-skin? Who put it behind the bed, I'd like to know. (*Moving toward the door, yawning and grumbling*) Have that ready, wife, when I get back. (*Shaking the boy's feet*) And as for *you*—you start work today for the tent-maker. You're too smart.

(*He opens the door wide. The dull flush of dawn comes in, showing the man clothed in a long, loose garment of rough material, striped with wide bands of brown and yellow. A fold of it covers his head, almost hiding his face. A long, gray beard lies on his chest. His legs, below the garment, are bare. He reaches outside the door for a pair of sandals and then stands gazing out, holding them in his hand. Over his shoulder is the empty wine-skin. . . . The room behind him, in the parts where the light penetrates, is shown quite stark and empty of furnishings, save for the pallets on the floor, a tall earthen water-jar, a few odds and ends of clothing and rugs, an open brazier, and the crude mill at which the woman is seated.*)

FATHER (*brooding*) : You might be a better town for a poor man, Jerusalem—and you might be a whole lot worse. Why can't they leave you alone, I wonder. We're all right. We get along somehow. It's the outsiders comin' in here. The outsiders. Men with nothin' depending on 'em—no responsibilities. Agitators! Why can't they stay—(*turning his head*) Where 'd this fellow come from, anyhow? Who is he? What 's he do?

LODGER : Oh, he's a carpenter—when he's working, that is. Comes from up Galilee way, they tell me—Nazareth, I guess. I don't know his name.

FATHER (*bitterly*) : Nazareth! That 's a good-enough town. Now why can't he stay up there, instead of botherin' us—stay up there and do his honest work in the world and have children and leave something behind him when he goes—something besides curses, and, maybe, a cross? I can't see. (*Shakes his head slowly*) I can't understand. (*Lifts his head and hitches the wine-skin to a more comfortable position*) Well! (*Goes out, closing the door.*)

(*For a moment, all that can be seen distinctly is the woman's head swaying rhythmically over the mill, sad and heavy. Her crooning is the only sound for a moment, and then the lodger begins to snore.*)

CURTAIN

Eugene O'Neill in Provincetown

Barbara Gelb

This is an excerpt from a talk given at "Beginnings: 1915, The Cultural Moment," in Provincetown, June 1987.

When Eugene O'Neill was discovered by the Provincetown Players in the summer of 1916, he was a rather elderly prodigy. He was nearly twenty-eight and still existing mainly on handouts from his actor father. James O'Neill had, in fact, all but given up hope of his son's ever being able to earn an honest living. The Provincetowners were, of course, the first to produce an O'Neill play—the poetic and for its time very original one-acter, *Bound East for Cardiff*. They were more astute, as it turned out, than the highly esteemed professor, George Pierce Baker, whose playwriting course O'Neill had taken a year earlier at Harvard. Baker told O'Neill that *Bound East* was not a play at all. True, it had no plot. It was a mood piece about a dying sailor, but it had something to say about man and God and the tragedy of life.

When the Provincetowners discovered O'Neill, he had actually been writing plays for three years, ever since being cured of tuberculosis in 1913, an event he regarded as his rebirth. Up to that time he seemed to have been squandering his life, driven by a sense of personal tragedy. Without realizing it, though, he was storing up the material of his plays. At twenty-five, he already had all the material he needed to write what many considered to be his final masterpiece, *Long Day's Journey into Night*.

The piercing portrait in that play of his mother Ella's drug addiction was something he had known and brooded about since he was fifteen. His profound nostalgia for the sea and its mystical meaning for him, tentatively displayed in the early sea plays like *Bound East*, were already part of his literary baggage by the time he was twenty-one, when he had been to sea both under sail and on steamships as an able-bodied seaman. His knowledge of alcoholism, as revealed in his portrait of the father and two sons in *Long Day's Journey*, had already been fully acquired and struggled with by the time he was in his early twenties. The twenty-four-year-old self he presents in *Long Day's Journey* had lived as a drunken derelict on the waterfronts of Buenos Aires and Liverpool and New York, had been hastily married and divorced, fathered a son he'd never seen, and been thwarted in a melodramatic suicide attempt.

From the very beginning, O'Neill wrote out of personal knowledge and what he was pleased to call Life Experience. He wrote like a novelist, rather than like the conventional playwrights of the period. And that was what misled Professor Baker into shortsightedly dismissing *Bound East for Cardiff* as "not a play."

The Provincetowners didn't know the details of O'Neill's tragedy-haunted life, but to their great credit they instantly recognized his tormented genius and the originality of his talent, and they declared themselves ready to nurture it. They realized that, like themselves, O'Neill saw the possibilities of theatre as a forum for serious ideas by American writers.

In 1956, three years after O'Neill's death, my husband and I began to research his life. It's hard to realize now how little was known at that time about O'Neill and about the inspiration for his plays, including what the Provincetown experience meant to him. After his marriage to Carlotta Monterey in 1929 he seldom spoke of his Provincetown

years, because Carlotta disliked hearing him speak of anything connected with Agnes Boulton, the wife who had preceded her. An elegant and rather snobbish woman, Carlotta also didn't much like hearing about O'Neill's Bohemian life-style, about his drinking sprees, or about the friends to whom he'd been close both personally and professionally during the Provincetown years.

Provincetown was home to O'Neill in both the physical and spiritual sense for nearly nine years. It was where he met some of the most challenging and emotional experiences of his life. Apart from providing him with his first production, it was where his love affair with Louise Bryant began, an ill-fated triangle romance that inspired his first long play, *Beyond the Horizon* (1918). O'Neill was married in Provincetown to his second wife, Agnes, and that was where she gave birth to their first child, Shane—in an apartment on Commercial Street. While living and working in Provincetown, O'Neill finally became reconciled with his father, James, who presented him with a house on Peaked Hill Bar in 1919, the old coast guard station that became Eugene's summer home for the next eight years. James bought the house from Mabel Dodge, who had renovated it and beautifully decorated it. O'Neill had coveted it ever since he first saw it.

It was here in Provincetown that O'Neill wrote his first really popular play, *Anna Christie* (1920), as well as the two experimental works that earned him international fame, *The Emperor Jones* (1920) and *The Hairy Ape* (1921). It was here, too, that O'Neill received the news of his first Pulitzer Prize, for *Beyond the Horizon*, and his second, for *Anna Christie*.

I'll never forget the first time my husband and I hiked across Snail Hill Road over the dunes to Peaked Hill Bar. The house itself had been washed into the Atlantic in 1931, of course, but we wanted to see why O'Neill felt so deeply and contentedly at home there. "I feel a true kinship and harmony with life out here," O'Neill told an interviewer, fore-shadowing a speech by Edmund Tyrone in *Long Day's Journey into Night*: "Sand and sun and sea and wind, you merge into them and become as meaningless and as full of meaning as they are. There is always the monotone of the surge on the bar, a background for silence. And you know you are alone. So alone. You wouldn't be ashamed to do any good action."

It was easy to understand O'Neill's sense of exaltation. It was less easy to understand the periodic drunken binges when he would go roaring into town and drag Agnes back across the dunes by her hair. The early years with Agnes, although sometimes stormy, were mostly loving and mutually supportive, and certainly productive for O'Neill creatively. During those years he wrote, in addition to the well-known plays I've already mentioned, two daringly experimental and highly controversial works, *All God's Chillun Got Wings* (1923), in which he called his two embattled protagonists by the actual given names of his parents, Ella and Jim, disguising them as a schizophrenic white woman married to a loving but defeated black man; and *The Great God Brown* (1925), in which he used masks, a play that even today can be considered avant-garde.

In early 1918, although in love with Agnes and planning to marry her, O'Neill suffered over having lost Louise Bryant. The affair with Louise began in Provincetown in the summer of 1916 when she was living with John Reed (though not yet married to him). Reed, who knew O'Neill from Greenwich Village, had come to Provincetown the summer before and been caught up in Jig Cook's enthusiasm for a new kind of theatre. It was Reed who suggested that O'Neill come to Provincetown. Louise had run away from her husband, a dentist in Portland, Oregon, to join Reed. She had ambitions as a writer and hoped to learn from Reed, who was at that time regarded as the boy wonder of journalism for his vivid coverage of the Colorado coal miners' strike and the Mexican Revolution.

O'Neill lived in a shack across the road

FIGURE 142. *Left foreground: Eugene O'Neill; right foreground, Wilbur Daniel Steele. Courtesy Peter Steele.*

from Louise and Reed and he took daily swims far out to sea. Louise would watch him from the beach, very impressed with his prowess as a swimmer. Reed was fitfully ill with a chronic kidney ailment that summer and when he felt well he was frequently away on a magazine assignment. Louise was lonely and restless and she would often wait for O'Neill on the beach and try to engage his interest. O'Neill was in love with her but out of loyalty to his friend, Reed, he tried to avoid her.

Finally, one day, Louise cornered him and confided that because of Reed's illness they lived together as brother and sister. O'Neill accepted the story and felt justified in becoming Louise's lover. To Louise, O'Neill's need of her was the justification for her faithlessness to Reed. Reed, she told herself, though temporarily out of commission, was successfully established in his career, whereas O'Neill was only just beginning to feel his way as a playwright and needed, she

truly believed, her tender support and encouragement.

O'Neill, I discovered, as I tracked his successive romances, was very good at making women feel he needed them. He persuaded Agnes Boulton that he needed her to make him forget Louise. And later he convinced Carlotta Monterey that he needed her to get him away from Agnes Boulton—and a houseful of demanding children—into an atmosphere of creative peace and isolation.

O'Neill cast Louise and himself in his one-act play *Thirst* (1914), which the Provincetowners presented later in that summer of 1916. The action took place on a life raft at sea, with O'Neill playing a West Indian mulatto sailor disinclined to conversation, and Louise playing a thirst-crazed and exceedingly garrulous dancer, as his only fellow survivor on the raft. While the dancer pleaded with the sailor for water she thought he was hoarding, he eyed her hungrily with a view toward dining on her.

FIGURE 143. *Louise Bryant, Provincetown, 1916. Bryant sent this photograph to John Reed, writing on the back, "This is to remind you of 'The Dunes' and all the nice months after the convention." John Reed Collection, Houghton Library, Harvard University.*

Though he may have had some misgivings as to how it would all end, O'Neill was painfully happy with Louise, and, as always, dramatized his great love. "When Louise touches me with her fingernail," he told a friend exaltedly, "it's like a prairie fire." In the end, it was Louise's ambition for a career and her thirst for adventure that ended the affair. Reed was going to Russia to cover the revolution and she couldn't resist the chance to accompany him and be in on what promised to be the story of the century. It was in the year that O'Neill lost Louise that he wrote *Beyond the Horizon*, about two brothers living on a farm who are both in love with the same girl.

O'Neill seldom wasted the material of his own life. He knew perfectly well that, although autobiography in the guise of the novel was an accepted literary convention, the theatre of his time—except for some European imports—was rarely literary. Farce, lurid melodrama, and musical reviews were what American playwrights turned out. Using the fabric of his own life as filtered through his innately tragic vision, O'Neill transformed American drama.

When *Beyond the Horizon* was produced on Broadway in 1920, critics who saw the play were aware that something out of the ordinary had happened. It was the first play by an American writer that combined naturalism and tragedy with native characters and contemporary language. Uncharacteristically, it employed no melodramatic tricks, nor did it rely on coincidence. It was built upon the development of character and it scorned plot for plot's sake.

To O'Neill's great personal satisfaction, even his father, who had grown up and made his career in the old-fashioned theatre that O'Neill was trying to replace, was deeply moved by the play and finally came to appreciate his son as an artist.

From Provincetown, where reporters were now beginning to seek him out, O'Neill tried to explain what his philosophy of drama was and how it had developed. It was a significant statement by a young writer at the beginning of his career and it had its effect, even then, on a handful of younger writers who began to think in terms of serious drama: men like Sidney Howard and Elmer Rice, who did not have the advantage of the Provincetowners' nurturing support and encouragement to experiment.

O'Neill said, "I have never written anything which did not come directly or indirectly from some event or impression of my own." He went on to explain the basic philosophy that was to dominate all his future work and that can still, in these materialistic times, serve as a guidepost to aspiring artists. "I have an innate feeling of exultance about tragedy," he said. "The tragedy of man is perhaps the only significant thing about him. What I am after is to get an audience to leave the theatre with an exultant feeling from seeing somebody on the stage facing life, fighting against eternal odds, not conquering but perhaps inevitably being conquered. The individual life is made significant just by the struggle."

Agnes Boulton was the dominant woman in O'Neill's life during his Provincetown years, even though she began her life with O'Neill feeling somewhat insecure because of Louise Bryant. Agnes didn't know when she first met O'Neill that she was catching him on the rebound from Louise. She turned up in Greenwich Village in the fall of 1917. That was where the Provincetowners had recently established The Playwrights' Theatre, where O'Neill was beginning to be seen by such influential critics as Alexander Wolcott. Agnes was twenty-four, four years younger than O'Neill, and she resembled Louise with her dark hair, gray-blue eyes

FIGURE 144. *Agnes Boulton and Eugene O'Neill, Provincetown, 1915. Courtesy Peter Steele.*

and Bohemian style of dress. By this time, Louise had left for Russia with Reed and O'Neill was suffering over her loss very publicly and dramatically. The Provincetowners were concerned about his state of mind. They were urging him to leave Greenwich Village, where there were too many distractions and too much temptation for O'Neill to go on drunken binges. They were hoping he would go back to Provincetown to write them a full-length play to produce.

But O'Neill lingered in the Village, simultaneously courting Agnes and suffering from a broken heart over Louise. Then, in January of 1918, something happened that shocked O'Neill out of his self-indulgent posturing and creative procrastination and led to his flight back to Provincetown and his more or less permanent residence there for the next half-dozen years.

Trying to piece together this episode from interviews with O'Neill's Provincetown and Greenwich Village friends, I found they were still, nearly half a century later, almost

afraid to recall what had happened. An old and valued friend of O'Neill's named Louis Holliday returned to the Village. Holliday, who had spent the summer of 1916 in Provincetown with O'Neill, had left New York at the urging of the young woman he loved to try and cure himself of drinking and to find dependable work, away from the temptations of the city, that would enable them to marry. Holliday had quit drinking and found his vocation in farming, and now he was back to claim his girl and to take her out West with him. He invited his friends to celebrate and on January 22 they gathered at a favorite saloon nicknamed the Hell Hole— O'Neill, Agnes and other old friends, including Dorothy Day, a young, fun-loving newspaper reporter who admired the experimental work of the Provincetown Players and who was half in love with O'Neill herself. Also present was an older man named Terry Carlin, a self-styled intellectual anarchist, who had attached himself to O'Neill. In fact, it was Carlin who had accompanied O'Neill to Provincetown in the summer of 1916 and had shared a shack with him. Carlin, who was disliked by many of O'Neill's friends, became a fixture of O'Neill's Provincetown household in later years and was memorialized by O'Neill as the cynical and amoral Larry Slade in *The Iceman Cometh* (1939).

Everyone except Carlin was dismayed to find Louis Holliday drinking again. After a while, Holliday announced that his girl had fallen in love with someone else. Holliday was an introverted man and his friends couldn't tell just how hard he was taking the loss. The only one who knew was Terry Carlin. The party went on, everyone, of course, trying to console Holliday and cheer him up, everyone except Carlin. Sometime during the evening, at Holliday's request, Carlin supplied him with heroin. Everyone knew that Carlin occasionally used heroin as well as other drugs. He was, however, the exception among O'Neill's friends, who mostly confined themselves to bouts of heavy drinking. It was entirely within

Carlin's code of ethics to provide a friend with what he knew could be a lethal dose. If someone wanted to kill himself, Carlin saw no reason to try to prevent him.

The party moved from the Hell Hole to another favorite local dive, Romany Marie's, where Holliday began to look ill and where O'Neill found out about the heroin. Terrified and feeling completely helpless, O'Neill bolted, followed by Agnes. Dorothy Day, thinking she could be of help, stayed on. A little before six-thirty in the morning Holliday, foaming at the mouth, collapsed at a table. An ambulance was called, but Holliday was dead before it arrived. His sister, who had been summoned, told the ambulance driver that Holliday had suffered from a weak heart and the doctor obligingly diagnosed the cause of death as heart failure. The police accepted the diagnosis. But for a time, many of Holliday's friends, including O'Neill, were in fear of a police investigation.

The episode had an appalling effect. The abrupt, senseless end of a life that had been filled with vitality and hope became to O'Neill and his friends an omen of disaster. They suddenly felt mortal and threatened. Probably the person most affected was Dorothy Day. She fled from the Village, threw herself into a nursing career, and converted to Catholicism. Later she established what became a famous Catholic mission house in lower Manhattan. Dorothy Day, incidentally, was one of several women from whom O'Neill drew bits of personality to form the composite character of Nina Leeds, the Everywoman of *Strange Interlude*, which he began writing in 1926 shortly before he turned his back on Provincetown for good.

O'Neill himself, as a result of Holliday's death, plunged into drunkenness. And Holliday's death became a painful memory that he carried with him always. When he finally roused himself from his drinking bout, he had come to a decision. No one was surprised when he packed his things and left for Provincetown. It was soon after that he be-

gan work on *Beyond the Horizon*. He knew at this point in his life that he desperately needed the Provincetowners and Provincetown. He needed their acceptance and understanding in order to believe in himself. In the atmosphere of artistic freedom that they created no one was judged, no one was shocked. O'Neill was free to explore the themes that interested him. What interested him was the motive behind the action, even if that action was, as in *Desire Under the Elms* (1924), infanticide, or, as in *Mourning Becomes Electra* (1931), incest.

The Provincetowners embraced him, encouraged him, and helped him to crystallize and articulate his philosophy. "I love life," O'Neill said, "but I don't love life because it is pretty. Prettiness is only clothes deep. I am a truer lover than that. I love it naked. There is beauty to me even in its ugliness. In fact, I deny the ugliness entirely, for its vices are often nobler than its virtues and nearly always closer to a revelation." In giving O'Neill his arena, the Provincetowners guaranteed their own immortality.

NOTES ON CONTRIBUTORS

ADELE HELLER is producing director of the Provincetown Playhouse on the Wharf, Provincetown, Massachusetts. She is editor of the newly reissued Provincetown chronicle *Time and the Town*, by Mary Heaton Vorse (Rutgers University Press, 1991).

LOIS RUDNICK is associate professor of English and director of the American Studies Program, University of Massachusetts/Boston. She is the author of *Mabel Dodge Luhan: New Woman, New Worlds* (University of New Mexico Press, 1984) and *Utopian Vistas: A Cultural History of the Mabel Dodge Luhan House, 1918–1990* (University of New Mexico Press, 1993).

JOHN BUENKER is professor of history at the University of Wisconsin/Parkside. Author of numerous books and articles on the Progressive Era, he has most recently written *The Historical Dictionary of the Progressive Era* (Greenwood Press, 1989).

EUGENE E. LEACH is associate professor of history and American studies at Trinity College, Hartford, Connecticut. He is currently collaborating on a book that explores the representation of mobs and masses in American history. His most recent publication is "'Just Human Atoms Massed Together': The Evolution of Mass Society Theory from Ortega y Gasset To Riesman and Mills," *Mid-America* 71 (January 1989).

ERNEST ALLEN, JR., is associate professor of Afro-American studies at the University of Massachusetts/Amherst. He has published "The Inner, the Outer, the Other: Conceptions of Double Consciousness in Du Bois' *The Souls of Black Folk*," *Contributions in Black Studies* (No. 9, Fall 1990). He is coeditor of the *Encyclopaedia of the Black Freedom Struggle* (Garland Press, 1993).

ELIZABETH AMMONS is professor of English and of American studies, Tufts University. Ammons is author of many articles on American women's literature, and her books include *Edith Wharton's Argument with America* (University of Georgia Press, 1980), and *Conflicting Stories: American Women Writers at the Turn into the Twentieth Century* (Oxford University Press, 1991).

ELLEN KAY TRIMBERGER is professor and coordinator of women's studies at the University of California/Sonoma. She has written on women's history and culture, and her most recent publication is *Intimate Warriors: Writings from a Modern Marriage, 1899–1940* (The Feminist Press, 1991).

JOHN C. BURNHAM is professor of history and lecturer in psychiatry at Ohio State University. His most recent books are *How Superstition Won and Science Lost* (Rutgers University Press, 1987) and *Paths into American Culture: Psychology, Medicine, and Morals* (Temple University Press, 1988).

SANFORD GIFFORD is associate clinical professor at the Harvard Medical School, librarian of the Boston Psychoanalytic Institute, and author of numerous works on the history of psychoanalysis. His most recent work is "Freud's Fearful Symmetry," in *Further Reflections on the Life and Death Instinct: Psychoanalysis and the Nuclear Threat*, edited by Howard B. Levine and others (The Analytic Press, 1988).

FRED MATTHEWS is associate professor of history and humanities at York University, Ontario, Canada. He is author of several works on the social sciences in American history, including *The Quest for an American Sociology* (McGill-Queens, 1977). His most recent publication is "The Attack on Historicism: Allen Bloom's Indictment of Contemporary American Historical Scholarship," *American Historical Review* (No. 95, April 1990).

MARTIN GREEN is professor of literature, Tufts University and the author of numerous books on

English and American cultural history. His recent publications include *New York, 1913: the Armory Show and the Paterson Strike Pageant* (Charles Scribner's Sons, 1988) and *The Mt. Vernon Street Warrens* (Macmillan, 1990).

MILTON W. BROWN is resident professor in art history at the Graduate Center, City University of New York. Former Kress Professor at the National Gallery of Art, Washington, D.C., he is author of numerous works on American art, including *The Story of the Armory Show* (Abbeville Press, revised edition, 1988).

EDWARD ABRAHAMS is Executive Assistant to the President and Director of Government Relations, Clark University. He is author of *The Lyrical Left: Randolph Bourne, Alfred Stieglitz and the Origins of Cultural Radicalism in America* (University Press of Virginia, 1986).

REBECCA ZURIER is the Schragis Faculty Fellow in Fine Arts at Syracuse University. She is the author of *Art for the Masses: A Radical Magazine and Its Graphics, 1911–1917* (Temple University Press, 1988).

MARY C. HENDERSON is a theatre historian, lecturer, and writer. She is former curator of the Theatre Collection of the Museum of the City of New York. Among the books she has written is *Theatre in America* (Harry N. Abrams, Inc., 1986).

ROBERT K. SARLÓS is professor of dramatic art at the University of California, Davis. He has contributed to numerous theatre publications and is the author of *Jig Cook and the Provincetown Players: Theatre in Ferment* (The University of Massachusetts Press, 1982).

BARBARA GELB is the author, with her husband, Arthur Gelb, of the biography *O'Neill* (Harper and Row, first published in 1962, revised and enlarged in 1973).

Index

Page numbers in italics refer to illustrations or captions.